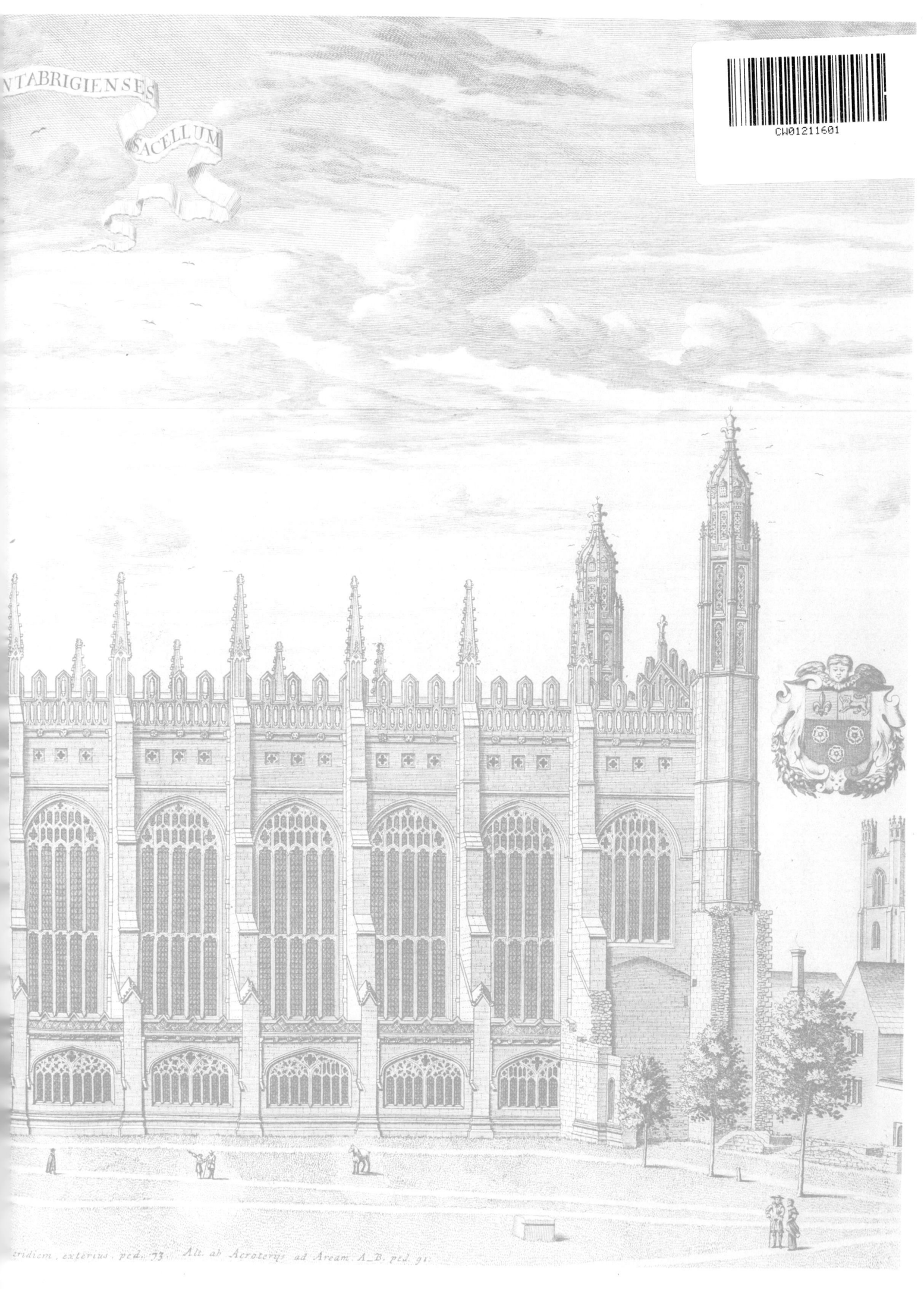

KING'S
COLLEGE
CHAPEL
1515–2015

KING'S
COLLEGE
CHAPEL
1515–2015

ART, MUSIC AND RELIGION
IN CAMBRIDGE

Edited by Jean Michel Massing
and Nicolette Zeeman

HARVEY MILLER PUBLISHERS

HARVEY MILLER PUBLISHERS
An Imprint of Brepols Publishers
London / Turnhout

British Library Cataloguing in Publication Data
A catalogue record for this book is available
from the British Library

ISBN 978-1-909400-21-4
D/2014/0095/176

© 2014 The Authors

All rights reserved.
No part of this publication may be reproduced,
stored in a retrieval system, or transmitted in any form
or by any means, electronic, mechanical, photocopying,
recording or otherwise, without the prior permission
in writing from the publishers.

Design and production: BLACKER DESIGN, East Grinstead, Sussex
Printed and bound in China on behalf of LATITUDE PRESS

FRONT COVER: Portcullis boss, vault of King's College Chapel, Cambridge. Mike Dixon, photograph, 2011.

BACK COVER: Buttress sculptures, west end of the south elevation of King's College Chapel, Cambridge. Mike Dixon, photograph, 2011.

Ill. 1. FRONTISPIECE: Henry Storer, *The Gateway, Old King's*, 1828, watercolour, 39.3 x 32.1 cm. Cambridge, King's College.

Contents

	Acknowledgements	7
	Introduction Jean Michel Massing and Nicolette Zeeman	9
	Chronology	19

Fabric and Furnishings

I	King's College Chapel: Aesthetic and Architectural Responses Jeremy Musson	25
II	The Structure and Construction of the Chapel John Ochsendorf and Matthew DeJong	63
III	Glassy Temporalities: The Chapel Windows of King's College, Cambridge James Simpson	79
IV	Provost Robert Hacumblen and his Chantry Chapel Nicola Pickering	97
V	The Altarpieces in the Chapel of King's College, Cambridge Jean Michel Massing	115
VI	The Great Glass Vista: A Condition Survey of the Stained Glass in King's College Chapel Stephen Clare	135

Life and Visiting

VII	The College and the Chapel Peter Murray Jones	161
VIII	A Spanish Choirbook and Some Elizabethan Book Thieves Iain Fenlon	181

IX	The Chapel Imagined, 1540–1830 Nicolette Zeeman	199
X	The Start and Stop of Simeon Ross Harrison	221
XI	Drama in King's College Chapel Abigail Rokison	241

Music and Performance

XII	Chapel and Choir, Liturgy and Music, 1444–1644 Roger Bowers	259
XIII	The Chapel Organ – A Harmonious Anachronism? John Butt	287
XIV	'As England knows it': 'Daddy' Mann and King's College Choir, 1876–1929 Nicholas Marston	303
XV	'A Right Prelude To Christmas': A History of *A Festival of Nine Lessons and Carols* Nicholas Nash	323
XVI	'The Most Famous Choir in the World?' The Choir since 1929 Timothy Day	347
	Epilogue: The Sound of the Chapel Stephen Cleobury and Nicolette Zeeman	364
	Notes to the essays	368
	Select bibliography	404
	Contributors	406
	List of illustrations	409
	Copyright acknowledgements	416
	Index	417

Acknowledgements

THERE IS PROBABLY NO CONTRIBUTOR who would not wish us to express our huge debt of gratitude to Patricia McGuire, the King's College Archivist, both for her great knowledge of the College Archive and for her tireless labour in searching out the documents, books and images that have been essential in putting this volume together. With his deep and wide-ranging understanding not only of the Archive, but also of the history of the College, Peter Jones, the College Librarian, has been an invaluable source of information and advice; we also thank him for reading through almost every essay published here. Nicholas Marston too has read essays and provided crucial advice on musical matters. We are also grateful to Ann Massing for her generosity with her time and meticulous care in helping us prepare the text. Many of the marvelous photographic reproductions that appear in this volume are due to the extraordinary photographic skill and patience of Adrian Boutel and Elizabeth Upper, and we thank them. We also acknowledge Elizabeth's heroic work on the collation and documentation of the illustrations, the excellent work of Johannes Wolf on the index, and the help of Peter Monteith in the Archive. The King's College Director of Development, Julie Bressor, and the First Bursar, Keith Carne, have throughout been wonderfully supportive of this project, for which we thank them. Finally, we have to say what a great pleasure it has been working with Johan van der Beke, Elly Miller and Mike Blacker at Harvey Miller.

Editors' note

The Notes to the Essays in this volume are all placed together at the end of the text on pp. 368 to 403. The abbreviation KCA found in the notes refers to the Archive of King's College, Cambridge.

Ill. 2. Jan Stradtmann, *Night Climbers of Cambridge*, from the series Night Climbers of Cambridge, 2007, digital photograph.

Introduction

JEAN MICHEL MASSING AND NICOLETTE ZEEMAN

THIS COLLABORATIVE VOLUME has been compiled in celebration of the five hundredth anniversary of the completion of the stone fabric of King's College Chapel, Cambridge (thought to have occurred in 1515, when College payments to the stone masons cease). The spectacular size and form of the Chapel – far too grand even for Henry VI's enlarged plan for a College of seventy Fellows – reveal that this was always a royal project whose horizons extended beyond the devotional servicing of a single Cambridge college. The long history of the Chapel, to which this book is a contribution, reveals the strikingly various individuals and social groups, both within the College and outside it, who have participated in its ritual and performative life, left their mark on its fabric, or simply visited and enjoyed it. *King's College Chapel 1515–2015: Art, Music and Religion in Cambridge* contains essays that focus respectively on the changing function and furnishing of the Chapel (*Fabric and Furnishings*), activities within the Chapel and external interest in it (*Life and Visiting*) and, finally, its musical scene (*Music and Performance*). The aim of the volume is not to revisit well-worked areas of the Chapel's early history, such as the detail of the construction of the building or its stained glass, but to explore in a series of new studies the ways that its religious, cultural and artistic history has developed and changed, often in radically different ways, over the last five hundred years.

One of the most notable features of the history that emerges from these essays is the sense that the Chapel has never been 'finished'. It is clear that plans for the original medieval building altered over the history of its construction (the seeming contradiction of the high walls that continue above the windows and a fan vaulting that springs from points much lower down on the walls, for example, has usually been seen as evidence that it was planned originally for the Chapel to have a beamed wooden roof attached to the walls above the windows). Other aspects of what is likely to have been the medieval scheme – saints in the internal niches, polychromy on some of the stonework – were also never constructed. While other features, such as the sixteenth-century windows and rood (and later organ) screen, did indeed complete other elements of what must have been the medieval scheme, they did so in forms that were entirely of the sixteenth century, and, as James Simpson makes clear in this volume, substantially in tension with emerging Reformation trends in ritual practice and ideology. Similarly, in the context of the original Chapel, the organ that today dominates the building, a combination of elements that derive from many periods, can only be seen as what John Butt calls 'a harmonious anachronism'. The Chapel is home to a series of splendid altar paintings of strikingly different historical moments and styles, while the function of its eighteen side chapels (such as that of Provost Hacumblen, described here by Nicola Pickering) have also altered over the years. Jeremy Musson documents the history of the many rearrangements and refurbishings of the east end, showing how debates about the area oscillated between questions of ritual practice and artistic aesthetics, and excited responses that ranged from the empassioned to the vituperative,

or to the downright jaded. While in the later nineteenth century Thomas Carter could lambast Essex's elegant and decorative eighteenth-century-gothic panelling as 'a masterpiece of extravagance and bad taste', the antiquarian and Provost M. R. James could describe, in a manner still recognisable today, the difficulty of securing agreement 'on a question of taste' among the Fellowship: 'everybody has an opinion: they are "not experts", they "know nothing about it", they "only know what they like"'. Such history provides crucial contexts in which to understand the long-running and immensely heated debates about the 1960s alterations to the east end, and the placement of Rubens' *Adoration of the Magi* behind the altar. We might note too that questions about the Chapel's fabric have also always been questions about restoration and preservation; John Ochsendorf, Matthew DeJong and Stephen Clare describe some of the new techniques available today for the analysis and care of the stonework and windows, but they also reveal that, even in the Chapel, many such procedures have their own history of controversy.

The history of music in the Chapel has its own tale to tell of constantly altering religious practices and musicological values. Roger Bowers documents the immense richness of the music sung in the first hundred years of the Chapel's existence, but he also charts by the 1630s and 1640s an apparent decline in the quality of the singing, symptomised in reduced levels of care and financial investment expended on the Choir in the same period. His observation that by the mid-seventeenth century the singing men included 'no gentlemen or graduates', but several 'scholars' servants' is suggestive about the social status of the Choir from this period onwards. Bowers' chapter also connects directly with the essays of Nicholas Marston and Nicholas Day, which chart a gradual reversal in this state of affairs in the later nineteenth century and first half of the twentieth; lay clerks were slowly replaced by students, while choristers, no longer the sons of College servants, came increasingly to be derived from more affluent social backgrounds and schools. A new, outwardly directed perspective, both in terms of ritual and performance, is exemplified in Nicholas Nash's history of the *Festival of Nine Lessons and Carols*, a service established in the aftermath of national and collegiate losses in the First World War by Dean Eric Milner-White, who had spent the war at the front. The role of a series of twentieth-century musical directors in the honing of the Choir's distinctive 'immaculate' sound and, increasingly, in the commissioning of a long line of new works for the Choir from contemporary composers continues to work in creative engagement with the enormous popular outreach of the Choir, not least in the *Nine Lessons and Carols*, annually broadcast round the world.

Constant change, and also a variety of levels of engagement with the secular world, are manifest in many other aspects of the life of the Chapel. Indeed, Ross Harrison's study of the evangelical preacher and Fellow of King's, Charles Simeon (1759–1836), provides striking evidence that religion as practised in the Chapel around the turn of the nineteenth century did not meet the piety or intensity demanded by a worshiper of Simeon's intensity. And yet he, like a good number of other King's Fellows, is buried here. Equally important, as Peter Jones documents, the Chapel has always been a place where the College has conducted central academic functions – in the early centuries royal visitations, university inspections and academic debates, throughout its history the election of the Provost, and more recently the admission of College Fellows. Until the nineteenth century the Chapel also housed the College Library, including the Cadiz Choirbook, brought back by Robert Devereux, the Earl of Essex, from his Cadiz expedition in 1596 – the implications of which are explored here by Iain Fenlon. Indeed, this was not the only moment that the Chapel was deemed a suitable site for the display of military propaganda: quite apart from its general plethora of aristocratic heraldry, in the eighteenth century military colours seized at Manila in 1763 were displayed on the altar rails. Essays collected here also reveal that, although the huge numbers of people who visit the Chapel today are unparalleled, the

INTRODUCTION

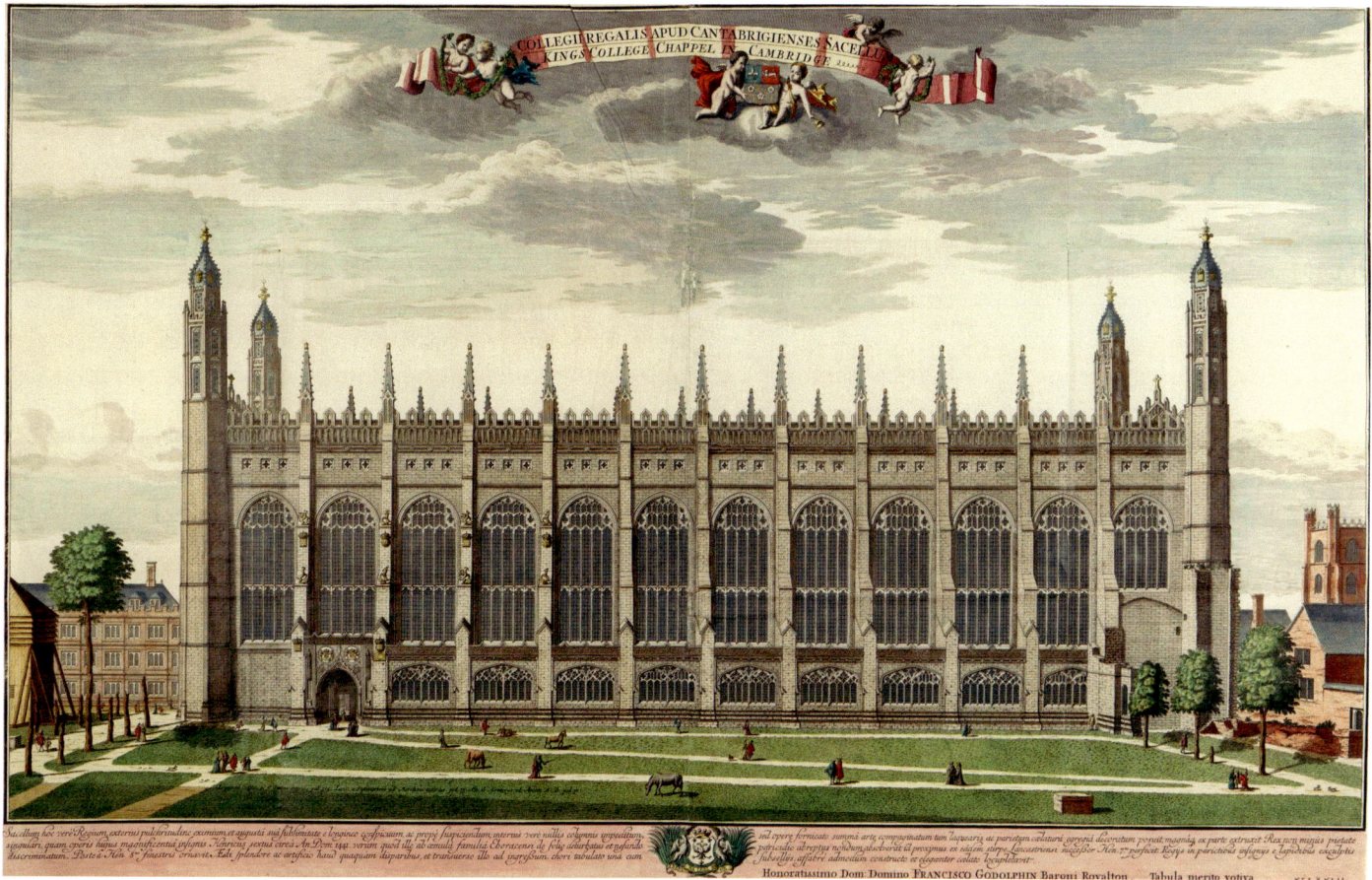

Ill. 3. *Collegii regalis apud Cantabrigienses Sacellum/King's College Chapel in Cambridge*, c.1706-12, engraving with hand-colouring, 64.0 x 97.2 cm. Cambridge, King's College, KCC/123 (KCAR/8/1/1/7).

Chapel and its roof have long been a destination for British, European and royal visitors. It has also been a venue for all kinds of performative activities, not only academic, religious and musical but also dramatic; however, as Abigail Rokison shows here, the echo that is part of the Chapel's distinctive accoustic has always posed problems for theatre in the Chapel, just has it has done for readers and preachers – and for the early radio broadcasts.

Although the Chapel is a building in a league of its own, its changing history nevertheless reveals it always to have been something of a barometer of contemporary religious and social, aesthetic and musical practices and values. Today it is a place of worship famous for its celebrated Choir, a space used for concerts and a monument admired every year by a hundred thousand visitors. It is also still a meeting place of the College Fellowship for crucial decisions such as the admission of Fellows and the election of the Provost. The writing of the history of the Chapel is, of course, far from complete. We still await studies of the splendid woodwork of the screen and choir stalls, and the early graffiti that appears both in the choir and in the tower stairs and roof space; there is probably more to be said about the politics of the Chapel's foundation, the visit of Queen Elizabeth I, Chapel life and music in the eighteenth century, and the Chapel's appearance in the literature of later centuries. We believe, however, that the diverse history that emerges in this volume is more than a start.

* * *

11

In the first chapter, 'King's College Chapel: Aesthetic and Architectural Responses', Jeremy Musson ranges widely over the history of the aesthetic reception of the Chapel and its place in the historical understanding of Gothic and Renaissance architecture. He notes that from the start this royal foundation seems to have been considered a building of national importance; he charts its impact on the surrounding architectural landscape and shows that debates about the nature of the Chapel continue in subsequent centuries to shape architects' thought about how to build the rest of the College around it. Turning to the complex history of the Chapel's interior refurbishments, Musson documents the degree to which arrangements at the east end were in the early centuries at the mercy of constant changes in the theology and ritual practice of the Reformation and post-Reformation English Church. This is not to say that aesthetic categories did not also shape decisions about the Chapel furnishings even then – the employment of Flemish glassmakers on the windows and woodcarvers from the Netherlands on the screen, both working in the latest styles, are sufficient evidence of this. However, recognisably art-historical concerns increasingly make their presence felt in later debates about the refurbishment of the Chapel, such as the eighteenth-century discussion about whether to have a Gothic or Neoclassical altar. Although in 1775 the College chose to affirm the Chapel's gothicism by installing Essex's reredos, whose pinacles echoed the external profile of the Chapel, by the early twentieth century the tide had turned in favour of a Renaissance Chapel, and Detmar Blow's replacement reredos was designed to speak to the sixteenth- and seventeenth-century woodwork of the screen and stalls. As Musson shows, one anxiety that beset twentieth-century debates about the final important refurbishment of the Chapel in the 1960s was whether or not aesthetic considerations had overtaken religious ones; the result of these debates, of course, was a much cleaner, sparer, modernist Chapel, but one substantially organised round the central altar, as the Founder would have wished, and a major seventeenth-century painting.

'The Structure and Construction of King's College Chapel', is the only essay centered on the stone fabric of the building. Here, John Ochsendorf and Matthew DeJong study the construction of the fan vaulting (built between 1512 and 1515), with its complex geometry and daring thinness, before analysing the structural design and the stability of the vault. They revisit previous studies, including that of William Bland (1839) and those of Jacques Heyman (ranging over many decades), but use contemporary engineering analysis methods and three-dimensional laser scanning to review the structural action of the vaults. Despite the still very real challenges involved in this project even today, they conclude that the fundamental structure of the Chapel is impressively resilient.

James Simpson, 'Glassy Temporalities: The Chapel Windows of King's College, Cambridge', explores the stained glass in its historical moment. He argues for the conceptual and visual dynamism of its particular version of traditional medieval 'typology', whereby the two scenes from the lives of the Virgin Mary, Christ and the apostles in the lower part of each window are 'prefigured' by two Old Testament scenes above. He then explores the paradoxical fact that these windows were created and completed in the decades running up to the English Reformation, decades in which thinkers such as Luther and Tyndale were formulating attacks on almost everything that the windows represented – not only their allegorical schemes but also any kind of Church imagery at all. As many have acknowledged, the arrival of iconoclasm in England between 1536 and 1559, and its recurrence over the next hundred years, make the survival of these windows truly amazing.

In 'Provost Robert Hacumblen and his Chantry Chapel', Nicola Pickering looks at the work of Robert Hacumblen, Provost from 1509 to 1528. Not only a scholar and composer, Hacumblen was also closely involved in the completion and the glazing of the Chapel, probably advising Richard Foxe on the iconography of the large windows and overseeing the actual glazing. He is best known for the

gift of the Chapel's monumental Netherlandish lectern that proudly carries his name ('Robertus Hacumblen'), but the best testimony of his faith is the side chapel that still contains his tomb, as well as quite a bit of the glazing and woodwork that he commissioned. The rich iconography of the surviving work undoubtedly reflects the traditional and intensely affective nature of his religion, including his devotion to the saints, the Virgin Mary and the passion of Christ – this last emblematised by a pervasive emphasis on the wounds of Christ. His side chapel offers distinctive evidence for devotion and patronage at the cusp of the late medieval and early renaissance periods.

In 'The Altarpieces in the Chapel of King's College, Cambridge', Jean Michel Massing traces the religious, liturgical and artistic changes that have transformed the Chapel over the last five hundred years as expressed in the Chapel's altarpieces. The earliest altar, completed by Master Mason John Wastell in 1515, was succeeded in 1544–45 by a monumental sculpted altar attributed to a 'Master Antonio', complete with a column and four reliefs for the canopy; if Reformation concerns are reflected in the installation of a table of the Ten Commandments at the altar in 1561–62, they are less in evidence in 1564 when Queen Elizabeth visited the Chapel and the altar was hung about with tapestries. In line with the new interest in painted altarpieces that emerged in the later eighteenth-century Anglican Church, Thomas Orde, 1st Lord of Bolton, commissioned a *Mater dolorosa* from George Romney, but the commission was superseded when Frederick Howard, 5th Earl of Carlisle, gave the College a grand Italian altarpiece, Girolamo Siciolante da Sermoneta's *Deposition of Christ* (1568–72). This was displayed within James Essex's neo-Gothic panelling until 1907, when the panelling was replaced by an inferior scheme, that of Detmar Blow and Fernand Billerey – itself finally removed for the present unpanelled arrangement. In 1961, Major Allnatt gave the College Rubens's great *Adoration of the Magi* (1633) and two years later A. C. H. Parker-Smith gave the College a *Virgin and Child with the Young John the Baptist* by Carlo Maratta (1625–1713) and studio.

The two other paintings given in recent times were more of a period with the original Chapel. In 1931, C. R. Ashby donated *The Madonna in the Rosary* (1512–1520) by a Westphalian painter, Gert van Lon, which he hoped to make the centre of a proposed remodelling of Provost Roger Goad's side chapel into a Founder's Chapel. Today, as Massing details, things are different again. Today, the Siciolante is on the west wall of this chapel. Above the altar is a splendid Antwerp altarpiece, with the *Adoration of the Magi* on the central panel, the *Nativity* with the Shepherds and the *Flight to Egypt* on the wings, by the so-called Master of the Von Groote Adoration. This was given by P. K. (Sunny) Pal (King's College 1955) and his family in 2010.

Stephen Clare's 'The Great Glass Vista: A Condition Survey of the Stained Glass in King's College Chapel' is based on Clare's 2010 survey of the state of the glass and its supporting metal and stonework, as well as his recommendations for the long-term conservation of the glass. The chapter details the techniques by which the windows were originally made and by which they are now conserved. It includes archival research on previous recorded restoration campaigns, as well as information bearing on the state of the glass, such as the heating systems formerly used in the Chapel (four large Gurney stoves installed in 1875–76), and the storage of the glass during World War II – dispelling the myth that the glass was sent to slate mines in Wales. Although Clare recommends careful monitoring, his conclusions about the state of this five-hundred-year-old glass are remarkably encouraging, not least in comparison to other glass of the same period.

Peter Murray Jones' 'The College and the Chapel' investigates several centuries of interactions and tensions between the College and Chapel. Tensions may have been fewer in the past, given that until 1861 all King's Fellows were also in orders (though Ross Harrison reveals that for an evangelical such as Charles Simeon even being in orders did not necessarily obviate discomfort with

the Chapel); it was only in the early twentieth century, however, that the College acquired a reputation for secularism. Going back to the earliest years of the Chapel, Jones explores the evidence that several Fellows established personal chantries (dedicated to prayer for the deceased) in the side chapels; the Chapel itself was regularly used for the funerals and burial of Provosts, Fellows, some students, and even the family members of Provosts. Nevertheless, a public dimension to the Chapel is also revealed in the number of Cambridge townspeople who were married here. The Chapel was also for many centuries central to the intellectual functioning of the College, not only used for academic disputations (possibly right up until 1830), but also containing in its side chapels the College Library and Muniment Room, which held the College's books, documents and treasures. Jones' history of the fluctuating requirements on College members to attend Chapel provides some index of the history of religiosity and secularism in the nineteenth and early twentieth centuries. The election of the Provost, however, has always taken place in the Chapel, even if it does not usually involve taking up residence in the Chapel for two days, as occurred in 1743.

Iain Fenlon's 'A Spanish Choirbook and Some Elizabethan Book Thieves' deals with the history and origin of the Cadiz Choirbook, MS 41, long held in the College Library in the Chapel. This is first mentioned in 1600 in the diary of a Moravian visitor, Baron Waldstein, as a 'Book of Psalms five spans in height that the Earl of Essex brought back from Cadiz near the Straits of Gibraltar'; Waldstein further quotes a Latin poem on the flyleaf – long since gone – in which the book 'speaks' to associate itself with the Earl of Essex, Robert Devereux. Fenlon narrates the 1596 Cadiz expedition – in which Essex failed to return with sufficient booty of value to his Queen but did bring back a substantial number of books – and then discusses the political significance of the volume at King's in the context of the personal propaganda campaign waged by Essex as his political career waned. Given Essex's execution in 1601, the chapter raises a number of intriguing questions about the presence of the choirbook, and its excised pro-Essex poem, just a year previously in the Chapel and Library of King's College.

Nicolette Zeeman's chapter is a pendant to Jeremy Musson's narrative of the dominant forms of the Chapel's aesthetic reception. In 'The Chapel Imagined, 1540–1830' she uses texts, images and maps to identify a number of alternative responses to the Chapel. From an early period the Chapel had a significant public dimension as a major destination for visitors, travellers, monarchs and musicians; many ascended to its roof, not least for the spectacular view. A number of commentators also seem to liken the Chapel to earlier 'temples', such as the Temple of Jerusalem, in a tradition that may owe something to Protestant thought and its reformist 'return to origins', but also to seventeenth- and eighteenth-century antiquarianism. Maps, images and visual similes (the 'cradle') also provide evidence of early reactions to the distinctive gothic shape and rhythmic linearity of the Chapel; it is also well known that many generations of devotees and patrons have marked their identity on the Chapel in the form of heraldry – and Zeeman finds one more popular form of visitor self-inscription in the roof leads.

In 'The Start and Stop of Simeon' Ross Harrison explores the relationship of Charles Simeon, King's most famous religious preacher and teacher, with the Chapel. This is a paradoxical relationship in that for Simeon, an extremely influential member of the evangelical wing of the Anglican church in the early decades of the nineteenth century, the Chapel seems to have represented much that was wrong with institutional religion – Chapel attendance having become largely a marker of religious and social orthodoxy. Simeon taught constantly, but from his rooms in the Gibbs Building; he preached widely, but

Ill. 4. Augustus Pugin, *View of the Antechapel of King's College, with Choristers*, 1815, watercolour, 28 x 20 cm. Cambridge, King's College.

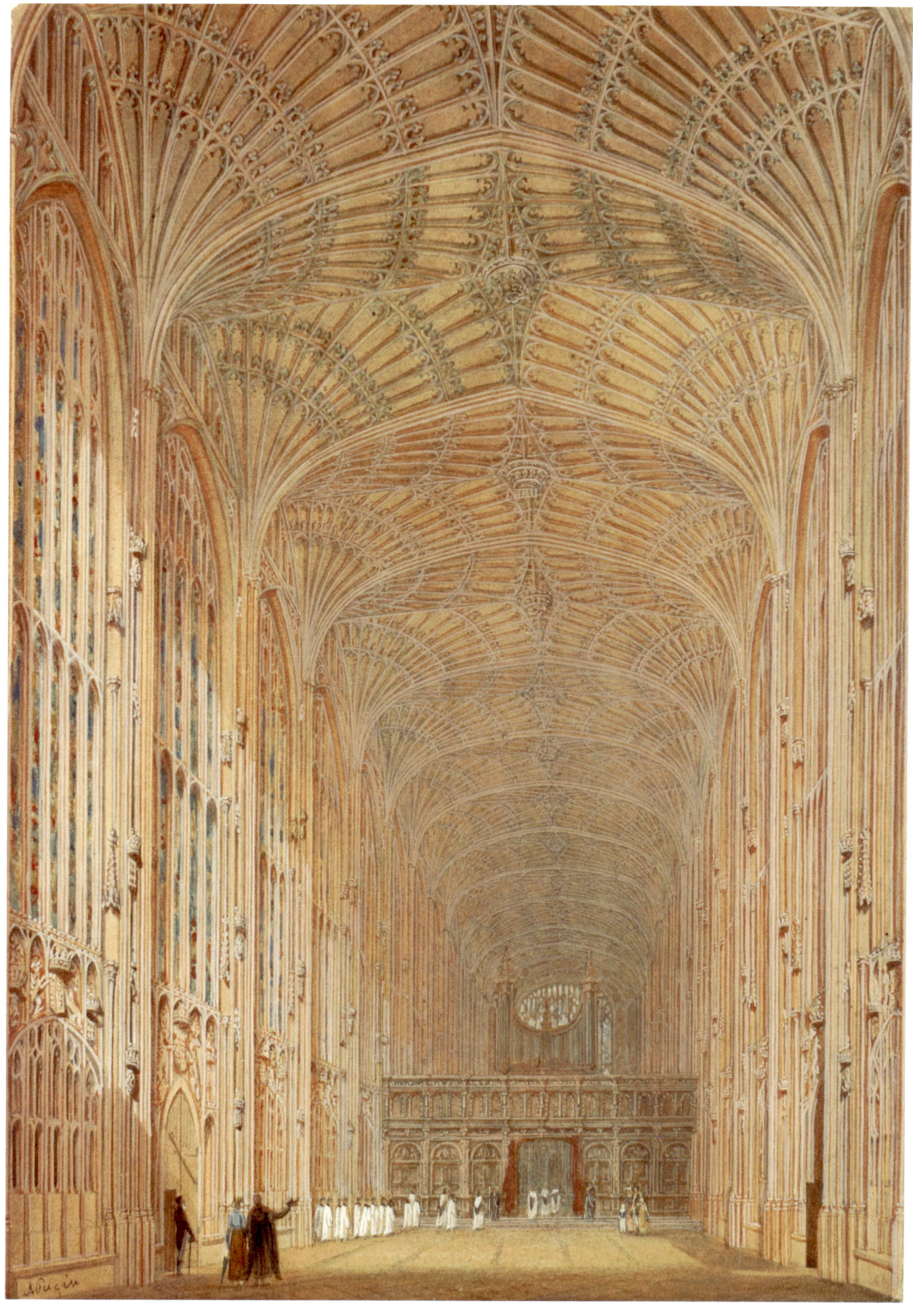

not in the Chapel. And yet, as Harrison documents, his first conversion experiences were in the Chapel, and his extraordinary funeral and burial – attended by huge crowds from the College, University, City of Cambridge and elsewhere – were once again in the Chapel.

In 'Drama in King's College Chapel' Abigail Rokison documents the various theatrical productions that have taken place in the Chapel: first, most politically, and certainly most elaborately, during the visit of Queen Elizabeth I in 1654; then, equally startlingly, in 1924 with a production of the late medieval morality play *Everyman*, directed by Lilian Baylis; and subsequently many times in the twentieth and twenty-first centuries with performances mainly by members of King's College and School. Despite the allure of the overwhelmingly dramatic space of the Chapel and the many productions that have occurred here, Rokison's evidence repeatedly illustrates the very real challenges of harnessing the space and its acoustics for purposes of actual theatre.

Roger Bowers, in 'Chapel and Choir, Liturgy and Music, 1444–1644', documents the musical culture of the first two hundred years of ritual worship, both in the Chapel that exists today and in its predecessor, a smaller Chapel that once lay to the north of the present building. He provides evidence for the rich range of late medieval sung polyphony (as well as organ music) that would have been part of late-medieval Catholic ritual, noting that in the early sixteenth century music at King's must have 'attained an all-time peak of enterprise and splendour' not reached again before the twentieth century. Bowers comments on the challenge of moving into the enormous (and internally unfinished) edifice of the new Chapel when the first one collapsed in 1537. However, from this point on Bowers is also obliged to chart how the Chapel's musical culture came to be at the mercy of the swiftly changing politics of the Reformation church: all sung service ceased under Edward VI; it was reinstated under Mary, and also under Elizabeth, but this time in ways that were shaped by the central role of the Book of Common Prayer, with its emphasis on the spoken, not sung, word. Although the early seventeenth century is again characterised by two periods of musical 'revival', Bowers' narrative concludes in the 1640s, with the melancholy vision of declining enthusiasm for church music and the spectre of the puritan Interregnum.

In 'The Chapel Organ – A Harmonius Anachronism?' John Butt investigates the organ which appears to grow 'seamlessly' from the Tudor screen. In fact, although the larger organ case has traditionally been thought to survive from the Thomas Dallam organ of 1605–6, Butt shows that at most only certain decorative components can come from that time; the current form of the organ is more likely to be contemporary with – or even later than – the 1661 smaller 'chaire organ' case, which hangs down over the entrance to the choir on the eastern side. However, telling a history that begins with the earliest, small organ (moved from the old chapel in 1537), Butt describes the baroque organ of Renatus Harris (1686–89), the three-manual organ installed by John Avery in 1802–4 and variously upgraded over the nineteenth century, and finally the reconstructed organ of Arthur Harrison, built in 1933–34. Musically, this is substantially the organ that is heard today. Its 'brilliant gentlemanliness' owes much to the musical aesthetic of the organist of the day, Boris Ord, and it is characterised by a series of distinctive sounds such as that of the dulciana pipes that give the organ 'that range of bell-like "tinkle" sounds that have become so familiar in Christmas carol arrangements from the 1960s onwards'.

Nicholas Marston's '"As England knows it": "Daddy" Mann and King's College Choir, 1876–1929' revisits the long musical life and work of the Organist and Choir Director, 'Daddy' Mann. Himself 'only' an organist and not even a Fellow till late in his career, Mann presided over substantial transformations both in the demographic of the Choir and in the College's valuation of and support for it – no doubt partly under pressure from Mann himself. This is a crucial era in the evolution of

King's College Choir. This chapter documents the new standards that Mann set for the Choir, and his cultivation of a choral sound so richly dramatic that, as an obituarist put it, 'the very building itself seemed to speak, with all its abundant echoes and lingering sweetness'. Marston reveals something of Mann's feisty and intense character, but also of the affection he inspired, not least as illustrated by a contemporary cartoon and squib. Mann was still directing the Choir well into the twentieth century, when it performed its first *Festival of Nine Lessons and Carols*.

Nicholas Nash's '"A Right Prelude To Christmas": A History of *A Festival of Nine Lessons and Carols*' explores the origins and history of this service, for which King's is today known world-wide. Intriguingly, the ultimate origins of this service lie in a Christmas Eve 'Festal Service' in the Cathedral of Truro in 1878. However, the Dean who brought the *Festival of Nine Lessons and Carols* to King's and gave it the shape it still has today was Eric Milner-White, a Kingsman whose egalitarian sense of religious mission was radically shaped by his experiences in World War I. In many ways Milner-White's service anticipates something about the many ways that the College as a whole was to turn its face outward to the world over the twentieth century. Drawing on his own experience in North American public radio, Nash charts the role of recording, broadcasting and digital technology in making this service the international phenomenon that it is today.

In '"The Most Famous Choir in the World?" The Choir since 1929' Timothy Day argues that the social history of King's College Choir in the twentieth century is closely entwined with the history of its sound. He shows how, under Boris Ord (1929–57) the Choir emancipated itself from the lush Victorian sound cultivated by 'Daddy' Mann; he suggests that the shared values of a certain kind of English public school ethos can be seen reflected in an aesthetic that favours the unity of the singing group over the virtuosity of the individual voice. Day links the development of the Choir's very distinctively precise and restrained mid-twentieth-century sound to particular strands of contemporary musical history, in particular the conjoined effects of modernism and the rediscovery of baroque – and even earlier – music. Noting the continual evolution of the Choir's distinctively brilliant sound even today, Day also documents its increasingly public face: not only its extensive and wide-ranging activities in performing, recording and broadcasting, but also the work of its current Director of Music, Stephen Cleobury, in commissioning new music.

The volume concludes with the reflections of some contemporary performers and composers on the sound of the space that is King's College Chapel.

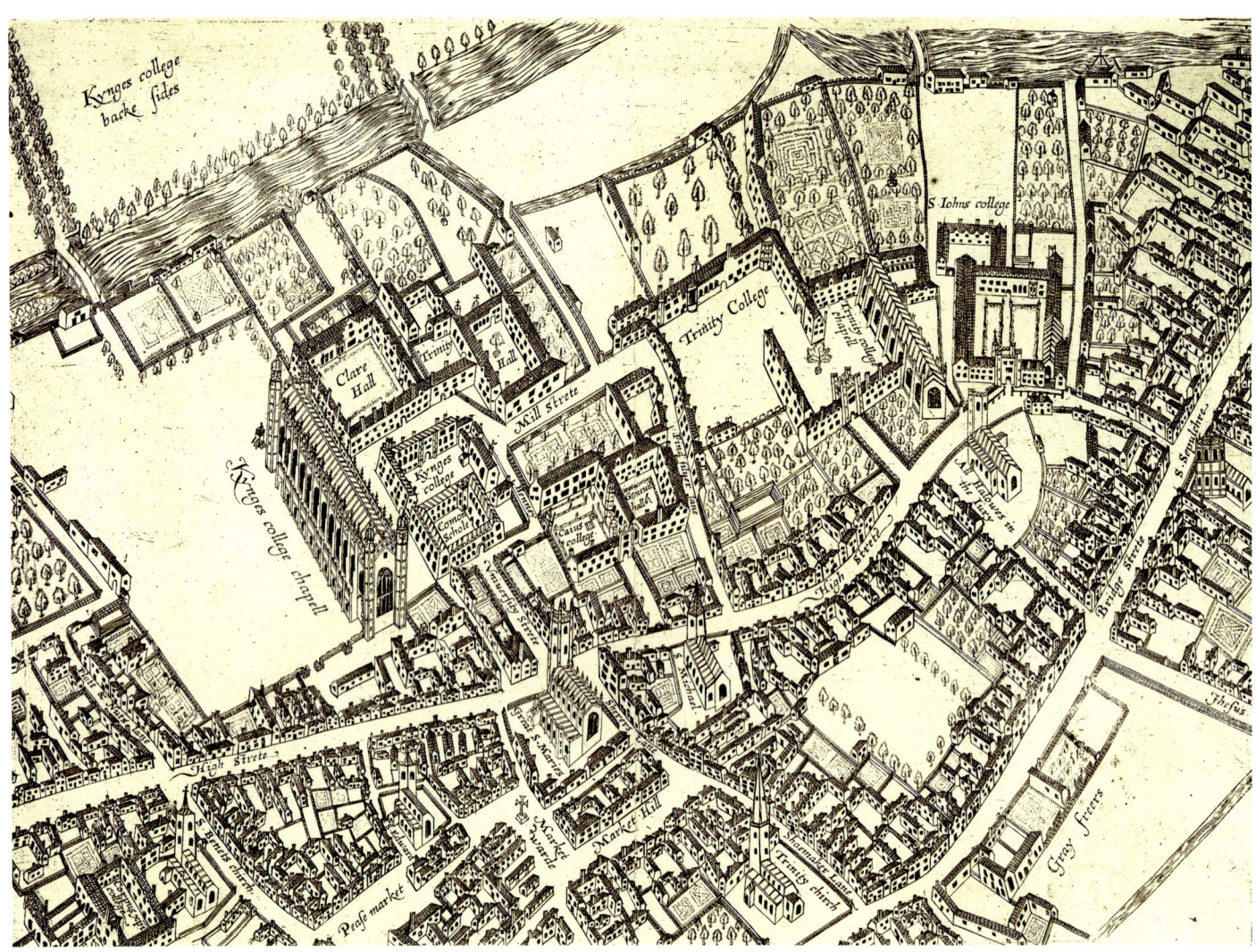

Ill. 5. King's College. Detail of facsimile of John Hamond, *Cantebrigia*, engraving on nine sheets, engraved by Augustine Ryther and Petrus Muser, 22 February 1592, full map 118 x 88 cm, in J. Willis Clark, *Old Plans of Cambridge*, 2 parts (Cambridge: Bowes and Bowes, 1921), part 2.

Chronology

1441	Henry VI lays the foundation stone of King's College.
1446	Foundation stone of the 'new' King's College Chapel laid.
1461	Henry VI captured and imprisoned; building work on the Chapel halts.
1483	Richard III ascends the throne; work on the Chapel resumes under his patronage.
1485	Death of Richard III; work on the Chapel halts, only sporadically to be taken up in the following years.
1506	Henry VII celebrates the Order of the Knights of the Garter on the eve of St George's Day in the partly-completed Chapel.
1508	Work resumes on the Chapel, under the patronage of Henry VII and his mother, Lady Margaret Beaufort.
1509	Henry VIII ascends the throne; Robert Hacumblen becomes Provost.
1515	Payments to the stone masons cease, indicating the completion of the stone structure of the Chapel; on 29 November a contract for the glazing of the windows is signed with Bernard Flower, the King's Glazier.
c.1530–36	The choir screen built.
1536	First injunctions to bishops in England against the misuse of 'images, relics, or miracles'.
1537	The first King's College Chapel collapses, necessitating a move into the recently completed 'new temple'.
1544–45	The new high altar delivered.
1547	Death of Henry VIII and accession of Edward VI, initiating further reform in ritual practice; all windows now complete, apart from the west window.
1553	Accession of Mary I, reversing all liturgical change.
1558	Accession of Elizabeth I, reintroducing reformed liturgical practices.
1564	Visit of Elizabeth I; drama performed in the Chapel for the Queen.
1570	College Library established in the south side chapels.
1596	The expedition to Cadiz of Robert Devereux, Second Earl of Essex.
1598	The future composer Orlando Gibbons admitted as a student at King's College.
1600	Zdenkonius Brtnicensis, Baron Waldstein, visits the Chapel and sees the Cadiz Choirbook
1605–6	Thomas Dallam's organ installed.
1612	New altar installed, 29 feet from the east wall.
1615	New wooden doors made for the west entrance; the antechapel partially paved, in anticipation of the visit of James I this year.
1631	Visit of Charles I and Queen Henrietta Maria to the Chapel.

1633	New high altar and reredos screen installed, under the influence of Laudian reforms; stall panels donated by Thomas Weaver, Fellow, and carved by William Fells.
1636	Doors in the organ screen installed, carved, like the reredos screen, by the joiner Woodroffe.
1640	Henry Loosemore appointed Master of the Choristers.
1643	Visit of iconoclasts to Cambridge under William Dowsing; organ removed.
c.1643–5	Roundhead soldiers billetted in the Chapel
1661	Organ replaced.
1671, 1681	Visits of Charles II to the Chapel.
1675–9	Stall canopies carved and wainscotting installed between the stalls and the altar screen by Cornelius Austin.
1689	Visit of King William to the Chapel.
1702	New marble floor laid in the choir.
1705	Visit of Queen Anne.
1717	Visit of George I.
1728	Visit of George II.
1735	Horace Walpole admitted as a student at King's College.
1736	William Cole, the future antiquary, admitted as a student at King's College, keeping rooms there till 1753.
1763	Military colours seized at Manila displayed on the Chapel altar rails.
1775–6	James Essex's Gothic reredos screen and a new stone floor installed in the choir.
1779	Charles Simeon admitted as a student at King's College.
1780	Girolamo Siciolante da Sermoneta's *Deposition* presented to the College and erected at the high altar.
1827	Unfinished stonework extensions on the exterior of the south-east corner of the Chapel (part of a planned building range) removed, lower lights opened up in the eastmost window on the south side, and the corner finished off.
1828	College Library removed from the Chapel to the new Wilkins Library.
1836	Funeral of Charles Simeon.
1843	Visit of Queen Victoria and Prince Albert to the Chapel.
1841–5	Sixteenth-century glass in the upper lights of the eastmost window on the south side transferred to the lower lights and new glass installed above.
1871	Compulsory daily Chapel attendance for undergraduates ends.
1874–9	Fountain in the main court commissioned and constructed.
1875	Choristerships opened up to non-local boys, and the Choir School established.
1876	Arthur Henry ('Daddy') Mann elected Organist of the Chapel.
1878	Bishop Edward White Benson's first carol service at Truro Cathedral.
1879	West window of the Chapel completed.
1882	M. R. James admitted as a student at King's College.

1886	First Choral Scholarship awarded. Funeral of Henry Bradshaw, Fellow and University Librarian.
1905	M. R. James becomes Provost.
1911	Detmar Blow's neo-renaissance reredos screen and panelling installed; the Siciolante *Deposition* inserted in the north panelling.
1912	Eric Milner-White becomes Chaplain at King's College.
1918	Eric Milner White becomes Dean; the first *Festival of Nine Lessons and Carols*.
1924	*Everyman* performed by the Lilian Baylis Company in the Chapel.
1926	The first BBC radio broadcast of the Choir.
1928	The first BBC radio broadcast of the *Festival of Nine Lessons and Carols*. The last lay clerk dies.
1929	Appointment of Bernhard (Boris) Ord as Organist.
1930	The first year that the Choir contains a full complement of choristers and Choral Scholars.
1931	Gert van Lon's *Madonna in the Rosary* presented to the College.
1933–34	Rebuilding of the organ by Arthur Harrison in collaboration with Boris Ord.
1941–1945	Choir directed by Harold Darke (while Boris Ord is at the front during World War II).
1950	The Chapel stained glass, removed during the war, is finally back in place.
1951	Visit of George VI and Queen Elizabeth for the Service of Thanksgiving for the Preservation of the Chapel.
1954	The first long-playing disc issued by King's College Choir.
1957	Appointment of David Willcocks as Organist, and later Director of Music.
1961	Rubens' *Adoration of the Magi* presented to the College.
1962	Visit of Elizabeth II.
1964	Detmar Blow's reredos screen removed.
1969	Chapel reopened after complete cleaning, laying of new floor and erection of Rubens' *Adoration of the Magi* behind the high altar.
1974	Appointment of Philip Ledger as Director of Music.
1982	Appointment of Stephen Cleobury as Director of Music.
1991	Visit of Elizabeth II and Prince Philip to mark the 550th Anniversary of the Founding of the College.
2010	Triptych of the *Adoration of the Magi* by the Master of the Von Groote Adoration presented to the College.

Ill. 6. OVERLEAF: The east end of the Chapel seen from the screen. Mike Dixon, photograph, 2011.

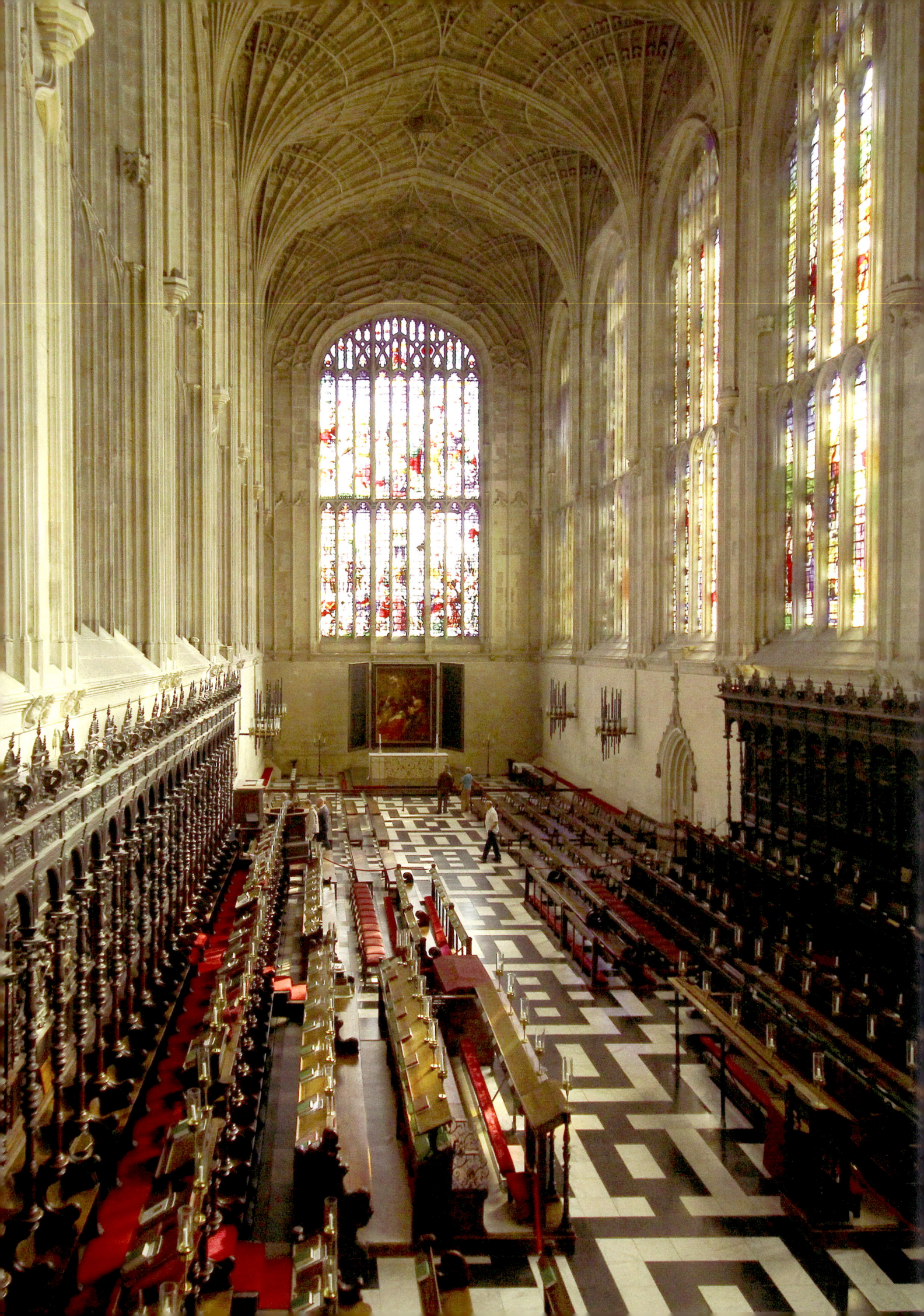

Fabric & Furnishings

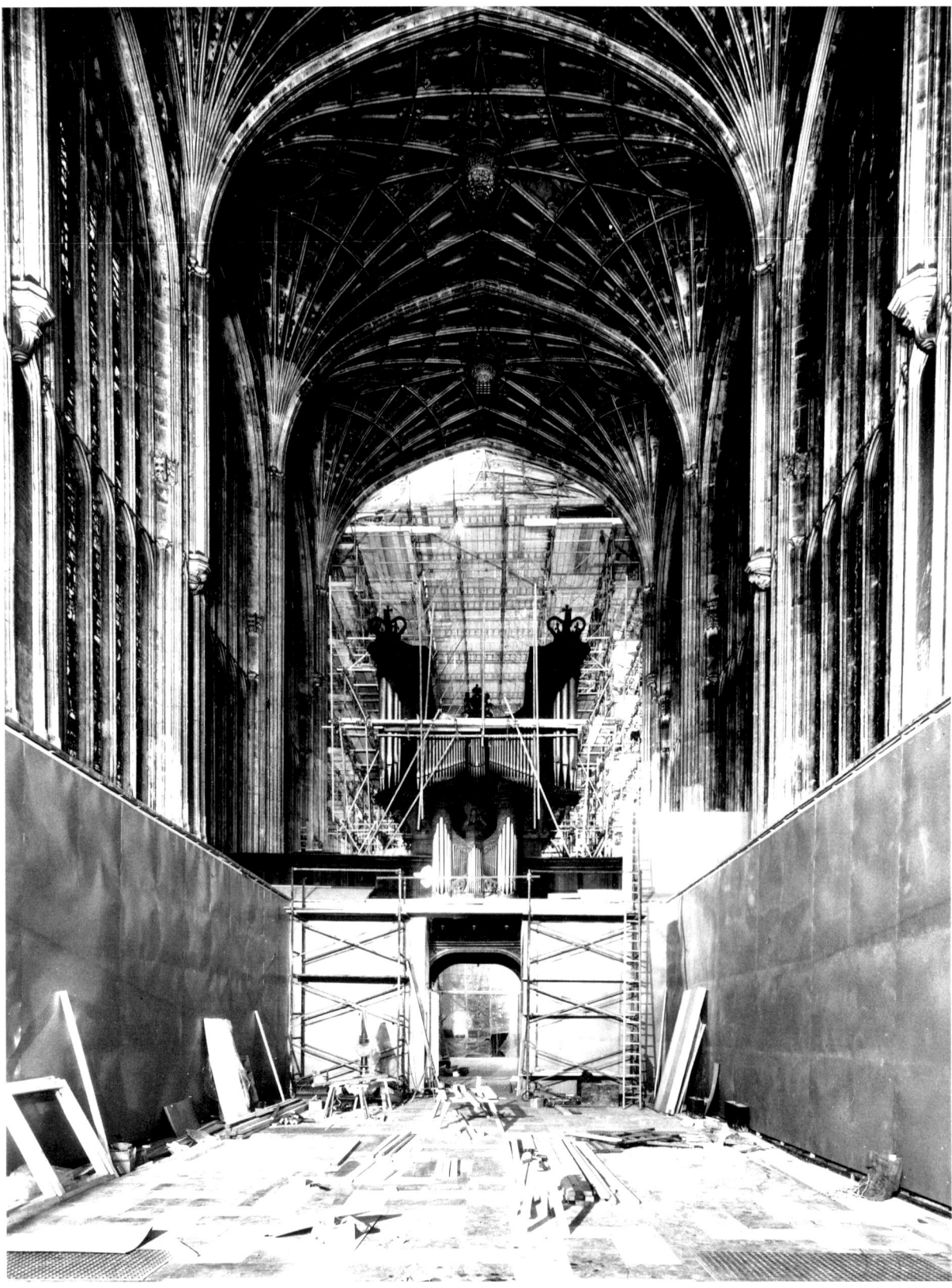

Ill. 7. The Chapel with scaffolding and the stalls and screen boxed in during restoration. Edward Leigh, photograph, 1968. Cambridge, King's College, Coll. Ph 972.

I

King's College Chapel: Aesthetic and Architectural Responses

JEREMY MUSSON

> For it is confessedly true, every man who has an eye to see, and a soul to feel, on entering York minster and Chapterhouse, or into King's college or Windsor chapel, or into the cathedrals of Lincoln or Winchester is irresistibly struck with mingled impressions of awe and pleasure, which no other buildings are capable of producing.
>
> *John Milner, 'Observations on The Means necessary for further Illustrating ecclesiastical Architecture of the Middle Ages', 1800.*[1]

FOR A WELL-KNOWN BUILDING of relative architectural uniformity, King's College Chapel in Cambridge has a famously complex and slow building history (1448–1515).[2] However long drawn out it was, a clear ambition was being pursued: to create a building of national and international reputation.[3] As completed – the combined work of the founder, Henry VI and his Tudor successors Henry VII and Henry VIII – it was an ecclesiastical building unlike any other church in England, one that also revealed how the University of Cambridge was basking in the warm glow of royal patronage.[4] This chapter looks at the progress of the reputation of the Chapel as a 'prodigy' work of religious architecture from its completion in 1515 to the present day. It also considers the effect of this reputation on later architectural responses within and without: as expressed in new building around the Chapel and in the re-ordering of the interior. The one central theme of these related building works (executed and unexecuted) was that they should be worthy of the Chapel. The cyclical re-ordering of the interior also, however, reflected successive national issues of liturgical reform.

Reputation: 'A meritorious work':

Henry VI's 1448 'Will' shows that he intended that his Chapel would be of phenomenal size: 288 feet in length and 90 feet in height, 'withoute any [a]ysles and alle of widenesse of .xl. [40] fete ... [the walls] embatelled vauted and chare rofed sufficiently boteraced, and euery botrace fined with finialx'.[5] The later 1509 bequest from Henry VII was made not only with specific reference to Henry VI's plans, but also with reference to the reputation of the building, even in its partial state: 'that therby shuld not be onely a notable Acte and a meritorious werke perfited [perfected], whiche els[e] were like to grow to desolacion and never to haue ben done and accomplisshed'.[6] And notable and meritorious the Chapel certainly seemed to those rare early visitors whose opinions are recorded. They evoked the Chapel's place in a national, even international, pantheon. For instance, Elizabeth I

KING'S COLLEGE CHAPEL 1515–2015

Ill. 8. James Essex, *Ground Plan of King's College Chapel*, c.1756, drawing in India ink, 51 x 20 cm. London, British Library, Cartographic Items Additional MS 6776.fol.10.b.

in 1564 was described as 'marvellously revising at the beauty of the Chappel, [and she] greatly praised it, above all other within her Realme'.[7] In 1577, cleric William Harrison selected the Divinity School at Oxford, King's College Chapel and the Henry VII Chapel at Westminster Abbey, and concluded that 'there are not in my opinion made of lime and stone three more notable piles within the compass of Europe'.[8] The antiquary William Camden extended the range of comparison for the Chapel as one 'deservedly reckon'd one of the finest buildings in the world'.[9]

Seventeenth-century observers were keen to place the Chapel in an international context. John Evelyn, demonstrating that his visit was informed by the expectation of what he would find, wrote in 1654: 'Afterwards to King's College, where I found the Chapel altogether answer'd expectation, especially the roof all of stone, which for the flatness of its laying and carving, may I conceive, vie with any in Christendome. The contignation [joining together] of the roof (which I went upon), weight, and artificial jointing of the stones is admirable' (Ill. 8).[10] Typically, in such accounts, the underlying engineering competence of the building was emphasised, as, for instance, by Thomas Fuller, mid-seventeenth-century cleric and historian of Cambridge: 'The chapel in this college is one of the rarest fabrics in Christendom, wherein the stone-work, wood-work, and glass-work contend, which most deserve admiration. Yet the first generally carrieth away the credit (as being a Stone-henge indeed) so

1 · KING'S COLLEGE CHAPEL: AESTHETIC AND ARCHITECTURAL RESPONSES

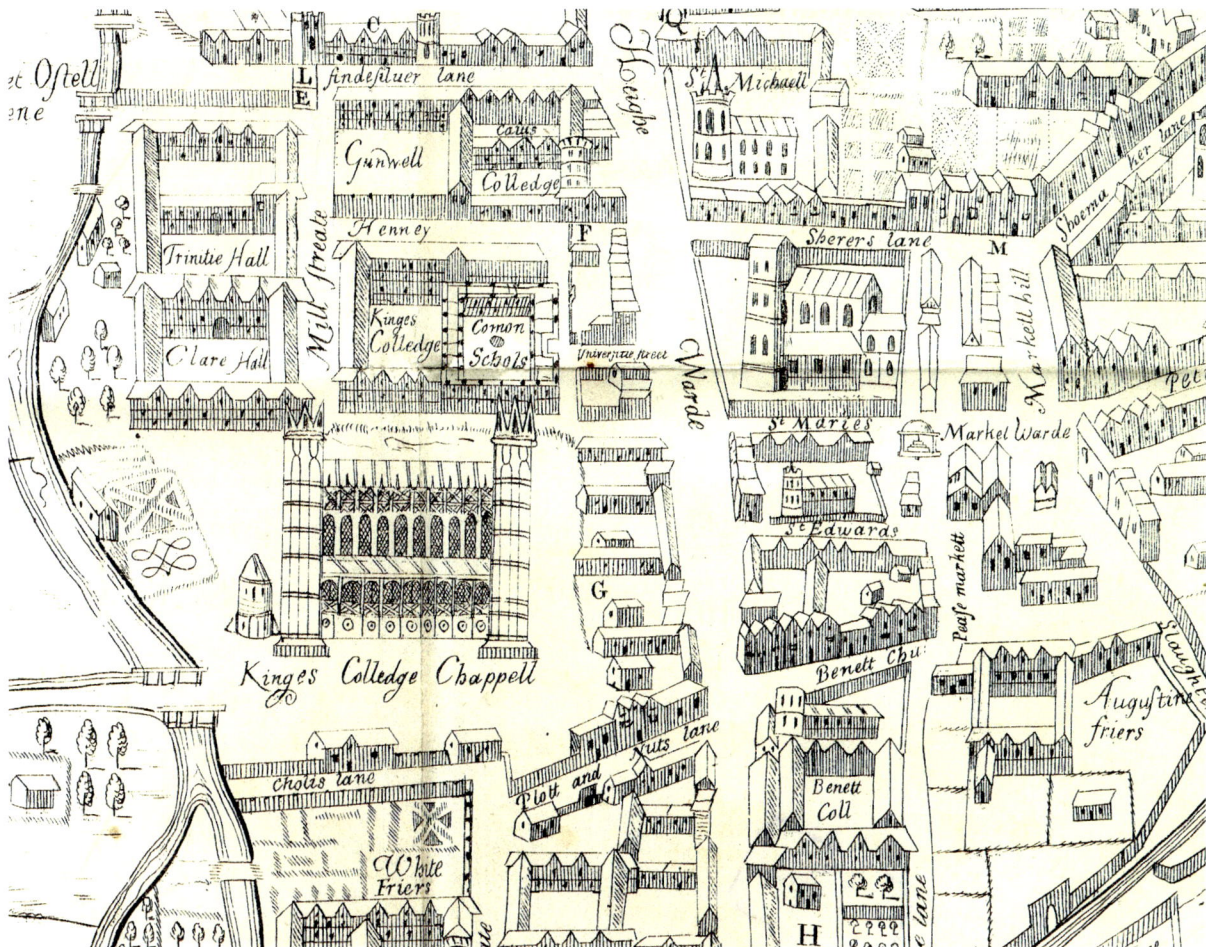

Ill. 9. View of King's College Chapel. Detail of the frontispiece to Thomas Fuller, *The History of the University of Cambridge, from the Conquest to the Year 1634*, ed. Marmaduke Prickett and Thomas Wright (Cambridge; London: University Press, J. W. Parker, 1840). Cambridge, King's College.

geometrically contrived, that voluminous stones mutually support themselves in the arched roof, as if art had made them to forget nature, and weaned them of their fondness to descend to their centre' (Ill. 9).[11] Some seventeenth-century observers even used the Chapel as a point of reference when discussing important architecture encountered on their travels in Europe. For example, in 1647 cleric Richard Colebrande observed that the cathedral at Tours 'strutts up with two Pinacles, not unlike to those, which the corners of Kings Colledge Chappell in Cambridge beare'.[12]

In the later seventeenth century, gentleman architect Roger North listed King's College Chapel (in his view 'much the fairest') as ranking alongside Westminster Hall and most of the cathedrals of England and 'among the best peices of the Gothick work in England'.[13] The structural strength impressed him most: 'It is an universall rule in building, that nothing is handsome which does not appear to the eye strong... Kings Colledge chappel in Cambridge is wonderfully thought, and executed, the abutment being small, and the roof broad and massy. I beleeve there is no coar, or filling in the buttresses, but it is all made up with squar'd stone, which adds much to the strength'.

So in the century and a half following its completion, and in spite of the increasing importance of the classical style from early in the seventeenth century, the Chapel's reputation remained consistent. Diarist Celia Fiennes visited in 1697: 'Kings College Chappel is the finest building I have heard off

27

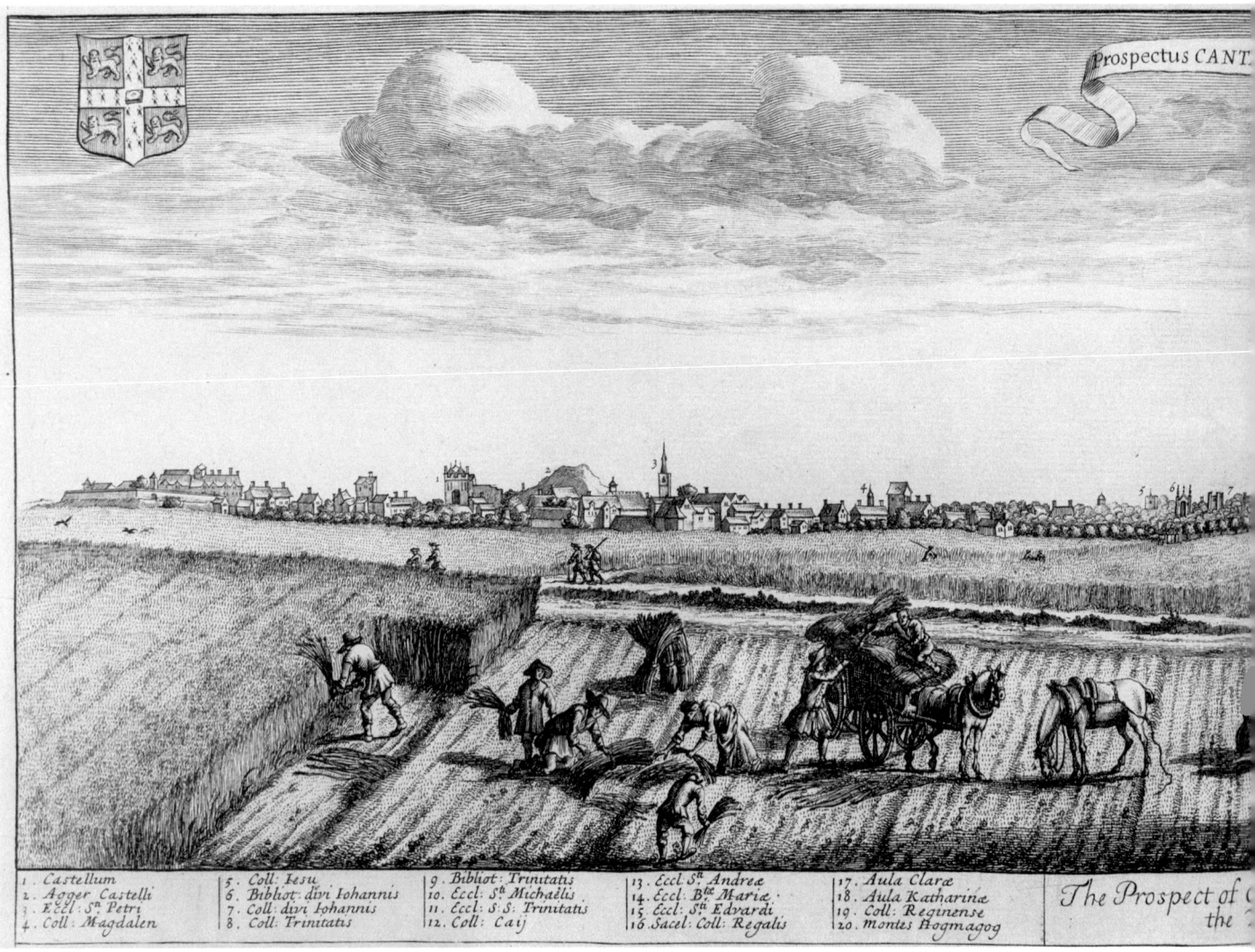

Ill. 10. David Loggan, *Prospectus Cantabrigiae Occidentalis/The Prospect of Cambridge from the West*, engraving, 32.2 x 44.8 cm. In David Loggan, *Cantabrigia illustrata...* (Cantabrigiæ: Quam proprijs sumptibus typis mandavit & impressit, [1690]), pl. 5.

[sic], Curious carvings of stone on the outside, twelve large windows and two at each end very large, all finely painted all over the history of the new testament ...this is a noble building and stands on so advantagious a ground and so lofty built that its perspicuous above the town'.[14] The Chapel's dominant physical presence, which rendered it for centuries the most notable building in Cambridge purely in terms of scale, can be seen clearly in David Loggan's topographical views and city plan of around 1690 (Ills. 10 and 11).[15]

The evaluation of King's College Chapel has a notably different complexion in the eighteenth century, as it begins to be used as an exemplar in the debate around the usefulness of the Gothic style for new architecture. In the early eighteenth century, the Chapel is often referred to as a kind of shorthand for describing medieval architecture. For instance, William Stukeley's *Itinerarum Curiosum* (1727) described the fan vaulting at Gloucester by reference to 'the style of king's college chapel in Cambridge', as part of an argument about the attractiveness of Gothic: 'tis the best manner of building for a gallery, library or the like'.[16] In 1728, architect James Gibbs referred to the Chapel as 'a beautiful Building of the Gothick Tast[e], ...the finest I ever saw', while nevertheless planning a classical court around it (Ill. 12).[17] Significant evidence of its repute was shown in the concern about any building project that might infringe on views of the Chapel. For instance, in the 1720s, there was a protest against proposals for a projected Consistory Court building being designed by Gibbs for a site

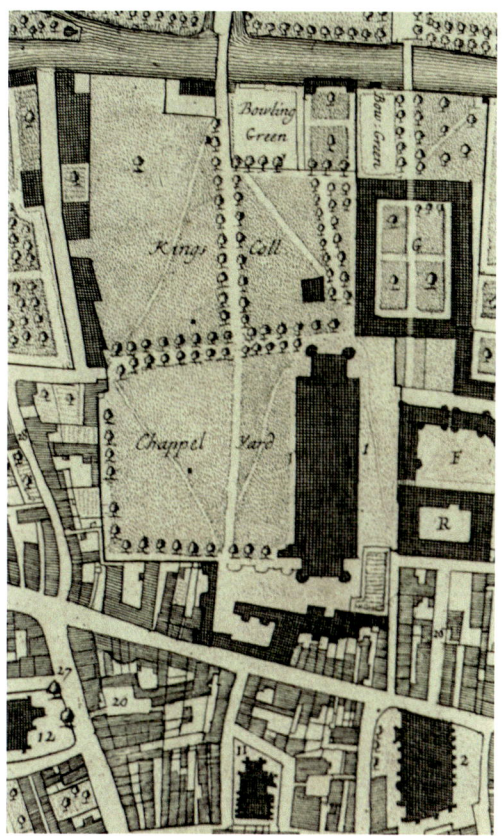

Ill. 11. Scale of foot-print of King's College Chapel compared to surrounding colleges. Detail of David Loggan, *Nova & accuratissima celeberrime universitatis oppidique cantabrigiensis ichnographia*, 1688, engraving, 40.8 x 52.2 cm. In David Loggan, *Cantabrigia illustrata…* (Cantabrigiæ: Quam proprijs sumptibus typis mandavit & impressit, [1690]), pl. 6. Cambridge, King's College.

west of the Senate House. In 1721, the Master of Caius refused to grant use of the necessary land and urged the Syndics of the University, almost emotionally, not 'to execute a Scheme for which I do in my Conscience believe the whole World will condemn Us; a Scheme that will so effectually shut out all View of that noble fabrick Kings-Chappell, that I wonder how the University or that College can bear it'.[18]

In the eighteenth century, the Chapel, a vast and functioning Gothic building, was more than just a national wonder; it was a living symbol of the medieval past. In 1771, the antiquary and historian of Ely Cathedral, James Bentham, referred directly

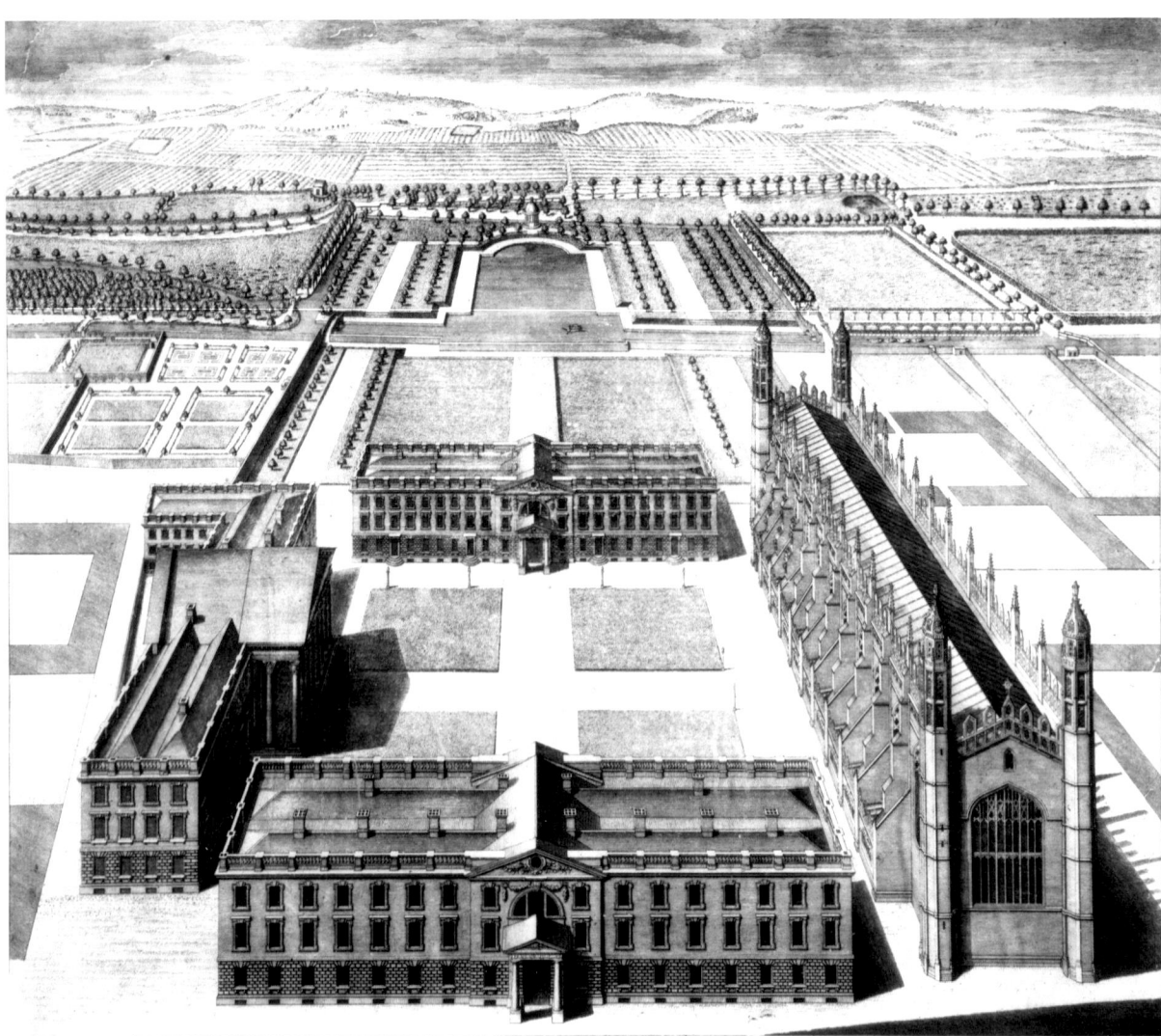

Ill. 12. James Gibbs, *The East Prospect of King's College in Cambridge, as intended to be finished*, 1741, engraving, 56 x 59.5 cm. Cambridge, King's College.

to the Chapel's effect on the imagination: 'the decorations, harmony and proportions of the several parts of this magnificent Fabrick, it's [sic] fine painted Windows, and richly ornamented spreading Roof, it's gloom, and perspective all concur in affecting the imagination with pleasure and delight, at the same time that they inspire awe and devotions. It is undoubtedly one of the most complete, elegant, and magnificent Structures in the Kingdom'.[19] Horace Walpole, a leading champion of Gothic, had attended King's College as an undergraduate in the 1730s and hung a picture of the interior of the Chapel by Canaletto at his Gothic-inspired home, Strawberry Hill (Ill. 13).[20] In May 1777, in a letter to the Cambridge antiquary, William Cole, Walpole observed melodramatically: 'I dote on Cambridge, and could like to be often there – the beauty of King's College Chapel, now it is restored [by James Essex], penetrated me with a visionary longing to be a monk in it'.[21]

Late-eighteenth and early-nineteenth-century commentators debated the success of the interior effect of the Chapel's architecture. In 1769, William Gilpin, champion of the Picturesque, commented negatively on the aesthetic impact of the Chapel's interior: 'King's college chappel gives us on the *outside* a very beautiful form: *within*, though it is an immense and noble aisle, presenting the adjunct idea of lightness, and solemnity; yet its proportion disgusts. Such height and such length, united by such

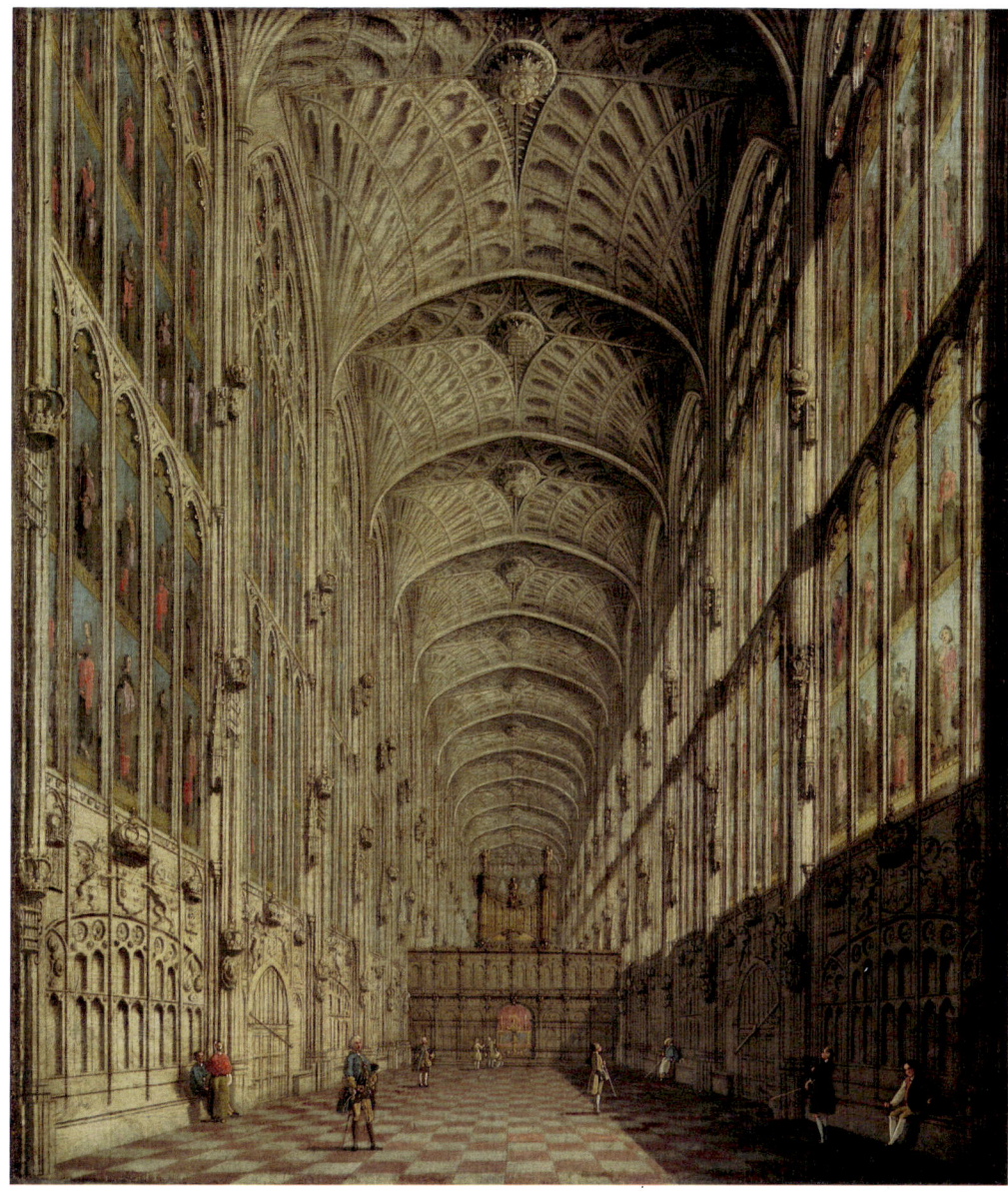

Ill. 13. Canaletto (Giovanni Antonio Canal), *Interior of Kings College Chapel* (previously displayed in Strawberry Hill, home of Horace Walpole), 1746–1755, oil on canvas, 75.5 x 66.7 cm. Richmond, Virginia Museum of Fine Arts, 2002.53. Gift of Mrs. Elizabeth Golsan Schneider, in memory of her mother, Mrs. Florence Ramage Golsan.

straitened parallels, hurt the eye. You feel immured'.[22] Richard Payne Knight, in *An Analytical Inquiry Into The Principles of Taste* (1805), professed a somewhat opposite view: 'No part of the interior of King's chapel is unornamented; and though the ornaments, considered with reference to parts only, often appear crowded, capricious, and unmeaning, yet the effect of the whole together is more rich, grand, light, and airy than that of any other building known, either ancient or modern'.[23]

These debates about the qualities of the Chapel were, however, not only aesthetic – they also had a spiritual dimension. Some observers actively compared the religious sensations experienced within the architecture of the Chapel to those experienced at St Paul's Cathedral in London, and clearly considered King's the more effective for spiritual reflection. One developing view was that the Gothic style was simply more appropriate for Christian worship. For Catholic and antiquary cleric John Milner, 'it is confessedly true, that every man who has an eye to see, and a soul to feel, on entering into York minster and Chapterhouse, or into King's Chapel or Windsor Chapel, or into the cathedrals of Lincoln or Winchester, is irresistibly struck with mingled impressions of awe and pleasure, which

31

no other buildings are capable of producing; and however he may approve of the Grecian architecture for the purposes of civil and social life, yet he instinctively experiences in the former a frame of mind that fits him for prayer and contemplation, which all the boasted regularity and magnificence of Sir Christopher's and the nation's pride, I mean St. Paul's cathedral, cannot communicate, at least in the same degree'.[24]

Admiration for the Chapel reached a pitch in the early nineteenth century. The critic the Revd James Dallaway, in *Observations on English Architecture* (1806), called the Chapel 'the wonder of its own and every succeeding age' and observed: 'being a mass, the height of which is sufficient to relieve the great length, it instantly communicates an idea of Gothic grandeur, almost without parallel'.[25] Thomas Rickman in *An Attempt to discriminate the styles of English Architecture from the Conquest to the Reformation* (1817), in which he sought to define terms to identify the different periods of Gothic including 'Perpendicular', described King's College Chapel as 'the flower of Cambridge and in many respects of the Perpendicular style ... simple in its plan, bold in its elevation, rich in its detail, and exquisite in its execution'.[26] In 1810, architect John Soane singled out the Chapel in his Royal Academy Lectures, as quite simply the apogee of English Gothic: 'Is it possible for the most unobservant spectator on entering Westminster Abbey, Salisbury Cathedral and similar edifices to be deceived as to their destination, or can they fail to be impressed by their magnitude and solemn appearance?' He then cited the much-quoted reference in Milton's 'Il Penseroso' to 'high embowed roof ... And storied windows, richly dight, Casting a dim religious light', continuing, 'in none of the large splendid buildings raised by pious zeal of our forefathers does the Gothic architecture appear more captivating and perfect than in King's College Chapel at Cambridge, the vaulted roof of which is geometrically constructed, affecting the imagination with pleasure and surprise, whilst the decorations of the roof, the painted windows, the gloom and the perspective, the harmony and general proportions of this chapel contribute to place this justly admired edifice amongst the most elegant and magnificent structures'.[27]

A reflection of the intensity of the admiration for the Chapel is illustrated vividly in the 1820s in the revolution in the Chapel's setting, with the creation of a new court in the Gothic style on its south side (along the lines of the one described in the Founder's 'Will' of 1448), combined with the opening up of the view of the east end of the Chapel as seen from the town. This was a decade in which Cambridge was transformed by a series of new buildings, many of which followed the model of perpendicular Gothic. Given that the Chapel was one of the best-known buildings in the country of this type, this meant that in a sense the University and town were being re-invented and re-drawn in a distinctive collegiate style inspired directly and indirectly by the architecture of the Chapel. Wilkins, for example, redesigned the New Court of Trinity, the first Gothic revival court in Cambridge (designed 1821 and built in 1823–25). It set the tone and, as well as his work at King's, he designed a chapel and court for Corpus Christi (completed 1827), while Rickman, quoted above, designed New Court for St John's in the perpendicular style (completed 1831); in the early 1830s, Wyatville also remodelled the chapel court at Sidney Sussex, which included two possible references to King's College Chapel, the bell turret and the porch.[28] Historian Timothy Brittain-Catlin has also noted how often King's College Chapel is referred to in the design of parsonages built in the 1830s.[29]

But just as the reputation of perpendicular as a style was at its height, the champions of an earlier form of 'pointed' (thirteenth- and fourteenth-century) Gothic entered the debate and effectively deposed perpendicular for a generation. In the early 1840s, for instance, A. W. N. Pugin dismissed the style in *The True Principles of Pointed or Christian Architecture* (1841): 'the moment the *flat* or *four-centred arch* was introduced the spirit of Christian architecture was on the wane'; Pugin condemned a century of Gothic architecture because '*height* or the *vertical principle*, emblematic of the resurrection, is the very

essence of Christian architecture'.[30] He conceded that 'King's College Chapel ... still retain[ed] the principle of internal height, with the use of the depressed arch, yet who can avoid being struck with the inconsistency of running walls to a prodigious elevation, and then instead of *carrying out the principle, and springing a lofty groin*, losing a considerable increase of height by a flattened thrusting arched ceiling; the form of which is a sort of contradiction to the height at which is commenced [sic]. I do not make this observation by way of disparaging the merits of this stupendous building, but merely to show the early decay of the true principles of pointed architecture which may be traced even in that glorious pile'.[31] John Ruskin was equally damning of the showiness of the Chapel's design, which he thought 'a piece of architectural juggling if possible more to be condemned [than Santa Sophia, Constantinople, now Istanbul] because less sublime'. In later editions he removed this criticism because 'it took no account of the many charming qualities [which the Chapel] possessed through its faults, nor of its superiority to everything else in its style'.[32] For Charles Eastlake, in *History of the Gothic Revival* (1872), perpendicular was simply: 'debased in general form, vulgarised in ornamental detail, and degenerate in constructive principles'. He added: 'King's College Chapel was regarded as the crowning glory of Gothic, [but] it requires no discernment on the part of modern critics to perceive both in the Tudor and Elizabethan styles abundant evidences of a fallen art'.[33]

However, a younger generation of more sensitive and eclectic architects (who, in domestic design, were often associated with Queen Anne revival, although they continued to design Gothic style churches and chapels) rediscovered the perpendicular style; they reacted against the High Victorian obsession with the thirteenth century, finding in perpendicular a distinctly national style and source of inspiration. G. G. Scott Junior, for instance, made a serious study of the Chapel when assisting his father in his restoration of the roof in 1860–63 and in other work that continued into the 1870s.[34] In his *Essay on the History of English Church Architecture* (1881), he argued forcefully that 'the later phase of the perpendicular style was the most original and able thing that the English have achieved in art'.[35] Indeed, this almost nationalistic idea remains significant in the twentieth century too, and ensures the continuing reputation of the Chapel. Henry James's lyrical description, published in 1905 in *English Hours*, may at first seem a summation of earlier views but it is also, in a sense, detached from debates about style. James approached the Chapel more in terms of a connoisseur: 'the single object at Cambridge that makes the most abiding impression is the famous chapel of King's College, the most beautiful chapel in England. The effect it attempts to produce within is all the sphere of the sublime. The attempt succeeds, and the success is attained by a design so light and elegant that at first it almost defeats itself. The sublime usually has more of a frown and a straddle, and it is not until after you have looked about you for ten minutes that you perceive the chapel to be saved from being the prettiest church in England by the accident of its being the noblest. It is a cathedral without aisles or columns or transepts, but (as a compensation) with such a beautiful slimness of clustered tracery soaring along the walls and spreading, bending, and conmingling in the roof that its simplicity seems only a richness the more'.[36]

Throughout the twentieth century the Chapel has hardly been omitted from any history of English architecture. In 1926, Christopher Hussey described it as 'perhaps the supreme achievement of English architecture in any age'.[37] In 1928, Kenneth Clark, in his history of the Gothic revival, thought that King's College Chapel, was 'not completely successful', but in 1949 wrote in a footnote: 'I forget now why I thought it was so grand to be so critical of King's College Chapel'.[38] In 1943, Nikolaus Pevsner in *An Outline of European Architecture* considered King's College Chapel, Eton College Chapel, St George's Chapel, Windsor and the Henry VII Chapel at Westminster Abbey as a significant group: 'extremely simple exteriors and plans, but with plenty of masterfully executed decoration'. At

Cambridge, he especially observed how the builders imbued a 'practical matter-of-fact spirit with a sense of mystery and an almost oriental effusion of ornament'.[39] David Watkin in *English Architecture* (2001) observed succinctly: 'Nowhere is there a more complete example of the will to create a great open cage by unifying walls, windows and roof into one uninterrupted, unified space defined by vertical lines. The interior is enthralling because the immense stone vault appears to rest on nothing more solid than walls of glass'.[40] The Chapel has thus retained a national status in its reputation through five centuries, in a way that cannot be said of some comparable buildings, such as St George's Chapel at Windsor. Equally revealing of this persistently high status are the 'reactions' to the building by the designers who were commissioned to build around the Chapel.

'To give full view of the Chappel': building and rebuilding the College around the Chapel

It is a paradox that the Chapel, which from its completion evidently occupied a place of international repute, should have been the only part of the original conception for the College set out in the 1448 'Will' of King Henry VI to be completed. Grand, sublime, unforgettable, the Chapel was for a long time oddly isolated and adrift (the College originally occupied the court to the north, now part of the Old Schools). The vision of the buildings in the Founder's 'Will' for College buildings to the south, as well as his guidance on style, namely that they should be 'clene and substancial, settyng a parte superfluite of too gret curious werkes of entaille and besy moldyng',[41] seem to have been explicitly drawn to the attention of architects working on the successive plans for the completion of the court in the eighteenth and early nineteenth centuries.

The desire to build more of the College as envisioned in the 'Will' must have been a subject of regular debate through the sixteenth and seventeenth centuries. Evidence of sixteenth-century interest in further building on an ambitious scale is given by the existence of an unexecuted design, in the British Library, for a vast bell tower which would have dominated the town. That drawing has now been dated to the mid sixteenth century – an exact copy made in 1793 held at King's College suggests late eighteenth-century interest in this dramatic proposal (Ill. 14).[42] King's College Library also holds an anonymous set of verses addressed to James I exhorting him to complete the College.[43] How an early seventeenth-century mason might have approached the design of the College ranges is a matter of conjecture, but we do have the interesting example of the rebuilding of Clare College's front court in 1638 – including the deliberately restrained style of the front that looks over the Chapel and the lawn of King's. Until the early nineteenth century, when the new court by Wilkins was created, Clare's east entrance framed the principal approach to King's College Chapel. The master mason was John Westley. Clare (then still Clare Hall) had been advised to set the court back away from the Chapel 'for convenience of light and air'.[44] The obvious mutual advantages of this proposal led the master and Fellows of Clare to petition King's College and the king for some land along the river bank opposite Clare but owned by King's College (and known as Butt's Close). This request ignited a vituperative exchange between the colleges.[45] This debate produced the interesting statement by Clare that the removing of their buildings west of the line of King's Chapel would be an obvious advantage for 'the beauty of their Chapel to be better seen'.[46] King's was firmly opposed. Clare's response was to appeal again to the aesthetic importance of the Chapel: 'We answer that the beauty of Kings Coll: Chapel is not pretended [claimed falsely], but that it will be really advanced by

Ill. 14. Barak Longmate, *Design for Proposed Campanile*, King's College Chapel, 1793, pen, ink and wash drawing on paper, 136.7 x 39.2 cm. Cambridge, King's College. Copy of *Proposed Belltower for King's College Chapel*, mid-sixteenth century, drawing on two sheets of paper, 131.5 x 37.5 cm; London, British Library, MS Cotton Augustus I i 3.

the remoove of Clare-hall as is obvious not only to men of skill, but to every ordinary and indifferent eye'.[47] The matter was referred to the king, who finally resolved the issue by enforcing a mutual exchange of land. The very plainness of the 1630s Clare range seems significant too, reading as an architectural foil to the dramatic scale of the Chapel. The vaulting inside the main entrance gate to Clare also may have been a deliberate homage to the vaulting of the Chapel.[48]

A design for a new court for King's College was vigorously pursued in the early eighteenth century. In March 1713, Provost Adams instructed Nicholas Hawksmoor to draw up new designs. Hawksmoor produced models, of which Adams commented, 'I desird this wing might be set more backward to give full view of the Chappel'.[49] Hawksmoor's own 'Drawn Plans of the Town of Cambridge as it ought to be reformed' also showed how he imagined the Chapel as a focal point for a new classical civic forum for both town and University, imagining a dramatic vista focused on the great Gothic temple (Ill. 15).[50] Provost Adams advised Hawksmoor that a certain austerity in the elevations of his new ranges would be the best way to honour the architectural importance of the Chapel, and Adams replied that 'the hight would be Majestick of its selfe & in its plainness more answerable to the Chappel: and [he] desird all Ornaments might be avoided: This too the Rather because something of that Nature is in the Founders Will'.[51]

Provost Adams failed to secure funding. His successor, Andrew Snape, approached architect James Gibbs (then building the Senate House) to provide a new design for the College. Work began on

Ill. 15. Gordon Cullen, *The Forum Seen from the Marketplace (as in Hawksmoor)*, David Roberts, *The Town of Cambridge as it Ought to be Reformed: The Plan of Nicholas Hawksmoor* (Cambridge: Printed privately at the University Press, 1955), reproduction of a drawing representing an imaginative reconstruction of the view towards the Chapel suggested by Hawksmoor's plan, 15 x 22 cm.

Ill. 16. James Wyatt, *Proposal (Perspective looking north to King's Parade)*, 1795, pen and watercolour. Cambridge, King's College, KCD/628.

the west range facing the river in 1724.[52] Only this portion was ever completed. In Gibbs's 1728 *Book of Architecture* he refered to this as 'detach'd from the Chapell as being a different kind of Building'; he had pointedly kept the new range physically distinct from the Chapel.[53] Late-eighteenth-century proposals to complete the main court continued broadly to defer to the Chapel in scale and arrangement, including Robert Adam's proposals of the 1780s.[54] The first plans for a new court that honoured the Chapel anew by taking its perpendicular Gothic style as a guide, were those presented in 1795–7 by James Wyatt (Ill. 16).[55] Wyatt also proposed to clear away the warren of buildings in front of the Chapel and to widen the street, 'by which means the whole of the New front of Kings will be seen in an oblique direction & the south side of the Senate house in front as they are approached up Trumpington Street'.[56] Nothing of Wyatt's plan was built but the focus on the significance of the eastward view from the town was a turning point.

In 1822, an open architectural competition for the completion of the College was held. In March 1823, the Governing Body chose the perpendicular Gothic style, and the architect William Wilkins was awarded the commission, out of a field of twenty-three (Ill. 17).[57] The issue of how the new buildings related to the Chapel was clearly significant, as can be seen in the variety of approaches by the architects in this competition to the eastern enclosure of the court – some of which revealed more of the Chapel to the town, some less (Ill. 18).[58] Wilkins' own front screen (either side of a gatehouse) was first imagined as a full cloister, detailed in homage to the Chapel – and possibly reduced to a single screen on grounds of cost (Provost Coke had suggested a cloister to James Wyatt in 1793). John Nash and Jeffry Wyattville, then engaged to advise the College, observed that: 'as the beauty of the Chapel front demands that it should be identified and to a certain degree insulated we recommend that the junction

Ill. 17. William Wilkins, *Perspective towards the Southwest from King's Parade*, c.1823, not exactly as executed, but as exhibited at the Royal Academy in 1824, 1825 and 1828, watercolour, 11.9 x 24.8 cm. Cambridge, King's College.

Ill. 18. Lewis Vulliamy, *No. 1. View of the Front towards Trumpington Street of a Design for King's College. Nisi utile nil pulchrum*, c.1822–23, pencil and wash, 39.0 x 63.3 cm. Cambridge, King's College, CMR/83.

be by an open cloyster but of sufficient heighth [sic] so as to give the impression of the three sides of the Quadrangle being united'. Wilkins was confident that he had provided an unparalleled 'attention to the observance of the antique character'.[59] Wilkins' work required the demolition of the venerable Provost's Lodge and other buildings that lay between the Chapel and Trumpington Street, which then allowed a much better view of the east end of the Chapel (Ill. 19). Wilkins' entrance screen soon became much valued for this reason, because it gave visual access to the Chapel, so when plans to replace the screen with a new double height building were explored in 1877, the architect G. G. Scott Senior

Ill. 19. *Ground Plan of Provost's Lodge* (showing buildings removed from around the Chapel during Wilkins' rebuildings). In Robert Willis, *Architectural History of the University and Colleges of Cambridge and Eton*, ed. John Willis Clark (Cambridge: University Press, 1886).

wrote, 'you are proposing to close in an opening which has been viewed for half a century as the Glory of Cambridge . . . and, in part at least, to obscure what may be called the Glory of all lands. The public will severely resent this'.[60] The 1820s screen has survived and the view preserved.[61] In 1864–67, Scott had also raised the south range of the Schools building by a storey: the original two storeys were fifteenth century, and the finished elevation was again carefully composed to be a fitting foil for the Chapel it faced.[62]

'As it was to be a work of public view and of lasting use': Re-ordering the Interior

Similar, if not more complex, debates have been played out in the treatment of the interior of the building throughout the Chapel's long history – but given additional heat by English policies of religious reform. The east end – and the altar table in particular – was functionally the visual and liturgical focus of the Chapel, and was thus also a battleground for ideas about religious ritual, here being fought over in the context of this nationally admired building.[63] The very scale of both the Chapel and the east window itself has perhaps also meant that arrangements at the east end always seemed to some degree unsatisfactory. The ritual for which the Chapel was moreover designed changed radically with the Reformation; from the end of 1540s the process of change was rapid and confusing, as Church policy altered every few years, settling down in the late sixteenth century.

39

The east end arrangements were nonetheless revisited again and again throughout the history of the Chapel. A high altar is mentioned in the Founder's 1448 'Will', but the details of his intention are not clear (whereas at Eton quite precise instructions were given for an altar eight feet from the east end). Neither is it really clear what was executed at the time of the completion of the building of the Chapel, as the fitting out continued well into the 1540s. The first high altar seems to have been the one delivered as late as 1544–45; and it may well have been intended to be sited in the easternmost bay, following the pattern of the Founder's instructions for Eton, as the distance between the altar and choir stalls would have all contributed to the grandeur and drama of the mass. However, documentary evidence is not conclusive, and historians such as William Cole in the eighteenth century and Willis and Clark in the nineteenth argued that the 1540s high altar might have been sited in the second bay in from the east end – in the same position that the high altar that existed from 1633 to 1775.[64] This would have still given a good distance between the end of the stalls and the activities of the priests at the altar – although Willis and Clark based their view largely on the payments in 1611 for laying 'white tiles' in conjunction with other works at the east end. However, some modern scholars, including Roger Bowers, have suggested the third bay in from the east end, between the two vestry doors, as the possible site of the 1540s altar.[65]

This 1540s high altar was described in the accounts as richly carved gilded and ornamented (by a Master Antonio – possibly Antonio del Nunziato).[66] However, its form is otherwise visually unrecorded and it was removed after only around five years, under the reforms initiated by Edward VI, being replaced with a table. In around 1553, following Mary's accession, a new high altar suitable for celebrating the restored Catholic mass was created – presumably in the same position as the 1540s high altar. However, shortly after the accession of Elizabeth I, this was also removed and a table re-introduced; at the same time some costly altar hangings were converted into costumes for theatrical performances and others sold to finance a new library.[67] In 1561–62, instructions were given for commandments to be set up over what was then still described as the 'the High Altar', which might suggest that there was still some kind of arrangement of altar, reredos and screen at the east end, though what form this took is not known.

In 1564, during Queen Elizabeth's visit, there was a description of temporary tapestry hangings being installed between the door to the north vestry 'round by the Communion-Table unto the South Vestry dore', which could suggest that the communion table stood then between the vestry doors (it is also described as standing on a north-south axis) with the hanging behind it on the east side.[68] A pulpit was also introduced in 1570–71. Robert Smythson's survey plan of around 1609 shows the extent of the puritan re-ordering that took place under Provost Goad (Provost 1570–1610; see Ill. 20).[69] This clearly shows the communion table by now set longitudinally (on an east-west axis) in the middle of the choir, with an organ standing on the floor (set between the doors to the vestries) in the third bay from the east end. The area east of the organ is described on the plan as 'the Place where thay burie in' – although it is not clear when this practice began.[70]

Not surprisingly, the revival of rich church furnishing encouraged by Archbishop William Laud had an immediate impact on the Chapel. In 1633, Woodroffe the joiner was paid handsomely to erect a new screen to act as a reredos to a new high altar (now once more aligned north–south) 'in parte orientali novi Templi', with the screen running across the width of the Chapel, one bay in from the east end. He also fixed rails around the altar table and damask hangings, while Tolly, the upholsterer, provided new footstools covered in damask. The Provost, Dr Collins, had already contributed towards 'a purple velvet Communion Cloth with silk and gold fringes'.[71] There are also payments for replacing (or possibly rebuilding?) the sanctuary steps. It must have seemed an aesthetic revolution to those used to the

Ill. 20. Robert Smythson, *Designs by Reginald Ely (1438–1471) of King's College Chapel: Survey Plan*, c.1609. Detail of drawing A188. London, RIBA Library Drawings Collection, SC229/I/4.

austerity of Goad's puritan arrangements. Again no illustration survives, but antiquary William Cole's 1740s description of the Chapel gives a good account of this repaired Laudian high altar arrangement (which also corresponds with a shorter account given in a puritan report of 1641): 'the High Altar is not erected immediately under the E. Wall or Window, but at a pretty distance from it, against a fine Wainscote Screen for that purpose which runs quite across the Chapel from the division of the 1st and 2nd Window, which has a kind of Canopy over it adorned with fine carv'd work; and in the middle directly over the Altar are the Arms of the College royally crowned'. There were two doors to enter the space behind altar and screen, one with the arms of James I, the other with those of Henry VIII, 'elegantly carved as is all what is about the Screen of the Altar . . . The back of the Altar is hung with a rich silk Damask of Purple and Crimson'. The altar 'stands on an Eminence of one step above the rest all round and railed in about it with neat wainscot & rails' and was surrounded by kneeling stools upholstered in damask, and, outside the rails, kneeling cushions in a 'blew Cloth'. Cole thought this was probably the original site of the sixteenth-century high altar.[72]

Remarkably, the high altar of the 1630s and associated east end screen, which linked the reredos to each side of the Chapel, seem to have survived largely intact through the Civil War and Commonwealth period. It is not possible to say whether this was by chance or by active diplomacy. The magnificent sixteenth-century stained glass also survived.[73] Dowsing, the parliament-appointed 'Visitor' charged with seeking out and destroying 'superstitious images', came to King's College in December 1643, when he noted: '[chancel] Steps to be taken [up]. One thousand superstitious pictures' [in the glass].[74] The sparing of the glass may have had something to do with Dowsing's visit to the Chapel being the last of a series of five visits to college chapels in one day, and the practical fact that there were soldiers quartered there who would have been disrupted by the sudden removal of the glass.[75] The unlikely idea that Cromwell had personally intervened to spare the glass had a long currency; in 1748, a Thomas Salmon, in *The Foreigner's Companion through the Universities of Cambridge and Oxford*, set out the popular legend that 'Cromwell seems to have had a particular Regard for the University where he had his Education, and for a Town he had the Honour to

Ill. 21. Survey of King's College Chapel. Detail of James Gibbs, *The Quadrangle of Kings College as its now begune*, engraving, 25.5 x 38 cm (plate). In James Gibbs, *A Book of Architecture: Containing Designs of Buildings and Ornaments* (London: Printed for W. Innys and R. Manby, J. and P. Knapton, and C. Hitch, 1728), pl. [32].

represent in Parliament, or it is not to be conceived why he should suffer the Figures of Saints and Angels, and even an Image of God the Father, to remain, when every thing of this Kind was erased in every other Part of the Kingdom almost and scarce a Cross permitted to stand in Colours, or on a Sign-post'.[76] But there is no documentary evidence for this story. More likely, as historian Carola Hicks has suggested, the Provost and Fellows probably acquiesced in his injunctions but played a waiting game and won. By 1662–63, the 1630s high altar was being repaired by Cornelius Austin who also panelled the area behind the screen. In 1678–79 Austin installed further wainscot of a classical character at the east end (between the choir stalls and the high altar screen).[77]

Nonetheless, the survival of this ecclesiastical and historical curiosity did not satisfy the next generation, and the first Chapel guidebook of 1769 called this altarpiece 'decent, though not grand', hinting perhaps at a dissatisfaction with its scale as much as anything.[78] In 1702 a new marble floor was laid in the choir and sanctuary; the different levels of this floor in the eastern bays, which rose in two stages towards the sanctuary, can be seen in an interior drawing by William Stukeley made in around 1705, which leaves the last bay undrawn, suggesting that he did not see behind the screen; (see Ill. 162). In 1707 Charles Roderick (Provost 1689–1712) gave £150 towards a new altarpiece, but it was nearly three quarters of a century before a new one was installed in 1775–1776.[79] This was despite the fact that in the 1720s Gibbs provided at least one elegant classical design for a reredos that also drew somewhat on the character of the Renaissance screen of the choir. This was clearly intended to replace the 1633 altarpiece on the same location – as is suggested by the plan of the Chapel published in plate 32 of Gibbs's *Book of Architecture* (1728), which shows a slightly more

complex reredos than the surviving design: (see Ill. 21).[80] In May 1772, the Governing Body recorded that they were still accumulating monies, for 'the new Intended Altarpeice [which] has been preparing for sometime past'.[81] In late 1758 or early 1759, James Burrough had offered two designs (one classical in wood, the other Gothic in stone, both drawn up by James Essex). These were taken to London for the opinion of the architect, James 'Athenian' Stuart: 'as it was to be a work of public view and of lasting use, Mr Upton, as was thought advisable, took [them] with him to London for the opinion of those who might be competent judges in such a matter'. Gentleman amateur Sanderson Miller, one of the leading champions of Gothic, was also consulted.[82]

Stuart recommended the Gothic style be followed, despite not being a particular champion of it. Stuart was approached for further ideas, with the agreement of the senior Fellows, 'that we may have his judgement and character for knowledge in such things – to justify us to the world', a phrase that reveals how the opinion of the 'world' might be expected for any revision in the arrangement of the interior of the famous Chapel.[83] But Stuart must have demurred. Burrough died in 1764 and the next designs presented were by James Adam: first a dignified classical design of 1768, which he felt echoed the detail of the Woodroffe wainscot and the Renaissance choir screen, and was to be wood painted a stone colour (Ill. 22), and then an ornate but only superficially Gothic design of 1769 also

Ill. 22. James Adam, *Elevation of Design for Altarpiece*, [1768], paper, 48.4 x 58.3 cm. Cambridge, King's College, KCC/277 (KCAR/8/1/2/1).

Ill. 23. James Adam, *Design for Altarpiece, Classical, showing relationship to east window*, later title inscription in the hand of William Adam, 'Design of a Skreen for Kings College, Cambridge', [1768], pen and pencil on laid paper, 600 x 497 mm. London, Soane Museum, SM Adam volume 31/22.

to be painted to resemble stone (Ill. 24).[84] Although Richard Potenger, the Fellow who had sought these designs felt that this one was 'in a superior Taste', and did answer to the grandeur of the Chapel, it nonetheless did not recommend itself to the Provost and others, principally because it obscured part of the east window. This was shown dramatically on the drawing Adam produced to explain the relationship of the classical reredos to the east window (Ill. 23). It seems from this drawing that Adam's altar-piece was also to stand on the same line as the 1633 reredos – one bay in from the east end – and also shows Adam bravely tackling the issue of scale in the Chapel.

Ill. 24. James Adam, *Design for Altarpiece, Gothic*, with later title inscription in the hand of William Adam, '2 Design of a Skreen for Kings College, Cambridge', [1769], pen, pencil and wash on laid paper, 602 x 739 mm. London, Soane Museum, SM Adam volume 31/23.

In the end, the commission went to James Essex, a Cambridge man who was also considered a national authority on Gothic architecture (and much admired by Horace Walpole).[85] In 1775 Essex's reredos, which followed the perpendicular style of the Chapel's exterior architecture, was installed, right up against the east end under the window, with slender pinnacles in the form of crocketed finials, carefully aligned to the stone mullions of the east window and two large stone canopied niches to north and south of the east window (Ills. 25 and 26). The panelling either side of the central altar-piece had just enough space behind it to allow access to the turret staircases. The position of the reredos under the east window was in part motivated by an idea of the original medieval intention, but also probably by the more prosaic anxiety about the need to see the window more clearly, which had been stirred up during the discussion of James Adam's proposals. The woodwork, including rails, was executed by Cotton and Humfrey, with stonework by Jeffs and Bentley, and the floor was also relaid in a new pattern in the eastern three bays. The reredos was designed to contain a painting by George Romney, a *Mater Dolorosa* to be presented by Thomas Orde (Kingsman and later 1st Lord Bolton).[86] But before the completion of the reredos, Frederick, 5th Earl of Carlisle, presented to the College a magnificent sixteenth-century *Deposition* by Girolamo Siciolante da Sermoneta, now in the Founder's Chapel on the

Ill. 25. James Essex's altarpiece. Detail of Richard Bankes Harraden, *View of the Choir of King's College, Cambridge*, 1797, watercolour on paper, 46.4 x 35 cm. Cambridge, King's College.

Ill. 26. *Interior of King's College Chapel* (looking east from the organ loft to the altar), before 1896, photograph, 19.6 x 27.1 cm. Cambridge, King's College, KCPH/5/2.

north side (and discussed by Jean Michel Massing below); Romney's painting was never finished. Essex's spirited work was widely admired at the time of its execution, described in one journal as 'peculiarly corresponding to the simplicity and the magnificence of the building'.[87]

By the mid-nineteenth century, however, with the increasing intensity of the Gothic revival, there was a growing dissatisfaction with the Essex reredos – and the position of the altar remained a flashpoint. When in 1867 the Fellow T. J. P. Carter published a punchy new history of the Chapel, he condemned Essex's reredos as 'a masterpiece of extravagance and bad taste', insisting that the woodwork should be removed: 'the whole work is a violation of the original idea; it has no character, and belongs to the taste of no period'.[88] Later nineteenth-century architects felt that Essex had been wrong to assume that there had been a reredos against the east wall. In an appendix to Carter's new history, G. G. Scott Senior suggested a new altar table 'on a raised foot-pace, at about the centre of the eastern bay, or half a bay in advance of the east wall, thus following the rule laid down by the founder for Eton College Chapel'. The altar table would stand before a detached reredos 'of rich materials and

Ill. 27. J. C. Stadler after F. Mackenzie, *The Choir. King's Chapel*, aquatint, 28.0 x 20.1 cm. In Rudolph Ackermann, *A History of the University of Cambridge, Its Colleges, Halls, and Public Buildings* (London: Printed for R. Ackermann, by L. Harrison and J. C. Leigh, 1815), pl. VI. Oxford, Sanders of Oxford.

workmanship', which Scott felt should be 'of material and art proportioned to the magnificence of the building' with rich tapestry hangings in the eastern bays.[89] It appears Scott may have even drawn up some designs, but his suggestions were not pursued, though his son G. G. Scott Junior, who worked with him at King's and had also advised T. J. P. Carter on his history of the Chapel, did design two magnificent neo-Renaissance brass candle-standards inspired by Hacumblen's early sixteenth-century bronze lectern. These were executed by Barkentin and Krall of London and installed in the sanctuary in 1872 (they were removed in the 1960s, and unfortunately sold in 2005).[90]

In 1872 architect William Burges was approached unofficially by a group of old Kingsmen and Fellows, in order to secure a design for a new altarpiece.[91] Like Scott, Burges began with a thorough assessment of the history of the east end (and also drew on comparable evidence from the chapel at Eton). He wanted to give the sanctuary an arrangement closer to that intended by the Founder – he proposed an altar fourteen feet forward of the east end. Burges took great exception to Essex having placed the reredos directly against the east wall – 'a change to be deplored from every artistic point of view' – and wrote witheringly about the sculptural niches which Essex introduced (T. J. P. Carter called these niches 'unpardonable'). Burges imagined an ornate carved altar-screen framing a central altar, enlivened with groups of figures telling the story of the birth of Christ, following the style of Bishop West's Chapel in Ely. Burges wrote that he had tried 'to steer a middle course between the pure Perpendicular of the Chapel and the pure Renaissance of the Rood Screen' (Ill. 28). In 1889, the

Ill. 28. William Burges, *Design for a New Altar Screen, King's College Chapel, Cambridge*, June 1874, pen and wash drawing on paper, 34.5 x 45.7 (window in mount). Cambridge, King's College Library, KCC/76.

Ill. 29. Copy distributed to Fellows of King's College, Cambridge, of George Bodley and Thomas Garner, *Design for New Altar*, 1895, paper, 35.5 x 20.8 cm. Cambridge, King's College, KCC/145.

same committee also approached the architect J. L. Pearson, who was working on the restoration of the Chapel, for an alternative design (which was felt to be 'less costly and elaborate').[92] In 1892, the unofficial committee handed over these designs to the College.[93] At the same time designs were sought by the College from leading ecclesiastical architects Bodley and Garner.[94] The process of resolving the re-ordering of the east end (which began in the 1860s) took a painfully long time. M. R. James (Provost 1905–1918) recorded gloomily in his memoirs: 'when you have to take counsel with a body of forty-six persons on a question of taste, unanimity is not easily secured. Everybody has an opinion: they are "not experts", they "know nothing about it", they "only know what they like". I should be loth to pass through the many stages of committees, reports, discussions, again'. It is a view that certainly echoes across the centuries at King's.[95]

In November 1894, Bodley and Garner offered up a design for a magnificent carved triptych-type of reredos as a back-drop to a marble altar table. The triptych would be fixed in its 'open' position, 'low and broad in proportion, so as not to encroach on the beautiful East window, and, at the same time, to fill up the wide space of the Chapel and prevent the Altarpiece from looking insignificant ... The style of the ornament ought, we think, to follow that of the Chapel and its beautiful fittings. Also we have endeavoured to make the general character Gothic, introducing Renaissance ornaments into the details'. The reredos was to be oak, with figures in alabaster, partly gilded and coloured, and Essex's 'ugly modern' panelling removed and replaced by hangings (Ill. 29). The altar table itself, standing on a raised platform (known as a 'pace') against the east end, was initially to be of black

marble and gilt bronze, 'in the way often seen in similar works, as at Westminster Abbey'.[96] Tellingly, despite this tactful homage to Westminster in the form of the altar table, the inspiration of the chosen triptych form of the reredos was northern European and German, rather than English. James took strong exception to this insistence on a triptych: 'I should like to point out that it is not in the least likely that any altar-piece designed for the Chapel at the time of its completion would have taken this form: a form which does not seem to me at all characteristically English. Now the Chapel is in all main points a truly English building, notwithstanding the fact that foreign workmen were employed upon the windows and the woodwork'.[97] The Essex reredos was removed in 1896, under the supervision of Thomas Garner, and approval given in principle for a new altar table and hangings.[98] In 1899, Provost Austen Leigh expressed clear views about the limits of what could be achieved: 'it is a pure waste of time (& perhaps of our money) to be making designs for a reredos, which will be put up by another generation – who may have totally different ideas. What we want (in my view) is something that may have to last for 20 or 30 years – in the way of an Altar Table, and satisfactory hangings all round the sanctuary'.[99] In 1898, a Burne-Jones-designed tapestry depicting the Holy Grail was loaned briefly to hang at the east end.[100]

In June 1900 a model (in plaster and wood) of Garner's altar table was in place and two embroidered hangings were produced by Watts and Co to his designs for the eastern end of the Chapel (one now hangs on the stairs to the College Archive). The altar table with a 'dark Irish Fossil Marble' slab on supports of finely carved alabaster was approved, constructed by Farmer and Brindley and installed by Advent Sunday 1902.[101] M. R. James noted that at this stage the levels and the steps 'were restored to what is believed to have been their original position' – and it is interesting that he expressed this in such a cautious tone. The Wilkins' survey of 1805, read with other visual records such as the 1797 Harraden view, shows the floorplan of Essex's alterations included a new marble floor in the first, second and third bays from the east wall. After one step up from the choir, which retained a 1702 marble floor, the 1770s floor continued on the same level to the sanctuary (on the division of the first and second bay) which was then approached by central flight of three steps aligned on the altar and framed by two low screens. The altar and reredos stood centrally, directly against the east wall, and raised on an altar platform known as a 'pace' (Ill. 30). Garner's 1890s re-arrangement of the floor included an adjustment of the depth of the presbytery, so that after a single step at the end of the choir stalls, there followed a set of three steps one and a half bays in from the east end, and another single step at the division of the first and second bay. The altar table stood on a raised 'pace' of two steps, half a bay in from the east end (Ill. 31).[102] In 1903, Garner was told that the College had finally decided not to pursue his proposals for the treatment of the east end, which included the rejection of the elegant hangings already supplied. This parting of the ways was described by Garner as a 'bitter disappointment'.[103]

Finally, in an attempt to begin the process afresh, W. R. Lethaby was informally consulted on the east end by the College and made some recommendations, noting that the College had been in a 'muddle' for some time since removing the 'bogus Gothic' altarpiece by Essex.[104] Lethaby agreed with the reredos committee's hope 'that the work should be in harmony with the Renaissance style but beyond that ... sh[oul]d not go. In fact of course it is as impossible to be Renaissance as it is to be Japanese'. He also advised approaching the painter G. F. Watts for an altar-painting, and having tapestries woven by Morris & Co to designs by Burne-Jones, stressing that 'the position governed by the marvellous beauty of the old work calls for very simple and careful treatment'.[105] Perhaps at Lethaby's instigation, and to resolve the long-running saga, the reredos committee then invited three younger architects to submit designs: Detmar Blow (of Blow and Billerey), Ambrose Poynter and

Ill. 30. John Roffe, after John Linnell Bond, after William Wilkins, *Ground Plan with the Groining &c. of the Roof of King's College Chapel, Cambridge*, 29 September 1805, engraving. In John Britton, *The Architectural Antiquities of Great Britain*, vol. I (London: Longman, Hurst, Rees, and Orme [etc.], 1807).

Ill. 31. *King's College Chapel: With Traces of Destroyed Buildings Visible in 'Crop-Marks'*, 1955. In *An Inventory of the Historic Monuments in the City of Cambridge* (London: Her Majesty's Stationery Office, 1988; first printed 1959).

Ill. 32. Detmar Blow, *The Proposed Reredos and Panelling shown in the context of the east end of King's College Chapel*, signed and dated, 'D. Blow, 1906', oil on canvas, 211 x 128 cm. Collection of Simon Blow.

Thomas Carter (a pupil of Bodley). Blow and Billerey's essentially Renaissance design for a reredos that would stand against the east wall and frame the existing Garner-designed altar table on its platform was chosen by the Governing Body (the reredos committee having favoured Poynter) and accepted in 1905 (Ill. 32).[106] Remarkably, a full-scale plaster model of the reredos was trialled (Ill. 33). Blow was required to make a large number of modifications, including extending his panelling to the three steps (i.e one and a half bays in), which required a removal of some of the later seventeenth-century Austin wainscot.[107] Blow's panelling and reredos, with three shell-headed niches, and the design for the sedilia (seats for the priests) deliberately echoed the Renaissance character of the choir screen, with carved cresting copied from the choir of the Church of San Pietro in Perugia. M. R. James issued a published appeal for funds to complete the project: they needed a

Ill. 33. *Full-scale plaster model of Detmar Blow's proposed reredos for King's College Chapel.* Edgar Allan Basebe, photograph, 39 x 50.7 cm (including mount). Cambridge, King's College, KCC/144 (KCAR/8/1/2/1).

Ill. 34. *John Rattenbury Skeaping's Wooden Statues of Virgin Mary, Jesus and St Nicholas* (installed 1957–60 in the reredos designed by Detmar Blow and Fernand Billerey), [1964], photograph, 25 x 20 cm. Cambridge, King's College, Coll Ph 718.

further £2,500 – without the sculptures for the niches.[108] Blow suggested casts of sculptures by Donatello be acquired for the niches until such time as new sculptures could be afforded.[109]

After the numerous meetings and modifications to his design, Blow's work was only finally completed in 1911 with a new altar cross by W. Bainbridge Reynolds (Ill. 33).[110] The *Deposition* by Siciolante was moved to the north side of the chancel and incorporated into a frame within the panelling, and a credence table for the eucharist and sedilia incorporated in the panelling to the south. Although the reredos had always been designed to house three carved figures, Christ flanked by the two patrons of the College, the Virgin Mary and St Nicholas – funds for these were not forthcoming. A former Fellow, Arthur Hill, offered to leave a bequest for figures.[111] Hill died only in 1941, however, when the commission was first offered to Henry Moore, who later withdrew, and then to J. R. Skeaping, Professor of Sculpture at the Royal Academy; he executed three Primitivist carved wood figures in a Nigerian *Opepe* wood of a 'honey colour', which were installed in 1957–60 (Ill. 34), but removed in 1964 as part of the wider re-ordering.[112]

'So much brass': the 1960s re-ordering and the arrival of the Rubens

This 1960s re-ordering is undoubtedly one of the major events in the modern history of the Chapel's interior. The long drawn out and complex debate surrounding it once again reflects the importance of the Chapel in the national architectural canon and also replays the complex internal and national debates that have shaped the east end over five centuries. Post-1945 responses to the Chapel are made more opaque by the context of accelerated secularism, both nationally and within the institution (Chapel attendance was relaxed in 1871 and ceased to be compulsory for undergraduates in 1912[113]). On the one hand, although the Chapel and its Choir remained a defined element of the constitution of the College, the Christian faith and the Anglican tradition were no longer as significant to many Fellows as they had been; on the other hand, for some Fellows wider debates over High and Low Church practice remained significant.[114] In line with the post-war Anglican liturgical reform movement that favoured a more congregationally focussed Eucharist, a review of the sanctuary arrangements was begun. In 1960, the specialist firm of church architects Maguire and Murray was approached by Dean Alec Vidler and Chaplain-Succentor Victor de Waal to consider the rearrangement of the Chapel's east end for modern liturgy.[115] This also reflected a continued general anxiety about the east end being 'a muddle' – curiously the same word used by Lethaby in 1905, which does suggest that the perennial dissatisfaction with the east end is really a question of scale. Maguire and Murray carried out a thorough historical investigation and analysis of the character of the Chapel, their principal desire being to restore an 'appreciation of the intrinsic qualities – spatial and structural – of the building'.

Before their report was completed, however, they were obliged to incorporate an unexpected element.[116] In 1959, a property developer, Major A. E. Allnatt, had bought Rubens's magnificent 1634 altar-painting, *The Adoration of the Magi*, for £275,000, and in March 1961 he generously offered it, not to a national museum, but to King's College for installation in the Chapel.[117] Noel Annan (Provost 1956–66) and Michael Jaffé (Fellow, Rubens expert, founder of the Department of the History of Art at Cambridge, and from 1973 Director of the Fitzwilliam Museum) were keen to accept it for the College. Annan, conscious of the serious challenge of placing it satisfactorily, seems to have been motivated, at least, in part, by anxiety about what his successors might say about a refusal of so munificent a gift.[118] Annan asked Maguire and Murray to report on how the painting might be included in the Chapel. In May 1961, fifty Fellows voted to accept Allnatt's 'munificent gift

Ill. 35. *Peter Paul Rubens' Adoration of the Magi Being Installed Temporarily in the Antechapel for a Period of Experiment*, April 1961. Ronald A. Chapman, photograph. Cambridge, King's College, KCC/467.

and rare addition to the worship, dignity, and beauty of the Chapel'.[119] Allnatt had suggested that it be hung on the screen facing the antechapel, above the entrance to the choir. The highly sensitive matter of its placing was referred to the Chapel Adornment Committee, chaired by Dean Alec Vidler, with Jaffé and the Domus Bursar, Tim Munby, among the members.[120]

Maguire and Murray's principal recommendation, intended to 'achieve the integration necessary to encourage participation of the laity in the action of the Eucharist', had been to position the altar well forward either in the first or second bay from the east, under a baldacchino ('a fabric canopy on light columns'), with the Rubens painting reluctantly included as the reredos. The altar-table was to stand forward of the painting so that the celebrant priest could stand behind it facing west.[121] A second, revised proposal would have placed the Rubens painting just in front of the east wall (within a stone pedimented frame), with the altar-table well forward in the second bay from the east in a 'free

standing square sanctuary', quite independent of the painting. Maguire and Murray also urged on the removal of the Blow reredos and panelling, as well as the 1670s wainscot on either side, which connected Blow's work to the choir stalls, to create a 'clarified space'.[122]

Few re-orderings can have received such national attention – reflecting the national status of the building itself. In late 1961, several experts were asked by the College to comment on Maguire and Murray's report and the inclusion of the painting.[123] Kenneth Clark, who gave his opinions verbally, felt that a Baroque picture was not necessarily out of place in a perpendicular Gothic church, and favoured an east end position, although he later revised this because he thought the painting conflicted with the window.[124] Nikolaus Pevsner was doubtful that a satisfactory solution could be found. The Rubens was, he felt, simply visually too strong to stand against the east wall: 'its orchestration has so much brass'. He urged the radical alternative of placing it in the antechapel, twelve or fifteen feet west of the organ screen.[125] John Summerson suggested the best 'semi-permanent' site would be on the line of the division of the panelling between the Blow and the Austin work (i.e. just one bay west of the east end, and where the 1633 reredos had stood). Anthony Blunt favoured a position against the east wall, and argued that either the east wall or free-standing sanctuary position would need a considerable piece of architectural framing; while Geoffrey Webb preferred the free-standing position.[126]

At Maguire and Murray's suggestion, on 15 November 1961, the painting was installed experimentally on an easel in the antechapel near the south end of the screen, where it remained until 1963, so Fellows and the public could express their views (Ill. 35).[127] Fellow John Saltmarsh observed at that time, 'I feel very strongly that it should be placed in the sanctuary ... [whereas in its present position] I cannot feel it to belong to the Chapel: rather, something brought in and placed on exhibition'.[128] Saltmarsh's letter indicates how the impetus from the modern requirements for a congregationally-engaged eucharist was subsumed in a debate about the positioning of a historic work of art. Indeed, Saltmarsh thought 'alterations to the present treatment of the sanctuary will be more readily accepted by public opinion now that the Adoration is actually in the Chapel and on view and these alterations will be clearly intended to provide it with a suitable setting'.

The whole process became fraught. Late in 1962, Maguire and Murray felt forced to resign and were, on Jaffé's recommendation, replaced by Sir Martyn Beckett, who had already been consulted and asked to provide new proposals for a framed reredos as a setting for the painting at the east end.[129] Victor de Waal's observations on Beckett's initial proposals, made on May 16, 1963, also vividly illustrate the tension between the desire for liturgical renewal and the incorporation of the painting: 'by keeping the [Rubens] picture and altar as a unit the altar is overwhelmed by the picture (especially as the picture will be lighted)'; according to de Waal, this made it: '"the side-board" altar of a period of Christian history whose understanding & practice of the eucharist is agreed by all sides (Catholic and Protestant) to have been decadent'. He commented that Beckett's initial scheme 'has much to commend it from a purely *visual* point of view; as an architectural expression of the nature of Christian worship, the understanding and *use* of the Chapel, it leaves something to be desired ... it would be a major mistake to put the sort of altar he envisages into King's Chapel now'.[130]

In a second period of experiment, in April 1964, Blow's reredos and panelling (and the seventeenth-century Austin wainscot linking it to the choir stalls) were removed, leaving the ashlar walls bare – Blow's work and the section of Austin wainscot all went into store. The Rubens was then installed at the east end for a trial period and placed beneath the east window at the height it would be if the floor was levelled (between the choir and east end) – the idea being to reduce the visual interference with the stained glass caused by the altar-painting being installed as a reredos over the altar table. The painting was to be just forward of the east wall, mounted on a metal structure at the

rear, which would hold the painting very slightly canted forward. There was also to be a space of five foot six inches behind the Garner altar-table (reduced in length) for the priest to stand in order to celebrate the Eucharist while facing west.[131] Beckett's revised design also included the addition of shutters to either side giving a triptych effect. If the plan was accepted, the altar was still to stand on a pace approached by steps, but with the top of the frame of the picture remaining firmly under the level of the bottom sill of the east window.

A new altar frontal by Joyce Conwy Evans was part of the proposal, as were new modernist wall sconces in metal designed by Beckett and new pews. The walls of the Chapel were also to be cleaned and, perhaps most significantly, electric lighting installed for the first time and smokeless candles introduced. The floor at the east end was to be lowered (and when this was done historic brick arches which had supported the floor at the east end were exposed and cut down, and human burials were exhumed and removed).[132] This was an entirely new level for the eastern end of the sanctuary.[133] The marble pattern of the new floor at the east end was to be a continuation of the distinctive pattern of the 1702 choir paving. On 30 November 1965, the Governing Body was presented with Beckett's fully worked out plan.[134] There was still a considerable opposing lobby amongst the Fellows, who felt that the altar was 'becoming virtually an appendage to a picture' and that 'enthusiasm for a great work of art, the Rubens, may lead to the spoiling of an even greater one, the Chapel'.[135] The revised scheme was, however, approved by the slimmest of margins (just three votes) and put into train. The Chapel reopened for Christmas 1968 with Beckett's scheme, outlined above, fully executed. This is largely the arrangement we see today, with the wall-mounted candle-branches and plain stone benches added to north and south, intended to bring the congregation around the altar-table, which is positioned on a projecting pace that extends well out from the east wall (Ill. 36).

The 'Astragal' column in *Architect's Journal* said that the Chapel had been 'tastefully secularised' and the ensemble 'motivated not by the demands of liturgical worship but by those of museum display'.[136] With more enthusiasm, the *Illustrated London News*, recording that the cost of the project was around £150,000, observed that 'the east end has been greatly improved by the removal of the dark oak panelling ... The original plain stonework makes an ideal background for the painting'.[137] Jaffé wrote to Pevsner in June 1968, with a suggested entry for the new *Buildings of England* volume on Cambridgeshire: 'At long last the E[ast] end has a worthy focus at a level below the cill, the *Adoration of the Magi*'. Pevsner demurred and in 1970 published his own frank view that 'if any building in the whole country was not made for (the Rubens) it was King's College Chapel'.[138] In 1992, historian Graham Chainey wrote along the same lines: 'in 1968 one of the most inspiring interiors of any Christian building was spoilt to make it accommodate a picture that did not belong there'.[139] Similar views continue to be expressed, for example, by Gavin Stamp in *Apollo* in 2004, for whom the re-ordering was one of the 'greatest aesthetic scandals'.[140] Nearly half a century on and debate about the re-ordering continues, but the Rubens *Adoration of the Magi* is clearly considered, in its own right, one of the great treasures of the College and a considerable attraction to many visitors.[141]

The intensity of the debate that still surrounds this last major alteration to the Chapel again underlines the national reputation of the building and the aesthetic and emotional investment it continues to inspire. But the fraught history of the many changes that have been effected in the Chapel, and the complex deliberations and long impasses that have accompanied them, suggest that they are the inevitable symptom of the difficulties of living with such an important but functioning historical building, and one on to which differing and changing religious and social values are also unavoidably projected. However, although the international reputation of this massive, sublime and majestic piece of architecture has varied over the centuries, it has never decreased.

Ill. 36. Adrian Boutel and Elizabeth Upper, *East End of King's College Chapel*, 2014, digital photograph.

Plans for the Front Screen of King's College

The College never lost sight of the vision of the Will of its Founder, Henry VI, in its hope to complete the College according to his plans. Architects such as Nicholas Hawksmoor and James Gibbs proposed schemes to do so, more or less successfully, but it was only in 1822 that the College established a competition to complete the quadrangle. The winner was William Wilkins; in 1823 the ground was cleared and in the following year work started. Wilkins' neo-Gothic front screen, separating the College from King's Parade, was finished about four years later, costing more than £100,000. On the right and left of the porter's lodge, its 'battlements' were meant to be 'similar to those of the low [side] Chapels'.

Ill. 37. James Wyatt, Proposal (Perspective of the front court towards the east), 1795, pen and watercolour. Cambridge, King's College.

Ill. 38. BELOW: William Wilkins, Elevation: The Eastern Frontage of the Screen presumably drawn for the competition, 1823, wash drawing, 49.9 x 14.1 cm. Cambridge, King's College, KCD/510.

Ill. 39. James Gibbs, Unexecuted design for screen and companion building to Gibbs Building, 1741, watercolour, 34 x 51.5 cm. Cambridge, King's College.

Ill. 40. James Wyatt, Proposal (Perspective looking north to King's Parade), 1795, pen and watercolour. Cambridge, King's College, KCD/628.

Ill. 41. Three bays of roof vaulting, King's College Chapel, Cambridge. Mike Dixon, photograph, 2011.

II

The Structure and Construction of the Chapel[1]

JOHN OCHSENDORF AND MATTHEW DEJONG

Introduction

This essay describes the structure of the Chapel, with an emphasis on the remarkable fan vault constructed between 1512 and 1515. For its complex geometry and daring thinness, the stone vault of King's College Chapel represents one of the greatest achievements in masonry construction anywhere in the world. The structural behaviour of the vault and the stability of the supporting buttresses are analysed together for the first time, demonstrating the safety of the structure. Additionally, a new three-dimensional laser scan captures the present geometry of the Chapel, and an examination of the geometry sheds new light on the vault construction and its structural stability.

History of Construction (1446–1515)

Henry the VI laid the first stone of the Chapel on July 25, 1446, and construction proceeded from the east to the west toward the river Cam. By the time of his death in 1471, the foundations were complete and the walls and buttresses were approaching their full height at the east end of the Chapel (see Ill. 42). Construction proceeded somewhat sporadically through the late fifteenth century, until the substantial contributions of Henry VII in 1508–1511 provided funds to complete the Chapel. The financial accounts of the work are most detailed from this final phase of construction, and they provide insight into the construction of the main vault. At 289 feet, the interior is longer than the nave of any cathedral in England. Yet, the twelve bays of the main vault were built in an astonishingly brief period from 1512–1515, and they represent the most notable element of the entire construction.[2]

When the Chapel was begun, it was not intended to be crowned with fan vaulting. This uniquely decorative use of radiating ribs is an English invention in vaulting which began in the late fourteenth century and reached its apogee in the fan vault of King's College Chapel. The 42-foot span of the Chapel vault is the largest ever constructed using fan vaulting. The complex double-curvature of the vault is among the most daring constructions ever built in stone, with the flat stones of the vault web less than four inches thick in some locations between the ribs. The total depth of the ribs is only about twelve inches, which is less than the thickness of most Gothic masonry vaults. A sectional view through a recent three-dimensional laser scan of the Chapel demonstrates the remarkable thinness of the vault in stone (see Ill. 43). Clearly, the Chapel vault is the work of highly-skilled masons.

Ill. 42. Diagrammatic sketch indicating the building progress over time.[3]

II · THE STRUCTURE AND CONSTRUCTION OF THE CHAPEL

Ill. 43. Sectional view through the vault taken midway between the transverse rib and the boss stone, extracted from a laser scan of the vault.[4]

Though the Chapel had multiple master masons throughout its long history of construction, the vault appears to be the work of John Wastell, who was contracted to build the vaulting at a cost of £100 per bay, or £1200 total, in 1512. His salary as master mason in 1508 was just over £13 per annum, during a period when 50–100 masons were employed in completing the Chapel in the final campaign.[5] The short construction time of less than three years for the entire vault, or only three months per bay, is a testament to the large number of labourers as well as the organised work site. Wastell is also credited with the fan vault of Peterborough Cathedral retrochoir (either 1508 or 1518), and he was certainly influenced by the fan vaults of Henry VII's Chapel, Westminster Abbey (c.1509) and Bath Abbey (c.1503). The fan vaults of Bath and possibly Westminster have been attributed to royal masons Robert and William Vertue, and the latter visited Wastell at King's College on several occasions prior to the start of construction of the vault, likely on behalf of the executors of the will of Henry VII.[6] The three fan vaulting examples of Westminster, Bath, and King's College are among the greatest achievements of English masons of any period (Ill. 44).

Geometry and Construction of the Fan Vaulting

Fan vaulting is constructed of ribs radiating outward from a common support. By having the same curvature and by rotating around a common vertical axis, the ribs form a conoid that converges at the support. Assembling multiple conoids over a rectangular plan typically leaves a spandrel opening at the intersection of the elements (Ill. 45). The geometry of a fan vault is much more controlled than conventional Gothic vaulting (such as quadripartite or sexpartite), requiring an extensive number of ribs and the need for precise geometry. In addition, the complex curvature requires the entire fan vault to be supported by centering during construction, unlike Gothic vaults, for which centering was often only needed to support primary ribs. Due to the need for both elaborate stone cutting and extensive centering, fan vaults were more expensive to construct. For example, in the side Chapels of King's College Chapel, more elaborate fan vaults originally cost £20 per bay to construct, while simpler vault geometries were built for only £12.[7] In this case, some of the difference in cost is due to the decorative carvings in the more elaborate vaults, but it is clear that the more stringent geometric and centering requirements of the fan vaulting contributed to higher costs as well.

Ill. 44. Fan vaulting of King's College Chapel, constructed 1512–1515. Mike Dixon, photograph, 2011.

II · THE STRUCTURE AND CONSTRUCTION OF THE CHAPEL

Ill. 45. Partial plan view of the fan vaulting and supporting structure.

Ill. 46. Upper surface of Peterborough Cathedral fan vault showing complex geometry of the stone blocks.[8] This vault was also built by John Wastell and is nearly identical to the King's College Chapel vault in geometry and execution.

Fig. 26.

N.B. *The Spandrel Wall shewn at x,y (Fig.s 24. 25.) is omitted in this Drawing to avoid Confusion.*

67

Two features of the fan vault at King's College Chapel are worthy of particular mention: the transverse arches dividing each bay and the decorative boss stones at the centre of each bay. The large transverse arches were implicit in nearly all work completed before 1512, and may have been inherent architecturally, but they are not strictly necessary from a structural standpoint. Due to their self-weight, the arches have the negative effect of increasing the thrust of the vaults on the supporting buttresses. However, the transverse arches were constructed on wooden centering before the rest of the vault, and would likely have been beneficial to guide the construction of each bay. Additional centering was still needed to support each radiating rib of the vault during construction due to the complex curvature. As the vaulting stones were laid, proceeding toward the centre of the bay, a large circular hole remained, which was then filled with the finely carved boss. The size of the boss stones is noteworthy, being approximately three feet in diameter and five feet in height. The stones were carved in two halves with a vertical joint in the centre, and the two halves of each boss together weigh more than one tonne. The vault builders may have added the heavy transverse arches precisely because of their concern over the mass of the great boss, in addition to the unprecedented span of the fan vault.

The construction of the vault has long been cause for both wonder and speculation. Sir Christopher Wren (1632–1723) is reported to have visited the vault often and to have remarked that 'if any man would show him where to place the *first stone*, he would engage to build such another'.[9] Because of its complex geometry and relative speed of construction, it seems likely that the Chapel vault was prefabricated in the masons' workshop. The entire vault would have been carved and pre-assembled on the ground to ensure accuracy of the geometry. Mason's marks number the major pieces of each bay and line up with adjacent stones, suggesting that the stone locations were assembled and verified prior to their final installation in the Chapel.[10] The geometry of the King's College Chapel vault is very similar to that of Peterborough Cathedral, also by John Wastell in the same period (Ill. 46). The crown of the King's vault is a horizontal surface in the longitudinal direction, and such horizontal surfaces were primarily used to register the geometry and to maintain consistency during construction.[11] At the intersection of adjacent fan vaults, mid-way between the primary transverse arches, the vault stones are remarkably thicker than anywhere else in the vault. This can be seen in the carefully shaped stones which protrude like steps on the upper surface of the vault. The added thickness may have improved the stability of the vault and would have eased the shaping of the stones to connect adjacent vaults.

The vault is constructed of a variety of materials, though the primary construction is Weldon stone. This medium-strength limestone was quarried about 45 miles northeast of Cambridge and was transported by road to the building site.[12] Rubble mortar applied on top of the stone was used to even out some regions of the vault between the ribs, as well as for a substantial region of fill in the hollow of the conoid, which helps to stabilise the vault. Between the stones of the vault, lime mortar was used in the joints, along with small wooden pegs driven into the joints, likely to adjust the stone locations during setting. At some point in its long history, the entire extrados of the vault was covered with a thin layer of cementitious mortar, though much of the mortar has now disappeared.

The structure of King's College Chapel was surveyed in detail and published by MacKenzie in 1840.[13] In 2011, a three-dimensional laser scan of the Chapel was carried out in order to create an accurate geometrical model of the Chapel structure (Ill. 47).[14] Though the geometry varies slightly from MacKenzie's initial survey, the laser scan confirms the accuracy of his drawings. By considering a transverse section of the vault and supporting buttresses, it is possible to understand and quantify the structural function of the stone Chapel.

II · THE STRUCTURE AND CONSTRUCTION OF THE CHAPEL

Ill. 47. LEFT: Transverse section of the Chapel by Frederick MacKenzie (1840);[15] and RIGHT: from a three-dimensional laser scan (2011).

Structural Design and Stability

Stone masonry is strong in compression, but the joints between stones are typically weak in tension. While structures of impressive grace and durability can be built in masonry, the structure will only stand if it can safely transfer loads in compression down to the supports. The design of a stone vault on buttresses is essentially a problem of geometry: if the form can contain a compressive solution within the masonry, then the structure will stand.[16] For King's College Chapel, the builders faced two fundamental challenges: 1) to determine a vault geometry which could safely span between the buttresses; and 2) to ensure that the forces exerted by the vault would not exceed the stability of the buttresses. In short, the horizontal thrust from the vault had to be resisted by the sheer mass of the buttresses. Their stability against the thrust from the vault has not been studied in detail, and therefore a simplified structural analysis of the vault on buttresses is carried out below.

The original builders of the Chapel designed the structure according to geometrical rules that were assumed to ensure the safety of vaulted masonry, but the ability to calculate the internal forces in the structure was beyond their capability. One geometrical rule for estimating the required buttress width, developed in 1683, is known as Blondel's rule; applied to a transverse section of the Chapel, the rule demonstrates that the buttresses are substantially wider than necessary and that the Chapel design is therefore conservative (Ill. 48).[17] The first author to attempt to determine the actual forces acting in the Chapel structure was William Bland, who published his scale model experiments in 1839 (Ill. 49).[18] Though Bland was unable to compute the thrust of the vault and the load capacity of the buttress, his experimental wooden block model of the Chapel demonstrated that it was

Ill. 48. Blondel's rule for buttress sizing applied to King's College Chapel to demonstrate the relative stability of the buttresses[19]

Ill. 49. William Bland investigated the stability of the Chapel using scale models of wooden blocks constructed according to the proportions of this rudimentary section.[20]

'balanced firmly'. He also correctly concluded that the slender pinnacles atop each buttress did not contribute in any substantial way to ensuring the safety of the Chapel structure and were therefore largely decorative.

The structural behaviour of fan vaulting was first studied in depth by the leading engineer of historical masonry, Professor Jacques Heyman.[21] He demonstrated that fan vaults can behave as shell structures and that the exact geometry is quite forgiving due to its double curvature, which allows for many possible load paths within the masonry. In his words:

> a fan vault is an efficient form of roof system. A late fifteenth-century masonry designer specialising in fan vaults could pick any likely-looking profile, could decorate the surface of the vault with non-structural ribs and could insert on the centre line of the nave a series of heavy bosses, all with the assurance that his structure would be stable.[22]

Heyman was the first to estimate the forces exerted by the King's College Chapel fan vault on its supports using an analytical engineering approach. Based on membrane theory, which assumes that all forces are carried in the plane of a shell that has no capacity to resist bending (Ill. 50), Heyman explored a variety of possible assumptions regarding the stress distribution in the membrane, which result in different vault profiles and different vault thrusts. The most reasonable approximation appears to be his inverse profile solution for a span of 12.8m (42 feet) and a uniform thickness of 17.8cm (7 inches), which accounts for the weight of the decorative ribbing, giving an estimated horizontal thrust of 164 kN (about 16 tonnes) per bay of vaulting.[24] This pioneering study provided

II · THE STRUCTURE AND CONSTRUCTION OF THE CHAPEL

Ill. 50. LEFT: An example membrane assumption of compressive forces in a fan vault,[23] and RIGHT: a 2D depiction of the resulting forces for a typical bay of the Chapel vault.

a first estimate of the internal forces in the vault structure. Heyman later applied Blondel's rule to demonstrate that the enormous Chapel buttresses were conservatively large.[25]

In the last decade, several new studies have applied different approaches to evaluate the order of magnitude of the thrust that Heyman predicted. Using a three-dimensional laser scan, the actual profile of a radial section through the fan vault was used to create a discrete element model (DEM) (Ill. 51a).[26] While the profile is accurate, the model is of uniform thickness and neglects the detailed geometry (ribs, extrados stepping, bosses, etc). The vault above the fill level is unsupported by the nave walls, providing a similar assumption to that used by Heyman to obtain the inverse profile membrane solution. However, unlike Heyman's membrane solution, the DEM model includes the spandrel directly, in lieu of a specified uniform load at the top edge of the conoid. Using the same density and uniform thickness assumed by Heyman, DEM results in an estimated minimum horizontal thrust of 182 kN (about 18 tonnes). Finally, another calculation approach, known as thrust network analysis, was also used to predict a similar horizontal thrust of 176 kN (Ill. 51b).[27] This analysis includes the rib dimensions and a more accurate vault profile than in previous studies.

Overall, these various solutions compare well (Table 1). Although determining the exact forces exerted by the vault on the buttresses is impossible, these studies use vastly different approaches to converge on an estimate that the horizontal thrust of the vault lies between 160 kN and 180 kN (16–18 tonnes). Thus, a reasonable estimate of the vault thrust is 170 kN, or 17 tonnes, without eliminating the possibility that the horizontal thrust of the vault could well be lower.

The thrust exerted by the vaults must be resisted and carried to the ground by the buttresses. This is depicted in Ill. 52, where the thrust line indicates the path of the resultant internal compressive force in the masonry. To maintain stability, the buttresses must be both massive enough and thick enough to contain the thrust line so that it falls within the base of the structure at the foundation support.

Table 1.
Comparison of previous estimates of the horizontal thrust
from one bay of the Chapel vault.

Analysis Method	Geometric profile	Uniform Thickness	Thrust [kN]	Reference
Membrane	Conoid (inverse profile)	17.8 cm (7 inches)	164	Heyman [1995]
DEM	Actual	17.8 cm (7 inches)	182	McInerney et al. [2012]
TNA	Actual	Actual (non-uniform)	176	Block [2009]

* Assumed stone density = 2310 kg/m³ (144 lb/ft³)

Ill. 51. Recent structural models of the Chapel fan vault. (a) Discrete element model and simplified geometry of vault (2011); and (b) thrust network analysis solution for internal compressive forces in vault (2009).[28]

II · THE STRUCTURE AND CONSTRUCTION OF THE CHAPEL

Ill. 52. Internal compressive lines of force in the Chapel vault and buttresses. The stepped buttresses save material while safely transmitting the vault thrust to the ground.

The strength of the buttress against overturning can be calculated by determining its mass and centre of gravity. Each buttress is constructed of approximately 120 cubic metres of limestone and weighs about 2700 kN (270 tonnes), the horizontal centroid of which is located 3.4 m (11.2 feet) from the outside edge of the buttress. The horizontal thrust of the vault acts at a buttress height of approximately 20m (66 feet). Based on these approximate values, the stabilising capacity of the buttresses is about three times greater than the overturning effect caused by the vault thrust.[29] This is a remarkably stable structure.

73

Structural Behaviour

The analyses above demonstrate the global stability of the structure, but this does not eliminate the possibility of structural concerns. Massive masonry structures are known to move considerably during the first 25 years after construction due to ground settlement. Additional movements can also occur after this initial settlement period, due to changes in the water table or adjacent construction. These movements increase with the mass of the structure, so the same mass that ensures initial stability also poses a challenge regarding the long term structural behaviour. If settlement is uniform, the structure is affected very little by ground movements, whereas differential settlement can lead to cracking in masonry or even to collapse. In the case of vaulted structures, buttresses settle vertically due to their own mass, but also tend to rotate outward at the base due to the vault thrust. The vault accommodates this outwards rotation by spreading, causing the crown to descend and separate, and Sabouret cracks to form.[30] These separation cracks occur at the intersection of the vault and the nave wall (between the transverse arches), where the vault is forced to separate from the walls in response to the spreading. Alternatively, Sabouret cracks form through the vault itself, adjacent to the intersection of the vault and nave wall.

In the case of King's College Chapel, there is evidence that this type of movement has occurred, leading to some separation between stones in the vault near the wall. Perhaps the earliest evidence is described in an 1860 letter to the College by architect George Gilbert Scott (1811–1878), who wrote:

> I would further beg to call attention to the fact that there has been a considerable amount of sinkage in the roof by which a powerful outward pressure is brought to bear upon the walls. The walls show a decided tendency to spread outwards and the stone vaulting has consequently cracked and in some degree varied from the true form of the arch, most of the ribs having some of their joints very much opened. These derangements of form are no doubt of early origin and it is not possible to say whether or in what degree they may have been increased by the partial deflexion of the roof timbers, but as the latter is exercising a constant pressure, and as that pressure must increase as the strength of the roof becomes reduced by age I would beg to suggest the insertion of a system of horizontal iron ties at the feet of the principal rafters and lying upon the upper platform of the stone vaulting. This would secure the walls against any further thrust from the timber roof.[31]

Scott's description is a direct indication that the buttresses had indeed moved, causing the apex of the roof to descend, and the vault to distort. Importantly, he notes that these movements were 'no doubt' of early origin, meaning that they likely occurred soon after construction of the vault. However, the poor condition of the timber roof seems to have led to concern that the thrust from the roof may have been increasing. The spliced, curved beam within the roof would have initially acted as a tie to resist the thrust from the roof itself (Ill. 53). However, this timber tie within the roof would only be effective at preventing thrust on the supports if the wooden peg connections were not compromised. Thus, Scott's concern was logical, and indeed the lead-clad timber roof is quite heavy. If the timber tie were completely ineffective, the thrust from the roof would be approximately half of the thrust of the vault. Even with the additional thrust from the roof, the buttresses would still be stable with no roof tie (timber or iron), although the factor of safety would be considerably reduced.[32] Scott did insert the proposed iron ties, which are still present in the Chapel today (Ill. 54). In its current state, either the timber ties or

II · THE STRUCTURE AND CONSTRUCTION OF THE CHAPEL

Ill. 53. Cross-section of the vault and roof of King's College Chapel by MacKenzie from 1840.[33] The right half depicts the cross-section through the transverse arch between bays. The left half depicts the cross-section through the boss midway between the transverse arches.

Ill. 54. Scan showing cross-section of two bays of vaulting, including the ties inserted by G. G. Scott.

the iron ties are capable of resisting the thrust. Thus, the tie bars are likely unnecessary, though they were a reasonable intervention in response to the observed movements. The iron ties that Scott installed in the 1860s provide additional safety and are now part of the structural history of the Chapel.

Drawings from the time of Scott's letter also indicate previous efforts to mitigate the effects of the vault spreading. In particular, drawings depict existing 'old iron cramps' connecting stones in the region where Sabouret cracks would form. These iron cramps would have served to prevent local movement between stones but would only have forced new cracks to form between adjacent stones if further buttress movements occurred. A recent survey documented the existence of these cramps and noted the locations of numerous filled and unfilled cracks in similar areas. It should be noted that these cracks are of minimal concern to the global stability of the vaults, as the analyses in the previous section all neglect any transfer of compressive force between the vault and the nave wall where the Sabouret cracks have formed. Where the vault has separated from the wall above each window, compressive forces cannot be transferred across the open cracks.

Therefore, in general, there is significant local evidence regarding the nature of the movements of the Chapel. The recent laser-scan of the entire Chapel can be used to evaluate these movements from a more global perspective. The results are interesting in lieu of the discussion above. The data indicate that the crown height of the vault decreases about 12 cm from east to west (Ill. 55). Further, the buttresses do lean slightly outwards; the lean is minimal on the east end of the Chapel, and tends to increase towards the west end. The outward lean also tends to be larger on the north side compared to the south.

It is difficult to draw definite conclusions from this data without prior surveys for comparison. However, both the outward lean and the relative crown heights consistently indicate a spreading mechanism and suggest that movements may have been greater towards the west end of the Chapel. The reason for this cannot be determined definitively, but the order of construction could well have played a role. By 1465, half of the eastern Chapel walls were completed, and by 1485, the eastern walls were nearly complete. However, the vaults were not then completed until 1515. During the intervening decades, settlement due to soil consolidation would have occurred. The pressure on the

Ill. 55. Variation in vault height measured in cm above the bosses (from laser scan data) for each of the 12 bays. The vault ridgeline increases in height from west to east. The inset image is a horizontal slice of the laser scan data through the mid-height of the vaults.

II · THE STRUCTURE AND CONSTRUCTION OF THE CHAPEL

soil would have been relatively uniform, so a uniform settlement would follow if the soil properties were also uniform beneath the Chapel. If anything, the stepped buttresses would settle less at their outer edge than at their inner edge, which would cause a slight inward lean of the buttresses. Subsequently, the rest of the walls and the vaults were completed in a relatively short period from 1508–1515. After completion, the western half would settle considerably under the influence of the horizontal thrust, while the majority of settlement of the eastern half would have occurred previously, without any thrust present. If it is assumed that the vaults were level at the time of completion, then this would result in a downward sloping ridgeline from east to west, and a larger outward lean of the buttresses at the west end.

It must be mentioned that the construction sequence is only one factor which may have influenced the structural behaviour. Imperfections in the initial constructed geometry, the presence of the river to the west of the Chapel, local variations in soil properties, and variations in the techniques of construction, which progressed from east to west, could also have played a role. Regardless, the magnitude of the observed movements is not of concern to the global stability. The analysis in the previous section has demonstrated why the vaults and buttresses of the Chapel are maintained in equilibrium.

Summary

The design and construction of King's College Chapel is a remarkable technical achievement. While master masons of the time were highly skilled and familiar with vault construction, no fan vault of this scale had ever been built. Further, the Chapel walls and buttresses were already in place before the option of a fan vault was even considered – something that renders the design especially daring and ingenious.

Without the benefit of modern engineering analysis methods, the original designers used known geometric proportions and would likely have built scale models to investigate stability. Recent investigations have demonstrated that the fan vaults themselves are remarkably stable, despite the dramatic thinness of the vault in places. These methods broadly agree that each bay of the vault exerts a horizontal thrust on the supporting buttress of approximately 170 kN (17 tonnes). The new results in this study quantify the extent to which the buttresses are sufficient to resist the vault thrust, and also demonstrate that the buttresses could safely resist the roof thrust if required. Indeed, the buttresses have supported the thrust of the vaults and the roof for at least 350 years, and the iron ties have only added additional safety over the most recent 150 years.

In addition, recent geometric survey data provides further insight regarding the behaviour of the structure throughout its existence. Movements are clearly evident, and some minor cracking has appeared in the vault, but the magnitudes of these movements are not of concern when considering global stability. Further, the iron ties inserted by Scott in the 1860s were based on good understanding, though they are unnecessary.

In general, fan vaults are intricate three-dimensional structures that are complicated to analyse and build. Even with today's engineering analysis methods, understanding the structural action of the vaults of King's College Chapel still poses a formidable challenge. The intricacy and scale of the Chapel's fan vaulting has astonished visitors for over five centuries. For anyone who has stood above the vault, supported on thin pieces of stone more than 80 feet above the ground, the mystery of these miraculous interlocking stones rivals the splendid view from the Chapel floor.

Ill. 56. Barnard Flower (attr.), *Annunciation*, 1515–31, stained-glass window. Cambridge, King's College Chapel, Window 3a. Adrian Boutel, photograph, 2014.

III

Glassy Temporalities: The Chapel Windows of King's College, Cambridge

JAMES SIMPSON

T HE CHAPEL WINDOWS OF KING'S COLLEGE CAMBRIDGE are an astonishing work of art, for their intellectual conception, their extraordinary technical accomplishment and their massive scale. In this essay I aim to elucidate their intellectual conception, coherence and reach. I also aim to deepen our astonishment at this great work of art, our 'strong regard and awe',[1] by illuminating the ways they *fail* to express vibrant currents of their historical context. Instead of delineating their consonance with their ambient culture, I shall rather underline their profound dissonance with the hermeneutics and theology of the visual in the sixteenth century. Dynamic currents of the culture within which they were produced sought to destroy the culture expressed by windows such as these. The windows express one mighty temporal scheme; they were produced within the hostile environment of another. The windows express a recuperative cultural scheme; the theology that surrounds them is energised by the promise of repudiations, including repudiations of the cultures that produced these very windows.

I

The foundation of what became King's College and its Chapel predates, by seventy-five years, the beginning of work on the windows, which were installed as the final, though long stage of completing the Chapel. Henry's VI's foundation of the College Royal of Our Lady and St Nicholas fell on 25 July, 1441. Initially both College and Chapel were modest in conception, but by at least March

Ill. 57. Plan of King's College Chapel showing the window numbering.

1448 Henry VI's plans for each had enlarged massively: from an initial conception of twelve fellows, Henry re-envisioned a college of 70 Fellows, and instead of the relatively modest chapel, begun in 1444, he doubled the size of the plan, which required an entirely new building project. Between this grandiose foundation and 1515, successive kings were inveigled into contributing to the building of the Chapel itself (before the production and installation of the windows): Edward IV, Richard III and Henry VII each contributed to the same building project, despite the dynastic conflicts with their immediate predecessors that brought them to power in the first place.[2]

The first mention of glaziers and glass comes in August 1484, when Richard III issued an order to 'take stone cutters, smiths, carpenters, masons, glaziers and other workmen' to resume work on the unfinished Chapel.[3] Richard's death in 1485 put a stop to this intervention, and it was not until the end of the reign of Henry VII, in 1508–9, that a further contract for works was made.[4] To make good on this commitment, Henry, who died in April 1509, left £5,000 in his will to the College begun by his relative Henry VI.[5] The plans and works on the windows, then, were almost entirely executed in the reign of Henry VIII (1509–47).

Richard Foxe (c.1448–1528), Bishop of Winchester, was the executor responsible for planning the scheme of the windows.[6] Fox was Henry VII's leading minister, who had taken charge of building operations in Durham and probably Winchester before Henry's death. He continued as Keeper of the Privy Seal after Henry's death, until 1516, during which period he undertook significant works in Winchester Cathedral and King's Chapel.[7] Despite a further £5,000 from the will of Henry VII in 1512, the Provost and Fellows of King's were obliged to importune Henry VIII for money to execute the windows. A further £5,000 was released in late 1515 for this final phase of the Chapel building. All the windows were to be glazed 'with such images, storis, armys, bagis, and all other devices as shal be devised by the said executors'.[8] In November of that year, the King's Glazier Barnard Flower (or Floure), probably a German, was in receipt of £100 as an advance for glazing the Chapel 'in such forme and condition as my Lord of Winchester shall devise and command to be doon'.[9]

The King's Chapel windows were completed in three stages (four if one counts the nineteenth-century construction of the west window). Flower, who had been working for the king since at least 1505, when he was appointed King's Glazier,[10] began work on the windows in 1516. By 1517 four windows (2, 6, 9cd, 10ac, and 12[11]) were finished.[12]

Flower died in 1517,[13] but his plan for the windows was still intact in 1526, when a contract determined that the windows be completed 'accordingly and after such manner' as Flower had undertaken in 1515.[14] The iconographic programme for King's was specified as follows: 'imagery of the story of the old law and of the new law after the form, manner, goodness, curiosity and cleanliness, in every point, of the glass windows of the king's new chapel at Westminster' (i.e. the Chapel of Henry VII in Westminster Abbey).[15] The glazier appointed to succeed him was Galyon (or Gheleyn) Hone, like Flower a Southwerk glazier, though originally from Holland.[16] One of the 1526 contracts directs the glaziers to erect 18 windows, 6 to be completed and installed in the following year, and the rest by 1531. These rigorous terms were almost immediately mitigated to having the 18 windows done within five years.[17] Another contract of the same year commissions 4 more windows. Of the 22 windows contracted in these two contracts, the following were likely to have been completed by 1531: 1, 3, 5, 7, 9b, 10b, 11, and 24.

Windows 4, 9a, and 13–23 'probably date from the years 1535–47'.[18] The East Window (13) embeds references to Prince Edward (b. 1537), and to the marriage of Henry VIII and Katherine Howard (1540). Window 20 can be dated to after 1544, and Window 25 is also most probably from this late period.

By the death of Henry VIII in 1547 the west window remained undone, and was executed only in 1879.[19] In the discussion below I shall regard the topic of this window (the Last Judgement) as part of the original conception, despite its late nineteenth-century execution.

2

This brief account of the installation of the glass in King's College gives no sense of the fierce cultural convulsions, contemporary with that installation, which would contest the culture behind the entire project of the windows. I now turn to the conception of the windows, before turning to the ways in which that conception would in principle be a target of Reformation convulsions and repudiations. I begin with an account of how the windows work, leaving aside presumed changes to the original scheme, and focusing instead on the entirely-visible conception of the entire sequence.

There are twenty-six windows in the scheme as a whole. (The answering east and west windows are distinct and do not conform to the basic window pattern that I will describe in this paragraph.) With some exceptions, each window has five vertical panels. These vertical panels are divided horizontally across the middle, so as to distinguish New Testament scenes below, from Old Testament scenes above. The basic window pattern for both Testaments has two panels on the left devoted to one story, while the two on the right narrate another story. Each window therefore presents four narratives, two below (New Testament: a and c) and two above (Old Testament: b and d). These narrative sequences on both left and right are divided by a single vertical strip down the middle of each window, in which prophets or angels, known collectively as 'messengers' (one above, f; one below, e) announce the relation between the upper and the lower narratives. Each huge window therefore has ten principal formal divisions: five above and five below, with a vertical panel dividing the narrative sequences on the left from that on the right, for both Old and New Testaments. The tracery of each window then has many more small divisions devoted to Tudor insignia (i.e. roses, hawthorn bush, portcullis, fleur-de-lys).

The intellectual pattern produced by many windows with this scheme has two principal temporal threads, one lateral and one vertical. The lateral, or what might be called melodic, temporal thread occupies the lower panels of each window. I begin by focusing on this thread, leaving aside for the moment the upper, Old Testament windows and their harmonic relation with the windows below them.

Follow the lower windows all the way around the Chapel from north-west to south-west corners of the Chapel, and a consistent, highly dramatic story emerges, beginning and ending with the story of the Virgin Mary, to whom, along with St Nicholas, the Chapel is dedicated.[20] Between these narrative sequences focused on the birth and death of the Virgin, the lateral panels narrate the story of Christ's birth, infancy, public life, ministry, passion (the east window), Entombment, Harrowing of Hell, Resurrection, post-Resurrection appearances, including his Ascension, which is followed by scenes from the Acts of the Apostles, before ending with the Death and Coronation of the Virgin. The Last Judgement in the west window, facing and answering to the Crucifixion just over ninety-six yards away, completes this tightly-bound salvation history.

The high drama of this narrative sequence is generated by rhythms of female and male, domestic and public, birth and death, recognition and failure to recognise, kindness and violence. The windows of the lateral sequence begin and end with women and mothers – Saints Anne (1ac, 2a) and Mary (2bc, 3ac, 24ac–25ac). They also begin with births, those of both the Virgin (1c) and of Christ (3c). Then follow a sequence of domestic scenes: Circumcision, and Adoration of the

Magi (4ac), Presentation of Christ in the Temple, and Flight into Egypt (5ac, 6a). At this point a very different, public and violent note is first struck with the Massacre of the Innocents (6c), and this continues for the remainder of one's movement along the Chapel's north wall. This marks the end of Christ's infancy and the start of the sequence devoted to Christ's ministry and passion. These scenes, dominated by men, become increasingly violent, moving as they do through the Baptism and Temptation of Christ (7ac), the Raising of Lazarus (8a) and the entry into Jerusalem (8c). The temporally tight passion-week sequence – the week on which salvation history turns – from Last Supper (9a) through to Crucifixion in the mighty east window (13), is populated principally by men, and characterised by betrayal (10a), humiliation (10c), interrogation (11ac), beatings and affliction (12ac), final judgement by Pilate (13), and Crucifixion (13).

Two women (e.g. Mary, and Veronica, holding the cloth that will imprint the true image of Christ's suffering face) appear in the drama of the Crucifixion (13). Only after the Crucifixion, however, does the female presence reappear in high profile, with the Lamentation over the body of Christ (14a). Women then appear consistently in all the following sequences: the Entombment (15a), the Harrowing of Hell (in which Eve figures prominently (15c)), the non-scriptural appearance of the resurrected Christ to Mary (16c), the Three Maries at the empty tomb (17a), and, finally, the resurrected Christ's meeting with Mary Magdalene in the Garden (17c).

The reappearance of women also coincides with the recognitions of Christ, after a long sequence of male-dominated public scenes in which Christ is successively mocked, interrogated, condemned and crucified. From the moment that Veronica imprints Christ's face in the great east window (13), as we continue to move around the Chapel and begin our walk westwards along the south wall, Christ is recognised by the following: Adam and Eve, in the Harrowing of Hell (15c); Mary (16c); Mary Magdalene (17c); the pilgrims going to Emmaus at Christ's breaking of bread (18c); Thomas and the disciples (19ac).

Those female scenes and these recuperative recognitions also mark the movement out into the world and into subsequent history. As the viewer moves back along the south wall, passing to the west of the rood screen and so moving back into the lay portion of the Chapel, so too do we move into scenes drawn from the Acts of the Apostles, for example preaching (16a), miraculous healing (16c) and the conversion and persecution of St Paul (22 and 23). After these scenes of the beginning of the Church Militant we return again to women (the Death and Coronation of the Virgin) in Windows 23 and 24. This rhythmic movement through three generations of the Holy Family (Anna through Mary through Christ, and then through Peter and Paul) finally leads to, and prepares the way for, the majestic Last Judgement – the end of human time – in which an enthroned judge Christ looks back down the Chapel towards the secular judge Pilate washing his hands of Christ's execution, in the lower half of the east window.

The lateral temporal thread of the windows, then, is itself an extraordinary account of dramatic events across three generations that, according to Christian tradition, opened new possibilities for mankind in its relation to God. The temporal thread just described is, however, only part of the temporal richness of the windows. The artists of these windows assumed that the eye looks up from the floor of the Chapel, starting with the lower frame and moving upwards. As it does so, it encounters a different temporal scheme, rooted in Old Testament narrative. It is, of course, an eye informed by longstanding Christian practices of biblical exegesis that moves upwards from New Testament time to its predecessor; as it does so, it reincorporates old into new. The old is drawn into the dynamic, lateral passage of new time in the lower windows. For each upper window (with some exceptions) represents an Old Testament pre-figuration of the New Testament scene immediately below.

The essence of such a representational scheme is a historiographical persuasion: the old prefigures the new; the old prepares the way for, and is fulfilled by, the new. So far from being superseded, or rendered otiose, the old is instead reincorporated into the dynamism of lateral, forward-moving, salvation history.[21] Of course this is history as generated from the perspective of those who see themselves as victors (i.e. Christians): someone else's history (that of the Hebrew people) is appropriated by Christians as a history pointing to Christianity. That said, the scheme is exceptionally dynamic.

According to long-standing Christian exegetical practice, the Hebrew scriptures were understood to be principally divisible between the literal sense and the mystical senses.[22] The literal sense designated the historical actuality of an event; the mystical sense – subdivided into various sub-senses often described as the allegorical, moral and anagogical – designated what the historical event meant for the present and future. This primary division between literal and mystical is of cardinal importance in recognising the historical truth of a past event: interpretation of this kind does not merely see through a past event to its true meaning and then discard the event. On the contrary, it preserves the historical substance of the historical event related by the text. That said, it then makes that historical event relevant to the present: insofar as the past event points forward to its historical fulfillment in Christ, it signifies in an allegorical sense, often also known as a figural or typological sense. Insofar as the past historical event provides imitable ethical models, it signifies in a moral, or tropological, sense. Finally, insofar as the past event points forward to a future, eschatological fulfillment at the end of time, it signifies in an anagogical sense.[23]

Such schemes had their roots in comments made by Paul about the relation of the Hebrew scriptures to the Christian dispensation.[24] Fully elaborated, these schemes may seem rather unwieldy, but the fact that they had survived for so long as the prime interpretative model of sacred Christian texts for Western Europe (more than 1,000 years, from the third to the sixteenth centuries, and in some contexts even later) suggests that they answered to profound needs. Evangelical polemicists found it easy to mock the analytical distinctions as academic jargon ('chopological' senses),[25] but the schemes were, in practice, more of a flexible frame within which interpreters could develop one interpretive theme or another. Rarely in fact did interpreters feel compelled laboriously to account for each level of meaning.[26]

Brief reflection on the scheme reveals how it answered so fully to need. Any interpretative school wants its canonical texts to remain historically pertinent to the present; often interpreters want canonical texts to have ethical application; and some interpreters also want their texts to retain a hold on the future. Figural allegory provides a schema within which these different temporal needs can be satisfied. Figuralism recognised the past without being a prisoner to it; tropology underlined the ethical force of the text for the present; and anagogy clarified the way in which the text points to the future and to the end of time.

Figural allegory is, in short, fundamentally a way of managing history. It preserves the precious historical document without becoming its prisoner. It creates dynamic relations between past, present and future. It also creates dynamic relations between history and ethics. It recognises historical rupture and change, since it recognises the reality and difference of the past; but it also countenances an ongoing historical tradition of reception. It is fundamentally a poetic system, insofar as the allegorical connections between past and present are likenesses: Abraham's readiness to sacrifice Isaac is simultaneously historical *and* metaphorically resonant with a later event – God's preparedness to sacrifice Christ. Figural allegory seeks out images; it satisfies a pleasure for poetic, imagistic code-breaking whose easy solution reveals the recuperative sense of dynamic salvation history.

How does this scheme work artistically in the windows of King's College Chapel? The *lateral* sequence of the upper windows is weak: if the viewer of the windows were to walk around the Chapel from north-west to south-west, from Window 1 to Window 26, considering each upper, Old Testament window in turn, as we have imagined ourselves doing for the lower, New Testament sequence of windows, no coherent temporal scheme would emerge. Instead, viewers would recognise many scenes from the Hebrew Scriptures, but they would be out of chronological order, and bear no significant lateral connection to each other in order. The first Old Testament scene proper – the Temptation of Eve (2a) – is indeed early in the chronological sequence of the Hebrew Scriptures, but the scene beside it (Moses and the Burning Bush (3d)) bears no evident relation with the Temptation of Eve; later in the sequence, we observe the Fall of the Rebel Angels (9d), which is chronologically prior to the Temptation. There are many such jumblings of historical sequence as one moves laterally along the upper windows.

To understand the sequence as 'jumbled' is, however, to misunderstand it. The key relations of the upper windows are not lateral, but rather vertical. Each of them, that is, points downwards to the New Testament scene below it. The key formal relations are vertical and chiastic, or crossed.

I restrict myself to three spectacular examples, though there are very many breathtaking possibilities. Window 3a presents the Annunciation (Ill. 56), while 3b directly above depicts the Temptation of Eve by the serpent (Ill. 58). The conceptual relation centres in both cases on the notion of otherworldly visitation to a woman: Mary is visited by a winged angel, Eve by a fallen angel disguised as a serpent. The formal, chiastic relation consists in the placing of otherworldly visitor and woman: in the lower frame, the otherworldly visitor (the angel Gabriel) is on the left, while in the upper two panels immediately above, the otherworldly visitor is on the right. And so the earthly women are themselves in crossed positions: Mary to right below, and Eve to the left above. The words of Gabriel to Mary, 'Ave [Maria]', as some medieval lyrics have it, reverses 'Eva'.[27]

In Window 15 we see an especially impressive deployment of the same representational scheme and possibilities. Window 15c (Ill. 59) represents the apocryphal scene of Christ harrowing Hell, taken from the Gospel of Nicodemus. The Old Testament scene immediately above (Window 15d; Ill. 60) represents Moses leading the Israelites out of Egypt, having just crossed the Red Sea. The conceptual link is liberation: Christ liberates the patriarchs and the matriarch from the bondage of hell and sin, while Moses liberates the Israelites from the bondage of Egypt, itself understood morally as a metaphor for the slavery of sin. The chiastic relation is striking: Moses, in red, stands on the right of the upper two panels, while Christ, also in red, stands on the left of the lower two panels. In both cases, the foot of the conquering hero is significant and paralleled: Christ's bare and gored foot stands triumphantly on the broken door of hell (the hinge of the broken door being clearly visible), while Moses' sandaled foot above steps triumphantly onto dry land.

The power generated by the relation of these scenes is recuperative: the Christian story sees its prefigurations and prophecy in the Jewish scene. The recuperations are not only historical, however, but also cultural: the representation of Christ recuperates the non-canonical, apocryphal story of the Harrowing of Hell; and the representation of Christ also recuperates the world of popular medieval drama, with the vast mouth of hell, characteristic of the medieval mystery plays, atop the gates of hell, while the pop art, horrified devil beside and subdued by Christ, also drawn from popular drama, is simultaneously lively, absurd and utterly overshadowed by the wholly serious, moving encounter between Christ and the rescued Adam and Eve, who look up to Christ in recognition. Above all, Christ recuperates Adam and Eve; Old and New Testament meet in a scene of profound recognition. Moses is both pre-figuration and an inversion of what he prefigures, since he looks forward to Christ, but

Ill. 58. Barnard Flower (attr.), *Temptation of Eve*, 1515–31, stained-glass window. Cambridge, King's College Chapel, Window 3b. Adrian Boutel, photograph, 2014.

Ill. 59. James Nicholson, *Harrowing of Hell*, before 1535, stained-glass window. Cambridge, King's College Chapel, Window 15c. Adrian Boutel, photograph, 2014.

Ill. 60. Dirk Vellert(?), *The Exodus*, before 1535, stained-glass window. Cambridge, King's College Chapel, Window 15d. Adrian Boutel, photograph, 2014.

Ill. 61. School of James Nicholson(?), *Jonah Spewed out by the Whale*, before 1535, stained-glass window. Cambridge, King's College Chapel, Window 16b. Adrian Boutel, photograph, 2014.

Ill. 62. School of James Nicholson(?), *Resurrection*, before 1535, stained-glass window. Cambridge, King's College Chapel, Window 16a. Adrian Boutel, photograph, 2014.

leaves the drowning Egyptian army behind him; Christ, by contrast, recuperates those imprisoned in hell. The key gesture that generates the mighty historical power of the whole is the anagnorisis, or recognition, between Christ and Adam, looking across time and historical rupture directly into each other's eyes.

My final examples of recuperative typology in action are the left-hand panels of the window adjacent to the windows just discussed, Windows 16b and 16a (Ills. 61 and 62). In the upper scene, Jonah, with hair matted by the slime of the whale's belly, issues from the massive green leviathan, whose coils move the eye upward along the vertical of the window to the elaborately rigged, beautiful ship, with Nineveh atop the entire pictorial structure. This scene of issuing forth from the darkest passage is echoed and fulfilled by the scene in the lower windows: Christ issues from the black space of the now empty tomb, a sarcophagus. In this magnificent scene, there are references both up and down (most obviously), but also sideways: Christ's gored foot on the now broken lid of the tomb reminds us of the same gored foot atop the broken hell door in the scene immediately to the left (Window 15c).

There are no exceptions to the lateral scheme of chronologically ordered scenes in the New Testament lower windows: each follows chronologically from the preceding episode. There are, however, exceptions to the vertical scheme of old and new. Some of these exceptions seem determined by the need to give priority to the New Testament story (e.g. Window 1, where all the narratives relate to the story of Anna and Joachim); or, more interestingly, by the fact that typology is a self-consuming system. Once, that is, the old has been fulfilled by the new, then the forward march of history can begin, fuelled as it has been by the energies of the old. Thus Windows 21–23 are entirely devoted to the New Testament present of the Acts of the Apostles. The most powerful moment of purely New Testament scenes is of course the east window, where the fulfillment of the Crucifixion so fully absorbs all the energies of the old that it no longer needs to represent them: the magnificent, multi-scene drama of the Crucifixion occupies the entire, vast window, upper and lower.[28]

The intellectual scheme embodied by these windows had immense historical reach: it was centered on the fulcrum of salvation history (the life of Christ), but that history is brought into vital relation with the history and future of mankind, from the Fall of the Angels to the Last Judgement. For many viewers, it was also a deeply satisfying scheme, provoking poetic recognitions to incorporate the past dynamically into present and future. Its logic was, however, a fundamentally recuperative one.

3

Even this scheme, however, necessarily involves exclusions of different kinds. One of those exclusions is pagan religion, which, as we shall see, was itself understood as a code for Catholic religion by Reformation polemicists.

To be sure, Window 2 includes a striking, not to say astonishing, image of pagan religion as a typological prefiguration of the Christian order. In 2b fishermen present a table of gold to the sun god Apollo, while below, Window 2a represents the apocryphal presentation of the Virgin at the Temple. The pagan scene here, ultimately derived from Plutarch and Valerius Maximus, is copied with iconographic and stylistic precision from the *Speculum Humanae Salvationis*,[29] replete as it is with the statue of Apollo as the recipient of the precious offering.

Window 6a (dated 1517, and, like Window 2 from the earliest period of the window installation) presents, however, a contrasting account of classical paganism's relation to Christian dispensation. In this window (Ill. 63), the apocryphal scene represents the fall of the pagan idols. As the Holy Family enter a temple, the governor of the city kneels to them, while the statues of the pagan gods spontaneously break up and fall headlong to the floor. The crashing idols reiterate the more frequent image of the idols who fall as the Holy Family flee into Egypt, a scene visible in Window 5c.

These scenes of idols breaking in both the Flight into Egypt and the Egyptian temple derive from the *Speculum Humanae Salvationis* and the *Biblia Pauperum* respectively.[30] The Flight into Egypt scene is further prefigured by the Old Testament window above, the Worship of the Golden Calf (6b): idols are pulverised as the Israelites exit from Egypt no less than as the Holy Family takes refuge in Egypt. All these scenes use the breaking of images to register the profound change of dispensation from idolatrous, visually-enthralled paganisms either to pure worship of the God of the Old Testament, or to 'pure' Christianity.

These images of idolatry had been extremely widespread and popular throughout the later Middle Ages. Already in early fifteenth-century England, however, such images were accruing a different valence, as proto-Protestants described the cultic and visual practices of the Catholic Church as *themselves* idolatrous. The intellectual and arsenal upon which Christians had drawn to attack pagan idolatry was being redeployed, that is, against their own putative idolatry.[31]

If that was true in the early fifteenth century, how much more so in the momentous year 1517, the very date of Window 6 (the Flight into Egypt and the Worship of the Golden Calf). Now these apocryphal scenes of the falling idols transgressed evangelical strictures on use of non-scriptural sources; still more damagingly, they were pictures, and so fell foul of evangelical hostility to the visual itself, when used in religious contexts. But now even their typological relations were thrown into question by hermeneutic objections to typological allegory. Beginning with this last point, I shall devote what remains of this chapter to these powerful objections, all of which gained intense force across the period of the windows' installation, to the culture expressed by the windows themselves.

Luther repeatedly insists that Scripture is an open text. That everything is not plain in Scripture is, he says in his opening salvo against Erasmus in the *De servo arbitrio* (1525), an idea put about by 'ungodly sophists'. Of course there are many abstruse scriptural texts, but now that the seals have been broken and the door of the sepulcher rolled back with the coming of Christ, then nothing in Scripture can remain hidden. So 'the subject matter of the Scriptures…is all quite accessible', even if 'some texts are still obscure owing to our ignorance of their terms'. For Luther the only problem is a philological one concerning a few words, but the fundamental message of the Scriptures is absolutely

Ill. 63. Galyon Hone, Tomas Reve or Dierick Vellert (?), *Fall of the Idols*, before 1535, stained-glass window. Cambridge, King's College Chapel, Window 5c. Adrian Boutel, photograph, 2014.

plain: 'truly it is stupid and impious, when we know that the subject matter of Scripture has all been placed in the clearest light, to call it obscure on account of a few obscure words'.[32]

Luther's most eloquent and philologically able follower in England, William Tyndale (1494–1536), also championed the plain literal sense. Tyndale insisted that Scripture 'hath but one simple, literal sense, whose light the owls cannot abide'.[33] Promotion of that simple, literal sense required strenuous repudiation of its competitor, allegory. Throughout his prefaces Tyndale warns his reader to 'beware of subtle allegories',[34] since allegory is the surest tool the clergy can wield to preserve their own power over and possession of Scripture. 'Here a man had need to put on all his spectacles, and to arm himself against invisible spirits', he says about 'false allegories': they can prove nothing, and are useful only as a teaching device, used to 'declare and open a text', by the use of analogy.[35]

Tyndale gives his fullest exposition of the case against allegory and for the literal sense in *The Obedience of a Christian Man* (1528). He begins by inaccurately summarising the allegorical scheme described above, and mocking it with the word 'chopological'. That allegorical 'trash and baggage stuff' swept away,[36] he proclaims his central conviction: the literal sense is the 'root and ground of all'.[37]

Tyndale instantly goes on to make a standard scholastic point (made by Thomas Aquinas, for example), though he does not acknowledge here that this is a scholastic one: that of course Scripture uses figurative language, but the meaning is nevertheless clear, and this meaning *is* the literal sense.[38] So, if a preacher should allegorise, it is for purely pedagogic ends, designed better to 'paint' the truth. Thus the sword of Peter cutting the ear of Malchus (John 18.10) is like the Law, and Christ's healing is like the delivered promise of the Gospel. Such analogies are only a question of likeness, not, we might say, of ontology: 'the allegory proveth nothing neither can do'; they are used only for psychological effect of impressing truth on the hearer, 'to root it and grave it in the heart'. So allegory is to be used with sobriety, rarely, and only 'where the text offereth thee an allegory'.[39]

Acceptable, duly chastened forms of allegory once defined, Tyndale proceeds to encourage utter revulsion at any form of allegory that makes stronger than pedagogic claims: he teaches his reader how blind proponents of allegory are, 'that thou mayest abhor them and spew them out of thy stomach forever'.[40]

Tyndale's repudiation of allegory is obviously part of a larger evangelical movement; the story is itself a large one, driven by evangelical need to ground all authority in Scripture, and all authority on its explicit statements.[41] Suffice it for present purposes to say that the hermeneutic programme promoted by Tyndale was triumphant in Protestant England, gaining enormous force precisely across the years in which the King's windows were installed. That triumphant evangelical programme described the tradition of figural allegory as, precisely, tradition, as human invention laid upon and disfiguring the pure text of Scripture, as the work of those who have 'nailed a veil of false glosses on Moses's face, to corrupt the true understanding of his law'.[42] Allegory is 'the trash and baggage stuff that through papistical traditions had found a way to creep in'.[43]

4

The hermeneutic culture that produced the Chapel's windows, then, came under intense and finally successful attack in precisely the period of the windows' installation. In the latter half of this period in England, moreover, the very visual culture of the windows also came under radical attack. I devote this section to a brief account of that similarly successful assault.

In 1535, an English translation of a work promoting iconoclasm in Strasbourg by Martin Bucer was published. The *Treatise declaring…that pictures and other images…are in no wise to be suffered in the temples or churches* is the first English treatise promoting systematic iconoclasm in England. It recognises that hard handling will be necessary. Images must not be attacked 'softly and so tenderly handled', in the manner of weak minded men who, with a 'folisshe imagination' are 'wont to have compassyon and to sorowe somewhat when they ar broken'. These would-be iconoclasts are moved to pity because the images resemble suffering humans, 'as though with the fygure and symilitude of man they had also mans wyttes and reason'. The breaking must, accordingly, be official and applied with what Spenser would soon call 'rigour pittilesse'.[44] It must also work according to the dictates of Scripture: 'we oughte to breke them, yea, and that all to powder that they might never be made whole agayne nor be restored into so wycked an abuse'.[45]

To cut a long story short,[46] iconoclasm was enshrined in legislation very soon after the publication of Bucer's treatise, and well before the King's windows were completed. The first legislative program of English iconoclasm is concentrated in the twenty-three year span between 1536 and 1559.[47] Already in Henry's 1536 Injunctions to Bishops, priests were prohibited from showing 'any images, relics, or miracles for any superstition or lucre'.[48] By 1538 the prohibition was for the first time iconoclastic: all visible cult of the saints before their images was forbidden, and all images that are 'abused with pilgrimages or offerings…ye shall, for avoiding that most detestable sin of idolatry, forthwith take down and delay [destroy]'.[49]

Legislation of this kind has a fatal weakness, since it confidently assumes the ease of x-ray vision with which the bishop can see into the minds of those worshipers who might be idolatrous. The first injunction was, needless to say, followed up by two more. By 1547, at the very beginning of Edward VI's reign, the reign that was to introduce the purifying iconoclasm of the boy king Josiah, Archbishop Cranmer frankly declared how difficult it had proved to distinguish legitimate from illegitimate use of images: 'in almost every place is contention for images, whether they have been abused or not'. The simple solution is that 'all the images remaining in any church or chapel…be removed and taken away'.[50]

This, too, evidently proved inadequate, since the fully-fledged Edwardian iconoclastic programme initiated in 1550 plainly declares, by statute, that parsons having 'anye images of stone tymbre allebaster or earthe graven carved or paynted', shall 'deface and destroye or cause to be defaced and destroyed the same images and everie of them'.[51]

The Elizabethan articles and injunctions of 1559 are, it is true, more nuanced, and tolerant of at least some images, than the Edwardian statute. The nuance is limited, though, since the Elizabethan articles did direct bishops to enquire of their parish clergy as to whether they had 'removed, abolished and destroyed' 'all images, shrines…pictures, paintings, and all other monuments of feigned and false miracles, pilgrimages, idolatry, and superstition'.[52]

5

Did these cultural movements hostile to the allegory, to non-scriptural sources, and to religious images affect the making of the King's windows themselves? Some of the lower, New Testament biblical citations of the messengers are taken from the second edition of Erasmus' edition of the New Testament (1519), a text championed by evangelicals.[53] It has been argued that David holding the massive, truncated head of Goliath in Window 8d is designed to evoke Henry's defeat of the Pope;[54] that the inscription 'sic respo(n)des pontifice(m)' (sic; 'thus you respond to the pontiff'), written onto the cathedra of Caiaphas (Window 11a), carries anti-papal force;[55] and that the scenes from the Acts of Apostles in Windows 21–23 (without precedent in the *Biblia Pauperum* and the *Speculum Humanae Salvationis*), and particularly the primacy given to the evangelical Apostle Paul (windows 22–23), express evangelical commitments.[56] It would be surprising if the powerful and momentous theological currents of 1520–47 did *not* affect the production of the windows across that same period. One wholly persuasive piece of evidence for such an effect is found in a letter of the glazier James Nicholson. Nicholson had worked on the King's windows,[57] but by at least 1535 had abandoned the profession of painter and had become a printer of evangelical books. In 1535 he writes to Cromwell thus:

> Yt may playse your mastership to be so good master not only to me: but also unto the trouth (who hath unther the kynghys grace) your goodness for an only patrone unto her: as to visit the copie of the epistle dedicatorie for the bible to the kynge. And as your goodness ever and only hath put forth your fote for the preferremente of Gods worde: even so that your mastership wyll now sett to your helpynge hands that the hole bible may come forth.[58]

That these magnificent windows were in no way affected by the intense currents around them, despite their profound dissonance with that evangelical culture, is, as I say, unsurprising. What is much more surprising is that they survived, largely intact, the biblical literalism and the iconoclastic ferocity of the sixteenth and the seventeenth centuries.[59]

Ill. 64. Brass lectern given by Robert Hacumblen to King's College Chapel. Cambridge, King's College Chapel.

IV

Provost Robert Hacumblen and his Chantry Chapel

NICOLA PICKERING

Robert Hacumblen was Provost of King's College, Cambridge from 1509 to 1528 and a leading influence in the completion of the Chapel in the early sixteenth century.[1] Despite this, little research has so far been undertaken into his career and patronage. Hacumblen's legacy is found in surviving information on his life and achievements and in documents relating to his position as Provost at King's. But it is also expressed through his role in the completion of the College Chapel and in its decoration. His contribution to the Chapel can furthermore be seen in the objects he provided for it, such as the brass lectern (see Ill. 64), and in the chantry he founded within it. The survival of so much evidence for one Provost's involvement in the building and adornment of the College Chapel is unique.

Robert Hacumblen was born in 1455/56 of unknown parentage in St Andrew's parish, London, and admitted to Eton in 1469 as a King's Scholar.[2] He moved to King's College from Eton in 1472 and ascended the hierarchy: he became a Fellow in 1475, acted as Junior Proctor of the University (1483–4), College Bursar (1488–9) and Dean (1489–90).[3] He became a MA in 1483, Bachelor of Theology in 1490, and then Doctor of Theology in 1506. Hacumblen was a devout and orthodox priest and King's College presented him as parish priest to Prescot, Lancashire in 1492.[4] He was also named among the Commissioners of the Peace for Cambridgeshire in 1509 and 1514. He achieved particular eminence at King's, becoming Provost in 1509 until his death, on either 5 or 8 September, 1528. His arms feature a saltire between four lilies.[5] Hacumblen was a clergyman, a scholar and an administrator; furthermore he was a good composer and some evidence suggests he was an active art patron. In the archive at King's College is a copy of Aristotle's *Ethica Nichomachea* copied by Hacumblen; this is accompanied by an anonymous commentary, which may also be his.[6]

A musical piece composed by him survives in the Eton Choirbook (see Ill. 65).[7] This manuscript collection of English sacred vocal music was composed during the early sixteenth century (c.1500–1505) for use at Eton College, where the music was sung by the Choir. All of the compositions that have survived are in Latin. According to the index for the book there were originally 93 works, though part of its content has been lost and today only 64 works survive (54 *Motets*, 9 *Magnificats* and a *Passion*). A five-part *Salve Regina* is Hacumblen's only surviving composition in the book (number 23, fols 42v–44r, *Salve regina mater misericordiae* – Robert Hacomplaynt). This Marian hymn or antiphon is written in praise of the Virgin Mary, the patroness of both Eton and King's College.[8] It includes the well-known words of the hymn composed during the Middle Ages by Hermann of Reichenau, a south-German monk.

> Salve, Regina, Mater misericordiae,
> vita, dulcedo, et spes nostra, salve.
> Ad te clamamus, exsules filii Hevae,
> ad te suspiramus, gementes et flentes
> in hac lacrimarum valle.
> (Hail, holy Queen, Mother of mercy, hail, our life, our sweetness, and our hope. To thee do we cry, poor banished children of Eve; to thee do we send up our sighs, mourning and weeping in this vale of tears.)

The religious ritual practices so central to life at Eton in the early sixteenth century had been laid down by Henry VI at its foundation. The ceremonies in the College Chapel would have been complemented by the music chosen for worship as well as by the decoration and iconography of the inside of the building (as seen in the wall paintings of the north side of the Chapel which depict the miracles of the Virgin).[9] The Virgin Mary was prominent in the devotions at both Eton and at King's, and the singing of Marian antiphons was at the heart of the religious customs of Eton as a chantry College. The Eton Choirbook as a result demonstrates a strong Marian flavour.

Hacumblen's contribution to the Choirbook is intricate and ornate, with a rhythmic complexity that could be moderately difficult to perform. Its character is generally fairly conservative and formal,[10] and Nicholas Sandon calls it 'an accomplished if slightly stiff work, noteworthy for its intricate rhythmic style…and great variety of melodic ideas'.[11] It has an unidentified *cantus firmus* (or pre-existing fixed tune) taken from plainsong. That Hacumblen's work was included in the Eton Choirbook is not unusual: given the close links between King's and Eton, the annual migration of King's choristers to Eton, and of scholars from Eton to King's, the exchange of musical compositions was likely.[12] The work of other composers who were members of King's College appears in the Eton Choirbook (including Robert Wylkynson and John Sygar). Although no other surviving compositions can be certainly ascribed to Hacumblen, he presumably wrote others.[13]

As a Fellow of King's College, Hacumblen subscribed to the building fund for the College Chapel in 1476.[14] More significantly, he was Provost at the time of the final fitting out of the Chapel and therefore presided over the period of building when the windows were glazed.[15] He was a learned humanist of refined taste and earnestly desired to see the completion of the Chapel. Finding that no further funds were to be obtained from the late King Henry VII's executors, he appealed to Henry VIII for assistance: at least one petition was known to have been sent.[16] Hacumblen signed contracts in 1512 and 1513 for the Chapel vaults, pinnacles and towers. In addition, four contracts made with John Wastell the master mason survive today: 20 May 1512, 4 Jan 1513, 4 March 1513, and 4 August 1513.[17] Hacumblen also authorised contracts made with Galyon Hone and others for the great stained glass in 1526.[18]

The conclusion of the architecture and glazing of King's College Chapel was an outstanding achievement.[19] In 1512 a grant of £5,000 was awarded to the College, on condition that the Chapel was vaulted and the windows glazed with figure-subjects, arms and badges.[20] This impressive stained glass of the main Chapel windows was installed between 1515 and 1545. It is likely that Richard Foxe, Bishop of Winchester, would have been responsible for much of the design of the glass, including, for example, the iconographical scheme or subject choice.[21] There is evidence to support this supposition: a memorandum of 1515 for the 'glazing of the great Churche' stated that the work was to be carried out 'in such forme and condition as my Lord of Winchester shal devise and commande'.[22] By 1515 Foxe was a powerful and wealthy clergyman and statesman. He had spent

Ill. 65. Robert Hacumblen ('Robert Hacomplaynt'), *Salve regina mater misericordiae*. In the Eton Choirbook, 1490–1502, illuminated manuscript. Eton, Eton College, MS. 178, 51r.

time studying in Paris in the 1480s and there had become acquainted with Henry Tudor, whose favour he quickly earned. From 1485 until his death in 1528 Foxe held many important and influential offices (including Bishop of Exeter, Bishop of Bath and Wells, Bishop of Durham, Secretary of State, Lord Privy Seal, Chancellor of Cambridge University and Master of Pembroke Hall, Cambridge) before being appointed Bishop of Winchester in 1501. This extensive experience in the management of matters of Church and State (as well as his interest in building work at Durham Castle, Winchester Cathedral, Farnham Castle and St Cross) made him a man highly suited to undertake the supervision of work at King's College Chapel.

Although Foxe may have overseen the glazing of the windows it is likely that Provost Hacumblen was an equal if not more influential force in directing the scheme, and presided over the work in person. Hilary Wayment (King's College 1931–35, 1968–9, Fellow 1968–69) is convinced that Hacumblen would have been responsible for checking and agreeing the vidimuses (small-scale working sketches) for what was to be depicted in the glass.[23] According to John Saltmarsh (King's College 1925–74, Fellow 1931–74), the Chapel's development during his time as Provost must have been 'the climax of his life's work'.[24]

Hacumblen's contribution to the Chapel also lies in the objects he bequeathed and the chantry he founded. He left £33 6s 8d in his will for masses of the Five Wounds of Christ to be said for him, revealing his personal piety and commitment to this cult (which refers to the nail-holes in Christ's hands and feet and the piercing of his side by the lance of Longinus).[25] Upon his death he also left the College several possessions, including his 'chief bookes' and a gilt chalice. The chalice is no longer in the treasury of King's, but Hacumblen described it in his will:

> with scripture aboute that is Benedicam Domino in omni tempore [I will bless the Lord at all times, Psalm 31.4] and wrond [around] the bottom Orate pro anima Roberti Hacumblen [Pray for the soul of Robert Hacumblen] with a paten having thus graven on the one side and a schochyn [escutcheon] of the five wounds on the other side.[26]

The majestic and imposing brass lectern now in the choir of the Chapel was also given by Hacumblen, and bears his name (see Ill. 64). This elaborately decorated object has a circular moulded base, and is mounted on four rectangular feet surmounted with sculpted lions. Its double, revolving, book-rest is engraved with a continuous lower band of quatrefoils.[27] On one side (from which Old Testament lessons are read) are engraved roses and the word 'Hacumblen', and in the centre is the King's College crest. The other side (from which the New Testament lessons are read) features the four evangelists, seated and accompanied by their symbols (St Matthew and an angel, St Mark and a winged lion, St Luke and a bull, St John and an eagle). Also on this side is the word 'Robertus', with a rose at its centre. A full-length figure of Henry VI stands at the top of the lectern; he is crowned and holds a sceptre and orb, and a dragon crouches at his feet. The lectern is evidently monumental in character and likely to have taken up a permanent position in Chapel. Such lecterns were almost always made of copper, brass or bronze, and could be highly decorative. In the sixteenth century they were usually placed in the centre of the choir and used to hold the great and heavy books from which the chanters (who gathered around them) chanted the services. This splendid lectern is probably of Flemish manufacture. By the fifteenth century a highly reputed and well-known brass industry had developed in the Netherlands in the prosperous areas near the Meuse (Maas) river and in Brussels, Bruges and Tournai. In these areas medieval brass of excellent quality was produced, usually with stylised decorative patterns and punched bands of simple repeated motifs which surrounded central designs of religious or secular illustrations.

IV · PROVOST ROBERT HACUMBLEN AND HIS CHANTRY CHAPEL

King's College Chapel contains eighteen side chapels or chantries, some of which may have contained altars, and it is likely they were founded for private prayer and devotion. Each has a pair of four-light windows on its outer side. Hacumblen founded the second chantry from the west on the south side of the Chapel and watched over its construction. His will, dated and proved 21 October 1528, requested that he be buried here: 'And I will that my body be buried in the myddill Chapel within the body of the new churche of the saide college on the south side, which I have honoured att myne owne proper costes and charge'.[28] As Hacumblen had superintended the works in the main Chapel he had great opportunity of adorning his chantry, fitting it out and embellishing it at his own cost. Through this chantry he left a personal contribution to the Chapel: it is more beautifully ornamented than any of the other side chapels and the scheme and adornment reveal much about his character and personal faith.

The eighteenth-century manuscript volumes composed by William Cole, today in the British Library, provide a vivid description of how the chantry may have originally appeared.[29] Cole, a Cambridgeshire clergyman and antiquary, had been educated at Eton College and at King's College itself. He spent much of his life collecting historical information on the county of Cambridge, visiting nearly all the churches. The walls of Hacumblen's chantry may have originally been fully panelled, as in 1742 Cole described them as 'wainscoted', a term used to describe facing or panelling (usually of wood) applied to the walls of a room. The wooden stall with desk (see Ill. 67) and wooden panelling (see Ill. 68) against the west and south walls are the only parts of this scheme that still survive, dating from the sixteenth century. The desk is decorated in traceried panelling, as is the wall behind the stall. The side of the desk features a large Tudor rose, gilded with a blue background. The ends of both the desk and the stall are topped with a cabbage leaf motif. Above is a small area of wood panelling which shows traces of a decorative pattern, pigmented but difficult to read in its present state. It could have been a kind of pressed brocade, in front of which could have been placed a sculpture of some sort.

Ill. 66. *Plan of King's College Chapel*, 18.7 x 27.2 cm. In Robert Willis and John Willis Clark, *The Architectural History of the University of Cambridge, and of the Colleges of Cambridge and Eton*, 4 vols (Cambridge: University Press, 1886), fig. 42.

Ill. 67. Wooden reading desk/stall, early sixteenth century. Cambridge, King's College Chapel, Tomb Chapel (Hacumblen's Chantry).

The tomb of John Churchill, Marquis of Blandford, who died whilst an undergraduate at the College, was installed in the chantry soon after 1703. This tomb now dominates the chantry space and it is likely the chantry was remodelled when it was laid: the floor and surface of the east wall, for example, are more recent. An altar would have originally stood at the east side of the chantry, but no trace of it remains today. In 1742 Cole noted 'Holes in the East Wall' of the chantry, which he considered evidence for such an altar.[30] The vault features a large central Tudor rose with a poppy head, gilded in gold against a blue background (see Ill. 69). Traces of red and blue paint remain in the stonework arches here and there, and it seems that the whole stonework would have been dramatically decorated in blue and red with gold stars, as well as Hacumblen's initials. In 1742 Cole described the roof as 'elegantly gilt with gold and painted red and blew with stars on it', and in the 1769 account of King's College Chapel published under the name of Henry Malden, a Chapel Clerk, Hacumblen's chantry is described as 'more beautifully ornamented than any other of the others'.[31] These remnants of paint provide some information about how the chantry was originally decorated; Hacumblen may have hoped that the whole of King's College Chapel would also be decorated. Such decorative and painted ceilings were typical for this period.

The stained glass windows of Hacumblen's chantry were finished in the 1520s, with glass made specifically for the space.[32] With only a few exceptions the majority of the lights of the inside windows are original, though considerably fewer of the outside windows are. The losses, and replacement of parts of the glass are the result of ongoing repairs, and recurrent restorations of the

Ill. 68. Wood panelling, early sixteenth century. Cambridge, King's College Chapel, Tomb Chapel (Hacumblen's Chantry).

side chapel glass. At least five major maintenance works occurred between 1680 and 1765 alone, when pieces of glass were replaced. Unfortunately surviving records of restoration works are scarce. The only work concerning Hacumblen's chantry for which records survive was carried out by Cambridge glazier William Henry Constable (1831–1911) in 1857, when the outside lights were restored. Several names of earlier restorers, however, are engraved in quarries of the bottom inside windows. As John Saltmarsh relates:

> In the most westerly light stands 'John Barker 1744 Glazier & Plumber' and close beside him 'Thos Saunders'. In the third light from the west 'Samuel Dawson 1765', in the second from the east 'Thomas Sanders 1770' and in the fourth from the east 'Tom Thomas Taneen' or something similar.[33]

The inside windows of the chantry are devoted to the Virgin Mary and include either images of her, or symbols that celebrate her. The upper lancets of the inside windows contain figures of saints, from left to right: St Christopher (marked on Ill. 71 as light A),[34] St Ursula and the 11,000 virgins (marked on Ill. 71 as light B), the Angel of the Annunciation (C),[35] the Virgin Mary, with scrolls inscribed with quotations from Luke 1.28 and 1.38 respectively,[36] the Holy Dove descending towards her and a pot inscribed IHS (for Ihesus) containing a lily (D),[37] St Anne teaching the Virgin (E),[38] St John the Baptist (F).[39] Each figure stands on a pedestal or raised step and each is set against a background of varied flower quarries (with variously primroses, poppies, wood-sorrels). Hacumblen's belief in and

devotion to the saints as intercessors is evident from a passage in his will and helps to explain the presence of these particular figures in his chantry:

> By the intercession and prayer of the blessed virgine mary...seint John Evangelist, seint Michaell the archangel, seint Katheryn, seint dorathe and the blissed confessor seint Nicholas trowgh [through] whois prayers and the long wurshippyng and devocion which I have ever hade in tham god willing the same I trust verily to abtayn evlasting life.[40]

Hacumblen was particularly attached to St Ursula, illustrated by the fact he dated his will the 21 October 1528, the feast day of the 11,000 virgins.[41] That Hacumblen's arms feature a lily also reveals his personal devotion to the Virgin Mary, patroness of the College.

Much of the glass of these lights is sixteenth century in date, and part of the original glazing of the chantry. Several lights, however, are slightly damaged and repaired with original fragments or medieval glass from elsewhere. Wayment uses a passage from Cole's manuscript to explain the survival of these figures, which Cole claims was the result of their being considered too beautiful to be destroyed during the Reformation:

> ... being the figures of half a dozen saints, viz: the B. Virgin, St John the Evangelist, St Christopher, etc., the zeal of the Reformation could not bear to see them, so to qualify such a superstitious sight, they were daubed over by a sort of paint, which has so spoiled them that they have lost much of their original beauty.[42]

The smaller tracery lights above these main lights feature flowers and symbols relating to or honouring Christ, his Passion and the Virgin. These include either a seeded flower, which may recall

Ill. 69. Vault ceiling, 1512. Cambridge, King's College Chapel, Tomb Chapel (Hacumblen's Chantry).

Ill. 70. Vault ceiling, 1512. Cambridge, King's College Chapel, Tomb Chapel (Hacumblen's Chantry).

the sponge of the Passion, or a poppy, reminiscent of Christ's blood and a symbol of sleep, and therefore of his death (see Ill. 71, lights marked 1 and 4); an eight-petalled flower with a pistil in the centre that could be a lily, regarded as the flower of Paradise, standing for the purity or virginity of the Virgin (see Ill. 71, lights marked 2 and 5);[43] a rose, a symbol associated with the sufferings of the Virgin (7); a Crown of Thorns encircling the Pierced Heart (3 and 10); an orb with IHS within a glory (11); an orb with 'ma' (for Maria) within a glory (12); a woman's face emerging from petals of a central bud (9); a sun and moon with human features, both within glories (6 and 8). These last two symbols are references to the heavens, complementing the blue night sky and stars of the chantry vault. In the sixteenth century the Virgin was often considered as Queen of Heaven (*Regina coeli*), and these symbols are therefore consistent with the devotion to her that characterises much of the

105

A – St Christopher, Infant Jesus
B – St Ursula, 11,000 Virgins
C – Angel Gabriel
D – Virgin Mary
E – St Anne
F – St John the Baptist & lamb

1 – Poppy
2 – Lily
3 – Pierced heart, Crown of thorns
4 – Poppy
5 – Lily
6 – Sun with face
7 – Rose
8 – Moon with face
9 – Woman's face in petals

a – Lily-slip, Wood-sorrell
b – Wood-sorrels
c – Lily slip, RH
d – White rose, Rh
e – Lily-slip, RH
f – White rose, Rh
g – Lily-slip, RH
h – White rose, Primrose, Rh

Ill. 71. Plan of the inside windows of Tomb Chapel (Hacumblen's Chantry), King's College Chapel, Cambridge.

chantry. Most of the tracery lights of the upper inside windows described above are sixteenth-century in date and part of the original glazing scheme. There are, however, a few replacements or repairs of the nineteenth or twentieth century (possibly two poppies, one heart, and two orbs).[44] Certain lights (for example numbers 9, 6 and 8) correspond in style with the tracery of the outside window of the chantry (in particular for example the censing angel and centaur). Thus these lights were probably made in the same workshop, and have the same date.

The quarries of the lancets of the inside widows of the chantry are painted with small flowers (see Ills. 71 and 72). These are respectively, a lily-slip for Eton (marked on Ill. 71 as quarry a); wood-sorrels (b); a lily slip with the letters RH, for Robert Hacumblen (c, e and g); a white rose for King's College and the letters Rh for Henry VI, probably for Rex henricus[45] (d and f); a triple primrose and the initials Rh (h). At one time or other, and according to Cole in 1742, these quarries were

IV · PROVOST ROBERT HACUMBLEN AND HIS CHANTRY CHAPEL

Ill. 72. View of the inside windows of Tomb Chapel (Hacumblen's Chantry), reversed to show the view from within. King's College Chapel, Cambridge.

reversed and read HR, for Henricus Rex.[46] None of these lower lights date to the time of the original glazing of the chantry: their style differs from the flowers surrounding the saints in the upper lights and instead matches that of the lancets of the outside windows of the chantry, glass which is largely of a later date.

The presence of many of the symbols in the lights of the chantry's inner windows is explained by the fact they refer to Christ's suffering and Crucifixion: the Crown of Thorns appears in lights 3 and 10 and the sponge, which recalls the vinegar-soaked sponge offered to Christ upon the Cross, appears in lights 1 and 4.[47] As well as perhaps honouring the Virgin, the sun and moon symbols of lights 6 and 8 may also refer to the cosmic upheavals that occurred at Christ's death (for example the solar eclipse) or the world-embracing symbolism of eternity and Christ's victory over death.[48]

This inclusion of emblems of Christ's Crucifixion is in keeping with the decoration of the rest of the chantry and reflects Hacumblen's motto, which is inscribed in his brass memorial: 'Vulnera Christe tua michi dulcis sint medicina' ('Oh Christ, may your wounds be sweet medicine to me'). The chantry is dedicated to the cult of the Wounds of Christ: their symbolism and that of Christ's Passion are found repeatedly in the chantry and Hacumblen even requested in his will that masses for the Five Wounds be said for him. Devotion to the Five Holy Wounds of Christ, part of devotion to the redemptive sacrifice made by Christ on the Cross,[49] became more prevalent from the twelfth century onwards. Special prayers were composed to honour the Wounds and they were often symbolised in

107

A – Arms of Hacumblen
B – Henry VI
C – Arms of Provost Thackery
D – Arms of Francis Lord Godolphin
E – St John the Evangelist
F – Arms of Joseph Davidson

1, 20 – Dragon
10, 11 – Centaur with bow
2, 9, 12, 19 – Censing angel
3, 8, 13, 18 – Four white roses
4 – St Gregory
5 – St Jerome
6 – St Augustine
7 – St Ambrose
14 – Eagle (St John)
15 – Winged Ox (St Luke)
16 – Winged Lion (St Mark)
17 – Angel (St Matthew)

a – Red dragon
b – Greyhound
c – I.H.S. roundel
d – Tudor royal arms
e – Tudor rose
f – Red rose
g – College arms

Ill. 73. Plan of the outside windows of Tomb Chapel (Hacumblen's Chantry), King's College Chapel, Cambridge.

art or used as a symbol of Christian faith. At the time Hacumblen dedicated his chantry to this subject, it was popular to view the Wounds as the sum of Christ's suffering, and to use meditation on them to evoke a spiritual relationship with the Redeemer.[50] Hacumblen's arms, which feature a cross or saltire, reveal that his personal piety was highly invested in such meditation on Christ's suffering.

The outside windows of the chantry (see Ills. 73 and 74) are devoted to the Old and New Testaments. They contain less original glass than the inside windows, as they were restored in the nineteenth century and largely replaced by Cambridge glazier W. H. Constable in 1857. Much of the tracery glass, however, dates to the original glazing of the chantry and remains *in situ*.[51]

IV · PROVOST ROBERT HACUMBLEN AND HIS CHANTRY CHAPEL

Ill. 74. View of the outside windows of Tomb Chapel (Hacumblen's Chantry), King's College Chapel, Cambridge.

The tracery lights of the left side contain, in a symmetrical arrangement, a dragon, with a foliate crest and back (marked on Ill. 73 as lights 1 and 20), a censing angel (2, 9, 12 and 19),[52] four white roses, encircled by foliage (3, 8, 13 and 18), a creature, probably a centaur, with an animal's body and elaborate split tail, holding a bow and arrow (10 and 11).[53] The central area of the left side of the window has four quarries containing seated haloed figures of the Latin Doctors of the church, accompanied by their names on scrolls. These are St Gregory, with triple tiara (4); St Jerome in cardinal's hat with crosier and book (5); St Augustine, mitred, with crozier, book and heart (6); St Ambrose, mitred with crozier and heart (7). The right hand arrangement of the tracery follows the same arrangement but the central four quarries contain haloed symbols of the Evangelists, also named on scrolls. They are an eagle for St John (14), a winged ox for St Luke (15), a winged lion for St Mark (16), an angel for St Matthew (17). The majority of the figures in these two pairs of four central lights are original fifteenth-century glass, but their background infill is certainly made up of later replacements.[54]

At the very top of the tracery in the central quatrefoil, more glass has been replaced. Here is seen a red dragon (marked on Ill. 73 as light a);[55] a greyhound of Henry VII (b);[56] an IHS roundel (c);[57] the Tudor royal arms (d);[58] a Tudor rose (e);[59] a red rose (f);[60] and the arms of King's College, Cambridge (g).[61] The only quarries which survive from the original glazing here are the central IHS roundel and the greyhound. It is likely however that the design of the other quarries was based on the original scheme.

The lancets of the chantry's outside window (see Ills. 73 and 74) today feature the arms of

109

Hacumblen (marked on diagram 11 as light A); a figure of Henry VI, broken at the waist (B);[62] the arms of Provost Thackeray (1814–50), a benefactor the Chapel (C); the arms of Francis, Earl of Godolphin, who gave £400 in 1774 to pave the chantry (D);[63] a golden-haired figure of a saint, also broken off at the waist (E); the arms of Joseph Davidson, who gave large gifts to the glazing of the Chapel (F). Few of these lower lights are original; all were restored by Constable in 1857 in a style reminiscent of the fifteenth century. In 1894 M. R. James (Kings College 1880–1918, Fellow 1905–1918) reported that 'in the outer windows of this Chantry, there is glass, which has suffered and been mended more than once, and was brought to its present condition by Provost Thackeray'.[64] Some parts of the glass containing the image of Henry VI probably date to the sixteenth century, however: for example, the head of the figure, part of the figure's body nearest to his book, some of the pattern on the right and left in the background that surrounds the figure, and the angel of the right side. But the remainder of the light is later replacement glass. The rather more crude background to the figure of a saint (light E) is likely to be by Constable, no doubt copied from the background of the light with the Henry VI figure.[65] It is possible however that some of the face and garment of the saint figure in light E is original, the head reused in a replacement setting.

In 1750, when describing Hacumblen's chantry in his work *Collectanea Cantabrigiensia*, Francis Blomefield noted, 'in the Window is the Effigies of King Henry VI the Founder and that of St Nicholas its Patron'.[66] Hilary Wayment suggests that if Blomefield saw this figure in 1750, then the Henry VI figure is indeed original.[67] In 1742 Cole also described the figure of Henry VI and reported that it was 'to be the best Picture of him in being'. This too suggests it was painted in the sixteenth century. Cole also described another figure in the same window, which he proposed was St Nicholas.[68] Furthermore, the volume attributed to the Chapel Clerk Henry Malden also reports a Henry VI figure in these windows in 1769, as well as a figure of St Nicholas.[69] It seems likely, therefore, that the Henry VI figure and the figure of a saint were present in this window before the restoration work of 1857, having been seen in the mid-eighteenth century by both Blomefield and Cole: it is possible that they are made of medieval glass. The two half-figures (lights B and E), however, are painted in the Renaissance style, in a somewhat different manner to the earlier fifteenth-century character of the evangelistic symbols and Latin Doctors.

Wayment proposes that these two surviving half-figures were at one time complete, and furthermore that there were once other figures filling the lancets of this window. He suggests that 'perhaps the Virgin Mary may have been shown being crowned by the Almighty...Henry's gesture, with which he appears to be offering up his second crown towards his left, would then be explained'.[70] In this Wayment is in agreement with Saltmarsh, who refers to the passage from Hacumblen's will already cited above,[71] and asks 'may not the other five once have been there?'[72] It is indeed possible that other representations of saints accompanied the Henry VI and surviving saint figure. That the Chapel glass of the inside window was devoted to the Virgin Mary, who was also patroness of the College, strongly suggests that she also featured in the original sixteenth-century glazing of the outside glass. One might ask why parts of the two remaining figures have survived whilst others have not: Wayment offers a suggestion, noting that 'the unnimbed king and an apostle may have been defended successfully against iconoclasts as they could not be regarded as superstitious images'.[73]

The final feature of note in Hacumblen's chantry is a brass set into the floor marking the place of his burial (see Ills. 75 and 76). This includes a figure of Hacumblen in processional vestments or Doctor's robes with a cape and surplice.[74] Hacumblen's supplique is inscribed on a scroll proceeding from the figure's mouth and on the brass boarder around the tomb. The scroll proceeding from the

Ill. 75. Memorial to Robert Hacumblen, *c.*1530s, brass and stone. Cambridge, King's College Chapel, Tomb Chapel (Hacumblen's Chantry).

Ill. 76. Detail of memorial to Robert Hacumblen, *c.*1530s, brass and stone. Cambridge, King's College Chapel, Tomb Chapel (Hacumblen's Chantry).

mouth of the figure reads 'Vulnera Christe tua michi dulcis sint medicina' ('Oh Christ, may your wounds be sweet medicine to me'). These words can be found in prayer books of the sixteenth century.[75] The brass border around the tomb reads 'Domine, secundum actum meum noli me judicare. Nihil dignum in conspectu tuo egi. Ideo deprecor majestatem tuam; et tu, Deus deleas iniquitatem meam. Jesu, Miserere' ('Lord, judge me not according to my deeds. I have done nothing worthy in thy sight. Thus I implore thy majesty; and Lord, may thou destroy my iniquity. Jesus, have mercy'). This text can be identified as the eighth repository of the Office of the Dead, a prayer cycle said for the repose of the soul of the dead. These inscriptions, along with a shield featuring the Five Wounds to the right of the figure, once again reflect Hacumblen's devotion to the Passion.

A shield to the left of the figure as well as a brass plaque below are today missing: it is possible that the plaque was inscribed with Hacumblen's name (perhaps with the additional words 'pray for the soul of') and the plaque may have contained his coat of arms. The corners of the border depict emblems of the four Evangelists, their names inscribed on them. The four Evangelists feature frequently in Hacumblen's scheme for the chantry and are also found in the outside windows, and on the brass lectern he gifted to the College. Cosmological symbolism is commonly inferred by groups of four that stand for the new creation, identifying Christ as Lord of the cosmos.[76] Such a compositional scheme based on the number four is found frequently in Hacumblen's chantry: it is seen in the four Latin Doctors, four angels and four winged creatures.

The brass of the tomb is likely to have been a product of the Cambridge workshop and the style or appearance of the figure supports the supposition that it is probably contemporary in date to the time of Hacumblen's death.[77] Some brass elements of the tomb may not be original and it is possible they were recut and replaced in the nineteenth century. In his 1867 work *Kings College Chapel*, Thomas John Proctor Carter spoke of this brass as defaced.[78]

Numerous changes have been enacted to Hacumblen's chantry since it was first adorned by him and his tomb placed here. As noted, the decisive change to the chantry was the installation of the tomb of John Churchill, Marquis of Blandford. Many later memorials also crowd the east wall of the chantry.

With so much attention and scholarship lavished upon the great windows in King's College Chapel, no doubt owing to their beauty and size, it is not surprising that Robert Hacumblen's small chantry has been passed over and his career and patronage of King's College little commented upon. He died in 1528 when the initial construction campaign of the College Chapel was complete, except for the last stages of glazing and woodwork. As Provost of the College at this crucial time, Hacumblen must have been highly influential in determining the interior decorative schemes, the evidence of which we find in contracts bearing his name. But a more personal legacy of Hacumblen's time at King's is left through the chantry he founded in the Chapel, which he 'honoured' at his own cost and which he chose as his last resting place. The survival of much of the decorative scheme Hacumblen originally intended for the chantry is noteworthy. Even after major restoration repairs, the windows, the woodwork, and other decorative features allow us to identify what he originally intended for it and to imagine how it would have looked. Through an examination of the imagery of the chantry a good deal about Hacumblen's personal piety can be ascertained, such as his strong devotion to the Virgin, the saints, the four Evangelists and the Wounds of Christ. Only a few decades later such devotional practices (especially the worship of saints as intercessors) were to be regarded as superstitious and eradicated from ritual practice in England.

Ill. 77. Pieter Paul Rubens, *Adoration of the Magi*, 1633, oil on panel, 328 x 246.5 cm, Cambridge, King's College.

V

The Altarpieces in the Chapel of King's College, Cambridge

JEAN MICHEL MASSING

If THE CHAPEL OF KING'S COLLEGE is celebrated today for its architecture, especially the extraordinary fan vault and the heraldic decoration of the antechapel, it is also famous for its stained glass, its Renaissance wooden screen and its altarpieces.[1] And while it is seen by many as a unchanging space, taking the visitor back five hundred years, the fact is that the late medieval scheme was never finished, for lack of funds and because of religious and political change. The evidence is still visible today, with empty niches inside the nave; the unfinished state of the decoration also explains the total absence of polychromy, even on the heraldry, except for a few small sculptures. The history of the Chapel, in fact, is an account of a succession of religious, liturgical and artistic changes, and this is perhaps most obvious in the choir, with its many remodellings.[2]

Henry VI did not give specific instructions for the choir in his 1448 will, except to state that the high altar was to be three feet above the floor of the choir. The King himself seems to have laid the first stone at the altar, on St James's day (25 July) 1446.[3] In 1515, Master Mason John Wastell was paid 'For the High Altar, 100 shillings'.[4] A monumental sculpted altar is attested in the accounts for 1544–45 which concern the payment of its transport from London to Cambridge; it was complete with a column and four images carved for the canopy of the altar (*celatura*) by a Master Antonio and gilt by an artisan named Kelley.[5] This altar was removed under Edward VI for a fee of 16d, reinstated under Queen Mary and then destroyed in the first year of Queen Elizabeth I's reign.[6] In 1561–62, the Ten Commandments were set up over the 'High Altar'.[7] And, when Elizabeth I visited the Chapel in 1564, tapestries were hung all around the choir.[8] In the year 1612, a new altar was erected, 29 feet from the east wall.[9] Circa 1620, the communion table is shown, placed sideways, between the stalls, on John Smithson's survey plan (London, Royal Institute of British Architects), while the eastern part of the choir, behind a screen, is defined as 'the place where they burie in'.[10] In 1633–34, a proper wooden screen was erected by 'Woodrof le Joyner', at the level of the first buttresses, which formed a kind of reredos in front of which the altar was placed,[11] so that now 'a Laudian superseded a Puritan arrangement'.[12] It was perhaps at this time that a canopy with the arms of the College was placed over the altar. After the Restoration, in 1662–63, Cornelius Austin was asked to put new panelling behind the screen and to repair the altar; he also completed the panelling between the stalls and the screen, in 1678–79, for £155.[13] It is this kind of setting, 'decent but not grand' according to Henry Malden,[14] that William Cole described in 1742:

> The High Altar is not erected immediately under the East Wall or Window, but at a pretty distance from it, against a fine Wainscote Screen for the purpose which runs quite across the Chapel from the division of the 1st and 2nd Window, which has a kind of Canopy over it adorned with fine carved work; and in the middle directly over the Altar are the

Ill. 78. Richard Bankes Harraden, *View of the Choir of King's College, Cambridge* (detail), 1797, watercolour on paper, 46.4 x 35 cm, Cambridge, King's College.

Arms of the College royally crowned, and on each side of it 4 Fleurs de Lis de Florence crowned also. On each side of the Rails is a Door finely carved to enter the aforesaid void space; and over the South one are the Arms of King James the 1st.... Over the South [North?] Door are the Arms of King Henry the 6. crowned and supported by 2 Antilopes. These are elegantly carved as is all what is about the Screen of the Altar. Under both these Arms on the Doors is carved H. R. with Portcullices, etc. The back of the Altar is hung with a rich silk Damask of Purple and Crimson, with a Fringe of the same quite as far as the Rails reach. The Furniture of the Altar is of the same Stuff, viz: Covering, Cushions, and large kneeling Stools on both sides; though it is always covered again with a fine white Damask Linnen cloth.[15]

Funding for the Chapel, in fact, was increased in 1707 (when Provost Charles Roderick gave £50 towards an altarpiece),[16] 1723, 1758–59 and 1770–71, and as a result James Essex (1722–1784) was commissioned to remodel the choir. The stonework was by Jeffs and Bentley, the woodwork by Cotton and Humfrey. This remodelling was carried out in 1775–76 and cost £1,652 9s. 3d.; the last payment, of £80, was 'for Superintending the new Altar'.[17] The quality of Essex's neo-Gothic woodwork can still be seen in the panelling now found on the east side of the passage leading to the hall. Originally the woodwork went all around the choir, leading to Cornelius Austin's seventeenth-century panelling east of the stalls. As one can see on painted views of the Chapel, such as those by the Cambridge artist and dealer, Richard Bankes Harraden (1778–1862) (Ill. 78), Essex's scheme followed the vertical divisions of the great eastern window, with a central Gothic canopy for an altarpiece slightly receding from the panelling which was quite a few feet in front of the eastern wall and had a passage behind it; this can be seen from the position of the doorways, as the entrances to the turrets of the Chapel are in the north and south walls. Essex's panelling is divided into five sections separated by three-dimensional, vertical divisions which are surmounted by pinnacles linking the structure of the panelling to the architecture itself and to the divisions of the window. On the north and south side of the choir, Essex's woodwork went at least as far as the raised choir barrier.

At the centre of Essex's impressive remodelling was a niche for an altarpiece. There had been uneasiness concerning images in England since the time of Henry VIII, with both acceptance and rejection of religious art in public places of worship.[18] A new interest in altarpieces emerged, however, in the second half of the eighteenth century, as exemplified by Benjamin West's St Stephen Altarpiece for the church of St Stephen's, Walbrook, London.[19] This was of course after the founding of the Royal Academy had given a new emphasis to historical painting. The Rector of St Stephen's, Dr Thomas Wilson, was an advocate of religious painting and wrote an extensive Introduction to William Hole's *The Ornaments of Churches* published in Oxford in 1761.[20] His argument was that the greatness and magnificence of a building raises man's awareness of the majesty and power of God. Ecclesiastic decoration executed in a Protestant context should involve moderation, so as to avoid falling into some of the excesses of the past, when images were used to foster superstitious beliefs. The eighteenth century being in no danger of idolatry, Wilson encouraged both allegorical and Biblical subjects to convey the religious and moral message of the Scriptures.[21] But he added:

> There is yet another Motive which induces me to vindicate a Religious Use of these elegant Arts, I mean the Hope of their one Day appearing with all their Lustre in an Island, whose Heroes, Philosophers, and Poets, have done Honour to Humanity, whilst her Painters and Sculptors have scarce ever attained to Mediocrity.[22]

George Romney's Project

In the light of such discussions concerning the role of altarpieces in Anglican churches, Thomas Orde, 1st Lord Bolton (KC 1765), who became a Fellow in 1768 (Ill. 79), commissioned his friend the painter George Romney (1734–1802), after his return from Italy in 1775, to paint a *Mater dolorosa* for the altar of the Chapel. Agreed between them was the sum of one hundred guineas. The circumstances were recorded at length by John Romney, the son of the artist:

Ill. 79. After George Romney, *Portrait of Thomas Orde*, 1777, oil on canvas, 124.4 x 100.3 cm, Cambridge, King's College.

Mr Orde (afterwards Lord Bolton) was a friend of Mr. Romney's and frequently visited him about this time [1776]: he was an elegant scholar and a man of taste; and among his other accomplishments, was an able and emphatic reader. He used frequently to read to Mr. Romney such passages in the poets as he thought would afford good subjects for pictures. This gentleman... had intended to have presented to the Society of King's College, Cambridge, of which he himself had recently been a Fellow, an Altar-piece for their admirable chapel, a structure in every part perfect except for the decorations of the Altar, which seemed to require some picture of a solemn but splendid effect: he was, however, unfortunately, anticipated by the Earl of Carlisle, who gave to the College an old picture, said to have been painted by Dan. De Volterra [in fact Girolamo Siciolante da Sermoneta]; which, although possessing considerable merit, is of too cold a hue for the solemn gloom of that beautiful chapel. The idea which Mr. Orde had suggested was a Mater Dolorosa, or what the Italians call Maria alla Croce. The picture was in a state of great forwardness, but in consequence of this disappointment, it was never afterwards touched; and Mr Romney lost both his hundred guineas and his time, which latter was to him at that period a greater loss of the two.[23]

Ill. 80. George Romney, *Mater dolorosa* (project for an altarpiece for King's College), 1776, on paper, 38 x 22.9 cm, Cambridge, Fitzwilliam Museum, B.V. 48.

Ill. 81. George Romney, *Mater dolorosa* (project for an altarpiece for King's College), 1776, on paper, 49.9 x 29.5 cm, Cambridge, Fitzwilliam Museum, B.V. 47.

The altarpiece was planned for the centre of James Essex's wood panelling, against the east wall of the choir of the Chapel (Ill. 78). From John Romney, we learn that 'The picture was in fact considerably advanced'.[24] This basic information, the only surviving written document concerning the commission, is completed by at least eighteen definite or probable compositional drawings in public and private collections. Of these, 'four studies... designed for an Altar-piece for King's College Chapel' were listed in 'A descriptive list of the pictorial designs and studies by George Romney, which were presented to the University of Cambridge by his Son, in 1817, in order to be deposited in the Fitzwilliam Museum'.[25] The studies all show the single figure of the suffering Virgin Mary draped in her vestments.[26] In most examples, she is either raising one or two arms in front of her – recalling respectively the figures of the Magdalene in Titian's Pieta (Venice, Gallerie dell' Accademia) and the artist's Virgin in the famous Frari Assumption (Santa Maria Gloriosa dei Frari), two works Romney must have seen in Venice.[27] In one of the drawings in the Fitzwilliam Museum (Ill. 80), in pen and brown ink wash and black chalk, the Virgin is seen from the front, standing in a niche, fully draped and with her two arms raised.[28] Another drawing there shows her resting her two hands joined in prayer on a kind of plinth formed by the end of an arm of the cross, her looks directed to the spectator (Ill. 81).[29]

Girolamo Siciolante's *Deposition Of Christ*

Girolamo Siciolante da Sermoneta's *Deposition of Christ* (Ill. 82) was given by Frederick Howard, 5th Earl of Carlisle (1748–1825) (Ill. 84), to his Cambridge College in 1780, possibly to stop the completion of the *Mater dolorosa* altarpiece – as a number of Fellows seemed to have been 'alarmed at the prospect to having to accept an altarpiece by Romney'.[30] In the archives of Castle Howard, a document lists the 'Pictures purchased by me' during his Grand Tour from 1767 to 1768, the first of which is a 'Taking down from the cross Daniello da Volterra, Rome, 150 [guineas]'.[31] The erroneous attribution to Daniele Ricciarelli da Volterra (1509–1566) was possibly made in reference to his fresco of the Deposition in S. Trinità dei Monti in Rome.[32]

V · THE ALTARPIECES IN THE CHAPEL OF KING'S COLLEGE, CAMBRIDGE

FAR LEFT Ill. 82. Girolamo Siciolante da Sermoneta, *Deposition*, c.1568–73, oil on panel, 230 x 180 cm, Cambridge, King's College.

LEFT Ill. 83. Girolamo Siciolante da Sermoneta, *Study for the Virgin* in the King's College *Deposition*, c.1568-73, black chalk, brown and white brush work on blue paper, 27.5 x 9.9 cm, Stockholm, Nationalmuseum.

RIGHT Ill. 84. George Romney, *Portrait of Frederick Howard, 5th Earl of Carlisle*, oil on canvas, 74.6 x 62.2 cm, Cambridge, King's College.

OVERLEAF Ill. 85. Girolamo Siciolante da Sermoneta, Digital Reconstruction by Chris Titmus, of the Hamilton Kerr Institute, of the original colours of the *Deposition*, c.1568–73, oil on panel, Cambridge, King's College.

Early in his life (circa 1542–1544), Siciolante (1521–1575) painted another surviving *Deposition*, perhaps stylistically related to Perino del Vaga, today in the Muzeum Narodowe in Poznan which, according to its buyer Count Atanazy Raczyski, came from the church of the SS Apostoli in Rome, more specifically, from the Muti Papazzurri Chapel.[33] The provenance of the Cambridge panel however is not known, although it may have come from the church of San Giovanni dei Fiorentini also in Rome. Authors agree that it is a late work dating from circa 1568 to 1572, which may explain that it is not mentioned in the second edition (1568) of Giorgio Vasari's *Vite*.

Girolamo Siciolante (1521–1575) was born in Sermoneta, a fortified town south of Rome. Trained by Leonardo da Pistoia, he was one of Perino del Vaga's most trusted associates and worked with him on various papal projects, his first known commission being the Valvisciolo altarpiece of 1541 done at the age of twenty. In his paintings, he combines the influences of Raphael and his followers, developing what has been called an innovative conservatism with imposing figures, with expressive attitudes, but also a restrained theatricality within clearly ordered and constructed compositions.[34]

When it came to the College, the *Deposition*, originally constructed with an arched top as was usual with Italian altarpieces of the period, was already cut to its present rectangular shape.[35] The painting focuses on the body of Christ, which has been taken down from the cross, naked but for a loincloth. The upper part of his body is supported by Joseph of Arimathea, while Mary Magdalene kneels over Christ and holds his right arm in a gentle manner. The Virgin stands on the right, her hands clasped in prayer. She is comforted by an elderly woman, one of the Maries. Above Christ stands St John, his beloved disciple, with three men next to him. Of these, Nicodemus is probably the

121

man wearing an oriental turban, next to the centurion converted during the Crucifixion. The man on the extreme left, by contrast, could be the donor's portrait. He and the woman at the far right may have commissioned the altarpiece for its original location.[36]

Initially Siciolante's altarpiece was placed on the main altar of King's College; in 1897, however, it was removed along with Essex's panelling (Ill. 78). The painting was then placed to the north wall of the choir, and thereafter moved to various locations in the side chapels not open to the public. Today, some hundred years on, it is again on public view, but on the west wall of the Founder's Chapel which now has the early sixteenth-century *Adoration of the Magi* by the Master of the Von Groote Adoration on the altar.

Peter Paul Rubens's *Adoration Of The Magi*

Another major addition to the Chapel was gifted by Major A. E. Allnatt in 1961, the *Adoration of the Magi* by Rubens (1577–1640) painted in 1633 for the convent of the Dames blanches in Louvain (Cambridge, King's College) (Ill. 86). When Major Allnatt acquired it at the Westminster Sale at Sotheby's in June 1959 for the considerable sum of £275,000 he had the intention to donate it to an institution which would make it public. [37]

The church of the Louvain convent was completed in 1632; the monumental stone altar, with columns and pediment, was commissioned from an anonymous Antwerp sculptor, for 469 guilders, the total cost being 619 guilders.[38] The commission was evidently an important one for the artist: unusually for such a large-scale work, he executed much of it by his own hand, it would seem, and – if we can credit an eighteenth-century source – he executed it in eight days.[39] The same source tells us that he was paid only 800 guilders, but the accounts of the convent record that the artist received 920 guilders, on March 9th 1634, from the prioress, Anna van Zeverdonck.[40] Following the edict of Joseph II dated 28 April 1783 concerning the closure of religious houses (the nuns left by 15 June) the Rubens was sold on 12 September 1785.[41] In the painting, the Virgin and St Joseph together hold the Child who is venerated by the three kings placed one behind the other.[42] The Gospel of St Matthew – the only New Testament text to provide evidence for the Adoration of the Magi – gives few details about them, not even specifying their number (Matthew 1. 1–12). In the words of the Vulgate, St Jerome's translation of the Bible that continued to be in use among Catholics after the Reformation:

> When Jesus was born in Bethlehem of Judah, in the days of King Herod, behold, there came wise men from the East to Jerusalem.
>
> Saying: Where is he that is born King of the Jews? For we have seen his star in the East, and are come to adore him...
>
> And entering into the house, they found the child with Mary his mother, and falling down they adored him; and opening their treasures, they offered him gifts: gold, frankincense and myrrh.

In the early Christian commentaries, the wise men who brought the three gifts to the newly born Christ in Bethlehem became three kings, and were given the names of Melchior, Balthazar and Gaspar.[43] In the painting, the oldest king kneels in front, with a censer, frankincense being a gift fit for a God; behind, Gaspar holds myrrh, in a shell-like vessel, as the Son of God will die; while

LEFT Ill. 86. Pieter Paul Rubens, *Adoration of the Magi*, 1633, oil on panel, 328 x 246.5 cm, Cambridge, King's College.

Balthazar, the black king, holds open a gilt casket, as gold is the gift for kings. The black king's richly modelled face contrasts with the turban loosely wound round his neck – which is influenced by Rubens's portrait of Mulay Ahmad, Bey of Tunis, painted in 1613–14 and based on a print by Jan Cornelisz Vermeyen.[44] Needless to say, however, this connection was only formal, the Bey of Tunis being a not-entirely-savoury character, who would have no place in a devotional painting.

Rubens's first idea for the composition is found in a drawing of the Adoration in Besançon, a horizontal composition; the oldest kneeling king is quite similar, although he is praying instead of holding a censer, while the Virgin is leaning forward and presenting the infant Christ to the king. Joseph stands next to her, without assisting, however, as he does in the painting.[45] The next step is the oil sketch by Rubens in the Wallace collection, London, which is the modello for the painting (Ill. 87).[46] The composition is similar, except in a few details, such as the crossed hands of the second king, and the shell-shaped vessel now held by the third king. Also different are the features of the black king. The altarpiece has the coloristic splendour of Rubens's late period, with golden tones. It also contains fewer figures and presents a greater simplicity than his earlier Adorations of the Magi. Perhaps this is because Anna van Zeverdonck had only 990 guilders to offer. The fact that the

RIGHT Ill. 87. Pieter Paul Rubens, *Sketch of the King's College Adoration of the Magi*, c.1633, oil on panel, 50 x 36.5 cm, London, Wallace Collection.

painting is so freely executed, with clearly visible *pentimenti* may indeed be connected with the relatively modest price for a work of this type. As already noted, Rubens executed it quickly, only focussing on the main figures, and apparently without much help from his workshop. This is also why it is such a great work.[47]

The arrival of this magnificent gift to the College meant that a suitable location had to be found for it, and this led to an important alteration in the Chapel.[48] The College first commissioned a *Report on the Arrangement of the Interior of the Chapel*, from the architects Robert Maguire and Keith Murray. The remit was clear, to find a place worthy of a great painting without spoiling the architectural qualities of the Chapel or causing inconvenience in its use. Two possible positions were selected: the first near the screen, the second at the altar. On the screen, three possibilities were mentioned: above the entrance to the choir, on top of the screen; in front of the archway; and some distance westward of it, in the antechapel. If placed in the choir two alternatives were proposed: against the east wall or as part of the altar, if the latter were moved westward. Their conclusion was that if it is placed in the choir 'it should take the form of an altarpiece at the High Altar, and... be given... its own spatial environment in the form of a canopy on columns'. They thought it would be best at the level of the

two doors leading to the side chapels and proposed that 'the panelling eastward of the choir stalls should be removed' for a better integration. Such a place would 'command the space... and would integrate both altar and picture into the symbolic pattern of the Chapel'.[49] It was clear to Maguire and Murray that, with the panelling of 1907 by the then fashionable architects Detmar Blow and Fernand Billerey which had unfortunately replaced James Essex's fittings, the sanctuary space lacked the architectural quality which so consistently informs the rest of the building – an opinion which was shared by many.[50] Blow and Billerey had built a new reredos, communion rails and panelling on the two sides of the choir, with the painting by Siciolante in one of the panels of the north wall; later three sculptures by J. R. Skeaping were placed in the niches.

The College then commissioned a second Report, this time from Martyn Beckett: his *Preliminary Report on the Proposals for the Alterations to the East End of the King's College Chapel* suggests three possibilities while advocating the third:

1. Placing the altar and the picture together against the east wall.

2. Bringing the altar forward from the east wall, but leaving the picture against it, with or without an architectural surround.

3. Bringing both altar and picture, as an altarpiece, forward from the east wall.[51]

Leading art historians were asked for their advice, including Anthony Blunt, Kenneth Clark, John Summerson and Nikolaus Pevsner, and they came with divergent opinions.[52] The altarpiece was first placed on the right of the screen's passage, in front of the blind arch with the Fall of the Rebel Angels carving,[53] but it was Martyn Beckett's scheme which was accepted, with the lowering and repaving of the floor, the removal of the Detmar Blow panelling and the placing of Rubens's *Adoration of the Magi* behind the altar. The task of inserting the painting could never have been easy with considerations both architectural and art historical matched by liturgical and practical arguments and with an innate resistance to change. The main improvement is that the choir now has a visual focus with a grand painting, something the Founder would surely have approved.[54]

Side Chapel Altarpieces

Not much is known about the original arrangements of the side chapels after their completion, except in the case of the Hacumblen Chapel which is relatively well documented.[55] It is not even clear which ones had altars and which were used in the early sixteenth century.

GERT VAN LON'S *MADONNA IN THE ROSARY*

Placed today on the altar of the north-east side chapel is Gert van Lon's *Madonna in the Rosary*. A painting connected to the devotions to the Virgin Mary practised by confraternities of the Rosary (Ill. 88), this work was given to the College in 1931 by C. R. Ashbee (1863–1942; KC 1883).[56] As the Woman of the Apocalypse, the Virgin is 'clothed by the sun and with the moon at her feet' (Revelation, 12.1). She is holding the Child on her left arm and a basket of cherries in the other, from which Christ has already plucked some fruit; in late medieval symbolism the cherry stands for the

Ill. 88. Gert Van Lon, *Madonna in the Rosary*, 1512–20, oil on panel, 160.2 x 100 cm, Cambridge, King's College.

heavenly reward of piety, while its bittersweet quality alludes, in symbolic term, to both the joys and the coming sorrows of the Virgin. Mary stands within a rosary made of five decades of white roses, each flower symbolising a 'Hail Mary', separated by representations of the wounds of Christ for the beads devoted to the 'Our Father'. The combination of the recitation of a Pater Noster after each decade with a meditation on the Five Wounds of Christ first occurred on rosaries around 1500.[57]

The Westphalian painter Gert van Lon (circa 1465– before or in 1531) was probably born in Geseke and seems to have learnt his craft from the Master of Liesborn. His commissions are documented in archival sources between 1505 and 1529. He seems to have died shortly thereafter, as his son Johannes van Lon was in possession of his father's property by 1531.[58] The *Madonna in the Rosary*, beautiful but quite idiosyncratic, dates from the middle period of his life, between 1512 and

1520. The panel, originally planned with angels in each corner, as we know from the splendid underdrawing revealed with infrared reflectography, now shows two nuns reciting the rosary, wearing brown vestments and white headdresses. They may have been the patrons of the work which came, as we learn from an old label, from an unidentified (perhaps Ursuline) *Nonnenkloster* in Soest.[59] It is not even certain that it was intended as a panel on its own; it could have been originally an outer wing for an altarpiece as was another, quite similar *Madonna in the Rosary* by Gert van Lon, on an altarpiece of the Holy Kingship today in the Westfälisches Landesmuseum für Kunst und Kulturgeschichte in Münster.[60]

It has been recently made clear that C. R. Ashbee's gift was not as innocent as it might seem, since he saw it as the centrepiece of his proposed remodelling of Provost Roger Goad's chantry (the second side chapel on the north-west side) into a Founder's chapel (the denomination used today). The minutes of King's College Council for May 16, 1931 record the gift, and a letter from Dean Eric Milner-White, dated 27 September 1935, talks of it in the following terms:

> The picture has arrived safely. How lovely it is! I had not remembered either its richness or power. ... [nor] have I ever seen it in so admirable a light as it receives in the sacristy-chantry. It is a pity that the founder's chantry is not on the South side of the chapel! I am now very anxious to see the finished work in position and am beyond words grateful.[61]

The Annual Report of 16 November 1935 adds that 'Mr Ashbee himself designed and gave the frame and cresting'.[62]

In a letter dated 1932, Ashbee mentioned that a memorial chapel, dedicated to the memory of the Founder, had for him a very great significance.[63] Initially, his aim for the Founder's chantry was:

> A. To supply a fitting frame for the 'Madonna', thus resetting the picture as an altarpiece, for which purpose it was no doubt originally painted.
>
> B. To carry out the problem you set me, of utilising the chantry as a memorial chapel for distinguished Kingsmen, but in such a way as to retain a unity of design, and control or limit the memorials subsequently placed in it.

The chapel, according to Ashbee's plans, would have been panelled 'by a series of flat oak panels of varying shapes, free of all moulding, but with a uniform section capable of holding the metal tablets with such enamel as may be used from time to time... There should be room for 50 bronze, copper gilt, or latten memorials, with or without enamel, on the South and the North walls...' On the west wall would be 'episodes from the Founder's life [from the Beauchamp manuscript]..., on vellum perhaps or parchment, and put under glass in... five panels on the eye level'. Carved medieval motives from the Chapel would link the panelling to the frame of the *Madonna and Child* on the altar. 'The frame will be gilded, but in a subdued gilding to harmonise with the picture. On the wings of the folding doors I suggest two dedicatory inscriptions. That on the right is an extract from the Founder's will. The words are singularly beautiful, and as he undoubtedly used them himself it seems appropriate to incorporate them with his memorial. On the left I suggest a reference to the picture. It appears to have been painted about the year of his death, and it is undoubtedly the sort of picture he would have wished to see in his chapel'.[64]

Ashbee was not successful in transforming the side chapel into a Founder's chapel, except by name.

His plans have disappeared, but on the envelope which contained them, is clearly written, probably in the hand of Eric Milner-White, Dean of the College: 'Ashbee's plans for the Founder's chantry: very unsatisfactory'. Disagreement over the scheme, as well as lack of money, probably account for the curtailment of the project, as well as the fact that Ashbee's frame is much simpler than he originally had planned.[65]

MASTER OF THE VON GROOTE ADORATION'S *ADORATION OF THE MAGI*

The enrichment of the Chapel has continued in the present century. The triptych of the *Adoration of the Magi*, given by P. K. (Sunny) Pal (KC 1955) and his family to King's College in 2010, is a truly splendid example of a portable altarpiece produced in Antwerp in the first quarter of the sixteenth century. The anonymous painter goes under the name of the Master of the Von Groote Adoration (Ill. 89).[66] Antwerp, at the time a city of prime economic importance, played a remarkable role in the making and dissemination of images of the Magi, especially between 1510 and 1530, with works sold all over Europe, from Sweden and England to the Mediterranean, from the Canaries and Madeira to the Indies. Most of the artists, however, have not been identified, as it is only rarely that a connection can be made between particular paintings and archival and historical sources. When first studied by Georges Marlier in 1966, the painting was attributed to Jan van Dornicke who has been identified with the Master of 1518.[67] Max Jacob Friedländer had coined this *Notname* (a name given to an artist whose name is not known), for a distinct but anonymous artistic personality. The '1518' came from the fact that this date was inscribed on the painted wings of a carved altarpiece in the Marienkirche in Lübeck, around which he grouped the master's works. Later he proposed to identify the painter with Jan van Dornicke because of the influence of his oeuvre on Pieter Coecke van Aelst, who was Dornicke's son-in-law and probably also pupil.[68] The King's College altarpiece however is closer to the work of a painter who seems to be connected to, but not identical with, the Master of 1518, namely the Master of the Von Groote Adoration. Central to the definition of the latter's oeuvre is a triptych of the Adoration of the Magi – with the Old Testament prefigurations of The Messengers before King David on the left wing and Solomon and the Queen of Sheba on the right – formerly in the Collection of Freiherr von Groote, Kitzburg Castle, and now with his descendants.[69] This artist's style, qualities and idiosyncrasies are found in the King's College triptych which shows a continuous narrative, from the Nativity to the Adoration of the Magi and then the Flight into Egypt, reflecting an interest in storytelling and a horror *vacui* quite typical of the work of the Master.

In the painting, the scene is set in a ruined structure symbolising the demise of the Old Order with the Virgin on the right, presenting the child to the kneeling king who hands him his gift of gold. He wears a sumptuous dress and arms fit for a king. The black king behind him (Ill. 90), also richly adorned, holds a sceptre and his gift of frankincense, while the third king, in the middle of the composition, raises his hat in homage to the infant. He is greeted by St Joseph who lifts his hand to his cap, and who is followed by a figure which could be a portrait of the man who commissioned the altarpiece. A soldier and another figure behind him complete the kings' retinue. In typological terms – the biblical reading connecting the Old and the New Testaments – Catholic theologians had traditionally connected the passage from Matthew (1.10–11) with verses of Psalm 71: 'the kings of Tharsis and the islands shall offer presents: the kings of the Arabians and of Sabah will bring gifts…' This relation, found for example in the sixteenth-century typological windows of King's College Chapel, linking the Adoration of the Magi to the visit of the Queen of Sheba to Solomon, helps to explain why one king is shown as African. Sabah (Sheba) was often connected, following a statement

of the Jewish Roman historian Flavius Josephus, with Egypt and Ethiopia, as the land of the blacks.[70] In the triptych, the scene is set in front of a landscape with collapsing towers, a farmhouse and bluish rocky outcrops typical of early sixteenth-century art.[71] In the early sixteenth century, when the European vision of the world was challenged by Columbus's voyage to America in 1492 and Vasco da Gama's to the commercial perimeter of the Indian Ocean, Antwerp became the centre of the overseas spice trade, with an important Portuguese community residing there. In this context the popularity of the theme of the Adoration of the Magi is hardly surprising, given that it showed kings from three continents, bringing luxury goods to the newly-born child; sometimes, indeed, they arrive with bundles of goods and tied bales, in addition to their more traditional gifts of gold, frankincense and myrrh, exotic gifts from far-away countries.[72]

The left wing of the triptych shows the Virgin, Joseph and two kneeling angels praying over the child; above them, the angel announces the news of the birth of Christ to the two shepherds joining the scene. As in the central panel, the scene is set within a ruined classical structure, with the ox and the ass referring to Isaiah 1.3 ('The ox knoweth his owner, and the ass his master's crib: but Israel has not known me, and my people hath not understood me'), a passage reinforcing the idea that it is the Gentiles – represented in particular by the African king – who came to Christ. The ass also makes

Ill. 89. Master of the Von Groote Adoration, *Adoration of the Magi*, 1515–20, oil on panel, 118 x 171.7 cm, Cambridge, King's College.

RIGHT: Ill. 90. Master of the Von Groote Adoration, *Adoration of the Magi* (detail of the black king), 1515–20, oil on panel, Cambridge, King's College.

131

a connection with the flight to Egypt, shown on the right panel, where the Holy Family flee the persecution of King Herod. In the landscape can be seen a broken idol, with a sacrificial fire still burning in front of it, symbolising the fall of the heathen gods through Christ's incarnation.

The Antwerp mannerists produced hundreds if not thousands of Adorations of the Magi, of varying quality, between 1490 and 1530, primarily for the open market.[73] Some were essentially copies or variants of well-known compositions, others simply resorted to well-defined formulae or stock elements in what had become a serial production. Late medieval forms and devices competed with the Renaissance italianate style which, however, had been transmitted largely through prints. One of the great difficulties of identifying individual masters among the extensive production of the Antwerp Mannerists stems from the fact that they shared not only patterns of representation – such as the Nativity, Adoration of the Magi and Flight to Egypt scheme[74] – but also compositional formulae derived both from their predecessors and from their contemporaries. The Master of the Von Groote Adoration, for example, did not hesitate to use the composition of the Adoration of The Magi (Milan, Brera) by one of the few artists in Antwerp identified by name, Jan de Beer, in one of his own paintings (Frankfurt am Main, Städelsches Kunstinstitut und Städtische Galerie).[75] This also explains the similarities (stressed by Marlier), most evident in the subject matter and the compositions of the wings, between the King's College triptych and another panel, which is later and by a different hand, and was once in the church of Santiago in Teruel.[76] In painterly terms, the newly acquired altarpiece for King's College is a splendid, well-preserved example of Flemish late medieval and Renaissance art, carefully painted, layer over layer, with subtle transparencies. It shares with the other works by the Master of the Von Groote Adoration the stage-like use of the architectural setting, the Magi dressed in the richest and most lavish vestments and a certain stiffness in protocol, underlying the notion of respect and veneration. There is also, however, a balanced but rich palette of colours, with a splendid use of white for the vestment of the black king.[77]

The *Adoration of the Magi* is now placed on the altar of the newly opened second chapel on the north-west side, which C. R. Ashbee dreamed of transforming into a proper Founder's chapel. On its north wall now hangs the *Deposition of Christ* by Girolamo Siciolante. The opening of this space completes the campaign, which was begun more than twenty-five years ago, to make all the side chapels on the north of the nave accessible to visitors.

CARLO MARATTA'S *VIRGIN AND CHILD WITH THE YOUNG JOHN THE BAPTIST*

The last important painting in the Chapel, a *Virgin and Child, with the young John the Baptist*, has only recently been attributed to Carlo Maratta (1625–1713) (Ill. 91). It was given to the College in 1963 by A. C. H. Parker-Smith (KC 1902) with an attribution to Anton Raphael Mengs (1728–1779).[78] Placed over the altar in the Whichcote chapel, the painting is similar in composition, except for a few details, to a painting by Maratta possibly from the collection of Marchese Niccolò Maria Pallavicini in Rome, which was sold to Robert Walpole and acquired by Catherine the Great for the Hermitage in St Petersburg (Ill. 92).[79] There are a few variants in the dress of the figures, and the fact that the Hermitage John the Baptist is holding a rustic cross (with a *pentimento* of another cross) and fruits (cherries and apples). As in the King's College painting, the latter allude to the Fall of Man in the Old Testament and refer to Christ as the New Adam. The colours of the King's College version, however, are different, but the painting, in a traditional Roman 'Maratta frame', is a newly identified version probably done within the workshop of the artist which included very talented painters.[80]

The King's painting shows the Virgin in a loose deep pink gown with long sleeves over a plain

Ill. 91. Carlo Maratta and workshop, *Virgin and Child with the Young John the Baptist*, oil on canvas, 97 x 74 cm. Cambridge, King's College.

Ill. 92. Carlo Maratta, *Virgin and Child with the Young John the Baptist*, 1700–1713, oil on canvas, 100 x 84 cm. Leningrad, Hermitage GE 1560.

white chemise which is visible at the wrists and the neckline. A rich blue mantle is arranged across her back and then brought forward to cover her left arm and her lap behind the Christ Child. A loosely draped light brown cloth forms a headdress which falls to her shoulders. Below this, on her left shoulder is a length of semi-transparent gold fabric, possibly silk. This rather puzzling addition is perhaps explained by the Hermitage version where this element appears to be of the same fabric as the headdress. This would imply that the execution of the King's version was done by Maratta's assistants rather than by him. On her knees the Virgin holds the infant Christ, with an apple in his right hand and sucking the index finger of his left. He sits on a white tasselled cushion. With piercing eyes he gazes at the beholder, while the Virgin turns her eyes to the young John the Baptist. He wears an animal skin over his right shoulder and holds a scroll with the traditional wording *Ecc[e Agnus dei, ecce qui tollit peccata mundi]*, of which a few letters are still legible.

Rather than testifying to a continuous tradition, the transformations of the interior of King's College Chapel reflect the political, religious and artistic priorities of different periods. They also highlight the generosity and goodwill of five donors (all but one were Kingsmen). Most impressive is the fact that all the paintings are important and of the highest quality. With regard to the choir, if there is one regret, it is that James Essex's successful panelling was removed and replaced by a much inferior scheme by Detmar Blow and Fernand Billery. But the integration of Rubens's masterpiece has given a new focus to the Chapel, appropriate to an evocation of the sanctuary as it functioned in the time of the Founder.

Ill. 93. The vaulting at the east end, King's College Chapel, Cambridge. Mike Dixon, photograph, 2011.

VI

The Great Glass Vista: A Condition Survey of the Stained Glass in King's College Chapel

STEPHEN CLARE

THE SPLENDID CHAPEL at King's College is rightly celebrated. Its graceful proportion, and the marriage of delicate fan vaulting and superb stained glass, mark this as one of the greatest treasures of world architecture. This essay sets out to describe the condition of the stained glass and offers insights into the materials and methods of original production. It also reports on the comprehensive condition survey of the glass that was carried out in 2010, culminating in a report, and recommendations for a long-term conservation policy for the glass.[1] The urgent conservation work that resulted from that report is also documented. As will be seen, conservation is certainly not a sterile occupation for the mere technician, but also a job that requires taking into account many aspects of aesthetic, cultural and technical history. This beautiful and atmospheric building both inspires those charged with safeguarding it for future generations, and also places upon them a great burden of responsibility.

Ill. 94. Interior of King's College Chapel. Stephen Clare, photograph, 2010.

Ill. 95. Fan vaulting of King's College Chapel. Stephen Clare, photograph, 2010.

The Glaziers

The German and Flemish stained glass artists who were domiciled in England in the sixteenth century were both highly gifted and entrepreneurial; the fury of the English glaziers of the City of London, organised by the ancient Worshipful Company of Glaziers, against the granting of major commissions, including royal commissions, to foreign glaziers is well documented. Of necessity, therefore, these foreign craftsmen established their workshops and domestic quarters in Southwark on the very edge of the City, paradoxically the present home of Glaziers Hall and the Worshipful Company of Glaziers.[2] It was these gifted individuals, together with English colleagues trained in their working practices, who carried out this huge commission at Cambridge.[3]

Their work was an integral part of the great revolution in art we now know as the Northern Renaissance, and its emergence and flowering is documented in both stone and glass in this building. Furthermore, nowhere else in England is the ascendancy of glaziers from Germany and the Low Countries so visible. The Chapel reveals the fascinating story of the succession of a series of master glaziers: King's Glaziers no less.

The glazing campaigns at the Chapel were long and drawn out. Despite the release of funds in 1512, work did not commence until sometime around 1515; however the first group of windows was not installed until around 1526, about the same time that the final two contracts were drawn up

VI · THE GREAT GLASS VISTA: A CONDITION SURVEY OF THE STAINED GLASS

Ill. 96. Scaffolding erected to allow conservation work to the south elevation of King's College Chapel.
Stephen Clare, photograph, 2010.

to complete the scheme. Work to the stained glass continued until around 1545. This was forty years of episodic activity, with shortage of funding occasionally halting the process, followed by frenetic periods of creativity.

One of the later master glaziers at King's was Francis Williamson, a Flemish craftsman naturalised in England, who, along with his English colleague Simon Symondes, undertook to produce four windows at the western end of the Chapel under one of the final two contracts of 1526. The work of Williamson, as we will see, bridged the stylistic shift from the late medieval to the Renaissance, marking a distinctive change from the very different styles of two royal glaziers who had preceded him in the project.

Accessing the high levels of great buildings was, indeed still is, a risky undertaking. But, in comparison to secure modern scaffolding, subject to stringent Health and Safety legislation, climbing aloft on the timber scaffolding of the 1500s must have been an altogether more involving and unnerving experience for the glazier. We can imagine Williamson, then, ascending the scaffolding – a moving and creaking construction of poles bound with hemp rope: he was no doubt eager and excited to view the great building from the lofty perch and new perspective of the scaffolding, a privilege not given to many, and much enjoyed by glazier and stonemason alike, both then and now. Yet this was a pivotal moment, not only in the progression of the glazing scheme at King's College, but also for the direction of English stained glass. Directly opposite as he climbed was the window completed shortly after 1515 by the King's Glazier, Barnard Flower, a German stained glass artist who held the pre-eminent position in English stained glass from 1505 until his demise in 1517.[4]

Ill. 97. Barnard Flower (attr.), *Marriage of Tobias and Sara*, 1515–31, stained-glass window. Cambridge, King's College Chapel, Window 2.

Ill. 98. Detail of Barnard Flower (attr.), *Presentation of the Virgin*, 1515–31, stained-glass window. Cambridge, King's College Chapel, Window 2.

Williamson and all of the foreign glaziers would undoubtedly have held Flower in great respect: Barnard Flower was a hugely gifted individual, capable of interpreting the designs of his masters into glass works of great sophistication and beauty. The quality of his work ranks amongst that of the great masters of the Northern Renaissance. It is only the regrettable modern tendency to overlook stained glass as a major art form that prevents the work of master glaziers such as Flower being compared favourably with artists of the period such as such as Gerard David, Hieronymous Bosch, Jan Gossaert, or indeed those painters whom we know to have been involved with the design of

Ill. 99. Detail of Barnard Flower (attr.), *Presentation of the Virgin*, 1515–31, stained-glass window. Cambridge, King's College Chapel, Window 2.

VI · THE GREAT GLASS VISTA: A CONDITION SURVEY OF THE STAINED GLASS

Ill. 100. Galyon Hone's flatter pictorial style. Detail of Hone Group of Glaziers, *Adoration of the Magi*, 1526–31, stained-glass window. Cambridge, King's College Chapel, Window 4.

Ill. 103. Detail of Francis Williamson, *Nativity*, 1526–31, stained-glass window. Cambridge, King's College Chapel, Window 3.

Ill. 101. Design elements across stone mullions. Detail of Hone Group of Glaziers, *Adoration of the Magi*, 1526–31, stained-glass window. Cambridge, King's College Chapel, Window 4.

Ill. 104. Serpent. Detail of Francis Williamson, *Fall of Man*, 1526–31, stained-glass window. Cambridge, King's College Chapel, Window 3.

Ill. 102. Glass paint and silver stain. Detail of Hone Group of Glaziers, *Adoration of the Magi*, 1526–31, stained-glass window. Cambridge, King's College Chapel, Window 4.

Ill. 105. Eve grasping the Forbidden Fruit. Detail of Francis Williamson, *Fall of Man*, 1526–31, stained-glass window. Cambridge, King's College Chapel, Window 3.

139

stained glass, Bernard van Orley and Dirk Vellert. Learned and cultured, Flower was trusted by Henry VII and Lady Margaret Beaufort, and involved in many projects connected with them. He was also prolific, carrying out complex schemes at Westminster Hall, Eltham Palace, the Savoy Chapel and Croydon Manor (later Croydon Palace); he also probably carried out, or collaborated in, the schemes at St Mary's Church, Fairford and York Place (later the Palace of Whitehall).[5] Given his great talent, it was without doubt from the outset the intention of the King and his agents that Flower was to be entrusted with glazing the whole Chapel. Henry VII's executors, and in particular Bishop Richard Foxe, but also Robert Hacumblen, the Provost of King's College, in turn continued this commitment to Flower. Sadly, however, Flower was not to live much longer and only completed for King's Chapel one coherent window and parts of three others.

The design of Window 2, Flower's one finished window, is interesting. Whilst incorporating Renaissance formulae, such as allowing design elements to cross the mullions of the stonework, the design of the window is still restrained. It retains archaic conventions rooted in the late-medieval period, notably the use of demi-figures in niches at the foot of each light. Nevertheless, beautifully drawn, and illuminated with a restrained colour palette, the window is an undoubted masterpiece.

With Flower's death, a shift in the balance of power occurred in English stained glass. Flower's successor as King's Glazier, probably some time after Flower's demise, and perhaps appointed after the second group of contracts, was Galyon Hone, a master glazier of Dutch origin, who had probably been an assistant to Flower. Hone, with his group of collaborators, James Nicholson, Thomas Reve and Richard Bond, was given the largest share of windows yet to be completed in the Chapel, under the second group of contracts of 1526: they were allocated seventeen windows including the great east window.[6] Hone's emergence was the catalyst for a marked stylistic shift in the stained glass at King's College. His work fully embraced the verve of the Northern Renaissance, introducing vivacious narrative, with a dramatic, but flatter, less modelled, glass painting technique, and daring compositional shifts cutting across mullions and transoms in a final break with an ancient tradition. Very different from Flower's calm draughtsmanship and carefully modelled technique, Hone's energetic and theatrical embrace of the new style is arguably the major factor that makes the glass at King's world famous.

Despite Hone's ascendancy, the third important glazier, Francis Williamson, was obviously well enough respected, and confident enough, to secure a separate contract for his four windows in 1526. It is interesting to speculate on the reasons for this. Did the College doubt that Hone and his team could complete the task alone? Perhaps the agents for the College and the King recognised that Williamson's style would provide a smoother visual transition at the west end of the Chapel between Flower's restrained work and Hone's high drama? Or perhaps Williamson and/or Symondes did not get on well with the other glaziers? We will never know. Whatever the reasons, Williamson and Symondes produced their four windows in accordance with the contract. Williamson's mature style, characterised by beautifully drawn figures with aquiline noses, and a sumptuous colour palette, is amongst the most beautiful in the Chapel.

So we can be fairly certain that, when Williamson first stood atop the scaffolding and looked at Flower's one complete window and his jewel-like traceries, replete with Tudor symbolism, above the window spaces, he must have caught his breath. Without doubt he must have known about Hone's ambition and energy, and would have anticipated the great wave of activity about to be unleashed by him and his team to complete the long saga of the King's great work at Cambridge. But he must also have contemplated with pride the future installation of his own work and its part in the great glazing scheme. These were stimulating times indeed for the foreign glaziers of Southwark.

VI · THE GREAT GLASS VISTA: A CONDITION SURVEY OF THE STAINED GLASS

The Art of Stained Glass

Ill. 106. Dirk Jacobsz Vellert, *Three Designs for Stained Glass Windows*, c.1538, pen and brown ink, grey wash over black chalk on paper, 16.83 x 17.46 cm. Brunswick, Maine, Bowdoin College Museum of Art, 1811.109.

Historically, stained glass was primarily a European art form, probably originating in the Germanic Countries, further refined in and around Paris: these techniques were then exported wider afield, not least to the Low Countries and England.

The first element in the process was to produce a scaled design or *vidimus* (a 'we have seen') for the proposed windows. It is quite possible that Bishop Foxe devised the overall scheme at King's, and it was he who commissioned an artist, possibly Dirk Vellert along with others to produce the vidimuses. Foxe and Hacumblen supervised Barnard Flower in his interpretation of the *vidimuses* for the Chapel. It is likely that his iconography and basic compositions were largely adhered to throughout the project – subject, of course, to the glass painters' individual stylistic interpretations. Thus the glaziers had to

141

Ill. 107. Hawthorn tree with six tiny circles cut from a single piece of green glass, with tiny white florets inserted. Detail of tracery lights, stained-glass window. Cambridge, King's College Chapel, Window 24.

interpret the vision of those who designed the overall scheme on behalf of the King, and doubtless Flower with his great talents in draftsmanship admirably achieved this. Unfortunately, all but one of the original scaled designs for the Chapel are lost; we have none of Flower's *vidimuses*, although we do have the one by Dirk Vellert, believed to be designs for Windows 19 and 21 (see Ill. 106). In the next step of the process, the design was worked up from the scale design into a full size cartoon, which was carried out by scaling-up the *vidimus* into a full-scale drawing on a whitewashed table, on which both the lead lines and main design elements were traced.

The glass was then selected and cut. Sophisticated modern glass cutters were not available then; cutting required drawing a red hot iron across the glass surface and spitting on the line. Thermal shock broke the glass sufficiently to give a rough shape, which was then nibbled with a notched tool called a 'grozing iron' to obtain the precise shape. The results achieved with this most basic of techniques were extraordinary. Sixteenth-century glaziers could cut and groze the most complex shapes. We can only admire examples at Cambridge, such as the hawthorn trees with their multiple inserts of blossom, perched so high that no mortal eye can see their exquisite detail, in Windows 1, 3, and 24 (see Ill. 107).

VI · THE GREAT GLASS VISTA: A CONDITION SURVEY OF THE STAINED GLASS

The glass employed at King's College is of two types common in the period, cylinder glass and crown glass, both almost certainly imported from European glasshouses. Given that the glaziers hailed from Germany and the Low Countries, it is likely that their glass was sourced from glasshouses they knew and trusted, that is from suppliers in Germany rather than those working in Normandy. The glass was smelted from a mixture of sand and ash. Most commonly wood ash, primarily from beech trees, was used; the alternative was the ash from burnt kelp (seaweed). Metallic oxides were added to the glass to produce colours: cobalt for blue, gold for ruby and pink, manganese for flesh colours, and so on. By the period in which the windows were being produced for King's College, the making of coloured glass was a highly sophisticated craft.

Ill. 108. The cylinder process.

Ill. 109. Flattening the glass sheets.

143

Cylinder glass, the most common method of producing sheet window glass at this time, was made by taking a gather of molten glass onto an iron blowpipe (a punty) and producing a large bulb shape, which was then swung on the blowpipe over a pit in order to elongate it into a cylinder. One end of the cylinder was opened with the help of an assistant, who pierced the end and formed a neat edge while the blower rotated the cylinder. Working quickly with the glass still semi-molten and in a plastic state, the cylinder was cut along its length with shears and promptly flattened into a sheet on a large stone slab with wooden or metal tools. Later, this method was refined. The cylinders were allowed to cool prior to being cut along one edge and re-heated in order to open them out into a sheet in a more controlled manner. This improved method was probably in place when the glass for King's College was purchased.

Crown glass, the other main method of sheet glass production in this period, is possessed of great brilliance, as both faces are formed with a smooth fire-finish because the glass is not formed or flattened on a bed of stone. According to this technique, the molten glass on the blowing iron was blown into a large flattened flute, rather like the bowl of a huge wine glass. Following re-heating in the glory hole of the furnace, the 'miracle' of crown glass was enacted. The blower rested the punty, or blowing iron, on an iron support and spun it vigorously. Centrifugal action then flung the glass out with 'a great ruffling sound' to become a beautiful circular sheet or 'table' of glass with its central 'bullion' still attached to the punty. Historically, the crowns varied greatly in size; medieval coloured bullions were small versions, only a foot or so across, but at the height of crown glass production in the eighteenth century, huge crowns were blown, often six feet across. These huge crowns became very thin at the outer edge, often less than 1 mm thick, and possessing great clarity and brilliance in these thinner areas. The crowns at King's, in contrast, were probably fairly small.[7]

Ill. 110. First stage of the crown process: a large flute is produced.

VI · THE GREAT GLASS VISTA: A CONDITION SURVEY OF THE STAINED GLASS

Ill. 111.
The 'crown' of
the glass.

The cut glass was then placed on the whitewashed table and the designs (the figures, landscape elements and architectural frameworks) were painted on with glass paint, silver stain, or enamel. Glass paint (sometimes termed grisaille from the French) consisted of ground glass and iron or copper oxide with the addition of a flux to lower its melting point slightly, in order to enable it to fuse with the surface of the glass when fired in a kiln at about 675°C. It could be painted on in an opaque line, or laid on in transparent veils by the master glass painter.

Ill. 112. Painting on glass on a light box at Holy Well Glass. Stephen Clare, photograph, 2012.

In the early fourteenth century, silver stain was discovered. The application of silver chloride or nitrate suspended in a carrier of fine clay in water, painted onto the glass surface and fired in the kiln at about 600°C produced a range of colours from pale lemon yellow through to rich transparent reds, depending on the kiln conditions, type of glass and the temperature. This meant that details such as hair and nimbus could be separated on a single piece of glass without the need to introduce a lead line to separate the two pieces of glass. The stylistic impact of this was tremendous, and demonstrated at King's with dizzying virtuosity. Once the glass was fired, it was then set into its 'H'-section lead 'cames' (these were at this date cast in wood or metal moulds). These leads were hand-shaped around each piece of glass, and the joins were then soldered together. Some small areas in the traceries at King's still retain the original lead work. The network of lead was waterproofed by forcing a lime putty-based compound into the individual lead cames. Finally, the completed panels were set into the building into grooves in the stonework. Here, in the stonework, very substantial iron support armatures, or ferramenta, had previously been set, and many strips or 'bands' of lead, soldered firmly to the stained glass panels, were twisted around the supports to hold the window firm. The last job was to point all around the perimeter with lime mortar. As can be seen from this brief description, this was a hugely complex and demanding undertaking.[8]

VI · THE GREAT GLASS VISTA: A CONDITION SURVEY OF THE STAINED GLASS

Ill. 113. Varied yellow stains on the face of King Solomon. Detail of Galyon Hone, *Queen of Sheba*, 1526–31, stained-glass window. Cambridge, King's College Chapel, Window 4.

Ill. 114. Modern Glazier leading a panel. Stephen Clare, photograph, 2010.

The Survey

Today, it is not enough simply to look at one element of a great historical building in isolation and merely record its condition. In order to give the best advice, it is essential to take a holistic view and attempt to understand the factors that may have contributed to the present condition of the stained glass and its surrounding fabric. Only then is it possible to comment on the condition with any authority and to propose a strategy for long-term conservation.

The recent survey of the stained glass at King's College concentrated on several key areas of research. The information gleaned from the various strands of investigation was collated in the expectation that this would lead to a conservation strategy. The survey took into account the current state of both the internal and external faces of the stained glass; archival materials relating to the construction and historical maintenance of the glass; and a consideration of the history of the Chapel environment, coupled with laboratory analysis of samples taken from the surface of the glass. The glass survey itself included observations on the condition of the glass, the applied kiln fired detail, the lead matrix holding the glass, the supporting metalwork, the perimeter mortar and the surrounding stonework. Generic survey documents were designed for the project. Advantage was taken of the scaffolding in place on the south elevation, whilst access to the north side was gained from the side chapel roofs. Internally a large 'cherry picker' hoist was employed to survey the glass. A careful record was also made of scratched graffiti applied by successive restorers on both surfaces of the glass, of which there proved to be many examples. Some of these evidence a lively banter amongst craftsmen from previous centuries, which can be highly amusing. Peirce Wendy, a glazier whom we know to have been restoring the windows in the seventeenth century, proudly scribed his name; however, underneath, in a different hand, presumably one of his workmates has mirthfully given Wendy a doubtful pedigree: 'Pimp Roge Nave'.

Ill. 115. Graffiti ('peirce wendy, roge pimp nave'), seventeenth century. Cambridge, King's College Chapel, Window 24.

VI · THE GREAT GLASS VISTA: A CONDITION SURVEY OF THE STAINED GLASS

Ill. 116. Dirt layers on the stonework at a high level on a stained-glass window in King's College Chapel, Cambridge.

Ill. 117. Rivulets in dirt layer caused by condensation on a stained-glass window in King's College Chapel, Cambridge.

A study of archival material was undertaken to better understand the conservation/restoration history of the stained glass.[9] It concentrated on the recorded restoration campaigns, leading to the production of a restoration 'time line' for the glass. It is known, for instance, that the windows were removed for safe storage during the Second World War. Wartime storage locations and conditions were therefore investigated to form an assessment of their possible impact on the glass. Equally important, the historic heating systems for the Chapel were also studied, as experience has shown that this can have a great bearing on the condition of historic stained glass. It is also essential to know how the present environmental conditions may be affecting the stained glass and surrounding fabric. To that end a leading specialist in monitoring the environment in historic buildings, Tobit Curteis (fortuitously based in Cambridge), was commissioned to undertake this element of the research and to provide an interpretation of the data produced. As for the laboratory analysis, our aim in commissioning the renowned Surface Interface Unit at Bristol University to examine samples taken from the surface of the stained glass was twofold. This was, first, to establish if there are substantial amounts of the products of combustion from the coke-fired stoves historically situated in the Chapel; such products could potentially continue to react with cycles of condensation to attack the glass and its painted detail. Second, our purpose was to identify any algal or lichen infestations which might be damaging to the glass and its painted detail.

When the findings of the survey were collated, it emerged that the general condition is good. Seen from the ground, the windows and surrounding stonework appear to be in good order. However, close examination on the internal face showed that the stonework adjacent to the windows, the cills and transoms of which form deep shelves, is extremely dirty. There are drifts of debris and cobwebs in places, and the surface of the glass and the supporting bars have a heavy layer of dirt. What is more, condensation cycles can be seen to have formed rivulets in historic deposits on the surface of the glass. This state of affairs is not merely detrimental in aesthetic terms, marring the brilliance of the glass colour, but means that moisture is retained on the surface, which may compromise frail painted detail, especially when condensation occurs. Cleaning of the glass and stonework internally is therefore highly desirable as soon as practicable.

The glass itself survives in exceptional condition, and was obviously originally of very high quality. Corrosion associated with poorly durable early glass is minimal, limited to a very small percentage of the windows. Most of the glass retains a good 'fire finish', and the shiny surface produced during its manufacture is relatively undimmed, notwithstanding its great age.

We also investigated the structural stability of the leaded panels. Archival material demonstrated that the lead work of the windows to the north and south elevations, along with the great east window, dates from two distinct restoration campaigns, undertaken by prominent nineteenth-century stained glass practitioners: an 1840s restoration by John Pike Hedgeland, and a late-nineteenth-century campaign by Charles Eamer Kempe, completed in about 1906. Hedgeland was in fact dismissed following criticism of his over-restoration of the glass; he took great exception to this slur on his professional standing, and a very lively exchange of letters, which survives in the King's College Archive, ensued for several years following this.[10]

Part of the recent site survey involved opening the leads and scraping away a small section of the waterproofing cement. This allowed close examination and macro-photography of the characteristic 'mill marks' left in the centre of the leads during the manufacturing process. It was reassuring that this site examination of the lead clearly identified two distinct lead types, which tallied exactly with the contracts for work allocated to Hedgeland and Kempe as described in the archive. Thus the lead is in excess of a century old. It is, however, a common misconception that lead glazing requires renewal after a century; this is by no means the case. During the nineteenth century restorations the majority of the lead work was replaced and the original ties made from lead strip were replaced with copper wire ties. This had become, and continues to be, the norm. Today, these copper ties remain well fixed, both to the internal tie bars, and to the massive external ferramenta. Thus, for the moment, the tie system continues to support the leaded panels adequately and its condition is stable. Nevertheless the presence of slight bowing, some cracked solder joints and the loss of some stained glass cement[11] means that the lead glazing, some of which is now 170 years old, will certainly require attention in the not too distant future.

Ill. 118. 'Mill marks' in the centre of the lead on a stained-glass window in King's College Chapel, Cambridge.

Ill. 119. Corroded external bars and subsequently damaged stone and glass on a stained-glass window in King's College Chapel, Cambridge.

Quantifying the structural weakness of leaded panels and stating with certainty when re-leading will become necessary is very difficult; unsurprisingly, however, this was a central requirement of the survey and report. The advice given was that it can be assumed that a rolling programme of conservation work will be required, commencing in about twenty to twenty-five years' time. The situation is further complicated by the fact that it is possible that this stained glass could remain in position for a long time and appear to be sound, even when in fact in a weakened state, precisely because it is firmly fixed to the substantial iron supports and pointed firmly into the stonework at its perimeters. Nevertheless if left too long, when eventually freed from the support, the leaded panels could well be found to be in a state of collapse. Therefore, although the structural condition does not demand immediate large-scale conservation work, it is important to avoid complacency, to ensure that the glass is not gradually becoming weakened by small degrees. The College will need to make long-term plans for a conservation/restoration campaign commencing at the latest in about 2030/35. This will be an expensive task.

The condition of the supporting ironwork was also investigated. The many internal tie bars are ferrous, but these internal fixtures do not appear to have rusted and expanded, which would in turn damage the stonework. However, the situation with the massive external ferramenta (there are many of these bars, which are in section one inch square) was different. These have historically been replaced in an *ad hoc* manner, particularly on the north elevation. The situation was found to be even more serious on the south elevation, where many of the bars were found to have rusted and expanded to a significant degree. Concerns about this state of affairs were raised by the author, both in the survey and at the site inspections that preceded the 2008/9 conservation programme to the south elevation. The Chapel Architect, Henry Freeland, recognised that, given how very little supporting stonework the Chapel has in comparison to its huge expanses of stained glass, the risk to its structure from the expanding metalwork could not be underestimated. This was identified as a potentially serious threat to the structural integrity of the fabric and remedial work was carried out in a highly innovative fashion.

Ill. 120. Exposed bar ends and re-pointing with lime mortar on a stained-glass window in King's College Chapel, Cambridge.

Ill. 121. Exposed bar ends and re-pointing with lime mortar on a stained-glass window in King's College Chapel, Cambridge.

Ill. 122. Exposed bar ends and re-pointing with lime mortar on a stained-glass window in King's College Chapel, Cambridge.

Ill. 123. A stained-glass window in King's College Chapel, Cambridge, after conservation, 2010.

The ferramenta were not removed, as is common practice, because this would have necessitated the removal of all of the stained glass. This would have posed a marked risk for the glass, as it would have involved chiselling away hard nineteenth-century perimeter mortar and handling; it would also have posed a substantial risk to the stonework, as the bars are deeply set into pockets in the stonework. The decision was taken to leave the glass *in situ*, and very carefully to expose the bar ends using fine chisels and small drill bits. The bars were then decorated with a high performance epoxy resin-based paint system and firmly re-pointed in the correct lime-based mortar. This method was entirely successful, and should be seen as exemplary, adhering to the best principles of minimum intervention.

VI · THE GREAT GLASS VISTA: A CONDITION SURVEY OF THE STAINED GLASS

Of all the aspects of condition considered in the survey, the condition of the painted detail on the glass caused the greatest concern. The glass is of great age, and of course it is to be expected that the surface of the glass paint will be marked and disrupted; indeed, some would argue that the patina of age is part of the quality and beauty of the glass. However, the varied condition of the glass painting was of great concern; whilst large areas of the glass paint remained in remarkably good condition, some had serious paint loss, notably on the north side. This frail glass paint demanded careful consideration and treatment. There was also, as I have already noted, a heavy internal soot layer, which marred the legibility of the painted detail.

We also noted that the glass has been the subject of successive restoration campaigns, including cleaning. The cleaning has been heavy-handed, resulting in a disrupted paint surface. But we also considered that some of the paint loss might be due to cycles of condensation, perhaps allied to airborne pollutants. If this was so, we needed to know if that situation was ongoing or historic. The environmental survey therefore consisted of sensor measuring the surface temperature, the ambient temperature, the relative humidity and the surface wetness. The sensors were not only sited on or near the glass surface, but at other points inside and outside the building, to gather data relating to the whole building envelope. Data was collected via telemetric data loggers which allowed constant evaluation of data. The results suggested that today the building is comparatively well regulated. Condensation cycles certainly do occur internally on the stained glass, with implications for the frail painted detail, but are not frequent or severe when compared to similar buildings. The present environmental conditions are in fact comparatively benign.

Ill. 124. Damage from earlier repairs on a putto. Detail of Francis Williamson, *Nativity*, stained-glass window. Cambridge, King's College Chapel, Window 3.

Ill. 125. Test area of cleaning chosen to allow inspection from ground level. Detail of Barnard Flower (attr.), *Marriage of Tobias and Sara*, c. 1515, stained-glass window. Cambridge, King's College Chapel, Window 2.

We therefore engaged in test cleaning of the internal face of the stained glass. Cautious cleaning of small areas of glass on the south side, where the glass paint remains in good condition, showed that cautious wet cleaning with 50:50 solution acetone/ de ionised water is possible, and that great improvements in visual legibility would result from it. However the same techniques applied to the delicate north side painted detail demonstrated that, unless very great care is exercised, the painted detail is easily removed by slight surface abrasion. Therefore any future programme of cleaning will require carefully regulated methodology.

Archival research on the history of the Chapel heating systems was also undertaken. No information was found on heating systems prior to the nineteenth century, leading to the conclusion that there was no heating before this time. The Chapel Committee reviewed heating possibilities in 1867 and invited estimates for heating stoves for the Chapel at this time. Fortuitously, as part of a survey of the stained glass to the Lady Chapel at Gloucester Cathedral, I was alerted by the Cathedral archivist to the survival of an extraordinary and important document at Gloucester. This was an inquiry distributed to numerous cathedrals and great churches by Frederick S. Waller, the architect at Gloucester in the early 1880s.[12] The replies confirmed that a company, The London Warming and Ventilating Company, had secured title to the celebrated stove designs of Sir Goldsworthy Gurney and had supplied large numbers of the stoves to cathedrals in a concerted and successful sales campaign. It confirmed that four Gurney stoves were installed at King's College Chapel in 1875–6, one in each corner of the Chapel, with six-inch diameter cast-iron flues, to allow for the external venting of fumes. The stoves were of the Gurney Type A – the largest available, consuming approximately half a ton of coke or coal per week.[13] Air input to the coke burner was from the interior of the Chapel.

VI · THE GREAT GLASS VISTA: A CONDITION SURVEY OF THE STAINED GLASS

Ill. 126. Advertisment from the London Warming and Ventilation Company Ltd., 1874. Cambridge, King's College, KCC/375.

Ill. 127. A Gurney stove (patented 1856) similar to those installed in King's College Chapel. Bude, The Castle.

155

Due to significant soot and leakage of fumes, thought to be causing significant damage to the stonework and stained glass, in 1888 Professor Henry Middleton was asked to review the heating systems. Recommendations for minor alterations were made, but it is not clear if these were implemented. In 1906 the London Heating and Warming Company was asked to review the heating, which was considered inadequate. It was concluded that the volume of the Chapel was too great for the system and a recommendation was made for *six* Gurney stoves! It was said that, if these had external air input, they would be more efficient and involve less soot leakage. This recommendation was not taken up and the four existing Gurney stoves were refurbished in 1907.[14] This research into the historic heating systems of the Chapel proved to be one of the most illuminating areas of study. It confirmed that coke burning was carried out over a long period. The stoves were stoked within the Chapel, and the flue systems leaked directly into the Chapel shortly after installation. It must be assumed that the cycles of condensation were more severe at that time, and that the atmospheric pollutants produced by these coke-fired furnaces would have produced acidic condensation on the face of the glass, surely a major contribution to the loss of painted detail.

Ill. 128. Storage locations during World War II.

The storage locations of the glass during World War II were also detailed in the report. It was found that there is no correlation between the condition of the painted detail and the various storage locations in cellars around Cambridge. The wartime storage did not, in other words, significantly affect the condition of the painted detail. Again, researches in the College archive yielded fascinating results: a recently-discovered document confirmed that the windows were stored in the cellars of the College, and at several addresses in the city, dispelling for once and for all the myth that the glass was carried to slate caves in Wales for its safe storage.

Recommendations for the Long-term Conservation of the Stained Glass

The report did not propose any immediate conservation works over and above the ongoing works on external ferramenta. Cleaning of the internal face of the glass was not recommended. However, it will be necessary to allocate funds, or commence fund-raising, to progress a rolling programme of major conservation and re-leading, to commence in about twenty to twenty-five years from now. The financial burden of the conservation will be considerable. The report emphasised the importance of not being complacent as a result of the fact that immediate works were not advocated. Care must also be taken to ensure that the leaded panels do not become over-weakened. It was recommended that the condition of the glass should be closely monitored by establishing a regular inspection of painted detail and lead work stability; this should be a carefully-structured inspection that allows accurate comparison of selected areas of the glazing by employing photographic records and site notes. An inspection at five-year intervals commencing in 2011 was recommended. Any trends in deterioration of condition would thus be identified, and the actual start date and rate of progress of the conservation campaign could then be informed by these quinquennial inspections. Given that the glass and stonework are internally very dirty, a window-by-window cleaning programme is recommended for legibility of the glass. Of course, although opinions may vary as to whether or not cleaning is required for aesthetic reasons alone, the recommended quinquennial inspections may identify patterns of continuing degradation caused by layers of dirt holding condensation against the painted surface, which would suggest that cleaning is actually necessary. The College may, as part of a future conservation process, wish to evaluate other methods of protecting the stained glass, by taking advice on developments in conservation methods relating to historic buildings, and stained glass in particular. It may, for example, wish to consider a form of protective glazing for the glass, or the installation of local trace-wire heating, which would control condensation cycles locally. In the meantime, the preventive conservation measures involving re-setting external ferramenta into lime mortar should be continued as a priority. Finally, the report stressed the importance of maintaining the relatively efficient existing heating and ventilation systems, which are successful with regard to controlling patterns of condensation on the inside face of the stained glass, also providing good conditions for other important areas of the fabric, including the other internationally important art works within the Chapel.

The superb stained glass at King's College is 500 years old. Its surface bears the signs of age; corrosion, paint loss and the marks of generations of restorers. Nevertheless it is remarkably intact, and in relatively good condition compared to other glass of the same period. If complacency is avoided and we take the necessary conservation measures, this remarkable work of art will doubtless carry forward its message to many generations to come.

Life & Visiting

KING'S COLLEGE CHAPEL 1515–2015

Ill. 130. Richard Bankes Harraden, *King's College Chapel and Clare Hall*, engraved by Elizabeth Byrne, 1797, proof print with hand-colouring, 54.7 x 36.4 cm. Cambridge, King's College.

Ill. 129. OVERLEAF: Detail of Distant view of King's College Chapel from the north west, barges on river in foreground, *c.*1800, pencil, watercolour and crayon, 22 x 34 cm. Cambridge, King's College.

VII

The College and the Chapel[1]

PETER MURRAY JONES

In King's there is a distinctive spatial arrangement that means that the main range of College buildings, dating from the 1820s, face the Chapel across the Front Court. Other colleges do not demarcate the educational and residential, on the one side, from the religious, on the other, in such clear-cut fashion. This sense of demarcation is only emphasised by the statue of the Founder, King Henry VI, which stands over a fountain equidistant between the north and south sides of the Front Court (Ill. 131). King Henry, diffidently offering a charter, is joined on his plinth by two emblematic sitting female figures, Philosophy studying a scroll, and Religion bearing a model of the Chapel. The two ladies have their backs to one another, Philosophy facing the Chapel, and Religion facing the College Hall. The statue sculpted by Henry Hugh Armstead was erected in 1879 when the oppositional spatial arrangement of College and Chapel had plenty of symbolic weight, for King's was in the process of feeling its way tentatively towards a new understanding of the distinction between the religious and educational sides of the College community.[2] Opposition to compulsory attendance at Chapel for all resident members was growing; meanwhile the College had embarked on radical reforms through which it would open itself up to non-Etonians and undergraduates who were not members of the Church of England.

Of course the oppositional positions of College and Chapel are only a part of the story, and a distinctive modern development rather than a permanent feature of King's since its foundation. Even in the present, the gap between them should not be exaggerated. It may be that a proportion of the undergraduates and graduates of the twentieth and twenty-first centuries do not set foot in the Chapel during their time at King's. Even Fellows of the College may only attend for the ceremony of admission to their Fellowships, or for the election of a Provost. Yet the Chapel, a quasi-cathedral with thousands of visitors, and the Choir, a world-famous musical institution, do not flourish independently of the College. They are maintained in being by the College, and contribute much to the distinctiveness of King's. The Dean of Chapel and the chaplain have a prominent pastoral role in the College, taking care of its members as individuals, and are integral to the educational leadership of the College. Many members of the College, of all faiths or none, resort to the Chapel at intervals for inspiration, rest, or aesthetic enjoyment, as well as for spiritual refreshment. They do so of course on a voluntary basis, and the modern rapprochement of College and Chapel can be seen as a negotiated outcome to the struggle over compulsory attendance, the growing diversity of religious affiliations and the emergence of a largely secular twentieth-century ethos, which nevertheless could accommodate charismatic individuals like Bursar John Maynard Keynes and Dean Eric Milner-White as two poles of attraction rather than avowed opponents.

That struggle will form a later part of this chapter, but there is much to be said first about earlier stages in the relationship of College and Chapel, when the relationship was not oppositional. In

Ill. 131. Henry Hugh Armstead, *Founder's Fountain* (above: King Henry VI; below: Religion holding a model of King's College Chapel on the Bible and Philosophy holding a scroll and a book), 1874–79, bronze and Cornish grey granite (originally Portland stone). Cambridge, King's College, Front Court.

exploring earlier and later stages, the College's archival record (whose modern arrangement includes a large section devoted to the Chapel) is of considerable value, but also has major limitations. Financial and legal matters, disciplinary and administrative decisions, are there in abundance, but the lived experience of the community sharing the Chapel is very hard to catch in the archives. Sometimes the recollections of individuals, preserved in manuscript or printed memoirs, can throw light on what otherwise might be missed entirely by the institutional record of the College. But all too often the big questions about how the Chapel was used by the College, and the impact of the Chapel on College members, are very hard to answer from the evidence that survives.

We can be reasonably sure, though, of what the royal Founder intended for the Chapel. In specifying the position and scale of the new larger Chapel on the northern side of the great front court, as set out in King Henry VI's Eton Will of 1448, the King not only planned to outstrip all other chapels in Oxford or Cambridge in magnificence, but envisioned a great chantry in which seventy scholars of the College, together with chaplains, singing men and boy choristers, would undertake the performance of daily masses for the souls of himself and other members of his family already deceased, thus helping them to a swifter passage through purgatory to heaven.[3] The more masses

said or sung, the more members of the foundation involved, the better this purpose was served. These wishes were first carried out in the older small Chapel, in existence on a site north of the present Chapel from 1448, and they continued to be obeyed even after the deposition and death of Henry VI in 1471. The new Chapel may not have taken over as the great cooperative chantry that Henry had intended until 1537, when the older chapel collapsed, but in any case the existence of purgatory and the practice of chantry worship were both soon to be challenged in the reign of King Henry VIII. Despite the reversion to unreformed practices under Queen Mary, College participation in masses for the souls of the royal dead was abandoned permanently from 1558, as existing chantries were abolished and no new ones could be set up.

But the endowment of chantries in the new Chapel had not been restricted to the Founder. The original plan for the new Chapel had included provision for six side chapels between the buttresses of the antechapel, three on the south and three on the north. In the Founder's Will they are called 'closets', which meant especially a place of private devotion.[4] The King must have envisaged private chantries for the singing of masses for other individuals taking place alongside the use of the Chapel choir as a great chantry for the royal family. Before 1461 the design of the building was changed to allow for the creation of a total of eighteen side chapels on both sides of the Chapel. Four were probably intended to serve utilitarian purposes as vestries and storage areas (two on each side east of those off the antechapel), but the eight new side chapels seem to have been intended for ceremonial use. These were all therefore available for private chantry use. In fact we have surviving evidence that four of the side chapels were definitely used as chantries for deceased members of the College. Each was a site of burial as well as chantry for the man commemorated by a memorial brass set in the floor of the side chapel. These were for William Towne, Fellow, who died on 11 March 1495; John Argentine, Provost, who died on 2 February 1508; Robert Hacumblen, Provost, who died on 8 September 1528; and Robert Brassie, Provost, who died on 10 November 1558 (seven days before Queen Mary, and thus at the very end of the chantry era of the Chapel).[5] Robert Brassie's chantry was at least partially preserved until the eighteenth century, for William Cole recorded:

> on the outside of the Door of this Chapel is wrote in Gothic Characters & covered with Horn, on Parchment, according to the desire of Provost Brassie himself, these words: 'Orate pro Anima Roberti Brassie quondam Prepositi hujus Collegii' [Pray for the soul of Robert Brassie once Provost of this College], which words, as to the cheifest part of them remain on the door to this day.[6]

There may have been other chantries too, where burials were not involved, and the soul at stake not necessarily that of a member of the College. John Saltmarsh noted that John Hogekyns, Fellow, endowed in 1480 a weekly mass for the soul of his brother, also called John Hogekyns, sometime citizen of London and merchant of the staple of Calais, and for the souls of his relatives, friends and benefactors. Unless this mass was celebrated at the high altar of the Chapel, it was to include a special collect (a prayer for Hogekyns during the mass). Presumably another altar in a side chapel was the normal site of celebration. Hogekyns also made provision in his will for his own obit to be observed in the Chapel by one of the Fellows at a stipend of four marks a year. He died before November 1509, but he was buried not in the Chapel but in the chancel of Ringwood Church, one of the College livings.[7]

The Chapel, most particularly the side chapels, enabled private devotions and chantry practices on the part of the individual members of the College, at least up until 1558. However, while private

Ill. 132. Coat of Arms of Roger Goade (Provost 1569–1610) and King's College, 1610, stained-glass window, 55.5 x 46 cm. Side chapel window 28e3 (as numbered by Hilary Wayment), King's College Chapel, Cambridge.

VII · THE COLLEGE AND THE CHAPEL

chantries may have disappeared, the use of the Chapel as a place of burial for the College, first recorded 'in the nave of the new church' in 1458,[8] did not end in 1558 but continued up to the twentieth century (burials in the side chapels continued up to the eighteenth century). Provost Roger Goad, a staunch Protestant who died in 1610, seems to have appropriated a side chapel to his own posthumous use in the manner of his Popish predecessors – in fact it came to be called 'Provost Goad's Chantry'.[9] Much later it was rededicated with an altar and furnishings in 1935 as the Founder's or Royal Chantry, though without restoration of the full Catholic mass. A shield of Provost Goad's arms impaling those of the College in a fine floral surround with gaping skulls beneath can still be seen in the coloured glass in the north window (see Ill. 132). He was buried under a grave slab in the centre of the side chapel, and when the organist was restored to use in 1935 the slab was taken up for treatment. Underneath there were no bones or wrappings, though a human shape was outlined in the soil beneath. Instead there lay a boar's tusk, bearing out perhaps the accusations of necromancy circulating amongst the junior Fellows of Goad's time against their stern Provost.[10]

The ceremony of burying a member of the College in the Chapel was the most visible participatory event in the relationship of College and Chapel. We do not have many observers' accounts of the ceremony, at least before the twentieth century, but there are valuable records left by William Cole in his manuscript volume on the Chapel. Two of them relate to the use of the Chapel as a private burial place for the Provost and his family:

> in the North East Corner of the 3rd North Chapel from the East was buried the middle most Daughter of our present Provost with this Inscription on the Brass Plate of her Coffin: 'Margaret George, Ob: 23 March 1743 aged 7 years and 7 months'. She was buried privately at 5 in the Afternoon after Vespers, without being carried into the Choir, but brought out of the Lodge unto the Chapel by the Provost's Servants through the Door by the Clock, and the Service performed by the Rev: Mr. Betham the Dean on Easter Monday March 26 1744.

The perils of infancy were such that in the next year Cole was to record:

> October 2 1745 In the Evening the Provost's Lady was brought to Bed of a Son, which lived long enough to be baptised: it was buried close to the other Child in this Chapel on the South of it.[11]

By contrast with these very private family burials, we can place Cole's account of a burial ceremony for the Senior Fellow in the same year as the death of Margaret George:

> In the void Space behind the Screen of the Altar and the East Wall, about 7 foot from the 3rd Screen on the South side of the North door, was buried the Corps of Mr Seymour about 7 o'Clock at Night October the 15 1744 by Mr Betham, the Dean of Divinity, attended by the whole College in their Surplices & Hoods from the Hall of the old Court, processionally 2 & 2 the Juniors first & the Provost last of all: the 6 Seniors in College supported the Pall; viz. Mess: Smith, Southernwood, Showell, Belcher, Maul & Carter: the Choir viz: the 6 Singing Men & all the Choiristers preceeded the Bier (for the Corps was immediately taken out of the Herse at the West Door and carried into the Grave by reason of the Weight) in their Surplices with Wax Tapers in their Hands about 1/2

after 5. After the Bier, which had stood from 4 o'Clock in the Hall, with the Pall over it, on which were fastened the Verses on the Occasion by the Scholars, followed the 2 Chief Mourners, the Deceased's Friends from London, where Mr Seymour died, then the Poor Scholars, after them the Scholars of the House, then the Junior Fellows, & then the Masters of Arts & brought up by the Provost: before ye Procession got to the West Door the Organ struck & the Choir chanted the Sentences before the Burial Service solemnly while the Procession walked slowly up the Antechapel and then the Bier was placed during Evening Service, before the Brass Desk in the Choir: an Anthem composed by the organist, Mr Randal, M:B: was sung at the Grave: on the Lid of the outermost Coffin was a white plate fixed with this Inscription: 'Barclay Seymour Esqr, Senr Fell: of King's Coll: Cambridge obiit 4 Octob: M.DCCXLIV.-Aetat: LVIII.'

On digging Mr Seymour's Grave, the Chapel Clerk light upon Mr. Dodsworth's Coffin, which had not been buried 20 years, so that it was too fresh, and so a new Grave was made at his Feet: Mr Wells and Mr Thackham were buried just by. Mr Seymour was put into a Lead Coffin. He died in London, where he had lived for these 12 or 14 years last past; sometimes confined, & sometimes at his Liberty; being disordered in his Senses. He was of the same Family as the Duke of Somerset, and had been Proctor of the University.

No doubt Seymour's noble connections helped to secure him such a splendid send-off, but burials of College Fellows in the Chapel were the most elaborate ceremonies that took place there, discounting only the occasion of royal visits to King's.

The funeral in 1886 of Henry Bradshaw, Fellow and University Librarian, was vividly described by a King's undergraduate, C. R. Ashbee, in his unpublished journal:

There was music as we entered the Chapel, which was carpeted with cloth for silence sake. We passed by the open vault which was strewn all around with flowers and moss, and followed the coffin into the Choir. I passed by it, going to my seat; it was fragrant with rich white flowers. After the service they sang the lovely anthem from Spohr's Last Judgement and a still lovelier one which Stanford had composed for the occasion. [Professor] Westcott and [Archbishop] Benson both took part in the service. The dead march was played again, and the choir sang very beautifully around the grave, whither we all went. After the coffin had been lowered and all was over I went to the edge of the vault and looked down the steps. It was a beautiful sight. The sides of the vault were draped with black, flowers were strewn around and down below in the dark but lit up with candles was the coffin groaning under the burden of wreaths. I stooped to the edge of the grave and picked up a last token of the departed these symbol flowers.[12]

The vault in the antechapel (first opened in 1774) was used in the twentieth century to bury the ashes of deceased Fellows, and the burial of Henry Bradshaw was the last occasion but one (the burial of Provost Richard Okes in 1888) on which such a magnificent funeral in the presence of a coffin was held in the Chapel. Memorial services, usually celebrated some months after the death of a Provost or Fellow, succeeded funerals after 1923 as the great collegiate occasions in the Chapel, with elaborate music, spoken tributes, and readings accompanying the service of remembrance.[13]

The earliest marriage known to have been solemnised in the Chapel took place on 20 November

1666, when William Wells, vintner, one of the Aldermen of the Borough, was married to the widow of Alderman Richard Allen, vintner. Since Fellows had to remain celibate or give up their fellowships under the Founder's Statutes, it is no surprise that these marriage ceremonies, which became relatively common in the early eighteenth century, involved brides and grooms from town rather than gown. Nevertheless Fellows of the College who were in orders could act as celebrants of such marriages, and a number of records of these from 1710–21 are preserved in the same register as the burials (the most regular officiant was the Dean, naturally). Baptisms are not known to have been celebrated in the Chapel (when these occurred it was in the side chapels) until 1929, and these were normally the children of members of the College. Confirmations of members of the College were conducted by the Bishop of Lincoln, the College's Visitor, from 1949 onwards. In these ways the Chapel has functioned, and continues to function, much as an ordinary parish church does, offering the sacraments to its collegiate congregation.

Yet the Chapel had from the beginning a significant role not only as the church of the College, but as a place where education was to be furthered within the College. The Founder's Statute chapter 31 laid down requirements for disputations of Fellows and scholars of every faculty or science. Those who were scholars or Fellows who had not yet graduated as Bachelor of Arts were required to dispute at least twice a week (or once if there were fewer than six involved) in full term in the Hall or the College Chapel. Once they had graduated as Bachelor of Arts, they were required to dispute at least weekly in Hall or Chapel. Those who were studying for further degrees had also to dispute weekly, but for those studying canon law or theology the nave of the Chapel alone was specified as the place of disputation. The statutes were modelled on those of William Wykeham for New College, Oxford, and in both cases the large Chapels were intended for education as well as for worship. In relation to the advanced students, the Chapel alone was regarded as appropriate for scholastic disputation. Perhaps this was because the audiences for the more advanced scholastic exercises were expected to be larger, or perhaps it was because such exercises were more dignified in character. Once the new Chapel was completed in 1515 it took over as the site of these disputations.[14] Beyond these regular disputations there were examinations to precede the grace for the award of a BA degree. A College order of 1582 provided that the examination for the Bachelor's degree should take place in Chapel between 1 and 10 May each year, lasting for two days. On each day the junior Fellows were to be examined by the Seniors for two hours at a time.[15]

It is of the nature of scholastic disputation, an oral exercise by junior members of the College, presided over by their seniors, that it leaves little trace behind. There are no College records that indicate how often these exercises were performed in reality, as opposed to statutory requirements, or that signal any change in procedure. But one glimpse we have that tells us that the Founder's Statute 31 was still very much in operation on 25 October 1633, when Thomas Crouch, MA and Fellow, was admonished for proposing and defending the proposition, 'Invocacionem Sanctorum non esse impiam' ('Invoking saints is no offence against piety') in the College Church (ie. the Chapel) and refusing to recant for seven days. He was told to abjure his proposition, which must have been considered too Popish even at the high tide of Laudianism, at the next public disputation in Chapel. On 25 November 1633, presumably as a result of the same incident, he was warned for contumacious words used to the Vice Provost. This same Thomas Crouch was ejected from his fellowship at King's in 1650, and became a Fellow Commoner of Trinity Hall, though he bequeathed money to the College which allowed the construction of book cases for the College Library in the Chapel in 1680.[16]

The later history of disputations held in the Chapel is shrouded in darkness, for no records seem to survive. It is likely that, as in the University as a whole, formal exercises of disputation were given

up only about 1830.[17] Undergraduate examinations seem to have ceased before 1829, when an annual College examination was instituted for all scholars, with prizes for those who topped the class lists. Degree examinations were revived in 1836. The choir of the Chapel seems to have continued in use for this purpose down until 1851.[18] The Chapel was also a site for religious education alongside the regular pattern of services. In 1576 Provost Goad instituted weekly catechisings in the Chapel, to be conducted in turn by each ordained member of the College; all who in any way belonged to the College were required to attend.[19]

Goad was responsible for another innovation in the College's use of the Chapel, one that probably long outlived the practice of weekly catechising. The Founder's Will had specified a spacious library for the new College that would abut the Chapel at its west end. But that building was never begun, and instead by 1448 books were being bought, bound and chained for a library in the Old Court. This library was visited by the Founder, and by 1508, if not earlier, included both a 'great' and a 'small' library. But by 1570 both parts of the library were in a near ruinous state, and the abandoned space was converted into two chambers for Fellows. The books had almost all disappeared, and at this time Provost Goad fitted out a new library in the southern side chapels of the Chapel. 'I have caused a fayer new librarye to be made and furnisshed with bookes, specially of divinitye, both of ould and new wryters: whereas, before my tyme, the librarye was utterly spoiled, and this coaste upon the new librarye without eny charge in the college accompts'.[20] Goad may have exaggerated the extent to which the new Library in the Chapel was cost free: there are payments of 59s 7d for glazing the side chapels concerned.[21] He continued to restock the Library, and his son Thomas Goad left moneys derived from the sale of timber on estates at Milton to buy divinity books for the College (1638). Roger Goad also took a lead in encouraging donations by Fellow Commoners and Fellows. A handsome donors' book was started, headed by the name of Sir Francis Walsingham (see Ills. 133–135).[22] In 1610 Woodroffe the joiner fitted up some new bookcases, and in 1613–14 further alterations were contemplated, to judge from a payment for a 'platt of the library'. Tall oak presses to house the books were installed in the side chapels, some made in 1659 with moneys bequeathed by Nicholas Hobart, sometime Fellow. In 1677–8 new presses were made by Cornelius Austin, and others on the same model as Hobart's were added with the bequest of Thomas Crouch, who also gave a substantial collection of books (1680).[23] Three of the bookcases remain in the side chapels today, with the initials of their donors written in gilt on cartouches at the top (see Ill. 136).[24]

The appearance of the Library in the side chapels was described by William Cole in 1744. By that stage the Library occupied the fourth, fifth, sixth, seventh and eighth side chapels on the southern side, counting from the west. Books were chained to the bookcases until as late as 1777, and there are many records of payments for chains for new books. Cole records the existence of 'a neat wainscote Cabinet with Glass Doors for the MSS and other curious Books which are safer here than in any other part of the Library' near the entrance door from the Choir. These treasures were matched by 'a Wainscote Box with a Glass Door, in which stands the Sceleton of a Malefactor executed at the Castle of Cambridge'.[25] This part of the Library must have been a visitor attraction, but the Library as a whole was used by both Fellows and scholars for the purposes of education and learning. Two sets of rules, one to be observed by the Keeper of the Publick Library (c.1685), and the other by those who used the Library (about 1709–10), have survived. The first is headed 'Articles, Conditions and Covenants upon which the Provost and other Officers of King's College in Cambridge have admitted Michael Mills Scholar of the said College to be Keeper of the Publick Library of the said College' (see Ill. 137). The Public Library is clearly differentiated as the former 'bibliotheca magna', while there is also still a 'bibliotheca parva' or 'Inner Library', which no doubt contained books that were not under the control

Ill. 133. *Sir Francis Walsingham*, 1587, oil on panel, 74.3 x 61.5 cm. Cambridge, King's College.

Ill. 134. Original calf binding with chain of *Index bibliothecae Regalis Collegii* (Donor's Book), manuscript. Cambridge, King's College Library, Lib. 1.

Ill. 135. Francis Walsingham's name written calligraphically, *Index bibliothecae Regalis Collegii* (Donor's Book), manuscript. Cambridge, King's College, Lib. 1, fol. [163]r.

VII · THE COLLEGE AND THE CHAPEL

Ill. 136. Bookcase (with cartouche NH for Nicholas Hobart), 1659. Cambridge, King's College Chapel, side chapel L.

171

Ill. 137. 'Articles, Conditions and Covenants upon which the Provost and other officers of King's Coll. in Cambridge have admitted Michael Mills Scholar of the said College to be Keeper of the Public Library of the said College', *c*.1685, ink on paper, 43.7 x 33.5 cm. Cambridge, King's College, KCAC/6/1/1.

of the Keeper, but under that of the Provost and Dean of Divinity alone. The Keeper's duties include oversight of 'Globes, Maps, Tables, Pictures' and making sure they suffer no ill usage.[26] Strangers are to be allowed to see the Library under his supervision, but not to make use of the books as students without the leave of the Provost. Members of the College may use the books but must avoid entangling their chains and under no circumstances are they allowed 'to carry any Book out of the Library to their Chambers, or any otherwise to be us'd as a private Book, it being against the Statutes of our College'.[27]

By 1709–10 there had been a significant change. With the exception of Bibles and commentators upon the Holy Scriptures, or dictionaries, books may be borrowed for private use so long as the Dean of Divinity 'shall take a Note for it under the borrowers hand, when he delivers it'. The borrowing period is not to exceed two months unless the Provost and Dean of Divinity permit it. Many books remained chained to the reading desks, but clearly the loan books were removable. No foreigner or member of another College shall have a key to the Library or study in it, without the Provost's leave. There is an Under Library Keeper who is responsible to the Dean for the good order of the books, and is to report to the Provost or Dean 'if he discovers any one misusing his Privilege, by defacing, tearing, or cutting leaves or pictures out of any book'. In all probability these rules remained in force until the books were transferred to the new Wilkins Library in the south range of the College in 1828. The determining factor in building the new Library elsewhere in the College was the increasingly cramped conditions in the side chapels as the collections continued to grow. Most telling was the need to house the great bequest in 1804 of Jacob Bryant, a bibliophile's collection that included many examples of early printing, travel, and literary texts, hardly represented in the older collections of the Library, and had to be stored elsewhere in the College until a larger and purpose-built space could be created.

The move of 1828 was not quite the end of the use of the side chapels for the Library, however. From 1921 onwards the original divinity books acquired in Provost Goad's time and after were transferred back to the Chapel, as the Wilkins Library in turn ran out of space. Only when the Chapel exhibition was created in 1987, and more vestry space was needed on the south side were the last library books removed from storage in the Chapel. The Chapel's use as a College Library was succeeded by its use as a Muniment Room. The original foundation documents, charters, statutes and other important legal documents of the College had been intended by the Founder to be housed in a Muniment Tower, never built. Instead they were kept in a Treasury over the gate to the Old Court of King's. The Treasury room survived the demolition of the rest of Old Court in 1836, but by 1744 we know that part of the muniments had already been transferred to the easternmost of the southern side chapels (next to the Library). William Cole described this side chapel as 'now made use on as a place for the Archives of the College and is always safely locked up. It has lately had a new Door to it, and has had Cabinets and Chests of Drawers set all around it for the writings of the College to be placed in'.[28] Unfortunately Cole over-estimated the security of this new archive store. In 1802 the Cambridge burglar Richard Kidman mastered the locks of the side chapels and stole from the easternmost side chapel 'a valuable collection of coins and medals', perhaps the collections bequeathed in 1681 by Sir Thomas Page, Provost and traveller, that had included 'an Oriental Bezar Stone of an Extraordinary magnitude …A Hog Bezar Three peices of Porcupine Stone and a Skelleton of a Salamander'. Once the Library had gone from the Chapel in 1828, the rest of the contents of the Treasury in Old Court seems to have come to the side chapels vacated by the Library, so that the muniments eventually occupied the greater part of five of the southern side chapels. Only in 1920 did Wilkins' purpose-built Muniment Room on the opposite side of the College take possession of the records it had originally been intended to house. The Chapel therefore had served

Ill. 138. Wooden chest belonging to Henry VII, made before 1508, standing next to book-case in side chapel. Cambridge, King's College, Coll. Ph. 1198.

from c.1744 to 1920 as what Saltmarsh called 'the official memory of the College', as well as a store for valuable antiquities and treasure. All that remains today in the Chapel to testify to this is a fifteenth-century chest (see Ill. 138).

Attendance at Chapel for all members of the College was prescribed by the Founder's Statutes, and enforcement of attendance was a concern for the College's Provost and senior Fellows while those Statutes continued in force. The Protocollum Books of the College record such formal acts as admission of scholars and Fellows, transfer to a different category of Fellowship, or disciplinary measures. The Protocollum Books were witnessed and scribed by a succession of notaries on behalf of the College. The first occasion of censure of a College member for refusing to go to the Chapel for a service occurred on 2 January 1553/54, when Edmund Guest, Fellow, was the guilty party. Guest (1514–77) was a notable figure at King's; he had been Vice Provost, and was the author of *A Treatise against the Privy Mass* (1548). He became chaplain to Archbishop Parker in 1559, and was later successively Bishop of Rochester and Salisbury in the reign of Queen Elizabeth. No doubt he was censured by the Provost in January 1553/54 for several reasons: because the wheel had turned with the succession of Queen Mary, the Chapel was restoring full Catholic worship, and Guest was under deep suspicion as a reformer and enemy of the Mass.[29] This use of the statutory obligation to attend Chapel as a weapon in a wider struggle over the future of the national Church was exceptional, but very often the use of the Provost's power of censure for offences in the Chapel can be seen as the consequence of division within the College community.

VII · THE COLLEGE AND THE CHAPEL

Provost Roger Goad made the matter of attendance and behaviour in Chapel a battleground in his struggle with the Junior Fellows of King's. The fundamental reasons for this struggle lay elsewhere, in the efforts of William Cecil, the Chancellor, to strengthen the hand of College masters, and the resentment of Junior Fellows at their limited access to College dividends and the control of leases, which they considered that the Provost and Seniors unfairly reserved to themselves. But the sudden surge (witnessed in Protocollum Book 2) in the number of occasions Junior Fellows were censured for non-attendance, or lack of attention to prayers and divine office, or irreverence to Seniors in Chapel, witnesses to the intensity of the struggle between the two factions from the 1580s. It could fairly be said that the Chapel itself had become the main scene of strife in the College, with the Provost attempting to bring the Juniors to heel, and the Juniors appealing to the Visitor against the Provost's arbitrary ways. The Bishop of Lincoln's attempts to hear grievances and settle these disputes at King's involved a great expense of time and ink, but he also tried to use the Chapel as a seat of judgement. When on 7 May 1602 he inflicted penalties on three Fellows, one of them raised the cry 'We do appeal to the King'. Uproar followed, and the Bishop was unable to restore order. A similar near riot occurred in the Chapel on 19 August 1602 when the Bishop sent Commissioners to the College to confirm the Provost's decision to break up the College until 1 November on account of plague. The Chapel was the theatre in which such confrontations were played out.[30]

Personal differences rather than factional struggles could also surface in Chapel, as witnessed in a later entry in the same Protocollum Book:

> Memorandum that Januarie 18 1627[1628] Mr Pearson deane of divinitie was freindly convented before Mr Collins Provost of the King's College in Cambridge and Mr Byng and Mr Good Bursars and Mr Meredith deane of Arts (and Mr Vincent the Senior Deane being then not to be found) according to the 35th Statute, for a speech made in the chapell before a divinitie Act wherin hee undiscreetly touched Mr Smithson the Vice Provost and his office, and before the aforementioned persons did acknowledge his fault which the said viceprovost for charitie sake tooke as full satisfaccion for the wrong done to his person and place.

The tone here is remarkably different from the censures of Provost Goad, and it seems that the Chapel had been the platform for a personal outburst heard by many and regretted by the speaker later. An eirenic Provost used the Protocollum Book to record an apology that settled the dispute.[31] Perhaps surprisingly, the Chapel does not seem to have been the occasion of such disputes or given rise to censures for non-attendance thereafter, at least judging by entries in the Protocollum Books. Attendance at Chapel and behaviour in the Chapel are only incidentally mentioned. Thus in the case of a Fellow, Robert Smith, we learn that in 1697 Provost Roderick admonished him for emerging from the Mitre Inn drunk, and then throwing stones at the window of the Dean of Arts, noting in passing that he was infrequent in his attendance at public prayers and divine office (he was also admonished in 1698 and 1705 for unruly behaviour).[32] In the eighteenth century all the admonitions seem to be for riotousness, with no reference to the Chapel. Probably attendance at Chapel continued to be monitored, and individuals were summoned before the Dean of Divinity or Vice Provost for failure to attend, but these occasions have left no trace in the College archives. The Protocollum Books were reserved for more serious infractions of College discipline.

An insight into the fairly relaxed regime of Chapel attendance in the 1820s is provided by William Hill Tucker's reminiscences in 'The Old Court of King's College, Cambridge 1822–1825'.

175

Tucker was looking back from much later in the century at the ways of a less inhibited age, perhaps exaggerating the indulgence of the College authorities, but his account does chime with the practice of other Colleges at the time:

> To be sure we had chapel at eight – our great grievance – as no chapels were allowed us;[33] and it was so monotonous to get up every morning at eight. The Authorities had no doubt felt this, and had provided a relief. It was in the form of a Latin epigram of 4 lines, in which utter grief was usually expressed at the power of Sleep, and the regret which must be felt by the Dean-in-residence at our absence. It was personally to be given at his rooms before 10 o'clock. The 'personally' was imperative, – perhaps for a reason; and was another grievance, as it interfered with the latter portion of breakfast. In spite of our freedom and leisure it would seem that we had our grievances. An indulgence was given to our powers of sorrow and composition for the same epigram was sufficient for the whole three years of scholarship. Tennyson's Memoriam would have been a poetic triviality if we had been forced into novelty of thought. No; – the sorrow once expressed, remained. In the fervor of a first term I had composed two, – which were submitted alternately with the regularity of a loom.[34]

By the middle of the nineteenth century Chapel attendance was becoming a thorny College issue again. Seriousness in religion, inspired by the evangelical movement spearheaded in Cambridge by Charles Simeon of King's, but also by those motivated more by ritual and high churchmanship, was on the rise. It did not necessarily entail enthusiasm for enforced Chapel attendance, indeed it might work in the opposite direction, attaching spiritual value only to voluntary attendance by the committed individual Christian. But the stakes had become higher. As Christopher Brooke points out, it is easy for us to forget how much these issues mattered to contemporaries: 'it requires a powerful effort of historical imagination to recover that world, not far away in time, in which it was thought by many men of good will that regular attendance by undergraduates was essential to the preservation of discipline and the survival of the Anglican religion in the Colleges of Cambridge'.[35] From the opposite direction there was increased resistance at undergraduate level to what were seen as College rules that required them to attend daily services which Fellows never attended. The Protocollum Books once again from the 1830s onwards began to record cases in which students were admonished for non-attendance. On 28 April 1849 Henry Smith Mackarness, scholar, was charged with being out of College for the night, and 'also charged by Mr Williams Dean of Divinity with being absent from Chapel and Hall on the same Tuesday and also absent from morning Chapel the following day (during Newmarket Races) and for not visiting him in consequence'. He was deprived of Commons and confined to his rooms for a fortnight except at the hours of Lecture and Divine Services at the Chapel and the University Church. He was nevertheless elected Fellow in 1850, and later was ordained.

Momentous events in the constitution and governance of the College, precipitated by the University Commission of 1856, were enshrined in the Statutes of 1861, the first new set since the Founder's Statutes of 1453. The College was set on the path of throwing itself open to scholars from other schools than Eton, and succession to a Fellowship was no longer to be a matter of scholars waiting in order of seniority for a vacancy, but to be awarded on academic merit. The new statutes also formally abolished the requirement that Fellows should be in holy orders. Equally important was the repeal of the Universities Test Act in 1871, which reopened all Colleges to entrants from outside

the Church of England. In this context, what was to happen to compulsory Chapel attendance at King's? The undergraduates circulated and printed a petition to the Deans in December of the same year, 'We ... beg respectfully to represent to the Authorities our strong and sincere objections to the system of Compulsory Chapels'. Against the idea that the system was useful as a means of discipline they pointed out 'it is degrading to a religious observance that it should be confused with a mere matter of discipline, if regarded as a roll-call', and they argued that a course of sermons or lectures on the grounds of our belief would serve better as religious instruction. They stressed that 'Divine worship is so essentially a voluntary act that it loses its peculiar element if compulsion is introduced'. The Tutor, Augustus Austen-Leigh, answered in a private but printed letter addressed to the undergraduates, urging that Chapel provided a continuous supply of spiritual food by which a man's will is strengthened to resist evil within and around him, and that it forms a habit which will in time establish a future source of spiritual refreshment even for those indifferent to such values in the present.[36] Nevertheless the College soon conceded that 'undergraduates could, as an alternative to attending weekday chapel at that hour, sign a book at the Front Gate before 8.0 a.m. (an act often performed, as attendance at divine service could not be, in clothes hastily drawn over pyjamas)'.[37]

This concession was intended of course to apply to non-conformists as well as members of the Church of England. King's had opened itself more rapidly than other Colleges to those students outside the Church, and reaped the benefit by attracting a lot of able undergraduates still excluded from Cambridge by other Colleges. This inevitably meant that those willing to attend Chapel services, when an alternative was now possible, were a small proportion of a rapidly growing College. An attempt was made between 1876 and 1879 to draw up a register of attendance at Chapel, but this is the only one that survives.[38] When Austen-Leigh was elected Provost in 1889 his first act was to circularise the undergraduates, including non-conformists, with an appeal for regular attendance at 'the family prayers of the College'. But by the 1890s King's already had the reputation it was to retain as a bastion of secularism. One King's undergraduate witness, a devout Chapel attender himself, wrote an article for the *English Churchman* in October 1893 stating that among the Colleges King's was identified with scepticism (though elsewhere in the University it hardly seems to exist except at Caius, and smaller circles at Trinity and St John's).[39]

But the requirement to attend morning Chapel or sign in at the Lodge proved remarkably persistent, despite the speed with which the concession had been made in 1871, and the College's continuing reputation for scepticism. A Trinity undergraduate Thoby Stephen (brother of Virginia Stephen, later Woolf) wrote an inflammatory pamphlet on *Compulsory Chapel* in 1904, which was refused by the Cambridge booksellers but found its way to King's, probably through his fellow Apostles.[40] As late as January 1912, the King's Tutor John Harold Clapham wrote to his opposite number at St John's, Joseph Robson Tanner:

Dear Tanner

Can you give me a bit of tutorial information? We are having a little mild trouble here in the enforcement of the rule about getting up in the morning. Years ago—forty years—we allowed men to sign a book instead of going to six o'clock chapel. This is now regarded as a hardship in some quarters. I want to find out what other Colleges do. I imagine that you have chapel rules. What do you require of men in the morning? From what I gather our rule which in its day was a liberal one is now more paternal than the rules of most places.

As the historian of St John's remarks parenthetically in quoting this letter, 'which of course in King's would never do'.[41] The College Council accordingly resolved on 24 February 1912, as proposed by the Tutor, 'that Undergraduates who do not attend the 8 o'clock morning service in Chapel be no longer required to be marked in at that hour during term'.[42] This resolution, approved by a vote of 7 against 1, seems to be the quiet end of the noisy dispute about Chapel attendance.

Since the Founder laid the foundation stone of the Chapel in 1446, Kings and Queens have been regular visitors to the first royal College, and in particular to the Chapel. It was usually the focal point of royal visits to Cambridge.[43] Yet it was also the place in which the Fellows first asserted their right to elect their own Provost against the Crown. Although the Founder's statutes had vested the right of election in the Fellows, in practice from the first Provost William Millington until John Copleston, admitted Provost in 1681, the Provostship was in the royal gift. After the 'Glorious' Revolution of 1688, in which the royal powers to dispense with statutes and send mandates to nominate to vacant positions had been stigmatised as abuses of royal power, the Fellows of King's had an early opportunity to challenge the right of the new sovereigns, William and Mary, to nominate to the Provostship. In June and July 1689 several Fellows of King's were busy cultivating influential political figures in London in order to make a case for restitution of their right of election of a Provost, and push Charles Roderick, Headmaster of Eton, as their preferred candidate. Copleston was already ill and his death on 24 August 1689 was quickly notified to the court; the next day King William appointed a hearing at Hampton Court to allow the Fellows to make their arguments against the Crown's power to nominate. The King's ministers were eager to nominate Sir Isaac Newton, but he was not a member of the Foundation, and had none of the other qualifications required by statute.

On 2 September a royal mandate arrived in Cambridge nominating instead John Hartcliffe, a Fellow of the College. On the next day 3 September the Fellows met to elect. They had taken every precaution in terms of establishing an order of business, reading aloud of the relevant statutes, oaths sworn on the Gospel by each Fellow present, and two scrutators appointed to examine the votes cast. The list of votes cast in the Chapel survives, showing thirty votes cast for Roderick and three for John Hartcliffe. Dr Roderick set off immediately for Buckden hoping to be admitted by the Bishop of Lincoln, the College's Visitor, who, however, prevaricated. The King and his ministers went as far as procuring Hartcliffe a Bachelor of Divinity degree to qualify him, but then backed down. Parliament was about to meet, and the dangerous precedent of Magdalen College, Oxford, which had done so much to bring about James II's downfall, was very much on everybody's mind. The Chapel was chosen as a symbolic site for the King's concession. The King was at Newmarket for the October horse-races and rode over to pay a visit to the Chapel. One of the Fellows then made a humble speech of apology at the Chapel door (submitted to the King in draft a week before by the Provost of Eton), and the King in turn graciously assured the Fellows of his consent on Monday 7 October 1689.[44]

Succeeding elections to the Provostship always took place in the Chapel, following the precedents established in 1689. There were no further mandates from the Crown, although the King's right to mandate was never formally given up. But eighteenth-century elections increasingly became polarised on party political lines. Candidates presented themselves as favouring or opposing Whig and Tory principles. In 1743 this produced a spectacular closely-contested three-way election in which the Fellows were kept in the Chapel overnight until a majority for William George was secured. There is an account of the proceedings given in a letter by the antiquary and Queens' Fellow Daniel Wray to his friend Philip Yorke, later 2nd Earl of Hardwicke. It is based on an eyewitness account of an unnamed King's Fellow, a friend of Wray's:

The following is a comic picture of an Election, it is dated Cambridge, Jan. 19. 1743. The election of a Provost of King's is over. – Dr George is the Man. The Fellows went into Chapel on Monday before noon in the morning as the Statute directs. After prayers, & sacrament they began to vote. – 22 for George, 16 for Thackeray 10 for Chapman. Thus they continued, scrutinising, and walking about, eating and sleeping; some of them smoking. Still the same numbers for each candidate; till yesterday about noon (for they held that in the 48 hours allowed for the Election no adjournment could be made); when the Tories, Chapman's friends, refusing absolutely to concur with either of the other two parties, Thackeray's votes went over to George by agreement, and he was declared.

A friend of mine, a curious man, tells me, he took a survey of his brothers at the hour of two in the morning; and that never was more curious, or a more diverting spectacle. Some, wrapped in blankets, erect in their stalls like mummies: others, asleep on cushions, like so many Gothic tombs. Here a red cap over a wig; there a face lost in the cape of a rug. One blowing a chafing-disk with a surplice sleeve; another warming a little negus, or sipping Coke-upon-Littleton, ie tent [a Spanish red wine] and brandy. – Thus did they combat the cold of a frosty night; which has not killed any of them to my infinite surprise.[45]

Later elections were less prolonged, and less political. Repeated voting was not a mark of nineteenth- or twentieth-century Provostship elections, although some were keenly contested, with the outcome uncertain until the votes in Chapel were counted. These elections remained, however, the defining measure of participation in the Fellowship, and the solemnity of oath-taking and scrutiny in the Chapel has endured to the present.

Ill. 139. Richard Bankes Harraden, *Interior of the Chapel looking East from the West End*, 1831, watercolour, 80 x 62.2 cm. Cambridge, King's College.

VIII

A Spanish Choirbook and some Elizabethan Book Thieves

IAIN FENLON

In his catalogue of the King's College manuscripts, M. R. James wrote of MS 41 that it 'was always regarded as one of the curiosities of Cambridge, and is mentioned in many old books of travel'.[1] This fascination which the book evidently held for earlier generations is now not immediately apparent, since it is totally unremarkable in both contents and appearance, except perhaps for its size; James, who describes it as 'enormous', had probably not encountered anything quite like it before.[2] As a workaday fifteenth-century liturgical manuscript of no great aesthetic appeal, its contents are of little textual or philological interest. Although usually described as a psalter, it turns out to contain a sequence of psalms arranged in clusters; a first group contains psalms numbered in the seventies in the Latin Vulgate, but then the second group which follows presents a selection of psalms numbered in the twenties. Within these clusters a number of incipits for some psalms are accompanied by rubrics that refer to a folio number in a 'primo tomo', where the full text is presumably given. In other words, the ordering would appear to reflect local liturgical requirements.[3] Professionally copied on vellum, and bound in heavy oak boards decorated with protruding brass bosses and corner pieces, the manuscript is a typical example of the *cantorales* that have survived in considerable numbers in the archives of Spanish cathedrals and collegiate churches (Ill. 140). Although usually containing chant melodies as well as texts, in the case of psalters the reciting tones were sufficiently familiar that they did not need to be copied.

Such manuscripts were used throughout Catholic Europe, but in Spain they continued to have a particularly prominent functional role in the enactment of the liturgy after the Council of Trent. This was in large part because of the preservation of the Spanish *coro* in Spanish collegiate churches and cathedrals, despite the emphasis placed upon increased accessibility to and visibility of the central sacral area in the Council's decrees. In this sense the *coro* became a feature peculiar to later Spanish church design and liturgical practice. There is probably no more succinct and accurate description of it than that of the English nineteenth-century neo-Gothic architect George Edmund Street, who travelled extensively in Spain and published an account of the country's medieval buildings. In his description of Burgos Cathedral he wrote:

> The Coro is usually fitted with two rows of stalls on its north, south, and west sides, the front row having no desks before them. The only entrance is usually through the screen on the eastern side, and there are generally two organs placed on either side of the western bay of the Coro, above the stalls. In the centre of the Coro there is always one, and sometimes two or three lecterns, for the great illuminated office-books, which most of the Spanish churches still seem to preserve and use. High metal screens are placed across the nave to the east of the Coro, and across the entrance to the choir, or *capilla mayor*, as its eastern part is called...[4]

Ill. 140. Binding of Cambridge, King's College, MS 41. Fifteenth-century Psalter, manuscript on vellum, 80.3 x 53.3cm, 46ff.

The copying of King's MS 41 was carried out by a single scribe, who was responsible for executing both the text and the simple decorative initials in coloured inks (Ills. 141 and 142). Now lacking a number of folios at both the beginning and end of the volume as well as elsewhere, the choirbook presents the very sorry picture of a badly mutilated survivor of an extremely common type of liturgical book that was produced in enormous quantities by the *scriptoria* of the western church during the Middle Ages and later. Single leaves from manuscripts of the kind can still be picked up from the stalls of the *bouquinistes* that line the banks of the Seine. Framed on the walls of bookshops, or turned into lampshades to cast a warm glow over the diners in many a faux Tudor restaurant, they are a familiar remnant of the material culture of the past, but one that is of little interest to scholars. So why the fuss? Why was Kings MS 41 'always regarded as one of the curiosities of Cambridge . . . mentioned in many old books of travel'?

Ill. 141. 'Deus ultionum' (Psalm 93). In Cambridge, King's College, MS 41, fol. lvi v.

Ill. 142. Initial D of 'Deus ultionum' (Psalm 93). In Cambridge, King's College, MS 41, fol. lvi v.

Part of the answer is to be found in the diary of a young Moravian aristocrat, Zdenkonius Brtnicensis, better known as Baron Waldstein, which describes a tour of England that he made in 1600.[5] His itinerary was typical of that of the many foreigners, usually young men of means from the Protestant states of northern and central Europe, who came to England either as part of a diplomatic mission, or who travelled independently to improve their education, in much the same way that upper class Englishmen would later make the Grand Tour of Italy and France. The standard route, well established by the 1580s, was to cross the Channel from Calais or Boulogne to Dover, and then to travel by post-horse to Canterbury (where the Cathedral might be viewed), Sittingbourne, Rochester, and finally Gravesend from which London could be reached along the Thames. Having established himself in one of the taverns that specialised in catering for foreigners, the visitor would then set out to explore first the capital itself, and then the most important sights of the surrounding counties. The Universities of Cambridge and Oxford were high on the list of desiderata, as were the royal palaces at Windsor, Nonsuch and Hampton Court, as well as William Cecil's Burghley House in Northamptonshire, Sir Christopher Hatton's extensive palace at Holdenby in the same county and Theobalds in Herfordshire, where Cecil had built one of the most spectacular houses of the age. Waldstein's journey was of this kind, similar in outline to those of his contemporaries Paul Hentzner and Thomas Platter, both of whom travelled to England at about the same time (the former in 1598 and the latter in 1599), and both of whom have also left written accounts of their adventures.[6] Waldstein's diary is distinctly both humanist and antiquarian in tone, and his text is punctuated with Latin inscriptions copied from tablets, paintings, tombs, and monuments. For him the country was a vast library of unexplored knowledge, in which the shadowy evocations of a vanished Catholic presence were of great appeal. Shortly after arriving in the city he attended 'Divine Service in French', and it was Westminster Abbey, and particularly the Chapel of Henry VII, that attracted his admiration more than anything else. Together with his thirst for Latin inscriptions, the architecture of the Catholic past was one of his abiding interests.

Both were overshadowed by his susceptibility to displays of imperial splendour. Above all, it was the institution of the monarchy, and the apparent wealth of the somewhat unrepresentative slice of the country and its inhabitants that he encountered, that impressed. For many well-placed foreigners, not only those with diplomatic business to transact, a primary objective of their journey was an encounter with the Queen herself, in the hope that rewards and other advantages might follow. The quest for a royal audience is famously lampooned by Shakespeare in his unflattering and thinly-disguised portrait of Friedrich I of Württemberg who pressed Elizabeth to admit him to the Order of the Garter.[7] Waldstein's audience with the Queen, 'glittering with the glory of majesty, and adorned with jewellery and precious gems', took place in the Presence Chamber at Greenwich, where he made speeches of both greeting and farewell, and was promised letters of introduction to 'the Governors of the most important castles and palaces, and to the Vice-Chancellors of the universities'.[8]

From London he moved to Cambridge, taking in Theobalds on the way. In a sense this was merely an extension of the courtly experience, since Cecil's extraordinary house had been designed as a place to honour and entertain the monarch. In practice Elizabeth visited Theobalds no fewer than thirteen times in the course of her reign, effectively turning it into a subsidiary royal residence. Cecil's influence was important for Waldstein; it was through him that the Baron had secured his audience with the Queen, and it was Cecil who had introduced him to the Vice-Chancellor of Cambridge, Robert Soame. In the course of his three days in the city he visited Peterhouse, where he was received by the Vice-Chancellor and copied down some verses seen on a wall in a ground floor room, Trinity, where he transcribed an epitaph in the Chapel, and St John's, where he recorded an

inscription in memory of the recently deceased prominent Protestant theologian William Whitaker. From there he moved to Sidney, Emmanuel, Christ's, and finally King's, 'which is more splendid than any of the others'. It was here that Waldstein's bookish interests took hold. At Emmanuel he had been shown some of the treasures of the College Library, including a copy of Cicero's *De Officiis* 'printed almost as soon as the printing press was invented',[9] and at King's he was also shown the Library, which was then housed in a range of four rooms on the south side of the Chapel.[10] It was here that his apparently insatiable quest for Latin inscriptions has left some crucial historical traces for our understanding of the history and significance of the King's manuscript. As he noted: 'this contains a notable Book of Psalms five spans in height, which the Earl of Essex brought back from Cadiz near the Straits of Gibraltar where the crossing from Spain to Africa is shortest'. Waldstein then went on to record a lengthy poem in Latin distychs written on the flyleaf. It begins with an imaginary conversation between the book and its beholder:

> Quid tu quaeso liber? Cuius? Hispanus. At unde?
> Gadibus a laceris, hostis? At hospes ego.
> Tunc hospes quae te sors nostris appulit oris?
> Bellica: quis bellum hoc gesserat? Angla cohors.
> (What volume are you, I ask, and whose? A Spaniard. Whence come you? From the wreck of Cadiz? And an enemy? Rather, call me stranger. Tell me, then, stranger: what fortune has carried you here to our shores? It was the fortune of war. Who waged it? A force out of England.)[11]

By the time that James came to write his description of MS 41, the flyleaves carrying these verses, which unequivocally connect the arrival of the book in the College with the famous expedition to Cadiz in 1596, had been excised. It was not until some seventy years later, when the editor of Waldstein's diary wrote to King's to enquire whether the book that the Baron had seen in 1600 still existed in the College library, that the truth emerged.[12] In the meantime, the erroneous view – as will be seen, in fact a conflation of two separate incidents – that it 'was taken from the library of Osorius, Bishop of Algarve by the Earl of Essex in 1596, at Cadiz', was generally accepted.[13]

2

The victory of the combined English and Dutch fleets over the Spanish at Cadiz, and the sack of the city itself, on 21 June 1596, was one of the most decisive military successes of the long conflict between England and Spain, a conflict which effectively stretched from the Earl of Leicester's expedition to the Netherlands in support of the States-General in 1585 to the Treaty of London in 1604.[14] Intensified by the execution of Mary Tudor in 1587, the Anglo-Spanish wars were articulated by a series of English victories beginning with Francis Drake's raid on Cadiz in 1587, when the King of Spain's beard was famously 'singed', and the defeat of the Spanish Armada in 1588. Initially the expedition to Cadiz was planned as a necessary response to the intelligence that a refurbished Armada was being prepared in Spanish ports for action, news that was given fresh urgency by a minor Spanish raid on Cornwall in the summer of 1595.[15] The Lord Admiral, Charles Howard, was placed in charge of drawing up plans for the venture. Originally somewhat modest in conception, they were expanded considerably in scope following the appointment of Robert

Devereux, Earl of Essex, early in 1596, to take charge of the expedition's land forces. From Queen Elizabeth's point of view, the mission had two objectives. On the one hand the Spanish fleet was to be rendered incapable even before it had left port, while on the other the capture of booty from the treasure ships returned from South America would swell the royal coffers and help to finance the operation. Essex had more ambitious ideas. Resuscitating a plan originally advanced by Drake, he advocated not only an audacious strike against the Spanish fleet, but also the establishment of a permanent foothold on the peninsular by seizing a port and installing a garrison. This would create a barrier between the centre of Spanish power in Madrid, a centre already enfeebled by the continued weakness of Philip II's government in the final years of his reign, and the all-important trade routes with the Americas. For the purpose of separating metropolitan Spain from the sources of its wealth, the conquest of the southern port of Cadiz, the home of the Armada, would be ideal. Although Essex's bold plan was effectively vetoed by Burghley, Elizabeth's most long-standing, respected, and experienced advisor, it was not yet abandoned, and before setting sail Essex wrote a letter informing the Privy Council of his intention to implement it irrespective of the monarch's wishes. This he contrived to arrive well after the ships had left for Spain.

The fleet, made up of 150 English and Dutch ships, left at the beginning of June and arrived just outside the bay of Cadiz on June 18th. There it was learnt that a Spanish fleet of twenty galleys and sixty ships, including twelve of the so-called Apostle galleons, was at anchor in the harbour; the sea-battle that ensued secured its destruction. Attention was now turned to the town itself. Once ashore, the raiders took the castle of El Puntal virtually unopposed and then streamed across the bridge linking the island to the mainland. Essex, who had been in the first boat to land, led his troops over the walls and into the city, which was taken with little resistance. The poor state of the Spanish artillery together with a shortage of ordnance and, above all, the chaotic organisation of the hastily improvised defensive tactics all contributed to the ease with which the city was captured. As one Spanish observer, the Franciscan monk Pedro de Abreu, engagingly put it, 'the disorder had been, after the will of the Lord, the cause of the loss of this city, because all were heads of command and none were feet that would follow, and that is how they lost, for not having neither head nor feet'.[16]

Sixteenth-century Cadiz was a prosperous city with a number of elegant public buildings. Once in control, the English and Dutch soldiers set about sacking it, concentrating their efforts on churches and the houses of the wealthier inhabitants. An agreement was reached with the city authorities that permitted the citizens to leave. This was in exchange for a ransom of 120,000 ducats, and freedom for a number of English prisoners who had been captured by the Spanish in previous campaigns; a number of prominent local figures were taken hostage as a guarantee of payment. There was now considerable disagreement among the senior officers, with Essex and a handful of supporters continuing to press for adopting the proposal to retain Cadiz in Anglo-Dutch hands and establish a garrison, but in the end they were over-ruled by Howard and it was decided to lift anchor and sail for home, taking the hostages with them since the ransom had not been paid. Before leaving, the city was set on fire.

Reports of the scale of destruction vary. According to one account, some three hundred houses, almost one third of the total number in the city, were destroyed, as were most of the main public buildings including the cathedral and the nearby Jesuit College and its church dedicated to St James, the patron saint of Spain.[17] Iconoclasm was rife. In the cathedral, a wooden sculpture of the Virgin and Child was torn down from the high altar, and taken into the square where it was stoned and lacerated by pikes.[18] Rescued once the city had been regained by the Spanish, the mutilated statue was subsequently installed on the altar of the Royal English College of St. Alban in Valladolid. There

Ill. 143. Augustine Ryther, *The Sea Coastes of Andaluzia*, dated 1587, engraving with hand-colouring, 33.5 x 50.5 cm. In Lucas Janszoon Waghenaer, *The Mariners Mirrour...*, trans. Anthony Ashley ([London]: [Henry Haslop], 1588). London, British Library, Maps c.8.b.4.

Ill. 144. Anton van den Wyngaerde, *View of Cadiz*, 1567, pen and ink with watercolour, 27.1 x 106.5 cm. Vienna, Österreichische Nationalbibliothek, MS Min 41, fol. 75.

the Madonna Vulnerata, as the sculpture was known, became the focus for a new cult sanctioned as early as 1600 by an elaborate ritual attended by Philip III, which emphasised both the authenticity of English Catholicism and the illegitimacy of the Elizabethan regime.[19]

As a major institution, the Cathedral would undoubtedly have housed a collection of liturgical books and music both printed and manuscript, including choirbooks containing both chant and polyphony that would surely have been seen by the soldiery as no more than the tools of a despised religion. Together with much else, including images and vestments, they were presumably destroyed when the building was torched by the occupying troops before leaving the city.[20] Books from the Jesuit College did not necessarily share the same fate, even though it too was razed to the ground. Here Edward Doughtie, official chaplain to the expedition and later Dean of Hereford, selected a number of volumes from the library and brought them back to England.[21] As might be expected, these were exclusively theological. In 1618, two year's after Doughtie's death, they were purchased by the Hereford Chapter for the Cathedral Library along with a number of other books from his collection.[22] A sixteenth-century manuscript choirbook containing plainchant, now in the National Library of Scotland in Edinburgh, was also removed from the Jesuit College.[23] It contains an inscription allegedly in the hand of Sir Edward Hoby, who was present at Cadiz, where he was knighted along with a number of other officers for his part in the action.[24] It reads: 'Este libro era de Sto. Jago de Cadiz de los de la compañia de Jesus y tomado en el viage de la armada Jnglesa alla 1596' ('This book was from St James of Cadiz of the Company of Jesus and was taken on the voyage of the English Armada in 1596').

Ill. 145. Edward Hoby, Inscription ('Este libro era de Sto. Jago de Cadiz de los de la Compañia de Jesus, y tomado en el uiage de la armada Jnglesa alla 1596'). Flyleaf of Antiphoner, late sixteenth century, manuscript on vellum, 58 x 39.5 cm, c.1596. Edinburgh, National Library of Scotland, MS 1905.

Hoby was a keen scholar, whose interest in Spain was fostered through his contacts with a number of learned men including William Camden, who praised Hoby's achievements in his *Britannia* of 1590 (entries on 'Bisham' and 'Queensborough'), and had earlier dedicated *Hibernia* (1587) to him. An interest in languages, already evident from Hoby's translation of Mathieu Coignet's *Instruction aux princes* made shortly after its first edition had been published in Paris,[25] was further nurtured though his friendship with Sir George Carew, one of the foremost Hispanists among the circle of courtiers close to Queen Elizabeth. Carew, who had been a member of the Cadiz expedition, also left a diary of the campaign which is a prime historical source for any reconstruction of what actually took place.[26] He also translated *The Historie of Araucana*, a historical epic written by the Spanish nobleman, soldier, and poet Alonso de Ercilla based on his experience in Chile, something that encouraged Hoby in the belief that a knowledge of Spanish was essential for a successful Elizabethan statesman.[27] Just one year after the Cadiz expedition, Hoby's translation of Bernardino de Mendoza's *Theórica y prática de la guerra* was published by Richard Schilders in Middelburg, with a dedication to Carew in Spanish.[28] The removal of the Edinburgh manuscript from the Jesuit College in Cadiz is entirely in keeping with Hoby's growing interest in Spanish culture, even if its functions and contents would not have pleased his Protestant soul.

There were more book thefts to come. On the return journey to Plymouth the Anglo-Dutch forces landed at Faro in the Algarve in the hope of finding goods worth confiscating, but these ambitions turned out to be in vain. The inhabitants, forewarned of the fleet's arrival, had already fled, and Faro itself was of little attraction to the invaders; one member of the expedition, Sir William Monson, described it 'as a place of no resistance or wealth', of interest only for the library in the Bishop's Palace which he incorrectly believed to be that of the humanist scholar Jerónimo Osório, sometime Bishop of the Algarve, who had died in 1580.[29] Here Essex took charge. Finding the place deserted, he lodged himself in the Palace itself, and at leisure selected some 178 volumes to be brought back to England.[30] A few years later, he donated some two hundred and twenty-four volumes, including six manuscripts, to Sir Thomas Bodley's new library in Oxford.[31] Some of these books may well have come from the collection formed by Osório, who had studied civil law in Salamanca, philosophy in Paris, and theology in Bologna, and others may even have been removed from Cádiz. Many, however, clearly came from the library of Ferdinand Martins Mascarenhas, Bishop of the Algarve at the time of the raid (which he did not witness), who had been appointed only a couple of years before, having previously spent eight years as rector of the ancient university in Coimbra, the intellectual capital of the country.[32] A member of the Portuguese nobility, Mascarenhas had mostly bought books of theology, scholastic philosophy, and canon law, precisely what might be expected of someone of his class. Interestingly, many of those donated by Essex to the Bodleian are recent editions, even of texts which had long been in print, and were published not only in Spain (above all in Salamanca) and Portugal, but also in Paris, Lyon, Basle, Antwerp, and various cities in Germany and Italy.[33] The pattern is typical of Iberian collections of the period, since the peninsular was substantially an import market for printed books even in the vernacular. Altogether some seventy volumes now in the Bodleian Library, nearly all in Latin (there is no indication here of any curiosity about poetry or prose in the vernacular) are in bindings which carry his armorial stamp.[34] Not surprisingly, Mascarenhas himself took a dim view of Essex and his men, and his theological tract *De auxilijs divinae gratiae*, published some years after the raid, described them as 'hostes impij, insolentes superbi, truculenti, iracundi, piratae non minus ab humanitate quam a religione abhorentes'.[35] Be that as it may, after just two days in Faro, with the books safely aboard, Essex put the town to the torch and left. Four years later he made his donation to the Bodleian, only the second such gift in its history.

Nor is this the end of the story, since another volume which seems to have been liberated during the raid on Faro, namely a copy of a printed choirbook containing motets for four to seven voices by Tomás Luis de Victoria, is now in the library of Christ Church in Oxford.[36] Born near Avila, Victoria was the most renowned composer to be born in Spain in the course of the sixteenth century. The central decades of his career were spent in Rome, where he was associated with a number of institutions in the city including the German College, and where he encountered the work of composers in the orbit of Palestrina; it was not until 1587 that he returned to Madrid. Published in Rome by Domenico Basa and Alessandro Gardano, the *Motecta* is one of a series of choirbooks produced there during the 1580s that are clearly designed as a sort of *summa* of the Roman contribution to the corpus of polyphony of the Catholic Reformation. To some extent these editions seem to have been aimed at the Spanish and Portuguese markets. The Christchurch copy of the *Motecta* is elegantly bound in brown calf over boards with decoration tooled in gold, and carries two inscriptions in the same late sixteenth-century hand: 'Liber Rob. Westhawe ex domo Episcopali Faraonensi: 1596' and 'Liber Episcopi Faraonensis'.[37] About Robert Westhawe, who apparently was an early if not the first English owner of this copy, nothing is known with any certainty, but one possibility is that he can be identified with the undergraduate of the same name who matriculated at Trinity College, Cambridge, in 1577 and went on

Ill. 146. Signature of Robert Westhawe. In Tomàs Luis de Victoria, *Motecta festorum totius anni, cum communi sanctorum...* (Rome: Alessandro Gardano, 1585). Oxford, Christ Church College, Mus. 1, title page.

to graduate in 1580–81.[38] In 1594 Westhawe published *An almanacke and prognostication* for the year, which was in sufficient demand to be reprinted, and the following year he produced another. Although it is not known when the Christchurch copy of Victoria's motets entered the library (its arrival cannot be documented before the early eighteenth century), its separate provenance history indicates that other books from Faro, in addition to those from the Essex donation to the Bodleian, were in circulation in the aftermath of the Cadiz expedition.[39]

The important point is that the context for the removal of King's MS 41 from its home and its arrival in Cambridge is the wider phenomon of the removal of books of different varieties and uses from a number of places including Cadiz Cathedral, the adjoining Jesuit College and Church, and the Bishop's Palace at Faro in the Algarve. Those responsible undoubtedly had different motives for plundering, and the presence of Catholic liturgical books including volumes of chant and a collection of printed polyphony does raise the question of the intended function of these books in particular in their various new locations. As the description of MS. 41 in Waldstein's diary indicates, the King's choirbook was already on view in the College Library on the south side of the Chapel in July 1600, by which time the manuscript had already been in the College's possession for at least three years.[40]

3

One thing is certain. Whatever may have been the varying and differing motivations for the removal of books from Iberian ecclesiastical libraries during the Cadiz adventure, they had nothing to do with contemporary conceptions of booty. Booty was altogether a more serious matter. Booty was about silver crucifixes to be melted down, or secret hoards of gold ducats discovered in leather trunks, and it was here that the expedition did not meet the Queen's expectations. An early setback occurred at the beginning of the campaign, when the Duke of Medina Sidonia gave orders to set fire to the Spanish merchant fleet trapped in the bay rather than let it fall into the hands of the enemy; the size of the loss was calculated at twelve million ducats.[41] As to the sack of the city itself, accounts differ. That of Pedro de Abreu paints a vivid picture of a rapacious soldiery leaving no stone unturned in its feverish quest for spoil:

> On 4 July the sack continued throughout the city, with such wickedness and cruelty that it seemed that all the infernal legions had conspired against wretched Cadiz. They robbed houses of everything that they could find, carrying the spoil to the ships. They demolished walls, roofs, and attics where they suspected that money or other goods could be hidden. They constructed machines to excavate and drain the wells, and even sewers and cesspits in order to remove as much silver, gold and money as they believed that they were sure to find thrown there...and since there were all kinds of riches to be found, they did not have enough hands with which to take and fill the boats with the loot.[42]

According to Abreu, the English fleet left with spoil worth more than eight million ducats.[43] A similar picture is presented in an early report sent back to the Queen by Essex and Howard:

> The common souldiers, disdayning bagges of peper, sugar, wine and such grosse commodities, by the space of five or six dayes, with their armes full of silk and cloth of gold, as in their fullnesse they forbare St Lucas and two or thre prety villages.[44]

Even later accounts of the division of spoils that took place parallel the structural separation between the land forces and the navy; while the army was able to pillage with abandon, the navy could not. As one anonymous observer put it: 'within 2 dayes, all was sacked and spoiled, but the landmen had all', with the implication that both the English sailors and the Queen had been robbed of their rightful rewards.[45] Indeed, it was partly the criticism levelled by the mariners that stimulated the atmosphere of suspicion that followed Essex's return to England, as claims and counter-claims were made about the extent to which individual officers had benefitted at the expense of the royal coffers. In addition, it was claimed by his opponents that Essex had missed golden opportunities to return with a substantial hoard from the home-bound Spanish treasure fleet. These charges formed part of a sustained attempt to discredit Essex's reputation following his return from Cadiz, despite the undoubted triumph which the victory represented, and his popularity in the country at large.

Something of the national sentiment in the immediate aftermath of the Cadiz expedition comes through strongly in the verses copied down into Waldstein's diary:

> ...what man never heard tell of that fearful grappling with Spain,
> That famed Peninsular raid, which, under the command of a hero
> – Greater than Hercules he – came right to Hercules' Pillars!
> He (and in proverbs now, his name personifies valour)
> Who is friend and beloved of the common people of England,
> Head and shoulders above the rest in height and honours,
> Who held all menacing Spain in check, at the sack of Cadiz.[46]

While the victory at Cadiz was clearly regarded as a great success for the English both at home and abroad, subsequent disputes and divisions among the victors transformed an undoubted military success into a highly contentious issue in late Elizabethan politics. While on the one hand the victory was universally acknowledged as a great achievement, on the other a paper war broke out between rival factions who made every use of the press in order to disseminate highly partisan views of individual contributions.[47] Essex in particular not only wished to claim the lion's share of the credit for himself, but also wished to use it to advance his ambitious scheme for an aggressive campaign in Europe in support of a continuing war effort.[48] The Elizabethan regime, which had always applied a severe policy of censorship in support of a favourable press, dealt with Essex harshly. His reputation, which had always been subject to turbulence, now went into decline, in part because of the jealousy of the Queen, who feared that the Earl's popularity outstripped her own. In order to turn the tide, Essex was forbidden to publish his own account of the Cadiz adventure.[49] The regime moved quickly. Immediately after Essex's return to London, Elizabeth and the Privy Council determined that there should be one official account of the Cadiz expedition, to be drafted by Sir Anthony Ashley. All other versions were to be suppressed, the best-known example being that of *True Relacion*, composed by Henry Cuffe, one of Essex's secretaries, on his master's instructions and brought back to England. Once its existence had been made known by Ashley, circulation was forbidden on pain of death.[50] There was a bold attempt to circumvent this difficulty by arranging for translations to be sent to the Continent, while Henry Hawkins, Essex's agent in Venice, also attempted (in vain as it turned out) to lodge an Italian version in Cesare Campana's *Historia del mondo*.[51] Other attempts to print Italian accounts favourable to Essex's role in the expedition similarly failed.[52] Essex also attempted to circumvent the restrictions by sponsoring the publication of a map which shows a bird's-eye view of Cadiz together with scenes showing successive phases of the siege.[53] The policy of censorship was still in place in 1598 when

Richard Hakluyt was forced to recall copies of a new enlarged edition of his *Principall Navigations* in order to remove the narrative 'Voyage to Cadiz' and to substitute a new title-page which does not mention the event.[54] Of the surviving copies only one in four escaped the censor's knife.[55] Essex attempted to defend himself against the slanders that had begun to circulate at court, but in the end his *Apologie*, written in 1598, was not published until 1603, two years after his execution for treason.

Despite the difficulties which Essex and his supporters faced in the years immediately after Cadiz in presenting their version of the victory, the censorship of the *True Relation* being the main obstacle to the dissemination of a picture of the Earl as the heroic victor of the occasion, other means to achieve the same end were ingeniously deployed. A portrait engraving of Essex by William Rogers dated 1599 shows Essex within an oval frame bearing the titles 'EARLE MARSHALL OF ENGLAND AND NOW LORDE GENERALL OF HIR MA[JESTIES] FORCES IN IRELAND'.[56] Two flanking figures on pedestals, one representing Constancy, the other Envy, hold a laurel wreath above Essex's head, surrounding the motto 'Basis virtutis constantia' ('Constancy is the foundation of virtue'). Significantly, in view of continuing attempts to deprive Essex of credit for the success of Cadiz, Envy is shown attempting to tear leaves from the wreath. The Irish theme is continued beneath the portrait oval, where Essex's coat of arms together with his personal motto 'Virtutis comes invidia' ('Envy the companion of virtue') is shown between two roundels, one showing a map of Ireland, the other a plan of Cadiz.[57] While the Rogers' engraving is not entirely neutral in the propaganda wars that followed the victory,

Ill. 147.
William Rogers,
*Robert Devereux,
2nd Earl of Essex*,
1598–1600,
engraving,
28.5 x 22.4 cm.
London, British
Museum,
1863,0214.496.

193

neither is it particularly provocative. The image of Ireland refers to Essex's appointment as Lord Lieutenant of Ireland with the task of mounting an expedition to defeat the rebel uprising led by the Earl of Tyrone. This was not a success. A large force of 16,000 men arrived in April 1599, but by July, following a series of inconsequential actions, it was reduced to 8,000, and then again to 4,000. Having been ignominiously forced to sign a truce with the rebels, Essex returned to London to meet the Queen's displeasure in late September.[58]

Thomas Cockson's semi-regal equestrian portrait of Essex, issued about one year later, is altogether a different matter.[59] Here the Earl is presented as a heroic military figure, wearing sword and breastplate, and holding the baton of command, with a scene of soldiers locked in combat in the background. In the middle distance there are views of Cadiz and the Azores (where Essex had been despatched in 1597 to intercept the Spanish silver fleet), while Ireland can be seen on the horizon. These details are taken from 'An exact map of the town of Cales, made by the commandment of the lords general', drawn by Baptista Boazio and sponsored by Essex, which Cockson had also engraved.[60] Again Essex's coat of arms is displayed, while a couplet, laid out at the foot of the engraving, reads:

> Vertues honor, Wisedomes alure, Graces servaunt, Mercies love,
> Gods elected, Truths beloved, Heavens affected Doe aprove.

Here the association between Essex and the aftermath of Cadiz is much more explicit than in the Rogers engraving. And, as might have been predicted, the almost monarchical tag of 'Gods elected' was clearly a step too far, and in early 1600, as copies began to circulate, Cockson's engraving was banned. Not only that, in the wake of the scandal caused by the appearance of Cockson's engraving, it was decided that Essex would be tried in Star Chamber, the main charge against him being insubordination during his time in Ireland. Although Elizabeth initially cancelled the trial, and in the event it was not until February 1601 that the Earl was beheaded on Tower Green, this was effectively the beginning of the end.

In Spain itself, the sense of *desengaño* (disengagement) which began in the 1580s, and which was intensified by Drake's impudent raid on Cadiz in 1587 and the defeat of the Armada in the following year, had become widespread by the final years of Philip's reign. By this time the King, who had virtually become a recluse and was in chronically poor health, had been at the helm for over forty years, and many felt that he was no longer able to direct the affairs of state. A large debt, the social consequences of heavy taxation, and famine (there was a severe drought and harvest failure in 1593–4) were just part of his burden.[61] As Philip's troubles mounted, and the question of succession became more pressing, Savonarolan figures emerged from the shadows and apocalyptic ideas were in the air.[62] Admiration for Essex's part in the Cadiz expedition was put to use in a variety of polemic critical of the regime. A good representative of the type is the treatise *La anatomia de Espanna* (1598), an elaborate attempt, illustrated by genealogical tables, to argue that the Austrian King of Spain had no claim to the title. The text is particularly hostile to Philip, characterised in its final paragraph as 'perfido Felipe, gran Hipocrita, yncestuoso Rey, nefando Homecida, Ynjusto Usurpador, detestable Tirano, y Monstruo Castellano'. This theme, which runs throughout, is announced on the illuminated title-page of a copy of the Spanish original now in Cambridge University Library,[63] which shows the coats-of-arms of the principal states of Old Spain, each unflatteringly labelled ('Bastardia', 'Homocidia', 'Tirania', 'Perfidia', etc). At the top of the page can be seen the royal arms of Philip suspended from two columns labelled 'Miedo' (fear) and 'Sospecha' (suspicion) (see Ill. 149).

Ill. 148.
Thomas Cockson,
*Robert Devereux,
2nd Earl of Essex*,
1599–1602,
engraving,
33.2 x 26.3 cm.
London, British
Museum, O,7.283.

Later in the manuscript a full-page illumination shows a peacock standing on a pomegranate, familiar as the impresa of the Holy Roman Emperor Maximilian I and of Isabella of Portugal, the wife of his grandson Charles V of Spain and Philip II's mother.[64] Each of the peacock's feathers is decorated with one of the shields of the regions claimed by the Hapsburgs together with the Legend 'A TVERTO O DERECHO NVESTRA CASA HASTA EL TECHO' ('From start to finish we build our house, sometimes honestly, sometimes deviously'; see Ill. 150). In this context the description of the siege of Cadiz is particularly favourable to 'el muy magnanimo y alto señor Don Roberto conde de Essex' ('the very magnanimous and noble Sir Robert, Earl of Essex').[65]

Whatever may be the precise history of King's MS 41 immediately before its arrival in England, there is no doubt that the book was brought back from the raid on Cadiz and then presented to the College shortly thereafter. In the lost prefatory poem quoted by Baron Waldstein, the Spanish choir book explains somewhat enigmatically, in reply to the question 'who placed you here?', that it was brought back by 'one of Faldon's companions' ('Faldonis cum sociis socius'):

Ill. 149. Title page, *La anatomia de Espanna*, 1598, illuminated manuscript on paper, 22.9 x 16.7 cm (sheet). Cambridge, University Library, Gg.6.19.

Ut fierem insignis monumentum insigne triumphi
Alter ab eversa Gade November erat.
(To be a glorious token, recording a glorious triumph, in the November that followed after Cadiz was destroyed).[66]

However, it seems that King's College was also soliciting Essex's favour as early as Michaelmas 1594, when it presented him with 'a pare of gloves', no doubt elaborate in the style of the gloves presented to Queen Elizabeth on her visit in 1564 ('four pair of Cambridge double gloves, edged and trimmed with two laces of fine gold').[67] It may not be a coincidence that in the same year, 1594, William Temple, scholar and former Fellow of King's, became Essex's secretary (a position that he retained until Essex's death in 1601).[68] That the College may have continued to follow the fate of Essex's various naval enterprises is suggested by the following entry in the College Particular Book for 1596–7: 'Solut(is) pro libello precum conceptarum pro prospero successu navalium copiarum – iiid' ('Payment for a book of prayers collected for prosperity and success for our naval forces – iiid'). The sum is modest, and the precise reference unclear, but it could well be to one of Essex's post-Cadiz enterprises in either the Azores or Ireland.[69]

Certainly the volume derived from Essex's expedition stayed in the College Library, valued not only as a souvenir of a great military and naval victory, but also as a commemoration of the role of Essex as the hero of the enterprise. In this sense its intended function was analogous to that of the engravings by Rogers and Cockson. As with all the early books that have survived from the Library, the manuscript was chained to prevent theft from what was effectively a public space. It must have remained in the Chapel, along with the rest of the College Library, presumably until the new Wilkins Library was made ready for use. A couple of decades later the manuscript was restored and rebacked, and the original wooden boards were cleaned and polished together with their brass furniture.[70] At some point in this history the all-important flyleaves containing the verses in praise of Essex were removed; the most likely moment for this to have happened would have been between Waldstein's visit to King's and Essex's execution. Thereafter it would surely have been considered inappropriate that a manuscript in the library of a Royal foundation, housed in the Chapel whose very decoration constitutes a hymn of praise in stone and glass to the Tudor dynasty, should carry a eulogy to a man found guilty of treason. Not for the first nor the last time in its history, the College was obliged radically to alter its political allegiances at short notice.

Ill. 150. Peacock on pomegranate with motto 'A tverto o derecho nvestra casa hasta el techo', *La anatomia de Espanna*, 1598, illuminated manuscript on paper, 22.9 x 16.7 cm (sheet). Cambridge, University Library, Gg.6.19, fol. 292 [148].

Ill. 151. Roof space above the vaults looking west, King's College Chapel, Cambridge. Bill Knight, photograph.

Ill. 152. South Corridor at vault-level, looking east. Bill Knight, photograph.

Ill. 153. RIGHT: James Malton, King's College from King's Parade, showing former Provost's Lodge, 1794, watercolour, 35 x 50.4 cm. Cambridge, King's College.

198

IX
The Chapel Imagined: 1540–1830[1]

NICOLETTE ZEEMAN

THE EARLY MAPS OF CAMBRIDGE reveal how physically separate from King's College the Chapel was for the first few centuries. The main College buildings, which formed an irregular court at the western end of what were then called the 'Common Schools' (the area is now entirely occupied by the University Old Schools), were next to the Chapel, but did not include it. The Provost's Lodge, situated beyond the east end of the Chapel, was also a self-contained unit, separated by some kind of enclosure (see Ills. 19 and 153).[2] Even the Chapel's predecessor, the first Chapel, used in the early years while the second was being built, was in a similar position, located between the new Chapel and the linked mass of the old College court and the 'Common Schools'.[3] While both chapels were on College land, therefore, they lay outside the other College buildings, in a large open area

Ill. 154. Adolphe Rouargue, after Eduard Gerhardt (or another 'Gerhardt'), *Langen Aufriss*, from the series *Dom zu Coeln* (Aachen and Cologne: Ludwig Kohnen and J. E. Renard, c.1830–70), etching on chine collé, 22.8 x 30 cm (plate). London, British Museum, 1954,1103.139.

Ill. 155. BELOW LEFT: King's College. Detail of Richard Lyne, *Cantebrigia*, 1574, engraved broadside, 42.8 x 29.2 cm.

Ill. 156. BELOW RIGHT: King's College. Detail of Georg Braun and Franz Hogenberg, *Cantebrigia*, 1575, engraving, 32.5 x 44.2 cm. In Georg Braun and Franz Hogenberg, *Civitates orbis terrarum*, 3 vols. ([Coloniae Agrippinae, 1572]–1618), vol. 2.

named in David Loggan's 1688 map of Cambridge and later College records 'Chapel Yard' (Ill. 11). It is true that in the early years of the University some other colleges worshiped outside College bounds, using a local parish church instead of a designated College Chapel.[4] Nevertheless, the King's arrangement was distinct in that this was a purpose-built Chapel, for which an enclosing court had been planned, but simply not built.

One index of this unusualness may be the map of Cambridge made for Georg Braun and Franz Hogenberg's *Civitates orbis terrarum* (see Ill. 156), in which the Chapel has actually been 'regularised' by being given an adjacent court: it is generally agreed that the maker of this map could not have seen King's Chapel and that the map was copied, albeit using a different perspective, from Richard Lyne's map of 1574 (Ill. 155).[5] This seems plausible: Lyne distinguishes the two vertical elevations of the Chapel, but in such a way that, if the image is compared with the representations of three-dimensional college courts elsewhere on the same map, the two elevations could be mistaken for the two opposite sides of a rather cramped court. Nevertheless, this interpretative error must have been encouraged by the assumption that King's would have had a more orthodox college layout and a less isolated chapel.[6]

Ill. 157. King's College. Detail of facsimile of John Hamond, *Cantebrigia*, engraving on nine sheets, engraved by Augustine Ryther and Petrus Muser, 22 February 1592, full map 118 x 88 cm, in J. Willis Clark, *Old Plans of Cambridge*, 2 parts (Cambridge: Bowes and Bowes, 1921), part 2.

Ill. 158. King's College. Detail of William Smith, *Cambridge*, ink drawing. In William Smith, *The Particular Description of England, with the Portratures of Certaine of the Chieffest Citties & Townes*, 1588, manuscript, 1588. London, British Library, Sloane MS 2596, fol. 64v.

201

Ill. 159. *Exterior of the North Side of King's College Chapel*, c.1509–47, drawing on three sheets, 64.5 × 126.5 cm. London, British Library, Cotton MS Augustus I i 2.

Instead, the new Chapel of King's sat for several centuries in the open space of Chapel Yard, accessed from two different angles: either via Milne Street, which came round the back of the old King's College buildings and past the front of Clare College to where King's back gate still stands today, or via Glommery Lane ('Grammar Lane'), which ran from the church of Great St Mary's, past the Common Schools and into the space to the northeast of the Chapel. A sixteenth-century drawing found in British Library MS Cotton Aug.I.i.2 suggests something about the Chapel's appearance of

accessibility in this period (Ill. 159), providing the observer with a view of what looks like unimpeded access. Although substantial walls are visible at either side, they run round the back of the building, separating the Chapel from the Yard and its trees, not from the visitor who approached via Glommery Lane.[7] However, even this wall cannot be seen in any of the later sixteenth-century maps (Lyne, Braun, William Smith, and the much more precise one made by John Hammond in 1592; (Ills. 155–158). Nor do these maps show any gates, either here or elsewhere;[8] no doubt there were College gates, but once again the maps convey an *impression* of accessibility. Most revealing of all, however, is the fact that in the maps of Lyne, Braun and Smith the Chapel is (mis)placed, not wedged along the north side of the site, but floating free in the enormous space of Chapel Yard.[9] Several of

203

them also show the Yard itself as open, with tree-lined alleys running round it, across it and down to the river (see Loggan in particular: Ill. 11).

In 1724-30, of course, Chapel Yard was finally cut in two, when the Gibbs Building was constructed, forming the western side of the long projected new College court. However, even then there is evidence that the inhabitants of Gibbs, sitting in solitary splendour to the south-west of the Chapel, felt out on a limb at a distance from the hub of the main College court.[10] It was only in 1828, with the completion of the Wilkins building that formed the south side of the new College court, and the clearance of the buildings and streets to the east of the site for the erection of the Wilkins screen, that the Chapel was finally enclosed by anything like a built-up court and primarily accessible only through a substantial porter's lodge.

Up to this point the lack of a built-up enclosure for the 'church' of King's must have contributed to the sense that it had an importantly public dimension.[11] In this chapter I shall be looking at the Chapel mainly through the eyes of some of its visitors. Elsewhere in this book Jeremy Musson documents many of the more formally articulated and theorised responses to the building and the way these reflect changing tastes and responses to Gothic architecture; here I shall look at some of the other institutional, communal, personal, and even fantastical, responses to the Chapel, as they are recorded in contemporary texts and documents, but also by what visitors actually do in and around the building.[12]

Austen Leigh suggests that by the early seventeenth century the Chapel had become 'the Cathedral of Cambridge'. He notes the 1619 regulation of James I concerning the maintenance of services in the Cambridge College Chapels, and the prohibition against women attending services at any of them, with the exception of ordinary prayers in King's Chapel.[13] From an early period, it seems that there were few limitations on visiting the Chapel and, perhaps more suprisingly, on going up to the Chapel roof. For Samuel Pepys, the Chapel was part of an itinerary of Cambridge sites (along with Trinity College and St John's Library) to be visited with his wife and friends.[14] John Evelyn toured Caius College and King's Chapel, and in 1697 Celia Fiennes took in a number of colleges, reporting most extensively on Trinity College and King's Chapel (see below). The Chapel was not only visited by Elizabeth I and James I, but also by Charles I and Queen Henrietta Maria (1631), Charles II (1641, 1671 and 1681) and King William (1689).[15] In 1669, no less than Cosimo de Medici observed the schools, '& and from thence went to King's College Chappell where they had a music divertisement'.[16] A University correspondent wrote to Matthew Prior that the social season of 1700 took its toll on the inhabitants of Cambridge: 'while the season lasted at Newmarket I was plagued with visitants from thence who came to see King's College Chapel, etc. When I thought this fatigue over, Mr Boyle (I thank him) sent me Captain Delaval with a brace of Mahometans from Mechanes, to whom I was obliged to show our University (or rather them to it)'.[17] The eighteenth-century historian of Cambridge, Edmund Carter, is explicit that the Chapel is 'the only Public Chapel in Town, and...on a Sunday afternoon (especially in the Summertime and fine Weather) you may see it well filled, and amongst them Numbers of ladies'.[18] In the early nineteenth century, the anonymously published *Alma Mater*, a text partly written in the 'university wit' tradition, notes that there was a service in the Chapel every afternoon at 3.00 pm:

> to hear the chanting and anthem of which many gownsmen and others attend, promenading the spacious antechapel. On Sundays, like the Chapel at Trinity, we have also a pretty sprinkling of the lady-snobbesses [university slang for townspeople], who likewise go (emphatically be it understood) to see and be seen.[19]

IX · THE CHAPEL IMAGINED: 1540-1830

For many of these visitors the Chapel's awesome size made it not only a monument to see (and be seen in), but also *the* high vantage point from which to see. Indeed, the early maps encourage this emphasis on the raised viewpoint: drawn from a hypothetical elevation, they portray the ground and the buildings on it in three-dimensional terms, as if seen from a high, angled perspective: they are as much propositions about the ideal position from which to see the urban landscape as they are groundplans. These maps also register a set of perceptions about how the Chapel dominated the surrounding town: several of the sixteenth-century maps, for example, draw the Chapel as too tall for its width and length, with exaggerated corner towers and pinacles; and although the drawing of the Chapel in Hamond's map may be, in itself, more accurately proportioned, he still makes it disproportionately high in relation to the surrounding buildings, with the side chapels almost as high as the Common Schools.

Many visitors record ascending to the roof for a view of the surrounding land: 'from this roofe we could descrie Elie, and the Incampment of Sturbridge faire now beginning to set up their Tents & boothes [northeast of Cambridge]: also Royston, New-market etc: houses belonging to the King', reports John Evelyn.[20] When Celia Fiennes climbs to the King's Chapel roof, she notes:

> On these Leads you may see a vaste Country round, you see Ely-Minster and the towers; this is a noble building and stands on so advantagious a ground and so lofty built that its perspicacious above the town; this is in lieu of the theatre [the Sheldonian] at Oxford there being none here.[21]

Later, visiting Ely, she returns the gaze towards Cambridge. Her comparison of the Chapel with the Sheldonian Theatre in Oxford suggests that, despite her meticulous attention to the distinctive details of the two buildings, for Fiennes a central aspect is their provision of a panorama; from the Sheldonian's 'Cupelow or Lanthorne', after all, 'your eye has a very fine view of the whole town and country'; there must also be a theatrical dimension to her sense of Chapel.[22]

In the seventeenth century ascending to the roof of the Chapel seems to have been *de rigeur*: in 1671, Charles II 'heard an Anthem in the Chappell; from the top of the leads [he] had a fair prospect of the whole Town and Country'; returning in 1681 with his wife, he again visited the Chapel, 'where, after two Speeches and Presents made by Dr Coppleston, the Provost of that College, they were pleased to go up to the top, and view all that magnificent Structure'.[23] The French traveller, Jorevin de Rocheford, also records that 'we ascended to the top of the church, which has a platform surrounded with balustrades, with four small turrets at the four corners, which gives much grace to this edifice'.[24] Edmund Carter also regales his reader with information about the distinctive roof space: the Chapel 'is covered with a stone Arch, and that by a Timber one well Leaded, and room enough between each for a tall Man to go upright'.[25] The eighteenth-century antiquary William Cole notes that the Chapel towers can be 'seen at a very great distance', and explains 'on each side of the W[est] Door are Doors to go up to the Stupendous Stone Roof, upon which you may walk between the Oaken one which is quite covered with lead from one end to the other; on each side is a stone Gallery, also with holes to look out on from one end quite to the other, and has a mighty good effect'.[26] Other accounts indicate that the two spiral staircases at the west end were both in use and comment on the splendid view to be had from the elevation.[27] Celia Fiennes observed the detail of the Chapel's construction,[28] and Maria Edgeworth recorded visiting the roof space with her father, guided by Edward Smedley, a Fellow of Sidney Sussex College and friend of her brother's, and recounted the comic misunderstanding that resulted from her father's interest in the 'mechanical wonders' of the

roof and Smedley's preoccupation with the music ascending from below.[29] Dorothy Wordsworth, on the other hand, reported an attack of dizziness and rather different anxieties:

> My Guide persuaded me to go to the top of the Building, where I had a fine view of all the Colleges and the town. When I found myself there alone with that stranger an odd fright came upon me I seemed to be so completely in his power, he might, as I thought have done what he pleased with me and nobody would have seen or heard or done anything about it.[30]

Such various evidence, however, seems to indicate that E. Challis's 1833 watercolour of young men and women on the vaults, some clambering over the arched surface and some loitering in conversation, correctly points to the range of visitors who went up there (see Ill. 160). Some of the social diversity of Challis's scene is reflected in the different personnel who appear in the etching made from the watercolour by R. Backhouse for the *Cambridge University Almanack* (calendar). Here the visitors in the foreground have become a man in a top hat being guided by one in a gown and mortarboard, while in the distance an adult and children can be seen; but the presence of a bricklayer's hod, ladder, rope and trowel in the foreground now suggest a different kind of informality about arrangements on the roof and in the roof space.[31]

There are also more performative and public dimensions to the use of the Chapel roof. Roger Bowers notes, for instance, that in 1598 the Choir seems to have celebrated the Queen's birthday by singing from the leads.[32] The longevity of such practices is suggested by Edmund Carter, who says in 1753 that on Lady Day (25 March) the benefactors were commemorated with a sermon and 'extraordinary Music', adding that 'till within a few Years, after Sermon, the Music used to go up to the Leads of the Chapel and there Perform'.[33] And this may not have just been a matter of the Choir. Bowers notes that town musicians ('waits') sometimes attended Chapel services, and, from the 1630s onwards, came to the special commemorative services that took place on the anniversary of the averted Guy Fawkes plot (5 November), the King's birthday (6 December), and Lady Day (25 March).[34] We might compare this with the fact that when, on 10 May, 1660, news arrived of the restoration of the monarchy, members of the University processed to Market Hill 'with lowd Musick before them' and then 'the Musick…went up to the top of King's College Chapell, where they played a great while'. Two days later apparently celebrations took an altogether more military dimension, and, after the King had been proclaimed in the College, 'all the Souldiers were placed round on the topp of their chappell from whence they gave a volley of shott'.[35] Combined, such pieces of evidence suggest that the Lady Day 'Music' on the Chapel roof recalled in the eighteenth century by Edmund Carter may also have included the town waits. Once again, it seems, going up onto the Chapel roof seems to have been quite a public business.

Despite this high degree of access, it is not entirely clear whether visitors were able to climb to the Chapel roof unaccompanied or not, and what kinds of payment were made. Chapel clerks certainly showed many people around the Chapel. In the eighteenth century, Edmund Carter explains that the windows 'contain the old and new Testament, and the Chapel Clerk, for a small Gratuity, will explain to any one that goes to see the Chapel, their Several Meanings'; James Woodforde, the diarist, records visiting the Chapel and paying a shilling to 'the man that shewed it to us'.[36] Horace Walpole tells a jocular anecdote about a College Fellow commenting to an 'old sexton' that he must make a great deal of money out of showing the Chapel to visitors, only to receive the reply, 'Oh! no, master…every body has seen it now'; William Cole refers to people being shown around by a 'verger'.[37] The role of Chapel

IX · THE CHAPEL IMAGINED: 1540–1830

Clerks as guides, moreover, seems to be confirmed by a string of guide books published from the eighteenth to the twentieth centuries under the name of the 'Chapel Clerk'.[38] Nevertheless, although it is unclear who Dorothy Wordsworth's young man 'guide' was, Maria Edgeworth was accompanied by a Fellow of another College. It seems clear that Cambridge Fellows and students could accompany visitors to the roof – and they too published guides: an anonymous eighteenth-century description of Cambridge that includes a tour of the Chapel and an ascent to the roof is attributed to 'a student'; and the author of the 1867 *King's College Chapel* was Thomas John Procter Carter, a Fellow of King's.[39] The Backhouse etching, of course, shows a gentleman in a top hat climbing the vaults guided by another in a mortarboard (see above, note 31).

Things seem finally to have been clarified in the later nineteenth century. Congregation minutes of the years 1870-71 record debates both about the hours at which the Chapel should be open to the public and also the role of the Chapel Clerk in relation to this: at the Annual Congregation of 6 December, 1871, a salary rise was agreed for the Chapel Clerk 'in consideration of the Chapel being open to visitors for inspection free', and instruction was given for a notice to be put up, asking the public to refrain from giving gratuities to him. At a Congregation on 13 February, 1872, roof visiting was regularised. 'Visitors unless accompanied by some Member of the College shall only be allowed to ascend the roof on writing their names in a book provided for the purpose paying the sum of 6d per head; a notice to the effect being placed on the door to the staircase.'[40]

Sixteenth- to eighteenth-century descriptions of the Chapel reflect its glory and its strangeness in various ways. For Elizabeth I, visiting in 1564, one relevant paradigm was that of the glories of antiquity; she compared herself to Alexander, who had lamented that he was not himself responsible

Ill. 160. E. Challis, *King's College Chapel between the Fan Vaulting and the Timber Roof*, 1833, monochrome wash, 26.8 x 41.9 cm. Design for one of a series of illustrations in the *Cambridge University Almanack*, 1833. Cambridge, King's College.

207

for the glorious buildings constructed by his predecessors, and she commented that 'Rome was not built in a day'.[41] But both Classical and religious paradigms shaped her visit, as we see in the range of plays performed for her in the Chapel during her visit.[42] Nicholas Udall's Old Testament-inspired play *Ezechias*, which was staged on the third day, for example, dramatised the destruction of the bronze serpent and other idolatrous paraphernalia by Ezechias (2 Kings 18-19) and must have directly addressed the religious politics of the early years of the Queen's reign.[43] It also, I suggest, addressed its dramatic venue, the Christian 'temple', in which it was being performed: as Abraham Hartwell exclaimed in his poem, *Regina Literata*, 'Regali in templo magni spaciosa theatri!' ('In the royal temple, the vast space of a great theatre!'). Although we no longer have the text of the play, Hartwell's description suggests that the play's concern with the temples of the Jews and the altars of Jerusalem would have spoken to the cleansed Reformation 'temple' in which it was being performed.[44]

This is not, however, the earliest context in which the Chapel is referred to as a *templum*. Already in the College Mundum Books (account books) that date from shortly after the Chapel's completion, the Chapel is systematically referred to as the 'novum templum' ('new temple'). Although the routine expenses of the Chapel continue to be listed as for the previous chapel under the heading 'Custus ecclesie' ('outgoings for the church'), repairs to the building's fabric occur under versions of the heading 'Reparaciones novi templi' ('repairs of the new temple').[45] Indeed, in the eighteenth century work on the fabric of the Chapel is still being logged as 'Reparaciones novi templi', and we find the same phrase in other miscellaneous expense listings.[46] While institutional habit is no doubt partly responsible for the repetition of this terminology over several centuries of College accounts, what does the use of this term *templum* from the sixteenth century onwards say about early attitudes towards the Chapel?

On the one hand, the Latin and English terms *templum* and *temple* are quite commonly used to describe Christian churches both in the later Middle Ages and early modern periods;[47] on the other hand, the renewed biblicism of the reformist sixteenth century may mean that these words now have a certain resonance. The primary Old Testament point of reference for Latin *templum* is the Temple of Jerusalem; but in the New Testament the word is often also used more figuratively to refer to the places where God dwells and is worshiped: Christ, the individual believer, the human heart or conscience. The terminology of the temple, in other words, has the potential to allow Reformation writers to allude to the origins of the Christian church in the Temple of Jerusalem, but also provides a tool with which to think about the 'new', reformed church, not least as it is seen in contrast to the Catholic church.[48] Certainly by the seventeenth century (illustrated in George Herbert's *The Temple*, for instance) the Judaic Temple is a major reference point in debates about the nature of the Church and the validity or otherwise of Church ceremony. In the following centuries, moreover, a range of theories about the significance of the construction and dimensions of the Temple mean that it also becomes a paradigm for thinking about the structures of natural and Christian knowledge.[49]

But in fact the idea of the Temple of Jerusalem was also already an element in the ecclesiology of Henry VIII and his advisors in the 1630s and 1640s. In this period humanist and reformist biblicism began to result in the teaching of Hebrew at universities, and even in schools; among the northern European universities, Oxford and Cambridge led the way. In 1540 Henry funded the establishment of a Regius professorship in Hebrew at Cambridge.[50] As Henry began to identify himself as a divinely sanctioned monarch and Head of the English Church, moreover, Old Testament models of kingship, in particular those of King David and King Solomon, were crucial to the rhetoric of his self-identification. Both Solomon's establishment of the Temple and the independent rulership of David provide powerful analogies for Royal Supremacy.[51] Richard Rex has also argued that it is the idea of the Old Testament Kings Josiah and Ezechias that lies behind Henry's campaign against idolatry in the later years of his

reign; he cites an unpublished apologist for Henry who speaks explicitly of 'the blessed King Ezechias, who destroyed the Image of the Serpent, made by Moses by God's commandment, for Idolatry through the which that Image was misused'.[52] Indeed, Edward Fox, the reformist Provost of King's (1528-38), also made these connections in a treatise that gathered Old and New Testament and historical precedents for the power of kings over religious institutions, citing, amongst many others, David and Solomon as guardians of the Jewish faith and Ezechias and Josiah as purgers of idolatry.[53] Contemporaries were imagining Henry, in other words, as the cleanser of the Temple.

Given the studied neutrality of the College account books, it remains difficult to be sure what early descriptions of the Chapel as a *templum* may mean. Indeed, the word may simply allude to the Chapel's grandeur and size (earlier sixteenth-century building instructions, after all, often refer to it as the 'greate Churche').[54] But the Fellows of King's College, including Provost Edward Fox, were clearly aware of the emergent languages of Henrician reform. Henry VIII's close relation to the Chapel in the crucial years of the English Reformation, as evidenced in the very personal royal iconography of the screen and windows, suggests that the building, although in many respects modelled on an older notion of the Church,[55] may also have symbolised for him a new one.[56] This was a Church that was simultaneously being characterised in terms of pre-Catholic, Davidic and Solomonic origins, and yet also in terms of its reformed 'newness'. Can it be a complete coincidence that David and Solomon, the founder of the original Temple of Jerusalem, make so many appearances in the Chapel windows? Window 12, in which Solomon is crowned against a splendid Renaissance palace, contains some of the earliest glass in the Chapel (Ill. 161); later is Window 4, in which the Queen of Sheba (a figure of the Church) submits to Solomon (see Ill. 113). Whether or not this last is a portrait of Henry (as scholars have suggested), it remains at least a possibility that those furnishing the Chapel saw it as some kind of 'new temple'.[57]

Later responses connect the Chapel with the Temple of Jerusalem more explicitly. In his study of the third Temple, John Lightfoot, Master of St Catharine's College, Cambridge, compared the Temple to the pillars and cloisters of (the first) St Paul's Cathedral. When he came to discuss the Temple roof, however, it was to King's Chapel that he turned: despite acknowledging that the Temple was not leaded, he repeatedly describes the Jews walking on its 'leads'. He also insists that 'there were pinacles upon the battlements round about: as King's Colledge Chapel...is decked in the like manner to its great beauty', while 'the roofe was not a perfect flat...but rising in the middle...as King's Colledge Chappell may be herein a parallel also'.[58] The early eighteenth-century French commentator James Beeverell was certainly thinking in this tradition, when he spoke of the Chapel as 'truly a royal work. It is less a Chapel than a great and beautiful temple, oblong, very high, and adorned with the most beautiful carving. Four octagonal towers rise at the corners, finished with domes'. It cannot be entirely coincidental that Beeverell also notes 'King David with his harp in his hands' sculpted on the organ case.[59] Later in 1805, Charles Simeon, evangelical preacher and Vice Provost of King's, recalls something of the same sacramental Hebraic tradition, when he explains the dimensions of 'Noah's Ark, as given in the Scripture' with reference to those of the Chapel (twice the length and breadth, and two thirds of the height!).[60]

The seventeenth-century historian Thomas Fuller was also eloquent in his praise of the Chapel (see Musson above, pp.26–27); but what should we make of his description of the Chapel as 'a Stonehenge indeed'– an opinion quoted in 1753 by Edmund Carter?[61] The context for this comment is a resurgence of interest in the sixteenth, seventeeth and eighteenth centuries in prehistoric barrows and megaliths such as the Avebury Ring and Stonehenge.[62] Both James I and Charles II visited Stonehenge, and Edmund Burke cited Stonehenge as an example of the 'difficult' sublime.[63] Thought by some to have

209

Ill. 161. *Crowning of Solomon*, before 1535, stained-glass window. Cambridge, King's College Chapel, Window 12. Adrian Boutel, photograph, 2014.

been produced by natural or divine forces, these monuments were for others, such as Inigo Jones, Isaac Newton, William Stukeley and John Wood the Elder, evidence of early forms of religion and knowledge. Indeed, Stukeley traced Druid religion back through the Welsh language to Hebrew origins and explicitly compared the Church of England with this pre-Catholic religion; others, such as Jones, Newton and Wood, saw these monuments as embodying ancient forms of knowledge. These megaliths, in other words, merited comparison with the pillars erected by Moses and the patriarchs – and, once again, the Temple of Jerusalem.[64] It is therefore perhaps no coincidence that a few pages after his comparison of King's Chapel with Stonehenge, Fuller goes on (in the context of a discussion of College benefactions) to recall the monarch associated with the first Temple: 'Solomon saith, "What can the man do that cometh after the king?" [Eccl. 22.12] It is a petty presumption to make addition to kings' works and to hold benefaction in coparceny with them'.[65]

Of course not everyone thought of prehistoric megaliths and barrows as manifestations of some kind of ur-Christian religion, and for many they were pagan temples (or even *chapels*). Regarded from this angle, Stonehenge, whose construction the twelfth-century Geoffrey of Monmouth had attributed to the Arthurian wizard Merlin, was a pre-Christian or Roman temple or tomb; in his *Particular Description of England* (1588), for example, William Smith pictured it, describing it as fifth-century Roman and 'one of the 7 wonders of England'. This was, in other words, a more pagan notion of Stonehenge altogether.[66] Fuller and Carter's remarks about King's Chapel and Stonehenge might thus suggest a sense of awe or exoticism (or even Catholic exoticism?). The verses of Kingsman Horace Walpole (1707-97) should probably be situated somewhere in this tradition:

> When Henry bade this pompous Temple rise,
> Nor with presumption emulate the skies,
> Art and Palladio had not reached the land,
> Nor methodiz'd the Vandal Builder's hand.
> Wonders, unknown to rule, these piles disclose...[67]

A sense of the Chapel's strangeness persists into the nineteenth century. In 1815, the historian Rudolf Ackermann wrote that, 'considered as a whole, [the Chapel] cannot be paralleled by any edifice in the world in beauty of Saracenic architecture...we perceive not only the operation of a master artist, but almost of magic art. The roof looks as if cut at once by an invisible power out of a solid quarry of stone'. Similarly, for the anonymous author of *Alma Mater*, the Chapel is a 'magnificent temple...one of the wonders of the world...said by travellers in many respects to have no parallel'.[68]

Other responses to the Chapel, however, more explicitly register its distinctively Gothic style. The early maps, for example, represent its repeating vertical and horizontal lines usually by means of an impressionistic grid effect, along with over-size corner towers. Such images suggest something about the stiffly linear way that the structures of Gothic architecture were seen, offering a (much less negative) visual equivalent of William Gilpin's view that 'such height and such length, united by such straitened parallels, hurt the eye' (referring to the trip made in 1769).[69] If anything, the maps reflect something closer to the excitement that is conveyed by William Stukeley's vividly geometrical ink drawing of the interior of the north elevation of the Chapel, apparently made while a student at Cambridge in the early years of the eighteenth century. Here, the linear grid of the image, including that of the tiled floors, gives a powerful sense of the dynamic visual rhythms of the Chapel (see Ill. 162). Stukeley wrote demurely: 'Architecture was ever a favorite Diversion to me, & I could sit an

hour or two together in the Antichappel of Kings College viewing & contemplating the building, & made a draught of a longitudinal section of it'.[70] It is surely this same visual rhythmicity to which the young Horace Walpole refers when he describes music fading through the building:

> Sweet strains along the vaulted roof decay,
> And liquid Hallelujahs melt away;
> The floating accents less'ning as they flow,
> Like distant arches gradually low.[71]

Towards the turn of the seventeenth century several writers record a rather different way of responding to the linear and rectangular shape of the Chapel. Celia Fiennes wrote that when she ascended to the roof of the Chapel, she walked on 'the arch, or cradle, as it's term'd'[;] there is 32 little windows [sic] cut in stone just as you ascend to the cradle or arch which runns on either side, and a pair of staires of 8 stepps to every three windows which lead up to the arch'. Three years later these words are echoed by Edward Ward, describing his arrival:

IX · THE CHAPEL IMAGINED: 1540–1830

Ill. 162. William Stukeley, *North Elevation of Chapel Seen from Within*, 1705, pen and ink on paper. Cambridge, King's College, KCC/279.

within four Mile of Cambridge, at which distance the top of King's College Chapel was discernible, appearing in a Figure resembling a Cradle, and by Travellers is so call'd; which happen'd to draw into my Noddle, the following scrap of Poetry.

Old Cambridge brings forth Men of Learning and Parts,
Dame Natures dark Laws to unriddle;
And since she's a Midwife of science and Arts,
'Tis fit she is known by a Cradle.[72]

It seems that Fiennes understands 'the arch, or cradle' to refer primarily to the convex, bed-like surface of the Chapel vault. In Ward's case, however, the description and rather poor poetry appear to refer to the shape of the Chapel as seen from a distance: its unusually long and severely box-like form, but also, no doubt, its four high vertical corner towers.[73] In fact, medieval and early modern 'box' cradles quite often have long, high (and sometimes decorated) sides, as well as upright cornerposts. The early modern English cradle with turned corner posts shown in Illustration 163, for instance, is a good example of such a shape.[74] Some hooded cradles in this period also have pointed gables on the hoods – perhaps a bit

213

Ill. 164. German, Christ Crib, 1340–1350, oak, plaster and parchment, 31 x 28 x 17 cm. Cologne, Museum Schnutgen, A 779.

Ill. 163. English, Child's cradle with turned posts, c.1680, oak, 50 x 89 x 31 cm.

like the gables of the Chapel.[75] However, the most striking cradle analogies for the Chapel can be found in late-medieval and early modern 'Christ child cribs', such as the fourteenth-century German example shown in Illustration 164: this one has both end gables and side windows (not to mention faces peering out of the windows), and is really a miniature church, both literally and symbolically 'containing' Christ. An even more striking comparison is provided by the marvelous fifteenth-century wood and polychrome crib from the Netherlands in Illustration 165. The structure of this crib, with its high side windows and very tall corner 'towers', echoes the form of King's Chapel almost exactly.[76] Although there seems to be more evidence for the use of such devotional cribs in the late Middle Ages and in the early modern period in mainland northern Europe, this very fact might lead us to take seriously Ward's comment about the 'cradle' of King's: that 'by Travellers [it] is so call'd': the Chapel was, after all, visited by many travellers from the Continent.[77]

By the eighteenth century, of course, Gothic architecture was much more widely appreciated: the Chapel's towered and pinacled profile was now echoed in the finials that had been erected on the towers of the organ case (see Ills. 139 and 210) and in the marvelous pinacled east end panelling and screen of James Essex (1775; see Ills. 25–27). Horace Walpole was a famous enthusiast for Tudor Gothic, as exemplified in Henry VII's Chapel in Westminster and in King's Chapel; the papier-maché pendant fan vaulting of the Long Gallery in his house at Strawberry Hill is an overt homage to the Westminster Chapel, although King's fan vaults must also be an imaginative presence.[78] Indeed, Walpole had a 'Canaletti' of the inside of the Chapel in the Waiting Room of Strawberry Hill (see Ill. 13).[79] When in May 1777 he visited William Cole in Cambridge and expressed his yearning for the bookish life of a 'monk' (we might recall that the Chapel then contained the College Library), Walpole also commented, 'King's Chapel is more beautiful than Strawberry Hill'. By this period, however, Walpole was partly responding to the Chapel through the Gothicising work of Essex, whose

IX · THE CHAPEL IMAGINED: 1540–1830

Ill. 165. South Netherlandish (Brabant), Christ Crib, fifteenth century, wood, polychromy, lead, silver-gilt, painted parchment, silk embroidery with seed pearls, gold thread and translucent enamels, 35.4 x 28.9 x 18.4 cm. New York, Metropolitan Museum of Art, 1974.121a.

Ill. 166. William Fells, Lion and unicorn supporting the arms of Charles I with the garter and motto of the Order of the Garter, stall panel, north side stalls (fifth from the eastern end), 1633, elm wood, 106 x 128 cm. Cambridge, King's College Chapel.

east-end screen, with its distinctive and decorative finials, had been erected just a couple of years before. Shortly after the visit to Cole, Walpole again expressed his 'monkish' desires, and made clear the importance of Essex's 'restoration', 'the beauty of King's College Chapel, now it is restored, penetrated me with a visionary longing'.[80] In fact, in the previous year Essex had designed and built for Walpole 'a tower so exactly of the fourteenth century…one of those tall Flemish towers that are crowned with a roof like an extinguisher' (no doubt a pointed-cap candle extinguisher). Not quite in the manner of King's, but a domestic echo of sorts.[81]

Walpole was also a collector of medieval and Tudor heraldry, something else he would have seen plenty of at King's; such 'heraldic' responses to the Chapel are the last topic of this essay.[82] Medieval churches had always, after all, been respositories for the chivalric and familial self-identifications of their founders and patrons, as well as those of the people memorialised and buried within them; the Tudor monarchy developed this practice to a new level, and Henry VII's extravagant Westminster Chapel, with its plethora of heraldic materials, was designed both as a shrine for Henry VI and as a mausoleum for Henry VII and his heirs. King's Chapel was completed (if not begun) in this spirit, and instructions for the glazing in 1511–12 specify that the windows are to contain 'such Images, storis, armys, bagis [badges] and other devises as it shalbe devised'.[83] Various royal insignia, startlingly present all over the antechapel, are part of a long tradition of royal self-advertisements that was to include Charles I's arms in the screen gates, James I's and Henry VI's arms over the south and north doors of the Essex screen, the College arms over the seventeenth-century altar canopy, not to mention the arms of the many Provosts, Fellows and even students buried in the Chapel.[84] Henry VII's celebration of the Order of the Garter (almost certainly in the first chapel) on St George's Day 1510[85] was to be echoed in the garter motif and motto – 'Honi soit qui mal y pense' – that appear in the screen, on the organ case and repeatedly on the stall panels of the new Chapel, as well as in the single top light of all the north and south side windows (see Ill. 166).[86] Jorevin de Rocheford describes how 'in bas relief…the blazons of the finest men of the country…serve round that fine church like a tapestry',[87] while much of the Chapel survey by the eighteenth-century antiquary William Cole (friend of Horace Walpole) is devoted to detailed documentation of the heraldry, paying

Ill. 167.
Royal Arms with the Garter motto. On (?) English Page Alms dish, 1668–69, engraved silver-gilt, 61 cm (diameter). Cambridge, King's College.

careful attention to this garter iconography, including the presence on the high altar of a huge silver dish inscribed with a garter and, once again, the garter motto (see Ill. 167).[88]

Among visitors, however, the Chapel also seems to have inspired more inclusive and impromptu forms of self inscription and 'insignia'. Two records from 1627 testify to the practice of having the shape of the sole of your shoe inscribed into the leads of the roof, along with your name or coat of arms. According to Joseph Mead, the Duke of Buckingham, favourite of James I, 'was on the top of King's Colledge Chappell, but refused to have his foot imprinted there as too high for him'.[89] The activity being described here is clarified by an entry in the autobiography of the parliamentarian and antiquary, Sir Simonds d'Ewes (1602–50), who visited Cambridge with his new bride:

> We went both up to the top of King's College Chapel, on the south side whereof, upon the leads, my wife's foot was set (being one of the least in England, her age and stature considered), and her arms cut out within the compass of the foot, in a small escutcheon.[90]

This seems to have been a reasonably common practice. Later editions of the *Annales* of John Stow, for example, document its occurrence in 1606 at old St Pauls:

> After dinner, the king [of Denmark] being accompanyed with the Lord Admirall, the Lord Chamberlayne, and others, went...unto Pauls church...ascended the top of the Steeple, and when he had survayd the cittie, hee helde his foote still whilest Edward Soper, keeper of the Steeple, with his knife cut the length, and breadth therof, in the Lead: And for a lasting remembrance therof, the said Soper within few dayes after, made the kinges Character in gilded copper, and fixed it in the middest of the print of the kings foote.[91]

In the early seventeenth century it seems to have been a common practice for well-connected travellers to inscribe themselves in the relatively malleable substance of the lead roofing of famous architectural landmarks. Similar forms of self-recording on church leads are in fact well documented

217

Ill. 168. Shoe shape, with saltire cross, nineteenth century, inscription on the lead roof of St Ethelbert, Tannington, Suffolk.

Ill. 169. Plan of images inscribed on lead roof of tower of St Michael's Church, Cookley, Suffolk. Earliest legible inscription 1632.

in subsequent centuries, although in later periods this seems to involve people of lower social strata, sometimes church wardens, but above all the lead plumbers who worked on the roofs: Stuart Boulter, Warwick Rodwell and Timothy Easton have recorded the presence of shoe – and hand – outlines in many parish churches in the east of England, often inscribed with what Easton describes as 'significant' and apotropaic symbols such as saltire crosses, hearts and even 'spider's webs for entrapment'. Easton explains that in many of these 'shoes' the lines are 'redrawn by pressing down and "walking" a narrow tool in a side-to-side, forward zig-zag movement; this was the technique used in the earliest surviving sole outlines dating to the early seventeenth-century and [it] takes several times longer to execute than a straight forward scribed line' (see Ills. 168 and 169). Such images are, of course, just one instance of the more widespread practice of making inscriptions (initials, names and dates) and even quite elaborate drawings in church leads.[92] William Cole notes that similar practices were occurring at King's into the seventeenth and eighteenth centuries, when he comments: 'the Leads are partly new, being to the E[ast] end within these 2 or 3 years put there; the greatest part of the rest is about a hundred years standing, as appears by several accidental Dates on them' (that is, dates put there 'by chance').[93] Given that lead roofing requires replacement after about a hundred and fifty years, nothing remains of these early inscriptions today. However, the continuation of these practices is revealed not only in the raised inscription left by those who worked on the releading of the roof in the 1860s, 'A. Greef. Plumber. Rattee & Kett. Carpenters.', but also in two boot outlines that can still be seen today on the northern slope of the main roof, one apparently inscribed by a certain G. F. Turtle (see Ill. 170).[94]

Once again, the evidence suggests a long history of public and personal appropriations of the Chapel – as well as the enduring fascination of ascending to its sublime heights. *Lexicon Balatronicum*, an early nineteenth-century compendium describing itself as made up of 'buckish slang, university wit, and pickpocket eloquence', contains an entry entitled 'To cut', which ennumerates the various ways to avoid an undesirable acquaintance: the 'cut direct' (crossing the street at his approach), the 'cut indirect' (looking the other way), the cut infernal (attending to your shoe laces), and the 'cut sublime', which was 'to admire the beauty of King's College Chapel, or the passing clouds, till he is out of sight'.[95]

Ill. 170.
Shoe shape and inscription, north side of main roof of King's College Chapel, Cambridge. Post 1860s.

Ill. 171. Augustus Pugin, *King's Chapel, South Porch*, c.1815, watercolour, 26.7 x 20.2 cm. Cambridge, King's College.

X

The Start and Stop of Simeon

ROSS HARRISON

THE 29 JANUARY 1829, AN AUSPICIOUS DAY for Charles Simeon, was ushered in by church bells ringing all over Cambridge to mark the anniversary of the King's accession. But this was merely an additional bonus; Simeon's attention was instead on a closer and more personal anniversary. It was exactly the fiftieth anniversary of his admission to King's on 29 January 1779, and he had been there ever since. It was also the day in which the King's Fellowship would meet to elect officers, then as now finishing uncompleted business left over from the annual election meeting in November (although on this occasion it required the special direction of the Visitor, the Bishop of Lincoln, requiring the Provost to summon the meeting). Simeon was the senior Dean. The normal election in November having failed to take place, he expected (and was) re-elected to the office along with his junior partner on this day in January. (Before the advent of Tutors, the Deans were the officers of the College responsible for the education and discipline of undergraduates; they were not particularly concerned with the Chapel.)

Simeon noted in his diary three days before the 'astonishing coincidence' whereby 'the whole College of above forty members' would meet 'at the very day of my Jubilee, and at the very hour on which I was first admitted' to reappoint him to this 'prominent' office. He then went on to record in anticipation the aspect of the coincidence that mattered most to him: at the very hour of the College meeting, 'not much less than thirty friends will be assembled in my rooms for reading the Scriptures and prayer'. These rooms were at the top of the Gibbs building and included the semicircular windows looking both directions above the central arch. The iron banister that was inserted to help Simeon haul himself up to his rooms still exists on G staircase and was called 'The Saint's Rest' (Ill. 173). As will be seen, these rooms rather than the Chapel were the focus for both his private and his public religious life in King's, and so it was wholly appropriate that his friends should be meeting in them for prayer and Bible reading while he was obeying the Provost's summons to attend the College meeting.

Simeon knew, or at least he says here, that God was watching over him. His whole life from when he came up to King's was devoted to furthering God's purposes as he saw them. As soon as was possible he became a priest. So, a few years after what he calls the 'jubilee' of his admission to College, he celebrated another one marking his fifty years in charge of a local church. This was Holy Trinity, near the Cambridge market, where Simeon was vicar for fifty-four years in all. He lived in King's, he worked in the town, and he moved between the two with his trusty umbrella. As it says on his memorial tablet in the church, 'whether as the ground of his own hopes, or as the subject of all his ministrations, determined to know nothing but "JESUS CHRIST, AND HIM CRUCIFIED"'.

With religion central to his life and the Bible central to his religion, Simeon's celebration of fifty years in College or church was not idly called a 'jubilee'. This term (which we probably now associate more naturally with anniversaries of sovereigns) is biblical. On the auspicious morning he laid out its

Ill. 172. James Northcote, Charles Simeon, 1810, oil on canvas, 76.2 x 62.9 cm. Cambridge, King's College.

Ill. 173.
Rail added for Charles Simeon ('Saint's Rest'), installed between 1812 and 1836, iron. Cambridge, King's College, G staircase.

significance to his prayerful friends gathered in his rooms. As he puts it in his diary (quoting now from the day itself, 29 January 1829), the joy of a jubilee was the joy of a prodigal 'whose joy would not only be tempered by, but almost wholly consisting in, retrospective shame, and prospective determination through grace to avoid in future the evils, from which God's free mercy, founded on the atonement, has delivered us'. He reminded his friends that in the Old Testament the jubilee was pronounced on the Day of Atonement. He refers to Leviticus 25.9, where in the King James Bible they used they would have read, 'Then shalt thou cause the trumpet of the jubilee to sound ... in the day of atonement shall ye make the trumpet sound throughout all your land'.

This extensive quotation explaining a jubilee to his religious friends contains the heart of Simeon's doctrine and its associated religious psychology. Almost every word in it is freighted with significance: shame, grace, mercy, and above all atonement. We are all unworthy sinners, Simeon included; not for him the confidence of their own perfection of the early Methodists. As he put it in a slightly later talk in these Gibbs rooms recorded by a visitor, 'I want to see more of this humble, contrite, broken spirit among us'; 'the very first and indispensable sign is self-loathing and abhorrence'. However, he also believed that by the grace of God and His mercy shown by the atoning sacrifice of his Son, there is the hope of deliverance; we may be certain, through faith, of the possibility of salvation although we cannot be certain of its application in a particular case. The crucial economy of the cross is the central essential component: everything depends on the atoning sacrifice of Christ in which, by bearing away our sins like the Old Testament scapegoat sent into the wilderness (described in the next chapter of Leviticus), he makes us at one with God. So atonement was the central factor of Simeon's conversion; it sounded the central theme of his movement in the church; and the changes that this movement created in national life have led to its leading historian Boyd Hilton entitling his leading book about it *The Age of Atonement*.

Among the friends that Simeon invited to the occasion of his jubilee was the prominent politician William Wilberforce. Wilberforce did not feel well enough to make the journey, but apart from saying that he would be there in spirit (and Wilberforce's spirit was the spirit of the Age of Atonement), he wrote (22 January 1829): 'the degree in which, without any sacrifice of principle, you have been

enabled to overcome, and if I may so term it, *to live down* the prejudices of many of our higher Ecclesiastical authorities, is certainly a phenomenon I never expected to witness'. Thomas Macaulay, writing to his sister (after Simeon's death, in 1844), said, 'as to Simeon, if you knew what his authority and influence were, and how they extended from Cambridge to the most remote quarters of England, you would allow that his real sway in the Church was far greater than that of any primate'.

Wilberforce, layman and politician, represented the practical effects of the new evangelical tendency, above all in the campaign to abolish slavery. Simeon's concern and influence was with the Church, at home and abroad. He was joint founder of the Church Missionary Society and he fed a string of clergy to India, in particular the saintly Henry Martyn, formerly his curate at Holy Trinity. He organised and promoted the better training of ministers and, above all, he devoted his and others' wealth to the purchase of advowsons (that is, the right of presenting clergy to parishes), so that his godly priests might have a living and be placed where they would be enabled to do most work for their Lord. In this he was helped towards the end of his life by an act forbidding municipal corporations to make such presentations. But he started well before then, in 1817 with Cheltenham. By the time he died, the Simeon Trust controlled well-populated plums in Bradford, Chichester, Hereford, Ipswich, Northampton and elsewhere. In Bradford the Trust had what was later the cathedral, a parish of over 100,000 souls and an extensive field for evangelical tillage.

Cheltenham, the first, is a good example of how it worked. It cost Simeon £3,000, and for this he got the control of an extensive parish, which in turn controlled a rising town. On Simeon's nomination, Francis Close (better known as Dean Close, because of the school founded in his memory) was appointed. Under Close, 'the pope of Cheltenham', the town was subject to a rule of saints in such matters as Sunday observance in a manner seldom seen since the seventeenth century. They also got a cleric who was not just a follower of Simeon and presented at his choice, but who also attempted to emulate him in his sermon construction and priestly practice.

Simeon therefore has a claim to be the most important religious figure in the long history of King's. But what has this to do with the Chapel, its most important religious building? Simeon concentrated on his town church, not the Chapel; his religious life in College was in the Gibbs Building rather than in the large building specifically constructed for religious purposes. Nevertheless, King's Chapel plays the central role in two most important events in his religious life, and it is this, the start and stop of Simeon, with which this chapter is chiefly concerned.

The world in which Simeon first came up to King's was a world of King's scholars. Sustained by the bounty of their joint royal founder, select scholars were first boarded and educated for free at Eton before completing their education on the same basis at King's. In theory there was selection for the scholars of King's but in practice they were admitted in their original Etonian order. So the King's to which Simeon came was a College completely composed of Etonians. It had a tiny number of undergraduates and everyone knew each other from school. Simeon's January admission was not unusual; it depended on places becoming available to make up the founder's sacred number of seventy scholars and Fellows supported by his foundation. So once someone was elected a King's Scholar at Eton, they could, like Simeon, live on King Henry's bounty for life. As he wrote to an old Etonian friend in 1823, 'King Henry finds me with a very adequate supply to my wants, though I should have nothing else'.

In the same letter, Simeon wrote, 'you remember me a very different person at Eton from what I have been these forty-five years since I came to College'. The reason is that a surprising thing happened to Simeon when he came to College, and it happened in the Chapel. Simeon became singular, standing out from the normal influx of Etonians. As an undergraduate, like them, he had to attend the Chapel services daily and, as he remarked much later, 'the service in our chapel has almost at all times been

very irreverently performed'. But Simeon's response to this daily poorly performed act of worship set him apart from the other scholars. For him, unlike them, worship was with tears, with agony in his face, and with constant reprimands to himself in his diary for wandering attention.

So how did this strange singularity start? Simeon frequently tells the story. Here is how he puts it in his most consciously written fragment of autobiography (dating from 1813 and from which the quotation about irreverently performed services is also taken). After coming to College, he writes, 'the gracious designs of God toward me were soon manifest'. The occasion was a letter he received from the Provost (Cooke) saying that he would be expected in three weeks' time to attend communion in Chapel. In this later account, Simeon notes that 'I am far from considering it a good thing that young men in the university should be compelled to go to the table of the Lord; for it has an evident tendency to lower in their estimation that sacred ordinance'. In his case, however, it worked. Procuring and studying the only religious book he knew to prepare himself (*The Whole Duty of Man*), he soon started 'crying to God for mercy' and was so earnest in his endeavour that within the allotted three weeks he made himself 'quite ill with reading, fasting, and prayer'. Not the normal behaviour of an Etonian come to College, particularly one with a rich background and a good eye for a horse.

It is worth unpacking a little more of the background. The requirement that the young men should take communion in Chapel at the middle of each term was not (as would naturally be supposed) to promote their spiritual welfare. It was, instead, to check that they were proper members of the tribe and so fit for positions in church and state. England was run by an Anglican establishment and the ticket of entry was to be in communion with the established church: those in communion could vote, become Fellows, and hold local or national offices; those not in communion (such as atheists, Roman Catholics, or dissenters refusing 'occasional conformity') were outside the controlling circle. So the termly communion (sometimes referred to as the 'terminal sacrament') was a test of someone's eligibility to be a member of the College (and to go on to be priests, as very many of them did, solely on the strength of their Fellowships). Even after Simeon's death, in the first set of new statutes since the founder's, every Fellow on admission had to swear that he was a bona fide member of the Church of England. This only disappeared in the 1880s, although enforced communion in College Chapels dropped away considerably earlier (and indeed stopped having its primary significance after Roman Catholic emancipation in 1829). When Simeon came up, the Anglican establishment was confidently in place and the Provost was only writing to the newly arrived freshman to confirm that he had the entry ticket to the governing echelons of English society.

This might be the whole conversion story: compulsory communion, a more than usually scrupulous undergraduate, tears and fasting, and the salvation experience at the altar of the Chapel. What the Chapel (and Provost) had done was to change this person's whole life, and through it the life of Cambridge, the nation and the Empire. If people are aware of Simeon's story at all, this is how it is normally dimly remembered. The real story, however, is interestingly more complex than this telescoped version. It involves not one profound experience in the Chapel but two. For there was a second, later, communion service that is more significant in Simeon's salvation story.

This second occasion was one for which Simeon was significantly better prepared. It was on Easter Sunday, after the end of his first term. Easter was one of the very few occasions on which a parish church at this time would celebrate Holy Communion, and Simeon, staying in residence, was again expected to attend. He joined the Society for Promoting Christian Knowledge to get better books about it, and so acquired Bishop Wilson's *Instruction for the better understanding of the Lord's Supper*. This became the key document for Simeon, although it is somewhat strange that the writings of this Manx bishop were important both for a leading evangelical like Simeon, and also for John

Henry Newman and John Keble, leaders of the opposing Anglo-Catholic persuasion. Much distressed, Simeon thought of his sins for three months and had some indistinct hope. Then in Easter Week he read in Bishop Wilson that 'the Jews knew what they did when they transferred their sin to the head of their offering'. Immediately 'the thought rushed into my mind, What? May I transfer all my guilt to another?' Accordingly (as Simeon puts it in this carefully composed later memoir) 'I sought to lay my sins on the sacred head of Jesus; and on the Wednesday began to have a hope of mercy'. From there on it was downhill to the decisive event, the hope increasing daily. By Easter Sunday itself he awoke early with 'Hallelujah!' on his lips and 'from that hour peace flowed in rich abundance into my soul; and at the Lord's table I had the sweetest access to God through my blessed saviour'. Thus came the confirming conversion of Simeon in King's College Chapel on 4 April 1779. The key, in what he took from Bishop Wilson, was atonement: as with the Old Testament sacrificial scapegoat sent into the wilderness, Simeon saw that he could lay his sins on the saving sacrifice of Christ.

Following this, Simeon's prayers in Chapel were 'as marrow and fatness' to him, strikingly different from the other indifferent students as he prayed to the Lord 'with strong crying and tears'. He read the good book to his servants and attempted to introduce family prayers at home, but he did not in his three years as an undergraduate know another truly religious person. He went to the church across the road (St Edward's), thinking that the vicar might be sympathetic, but although week by week he was the only gownsman in the congregation, the vicar did not take him up. He became an extravagant and amusing auditor at the University sermons in Great St Mary's but, again, he lived his religious life alone. It was only when he had passed through this wilderness and become a Fellow that the Vicar of St Edward's eventually relented and introduced him to John Venn. Through Venn he met his father, Henry Venn, and so connected with the leading lights of the older evangelicals, as well later with 'The Clapham Sect'; John Venn was subsequently Vicar of Clapham.

When Simeon and John Venn eventually met, Venn had only a week left in Cambridge, but they saw each other every day for tea. Tea is indeed a constant theme: Simeon's followers at Magdalene ('the Sims') were said to drink so much tea that it choked the river below the bridge. Simeon's conversations in King's were formally tea parties and he diluted his religious instruction with advice on the most economical way to purchase and use tea. His teapot (the nearest we have to a relic with which to remember him) is preserved to this day in his church, Holy Trinity.

In his memoirs of being a scholar in the Old Court of King's early in the 1820s, William Tucker says that he never saw Simeon in Chapel. Simeon clearly didn't come to Morning Prayer, but he did in fact sometimes come to the Chapel for special occasions. Among these were the University sermons given then (as now) once a year in King's College Chapel. In Simeon's time (and long afterwards, but unlike now) this was on a specially significant day for the College. King's is dedicated to two saints. St Nicholas, the birthday saint of the founder, is celebrated early in December. But the other saint to whom the College is dedicated is St Mary, and on her day ('Ladyday', March 25th, the Feast of the Annunciation) the University sermon was always given in King's by 'one of the society', that is by one of the Fellows of King's.

Simeon preached this sermon in both 1828 and 1829. In 1828 he preached about the new Wilkins buildings at King's; in 1829 his topic was Catholic emancipation, currently being considered by Parliament. Simeon, a staunch upholder of the Anglican Church and State, was strongly against any such emancipation; he refused, for example, to vote for the son of one of his oldest friends in the preceding general election because of the son's support for Catholic emancipation. However, although Simeon talked in the sermon of 'the present awful crisis', he in fact ended hopefully. In the inscrutable ways of providence, he proposed, the Lord was sending Catholics to try them. They had to

be on their guard against being converted to Catholicism but (as he stated with misplaced optimism) the Lord might be doing this to give them a chance of converting the Catholics.

It is not just as an undergraduate that Simeon stood out as singularly alone. He was also far removed from being a typical Fellow. Generally shunned, he recorded with surprise how a Fellow spent fifteen minutes talking with him on the grass before Clare. Tucker records Simeon dining daily with the two bursars, one of whom refused to talk to him. (The bursars ate separately in their own room and Simeon as a former bursar was entitled to join them.) He did not suffer a complete dearth as regards King's company, however; one of the junior Deans working with him as senior Dean wrote to him about how together they would reform the College. And even if Simeon was egregious, he was still trusted enough to hold central offices: he was continuously in a College office between 1788 and 1805, as Dean of Arts, then Dean of Divinity, then Vice-Provost (the second position in the College, elected at the relatively tender age of 31), then Second Bursar. Later on, as has been seen, he was again elected senior Dean. In this later period he notes how a 'senior Fellow, once as gay as any, who now in his illness is glad to have me every morning and every evening to pray with him', although he adds mordantly 'alas, he does not make that progress that I could wish'.

The Fellows were not religious, at least as understood by an evangelical, but they were sometimes gay beyond the possibility of deathbed repentance. Simeon can be contrasted with Scrope Davies, who was also a Fellow at this time. Simeon constantly counted his pence, kept scrupulous accounts, and gave substantially to charity; he noted with satisfaction how when most of his undergraduate contemporaries (then, as now) graduated hundreds of pounds in debt, he had none at all. Scrope Davies, friend of Byron, wit and high liver, made money through gambling and lost his substantial fortune suddenly in the same way. The College tradition, as told by his bedmaker, is that he lost it at Newmarket, but it seems that he lost it on the baize cloth in London rather than on the local turf; whatever the cause, he had suddenly to exit from his Gibbs rooms and live abroad for the rest of his life, avoiding debtors. Meanwhile his fellow Fellow Simeon remained in Gibbs, calculating the cost of his tea, and making sure that the young men who visited him wiped their feet properly at his door, with its specially provided additional mats, to prevent any trace of the gravel from the court beneath getting on his carpet. ('Sir, is that the way to come into a gentleman's room and dirty his carpet?')

Simeon's contributions to King's extend beyond his several official functions and very occasional pastoral support. He was instrumental in moving the bridge from its central position to its current more oblique and romantic setting. Furthermore he paid for it, something he remembered bitterly when he took out his anger on another Fellow in his occasional journal. He did this so that he didn't respond in the flesh and provoke an argument; instead he turned the biblical other cheek. Rhetorically, however, he asked his journal, 'who would have believed, that a person who but lately gave £700 to the College towards the building of the bridge, should receive such treatment as this?' (Ill. 174).

Standing out from the prevailing attitudes of the world, both inside and outside College, Simeon clearly had a struggle. It was by no means to be expected that, as he rather complacently put it in a remark recorded from a conversation party in the 1829 jubilee year, 'thirty years ago £500 could not have collected such a party as now surround me in this room. It was a University crime to speak to me and was reported to parents and now my views are received with respect and even esteem by men of rank, by Archbishops and Bishops'. He may have been thinking of how, three years before, three bishops at once came to visit him in his Gibbs rooms whereas, as he reported the visit in a letter, 'in former years I should as soon have expected a visit from three crowned heads, as from three persons wearing a mitre'.

This shows that Simeon's struggles, or the awkward effects of his singularity, were as profound with the church as with the gambling Fellows of King's. It should not be supposed that Simeon

Ill. 174. The King's College bridge (1819), planned and paid for by Simeon; behind, the Gibbs Building, with the semicircular window of Simeon's room in the centre at the top; and the Chapel, where he was converted and is buried. Adrian Boutel, *View of King's Bridge*, photograph, 2014.

merely had some years alone but then, after finding congenial religious company and a local church, a long and successful life working mightily for the Lord. He did work mightily, but it took patient endurance before he achieved success even in his own church of Holy Trinity. The undergraduates came to disrupt the services and threw stones through the windows. The churchwardens locked the pews so there was scarcely anywhere for the congregation to sit. Indeed, they also on occasion locked the church against him, preventing his entry; at first he summoned a smith to break open the door, but subsequently decided to accept defeat, even though he knew that the churchwardens were not legally entitled to prevent him entering his own church. So the surprise that Wilberforce expresses at his esteemed position toward the end of his life is perfectly rational.

In his already-quoted memoir of the period, William Tucker notes that a defect of his Cambridge education was that it provided no training for the profession which most of the undergraduates (including himself) would enter, that of being a priest. This is correct in that there was no official instruction either in the University or the College (and this was long before the start of the Theology Tripos). But the part of Simeon's life work not given to his Cambridge parishioners was given to the young men of the University, training them to become better priests. As Simeon said, 'Let every man see what his line of work is and keep to it. I have, as my work, undertaken to provide Ministers for immortal souls'.

To this end, Simeon held two regular series of meetings in his rooms at King's. One was his famous tea parties, from which the remark just quoted is taken, and which will shortly be more fully described. The other, more specifically directed to the training of ministers, was a fortnightly sermon class, which he ran for undergraduates who expected to be ordained in the established church. This

229

Ill. 175. August Edouart, *Silhouette of Charles Simeon*, 1828, black and white paper, 24.5 x 17.8 cm. Cambridge, King's College.

was very similar to a modern group supervision. Simeon gave out the text on which to base a sermon for the following meeting and the participating undergraduates each wrote a sermon outline on the topic. They then read them out while Simeon criticised, encouraged, and suggested improvements.

At these classes Simeon also gave general advice on such matters as demeanour and voice projection while preaching. At this period, after all, someone such as Simeon might occasionally preach to two thousand hearers using his own, unamplified, voice in such a way that they all could hear him. He regularly preached to a thousand on Sunday in his own church and was clearly a captivating preacher. Taking on St Edward's for the vicar as his first (summer stand-in) job, he filled the church in a manner that was beyond the vicar. The peasants of the surrounding Cambridge villages regularly walked in to hear him preach the Sunday evening sermon at Holy Trinity. Right from his first Great St Mary's sermon to the University, he was specially noticed. His preaching manner, with its wide repertoire of gestures, has been captured in an admirable series of silhouettes made of his preaching in the 1820s.

Providing materials to enable the new evangelical clergy to give better sermons was a central, guiding, project of the second half of Simeon's life. In addition to his classes, he composed and published sermon outlines, which he called 'skeletons', for the use of actual and incipient clergy. These were finally published in twenty-one volumes containing 2,536 sermon outlines, taking thirty-two men sixteen months to print. Simeon then personally presented copies to the King, the two archbishops and so on, besides sending copies of the set to foreign embassies and Cambridge Colleges.

Given this massive activity devoted by Simeon to training the clergy and given that Tucker himself was a prospective clergyman and that both Tucker and Simeon were members of the same College, residing close to each other throughout Tucker's time as an undergraduate, why did Tucker claim that there was no training? The answer is that Simeon was not educating members of the College (or the University) as such but, rather, those who wanted to come to him for instruction. He was educating the faithful, whereas Tucker (although he did subsequently hold a College living for over forty years) was more old-school casual. The men being educated by Simeon were the prospective evangelical clergy, who knew what was happening and had friends or other contacts among the elect.

The same is true to some extent of Simeon's more famous weekly meetings, of which many accounts survive. This was when he kept open house in his Gibbs room every Friday at 6 pm, holding a tea party. These were not specifically religious meetings as Simeon was scrupulous about the Conventicle Act, which prohibited religious meetings outside parish churches or licensed dissenting chapels. So there were no communal prayers. Instead, Simeon, sitting by his fireplace on his high stool with his large Bible in reach, answered questions on any matter which anyone wished to bring up, until the clock struck seven. The questions were, however, predominantly religious and while his servants passed round the tea Simeon was giving informal religious instruction. (One account observes that the tea was rather a nuisance as it got in the way of the discussion.) Simeon started these weekly conversation parties soon after he moved into this top set of rooms in 1812; some sixty to eighty people came, crushed into the room that looks through the semicircular window over the back lawn towards the river.

Although the discussion was primarily religious, Simeon was also prepared to give other advice or information. He did not hold that, if an undergraduate studied the Bible and thought about God properly, it didn't matter what else he did. On the contrary. Simeon, loyal supporter of established church and state, was very much an upholder of set duties. He practised and promoted the precept of the Anglican catechism 'to do my duty in that state of life, unto which it shall please God to call me'. He therefore told his undergraduates that their duty as students was to study hard, and several

Ills. 176–179. August Edouart, *Silhouettes of Charles Simeon*, 1828, black and white paper, 23.2 x 21.6 cm (max). Cambridge, King's College.

Simeonites, including Henry Martyn, were in fact Senior Wranglers (that is, the best students of their year in the whole University). He also insisted that they took regular afternoon exercise to enable them to study hard. He told them that they should see daily that no one had taken away the third milestone on the Trumpington Road, checking its far side for damage; before the advent of organised sport, the chief undergraduate exercise was walking. The third of these early eighteenth-century milestones still stands undamaged, awaiting inspection and marking the middle of a six-mile walk from King's.

It might be thought that, as an evangelical particularly concerned with preaching, Simeon promoted the ministry of the word without much care for the liturgy. This, however, would be a mistake.

Ills. 180–183. August Edouart, *Silhouettes of Charles Simeon*, 1828, black and white paper, 23.2 x 21.6 cm (max). Cambridge, King's College.

Among his University sermons is a published course on the importance of the prescribed Anglican liturgy, which caused a pamphlet war in Cambridge. Simeon thought that participating in the Anglican liturgy was the nearest we could get to heaven on earth. Not everyone would eagerly look forward to the next life as a non-stopping service of Holy Communion, even if they might share his relief at the prospect of returning to England from Scotland (although in his case this was because he was returning to what he saw as the land of liturgy, as opposed to sermon-giving and psalm-singing Scotland).

The central importance of Simeon for the Church of England is that he kept the later wave of the evangelical revival inside the established church, in contrast to the earlier wave, when, in spite of John Wesley's best intentions, the Wesleyans departed after his death to become separate

Ill. 184. Profile of Charles Simeon, 1800–36, engraving. Cambridge, King's College, KCAC/1/4/Simeon/2.

X · THE START AND STOP OF SIMEON

Methodist churches. Here liturgy is crucial. In keeping his followers inside the Church, Simeon preserved clerics who performed the prescribed liturgy of the established national church, as well as training them as effective preachers. His purpose was to give the best that dissent could provide without people leaving the legally established church; to this end he educated clergy who were evangelical but remained Anglican.

If the Anglican liturgy was so important for Simeon, it might reasonably be asked why he did not daily approach heaven by attending morning prayer in Chapel with Tucker and the other undergraduates. The answer is that Simeon said it in his room, having risen at four and engaged in private prayer and study of the Bible, interspersed with walking with God along the leads between the twin roofs of the Gibbs Building. After several hours of this, he said the morning office daily with his servant. And even if he rarely appeared in the Chapel during this time, the great building just outside his door could not be completely ignored. It got used as an example in his weekly tea party discourses (just as, on the next staircase in the next century, Wittgenstein's weekly discourses at the Moral Sciences Club used the Chapel as a philosophical example). In one recorded tea party discussion, Simeon uses the Chapel to illustrate the difference between experiencing something and knowing it by mere description. (Wittgenstein might well have wanted to make the same point by the same means, but he would not have been talking about heaven.) When Simeon wishes to explain the dimensions of Noah's Ark, he says that it was twice the length and twice the breadth and two thirds of the height of the Chapel. And when visitors, such as the three calling bishops, had to be shown round, he would take them to the Chapel before moving on to the Wren Library at Trinity. But the Chapel was not central to Simeon's work and mission, and so was neither used, nor worshipped in, nor visited.

Except for his end. For we now come to the second of Simeon's two significant encounters with the building that dominated the view from his front room in Gibbs. The first significant encounter marked the start of Simeon's fruitful religious life; this second one marks the end. In his will Simeon gave the instruction, 'If I die out of College, I am not careful where my body shall be buried: but if I die in Cambridge, I should wish to be buried in my College Chapel'. He did die in Cambridge, in his room at the top of G staircase in King's on 13 November 1836; the day is still celebrated in his memory in the official Church of England calendar. Dying in Cambridge, his funeral was accordingly held in the Chapel.

The importance of this was not just that Simeon entered the Chapel in death more than he had in life, but that the event itself was felt to be unusually significant at the time and many accounts of it survive. They are united by the theme that Cambridge had not in living memory seen anything like it before, and was not likely to see anything like it again. To set the context, it should be remembered how singular and unaccepted Simeon was for much of his life. The undergraduates who came to 'scrape' (drag their feet on the floor as a sign of disapproval) at his University sermons in Great St Mary's stayed to admire; the other students who came to rough up his town church stayed to become his missionaries to India; whereas his churchwardens had once locked the doors of his own church against him, his later parishioners and churchwardens regarded him as a saint and squeezed into his enlarged church to hear him preach. More generally, there was the change of sensibility in city, University and country, which may be described as a shift from 'Regency' to 'Victorian' (although Simeon, dying a year before that queen's accession, never lived under other than a king). How far in Cambridge this was caused by Simeon himself is not the particular point, although John Willis Clark, who was supremely well placed to know, says that the 'moral regeneration of Cambridge dates from Charles Simeon'. The important point is that, whether through his life's labour or through happy

coincidence, by the time of his death the once mocked or disregarded outcast had become an admired oracle. It is this that is represented by his extraordinary funeral.

In the death that preceded it, we have something of a good natured battle of wills between Simeon and his chief biographer, William Carus (who succeeded him at Holy Trinity). For a fortnight as he died, Simeon was adamant that he did not want any significant deathbed scenes, while Carus scanned every twitching of his eyebrows for a special message. Simeon was firm that someone giving sermons in his place because he was prevented by his fatal illness should not preface them with any kind of personal eulogy. Carus managed to extract some significance from the time of the death: Simeon died in Gibbs just as the bells of Great St Mary's were tolling for the University Sermon that Simeon had been appointed to preach. And the following Sunday, the sermons in Holy Trinity, Great St Mary's, and elsewhere, were prefaced by, or composed of, personal eulogies to Simeon, many of which were published.

The funeral was on 19 November, the day before these eulogy sermons. Simeon himself would clearly have wanted it small and simple, and that would also have been the normal preference and practice of the College authorities. But it was not to be: Simeon had become too generally revered for this to happen. For a start, there were his Holy Trinity parishioners; they had to be allowed to come to their pastor's funeral. They were allowed to apply for tickets to be admitted to the antechapel. Then very many undergraduates from other Colleges wished to come; they could stand in the chancel. Then there were more senior members of the University; then members of the College… It all added up to an unprecedented spectacle and it stopped other normal activities. It was a Saturday morning, a busy Market day for the town and a time which the Colleges used for lectures to their undergraduates. Yet the shops were closed, the market was deserted, and the Colleges cancelled their lectures. People in the streets generally wore deep mourning and many, town and gown alike, converged on King's for Simeon's last ceremony, the townspeople ineligible for admission massing against the railing that then topped the wall along King's Parade.

The town part that was admitted, bearing their tickets, went straight into the antechapel to wait, while the University part, in their black academic dress with added black ribbons and scarves of mourning, assembled in the new College hall in the recently-erected Wilkins Building. Meanwhile, the members of King's combined in the new Combination Room next to the Hall in the same building. Simeon in his coffin took his last descent down G staircase, his bearers no doubt aided by The Saint's Rest, and joined the great throng of University men emerging from Wilkins' new building to process with the coffin. The contemporary description printed in the *Pulpit* estimates that there were 2,000 University men in the procession; Francis Close estimates more than 1,500, but all observers agree that, even with men walking three or four abreast, the procession stretched right round all four sides of 'the quadrangle'. And this was just the University followers; the town was already tucked up waiting in the Chapel.

The general shape of the procession circling the quad was College before the coffin, University after. It was headed by a verger, followed by the choristers in their surplices, the conduct (that is, the clergyman paid to help with the Chapel services), the scholars, the Fellows, and then lastly the Provost, Dr Thackeray, in deep mourning. Then came the coffin accompanied by eight senior members of the College. Immediately after the coffin was the chief family mourner (Simeon's brother) before what the *Pulpit* calls 'an immense body of members of the University', headed by eight heads of other Cambridge Colleges, who led the professors, MAs, BAs, and undergraduates in proper order.

The procession entered by the great west door of the Chapel. Once there, the people processing were struck by the multitude filling the antechapel as they passed through it *en route* to the screen.

X · THE START AND STOP OF SIMEON

This was the Holy Trinity congregation, very many of them women, sighing and crying, all dressed in deep mourning. And so, leaving the women behind, the men reached the choir. The members of the College had their own seats and seats had been found for heads of other Colleges in vacant Fellows' stalls; the MAs had seats in front and the great mass of junior members stood between the coffin and the Communion rails.

The funeral service was read by the Provost (who, as was then required for the position, was an ordained priest of the established church) 'in a voice which betrayed at times the deep interest he felt in the solemn duty', as *The Pulpit* account put it, adding that the sung parts 'were beautifully performed by the choristers of the College'. So far the coffin sat in the middle of the choir. But for the final part of the ceremony, it had to be taken back out through the screen to the antechapel again, followed as far as possible by the University procession. Again the Provost read 'most impressively' as Simeon was lowered into the vault beneath, burying him, as he wished, in his College Chapel. Then, to quote *The Pulpit* again, 'the "Dead March in Saul" was performed, with its grand thunders on the organ, by Mr Pratt, the usual performer'; another witness, no doubt moved by the occasion, noted that the organ tones were 'more solemn than ever I heard them'.

And so the start and stop of Simeon's religious life were two significant events in the Chapel; both public, but the first of immense private significance, while the second was a great public occasion of which he was insensible. The Chapel made its mark on him throughout his life and in return he made his mark on the Chapel after his death. Not noticed by the crowds streaming away from visits or services, Simeon's final place of rest is marked on the pavement on which they tread. This is in the antechapel, in the middle of the passage between the two porches by which people enter or leave the building. Here there is a cross, a date (1836), and two letters (C S) marked in lead on the eighteenth-century paving. Simeon was later joined by two other King's nineteenth-century worthies, Richard Okes and Henry Bradshaw. During Bradshaw's final deposition, some fifty years after Simeon, the crowd could still see Simeon's coffin as Bradshaw's remains were lowered into the same vault. And so, safely stowed, he persists in making his mark.

Ill. 185. Letters marking the grave of Charles Simeon (1759–1836), late nineteenth century. Cambridge, King's College Chapel.

Screen
& stalls

The English oak screen (the *roodloft* of Henry VI's Will) that separates the antechapel from the choir was carved in the 1530s, probably by Netherlandish craftsmen. Its form is that of triumphal arch, like the arch of Constantine in Rome, except for the fact that there are three blind arches on either side of the opening; this reveals that the antique influences were not direct, but conveyed through secondary sources, such as later drawings and engravings of antique architecture. The pilasters of the Tudor woodwork are decorated with grotteschi. The screen incorporates heraldic badges and devices that include the initials of Henry VIII (HR for Henricus Rex) and Anne Boleyn (AR for Anna Regina), but also the intertwinned initials HA for Henry and Anna. They married on 25 January 1533 and Anne was executed on 16 May 1536, which indicates that this part of the carving must have been completed during the period of their marriage.

Ill. 186. BELOW: God commanding the Flood, tympanum on west side of screen (south end), 1530-36, 58 x 122 cm. King's College Chapel, Cambridge.

Ill. 187. OPPOSITE, TOP LEFT: Torso with body armour and halberd, detail of ornamental pilaster on west side of screen (south end), 1530–36, 20 x 28 cm. King's College Chapel, Cambridge.

Ill. 188. OPPOSITE, TOP RIGHT: Sacrificial bull's head, detail of ornamental pilaster on west side of screen (north end), 1530–36, 20 x 34 cm. King's College Chapel, Cambridge.

Ill. 189. OPPOSITE, BOTTOM LEFT: Greyhound supporting shield, Provost's stall, east side of screen, 1530–40, height 20 cm. King's College Chapel, Cambridge.

Ill. 190. OPPOSITE, BOTTOM RIGHT: Ornamental armored head with halberds, detail of ornamental pilaster on west side of screen (south end), 1530–36, 20 x 33 cm. King's College Chapel, Cambridge.

Ill. 191. Performance of Thomas Kyd, *The Spanish Tragedy*, performed by Marlowe Society and Perchance Theatre (King's College Chapel, Cambridge, 7–9 November 2012). Nick Rutter, photograph.

XI

Drama in King's College Chapel

ABIGAIL ROKISON

It hath not ben seene in the remembraunce of Man, that a Princes hath come to see this place,
& therefore we thinke not our selves a little happy to see her Majestie here.[1]

ON THE EVENING OF SUNDAY 6 AUGUST 1564 Queen Elizabeth I entered King's College Chapel to attend the first of four plays prepared for her entertainment by members of the University. Not only was this the first time that a monarch had visited the University for forty-two years, but it was the first time that secular drama had been performed in the Chapel. These productions, for which a number of detailed contemporary accounts survive, and whose staging has been the subject of various modern reconstruction attempts, mark this as a moment of significance in both the history of the Chapel and the staging of early English drama. Nevertheless, despite a number of such highpoints, the performance of drama in the Chapel has been sporadic, with large gaps during which no plays appear to have been performed at all.

Early References to Drama at King's

The earliest evidence relating to the production of plays by College members is found in the accounts of King's College 1482–83:[2] 'Item soluti Goldyng & Suthey pro expensis circa ludos in festo Natalis domini, vij s ij d' ('Likewise paid (to) Goldyng and Suthey for expenses in relation to plays at Christmas, 7s 2d').[3] It is not clear what form these Christmas *ludi* took, or where they were mounted. The King's College Mundum Book contains similar references to external payments for *disgysyngs*, *ludentes* ('players'), *mimi* ('actors') or *histriones* ('players') at Christmas and other religious festivals for a number of years from 1450 onwards. Many of these, however, are simply accounts for meals, and even those that do suggest that some form of performance took place in College provide no information as to the nature or location of such events. Indeed, Alan H. Nelson suggests that the terms *histriones* and *mimi* may well have been used to refer to musicians rather than actors.[4]

Academic plays were usually performed in College halls.[5] However, it is likely that a number of the references to performances on the Feast of St Nicholas allude to the ceremony of the Boy Bishop, which would almost certainly have taken place in the College Chapel.[6] The Statutes of King's College (1442–3), unlike those of any other Cambridge College, make reference to this popular medieval custom, which originates in around 1222,[7] stating that on the feast of the College patron, St Nicholas (6 December), the boys may be allowed to 'say and carry out vespers, matins, and other divine services,

241

saying and singing [them] according to the use and custom hitherto usual'.[8] Although to some extent the custom is less theatrical than festive, the event certainly involved forms of theatricalism in the performance and personation of members of the clergy.

On the feast day of St Nicholas, a chorister would be appointed Boy Bishop, and was thereafter permitted to play a member of the clergy for the day of the festivities; his performance would have excluded the consecration of the bread and wine at Mass, but would have included 'the burlesque of divine service', a *quete*, or collection, and a banquet.[9] The King's College Mundum Book contains a number of specific references to expenses relating to the Boy Bishops, and an inventory of 1505–1506 provides an extremely comprehensive list of wardrobe items 'Pertinentia ad Episcopum' ('relating to the bishop'), including 'a white wolen Coote', 'a gowne of skarlett with a whode for the same furred with white', 'Ringes of gold for the bishop' and 'a miter of white damaske with a white perle in the top', all of which suggest the spectacular nature of the practice.[10] However, under pressure from early Reformation thought and, in England, the influence of Thomas Cromwell, the custom of the Boy Bishop gradually died out during the 1530s,[11] and was banned in England on 12 July 1541.[12] The last mention of the Boy Bishop in the King's College records is in 1534–5.

Another intriguing connection between the Chapel and College drama is the transformation of liturgical garments into costumes and their storage in the Chapel. In 1552–3 the King's College Inventory records 'certayne vestments transposyd into players garments cowtaynyd in a chest on the sowthe syde of the Churche'; these include 'one coope [cope] of the best redde tusshes [silk cloth with gold and silver threads] turnyd into a cloke with a cape of the best redde' and 'a vestment of Doctor Luptons gyft turnyd in to a coote wyth a whyt lentten Curtayne to wrappe hit in'.[13] The practice of transforming liturgical garments into costumes around this time seems to have been common. Ann Rosalind Jones and Peter Stallybrass document the way in which, after the Reformation, many of the elaborate garments of the Catholic Church were sold or rented out for players' costumes;[14] Stephen Greenblatt too notes that many of the 'gorgeous properties' of Catholicism were sold to the theatres.[15] Such practices seem in turn to relate to Robert Hornback's claim that in this early period of the Reformation evangelicals actually employed the forms of festive misrule as part of their propaganda against the Catholic church.[16] The St John's College Register of Inventories in 1540–1 lists the costumes stored in the master's chest, including 'an olde white vestemente' and 'green vestimentes sprynklede with whyte',[17] whilst the Queen's College Miscellany of 1554–5 includes in its list of 'playng gere' 'two white satyn cassockes', 'a cassocke of blewe Veluet' and 'ij cassocks of badken'.[18] However, this transformation of garments in King's, which occurred under the reign of the Protestant King Edward VI, was reversed during the reign of the Catholic Mary, when the garments 'had to be converted back into vestments again':[19] 'Item soluti Carleton sacriste pro labore suo in convertendis tunicis histrionum in vestimenta ecclesie' ('Likewise paid to Carleton the sacristan for his labour in making over entertainers' tunics into church vestments'). In the King's inventory listing the transformed 'coope of the best redde tusshes' mentioned above, another hand has added, '& and now in to a coope againe'.[20] This process was to come full circle, however, when in 1570 'Provost Goad, with money realised by the sale of the Popish vestments which his predecessor Provost Baker had hoarded, fitted up a new library in the southern side chapels and stocked it with works of divinity and other books'.[21]

The Visit to King's of Queen Elizabeth I, 1564

Contemporary interest in Queen Elizabeth I's visit to Cambridge is indicated by a series of accounts written about the occasion. These were by Matthew Stokys, former student and Fellow of King's College and from 1557–1585 one of the Esquire Bedels of the University, with ceremonial duties, and a member of the Registry; Nicholas Robinson, former student and Fellow of Queens' College, and now an archdeacon of Merioneth, visiting Cambridge at the time of Elizabeth's visit; and Abraham Hartwell, a Fellow of King's College. There was also a wealth of other records,[22] including the accounts of the staging erected for the event, which have attracted great interest among modern drama historians.[23]

The University Orders for the Royal Visit assert that, among the entertainment laid on for Queen Elizabeth, the University should 'provide Hercules furens, Troas, or some Princely Tragedye'.[24] In fact, the University chose on the first night to produce a comedy – Plautus's *Aulularia* – presented to the Queen by '"certayne selected" persons whom Dr Kelke had picked out of all the Colleges, "King's-colledge being only excepted"',[25] since its members were to be responsible for the productions of Edward Halliwell's *Dido* and Nicholas Udall's *Ezechias*. The final night's offering was to be Sophocles' *Ajax Flagelliger* (*Ajax the Scourger*), though there is some confusion as to whether this was to be a University or King's College offering. John Nichols records that the play was to be performed 'by the Students of King's College onelye',[26] but Robinson states that Dr Kelke and four younger masters of the University 'took charge of the comedy and one tragedy' ('Isti Comoediam vnam tragoediam que curarunt'), with King's College taking responsibility for the other two productions.[27] What Nichols' statement does reveal is that students were among the cast members of the plays, apparently alongside Fellows, since Thomas Preston, who is recorded as having appeared in *Dido*, was at the time a College Fellow.

The performances had originally been planned to take place in King's College hall, which had, according to Nelson, 'long suited private college performances'.[28] The old hall was located on the south side of the old College court, where the west court of the Old Schools now stands; by around 1562, the hall had been expanded to fifty feet in length and twenty-five feet in breadth.[29] A number of payments recorded in the College accounts testify to the erection of stages for performances, often taking days to build.[30] However, when Lewis Stocket, Surveyor from the Royal Office of Works arrived to inspect the stage in advance of the Queen's visit, he found it 'to be to Lytle/ and to cloose for her highnes/ and her companye & also to farre from her Lodgynge', which was in the Provost's Lodge, then located beyond the east end of the Chapel.[31] Stocket ordered the re-location of the performance to the Chapel, and this was, according to F. S. Boas, carried out 'without any regard to the sacred character of the building'.[32]

Robinson describes the Chapel as 'most elegant on account of (its) design and quite spacious on account of its size' ('qui est locus et propter artifitium politissimus, et propter amplitudinem spaciosus satis').[33] It was, in fact, the largest building in Cambridge. The antechapel, being 40 foot wide and 120 foot in length, and free of permanent seating, provided the largest and most appropriate space for the performances. The stage platform 'spanned [its] whole width…and ran the length of two side chapels', indicating a platform that was 40 foot wide, nearly 50 foot deep and 5 foot high.[34] The side chapels offered additional benefits for performance, and the little information that exists about the performances themselves suggests that they served as stage 'howses'.[35] These, Dana F. Sutton explains, were 'no doubt an inheritance of the booths employed in mystery plays'.[36] They were probably

employed as the hall screens were in College hall performances: in the absence of a *frons scanae* (a backdrop to the stage, like those in the Roman or Elizabethan amphitheatres, containing two or three doors), these structures and their doors would have been entry and exit points, as well as being used to represent the various fictive houses or buildings demanded by the plays.

All documented drama productions in the Chapel have been located in the antechapel. Most have used an end-on configuration with the screen acting as a back-drop – more akin to the proscenium arch stages which have been a feature of many British theatres since the eighteenth century. But things were slightly different in 1564. Some form of platform was built on the 'roodelofte' (the top of the screen) from which the 'ladies and gentlewemen' watched the plays, and in front of it, under the 'roodelofte', was an enlarged platform for 'the choise officers of the courte'.[37] The result must have been a form of tiered or galleried seating, not dissimilar to that found in the Elizabethan playhouses. But the Queen herself sat on the stage. Stokys explains that 'vpon the Sowth wall was hanged a clothe of state with thappruntenaunces and halpaces [raised platforms] for her maiestie'; this is where her throne was placed, on the stage 'against the side wall of the antechapel on the south'.[38]

Stokys describes the Queen's entrance for the performance of *Aulularia* on the first night of her visit. First to enter were the Lord Chamberlain and Master Secretary with 'a multitude of the garde'. These members of the guard brought with them torches – the only lights used for the play. The guard were also tasked with ensuring that no other member of the audience obstructed the Queen's view of the stage: they 'would not suffer/ eny to stande vpon the stage, savyng a veraye fewe vpon the north syde'.[39] The Queen, who must have come from the Provost's Lodge, entering the Chapel by a door in the most eastern of the north side chapels,[40] then came 'from the eastern or high-altar end of the Chapel, through the central opening of the rood screen … and along a raised "bridge" leading to the stage'.[41]

Aulularia was, perhaps, an unsurprising choice for the first night of the Queen's visit, given the popularity of Plautus at Cambridge. Sixteenth-century humanist education in England required the use of Classical texts as a model for developing skills in writing and speaking. Latin drama was particularly popular in the universities, with Plautus and Terence (comedy) and Seneca (tragedy) being the most widely performed, ostensibly for educational purposes. Although the whole play is no longer extant, the portion which survives tells the story of Euclio, a miser who spends much of the play feverishly guarding his pot of gold. His daughter Phaedria is, unbeknown to him, pregnant by a young man called Lyconides, but has been promised in marriage to his uncle Megadorus. Eventually her pregnancy is revealed and the gold is stolen by Lyconides' slave. Surviving accounts suggest that the play finishes with Euclio recovering his gold, and giving it to Lyconides and Phaedria, whose wedding ends the play.

The play, possibly in part an allusion to hopes for Elizabeth's own marriage, is likely to have been chosen as 'a way of starting the festivities on a light-hearted rather than an obviously topical note'.[42] The Cambridge performers seem to have 'added a novel ending', making the production more visually and aurally spectacular, with a country dance, 'most likely at the conclusion of the comedy, to celebrate the eventual wedding of Lyconides and Phaedria'.[43] The University audit book for the production includes payments for 'a bryde Cake', twelve pence 'to a shoemaker for letherings the Belles for the morrys daunsers' and twelve pence 'for Belles to Bell and Rydgdale'.[44] Although it is no surprise that the University chose to present a Latin comedy for the educated young Queen, it is, as Boas notes, perhaps surprising that 'not one of the annalists has a word to say on the remarkable episodes of a Plautine comedy being acted on a Sunday evening in a Cambridge College Chapel'.[45]

XI · DRAMA IN KING'S COLLEGE CHAPEL

The Monday night performance was a Latin play entitled *Dido*, by Edward Halliwell, Fellow of King's; this was the tragic story, derived from Virgil's *Aeneid*, of Dido, Queen of Carthage, and her fated love for Aeneas, produced and performed by members of the College. It is described by Robinson as 'made up in large part of verses from Virgil' ('virgilianis versibus maxima ex parte compositum'), but it was, in his view composed 'with enthusiasm for learning but with a weaker instrument' than that of its Latin model ('discendi studio…sed tenuiore auena'). Halliwell, in other words, did not possess the poetic skill of his Latin source.[46] Like *Aulularia*, the play 'enabled the staging of impressive spectacle', appropriate to the visit of the Queen, including the construction of the walls of Carthage, 'representations of the storm from which Dido and Aeneas shelter', which 'probably included the use of artificial thunder', and possibly the 'hire of live hounds' for the hunting party. A precedent for this had been set with a King's performance of Euripides' *Hippolytus* in 1552–3;[47] this production had been, like the other productions recorded for King's College in the Renaissance, performed in the Hall, with a stage platform constructed for the event; in addition to the purchase of planks and nails for the stage, the College accounts also record the purchase of a dry vat to make the sound of thunder, lightning, gunpowder and hunting dogs. It seems that the College was accustomed to mounting quite spectacular productions, even when royal visitors were not present.[48]

Members of King's College also took on the performance of *Ezechias* on the Tuesday night ('the play called Ezechias in Englishe which was played by the kynges colledg').[49] The play's author, Nicholas Udall, had been dead for eleven years; although he had been a member of Oxford rather than Cambridge University, he had then become headmaster of Eton, sister College to King's. Udall was interested in reformist thought and theology, and involved in a number of projects to translate parts of the works of Erasmus into English.[50] The crucial features of his *Ezechias* in relation to contemporary Elizabethan religious politics are no doubt that it involved scriptural materials in English and addressed questions of church imagery and idolatry: Hartwell's description of the play is detailed, and indicates that it was adapted, relatively closely, from 2 Kings 18–19, in which Ezechias, King of Jerusalem, purifies religious practice by destroying the icons being worshipped by the people (including the bronze snake made by Moses) and stripping the temples of their gold.[51]

For this performance, Hartwell, a Fellow of King's, had also composed a poem, *Regina Literata*, about the occasion.[52] Here, in a formal display of modesty on behalf of the College, he offers an apology, ostensibly to the Queen, for this and the previous night's entertainments:

> Nam tibi quid dedimus, queis te, Regina, morati
> Muneribus? nostrum quid tibi dulce fuit?
> Horas ut longas et noctes fessas ederes
> Histrio dum raucos proiicit ore sonos.
> (For what have we given you? With what gifts, O Queen, have we stayed you?
> What of ours was sweet enough for you that you would sit, tired, for long
> hours and nights, with the actor spouting hoarse sounds from his throat?)[53]

As it transpired, such an apology appears to have been more than a nicety, since the Queen declared herself too tired to attend the performance of *Ajax Flagellifer* planned for the Wednesday night: a Classical Greek tragedy, no doubt designed to complement the Latin comedy, Latin epic play and English biblical drama performed on previous nights, and to show the full complement of Classical learning at the University. In the Queen's absence the performance was cancelled 'to the great sorowe not onlye of the players/ but of all the whole vniuersitie'.[54] As Robinson reports:

245

> Siquidem in basilica regali omnis hic conatus fit, vna sola abfuit, quae omnium harum motionum autor et impulsor esse potuit. Itaque accidit nobis per incommode, quibus ne hiscere quidem visus est Ajax ille flagellifer, quem furentem cernere desiderabamus ... Siluit ergo hac nocte Tragedia'
>
> (Even if all this endeavour were made in King's [College] Chapel, that one [lady] alone was not there who could be the author and mover of all this activity. And so, most inconveniently, we who were desirous of seeing that Ajax in his madness (or that *Ajax Flagellifer*) did not even happen to see that madman begin to speak ... that night the tragedy was silent.)[55]

However, the success of the Queen's visit, and of the plays, is indicated in part by her awarding to Thomas Preston, Fellow of the College, twenty pounds *per annum* (sic) for having 'acted in the Tragoedy of Dido so excellently well'.[56]

Nevertheless, Nelson reflects the views of many later commentators when he reports that 'King's College antechapel was not really suitable for plays'; it appears that after the Queen's visit the College resumed its habit of playing in the College Hall.[57] In the case of Queen Elizabeth's visit, of course, the concern was less with finding the venue most suited to vocal performance, and more with using the most spectacular venue available. Indeed, Elizabeth's presence and the nature of her arrival at the plays were themselves a crucial part of the 'performance'.

King James visits Cambridge, 1614–15

Over fifty years after Elizabeth's visit, her successor James I made a trip to Cambridge, and was similarly entertained with a series of plays. The Dering Manuscript indicates that the first four plays presented to King James were performed in the Trinity College hall between Tuesday 7 and Friday 10 March 1614. On the following Monday, the manuscript informs us, Kingsman Phineas Fletcher's fishing-pastoral drama *Sicelides* or 'The Piscatory an english Comedy was acted before the Vniuersity, in Kinges college'.[58] This English play was written in a classicising style, with choruses between the acts; its story of Olinda's rescue by Thalander has clear echoes of Ovid. According to the Dering Manuscript, 'master Fletcher of that College had provided [it] if the Kinge should have tarryed another night'; however, his party left one day earlier than planned, much to the disappointment of those involved.

From this particular entry, however, it is not possible to be sure whether the performance took place (or was planned to take place) in King's College hall, or in the Chapel. A private letter from John Chamberlain to Sir Dudley Carleton provides some details of the King's visit. We are informed that the Lord Treasurer 'lodged and kept his table at St John's College', 'his Lady and her retinue at magdalen' and the King and Prince 'at Trinitie college'.[59] The Treasurer of the Chamber accounts support this information, detailing payments for 'makinge ready, for his maiestie at Trinitie college in Cambridge twelve daies' and 'the Hall in Trinytie college for fower Comedies eighte daies'. These accounts also detail a payment for the making ready of 'Kinges college Chappell six daies'.[60] Since there is no other mention of King's College in either the Dering Manuscript or Chamberlain's letters, it is tempting to surmise that these expenses were in anticipation of the performance of *Sicelides* taking place, as those for Elizabeth had done, in the Chapel; but we do not know for sure. Wherever it occurred, however, unlike the performance planned for Elizabeth and cancelled after her departure, it

appears to have gone ahead in the King's absence; the title inscription of the 1631 edition reads, 'As it hath beene Acted in Kings Colledge, in Cambridge',[61] and Cooper records in the *Annals of Cambridge* that the play 'was acted at the author's College on the evening of the day on which the King left'.[62]

It was, however, also 'the last known production by King's'.[63] Douglas Paine points out that the royal approval granted by James to the plays which he attended in Cambridge became a double-edged sword for drama at the Universities, both stimulating the production of plays into the reign of Charles I, but also in time potentially contributing to its decline, due to 'the association with Royalist entertainment'.[64] Although Cambridge Colleges were technically exempt from Parliamentary prohibitions, at the University as elsewhere in the country drama came to 'a complete halt' in the late 1640s, with the rise of puritanism and the advent of the Interregnum.[65]

Drama after the Interregnum

There is very little information relating to the performance of plays in Cambridge from 1642 up until the middle of the nineteenth century. Plays appear to have been performed in some Colleges in the late seventeenth and early eighteenth centuries, but Cooper's *Annals* of 1842 record that a 'comedy called A Trip to Cambridge, or the Grateful Fair' performed at Pembroke in 1747 was 'the latest [last] instance of a public dramatic performance in any College here'[66] – presumably until the formation of University drama clubs in the nineteenth century. During the eighteenth and early nineteenth centuries, the authorities took the view that drama encouraged immoral behaviour, a view exemplified in the Players and Tavern Act of June 1737, which stated that 'all persons whatsoever who shall for gain in any playhouse, booth, or otherwise, exhibit any stage play, interlude, shew, opera, or other theatrical or dramatical performance, or act any part, or assist therein, within the precincts of either of the said universities ... shall be deemed rogues and vagabonds'.[67] Seventy years later, the Act for Regulating Theatres of 1843 extended the Vice-Chancellor's powers of veto over theatres to within fourteen miles of the University. Such acts seem to have been largely aimed at restricting public performances and ensuring that University students were not distracted from their studies.

Nevertheless, in 1830 the 'Shakespeare Club' was established, quickly succeeded in 1833 by the Cambridge Garrick Club. The members of the Garrick defended themselves in *The Album of the Cambridge Garrick Club* (1836), all the while acknowledging that 'in advocating the cause of the Drama, and proposing the formation of Dramatic Associations to further its views and advance it in public estimation, we are aware that we are assuming a dangerous position'; they asserted that, in forming their society, they would not 'thereby blind [them]selves from the fact, that serious evils would undoubtedly arise from the formation of such societies, were they not under strict and wholesome regulations , and vigilant and respectable control'.[68] The establishment of these two clubs was followed in 1855 by the founding of the ADC (Amateur Dramatic Club), and then the advent of The Cambridge Greek Play (1882), The Footlights (1883) and The Marlowe Society (1907).

In the twentieth century, members of King's College played a key role in Cambridge drama, in particular John Maynard Keynes and George ('Dadie') Rylands, who shared what Rylands described as 'a passion for the stage, Shakespeare and the English poets'.[69] Keynes came up to King's in 1902 to study mathematics, later undertaking an MA in Economics, before becoming a lecturer in this field (1908–15), and a Fellow and Bursar of the College (1909–1946). A member of the influential Bloomsbury Group and an art collector, Keynes was a key figure in CEMA (the Council for the Encouragement of Music and the Arts), and the founding chairman of its successor, the Arts Council

of Great Britain; he was also a personal supporter of The Royal Opera House and Sadler's Wells. However, conceivably one of his most significant contributions, not only to Cambridge theatre, but to British theatre as a whole, was in 1936, when he and his wife, the celebrated ballet dancer Lydia Lopokova, founded the Cambridge Arts Theatre, on land leased at a peppercorn rent from King's College. The ties between the Arts Theatre and the College remain strong today, with the launch of a major theatre rebuild taking place in King's College Chapel in May 2011.

Keynes' close colleague, Dadie Rylands, had arrived early from Eton to study at King's College (in January 1921), coming up, at the request of Provost Sheppard, to perform in the Cambridge Greek Play – Sheppard's production of *The Oresteia*. Beginning in the Classics tripos, he subsequently transferred to English, later becoming a Fellow of King's (from 1927 until his death in 1999) and a University lecturer in English (1932–1962). An active participant – both as actor and director – in the Cambridge Greek Play, the Footlights, the ADC and the Marlowe Society, it was through the Marlowe Society that Rylands had his most profound influence on the English theatre,[70] working with students who included Ian McKellen, Derek Jacobi, Trevor Nunn, Peter Hall and John Barton, all of whom were to become leading figures in the British theatre. For this generation, Rylands had a huge influence on the speaking of Shakespearean verse. He himself became the Arts Theatre chairman from 1946–1982. Throughout his time at King's he was also a regular reader at services in the Chapel and responsible for devising a number of special readings of poetry and drama in the College including 'readings in the Provost's drawing room', 'recitals in the hall' and 'pageants…in one of which Boris Ord, Donald Beves and John [Barton] were all dressed up as puritans'.[71]

Everyman, 1924

However, it may in fact have been Edward Dent (1876–1957), the musical scholar and critic, who was at least partly responsible for the first dramatic performance in King's College Chapel since the visit of Elizabeth I that we know of for sure. Although throughout the eighteenth century the College 'Votes of Council' regularly record permission granted for musical events in the Chapel, predominantly for the performance of religious oratorios, it is not until 1924 that the first permission appears for a dramatic performance: on 2 February, the minutes record a decision 'to allow the use of the Ante Chapel on March 15, for two performances of the Morality *Everyman*, by the company of the Old Vic, one of the best known theatre groups in the country', then under the management of Lilian Baylis (from 1912 to 1937).[72] It seems likely that Dent, who came up to King's in 1895 and was a Fellow in 1902–8 and 1926–41, had something to do with this. From 1927 to 1948–9, he was a governor at the Old Vic (and later on the board of Sadler's Wells). In 1929, he wrote on 'Social Aspects of Music in the Middle Ages' for *The Oxford History of Music*; he was responsible for a number of revivals of early musical theatre, several of them in Cambridge – Mozart's *Magic Flute* (1911), Purcell's *Fairy Queen* (1920) and Handel's *Semele* (1925); he was, moreover, 'keenly interested in drama', once attending the medieval passion play still performed at Oberammergau in Germany.[73]

Although *Everyman* dates from the late fifteenth century, the King's performance has its origins in a 1901 production by theatre director William Poel, who was well known for reviving Shakespearean and medieval drama. Poel was suffering trauma after the recent death of his mother, and the play was suggested to him by his friend Adolphus Ward, who felt that it might provide Poel with some comfort.[74] The production, the first of *Everyman* for well over one hundred years, was initially mounted at Charterhouse school and then at University College, Oxford. These were a huge success

and Ben Greet, an actor, director and producer who had worked closely with Poel, teamed up with him to take the play on a tour of Britain and America, and finally into the Old Vic, where it was directed first by Greet and then by the famous actor and director Robert Atkins. *Everyman* became a staple of the Old Vic repertoire, being 'regularly performed in Lent, starting in 1915'.[75] It can be no coincidence that this tradition began one year into World War I; it continued until 1950.

In March and April 1924, the production of *Everyman* was in the company's repertoire, playing at the Old Vic every Tuesday afternoon in Lent, and on 14–16 and 19 April during Holy Week. It must have been something of a coup for the College to have secured a performance from the Old Vic theatre, directed by Atkins and featuring a cast of actors including D. Hay Petrie, John Laurie (later of *Dad's Army* fame) and Dorice Fordred.[76] The King's College production on 15 March was, it appears, a one-off external performance undertaken at the invitation of the Provost and Fellows. The Provost, Walter Durnford, was himself an enthusiastic participant in University drama, especially in the Cambridge Greek Play, with which he was involved for a number of years.[77] In February, Baylis wrote to Dent, 'I think you will like to know that we are invited by the Provost and Fellows of King's College, Cambridge, to play Everyman there…Isn't it delightful, especially as I am hoping that the College Choir will help with the music'.[78]

The performance was clearly a momentous event, with demand for tickets extremely high. Lilian Baylis valued the invitation as a great 'tribute',[79] describing the performance, 'given on the chancel steps' (with the screen as a backdrop), as having been highly 'moving' and 'worthy of its ideal setting in that lovely Chapel'.[80] Nevertheless, the production's reception in Cambridge was rather more mixed than Baylis's remarks might suggest. Writing in *The Granta*, an anonymous reviewer begins:

> There may be some truth in the saying that at 5 o'clock on Saturday, 15th March five hundred people were furious because they had obtained tickets for the performance of 'Everyman', and a thousand were furious because they had not.[81]

He explains that whilst the company 'certainly succeeded in creating wonderful "atmosphere" … helped by the setting' (that is, the screen, which 'provided a background such as no scene painter ever achieved', and 'the glorious singing of the hidden Choir'), 'the Antechapel of King's is not in the least suited to the presentation of a play to an audience which fills the whole space, and which is seated on the same level as the stage [in fact there are two low steps]; and it is also true that the acoustic properties are exceedingly bad'. The reviewer concedes that should the morality play have been observed by an audience of 'say, forty or fifty people', then 'no building could be more suitable'; but it seems that, apart from those audience members sitting in the 'first few rows of seats', much of the performance was inaudible and difficult to see.[82]

Chapel Dramas in the 1960s

Whether for reasons of practicality or acoustics, it was to be another thirty-eight years before the Chapel was used again as a theatrical venue. The Annual Reports of the College Council record two pageants performed in 1962 and 1963, directed by Mrs Camille Prior in aid of the Milton Church restoration fund.[83] Prior was, in the words of Sydney Castle Roberts, an 'indefatigable producer of every kind of dramatic and musical show'.[84] She was famous for the pageants that she would stage 'during long vacation terms' which, according to Raymond Leppard, 'each … set out to illustrate

different aspects of history – Queens of England, Cambridge through the ages, Kings of England – but ended up much the same each time, with the celebrated "Prior step" [some simple dance move?], the only one she knew to give a semblance of corporate dancing'.[85] The two pageants produced in the Chapel were religious in subject – *A Candlemas Pageant* (1 and 2 February 1962) and *A Pageant of Paul* (25 and 26 January 1963).

Little information survives about *A Candlemas Pageant*, but one might surmise that it was modeled on the pageants that were customarily performed in the Middle Ages on Candlemas day (2 February) – 'dramatisations of the Purification incorporating processions with candles' of which some records survive.[86] *A Pageant of Paul* was mounted to celebrate the feast of the conversion of St Paul. Stephen Culverwell, in *The Cambridge Review*, reports that the performance was 'smaller in scale' than most of Prior's 'previous productions, and certainly shorter in length'. It was performed in the antechapel and consisted of eight tableaux, beginning with 'the stoning of a sympathetically wistful Stephen'. The tableaux were linked with a commentary read by the Rev. P. G. S. Cameron, whilst Dadie Rylands read 'selections from the Apostle and from other authorities (John Donne amongst them)'. Culverwell's review is not particularly lavish in its praise, describing the performance as 'effective and careful enough'. The only reference to the Chapel is a negative one: 'the great drawback was the cold…shivering in King's is not the same', he says, as shivering on St John's College lawn, as audience members might have done for Prior's summer pageants.[87]

The following year (27–28 June 1964) the College granted permission to a London amateur theatre group – the Lambeth Players, in collaboration with the St Bartholomew Singers – to perform *The Play of Daniel* in King's Chapel as part of a larger fund-raising tour, which also visited the Priory Church of St Bartholomew the Great, Westminster Abbey, the Edmundsbury Cathedral, Lavenham Parish Church in Suffolk and Rochester Cathedral in Kent (see Ills. 192 and 193). The thirteenth-century *Play of Daniel* with music was written for Beauvais Cathedral; it is in two parts, the first dealing with Daniel at Belshazzar's court, and the second with Daniel's trials at the court of Darius. Its monophonic music is not so much dramatic as an outgrowth of the plainsong liturgy. Nevertheless, in 1964 the programme for the performance opined that it was to be sung 'monophonically without any attempt at harmonisation in order to give the performers as much freedom as possible to interpret their roles dramatically'.[88] No information survives about the way in which the Chapel was used as a venue for this production; however, the stage directions in the W. H. Auden translation of the Latin text, provided in the programme, give some indication of how it might have been performed: 'The King ascends the throne and the court acclaims him', 'The processional of the Queen', 'Daniel retires to his house to worship his God privately. The envious see this and run to the King'.[89] It is possible that the thirteenth-century performances in Beauvais Cathedral would have been richly ceremonial and, as well as using the main aisle for elaborate processions, it is likely that they made use of the nave to accommodate 'three stages to denote the areas for the palace of King Belshazzar and later King Darius, Daniel's house, and the lion's den'.[90] Certainly King's Chapel lends itself to a similar style of staging, and with a cast of fourteen solo singers, seven narrators and choruses of singers and dancers, the performance must have been an elaborate event. It is also likely that, being sung rather than spoken, the performance may have been less subject to the problems of audibility experienced at *Everyman*, and at many of the dramatic productions that were to follow.

A further performance of *The Play of Daniel* took place in the Chapel on 19 January 2007 – the first professional production to have taken place in the Chapel since *Everyman* in 1924. Performed by eight singers and six musicians from the Harp Consort, the piece, whilst again predominantly sung, merits mention here due to the fact that it was fully and elaborately staged. This production, which was also

Ill. 192. Cover of playbill for *The Play of Daniel*, performed by the Lambeth Players and the St Bartholomew Singers (King's College Chapel, Cambridge, 27–28 June 1964). Collection of the author.

Ill. 193. Title page of playbill for *The Play of Daniel*, performed by the Lambeth Players and the St Bartholomew Singers (King's College Chapel, Cambridge, 27–28 June 1964). Collection of the author.

The Play Of Daniel

presented by

The Lambeth Players

and

The St. Bartholomew Singers

produced by

Jean Claudius

Conductor of the St. Bartholomew Singers	Brian Brockless
Instrumental arrangements	Freda Dinn
Musical Adviser	Guy Oldham

251

performed in Southwark Cathedral as part of the celebration of the 'Feast of Fools', was conducted by Andrew Lawrence-King, who encouraged his musicians to improvise around the single line of notation 'within the ordo of authenticity'. Believing that the medieval *ludus* 'bestows a licence to break the accepted rules, and throws down a challenge to understand the conventions well enough to flaunt them', he challenged his performers, 'to be appropriately disobedient, to have serious fun'.[91]

Student and School Productions in the Chapel, 1977–2012

All dramatic productions in the Chapel from the 1970s onwards appear to have been either by Cambridge University students, beginning in 1981 with a production of T. S. Eliot's *Murder in the Cathedral* (King's Drama Society)[92] or, on three occasions, the pupils of King's College School (KCS). The first of the School productions was a version of the *Chester Mystery Plays* staged by the School's headmaster David Briggs to mark his retirement.[93] Many of the plays and one musical drama performed by the students of the University and School have, like these two productions, had some notional connection to the building, most commonly a religious one: Jean Anouilh's *Becket* (King's Actors and the ADC, 1997) set, like *Murder in the Cathedral*, partially in Canterbury Cathedral; the religious morality play *Mankind* (King's Drama Society, 1989); *Go Down, Moses* (KCS, 1986), described in its programme as 'The Pharaoh Play from the mediaeval Wakefield Mystery Cycle, in the modern version by Martial Rose' with additional hymns, spirituals and songs;[94] Benjamin Britten's opera *Noye's Fludde* (KCS, 1990); and Robert Bolt's *A Man for All Seasons* (King's Drama Society and Clare Actors, 1995), a play about the conflict between Thomas More and Henry VIII over Henry's marriage to Anne Boleyn and break with Rome – a conflict that was unfolding at exactly the time that Henry was completing the Chapel windows and screen.

For most of these productions, the use of the Chapel as a venue seemed fitting, partly for its appropriateness to the subject matter of the plays, and partly due to its sheer size and status. Where reviews exist, they are, for the most part, fulsome in their praise of the physical impact of the building. If, in the case of *Becket*, for example, a *Varsity* reviewer could call the production 'exceptional', it was 'because of the setting – and the use made of it – rather than anything else'.[95]

The Chapel might seem a less obviously appropriate venue for the Elizabethan and Jacobean plays performed there: *The Duchess of Malfi* (1984), *A Midsummer Night's Dream* (Pembroke Players, 2008) and *The Spanish Tragedy* (Marlowe Society and Perchance Theatre, 2012, see Ill. 191). Nevertheless, in two of these cases, the directors have commented on the importance of the scale of the building for their respective performances. Niall Wilson, director of *The Spanish Tragedy*, asserted that for him the Chapel seemed the perfect venue for Kyd's play, matching the 'grand' scale of the revenge tragedy,[96] while James Lewis, director of *A Midsummer Night's Dream*, was keen to find a venue that could match the scale and style of the large proscenium arch theatres in which the production had performed while touring in Japan. For both productions the Chapel setting also lent itself to the plays' supernatural elements. The Chapel felt to Lewis 'like a place in which Oberon and Titania might exist', its atmospheric evocation of a magical world being heightened by the use of 'candles on either side of the stage' and up-lighting at the sides, casting strange and 'beautiful' shadows on the building's walls.[97] For *The Spanish Tragedy*, the sense of a constant supernatural presence – the action of the play being observed throughout by the personification of Revenge and the ghost of Andrea – was enhanced by the angels protruding from the Chapel organ, 'a towering, powerful presence over the play's action'.[98]

Without being able to construct the kind of raised stage platform that was erected in 1564, one of the challenges of performing in the Chapel has always been how to use the available space so that all audience members can see the action. Apart from that of 1564, all productions seem to have elected to make use of front-on seating, facing the screen, with actors performing on the raised steps. However, such a configuration creates sight-line problems, particularly when trying to accommodate a large audience. Nancy Napper Canter, reviewing *The Spanish Tragedy* in the *TAB* (the Cambridge student tabloid newspaper), wrote that 'only the people sitting in the front half could enjoy it'.[99] Even though Lewis limited his audience for *A Midsummer Night's Dream* to seven rows (around 116 people), he concedes now that 'it was difficult to see what was happening unless you were on the front row', adding, 'and when you were on the front row it was difficult to take in the production, because you were too close for a decent perspective (it was full of carefully-designed proscenium stage pictures)'.[100]

This is not to say that these, and other productions, have not made imaginative use of the space available. Wilson made every attempt to make full use of the length of the Chapel for *The Spanish Tragedy*, creating a sense of 'three distinct spaces – the private Spanish court (behind the screen, between whose doors the Queen emerged, triumphant, in the first major scene), the public Spanish court (the stage and surrounding area) and 'other' places (Portugal, and in some scenes, Hell) behind the audience'. He also utilised the screen doors, antechapel doors and aisles to 'create a sense of six distinct entrances and exits', giving the audience the sense of being immersed in the action.[101]

However, perhaps the most successful use of the antechapel space has been in a promenade configuration, according to which the audience follow the actors as they pass round the performance space. This was used for the KCS production of *Go Down, Moses*. Here, the antechapel was cleared, as far as possible, of seats, enabling the cast of around thirty pupils to move from 'the Burning Bush by the south door', to 'Pharaoh's court on the screen steps', whilst the young actor playing God was wheeled around the space on a scaffolding tower,[102] a device not dissimilar to that used for the figure of God in the medieval mystery plays. This had the great benefit of enhancing the audience's ability to hear as well as see the performers; its director, Gerald Peacocke, school headmaster and Master Over the choristers from 1977–1993, aware of the 'severe challenge' faced by 'the spoken voice in the Chapel', observed how much better the audience was able to hear as it followed the actors 'from area to area'.[103]

The problematic acoustics of the Chapel, however, have continued to plague productions. Both *Murder in the Cathedral*[104] and *Becket* were criticised by reviewers who struggled to hear the words: one complained, in the case of *Becket*, that towards the back of the seating area 'the echoes take over and the play becomes almost operatic'.[105] Simon Scardifield (now a professional actor), who appeared in *Mankind*, comments, similarly, that he recalls little of the production other than 'the seven second echo', adding that the actors' speech felt 'very exaggerated and probably sounded it'. He says he 'despaired of the comedy ever working because it was all too much like driving an oil tanker'.[106]

The unsuitability of the Chapel as a theatrical venue became an issue of contention early in the twenty-first century, leading to drama productions in the building being halted for a time. A lengthy exchange in the College files records an unsuccessful attempt in 2003 by English student Chris Till of the King's Drama Society to persuade the College to allow the students to mount a production of *A Sleep of Prisoners* by Christopher Fry. This was a form of modern passion play, set in a church, in which four soldiers are held captive for the night, and must have seemed a perfect choice for the Chapel. Nevertheless, the request was refused by the Dean and Chapel administrator on the basis that 'all of the last three' dramatic performances in the Chapel 'had created problems of one kind or another'. According to Derek Buxton, the Chapel administrator John Boulter was, because of the

poor acoustics, 'strongly opposed to the concept of drama in the Chapel'; apparently 'on previous occasions he ha[d] had to deal with angry customers'.[107]

It is then, perhaps, surprising to find in 2008 the Pembroke Players' 'home run' of their Japan tour of *A Midsummer Night's Dream*[108] taking place in King's Chapel (11–13 October 2008), with reviews which re-iterate the same problems: 'what the Chapel makes up for in atmosphere and occasional reverberating acoustics, it lacks in the practicalities of an actual theatre'.[109] So why did Pembroke players opt for King's Chapel for their Cambridge venue, and how were the authorities swayed to repeal the ban so firmly insisted upon in 2003? With the arrival of a new chaplain, Richard Lloyd Morgan, a former opera singer, and the new Dean, Ian Thompson, there seems to have come a change in attitude towards the use of the Chapel. The antechapel had in fact been used for The King's Affair – the College's equivalent of the college ball – that summer. Thus, when the company approached Richard Lloyd Morgan, he was, according to director James Lewis, 'keen on the idea', whilst the Dean, in giving his consent, cited the 1564 precedent for drama in the Chapel.[110]

One solution to such problems was to stage an operatic play. In 1991, on the 550th anniversary of the College, KCS staged a production of Britten's *Noye's Fludde*, involving a cast of ninety-one. This was, of course, completely in accordance with Britten's own instructions that the opera should be performed in a church or other large building, but not in a theatre.[111] Again, Peacocke details his and director Chris Chivers' attempts to overcome the problems with the Chapel acoustics for the spoken word. It was agreed, for example, that Peacocke himself should perform the role of God 'from the organ loft [screen], standing on the wooden casting'. Peacocke reports that 'the combination of height and a big vocal effort on my part succeeded', and recalls with pride that one woman, sitting near the front of the audience, jumped 'about a foot in her seat, as I bellowed the opening words'.[112] But of course most of *Noye's Fludde* is sung, and here Peacocke and his experienced Chapel choristers would have been in their element, as no doubt they would have been with the hymns, songs and spirituals included in the production of *Go Down, Moses*, including the famous negro spiritual from which the production took its name.

The fact that Chapel acoustics challenge the clarity of the spoken word but enhance music and other forms of sound is also illustrated by accounts of both *Murder in the Cathedral* and *The Spanish Tragedy*. As composer George Benjamin recalls of *Murder in the Cathedral*, for which he wrote the incidental music:

> [this] featured a solo trumpet, two voices – and the organ. At certain moments I attempted to evoke a dark and menacing atmosphere by exploiting dense clusters at the bottom of the organ pedals, using only the lowest 32' stops. The whole building seemed to vibrate in sympathy with this ominous sound – indeed, at one moment, I feared a headline in the next day's *Cambridge Evening News* along the lines of: 'Student causes King's Chapel to collapse with ill-judged musical experiment'. Fortunately that didn't prove necessary.[113]

Similarly, with *Spanish Tragedy*, whilst reviewers noted that the echoes produced by the building tended to 'drown out the dialogue', particularly for those seated further back in the audience,[114] so that 'many people further back couldn't hear a thing',[115] they also commented that the points at which the echoes complemented the script were 'striking throughout',[116] exaggerating both the shrieks and silences and creating a 'sensory experience, quite unparalleled' in other University shows. Wilson reports that although 'the acoustics/ audibility was certainly the main point of criticism leveled at the production',

they also enhanced the use of the organ and Choir music, particularly in the opening sequence.[117] He had fought hard to be allowed to use the organ for his production: 'it seemed perverse to come into the Chapel, stage a Gothic tragedy and not use it'. The production thus opened with a spectacular funeral march, with Minos, Aeacus and Rhadamanth, in black robes and carnival masks leading a procession, carrying Andrea's body, to the stage, Revenge bringing up the rear, whilst a military drummer played, and the organ blasted out Purcell's *Music for the Funeral of Queen Mary*. Wilson describes this march as 'probably the most effective piece of staging in the whole show in terms of utilising the Chapel', but adds of the Chapel, 'it's simply not built for a play'.[118]

James Lewis's production of *A Midsummer Night's Dream*, one of the more successful student performances to have graced the Chapel, also apparently benefitted from its acoustics, rather than being hampered by them. As for *The Spanish Tragedy*, the musical elements of the production – in particular Finn Beames' 'haunting, moving score'[119] – were especially effective in the Chapel setting, and Lewis recalls that the first time that he heard the production's opening unaccompanied song, sung in the Chapel by cast member Celeste Dring, he was 'blown away'.[120] Certainly the reviews do not comment on difficulties with audibility, only on the enhancing properties of the reverberating sound. This may, in part, Lewis suggests, be due to the limited number of audience members. However, it was also undoubtedly due to the skill of the company in managing the space.

Lewis explains, 'weirdly, a very quiet delivery was more effective than a loud one. If you shout then the noise hangs in the air for ages. Better to whisper and let the building do the work for you'. Of course, the echo could also be exploited, and was, in comic fashion, for Bottom's performance of Pyramus' lines: 'after Bottom (Adam Hollingworth) delivered his line "The Raging Rocks/ And shivering shocks", he stood for a beat or two and admired its echo. He then made a little gesture up at the building as if to say 'Not bad, eh?' That always got a laugh!' The production sold out on every night.[121]

Ill. 194. OVERLEAF: The Chapel screen viewed from the west side. Photograph, *Country Life*; reprinted Christopher Hussey, *King's College Chapel, Cambridge and the College Buildings* (London: Country Life 1926). Cambridge, King's College, KCAR/8/9/2/15.

Music & Performance

Ill. 195. Cherub, Provost's stall, east side of screen, 1530-40, height 38 cm.
King's College Chapel, Cambridge.

XII

Chapel and Choir, Liturgy and Music, 1444–1644

ROGER BOWERS

As conceived by Henry VI King's College was endued with a dual purpose. One role was the facilitation of the progress of its academic members through the diverse courses of university study towards receipt of their degrees; the other was the amplification and enhancement from its Chapel, for the benefit of all mankind and especially of its founder, of the existing volume of earthly worship offered daily up to God. While the forms of worship were tendered by the existing liturgy of western Christendom, the supply of an appropriate chapel locale, and of the means of subsistence for its enactors, was a function of the founder. Thereafter it was the duty of successive Provosts to ensure that the requisite staff were duly recruited, that they fulfilled their duties, and were supplied with the necessary materials. For most of this period, therefore, it was less by any particular initiatives on the part of the musicians than by the personality and objectives of the incumbent Provost, whose bidding they observed and whose policies they implemented, that the character of Chapel music was most pervasively determined.

The ambience, quality and character of the Chapel service and of its music evolved markedly over these 200 years. In pre-Reformation times these responsibilities exercised for successive Provosts the highest priority, as a barometer of their zeal in fulfilling, within contemporary expectation, the exalted vision of the founder. Later, during the period of religious reform, the nature of Chapel observance served as a cardinal advertisement for the intensity of the College's adherence to the immediate heat of religious change. Only briefly, in the early seventeenth century, did the life of the Chapel begin to detach somewhat from the College's mainstream work, so disconnecting its staff unpropitiously from central oversight, direction and vision; and nothing could obviate the extinction of elevated music from Chapel observance at the onset of the Civil War.

The Foundation, and the First Chapel

On 29 September 1444 there was laid the foundation stone of a dedicated Chapel sited immediately south of the 'Old Court' of King's College (where now lies open lawn north of the present Chapel), and on 17 October 1447 the completed building was dedicated for use.[1] Of its design and appearance almost nothing is known, and as a structure it was but interim; however, progress upon erection of the new Chapel was slow, and until 1537 this first Chapel served for all observance of divine service.

Under the College's statutes (as codified in 1453), its personnel incorporated a dedicated Chapel staff required to observe, according to the liturgy of Salisbury Use, the full round of religious service as performed in any great corporate church of the time. Consisting of the sacred texts themselves, the immense body of plainsong chant to which they were sung, and the elaborate ceremonial of

vestment, ornament and movement by which all was accompanied, the contemporary Latin liturgy was a construct of immense complexity; and, from choir stalls disposed in facing ranks on the two sides of the quire, it was performed by three dedicated grades of clergy: senior priests, younger priests and singing-men, and chorister boys.

At King's there were to be ten chaplains in priest's orders (known as 'conducts') to stand among the Fellows (when present) and service the top row of stalls; six professional singing-men or 'lay clerks' to serve (with the junior Fellows and scholars) the second row; and sixteen boys, below the age of twelve at admission, as choristers of the third row. High Mass, the Mass of the Blessed Virgin (Lady Mass), and the cycle of eight services of the Office, consisting of matins and lauds at daybreak, prime, terce, sext and none during the morning, and vespers and compline at mid-afternoon, were performed daily. Also celebrated were numerous offerings of low mass.[2] The Hours of the Virgin were sung by the choristers alone, as was also, before an image of the Virgin Mary and 'in the finest manner they know', the evening votive antiphon. On the patronal festival (St Nicholas, 6 December) the 'boy bishop' liturgy was observed; and on such festal occasions music could also be made after dinner in hall, as the Fellows and scholars lingered over songs and other honest relaxations. Daily in hall, all present concluded grace by singing a Marian antiphon and a psalm.[3]

On the Provost was laid a special responsibility for ensuring that all the places for Chapel staff were continuously filled. Further, each year a chaplain was appointed as precentor, responsible for the satisfactory performance of all aspects of divine service. To each chaplain and clerk there was appointed a stipend, with livery, board and lodging; within the 'Conducts' Court' and 'Clerks' Lodgings', a composite edifice lying immediately south of the then Provost's Lodge, each enjoyed an individual room. Here also was the schoolroom and, apparently, also the keeping-room and dormitory for the choristers. These boys were to be chosen from among the poor; they were wholly boarded, lodged and clothed, and in hall they waited on the Fellows' tables.[4] Their material welfare was overseen by a College bursar acting as their 'supervisor'; their training in singing and in other Chapel duties, and in liturgical Latin, was committed to their Master, an office deputed to either a clerk or a chaplain. Suitable choristers were given preference in elections to scholarships at Eton College, and likewise for election to return to King's as scholars in due course.[5]

This choral body was of middling size for its period. The number of choristers, sixteen, was excessive, but it enhanced propitiously the College's educational value; ten chaplains were needed to celebrate the daily masses stipulated by the founder. Six was about the working minimum of professional singing-men as lay clerks, enabling especially the enhancement of the services by their singing of pieces composed in mensural polyphonic music (in replacement of certain plainsong items). In the 1440s this manner of performance was rising to a newly special prominence, for use particularly at daily services votive to the Blessed Virgin – both for the ordinary of Lady Mass, and for stanzaic texts suitable for its sequence (sung between the epistle and gospel) and also for the evening Marian antiphon. Additionally, celebratory motets on specific texts were sung at the conclusion of High Mass on feast-days. This music was composed most commonly in three parts, for the solo adult voices of an alto and two tenors. Finally, the Chapel was furnished with one or more of the modest organs of this period, of which always one of the clerks or chaplains was to be a competent player.[6]

XII · CHAPEL AND CHOIR, LITURGY AND MUSIC, 1444–1644

The Chapel Choir: Consolidation, Attenuation, Restoration, 1444–1479

Anticipating needs, in December 1443 King Henry delivered to the College a large stock of service books, including one volume of polyphonic settings. A huge supply of vestments arrived at Ascensiontide 1444, and by the end of that year the nucleus of a Choir existed, of four men and four boys, singing service in the nearby parish church of St John Baptist.[7] As the first Chapel neared completion, under John Chedworth (Provost 1447–52) full-scale recruitment was inaugurated early in 1447. By May the King had seconded William Boston from the Chapel Royal to be both precentor and Master of the Choristers,[8] and to inaugurate the newly completed Chapel in October there existed an adequate working personnel of three chaplains, four clerks and nine choristers. Late in 1448 more chaplains and clerks were engaged from Boston, Eton and London, and during 1450–51 choristers from London. By January 1449 statutory numbers were already as good as full; and King Henry duly commended the oversight of his College to Robert Wodelark, Provost 1452–79, 'desiring alway that, like as in alle thinges pertcyning to thobservance of dyvyne service... hit passeth ... all other'.[9]

By 1452 the Chapel was amply provided with books of chant; also, the services were being enhanced with singing from three books of polyphony, including one starting with settings of 'Kyrie eleison' for Lady Mass, while another was perhaps a book of motets. The Chapel was equipped with the usual pair of organs, one 'great' (probably sited on the rood-loft) and one small; this latter was placed by the altar of the Virgin Mary, before whose opulent image the choristers also gathered to sing the evening votive antiphon.[10] For the liturgy of the 'boy bishop' there had been procured a resplendent aggregation of vestments; and the provision made for patronal feasting was always copious, augmented when (as in 1476) expenditure on the boys was amplified by a contribution from the bishop's own proud father.[11]

The deposition of Henry VI in 1461 introduced a period of anxiety and instability, brief but doubtless acute. The College suffered loss of estates, and for some forty years thereafter could operate on only a much reduced scale. In 1465 it was maintaining only twenty-three Fellows and scholars, and up to 1469 the Choir was reduced to two chaplains, three or four clerks and eight choristers.[12] Circumstances during the 1470s permitted a gradual restoration of Choir numbers; nevertheless, College management was content to maintain solely the routine Chapel service, embarking upon none of the innovations in church music currently under exploration elsewhere. It appears that somewhat less was now expected of the choristers in Chapel; briefly, the eldest were sent to attend the town grammar school, which King's College hosted in premises first on School Street, and from 1467 on Milne Street, by the southern gateway into the close.[13]

The Fulfilment of the Vision: The Music of the First Chapel and the New, 1479–1547

In respect of the Choir, Provost Wodelark appears to have been pleased merely to have largely revived numbers and to have restored some stability; in particular, in c. 1480, the Chapel still possessed only its original books of polyphony.[14] It was Wodelark's successor Walter Field (1479–99) who fulfilled the true potential of the founder's vision, so generating a momentum sufficient to sustain the Choir

until the Reformation. Not least, Field furnished the Choir with a recognised liturgical manager, in 1482 appointing William Clerk as precentor.[15] Clerk's consummate expertise in the Salisbury Use liturgy contributed to his preparation of an authoritative revision of its standard guide, the *Directorium sacerdotum*, printed for issue in *c.*1499.[16]

Under Field the Choir was also brought abreast of recent far-reaching innovations in church music. Since *c.*1460 composers had been creating the quintessential sound of English cathedral music, introducing fully choral polyphony ('pricksong') conceived for performance by a compact five-voice ensemble of boys and men (treble, alto, two tenors, bass), applied to pieces of extended duration and great technical challenge.[17] Created primarily for the ordinary of both High Mass and Lady Mass, for the Marian antiphon (sung now by full Choir), and for the Magnificat at festal vespers, this extrovert style has become known as the 'Eton Choirbook' style, after the magnificent volume made in *c.*1502–4 for the Chapel of King's' sister college at Eton, where it yet resides.[18]

Having completed by 1481 the restoration of full Choir membership,[19] Field next oversaw the inauguration of the accumulation of a working repertory of this new and extravagant polyphony; this was busily copied by lay clerks who evidently included one who was able, as Master of the Choristers, to instruct the boys in all the skills of singing in this new style. During 1481/2 Marian votive antiphons (one by Edmund Turges), a Magnificat, and pieces for Easter and for the reception of royalty were acquired. Next year more Marian antiphons (one by a 'Mr Hacumblen'), office responsories, canticle settings of Nunc dimittis and Magnificat, two masses by Turges, and 'antiphons, responsories, and sequences' composed by the lay clerk William Suthey were added.[20] Also active, perhaps, was the 'Eccleston' (Henry or Alexander, Fellows, both former choristers) whose name was written across a passage of three-part music of *c.*1480 scribbled onto an account-book cover, as an exercise in informal mental composition later continued by others much less skilful (Ill. 196).[21]

The repertory so begun was soon amplified by later acquisitions.[22] It was sung unaccompanied; the function of the two organs at this period was primarily to improvise upon an apposite plainsong, at the Offertory of mass and in alternation with the Choir during repetitive items such as the hymn and celebratory Te deum.

Ill. 196. Informal musical workings with the name of [Alexander or Henry] Eccleston, *c.*1480. In Mundum Book 1456–1459. Cambridge, King's College, KCAR/4/1/1/3, fol. 61 v.

XII · CHAPEL AND CHOIR, LITURGY AND MUSIC, 1444–1644

The momentum generated by Field was sustained fully under Provosts John Doggett (1499–1501), John Argentine (1501–08) and Richard Hatton (1508–09). As Chancellor of Salisbury Cathedral, Doggett had experienced English liturgy at its fountainhead. Argentine, sometime Dean of the chapel of Arthur, Prince of Wales, was acquainted fully with elaborate chapel worship. Hatton made almost his first act the acquisition for the Choir of particular compositions from Fotheringhay collegiate church.[23]

Given the virtuosic and challenging nature of contemporary church polyphony, the recruitment and, in particular, the retention of singers and choir-trainers of appropriate quality soon became a serious concern. One chorister and two uncommonly able lay clerks, the composers Thomas Farthing and Humphrey Frevyll, were taken at Christmas 1498 for the chapel of Lady Margaret Beaufort, mother of King Henry VII; and her response to the College's letters of appeal was simply to seize another lay clerk.[24] However, John Doggett had influence at court, and in 1500 obtained from the King comparable royal licence to appropriate on demand from elsewhere the services of chosen singing-men and boys. This privilege was promptly used to recruit men from Buckingham, Northampton, Banbury and Bedford, and boys from London. In 1506 the King attended service in the old chapel on St George's day, and the privilege was renewed; and in 1507 four choristers, their Master and the precentor were taken from Fotheringhay College.[25]

Repertory-building continued apace, especially under Doggett. In 1499 the College was visited from Eton by the composer Robert Wylkynson; masses and Marian antiphons were copied by the chaplain John Sygar (composer of two Eton Choirbook Magnificats), and by Thomas Stephens, Fellow and former chorister (and boy bishop in 1490).[26] Doggett also oversaw the acquisition of a repertory of secular song, being twenty-four 'carols' and twenty 'baletts' for up to five voices, evidently for recreational usage in hall as envisaged by the statutes.[27] The texts of a group of four carols (without music) copied at the College at exactly this time indicate the kind of material then in favour for such diversion (Ill. 197).[28]

Under Argentine the accumulated polyphonic repertory was rationalised by binding into volumes (for which a substantial chest was made in 1502),[29] while a new organ was built in 1507/8 by Thomas Brown of London for £48.[30] There occurred intensive copying of Lady Mass sequences, and of masses and Marian antiphons (six and ten respectively in 1503 alone) composed by such as Robert Fayrfax and William Cornysh of the Chapel Royal.[31] Composers attracted to be lay clerks included William Rasar, Richard Hampshire, Robert Perrot and Robert Cowper; John Parker achieved the degree of Bachelor of Music (Mus.B.) in 1502, and John Sampson and one other Fellow (unnamed) prepared for the press the whole of the vast edition of the Salisbury Use antiphoner printed in 1519–20.[32] The choristers now were especially valued, and their status was elevated accordingly. No longer waiting on others, they dined with the College at a table of their own; here they fed adequately if not extravagantly, making do on a day in the 1480s with 'Befe pyes' while the lay clerks enjoyed pochard duck and pigeon, and the chaplains dined on 'porke pyes', capons, pigeon, pochard, snipe and larks.[33]

Under Robert Hacumblen (Provost 1509–28) Chapel music appears to have attained an all-time peak of enterprise and splendour, maintained fully under his successors Edward Fox (1528–38) and George Day (1538–48), but thereafter not again even to be approached until modern times. Probably sprung of the family that produced also the composer 'Hacumblen' (at least two of whose works were known at King's), Robert Hacumblen appears likely to have been directly supportive of Chapel music.[34] That Fox was fully committed to Henry VIII's royal supremacy was immaterial; the particular components of evangelical theology required to sustain it scarcely impinged upon the

Ill. 197. Text of carol 'There was a Friar of Order Grey', for recreational use in King's College hall, c. 1500. Cambridge, University Library, Add. MS 7350 (Box 1).

XII · CHAPEL AND CHOIR, LITURGY AND MUSIC, 1444–1644

Latin liturgy, which continued all but unimpaired.[35] Day emerged as a conventionally conservative ecclesiastic,[36] fully committed to the practices and ambitions of the pre-Reformation liturgy.

The repertory of polyphony was maintained and kept amply up to date, a process now requiring copying enterprise somewhat less intensive than that which had been needed earlier to build it. Copying extended to votive antiphons and masses, including in 1515/16 a Mass 'Tecum principium' and a Magnificat 'O bone Iesu' (perhaps those by Robert Fayrfax). Hacumblen took care for the plainsong service-books as well, initiating upon his appointment a large-scale programme of repair. Both organs remained in full use; in 1529 an antiphoner was identified as provided for their player, supplying plainsongs for improvisation at appropriate moments in the service.[37]

Ill. 198. Inventory of volumes of polyphonic music available for singing in Chapel, 1529. Cambridge, King's College, KCA/22, fol. 46r.

An inventory taken on 16 July 1529 recorded the astonishing amplitude and richness of the goods of the old Chapel, and particularly of its plainsong service books. It also listed the very ample contents of the chest containing the books of polyphonic music, now a very large repertory extending to at least nine sets of part-books and four individual choirbooks (Ill. 198).[38] One set of six part-books began with eight masses and antiphons by Edmund Turges, and contained in total thirty-five pieces by John Dunstable, Walter Lambe, Robert Fayrfax, William Horwood, Robert Wylkynson, Morgan and Hacumblen. A large collection of the 'most solemne' Marian votive antiphons for five voices was found in a set of five 'greate bokys'; a set of six part-books contained festal masses by Richard Pygott and William Cornysh and an antiphon by Richard Davy, and a small choirbook contained a Mass 'Regale' and a Mass 'A dew mes a mowrs'.

Music probably for Lady Mass included four partbooks containing settings of the ordinary by Cornysh and Cowper; one further set of four, and also a small choirbook, contained complementary propers by John Taverner. Also available were six books of 'squares', a term apparently denoting settings for use at Lady Mass of either the Kyrie eleison or of the whole ordinary. For occasional use were a set of three part-books for Holy Week, a volume for the Christmas season, and another for Lent with also a mass by Taverner for boys. Also kept in the chest (apparently for use by the Choir in hall) was a set of four part-books containing seasonal music set to texts in English, beginning with songs for Christmas. Expansion of the repertory continued thereafter; in 1532/3 a substantial volume of masses was purchased from William Crane of Henry VIII's Chapel Royal.[39]

Recruitment to the Choir continued to be assisted by deployment of the royal privilege, re-issued by the new King, Henry VIII, in 1509; thus in 1511 singing-men were acquired from Norwich and Lynn. During the 1530s and early 1540s its use appears to have intensified; the singing-boys taken from Higham Ferrers collegiate church (1537, 1542) appear to have settled in, though one boy taken from Ware in 1532 and one from Huntingdon in 1542 ran away home and had to be fetched back. Such transactions were not all one way; in 1546 Richard Bower of the Chapel Royal visited, and departed with one chorister.[40]

Especially in the case of the boys, these expeditions were commonly undertaken in the aftermath of deaths incurred by outbreaks of disease. In 1532 alone three boys perished,[41] and perhaps it was to effect improvement in their living conditions that in June 1533 their first dormitory (located apparently beneath their schoolroom in the Conducts' Court)[42] was replaced by new first-floor premises situated within St Austin's Hostel, a site located at the southern edge of the precinct otherwise providing accommodation for students additional to the foundation (Ill. 199).[43]

Among the Chapel musicians of this period, best known is the composer Christopher Tye. Already in 1536 admitted to the Cambridge degree of Mus.B.,[44] he was appointed lay clerk in March 1537; however, he served only until February 1538,[45] and none of his surviving compositions can be attributed with certainty to this period. John Nede, lay clerk 1502–19, was also a maker of clavichords, and possessed a personal stock of 'pricsonge bookes' which he bequeathed to the College.[46] John Watkyns, lay clerk 1515–19, became Mus.B. in 1516, conditional upon his submission of a mass and an antiphon as evidence of his expertise in composition; William Monk, lay clerk 1546–47, moved to Lincoln Cathedral, where he became organist and Master of the Choristers, 1552–59.[47] Other members used brief service as a springboard for engagement as Gentlemen of the Chapel Royal, including John Angell, Roger Centon, and the chorister William Mapperley.[48] Meanwhile, John Hullyer, a chorister during 1534–35, is remembered for only melancholy reasons; in adulthood a Protestant minister of unshakable conviction, he was condemned for heresy under the government of Queen Mary, and on 16 April 1556 perished by burning on Jesus Green.[49]

XII · CHAPEL AND CHOIR, LITURGY AND MUSIC, 1444–1644

Ill. 199. King's College and its neighbourhood as in 1593. Detail of facsimile of John Hamond, *Cantebrigia*, engraving on nine sheets, engraved by Augustine Ryther and Petrus Muser, 22 February 1592, 17.9 x 18.6 cm (full map 118 x 88 cm), in J. Willis Clark, *Old Plans of Cambridge*, 2 parts (Cambridge: Bowes and Bowes, 1921), part 2. Indication of approximate sites of: (A) first Chapel, 1444–1537; (B) parish church of St John Baptist, to c.1447; (C) chaplains' and lay clerks' lodgings, from 1444; (D) choristers' school-room, 1444–1644; (E) choristers' keeping-room and dormitory, 1444–1533; (F) choristers' keeping-room and dormitory, 1533–74; (G) choristers' keeping-room and dormitory, 1574–1644; (H) town grammar school, 1441–67; (I) town grammar school, 1467–1506, 1570–1618; (J) direction of the town grammar school (the 'Perse School') from 1618.

All this while, to the south of the old Chapel and bleakly looming over it, there had been rising by stages the vast, gaunt pile of the new. This was the work of Kings, not of Provosts and Fellows. The real needs of the College were but modest; instead, that which Henries VI, VII and VIII had seen fit to confer was not so much a dedicated Chapel as an extravagant and gigantically impractical tunnel. By their neighbour Dr Caius the first Chapel was described as 'mean and cramped';[50] nevertheless, even after 1515 those who actually used it were in no haste whatever to vacate it.

However, early in September 1537 the eastern wall of the old Chapel collapsed, and service was hastily removed to probably the antechapel of the new, as the area least unready. A vigorous effort of salvage evidently transplanted the choir stalls and altars, and likewise the organ, doubtless for location on the timber rood-loft just installed.[51] To fulfil the role thus prematurely thrust upon it the new Chapel required a service of dedication; indeed, a visit by King Henry was expected.[52] This, however, never materialised; in October Prince Edward was born, but Queen Jane died. Amid the national mourning the dedication was presumably but a subdued occasion, and has left no known written trace.

Over the next few years the choir stall seats and desks were fitted, 'formes' for the choristers were made for placement in front of the sub-stalls,[53] and by October 1544 the inner Chapel was deemed ready for use. An elaborate high altar, already made in London, was erected on a stepped plinth sited centrally in the third bay;[54] behind it, along the line dividing the third from the second bay (as the limit of the area so far paved), the Chapel was crossed by a timber screen as reredos and partition (see Ill. 20).[55] Perhaps the ceremony of consecration, and thus the inauguration of observance of divine service within the Chapel proper, was conducted on 17 October 1544, establishing continuity with that which it had replaced. So the inner Chapel at last resounded to the rendering of the daily Latin liturgy by the boys and men of its Choir, and to the intoxicating alloy of monodic plainsong, extravagant polyphony, and solo organ that copiously they distilled into its enactment. Yet this episode proved all too brief. The new Chapel had been brought into use just in time for the progress of the English Reformation to render it all but wholly redundant.

The Reformation Chapel, 1548–1592

The period of Provosts John Cheke to Philip Baker (1548–70) was one of successively oblivion, recovery and attenuation. Henry VIII's Reformation had but little consequence for the practice of liturgy in his Church of England. At King's College an unnecessarily austere interpretation of a 1536 Act of Convocation concerning 'holydays' did cause the premature termination of the 'boy bishop' observance.[56] Otherwise, apart from a vernacular form of Litany introduced as a wartime expedient from 1544 to 1546, fundamentally the liturgy of Salisbury Use remained in full adherence.[57]

The accession of Edward VI on 28 January 1547 launched the liturgical reform. Increasingly conservative in such matters, Provost George Day found himself on the defensive, for it appears that a substantial proportion of the Fellowship was at least sympathetic to incipient change. In reflection of Protestant values, especially those of Vice-Provost Edmund Guest, the College promptly discontinued the statutory 'private' masses celebrated in Chapel, a decision that Day condemned.[58] In October 1547 a government visitation prohibited the 'superstitious' use of images, probably terminating thereby the Choir's daily singing of an elaborate votive antiphon to the Blessed Virgin. Procession before High Mass was replaced by a recitation of the 1544 English Litany, now revived, for which 'little books' were purchased 'to sing divine service in English'.[59]

XII · CHAPEL AND CHOIR, LITURGY AND MUSIC, 1444–1644

At odds with such developments, early in 1548 Day resigned; he was succeeded in October by John Cheke, a courtier and tutor to King Edward, who since the death of Henry VIII had emerged as a dogmatic Protestant.[60] From court Cheke kept a close watch on University affairs, and in Cambridge Edmund Guest proved a willing conduit for his policies. Towards the music of the Chapel their intentions were especially hostile. Those whose aspirations already were represented by Calvin's Geneva understood the musical adornment of divine worship to constitute a corrosively pernicious distraction from the preaching of the Word of God, and from such interior processes of true godliness as contrition for sin. As such, the music of the service was fit only for entire oblivion.

In November 1548 a University commission, including Cheke, directed that all College funds dedicated to the maintenance of divine service by singing-men and choristers be re-directed to the support of Fellows or scholars in philosophy or literary studies.[61] Thus, in effect, was given order for the extinction of all contribution to Chapel service made by a professional Choir. In Cambridge the sole college so affected was Cheke's own; there can be no doubt that he was its author, and at King's the order was enforced with rigour. On 24 March 1549 seven of the then nine chaplains (and presently also the eighth), with four of the five lay clerks, were summarily dismissed and ejected.[62] Thereby was the Choir effectively disbanded, and its work extinguished.

After 1549 the Chapel was served by a single chaplain and, now as but caretaker, by a single clerk, John Wickham. In April 1549 the elaborate high altar was dismantled and removed,[63] to be replaced by a simple communion table. The service-books of Latin plainsong were discarded; two leaves of a fine fifteenth-century antiphoner, fabricated into the cover of an account-book, yield a faint impression of the riches so destroyed (Ill. 200).[64] Perhaps in recognition of their educational needs the College was marginally more lenient towards its now superfluous choristers; however, at some point in 1551 it lost patience and sent away likewise all those still remaining. Religious observance in the Chapel was limited to the spoken services of the Book of Common Prayer (introduced June 1549, revised 1552), and the hearing of sermons.

Ill. 200. Parts of two leaves discarded from a fifteenth-century antiphoner: gold leaf, and inks (red, blue, black), on parchment. Detail of inside rear cover (outer folio) of Bursar's Book 1549–50. Cambridge, King's College, KCAR/4/1/4/2.

The interruption was acute, but brief. The devoutly Catholic Mary I acceded as Queen in July 1553, and all liturgical change was reversed. As a supporter of Lady Jane Grey, Cheke was arrested and resigned the provostship. He was succeeded on 25 October 1553 by Richard Atkinson, under whom the College hastened to comply with government order that from 20 December 1553 observance of the Catholic liturgy be resumed.[65] Upon his death the office passed on 3 October 1556 to Robert Brassie.

Priority lay with the restitution of the Choir. Mary promptly renewed the royal privilege of impressment, and Wickham went recruiting in Peterborough, Boston, Newark, Newport (Essex) and elsewhere. In November 1554 a new text was obtained, in the names now of both King Philip and Queen Mary;[66] of this, a copy has chanced to survive (Ill. 201). Soon the lay clerkships and choristerships all were filled. The chaplaincies were less of a priority, and only three to six were ever occupied; any shortfall could be supplied by priest-Fellows, among whom there was evidently always a sufficiency of former singing-boys still possessing the necessary skills.[67] The choristers were restored both to their school-room and to the dormitory at St Austin's Hostel,[68] and the singing-men to their lodgings in the Conducts' Court – premises still in use when Loggan drew the west exterior of the Chapel in c.1690 (Ill. 202).

The appurtenances of the Catholic service of Salisbury Use were now restored. Plainsong service books were acquired in quantity;[69] the Henrician high altar was reinstated, and the organs both great and less were set in order.[70] Probably none of the Henrician stock of composed polyphony had survived; in 1553 Wickham immediately began acquiring an inaugural body of festal masses, Marian anthems, Magnificats, and settings of the propers for use at Lady Mass. Expansion continued with the copying in 1557–58 of some unspecified pieces and the acquisition of six settings of the mass.[71] A working repertory was thus restored, and on 11 January 1557, to open a visitation of the University, the Choir was ready in Chapel to conduct High Mass 'with great solemnitie': probably, that is, 'with pricksonge and organs', as certainly was the solemn mass celebrated in Great St Mary's on 7 February.[72]

Not every detail of the former regime was restored under Mary. Led by the more philistine asperities of the Tudor Protestantism unleashed under Edward VI, there was emerging a new religious and social order that diminished thoroughly the erstwhile appreciation of both formal worship and its enactors as valued contributors to the greater good. Thus it ceased now to appear seemly for any mere singing-boy to own a privileged opportunity to obtain election as a scholar of Eton College; never again after 1550 were senior choristers escorted there to exercise their former right.[73] Moreover, the office of Master of the Choristers was now evaluated as simply a College service, a skilled trade at wage-earner level (of 11s 8d per year). To this office in March 1556 was appointed the lay clerk Henry Cole;[74] his successors can be traced without a break.

On 17 November 1558 Mary's Protestant half-sister Elizabeth acceded as Queen, and much of the accomplishment of the previous reign was dismantled and lost. On sufferance the Latin liturgy remained in observance until June 1559, and the Chapel personnel were in no haste to abet its abandonment.[75] However, College and Choir were obliged to come to terms with the promulgation of the vernacular Book of Common Prayer of June 1559 (a re-issue, lightly revised, of that of 1552). The services per day were reduced from ten to the mere three of Morning Prayer, the Lord's Supper (preceded thrice weekly by the Litany, but truncated to mere ante-Communion except on Sundays and feast-days) and Evening Prayer. All the effusive pieties of the Latin liturgy were discarded, and replaced by a single small book containing text alone and not a single note of chant or of music of any kind. By its rubrics, which withheld all reference to the possibility of musical rendering, there was wilfully predicated an observance entirely spoken.[76] Ostensibly, the practice of church music in England by any professional Choir was thereby pre-empted and prohibited.

XII · CHAPEL AND CHOIR, LITURGY AND MUSIC, 1444–1644

Ill. 201. Text of royal licence to impress singing-boys and men, issued to King's College by King Philip and Queen Mary, 1554. Cambridge, King's College, KC/47 (KCGB/1/I).

Ill. 202. Part of the East Side of the Great Court of King's College, showing the 'Clerks' Lodgings' (D): the foundations of the intended east range of building (E): and part of the Provost's Lodge (F). Robert Willis and John Willis Clark, *The Architectural History of the University of Cambridge*, 4 vols (Cambridge: Cambridge University Press, 1886), vol. I, p. 552. Reduced from David Loggan, *Collegii Regalis sacelli facies Occidentem spectans*, 46.5 x 35.4 cm (plate), in David Loggan, *Cantabrigia illustrata...* (Cantabrigiæ: Quam proprijs sumptibus typis mandavit & impressit [1690]), pl. 11.

However, though Elizabeth I was a Protestant of true conviction, a church service without music was not to her tastes; and by an injunction issued in 1559 the Supreme Governor chose wholly to subvert the message sent out by the Prayer Book, and to order for the greater churches a retention of the tradition of choral service. All endowments supporting 'the use of singing or music in the church' were to be wholly retained. Always provided that the music was 'modest and distinct' and its texts fully 'understanded of the hearers', the injunction effectively granted leave for the priest to sing in monotone any passage appointed for him to utter, and for the Choir to sing in plainsong the psalms, and in suitable harmony such items as the responses, the canticles of Morning and Evening Prayer, and the Kyrie and Creed of ante-Communion. Also, 'for the comforting of such as delight in music', an anthem might be sung, not as a part of the service but immediately before or after.[77]

Thus Elizabeth procured for the Prayer Book services the preservation of the historic choral tradition. However, little else remained. At King's the commission to take up singing-men and boys from elsewhere lapsed with the death of Mary. It was not renewed; the expansive and virtuosic polyphony of the Latin service died with the Catholic Queen, and the abbreviated, inobtrusive and technically far less challenging music of its Protestant successor no longer required such degrees of talent and of extraordinary training and skill. Indeed, the relative inconsequentiality of just three daily services, and the obligatory modesty to which their requirements for music were now reduced, no longer provided either full-time employment for the singing-men or full-time occupation for the choristers.

Provost Robert Brassie died in November 1558; Philip Baker, his successor, proved to be predominantly conservative.[78] Among the Fellowship those who procured the dismantling of the Catholic high altar and its replacement by a simple communion table were evidently of rather an opposite opinion,[79] and there soon arose signs of conflicting priorities and policies. The conservative predilections of the Provost, compounded with the confirmation of Protestantism as the ideology of Chapel worship, combined to produce diverse ramifications for the Choir. The royal injunction rendered the choristerships and clerkships safe from spoliation. Indeed, given the now ongoing role of Chapel music, after March 1565 seven lay clerks were usually engaged, apparently perceived as consisting of the statutory six augmented by the Master of the Choristers. However, the need for a sacerdotal presence was now much reduced; the chaplains were classifiable as clergy rather than as singing-men, and after 1560 just three were employed (and in 1562–70 only two).

Further, from 1560 the office of precentor was abolished;[80] day-to-day management thenceforth was left wantonly to whatever provision the Choir could arrange for itself. From 1562 the fellowship further distanced itself from Chapel music by transferring the office of 'supervisor of the choristers' from that of a bursar down to that of their Master.[81] Probably, too, the choristerships were now returned to status as charity appointments. After 1550 there arise no further references to their own table in hall, indicating resumption of their statutory role as waiters at the tables of their elders; and into their work was now decanted the singing of grace.[82]

Within these constrictions, Philip Baker and fellow conservatives found themselves presiding over a Chapel Choir content to generate a programme of sung performance at a level now apparently apposite to prevailing circumstance. Within the country as a whole, up to about 1568 the Queen presided over an environment at least not unpropitious for a modest promotion of music within the liturgy,[83] and at King's a steady programme of acquisition was undertaken. Already during 1558/9 the Master of the Choristers, Richard Bramley, was 'gettynge songes and pryckyng them', and his successor Richard Pollye remained until 1569 industriously engaged in obtaining music in four, five and six parts.[84] Richard Adams, Fellow, composed sacred music, while Clement Woodcock, lay clerk, is also known as a composer.

Of this early Elizabethan repertory perhaps a fragment is still extant. Although determination is

not conclusive, at least the opening layer of twenty-four pieces of four-voice sacred music contained in a set of part-books begun in c. 1565 may have been of King's College provenance.[85] The composers included Thomas Causton, Christopher Tye, John Sheppard, [William] Mundy, [Robert] White, and 'R. Addams'; this latter may be identified with Richard Adams (scholar 1551, Fellow 1554–61), who in liturgy and in music certainly possessed training sufficient to qualify him to serve not only as a chaplain in the Choir during 1557–9, but also as precentor.[86] The repertory, unostentatious and workmanlike, was conventional for its period. It incorporated eight settings of canticles for Morning Prayer and seven for Evening Prayer, a 'Gloria' of Communion, and eight anthems mostly set to common biblical texts. None of the pieces is other than conventional in the demands placed upon the singers; Adams contributed canticle settings of Venite and Nunc dimittis (Ill. 203).

Although the vocal music of the Chapel was performed unaccompanied, a role was still found for both organs; thus the smaller instrument required attention in 1561/62, and both during 1564/65.[87] On the occasion of a visit to the College made by Queen Elizabeth in August 1564 Chapel music was put on due display (though the surviving record is brusquely untechnical). After welcoming her with a vernacular 'song of gladness', the Choir sang 'Te deum' in English, the organ sounding verses in alternation with the Choir's polyphony. Evening Prayer was then 'solemnly sung', all to the Queen's great satisfaction. The next morning she attended the sermon; the Choir preceded this with sung Litany, and followed it with 'in prick-song, a song'.[88]

For his conservative views Philip Baker came under increasing censure. In 1565 allegation was made that the Chapel was no better than a smouldering nest of reaction; into employment as chaplains and lay clerks Baker received none other than 'manifest Papistes', and he continued to harbour a great hoard of 'popish stuff', including Catholic service-books, in the belief that 'that which hath been may be again'. In 1569, nothing having changed, an enquiry was set up under the Vice-chancellor. The enquiry met; Baker took refuge overseas, and in February 1570 was deprived of office.[89]

On 19 March 1570 he was succeeded by Roger Goad (Provost 1570–92). Of the strength and vigour of his Protestant convictions there was no doubt; while conforming wholly to the authorised governance of the Church of England, he leant strongly towards the asperities of puritan values and practices. It was in the 1570s and 1580s that the cause of church music in Protestant England reached its nadir;[90] and at King's College, Chapel music and practice, as badges of adherence to the principles of reform, remained objects of acute concern, lest any form of gratuitous indulgence appear even to hint at neglect of duty in preventing the surreptitious reappearance of any pernicious 'weed of popery'. Only in the 1590s did such constraints begin to dissolve away.

After 1570 these preoccupations soon became apparent within the Chapel. The communion table was removed from its altar-wise orientation along the eastern partition, to be sited east to west between the choir stalls.[91] Baker's 'papist' chaplains and clerks were dislodged and removed; the Choir was indeed maintained, but only at the minimum level required by the Queen's injunction. Moreover, by c.1570 animosity at large among puritan clergy towards elevated music was finding expression in condemnation of the church organ; and during 1570–71 the great organ of the Chapel was taken down from the rood-loft and sold cheaply away.[92] Goad later insisted that this despoliation had been undertaken not upon his own initiative, but at the instance of the commission by which Baker had been dismissed.[93] There accrued no difference to the singing, since even at this period the organ enjoyed no function as accompanist to the voices;[94] gone, however, was its role as a solo contributor to the ceremony of the service on high days and holy.

Goad entertained no correspondingly destructive intent toward the sung music of the Chapel, now evidently maintained at a level sufficiently inobtrusive not to offend his puritan tastes. During

the 1570s some acquisition and copying of music continued, albeit at a low intensity.[95] Eight 'books of psalmes with the note' acquired in 1580–81 were apparently volumes of metrical psalms, sung before or after the free-standing sermon. Yet even this modicum of enterprise soon expired. Throughout the 1580s there settled upon Chapel music a degree of inertia; in particular, acquisition all but halted, alleviated only by the re-copying in 1586 of some old music, and a little copying of new.[96] Perhaps this latter was the work of Thomas Wilkinson (lay clerk 1580–95), putative composer of three full anthems on texts all of oppression and distress that perhaps hint at the manner in which members of the Choir were then perceiving its condition: 'Why art thou so full of heaviness, o my soul?' (Ps. 42.6); 'O Lord God of my salvation, I have cried day and night before thee' (Ps. 88.1); 'O Jerusalem, thou that killest the prophets' (Matthew 23.37).[97]

The 1570s and 1580s witnessed further diminution in the standing of the choristers. During 1573–74 St Austin's Hostel was rebuilt as a lodging for the College's wealthy 'pensioners', and the boys were evicted from their dormitory. Its successor, very much less salubrious, lay among a range of buildings situated along the river frontage directly west of the Chapel (Ill. 199).[98] Likewise, from c.1574 the College ceased to provide total maintenance for each boy; bed and board were continued, but clothing was reduced to a bare annual ration of one uniform coat, four pairs of shoes, two shirts, and two pairs of hose each.[99]

Moreover, from 1578 the office of their Master was occupied no longer by a professional musician but by a succession of chaplains. By preparation for and attendance at merely three services a day the boys were no longer fully occupied; apparently the grammar component of their education was

Ill. 203. Richard Adams, canticle *Nunc dimittis*, c. 1560, tenor voice. In a manuscript in octavo, c. 1565. London, British Library, Add MS 30482, fols 17v-18r.

now increased, to the point at which it could best be served by a Master who himself possessed a broad education rather than specialist musical skills. Correspondingly, by 1570 the category of the 'dry chorister' was also emerging – this was a youth who formerly had been a singing-boy but was selected to retain enjoyment of his choristership as an educational exhibition long beyond his change of voice. Thus George Wylde occupied a chorister's place from 1560 until his admission in 1569 – aged 18 – as a pensioner of Caius College.[100] Facilitating this departure into advanced grammar education was the College's fortuitous resumption in c.1570 of the provision of premises for the town grammar school, once again at its very convenient site on Milne Street.[101] During the 1570s and 1580s at least ten other boys became 'dry choristers'; to any resulting diminution of the Choir the College was indifferent.

Tempered Rehabilitation: Edward Gibbons to John Tomkins, 1592–1620

Commencing in the late 1580s some degree of rehabilitation of esteem emerged for church music at large. The older generation of puritan clergy, radicalised by exile and hardened by the fires of persecution in the reign of Mary, was beginning to die out. Their hair-trigger revulsion from music as self-evidently a 'weed of popery' began to expire, and they were replaced by a younger generation

who still were conviction Protestants in theology, but were prepared to admit some latitude in terms of style of worship. Among the Church's more reflective backwaters some respect for beauty and seemliness in the conduct of the liturgical service now re-appeared. Moreover, there also arose, in Orlando Gibbons, Thomas Weelkes and Thomas Tomkins, three composers of the very first rank, who exploited particularly the 'verse' style of composition for voices and organ to generate music characterised by extended scale and clarity of diction, as well as by an elevated musical expression of restraint and sobriety that resonated fully and constructively with the introspective spirit of early seventeenth-century English protestantism.

The fellowship at King's was not wholly hostile to this incipient rehabilitation, and response was prompt. In 1588 the office of Mastership of the Choristers was restored to occupation by a professional lay clerk, Thomas Hamond. Music acquisition was resumed; in 1589–90 an entire new set of books was obtained, and in 1592 Hamond acquired an ambitious 'whole service' for eight voices.[102] In September 1592 he stepped aside, and to the office of Master a musician of all-round professional qualifications was appointed.

This was Edward Gibbons, twenty-four years old, but already an accomplished composer and Mus.B. graduate.[103] Chapel music resumed momentum, and particularly during 1597–98 preparation was made for the copying of a very large tranche of material. The purchase of twenty-six new volumes suggests intent to create three double sets of part-books, for respectively four, four and five voices, while yet further sets of 'books for the use of the Choir' were also acquired.[104] Gibbons himself composed, though only two sacred songs and a setting of ante-Communion have survived. However, employed to restore some elevation to the instruction in music given to the choristers, he may well have been unable to teach them also in Latin; a division therefore now was made in their teaching day, whereby even working choristers attended the town grammar school for up to two hours each morning.[105]

Under Gibbons the acquisition of music diversified to hall as well as to Chapel.[106] A 'sett of song books' was obtained for hall in 1593–94, while in 1592–93 there had been obtained a 'sett of singing books' specifically for performance by the choristers, and in 1594–95 four 'grace books'.[107] To mark the Queen's Day in 1598 both lay clerks and choristers assembled, probably on the Chapel leads, to sing in celebration. During 1598–99 a chest of viols was obtained at the substantial cost of £14. However, this account entry was cancelled;[108] playing viols was not discouraged in College, but was a private venture for pursuit at private expense.

Chapel and hall, taken together, were now earning for the College some constructive repute as a community distinguished by its devotion to music. The biographer of Dr John Preston recalled that as a youth his subject had spent two years as a sizar of King's, and that upon entry in 1604 'he did as young scholars used to doe, that is applyed himself to the Genius of the College, & that was musique'.[109] Doubtless it was through the mediation of his elder brother Edward that in Easter term 1598 the future composer Orlando Gibbons, when matriculating in the University as a student in Arts, was accepted for entry to King's College as a sizar.[110] However, after only one year he abandoned these studies, and in practice probably made but little impact on the College.

Edward Gibbons's departure in September 1598 may have been unexpected, and to replace him as Master of the Choristers Thomas Hamond was re-appointed. Perhaps he was not the most propitious choice; by 1604 he and another lay clerk were being delated as prone to 'frequent Tavernes and drinking places scandalously', with the consequence that they 'for swilling ... are very much out of tune'. At his death in 1605 Hamond left at least a warm glow among his former colleagues and pupils, bequeathing fifty shillings to be spent at his funeral 'in a Drinking or banquett', and forty shillings on a supper for the boys.[111]

XII · CHAPEL AND CHOIR, LITURGY AND MUSIC, 1444–1644

In June 1605 Hamond was succeeded as Master of the Choristers by Thomas Jordan (lay clerk to 1625, chaplain until death in 1631); evidently a man of some substance, Jordan was considered a 'gentleman'.[112] The former rate of music copying now became somewhat relaxed; however, acquisitions for hall included in 1604/5 a set of 'Song-bookes of Mr Mundy',[113] probably John Mundy's *Songs and Psalms*, a collection of twenty-seven pieces published for domestic use in 1594.

In 1605 an organ was restored to the Chapel. The events that led up to this occurrence had begun two years previously. By 1603 the autocratic manner of Goad's government of the College was inciting dissension sufficient to provoke an episcopal visitation, to which eleven of the fellowship complained that the Provost's removal of the Chapel organ in 1570 was frustrating statutory requirement for the presence of one capable of playing at service. The Provost claimed that it was not on his initiative but in obedience to superior orders that he had procured its removal, so implying that it had never been any business of his to put it back.[114] Now, however, the temper of the times was such that to these complaints, so articulated, the College did begin to make a positive response; yet the manner in which it did so exhibits elements of the perverse that suggest the conflicts that still underlay the process.

Initial intentions were but grudging. During 1604/5 expedition was made into Norfolk and Suffolk for the purpose of finding some old but working organ for Chapel installation,[115] and one was found at the church of St Peter, Sudbury. However, this actually belonged to a Norfolk land-owner, Sir Edward Paston, who refused to sell;[116] and, now advised by John Mundy (organist of St George's Chapel, Windsor),[117] the College engaged Thomas Dallam to build a wholly new instrument. Hereby the Chapel was invested with an organ which (albeit modest by continental standards) was the grandest that England had ever yet seen.[118]

Built between June 1605 and August 1606,[119] this was a substantial two-manual organ of 'great' and 'chair' departments. No specification has survived; however, probably this instrument conformed fully to the observation that Dallam's overall achievement at this time was 'the consolidation of the two-manual "double organ", with twelve to fourteen flue stops without reeds, mixtures or pedals, as the norm for English cathedrals and larger collegiate churches'.[120] The case of the great organ presented five towers separated by flats, and the show pipes of both organs were decorated with moulded and coloured embossments.[121] Some serviceable impression of its likely appearance is afforded by the pair of cases made by Robert Dallam for his organ of *c.*1632 for Magdalen College, Oxford, yet surviving at Stanford-on-Avon (chair organ),[122] and Tewkesbury Abbey (great organ: Ill. 204).

Now in possession of the most impressive organ in the country, King's College set a fashion widely followed elsewhere. However, only mordant irony can have directed its location within the Chapel. Instead of being situated upon the rood-screen it was placed clumsily at ground level, positioned on the quire floor in the centre of the third bay from the east with its back to the screen. A plan of the Chapel prepared in *c.*1607–11 by the architect John Smythson reveals the significance of this location (Ill. 20): the organ had been deposited incongruously upon the plinth once occupied by the Catholic high altar.[123] It thus filled a spot still instantly and acutely associable with all the superstition and idolatry of that unreformed past towards the unwelcome restoration of which Dallam's instrument evidently represented (at least to some) a vividly eloquent regression. To the Provost went the last, and caustic, laugh. However, the floor-level location proved hardly felicitous, engendering in 1613 some major restorative work; in this position it was vulnerable to interference, and in 1616 some modest barrier was erected to procure its protection.[124]

From April 1606 one department of the organ was already being played, by [John] Fido as temporary organist;[125] in May the appointed player, John Tomkins (a half-brother of the composer

277

Ill. 204. Case (*c.*1632) of a Great Organ by Robert Dallam now in Tewkesbury Abbey, Gloucestershire, photograph, *c.*1942. English Heritage, NBR A43/6357.

Thomas) arrived. His appointment in June 1606 simultaneously to the new office of organist and to that of Master of the Choristers created a single directing authority, so that he soon became recognised as 'Master of the Quire'.[126] In June 1608 he received the degree of Mus.B.; among his few surviving compositions the seven-part motet 'Cantate domino canticum novum' probably was his degree exercise.[127]

For the Choir, which under Tomkins consisted of nine men (three chaplains and six lay clerks) and sixteen choristers, the novel availability of an organ demanded new repertory in verse style. John Fido brought a stock of books of music explicitly for Choir and organ, as also did Erasmus Tuddenham, a lay clerk recruited from Norwich Cathedral. Much further industrious copying involved in 1606–7 the acquisition of seven evening services and fourteen anthems, all for five voices, and in 1609 the borrowing of a repertory from St George's Chapel, Windsor.[128] Under Tomkins almost no chorister was 'dry', though the older choristers continued to spend some part of

each morning at the town grammar school located by the Milne Street gate; and even after the school relinquished this site in 1618, when it was endowed and relocated by the executors of Dr Stephen Perse,[129] the premises of the incipient 'Perse School' on Free School Lane remained sufficiently close for the choristers to be able to continue to attend.

Goad died on 25 April 1610; and as his influence dissolved and expired, within the Chapel, under his successors Fogge Newton (1610–12) and William Smith (1612–15), an incipient restoration of appreciation for formality and ceremonial in the Common Prayer liturgy became apparent.[130] Symptomatically, Newton raised Tomkins' annual stipend (with free livery, board and lodging) from £12 6s 8d to £14, while in 1614 on Smith's personal order it was raised again, to a generous £22.[131]

Moreover, an orderly Choir administration began to be established. In late 1610 the job of 'curator of the songbooks' was created for a lay clerk, while in 1614 the office of precentor was restored, though for conferment not on a chaplain but on a lay clerk, Thomas Jordan.[132] Musicians of elevated quality were attracted to the College. Among the lay clerks, Richard Patrick (1612–16) and Edward Smith (1618–23) were minor composers, while James Weaver (1605–18) obtained the Mus.B. degree, and owned scholarly books, a collection of lute books and an eighteen-string lute, a bass viol, and a great bass viol, along with a collection of virginal books and an organ book.[133] Under the new regime, and especially under Newton during 1611, the acquisition of new Chapel repertory accelerated, and recreational singing in the College was preserved.[134] So long as Tomkins remained 'master of the quire' the pace of music acquisition continued, in respect both of vocal music for the Choir and of organ music for Tomkins.[135] For the Choir, however, the regime following that of William Smith proved much less propitious.

Detachment, Adequacy, Extinction under Samuel Collins: 1620–1643.

Under Samuel Collins (Provost 1615–45) the environment for Chapel music was to change markedly; it was neither inhibited as under Goad, nor encouraged as under Newton and Smith, but characterised primarily by a detached indifference. In 1607 Collins had presented himself as a mainstream theologian of his time, prepared 'to defend ceremonies as a moderate Calvinist, [but] without making any case for their religious worth';[136] and under his government the work of the College and the work of the Chapel musicians began to diverge. The musicians, having no obvious relevance to academic pursuits, were left substantially to their own devices, and soon were to become not a little debilitated by the College's neglect of their interests. Prophetic of the new style of management was the confused manner of Tomkins' departure. From 1618–19 his salary was withheld; indeed, at St Paul's Cathedral the chapter evidently believed that it had appointed him their organist. However, he actually continued at King's until August 1620, eventually receiving only in grudging instalments his due arrears.[137]

In Chapel an interregnum supervened. Unrepresented by any senior figure as precentor, the musicians appear to have been unable to draw to themselves sufficient attention to procure the appointment of a successor. Tomkins' composite office of 'master of the quire' dissolved. The lay clerk Laurence Ewsden was appointed Master of the Choristers. There was no organist until the engagement of Matthew Barton in autumn 1621; only in 1623, however, did the College take enough notice even to pay him his first three terms' salary, and he left at Michaelmas 1624.[138] Another vacancy supervened before the appointment at Christmas 1624 of Giles Tomkins, younger

brother of John; but he left in June 1626. In October there appeared one Marshall, recommended by the earl of Mulgrave as one who 'hath very good skill both upon the Organ & many other Instruments, likewise doth Compose Anthems and services'. The Provost gave a distantly delegatory instruction that he be admitted to probation – and immediately granted him leave to depart the College to pursue his own affairs elsewhere.[139] Marshall did so depart; and was never heard of again.

Lacking a 'master of the quire', Chapel music probably was sustained at this time by such as the lay clerk and composer John Geeres (1622–26, Mus.B. 1626), and by musicians of the versatility of Thomas Jordan (who owned a virginals, a lute and a bandora), Stephen Mace (possessor of a strange collection of one treble, one 'Counterteneur', and six bass viols, four lutes, and a bandora), and the copyist Thomas Staresmore ('bookes, Instruments of musicke, & a deske'). Henry Molle, Fellow 1615–58, has been identified with the composer of that name, although there is no record of his having concerned himself with music within the College in any way.[140]

Meanwhile, the Chapel languished without a recognised organist for nearly a year. A suitor for the post, [John] Silver, was merely sent away.[141] Presently, in August 1627 the College appointed the still very youthful Henry Loosemore (born between 1605 and 1609).[142] Inaugurated at £10 per year, his stipend was raised in 1628 to £13 6s 8d and in 1633 to £20; and he continued in office until his death in 1670. He showed no interest in taking on in addition the office of Master of the Choristers. This in 1634 was conferred on Edmund Woodcock, no professional musician but a working student of the College who, aged but 21 or 22, was remarkably inexperienced. Woodcock left in June 1639 and, characteristically, at Michaelmas three months later the office still was vacant. However, by Michaelmas 1640 it had been accepted by Loosemore, who did thus become, belatedly, successor of John Tomkins as 'master of the quire'.

A report of that same year happened to note the disposition of the services, then current but also of long standing. Morning service, beginning with Morning Prayer, began at 8.00 a.m.; Evening Prayer was observed at 4.00 p.m. On Sundays and other holy days service was sung with the organ, in full Prayer Book observance by the whole College; on other days 'Cathedral service' was observed, by the choristers and singing-men.[143]

During the early 1630s the inner Chapel was subjected to a considerable degree of re-ordering, in response to initiatives originating with the government of Charles I. King's College did not court confrontation; consequently, no sooner were the High Church principles associated with the primacy of archbishop William Laud promulgated than Provost Collins and his colleagues were dutifully implementing within the Chapel features that signalled and enhanced the sanctity of the holy table.[144] In 1633–34 backs carved with heraldic arms were added to the upper choir stalls, while the replacement and relocation of the former east-end screen enlarged the whole ritual area by one bay eastward, the communion table being restored to status and position against it as a high altar.[145] These works necessitated the re-siting of the organ, which at last acquired a worthy location upon the rood-screen, now known once again as 'the organ loft' (see Ill. 213). Probably Robert Dallam's large bill of £22, presented in 1634, included his charge for the creation of a plain but presentable western face for the organ-case, now visible from the antechapel.[146]

One further innovation of the 1630s involved the occasional presence at Chapel service of the civic band of instrumentalists known as the town 'waits'.[147] Already long invited into hall some four times a year, on occasions during the 1630s they were present also in Chapel in the context of services of thanksgiving held on 5 November, the King's Day, and on Lady Day.[148] In general, waits were not necessarily literate musicians, and there is no reason to imagine that on these occasions they accompanied in any manner the singing of the Choir. Rather, they had as their repertory traditional

pieces learnt by rote and played from memory, so that items such as fanfares might be sounded at the entry and departure of the clergy and prominent attendees. However, there may well have been some players more literate than most, so it is conceivable that following the sermon concluding such a thanksgiving not only standard unwritten repertory, but also more ambitious items such as Henry Loosemore's 'A Verse for the Organ, A sagbut, Cornute & Violin' were performed.[149]

While dutifully re-ordering the ritual area, Collins appears to have been content to leave Chapel music largely to its own devices and under its own leadership. This, however, was barely adequate; the organist played the organ, the offices of precentor and Master of the Choristers were occupied each by a lay clerk (or, in the case of Woodcock, by a student), and no single individual was in charge. One casualty was the repertory, which was stagnating. Between 1618 and Loosemore's appointment not a penny was spent on the copying of new material; and other than by a set of 'grace books' obtained in 1631, the repertory for hall continued neglected.[150] Loosemore made some modest endeavour to update the Chapel repertory in 1629 and 1630, perhaps with early compositions of his own;[151] of his handiwork there yet survive two services, two Latin litanies, and twenty-nine anthems (ten full, nineteen verse), earning him in 1640 conferment of the degree of Mus.B. The compositional quality of those pieces that are complete or completable is reported to be variable, but marked at its best by rare senses of subtlety and sophistication, so permitting Loosemore to be considered as among 'the front rank of provincial composers'. He may himself have supplied singing copies of these works; certain leaves of music believed to be in his own hand are perhaps remnants of copies prepared by him for the Chapel.[152] Otherwise, up until 1642 there was but a single further acquisition, being certain 'anthems etc.' procured for the Chapel in 1637 by John Amner, organist of Ely Cathedral.[153] Indeed, with the exception of Loosemore's own works, the Chapel repertory of *c*.1620 appears thereafter to have languished largely unrefreshed and unaugmented.

Even so, after several years of diligent acquisition between *c*.1605 and 1618 that repertory was at least respectably full, and an organ book in Loosemore's own hand, compiled in stages over several years,[154] contains the accompaniments to eighty-one anthems. It is not possible to determine just how much was live repertory at any one moment; however, Chapel music in his time is revealed to have been largely in five parts, with a number of items in four, and just a few in six, seven or eight. Overall, thirty-eight are in verse style, and forty-three in full. Included were Loosemore's own accompaniments to pieces by Byrd and Tallis, originally unaccompanied; there followed full and verse pieces by Byrd, Hooper, Tomkins, Morley, Bull and Lugge, with further items by Ward, Weelkes, Orlando Gibbons, and Amner, and sixteen of Loosemore's own anthems.

Some pieces remain familiar today, such as Byrd's 'Sing joyfully' and 'Christ rising again'; Tallis's 'O sacrum convivium' and 'Salvator mundi', with Byrd's 'Ne irascaris' and 'Civitas sancti tui', all in vernacular adaptations; Weelkes's 'O Lord, grant the king a long life'; Bull's 'Almighty God, which by the leading of a star'; Orlando Gibbons's 'If ye be risen again' and 'Glorious and powerful God'; Thomas Tomkins' 'Almighty God, the fountain of all wisdom'; and Loosemore's own 'O Lord, increase our faith' (long attributed erroneously to Orlando Gibbons: (Ill. 205). Otherwise, most of the music then performed has now lapsed into obscurity. The aggregated repertory was comprehensive in its coverage of the Church's year, and safely mainstream in its selection of texts. In technical character it was moderately challenging, except insofar as only a single piece required divided boys' voices. Clearly there was available within the Choir at least a dependable nucleus of competent singers to whom the solo sections of pieces in verse style could confidently be committed; the full anthems, however, stayed safely in just four or five parts.

In the mid 1630s, as appeared evident to the anonymous observer who in 1636 compiled a

report for Archbishop Laud, the absence of good management was perhaps generating a resigned acceptance of certain shortcomings in the Chapel's choral endeavour as irremediable. The reporter was not endeavouring a balanced appraisal, and his concerns were not aesthetically musical; his job was predicated on disregard for all commendable practice, in favour of the identification of bad practice for correction. In respect of 'the Quire service' at King's (and in contrast to his report upon Trinity College), he made no observation that it was conducted on any basis other than properly daily, and no complaint was made about the liturgical suitability of repertory. However, he noted that oversight of the choristers (then under Woodcock) was poor. They attended with or without their surplices, just as fancy took them; and none began actually to attend to and concentrate on what he was doing at any service until it was well advanced. Yet more debilitating was the manner in which 'some of the Quiremen cannot sing and are divers of them very negligent'. Moreover, 'the Choristers are neere one half of them mutes'. The author detected enough sloppiness in the demeanour of the Choir for him to report that 'they commonly post over their service and perform it with little reverence'. Equally symptomatic was a prevailing absence of pride in the job that had procured that 'their song Books are very rude and tattered'.[155]

As merely a *primus inter pares*, Daniel Cawkett, lay clerk and since 1631 precentor, appears thus to have been but little able or inclined to generate leadership, instil vision, or sustain high standards of reverence. The stipends of the singing-men had been frozen since 1578 at £4 per year (plus livery, board and lodging), and their number now included several 'scholars' servants',[156] but no longer gentlemen or graduates. The position of Master of the Choristers was held by men of small consequence, and its occupants had been unable to prevent the reappearance of the 'dry chorister'. Of the thirty-eight boys admitted between 1621 and 1632 some eleven were suffered to remain long

Ill. 205. Henry Loosemore, organ accompaniment of the anthem 'O Lord, increase our faith', holograph, c.1633. In a bound manuscript. New York, New York Public Library, MS Drexel 5469, pp. 208–9.

beyond their due date for retirement; at times the concentration of such 'mutes' might inhibit perceptibly (as evidently in 1636) the Choir's accomplishment. Those among 'the Quiremen' who 'cannot sing' probably had never been able to do so; perhaps they were merely the least unsatisfactory among those available.

No complaint was made of the skills of those choristers who were not mute, or of those singing-men who could sing, or of the organist. Such shortfalls left the Choir with resources certainly compromised, but still adequate to perform at least the standard five-part repertory of the day. Nevertheless, for Collins and the Fellowship the Choir over which ultimately they presided probably was doing them rather less credit than its potential truly allowed. 'There let the pealing Organ blow, / To the full voic'd Quire below', wrote John Milton (in 'Il Penseroso') soon after going down from Christ's College in 1632; but probably it was by no experience in King's College Chapel that those effulgent lines were informed.

Matters were probably little different by the outbreak of the Civil War, instigated by a parliament determined to terminate every aspect of Prayer Book observance. The point at which the College found itself constrained to end the choral service and disband the Choir is not recorded, but in parliamentarian Cambridge this event probably occurred soon after the onset of hostilities in August 1642. By early 1643 workmen were dismantling the organ, and during the summer of 1644 the empty case also was removed; the very modest wages paid indicate that the workmen were allowed to take away the lumber as part of their reward.[157] The College did not discard the singers of its Choir quite so readily; each remained in receipt of his board, lodging, stipend and gratuities until he died, or chose to leave, or – in the case of the choristers – found his membership expired. However, as a house of formal sung worship the Chapel now, as once before, was silent.

The Stall panels

According to Henry VI's Will, the area between the screen and altar was meant to accommodate thirty-six stalls, on either side, for the seventy-two Fellows of the College. The heraldic panels above the stalls were carved by William Fells and donated to the Chapel by Thomas Weaver in 1633. They show on the north side the coats of arms of Eton College and of the University of Oxford, and on the south side those of the College and of the University of Cambridge. The canopies above the stalls were carved by Cornelius Austin between 1675 and 1678.

Ill. 207. ABOVE: William Fells. Cherub supporting the coat of arms of Eton College, detail of stall panel, north side (eleventh from eastern end), 1633, elm wood, 106 x 128 cm. King's College Chapel, Cambridge.

Ill. 206. LEFT: William Fells, Greyhound supporting the arms of Henry VII with the garter and motto of the Order of the Garter, detail of stall panel, north side (twelfth from eastern end), 1633, elm wood, 106 x 128 cm. King's College Chapel, Cambridge.

Ill. 208. William Fells, Cherubs supporting the coat of arms of Eton College, stall panel, north side stalls (eleventh from eastern end), 1633, elm wood, 106 x 128 cm. King's College Chapel, Cambridge.

Ill. 209. William Fells, Angels supporting the coat of arms of King's College, stall panel, south side (first at eastern end), 1633, elm wood, 106 x 128 cm. King's College Chapel, Cambridge.

Ill. 210. Richard Bankes Harraden, *Interior of King's College Chapel looking West from the Altar*, 1797, watercolour, 46.3 x 35 cm. Cambridge, King's College.

XIII

The Chapel Organ – A Harmonious Anachronism?[1]

JOHN BUTT

THE DISPUTES CONCERNING THE DISPLAY and placing of Rubens' *Adoration of the Magi* in King's College Chapel are well recorded, and hinge on the fact that the painting dates from around a century after the Chapel was fitted out, and even longer after the period during which the Chapel's structure was planned and completed. Most of the Chapel – so the story goes – was at least completed in a single historical sweep, however long and stuttering this may have been, which makes the Rubens something of an anachronism. But there is a far bigger and far more prominent anachronism in the Chapel than the painting, even if it is seldom recognised as such: the organ. This – as it looks today – could not have been imagined in the fifteenth century, nor in most of the sixteenth, however much it may appear to grow seamlessly out of the Tudor screen. While the larger case has traditionally been thought to survive from the Thomas Dallam organ of 1605–6 (see below), only certain decorative components, at most, could come from that time, and its current form is more likely to be contemporary with – or even later than – the smaller choir organ (or 'chaire organ') case, which is situated on the eastern side. This latter can be dated reasonably securely to 1661, over two decades after the death of Rubens.

The 'double organ' (i.e. comprising one large case – the 'great organ', with a smaller one placed lower down – the 'chaire organ') was new to seventeenth-century England. It was invariably designed to be played from a console situated between the two cases, so that the player's back faced the back of the 'chaire organ' (hence its name; similarly, in the Germanic terminology most often used to describe organs, the word 'Rückpositiv' refers specifically to a small organ at 'the back'). Already then, there seems to be something a little wrong with the present King's case, since in this instance there is no gap between the two cases, and the organ console sits on the north side of the main case. This is because the seventeenth-century appearance of the organ has itself been modified by expanding the main case to accommodate an instrument much bigger than was ever envisioned in the later seventeenth century. The extra pipework takes up all the room between the two cases and, moreover, pushes the western front virtually to the edge of the screen. Closer inspection shows that the organ has in fact spread well beyond the cases – pipes spread up the stairs to the organ loft in the north side of the screen; many more pipes are accommodated on the south side (most of the pedal organ and the enclosed solo organ, which contains many of the specifically 'orchestral' sounds).

Many of these major structural changes were undertaken in the nineteenth century, although the scheme was entirely revised in the 1930s when the organ reached more or less its present shape. But there is still the question of the tonal qualities of the organ – are these not in any way coterminous with the visual design of the instrument? It is true that some of the case pipes were working until the last decade of the twentieth century, when their lead composition became too soft

Ill. 211. Chaire case of the organ (view from the east), seventeenth century. Cambridge, King's College Chapel.

for them to be reliable, but the vast majority of the pipework dates from the nineteenth and twentieth centuries. Indeed, so complete was the last major rebuild of 1933–34 that all the older pipework was remade according to the aesthetic agreed between the organist, Boris Ord, and Arthur Harrison, director of the organ builders Harrison and Harrison. The result is essentially a very particular and coherent tonal design that has little directly to do with how the organ might have sounded at any stage in the earlier history of the Chapel.

The question immediately arises then as to why the organ has been so readily accepted, in both appearance and sound, as part of the essential identity of the Chapel. It is obvious that the original builders of the cases were sensitive to the material and style of the screen and also to the way the organ would cohere with the proportions and dimensions of the building. Therefore – one might argue – it has an organic relationship with the Chapel that the Rubens painting was never designed to have. Whatever the reasons for the general acceptance of the visual aspect of the organ, the issue

of its sound may relate to the fact that we judge what we hear rather differently from what we see. Hearing always presupposes a specific time frame during which the music happens, relating to the immediacy of experience in a way quite different from (although not necessarily superior to) the less specifically temporal experience of the visual. To put it simply, a reverberant building such as King's Chapel comes alive in a very real sense when music is performed. Although not all music works equally well, the building (and hence our hearing experience) does not immediately discriminate between historical styles in the way that the eye does.

Indeed, very little of the music performed in the Chapel today comes from the earliest period of construction, although the sixteenth-century repertory has been a rich component of the repertory for Choir and organ from at least the time of Boris Ord in the 1930s. In short, the musical practice of the Chapel is part of a living tradition, embracing many musical styles, and embraced in turn by the bloom of the acoustic. The musical aspects of the Chapel somehow harmonise in a way that could scarcely be paralleled by a more eclectic approach to its architecture and fittings. Perhaps, then, the organ is a synecdoche for the broader choral tradition of the Chapel.

But does this then imply that the 1933–34 organ is somehow the most ideal there can be, as if the evident perfection of the Chapel as a whole were mirrored several centuries later by the belated perfection of its principal sonic furnishing? This question can hardly be answered satisfactorily here. What can be said is that the history of the organ in King's Chapel reveals that virtually every stage is directly conditioned by the tastes and ideologies of its time, and that (together with the minor alterations undertaken over the intervening years up to the present) the 1933–34 instrument is no exception to this pattern.

Ill. 212. Upper case of the organ (view from the east), seventeenth century. Cambridge, King's College Chapel.

Ill. 213. West case of the organ (view from the west), seventeenth century. Cambridge, King's College Chapel.

Two points specifically distinguish the earliest organs in the Chapel from their later counterparts: first, they were relatively small instruments and almost certainly not fixtures built into the fabric of the building.[2] Given the complexity and extent of the Sarum liturgy, larger buildings usually had a pair of organs, 'great' and 'small', in order to accommodate different liturgical positions and occasions; King's was no exception in this regard. Repairs are recorded for both organs in the old chapel as early as 1451 and several times over the next few decades.[3] The 'great' organ was replaced in 1507/08 by a new, larger, one built by Thomas Brown; this seems to have required much modification and repair in the early years, perhaps owing to its increased size.[4] Given that the new Chapel was not complete until 1515 and even then an empty shell, this organ was installed in the old chapel and not moved to the new one until shortly after the partial collapse of the old in September 1537.[5]

The second main difference between the pre-Reformation organs and those of later centuries concerns their function. All the surviving sources for English liturgical organ music show that the organ was used to substitute for music that was otherwise sung by the Choir (whether monophonic chant or polyphony, 'pricksong'), principally in settings of the office hymns prescribed by the Sarum rite. The standard practice seems to have been for the organ to alternate verses with the singers on Sundays and major feast days.[6] In short, the organ was not considered an accompanimental instrument, as was also the case across the rest of Europe. Even after the Reformation, congregational psalms (or hymns in some traditions) remained unaccompanied until well into the seventeenth century. The first unequivocal use of the organ for accompaniment in England during the later sixteenth century is for the genre of the verse anthem and verse service, where the solo sections, at the very least,

require instrumental accompaniment. But this practice had been barely invented before King's Chapel next lost its organs in 1571 (see below), so it could not have happened during the sixteenth century. Organ books for verse pieces do not survive from before the seventeenth century (although some must undoubtedly have existed in the last decade or so of the sixteenth century) and organ doubling of choral lines in 'full' anthems and services was not ubiquitous until around 1630.[7]

The story of organs in King's Chapel after the Reformation is one that is shared in outline by most other choral foundations. References to organ maintenance predictably disappear in 1549, with the accession of Edward VI, and reappear after Mary's succession in 1553. There was another lurch towards Puritanism with a visitation from the royal commissioners in 1571 (in reaction to the governance of Provost Baker, who was considered to be influencing the College too far in the Roman direction), and the organs were removed from the Chapel, and remained absent for the rest of the century.[8]

After several complaints about the lack of an organ in the Chapel, contrary to the founding statutes, it is clear that the tide was turning yet again with the accession of James I. In 1604 various complaints within the College (of which the absence of an organ was only a small part) were addressed by the Visitor, William Chadderton, Bishop of Lincoln. Following this the College sought to obtain a second-hand instrument and even Sir Robert Cecil, as Chancellor of the University, added his voice to the appeal. With the failure of this attempt there followed one of the most closely documented projects in early English organ history, the construction of a new organ for the Chapel by Thomas Dallam (a recusant, who was highly favoured as an organ builder by the new regime). A closely-written double page inserted into the King's College Mundum Book (essentially an ongoing record of all College accounts) at the end of the 1606 entry gives us unparalleled detail about the conduct of Dallam, his men and associated carpenters and joiners.[9] The payments date from between June 22 1605 and August 7 1606, and Dallam seems to have been resident in Cambridge for over a year. In common with many organ builders of the seventeenth century, Dallam moved his entire workshop to the Chapel and procured most of the materials locally. In this respect his working methods were probably not unlike those of the builders of the Chapel itself; these were practices that would have been seen as hopelessly inefficient by the standards of the Industrial Revolution, but that implied a degree of integration and unification of craftsmanship that is difficult to replicate today. The organ was sumptuously decorated and was clearly to be viewed as a treasured possession. Although the specification is the one matter on which the Mundum Book is silent, it is likely to have been an ambitious instrument for its time, with two divisions (i.e. played from two keyboards corresponding to two discrete bodies of pipes). A surviving plan of the Chapel by John Smythson (c.1609) points to its being situated centrally in the third bay from the east end, probably on the site of the original Henrician altar.[10]

If any of the main case of this organ survives in the present organ case, Dallam's was clearly in a different form, with five towers (i.e. peaks within the sweep of the case, housing the longest pipes) rather than the two seen today.[11] Nicholas Thistlethwaite speculates that the receding perspective effect of the central pipes in the current western side of the case (which, it might be assumed, did not exist in the Thomas Dallam organ, since in its original position this side of the organ would have been facing east and thus not on public display) may have originated with Dallam's son, Robert, since this is characteristic of his work in the 1630s and shortly after the Restoration (1660).[12] But there is no direct evidence for this other than the fact that Robert received payments for repairs on the organ during the 1630s. What is also undocumented is the time at which the organ was moved from the east end to the top of the screen, formerly the rood loft. The Mundum Book could support 1613–14,

in anticipation of the visit of James I, or around 1633–34 when the Chapel was 'beautified' for the visit of Charles I. A *terminus ante quem* seems to be the year 1634, when a padlock was provided for the organ loft and when Robert Dallam submitted a particularly large invoice for £22.[13]

If the organ had finally reached what many today might consider its 'natural' home, this triumph was decidedly short-lived. Payments were made to take down at least the small case of the organ in 1643, in anticipation of the impending visit of the iconoclast William Dowsing later that year. Legend has it that the larger case was never removed, albeit stripped of its contents, but it is certain that the organ could not have been played at all during the Commonwealth era.[14]

Only after this third period of removal of organs did the King's organ become a continuous fixture in the Chapel. Lancelot Pease replaced the chaire organ in 1661 and Pease's colleague, Thomas Thamer, seems to have worked on the main case in 1674. Samuel Pepys attended the Chapel on 15 July 1661: 'Then to Kings College chappell, where I find the schollers in their surplices at the service with the organs – which is a strange sight to what it used in my time to be here'.[15] This is not only an interesting reflection of what it must have been like for someone who attended Cambridge during the Commonwealth returning just after the Restoration, it also suggests that the organ was already playing a prominent role, the reference to 'organs' perhaps even suggesting that something of the main case may already have been present, in addition to the new chaire organ.

In 1686–9, seemingly reprising the situation with Dallam at the outset of the century, the College engaged the most prestigious English organ builder it could find, Renatus Harris, in order to bring the organ fully up to date. It would presumably now be worthy for performing the expanding repertory of major Restoration composers such as Blow and Purcell, while also accompanying the entire Anglican repertoire of verse and full settings. Although no specification survives, this would undoubtedly have had the 'Baroque' characteristics of the period: reed stops and mutations (which double upper harmonics of the fifth or third), together with the 'foundation' stops sounding at the pitch of the fundamental (i.e. the 'normal' pitch corresponding to the key depressed, as would be expected on a modern piano) and those sounding at upper octaves.

By now the organ almost certainly looked in essence as it appears today (the earliest iconographic evidence for this, though only of the western prospect, can be dated to about 1690 and appears in David Loggan's *Cantabrigia illustrata*: see Ill. 215). Tonally, apart from the addition of two new stops early on, the organ seems to have remained fundamentally the same until 1802, the only references made to it for most of the eighteenth century relating to the gilding or painting of pipes.[16] This is thus the longest and most stable period in the instrument's history and one, it has to be admitted, when appearance and sound were presumably most cohesive. On the other hand, the later eighteenth century was a low point for virtually all English choral foundations, since the violent swings for and against music in the service of the previous two centuries had been replaced by an attitude that was equally detrimental to the survival of the choral tradition: pervasive indifference. Musically, England remained an enthusiastic consumer of secular continental music culture, but composers, particularly those associated with the church, remained in a sort of time-warp, unable to shake off the overwhelming influence of Handel's style. And, given that Handel's solo organ music and organ concerto writing is almost exclusively without pedals, there was little incentive to provide organs with the full pedal boards and pedal stops that had been a key feature of much north European organ building for several centuries. Thus, to any visitor from Germany, France, Scandinavia and the Low Countries, organs such as that in King's must have seemed remarkably primitive and archaic.

It was not until the installation of a new organ, by the prominent if somewhat unreliable organ builder John Avery in 1802–4, that anything approaching a pedal department was installed.[17]

Ill. 214. First page of organ details relating to Thomas Dallam, 1605–06. In Mundum Book (1605–11). Cambridge, King's College, KCAR/4/1/1/23.

Ill. 215. David Loggan, *Sacelli regalis apud Cantabrigienses Prospectus Interior ab Occidentali*, etching. 47.5 x 36.5 cm (plate). In David Loggan, *Cantabrigia illustrata...* (Cantabrigiæ: Quam proprijs sumptibus typis mandavit & impressit, [1690]), pl. 12. Cambridge, King's College.

But even this was only an octave and a half of 8 foot pipes (i.e. those at 'normal', fundamental pitch), controlled by toe pedals rather than a complete pedal board. Avery's three-manual instrument seems to have been largely new in terms of its pipework and mechanism,[18] although stylistically it was not that different from a late seventeenth/eighteenth-century English organ. It is difficult to determine whether much of the older pipework was retained, but it is likely that Avery would have made use of the metal, at the very least, together with the existing pipes of the case. Avery's work seems to have been more problematic than he had anticipated, as suggested by the Congregation Minutes of

November 1803, which state that he should be given an extra 100 guineas in respect to 'unforeseen Trouble, and Expences in his Construction of the Organ'.[19]

There are several references in recent literature to the notion that Avery's work must have been relatively poor, since he left the organ 'unfinished';[20] the Mundum Book for 1809 records, 'Paid Mr Elliot Organ Maker for repairing and compleating the organ left unfinished by Avery'. However, this comment comes under expenses for the Chapel, rather than the College's 'Chest Account' and amounts only to £36, which is a fraction of the original cost.[21] Whatever its ultimate quality, this instrument basically served in the Chapel for several decades, albeit undergoing the sort of continual expansion that was typical of English organs in this period.[22] A 'German' pedalboard (that is, a pedalboard of what is essentially a modern design to replace Avery's earlier toe pedals) was added for the first time in 1830 and some pedal pipes at 16' pitch (i.e. sounding an octave below written pitch) just four years later; in 1856 the pedal compass was expanded to just over two octaves. The following year, Thomas Hill submitted a plan for rebuilding the Avery organ, now as a three-manual Romantic instrument with a fuller pedal division and more characterful reeds. The action had the most up-to-date pneumatic assistance and the wind was provided by a hydraulic system, dependent on the town water supply (and liable to be unreliable, especially during Matins, which coincided with the time when the streets were hosed). It was at this stage that the organ console (i.e. the set of keyboards at which the player sits) was moved from its 'natural' position between the case of the choir organ and that of the great organ, to the north side of the loft, while the pedal pipes were situated on the opposite side of the case. The pedal division possessed for the first time a 32' rank (i.e. sounding two octaves below written pitch), laid horizontally across the loft, providing a depth of sound that would have been entirely unanticipated by the Chapel's original builders, but capitalising on the generous acoustic that they had created.

The expansion of the organ seems to have gone hand in hand with two basic developments in the performance and function of the organ. First, there was the growth in use of the pedals, several centuries behind the practice in central Europe. It seems that the organist for the first half of the nineteenth century, John Pratt, remained a manuals-only player throughout his career and left both Avery's toe pedals and Hill's pedalboard largely untouched.[23] William Amps, who held the post from 1855–1876, and who would have been brought up in the wake of Mendelssohn's tremendous influence on English organ practice, seems to have made much more of an attempt to master continental organ technique. Nevertheless, it seems that he was valued rather less than other prominent organists of the age, if the report of a combined Choir festival in the Chapel on June 6 1868 is anything to go by:

> Mr. Amps, the organist of King's Chapel, played a very soft introductory voluntary – so soft indeed that it was scarcely audible: it sounded as if he was using a stopped diapason on the swell alone. Mr. Amps, we may here remark, presided at the organ throughout the morning service; and the Professor of Music [in 1868 this would have been William Sterndale Bennett] officiated as conductor....The organ accompaniment however was far too heavy throughout; and at verses 6 and 7 of Psalm CXXXV, the attempt to imitate a storm on the organ was in anything but good taste: however the organist was paid out for this vagary by the wind suddenly failing him. We may remark, by the way, that it is a mystery to us how such a noise was produced on the organ, unless indeed one of Mr. Amps' pupils whom we observed in the organ-loft assisted his master by pulling out all the 16 foot force of the manuals, and then by sitting on the lowest octave thereof![24]

This report does betray several important developments, not least the fact that the organ was playing a significant role as an accompanimental instrument, with colour and word-painting playing a prominent role. It would seem that this practice dates more or less directly to the time of Hill's expansion of the organ and Amps' appointment, around 1855. Orchestral-style organ accompaniment was clearly taken much further with Amps's successor in 1876, Dr Arthur Henry Mann, who was also responsible for developing the Choir to a level well beyond what it had been for most of its prior existence.

Under Mann, the organist remained the leader for musical direction (he only conducted the unaccompanied services) and his playing was renowned for its orchestral style.[25] It was also Mann who presided over the largest rebuild of the organ in the nineteenth century, again by Hill, in 1889. One unusual aspect of this process was Mann's apparent interest in a new instrument by the greatest of nineteenth-century French builders, Aristide Cavaillé-Coll, as documented in a letter from the builder in 1883. This move seems entirely out of character for Mann, given that he was so antipathetic to fiery reeds and mixtures (his preference for orchestral sounds was presumably conditioned by a typically 'English' conception of the gentle differentiation of timbre). Perhaps he was unaware of the difference between English and French organs of this time, or, more likely, his enquiry was on behalf of a completely different institution. The rebuilt organ at King's, reusing much of the Avery pipework, came with a new console and tubular-pneumatic action, a solo organ providing sounds that were specifically imitative of orchestral instruments, and seven thumb pistons that enabled quick changes of registration on the main great and swell keyboards.

Ill. 216. *Arthur Mann at Old Organ*, 1914–16, photograph. Cambridge, King's College, AHM/5/2/02.

The subsequent history of the Hill instrument is testimony both to Mann's particular tastes (towards luscious sounds and away from sharp, penetrating upper work and reeds) and to the fact that his opinion was often ignored by both the College and Arthur Hill. It was the latter who took charge of the necessary repairs of 1911, including some revoicing and a certain amount of new pipework. Although this was the organ that was played in the first broadcasts from the Chapel, there is no surviving recording of how it sounded. One gains the impression that it was considered outdated in the years after World War I, and it seems that the urge to replace it soon after Mann's death in 1929 was extremely strong.

This next rebuild was undertaken under the signal influence of Mann's colleague and successor, Bernhard Ord (almost universally referred to today by his nickname, 'Boris' Ord).[26] This represents the last major change in the organ's history, one that – in terms of the thoroughness of the scheme, new stops and the total reworking of the existing pipework – essentially turned it into a new instrument. This point was stated outright in the order of service for the opening of the organ in April 1934: 'The present organ, though incorporating all that was best of the old, is virtually a new instrument'.[27] It is also the one with which the Chapel and Choir have been indissolubly associated ever since. While in many ways this work continued in the direction towards an instrument suitable for orchestral-style accompaniment, as inaugurated by Hill and Mann, it is also the product of the unique combination of musical and technical skills provided by Arthur Harrison (of the organ builder, Harrison and Harrison, and responsible for some of the most spectacular rebuilds of the day, such as the organs at the Royal Albert Hall and Westminster Abbey) and Ord himself. And such a seminal rebuild might not have occurred at all, particularly at a time of severe international financial crisis, without the support of the College's first bursar, John Maynard Keynes, who seems to have maintained a keen interest in the project throughout.

The process by which the new organ was designed and executed is exceptionally well documented, mainly through the correspondence between Ord and Harrison. Towards the end of 1931, schemes were submitted both by Harrison and Harrison and by the firm that had maintained the instrument over the previous century (now called Hill, Norman and Beard);[28] Harrisons' scheme was accepted by February 1932 and this went through two further iterations before work began in 1933. The organ was usable for the carol service that year, but was not entirely finished for another few months, and finally dedicated on 28 April 1934. Not only did Harrison reuse as much of the old pipework as he could, he also harvested several other ranks of pipes from no fewer than five organs (including the Royal Albert Hall); even the stop knobs from the Hill organ were reused for the new state-of-the-art Harrison console (which still serves today). But, despite all this recycling, it is clear that every sounding part of the organ was entirely reworked to establish its overall integrity.

The quality and workmanship of the instrument are clearly the legacy of Arthur Harrison, but the influence of Boris Ord in conceiving the tonal character can hardly be overestimated. Ord's musical character is worthy of study in its own right: he seems to have appeared virtually out of nowhere, having none of the traditional background in childhood vocal training within the Anglican tradition. His father was a Quaker and lecturer in German at Bristol University and his mother was herself German. As an undergraduate, he clearly excelled in both early and modern music, and, having studied at the Royal College of Music and served as organ scholar at Corpus Christi College, he became a Fellow of King's in 1923. Here he pursued a scholarly interest in music and eventually served as Mann's assistant,[29] but he also spent a year in Germany as an opera repetiteur and became increasingly known as both conductor and continuo player. His musical interests seem to have been far broader than could be expected of most church musicians of the time, ranging from early Tudor music to the present,

> King's College,
> Cambridge.
>
> May 30, 1932.
>
> Dear Sirs,
>
> I have pleasure in returning to you herewith copy of the memorandum of agreement between your firm and the College, which I have signed as Bursar, for the rebuilding of the Organ in King's College Chapel. I also enclose herewith a cheque for £1542. 10. 0, being 20% of the contract sum of £7712. 10. 0.
>
> Yours faithfully,
>
> J M Keynes
>
> Messrs. Harrison & Harrison,
> Durham.

Ill. 217. John Maynard Keynes to Harrison & Harrison, Organ Builders, 30 May 1932. Durham, Archives of Harrison & Harrison, Organ Builders.

though a present seldom more 'modern' than that of Vaughan Williams, or Stravinsky in his neo-classical phase. Indeed, 'neo-classical'[30] seems to be one of the strongest threads in his musical personality and his experience in both Germany and England seems to have conditioned him towards organs with a neo-classical accent (he seems to have consulted directly with Albert Schweitzer when the latter visited the College). This is most evident in his insistence that the new organ should have a main chorus that was capped by a mixture (a stop of several ranks, providing several upper partials that sound simultaneously) that worked without the conventional addition of reeds. Mann seems to have had an antipathy towards choruses topped by mixtures alone, without the blending effect of chorus reeds. Ord also desired softer mutations on the choir organ (stops that double separate upper partials beyond unisons and octaves). Here he overrode Harrison's preference for a 'dulciana mixture' by calling

for separate ranks at the upper fifths and third, something which was extremely unusual in England at the time. Nevertheless, these mutations, still situated on the choir organ (and dynamically controlled through a swell box), remained narrow-scaled dulciana pipes, quite unlike anything in historic continental organs, and giving the organ that range of bell-like 'tinkle' sounds that have become so familiar in Christmas carol arrangements from the 1960s onwards.

Ord's other requests often show a shrewd balance between imitative orchestral sounds and an overall smoothness of tone that does not clash with the acoustic of the Chapel: loud reeds are, he says, to be brassy and trumpet-like and not 'honky' (in the event they seem to be more the smooth and overbearing variety that Harrison was wont to provide); the clarinet is to be 'fat' enough to serve in the settings of Stanford (many of which were originally conceived for full orchestra); the horn is to sound like a real orchestral horn and thus to be labeled 'French horn'. The solo viol chorus seems a concession both to late romantic colour and to the recent interest in the historical revival of early instruments (Harrisons had become famous for such choruses, such as that in the nearby organ at Ely Cathedral). Ord also noticed the beauty of Harrison's style of claribel flute on the organ at St Mary Redcliffe, in his native Bristol, and requested one of similar quality for King's. This resulted in one of the most beautiful, liquid sounds in the King's organ, one that undoubtedly contributed to the sound world of much composition directed towards this organ (such as Howells's organ accompaniments in the Collegium Regale set). Ord also called for a bright but delicate 4' flute (i.e. an octave above written pitch) to match this, for solos in Handel's organ concertos – again, here a neo-classical taste is married with the romantic style of English organ building. Ever sensitive to the remarkable resonance of the Chapel acoustic, Ord was also responsible for the extremely quiet salicionals (very narrow pipes with a string-like sound) on the choir and pedal; these were meant to be as quiet as possible with the choir swellbox closed, given that virtually any sound is automatically amplified by the building.[31]

Ord's sonic ideal sound is very nicely summed up in a letter he sent to Harrison on 10 April 1932:

> I must...thank you for all your kindness, and...say how enormously I enjoyed hearing and playing your organs at Durham and in the City Hall. So far from finding the latter too brilliant, I was thrilled by it, perhaps because although manifestly a concert-hall organ it retains that innate 'gentlemanliness' which I like and Cunningham apparently doesn't. If C. finds your organ too gentlemanly, I hope he will never come to hear my choir – I'm afraid he would find it too refeened![32]

A 'brilliant gentlemanliness' does indeed seem to be behind Ord's musical aesthetic – almost a combination of the English and German stereotypes he may have been thought to portray. Certainly, German music was well represented in the opening service and recital of the new organ in April 1934: Ord (or his first organ scholar, Percy Higgs) played Bach's Passacaglia and Fugue in C minor within the service itself, and Henry Ley's recital included music by Buxtehude and Mozart (together with one French piece, Franck's Chorale in A minor). English music by Wood, Stanford, Gray and Vaughan Williams featured in both service and recital. Much of this must have been regarded as relatively 'modern' at the time (and actually would not sound out of place in a service and organ recital today), and Victoriana is strikingly absent. Ord's interest in the Germanic tradition as a player is reflected in his reference to playing Reubke's Sonata on the 94th Psalm in a letter of 1932; he was also renowned for regularly playing Bach's Art of Fugue from full score.

The order of service booklet also contains some interesting information about the history of the organ: it explains that, while much of the nineteenth century pipework is still present, albeit entirely

revoiced, two stopped diapasons remain the work of 'René Harris...carefully preserved by the present builders'.[33] There is no independent verification of this statement, however, and it might well reflect the opinions of Ord and Harrison rather than hard historical evidence. Indeed, Mark Venning, former managing director of Harrison and Harrison, who has looked after the organ for many years, believes that nothing beyond the case pipes dates from before the nineteenth century.[34]

The relatively minor alterations to the organ since 1934 have generally addressed in equal measure weaknesses in the Ord-Harrison design and changes of taste. Ord himself oversaw some changes to the main diapason chorus in 1950;[35] he also had a mixture added to the pedal (initially situated on the stairs leading up to the organ loft), doubtless an attempt to render the pedal organ clearer to the player, given that most of the rest of it is placed a long way from the console, on the south part of the screen. The attempt to make up for the deficiencies of the pedal organ (in terms of clarity, blend and balance with the rest of the organ) was taken further by David Willcocks in the work done on the organ in 1969. The mixture and fifteenth (which sounds two octaves higher than the notated pitch) were to be moved from the stairs into the pedal division, in place of some of the larger open wood ranks. A 'neo-baroque' aesthetic is clearly reflected here in the move against overly strong 'fundamental' tones, which is represented by the removal of the great organ's largest open diapason (which would have sounded unfashionably 'fat' and muddy). This was to be replaced by another high mixture, and both pedal and choir organs gained light reed stops with baroque names ('schalmei' and 'dulzian'). Moreover, the choir mutations were now rescaled towards a more penetrating Baroque voicing (partly by transferring some of the pipes from one stop to another). Notes in the Harrison archive give a good picture of the aesthetic of the later 1960s:

> We feel that these changes will bring the organ up to date with present day thinking, but will not in any way interfere with the basic Arthur Harrison tonal structure, and would be pleased to receive any other suggestions from Mr. Willcocks on these lines.[36]

One aspect of the 1933 organ that Willcocks had found particularly frustrating – particularly given his famously accurate sense of perfect pitch – was the fact that it was tuned slightly flat of the pitch that became customary after World War II. Willcocks had also experienced problems with orchestral tuning when combined with the organ, and noted in early 1968 that:

> I am so glad to know that you hope to be able to bring the pitch of the organ up to 523.3 as part of the programme of work being undertaken. It has always seemed to me unbelievable that Boris would have agreed to the organ pitch being 517.[37]

In fact, the existing pitch was only a fraction below 523.3Hz (referring to the pitch of the C above middle C, which is more commonly described today as A=440Hz), at 522Hz. It may be that Willcocks had read the first Harrison rebuilding scheme of 1931, in which 517 was referred to as the 'new French pitch', but this was modified upwards to 522 in the second scheme.[38] In fact, Ord could not possibly have envisioned the pitch of 523.3Hz (or A=440) as a standard in 1934, since no such standard yet existed.

Since 1969, the organ has been maintained without any major rebuild. Most striking among the various smaller repairs and improvements has been the restoration of some of the case pipes, which became too weak to bear even their own weight (they have not been sounding pipes since 1992). A completely new electronic piston system has also been installed for ease and reliability of registration, thus making the organ fully compatible with most other prominent concert and cathedral organs.

Perhaps the most interesting changes are those that reflect further changes of taste, particularly with regard to some of the 'neo-baroque' modifications of 1969. While this previous revoicing had been in the direction of stronger upperwork (particularly on the choir organ but also the great organ) and less of the fundamental, the 1992 work saw something of a reversal of this tendency, rather more towards the 1930s scalings.[39] Moreover, the acerbically neo-baroque dulzian on the choir – added in 1969 – was replaced by a rather more sympathetic 'corno di bassetto'. In other words, one form of historicism (the 'baroquification' of the 1960s) was replaced by another one, more faithful to the integrity of the original 1930s conception (which itself had neo-baroque elements of a gentler kind). Lest this be thought of as an overly conservative approach, there is also some material in the Harrison and Harrison archives showing that a much more radical rebuild had at least been discussed in the 1980s, one that might have involved the installation of a new mechanical action by a continental firm adept at this sort of mechanism.[40]

It is difficult to predict what changes may be made to the organ in the future. Certain obvious weaknesses relate to the placing and relative strength of the pedal organ; and the solo organ, also on the south side of the screen, sounds very late to the player, seated some distance away on the north side. Then there is the question of the position of the console and player, which results in an extraordinarily long time-lag between the organ and the choir in the stalls below; generations of organ scholars have had to learn to play well ahead of what they hear. Owing to the widely ranging temperatures and particularly to the remarkable amount of sunlight that the windows allow to glance on the organ case,[41] the instrument requires tuning on a very regular basis, at least during term time. Back in 1934, Keynes remarked that the cost of tuning had risen exponentially, the £40 per annum formerly covering weekly tuning being replaced by £70 per annum for fortnightly tuning. A similar complaint is made by the bursar of 1969, noting an increase of £100 since the last increase of 1966.

Other possible criticisms are more aesthetic: no-one can dispute the quality of the organ's soft sounds and the beauty of its solo stops; but at a louder volume – and especially in the wrong hands – the sound can easily become distorted and overbearing in the Chapel's acoustic (particularly when the great and pedal reeds are employed). Moreover, looking at the organ with its modified seventeenth-century cases from the east end of the Chapel, some might find its sound entirely incongruous and far 'fatter' than the physical appearance of the organ might suggest.

As 2015 approaches, should we gently continue to modify the 1930s' conception or is there a specific sonic hallmark of the present that should be more forcefully presented? Did the organ perhaps reach a 'point of perfection' in 1934, just as the Chapel itself did in the 1530s? An unkind judgment of the organ as it stands today might begin with the fact that it is a victim of its own success. In an 'age of mechanical reproduction' the organ has become an essential element of the 'King's sound' from the 1950s to the present – even more consistent in its voicing and musical character than the Choir has been under the four musical directors concerned. Perhaps this forces us into a 1930s' ideal that betokens our inability to conceive of an appropriate sound for our own era? If so, our present generation would seem to be less bold than any other one in the organ's history. On the other hand, such is the individuality of the Ord-Harrison design that the organ has a quality and integrity that are unmistakable. Built as an eclectic instrument, designed for music ranging from Tudor times, through the great German and French schools, to the England of the early twentieth century, our 80 years' distance might actually help us hear the instrument as a unified, historical whole, just as we see the Chapel itself. It is a sonic fixture that would be very difficult to displace, and any replacement design – however ideally conceived – could not necessarily be guaranteed the considerable success of the organ of 1934.

Ill. 218. Wilkins' Screen, 1829, graphite and watercolour, 26.7 x 42.6 cm. Cambridge, King's College.

XIV

'As England knows it': 'Daddy' Mann and King's College Choir, 1876–1929

NICHOLAS MARSTON

I

> For it was to King's College Chapel that we were usually taken; and that was another trouble: I couldn't bear the music there! I don't expect anyone to understand about this, but I simply hated the unfair, juicy way in which the organ notes oozed round inside the roof ... [1]

IMAGINE THE FIVE-YEAR-OLD GWEN RAVERAT creeping unwillingly to morning service in King's, say on Sunday 15 June 1890. She would have had two hymns and Macfarren's Service in E flat in prospect, its Evening counterpart teamed later that afternoon with Mendelssohn's 'Sing ye Praise' (*Lobgesang*, op. 52 no. 3: Ill. 219). As for the surrounding organ music, which 'sapped your vitals, and made you want to cry about nothing at all', she could have heard, played on the recently renovated instrument, four of the five movements of Widor's Symphony no. 5 in F minor of 1879, culminating in the yet-to-be-famous Toccata: not exactly a composition calculated to elicit Raverat's description of the organist, Dr Mann: 'I dare say that he was rather soulful'. (Indeed, it was precisely the Adagio movement which was omitted.) [2]

But Raverat's negative reactions to music in King's Chapel were not unshared, as Mann's obituarists would make clear when she was in her mid-forties. An echo of her childhood reactions lingers in the account, in *The Times*, of Mann's 'accompaniment [which] was inclined to be luscious, with passing notes and descants, and his extemporized preludes were wonderful pieces of colour and modulation, without any very precise development of form'.[3] Edward J. Dent, Cambridge Professor of Music and Fellow of King's, was expressing his own reactions when he recalled Mann's cultivation of 'an ideal of tone-quality which many people found rather too luscious'; meanwhile the *Cambridge News* claimed that 'his choir was unique, and in its own manner, which was not whole-heartedly admired by some musicians', while yet adding that 'it was the finest in the world. For sheer beauty it was unequalled.'[4]

By the time of his death, on 19 November 1929, Arthur Henry Mann – affectionately known to his Choir and others as 'Daddy' – had been organist of King's for a little over fifty-three years: not the longest tenure on record, but one whose beginning was rooted in significant changes both in the organisation of the Choir and Chapel and the College more generally.[5] The chief musical changes were, firstly, the decision, by a vote of the Annual Congregation on 30 November 1875, to open the competition for choristerships to non-residents of Cambridge, a change which paved the way for the

Ill. 219. Services at King's College Chapel, Cambridge, 9–22 June 1890. In *King's College Chapel: List of Services, May 12 to June 22, 1890*. Cambridge, King's College, CSV/2, fol. [2]v.

establishment of the present Choir School;[6] and secondly, five years later at the equivalent Congregation, the grateful acceptance from Augustus Austen Leigh, Vice Provost, and his brother William, 'of the sum of £270 for providing a choral scholarship in the College'. This initiative too opened the way for demographic change; whereas the lay clerks – professional singing men who, once appointed as altos, tenors or basses, might remain in post for some decades – were necessarily local to Cambridge, a choral scholar might come from anywhere in the country, would be youthful on appointment and would not grow old in the Choir. The College statutes of 1861 provided for a Choir of twelve lay clerks and sixteen choristers, in addition to the offices of (two) chaplains, an organist, and a master over the choristers; the statutes of 1882 would specify as the men of the Choir 'not less than six or more than twelve Lay Clerks or Choral Scholars'. The first scholarship was 'adjudged to Percy A. Thomas' by the Provost and officers on 12 March 1881, and the first substitution of a choral scholarship for a vacated lay clerkship occurred in 1886; but the gradual replacement of lay clerks by choral scholars would not be complete until 1928, and it would be two years after Mann's death that a statutory number of twelve scholarships was finally established.

These developments in relation to the front and back rows of the Choir not only brought signal changes to its social constitution and musical efficiency, but were also bound up with the College's wider educational concerns, not least its attempts to broaden the base of its undergraduate intake. By 1896 a printed circular describing the choral scholarship competition, and intended for distribution to schools, drew attention to the value of these awards as a means of furnishing 'an University education at a comparatively small cost'.[7] And in May the following year a committee appointed by Council to explore 'by what means the choral scholarships offered by the College can be

made more attractive' agreed a number of financial advantages for successful entrants to the College via this route: these included the remittance of the usual entrance fee, a reduction from £8 to £4 in tuition fees, and the provision of free dinners outside Full Term, when choral scholars were required to remain in residence while daily services continued.

Despite the provision for twelve lay clerks in the 1861 statutes, there was not necessarily always a full complement in place. This had been one of several issues addressed in the report of 15 May 1869 of a committee charged with considering 'changes necessary to ensure a satisfactory Choral service in Chapel'.[8] The College's failure to observe its statutory duty, again dating from 1861, to provide the choristers with board and lodging 'under proper supervision' was also noted, as was the disproportion between the difficulty of much of the musical repertoire and the time available for rehearsal. To remedy this, the committee recommended two full practices of one hour each week, supported by punctual and regular attendance; there should also be one unaccompanied service each week, and the occasional substitution of hymns for anthems. It further recommended that the precentor (a role sometimes taken by one of the chaplains) be given clear authority over discipline and musical efficiency in the Choir, and proposed negotiations with Trinity College, with whom the lay clerks were shared, over the pensioning-off of those whose voices were no longer suitable, and an increased salary for those retained or newly appointed.

The College's intention 'to augment the number of lay clerks and to raise the efficiency of the Choir', indeed, was the reason why Provost Richard Okes wrote on 7 February 1876 to William Amps, Mann's predecessor since 1855, inviting him 'to place his resignation in the hands of the Provost and officers'. This same group had on 15 November the previous year charged the Deans with expressing the 'considerable dissatisfaction' felt with Amps (who served also as organist of Christ's College and Peterhouse) 'in the execution of his duties as Organist and Musical Instructor of the Choristers';[9] and a draft of the Provost and officers' vote of 7 February 1876, transmitted in Okes's letter, reveals that while Amps was told, gently, of the College's desire to appoint 'another Organist', King's was in reality seeking a 'superior' one.[10] A further vote of 22 December 1875 requiring the organist to 'obtain permission from the Dean in charge before absenting himself from his duties' intimates another aspect of Amps's failings. He ultimately accepted the College's power of dismissal, as also its offer of a pension of £80 per year from Midsummer 1876 onward.

So it was that the Provost and officers – Congregation having already voted that a new organist's stipend would not exceed £300 – met on May Day 1876 to consider six applications and supporting references (this was the first time that the post had been offered through open competition). A fortnight later they agreed that Mann and T. H. Webb be invited to 'perform on the Organ' on the 23rd and 24th of the month, with Joseph Barnby, organist of Eton, present as an expert assessor. The result of these auditions was evidently indecisive, for on 25 May it was agreed to invite a third candidate, Langdon Colborne, to play on 7 June. The decision was made that same afternoon: 'Agreed that the office of organist be offered to Mr A. H. Mann for three years at a salary of £250 a year'.

What was the daily routine of the Chapel which the twenty-six-year-old organist entered to take up his duties some weeks later, on 16 July? In December 1871, the hours in which the Chapel was open to visitors had been fixed at 11 am–12 noon and 2–3 pm, though more liberal opening times were proposed to the next General Congregation; from 1872, one had from 10 am to 4 pm (in winter) or 4.45 pm (in summer: that is, just before Evensong at 5 pm) in which to explore the building, which at this time lacked any heating: debate on this issue occupied the Congregation between May 1872 and February 1875, when it was finally agreed that four Gurney stoves 'be ordered forthwith to be placed in the Chapel under the direction of the Provost and Officers'. Visiting was not permitted

during Choir practice. There was evidently a good deal more public traffic between the floor of the Chapel and the roof than has been sanctioned since: unanimous support for the proposal to the 1872 General Congregation that roof visits must be accompanied by the Chapel clerk or his assistant suggests a more lax attitude hitherto, while the decision in March that year to post in the Chapel a notice advertising the charges for ascending to the roof, and a box for payments to be kept with the visitors' book in a side chapel, point to incipient Health and Safety concerns as well as an eye to increasing revenue (though much later, in 1892, the suggestion that visitors be charged to pass east of the screen except to attend services was soundly defeated). At the same time, the suggestion – though not carried – that public notice be given that the Chapel clerk was forbidden to receive fees adverts to other, less formal aspects of Chapel finances.

Time and money were devoted to matters of seating, both for the Choir and congregation. In April 1873 it was noted that accommodation for 'Strangers' attending services was inadequate; in May 1874 a sum not exceeding £20 was voted towards the provision of temporary seating at the east end of the choir, while one month later a further six dozen chairs were agreed to be necessary. The provision of 'additional seats' for lay clerks and choristers was approved in principle by the Annual Congregation of 30 November 1875, and Sir Giles Gilbert Scott was 'requested to prepare Designs for an entire new range of Seats to be fixed in front of the present Sub-stalls on either side of the Chapel' in May 1876, just before Mann's appointment, although the precise detail of the matter was still among the Congregation Agenda in May 1877. In March 1879 eight dozen more chairs were ordered, and the same number again exactly a year later. Meanwhile, the agreement by the Provost and officers in May 1878 that at afternoon service on Sundays during that term 'the Choir-doors be left open, and the chairs in the Ante Chapel moved up to the eastern end of the Ante Chapel and that all the entrances to the Chapel be closed soon after the commencement of the Service' points both to growing congregations and interest in Choral Evensong as a 'performance', as well as to a keen sense of the separation between Chapel and antechapel.

The pattern of the services themselves, and particularly that of Morning Prayer, was much discussed and revised during the 1870s and 1880s, not least in response to national developments such as the sanctioning, in the Universities Tests Act (1871), of shortened forms of service.[11] Term cards for the period 1873–75 show the pattern as follows:[12]

SUNDAYS

8 am: (said) Holy Communion or Morning Prayer
10 am: variously (choral) Morning Prayer, Litany and Sermon, or Litany and Holy Communion, or Morning Prayer, Litany and Ante-Communion.
3.30 pm: Choral Evensong

WEEKDAYS

8 am: (said) Holy Communion or Morning Prayer
5 pm: Choral Evensong

SAINTS' DAYS AND HOLY DAYS (IN ADDITION TO EVENSONG)

10 am: Full Choral Service

The detail of the schedule of services was largely the business of Council or the Provost and officers,

including of course the Deans, to whom Congregation gave leave, for example in May 1877, 'to make from time to time such changes as shall be found expedient in the times and the divisions of the Sunday Chapel services, and in the number of Sermons (if any) to be preached at such services and the amount of attendance at such services to be required of the Lay-Clerks and choristers'. In March 1878 it was proposed that Holy Communion be celebrated at 10 am on at least three Sundays each term, but that the Communion service be omitted if it had already been read at an earlier service. A more long-running debate during 1884–87 concerned the introduction of a shortened form of 8 am Morning Prayer to be attended by some or all of the choristers on four days each week, and to include a sung psalm and hymn. By May 1887 the form of service was fixed, but the question of music remained open. A paper from Dean John Edwin Nixon noted considerable opposition to the inclusion of choral singing, not least from Mann and the master over the choristers and his assistant. Broader educational issues were again at issue: Nixon himself preferred 'the addition of a Hymn', which would require the presence of the choristers, but he nonetheless also pointed out that the recent success in arranging the teaching of French and instrumental music as part of the Choir School curriculum would suffer if the service were to be lengthened beyond the intended fifteen-minute duration.[13] It was eventually agreed by Council that during the summer half of each year a sung hymn and short psalm or canticle would be included on three days each week, and 'that some or all of the choristers, and the organist (if necessary) attend the service on these days', but the arrangement was cut short a year later once the forthcoming renovation of the organ was in prospect.

One of Mann's early administrative tasks upon taking office was, on 2 November 1876, to participate along with the newly appointed chaplain, Henry Biscoe, in the first election of choristers under the new terms agreed a year previously. Provost, Vice Provost, Deans and chaplains were all involved in this, and there survives a note from Augustus Austen Leigh to Okes dated 1 November and setting out a proposed timetable of events which would involve hearing the boys read aloud, providing lunch for them and their parents, and then handing them over to Mann to be 'examined in Music' in the Chapel. 'It will take time,' Austen Leigh warned, 'probably 'til 4 pm'.[14] Twenty-four boys were auditioned on this first occasion, of whom three were eventually selected to fill forthcoming vacancies. Writing later of his own involvement in the selection process during his years (1889–1900) as Dean, M. R. James gave an account of a similar procedure, though now involving a 'simple examination' in the Hall, administered by the master over the choristers, as well as a two-stage musical audition process whereby only selected candidates were required to sing a hymn in Chapel.[15] What James regarded as 'simple' was agreed by the Provost and officers, in 1878 at least, to include 'reading, writing, arithmetic, Scripture Knowledge, and Latin Grammar'.

The practice of some of the choristers waiting at table in Hall was now past;[16] and a printed set of 'Rules' from 1879 reflects the College's sense of concern for the children who were now in its care. choristers were forbidden, without special permission, to visit the rooms of any member of the College, or, 'on pain of dismissal', to receive gifts from members of the University (in 1880 this was extended to 'other persons resident in Cambridge'). They were likewise prohibited from auditioning for other choirs and from participating in public concerts and musical performances. Suspension or dismissal from the Choir followed failure twice in the annual examinations, as did failure to perform adequately their Chapel duties.[17]

The establishment of the first choral scholarship in November 1880 likewise required regulations to be drawn up. Meeting on 11 December that year, the Provost and officers determined the date for the examination and the value (£90 per annum, for three years) of the scholarship, stating that only tenors and basses might compete (there were presumably no immediate alto vacancies). Candidates were to be

aged twenty-five or under, and must provide references as to character and musical ability. Tests of the candidates' voice, ear and musical knowledge were to be supplemented with 'elementary papers in Classics and Mathematics'. The choral scholar was subject to the same disciplinary rules as all those *in statu pupillari*, with the exception that he was not required to read for Honours; and tenure of the award was subject to continuing 'musical proficiency' as well as ongoing progress in academical work. The importance to the College of this new development in the establishment of the Choir, and its concern to make a success of this inaugural competition, is indicated by the extensive plans for its advertisement: the third bursar (in 1880 this was Tristan Huddleston) was charged with arranging for a notice to be placed three times in *The Guardian, The Musical Times, The Musical Standard,* and *Church Bells*; at least once 'in the chief Daily Papers and in the *Cambridge University Reporter, Cambridge Review, Undergraduates Journal*, and *Oxford University Gazette*'; and additionally, with sending a circular to universities and theological colleges.

At this period, services were usually suspended for about a fortnight from 27 December, for about ten days in late June/early July, and during September. Apart from these periods, the regulations required, naturally enough, that the choral scholar attend all choral services and full practices, and remain in residence during the periods in which choral services continued. Mann's reputation at his death as 'one of the greatest trainers of choirs in the country' necessarily implies keen attention to rehearsal technique: 'his methods were firm and practical ... there were no loose ends, and time was not lost', as another obituarist remarked.[18] Nevertheless, evidence survives to suggest that some of Mann's initiatives toward that greater 'efficiency' of the Choir which he had been appointed to promote did not always find favour either within the Choir or within the wider College.

One successful innovation may have been an 8.30 am practice for the choristers, for on 12 November 1877 the Provost and officers agreed (or rather, the officers agreed; Okes added a note of his dissent to the record) that this practice, 'hitherto undertaken by Mr Mann be approved of and continued', on the understanding that 'weakly boys' might be excused during the winter months. A few months earlier, however, on 4 June, the Deans had found it necessary to formulate for the full practices of the Choir some rules that reveal something of the difficulties that Mann must have faced in working with a back row made up entirely of lay clerks. First, there would in future be no full practices on Sundays; if necessary, an extra practice would be allowed on Saturday, but if this would not suffice to prepare the music, a change of anthem or service must be made. Second, the lay clerks would be expected to have learned, before each full practice, the music to be sung in the following half week.[19] Finally, on occasions when the lay clerks proved deficient in this respect, or if there were 'notable failures in the service', the organist would be 'requested at the earliest opportunity to have an extra practice to remedy the defect.'[20]

The question of Sunday practices was clearly something of a battleground, for notwithstanding the Deans' directions, a note in Okes's hand headed 'organist and lay clerks June 1877' records that on one Sunday (perhaps 3 June?) Mann had roused the anger of the lay clerks by immediately re-rehearsing that morning's service, which had evidently not gone well; the lay clerks bridled especially at what they regarded as wasted time, since the setting was not due to be repeated for some time to come. Several years later, on Sunday 4 February 1883, the eighty-five-year-old Okes wrote to the Vice Provost to express his surprise that on leaving his stall after that morning's service he had encountered the Choir returning for a rehearsal. He hoped that the Vice Provost and the Junior Dean had not approved this, for 'Dr Mann knows I disapprove of it, because I forbade his doing it, when the responsibility of the Executive rested with me.' To the Provost, the solution was easy: if the Choir's performance was not 'sufficiently perfect' before Sunday, easier music should be substituted.[21]

The learning of music for the services inevitably involved access to copies, and it is notable that just a few months after Mann's arrival, in November 1876, the Annual Congregation voted to allow the Deans to spend not more than £20 for the purchase of 'additional copies of the Music already in use by the Choir' as well as new repertoire. Five years later the same meeting raised the figure to £25 and voted this as an annual sum for the purchase, binding and copying of 'Music for use in the Chapel'.[22] A new Anthem Book was proposed in November 1877 but did not materialise until 1882, by which time the Choir and congregation had adopted, on the suggestion of Nixon, *Hymns Ancient and Modern* (the second edition, edited by W. H. Monk, had been published in 1875) for use in the Chapel.

Towards the end of his first year in office, on 8 May 1877, Mann wrote to Okes, reporting on the boys who he expected to leave and enter the Choir, suggesting that new entrants should be aged between nine and ten-and-a-half and that they should ideally possess a 'rudimentary knowledge of music'.[23] (Provision of a termly or six-monthly report to the Provost and officers on the state of the Choir would later become a requirement, but the initiative seems to have come from Mann himself; the reports appear not to survive.) He also drew attention to matters human and otherwise. 'The greatest weakness in our Choir,' he wrote, 'is its lay clerks – as one to each part – on each side – is not nearly sufficient'. There were no appropriate candidates presently residing in Cambridge, so that 'any addition in this department will only be attained by an outlay of a considerable sum per annum'. As to the 'proper rendering of the services,' the 'greatest impediment . . . is the great distance between the two sides of the Choir'. He had, he wrote, 'tried the effect – in the Chapel – of placing the Choir closer and found that it was very satisfactory indeed – not only to myself – but also the members of the Choir'.[24] But a further impediment – though Mann was diplomatic enough not to describe it thus – was outlined in a postscript:

> May I venture to touch on more delicate ground and suggest that the more the Choir improves – as we hope will be the case – the more necessary will it be that the congregation should join in the singing with most careful discretion and taste – avoiding anything like interference with the antiphonal or soft renderings – or encroachments on parts assigned to solos – trios etc. I feel sure that I may calculate on the Provost and deans using their influence both with graduates and undergraduates to ensure this result.

This would not be the last time that Mann raised such issues;[25] and one other documented example is interesting in that it starkly illustrates the College's – or at least the Provost's – understanding of the status of its new organist.

The 1882 statutes, unlike those of 1861, allowed for the first time that the positions of chaplain, organist and master over the choristers could be tenable with a fellowship. Commenting on this change in some notes on the new statutes, Nixon mused that 'some day we may gain a valuable resident by this provision'.[26] Mann became resident in College from 1918 and was eventually elected a Fellow in late 1921. Yet Dent likened his status to that of a servant: his 'position in the college must for many years have been something like that of Leopold Mozart at Salzburg or Haydn's at the court of Prince Esterházy'.[27] The limits on his freedom of activity – he was, for example, forbidden in May 1890 from giving 'any Organ Recitals without permission' – were only exacerbated by the College's avowed interest in raising the dignity and musical quality of its services, and the presence among the officers of keen and informed musicians such as Austen Leigh and Nixon.[28] His reappointment in post in June 1879 brought with it a rise in salary from £250 to £275 'on condition that he gives special instruction in Music to choristers of exceptional promise under regulations to be hereafter made by the Provost and officers'. 'Instruction in instrumental music under the organist' for

choristers 'who have a talent for music' had already been a statutory duty in 1861; the 1882 statutes refer to 'unusual promise in music'. Mann was forbidden from appointing a deputy without the permission of Provost and Deans, and he was required to take 'a sufficient part in the daily musical training of the choristers, and to introduce ... some teaching in the theory of music'. When, in April of the same year, the Congregation voted to allow the organist and master over the choristers 'the same privilege of dining in Hall as belongs to the chaplains ... together with the use of the Combination Room and the Fellows' Garden', two Fellows attempted to restrict this privilege to those office holders alone, and not to their guests. And it was as late as May 1889 that Mann was finally allowed 'to keep a set of Chapel Keys for personal use' from Lady Day to Michaelmas each year, in order to have access to the Chapel outside its public opening hours. Even then, he was prohibited from using 'any candle or lamp for the purpose of playing the Organ'.

The relative status of organist and chaplains came to the fore in connection with Mann's half-yearly report in December 1885. He had evidently drawn attention to the poor intonation of the chaplain, Henry Biscoe, in the versicles and suffrages, which was making it difficult for the Choir to respond unanimously in tune. A correspondence survives between Provost and Vice Provost, Okes and Austen Leigh, which is revealing in various respects.[29] Okes, while not fully cognizant of the musical situation, took exception to the fact that Mann should have exposed the matter openly to the Council: 'Dr Mann, we must remember, is inferior in position to Mr Biscoe, Mr Biscoe is a chaplain of the College, and not in any way under the juris[diction] of Dr Mann'. Austen Leigh defended Mann: the College had ordered him to provide reports on the state of the Choir, and Mann had frequently consulted Austen Leigh in doing so; whether or not the issue had been raised in the report or in a separate letter, the Council would have had to hear of it. Okes suggested that the problem might be solved by Mann accompanying the choral responses at the organ (a reminder, this, that he did not usually conduct the Choir, unless the service were unaccompanied); Austen Leigh offered to explore this possibility, but 'I do not much like it, as our Chapel is particularly well suited for *un*accompanied music'. Most revealing of all, though, is the fact that by the end of the same month Biscoe's dismissal had been agreed, he himself admitting that the time had probably come for him (he was forty-five) to make way 'for someone more competent'.[30] Whatever the hierarchy of chaplains and organists, musical considerations were paramount.

For all his punctiliousness in musical matters, Mann was clearly not without his faults nor always an easy person to deal with. In the correspondence just discussed, Austen Leigh observed that he had sometimes had to remind Mann of his duty to provide his reports; writing to Nixon on another occasion, he noted that 'I have had at times to urge on Mann the necessity of practising thoroughly the *Sunday am* music; esp: the chanting of the psalms, because the Choir less often do the morning chants, & are therefore less familiar both with these and with the new pointing of the words. A word in season is often wanted to get men & boys to *begin* the chant strictly together'.[31] The raising on 10 June 1882 of Mann's salary from £275 to the £300 maximum (agreed back in 1876) had been made with the proviso 'that any increase in the amount of work hereafter demanded of him by the College shall not entitle him to claim any further increase of stipend'. But Mann evidently needed more income, which led him at the end of that same month to seek Oscar Browning's support in gaining the organistship of St George's Chapel Windsor, lately vacated by Sir George Elvey:

> I should like to ask the V. P. to do the same, but I do not like as the Coll: (thro the V. P.) raised my Salary last Term, and he might think I was dissatisfied. I am by no means so, as I consider the Coll: have been wonderfully kind for which I am ~~wonderfully~~ very

> thankful, but there is not enough work outside the Coll: work, and so I cannot get enough to maintain me.[32]

Whatever the outcome of this request, Mann remained at King's. Relations between him and Browning were sufficiently cordial for Browning to have lent him his tricycle for a period (Mann damaged it); and a planned visit by the pair to Bayreuth in 1901 had very reluctantly to be aborted by Mann because he was not able to leave the Choir in the hands of his deputy (Mr Robinson) for as long as a fortnight. Ten years before that, it was Browning who at a meeting of the Council in February 1891 moved 'that a house for the organist be built on some portion of the site now belonging to the Choir School'; this was to become 'Kingsfield', which the Mann family occupied from Christmas 1892 until his wife's death in 1918. Exactly what preceded Browning's proposal is likewise unclear (did Mann again solicit his intervention?). If the provision of a house next to the School, at an eventual cost of £1260, exclusive of architect's commission, speaks both to the College's continuing concern with the 'efficiency' of its Choir as well as to the improving status of its organist, this was not untrammelled largesse: the Manns were charged an initial annual rent of £60 for the convenience.

2

> Any American will tell you what a distinction it confers to have attended divine service in King's. It is the place in which heavenly music seems to flow mysteriously from nowhere, and after a stormy visitation to be swallowed again by the great sea of undisturbed silence which floods the building.[33]

This description comes from a review of the performance of Brahms's *Requiem* in King's Chapel on 14 June 1910 by 'Dr Mann's Festival Choir'. In October 1886 Mann had obtained permission from the College Council to hold a 'special choral service with orchestra' on 20 June 1887 to celebrate Queen Victoria's golden jubilee, and the practice continued from there for some twenty-five years. These were meticulously organised events, with special trains laid on between Cambridge and London by the Great Eastern Railway Company. The 1910 performance was originally to be of Mendelssohn's *Elijah*, but the death of King Edward VII at the beginning of May prompted a change of programme. This circumstance, as well as the original impetus for the 'festival services', is a reminder that Mann's long reign in King's overlapped those not only of five Provosts (Okes, Austen Leigh, James, Durnford, and Brooke) but also of three monarchs, as well as the First World War. Beyond the daily services for the College, the Chapel was expected to respond to events of University and national importance. And while the Chapel bills (service lists) prior to 1918 seem not to have survived with anything like completeness, extant orders of service give a precise account of several special liturgical and musical occasions, including those connected with the royal funerals and coronations of 1901, 1902, and 1910.

The 450th anniversary in 1896 of the laying of the foundation stone of the Chapel, on 25 July, was an occasion for special rejoicing, with three choral services throughout the day, the latter two of them employing an augmented choir. M. R. James (then Dean) signed a letter of invitation to those invited to sing, stressing the importance of attendance at two rehearsals on 24 July. Mann

personalised at least one of these letters, sent to a former choral scholar: 'Dear Knight, Now you must tear yourself away from the charms of Town life and come and sing to we poor benighted provincials. You must come'.[34] At 8 am the Choir assembled for (shortened) Morning Prayer and Holy Communion, with two Psalms, Benedictus, a hymn, and Macfarren's Communion setting in E flat. At 11.15 there was a procession from the Hall to Chapel for an 11.30 service based on Morning Prayer, with a processional hymn, 'Lord of all the worlds above' (sung to 'Darwall's 148th'), Purcell's Te Deum in D, the hymn 'Veni creator spiritus', and the reading of the Founder's Will, specially printed *in extenso* at a cost of around £20. Choral Evensong at 5 pm comprised three Proper Psalms (122, 132, and 133), Mann's Magnificat and Nunc Dimittis in A flat and (after the third Collect) Boyce's 'I have surely built thee an house to dwell in', the service eventually being brought to a close with 'Zadok the Priest' by Mann's beloved Handel. As well as Mann himself, his predecessors Amps, Pratt, Randall and Tudway were represented in the choice of chants and settings.

Other regular important College occasions were Commemoration of Benefactors services on Founder's Day and Lady Day (25 March), attendance at which was obligatory for undergraduates. Also of special importance, at least from the early twentieth century, was Choral Evensong on the Sunday in May Week, for which rigorous practical arrangements for seating were required. Separate letters were sent annually to Fellows and MAs, and BAs and undergraduates. Third-year students were allowed two guests each, first- and second-years only one. In 1900, these were expected to fill 245 out of an estimated 474 seats, since 'experience shows that this privilege is almost invariably exercised to the full'.[35] Thus, 229 seats were available to the forty or so eligible Senior Members. Within a few years numbers had increased such that first-year students and their guests had to be content with seats in the antechapel.

The coming of World War I of course had a catastrophic effect on numbers in College. The Annual Report for 1914 observed (p. 9) that of 170 expected to come into residence in Michaelmas Term, there were only sixty-four; by 1917 the number had dropped to seventeen, and those killed in action already included choral scholars of the years 1906, 1909, 1910, 1913 and 1914, as well as eight former choristers lost in the year 1916 alone. Yet *The Cambridge Review* noted, one year in, that 'Chapel services are being continued as usual';[36] and the composition in 1915 of Charles Wood's Magnificat and Nunc Dimittis 'Collegium regale' in F for double choir, if we may assume that it was performed in the Chapel prior to its publication five years later, suggests the availability of more than minimal forces. The Chapel inevitably became a focus for University-wide reflection and commemoration in these years. The first anniversary of the outbreak of war, on 4 August 1915, was the occasion for a service which began with a processional hymn and then followed the order of Evensong up to the first lesson; the usual canticles were replaced with two Psalms: 67 (*Deus misereatur*) and 51 (*Miserere mei*), the latter 'to be sung kneeling'.[37] Versicles, responses and prayers from the Commination service came next, followed by Goss's 'O Saviour of the World', a hymn, prayers for peace, and Blessing.[38] An almost identical service was repeated on the same date in 1917, while in 1916 the occasion took place on All Saints' Day (1 November) and included the reading of the University Roll of Honour, in two segments, by the Vice Chancellor; the first reading was followed by Croft's 'I heard a voice from heaven' and the second by the Russian Contakion of the Dead.[39]

The instruction in the 1915 order of service that 'the first and last parts of the service will be read, that the whole Congregation may join in saying the General Confession, Lord's Prayer and Responses to the Intercessions' suggests that in regular Chapel services at this time these and other unchanging parts of the liturgy were usually sung rather than spoken. In a lecture, 'Suggestions for Improvements of Various Parts of Our Sacred Services', addressed to 'a number of my brother organists of East Anglia',

Mann chose to focus on precisely such constant elements of Morning and Evening Prayer rather than on the varying canticle settings, hymns and anthems. As he was wont to remark, 'Any fool can sing an anthem, but it takes a Choir to sing a service'.[40] Delivered first in Manchester in April 1910, the lecture was repeated closer to home (Ipswich, Norwich and Peterborough) in 1915 and 1917.[41]

The first of Mann's four targets was the 'monotoning' – 'the most difficult work a Choir can be called upon to perform' (p. 4) – of the General Confession, Creed, and Lord's Prayer. Indistinct pronunciation of words and the maintenance of pitch were the chief faults here. Rectification of the latter involved attention to control of breath and larynx as well as 'ear control', the ability to discern maintenance (or not) of pitch; Mann regarded this as one of the most important aspects of chorister training. In dealing with clarity and unanimity in the delivery of the text, he advocated its division 'into a kind of rhythm, possibly shown by bar marks, resolving itself into a regular series of *Accents*' – not a strict metrical scheme, but 'a certain flow, or Rhythm' (p. 9: see Ill. 220). The test of good monotoning was total clarity of words at a long distance from the Choir. 'I am referring only to Choirs,' Mann quipped; 'Clergymen in this respect are hopelessly past even praying for' (p. 11).

Next came the treatment of prayers and responses. Mann's concerns were with the relationship between clergy utterance and choral response, in terms of both pitch (Biscoe was gone but not forgotten!) and rhythm. Strict time towards the end of the clergy part was vital if the Choir, being unconducted, was to enter with unanimity and without pause: 'the only conducting we can have, must be exemplified by the way the Clergyman sings his Versicle' (p. 15).

Psalm singing raised issues similar to those of monotoning. Mann's habit was to rehearse these with his choristers every morning, and at every full rehearsal, ('i. e. at least twice a week'). 'I never allow myself the use of a Psalter, I insist on hearing every word from the Choir' (p. 20). For rhythmic accuracy, flexibility was tolerable only in the first (reciting) bar of each half of the chant; strict time in the following bars, and especially the last, was vital if 'ragged pointing' was to be avoided. Too rapid a speed was a further pitfall.

Mann's final concern was with 'the simple two-chorded "Amen"': this deserved 'to be sung with as much care, reverence and finish, as the best part of our most beautiful anthems or even Oratorios' (pp. 23–4). The chief issues were commencement, tone, treatment, and ending. The key to the first was for each member of the Choir 'to beat two beats ... from the *last accented syllable* of the Clergyman' (p. 25). Tone was a matter of sweetness and blend in all parts; treatment involved differentiation, making the second chord softer than the first. Ending was a matter not of a sharp cut-off, but of letting 'the whole thing tail off smoothly and quietly as if vanishing into space'. And here, uniquely, Mann allowed himself to mention his own College Choir, explaining how the final 'Amen' at each service was sung as quietly as possible, with divided tenors (one holding the dominant, the other descending through the seventh to the third of the tonic triad). 'This last chord is then held on, getting softer and softer, until one can hardly tell when they leave off' (pp. 29–30).

'Instead of the service being a performance in a building, the very building itself seemed to speak, with all its abundant echoes and lingering sweetness'.[42] While there is perhaps in Mann's lecture little that would now surprise a cathedral musician, it powerfully evokes not just his rehearsal techniques but the very *sound* of King's Evensong in the first decades of the twentieth century: not least that sense of music emerging from and returning into silence which Mann's 1910 reviewer knew and which others, Mann told his audience of the same year, had likened to 'the whispering of angels'.

```
        Almighty and most merciful           Father
                |              |                |         |
We have erred,  and       strayed from Thy ways like lost sheep.
    |           |             |              |      |
We have followed too      much  the      devices & desires
                          ʇ
of our  own hearts.

We have    offended             against Thy Holy         laws.
    |          |                    |     |                         |
We have     left         undone those  things which we  ought to have done
    |          |                    |                        |
And we have done    those   things  which  we   ought    not to have done
    |          |                    |                        |
And         there is   no    health in  us
    |          |                    |                        |
But         thou,     O    Lord, have mercy      upon us, miserable offen-
    |          |                    |                              d/ers.
         Spare    thou    them,    O   God, which confess their     faults
         |          |                    |                            |
         Restore  thou   them that are penitent.
         |          |                    |
         According to Thy  promises  declared  unto    mankind in Christ Jesu
         /          |                    |                 /
our   Lord.         |                    |                /
         |          |                    |               /
         And   grant, O most   merciful   Father, for His sake
         |          |                    |        ↑
         That  we    may    hereafter live a godly,   righteous and sober life
         |          |                    |                 |
         To the  glory of Thy   Holy     name.   Amen.
```

Ill. 220. Arthur Henry Mann, proposed 'accenting' of the General Confession at Morning and Evening Prayer (Mann's 'accenting' survives largely unchanged in the spoken recitation of this text today). In Arthur Henry Mann, *Suggestions for Improvements of Various Parts of Our Sacred Services, April 1910 - July 1917*, typescript with manuscript annotations. Cambridge, King's College, AHM 1/6, pp. 9–10.

> King's Chapel at Evensong. The coloured windows faded gradually out: only a twilight blue was left beneath the roof: and that died too. Then, only the double rows of candle-flames gave light, pointing and floating above the immemorial shadows of the floor and the shadows of benches and the shadowed faces of the old men and youths. Hushed prayer echoed; and the long rolling organ-waves rose and fell half-drowning the singing and setting it free again. All was muffled, flickering, submerged deep under cloudy water.[43]

Rosamond Lehmann's first novel, dedicated to George ('Dadie') Rylands,[44] was published in 1927, but details of the narrative indicate that the undergraduate years of the central character, Judith Earle, are essentially those of Lehmann herself (1919–22), and that Judith's attendance at Evensong takes place in the Michaelmas term of her first year. No mention, in this fictional setting, of the parlous state of the heating in the Chapel in which Judith is sitting: the Annual Congregation of 29 November 1921, receiving the latest report of the Chapel Warming Committee, agreed to suspend any further action in relation to a proposed new system, and in 1923–24 the Chapel was without any heating whatever. The Annual Report of 1923 warned that 'the machinery of the Organ, which was built in 1888, is now almost worn out' (p. 10). As for Lehmann's evocation of music by candlelight, this might be set against the more prosaic fact that expenditure on candles in 1922 was, at £141, £10 less than it had been in 1913. As a 1926 report on Chapel expenditure put it, 'the Second Bursar has never ceased his vigilance It is true that very few people but the Choir can ever see anything during service, but the saving is sure'.[45]

The Second Bursar in question was Hugh Durnford, and the author of the report Eric Milner-White, previously chaplain but elected Dean in 1918 on his return from war service. He was, as Patrick Wilkinson puts it, a 'harbinger of post-war King's'.[46] The post-war history of the Chapel and Choir is much better known and documented (Chapel bills survive largely complete from 1918 onward, for example[47]) than that of the pre-war years and is particularly inflected by the inauguration, on Christmas Eve 1918, of the annual *Festival of Nine Lessons and Carols*.[48] Wilkinson notes that Milner-White introduced this just 'six weeks after the Armistice of November 11'.[49] Earlier in the same term, however, there had been other major occasions to arrange. On 17 November the admission as Provost of Walter Durnford took place. Earlier still, on All Souls' Day, the Choir had sung the funeral sentences by Croft and Purcell, *A Short Requiem*, op. 44a (1915) by Henry Walford Davies, and Alan Gray's *1914*, setting three War Sonnets of Rupert Brooke, at a memorial service for College and School members and servants who had died on active service. The complete Roll of Honour (199 names, according the Annual Report [p. 8] for that year) was read prior to the hymn 'O valiant hearts, who to your glory came', sung not to Charles Harris's majestic tune 'The Supreme Sacrifice' but to Song 4 by Orlando Gibbons, a King's chorister in the 1590s. Milner-White had proposed this service (it continued much in its initial form until 1921, after which some of the music was incorporated into Evensong), including the singing of the Brooke Sonnets, in a 1918 report on 'The Chapel'.[50]

Another suggestion made there by Milner-White was the introduction of an admission service for new choristers: 'in such little ways,' he wrote, 'much may be added to the religious motive of the Choir; and to its delight in its religious home and work' (p. [8]). The general pattern of services at this time was (said) Holy Communion at 7.30 or 8 am, and Choral Evensong at 5 on weekdays, with

Choral Morning service on Sundays and Feasts or other special days.[51] In reviewing the overall provision Milner-White was particularly critical of Sunday Matins, which he found 'tedious' and 'hopelessly uncongregational', this latter accusation being partly the result of the 'strange' Chapel acoustic which mitigated against congregational singing. As for the sung Ante-Communion service (which continued in use on Good Friday and Holy Saturday), this was 'meaningless and seriously misleading. It cuts the Holy Communion Liturgy into two halves, and devotes all the musical pomp and glory to the least important half. It trains the young – choirboys etc. – in the idea that the Church may and should be left just as its most sacred moments begin' (p. [4]).[52] As a general solution to the problem as he saw it, Milner-White proposed not the simple replacement of Matins by Choral Eucharist as had already been happening pre-war in other colleges (he named Trinity and Sidney Sussex) but a combination of Matins, Litany and Holy Communion with repeated material excised so as to create a service of a reasonable length (pp. [5–6]). He regarded the absence of Choral Eucharist in King's as particularly 'unfortunate' given its growth in popularity elsewhere.

The Annual Report of 1883 had noted the increased congregations attending services on Sunday mornings and weekday afternoons, remarking that 'this is probably due, in part, to the improvement in the musical services' (p. 1). Comment on innovations in the service music may be found increasingly in the Reports from the 1920s. In 1921 it was claimed (p. 6) that King's had been 'the first of the great English churches to sing William Byrd's "This Day Christ was Born" on its republication' (the performance took place at Evensong on Saturday 22 January).[53] New anthems by Parry (from the *Songs of Farewell*) had been introduced, and his Latin Magnificat of 1897 was due to be sung both in King's and at Eton on Founder's Day, which in 1921 was the quincentenary of Henry VI's birth. The singing of this setting on Founder's Day was repeated in future years; other 'traditions', even if sometimes short-lived, established around this time included the singing of Howells's 'A spotless rose', together with the carols 'Blessed be that Maid Mary' and 'The Holly and the Ivy' on the Feast of the Purification. Howells' brief masterpiece, composed in 1918 and published the following year, entered the Chapel bills on 2 February 1920; and the following year also saw the first performance of Charles Wood's *St Mark Passion* on the evening of Good Friday. This last composition – an example of Milner-White's concern, in his 1918 report, for 'richer provision for church seasons' – was the result of a collaboration between Milner-White and Wood, on Milner-White's initiative. 'By inspiring and producing this fine work,' it was noted in the 1921 Annual Report, 'we can feel that the Chapel is playing its true part in the service of English Church music (p. 6)'.[54] Yet the first mention of the *Nine Lessons and Carols* came only in the 1930 report, with the laconic observation (p. 13) that 'the Christmas Eve Carol service was again broadcast'.

Permission for the Second Bursar, in consultation with the Deans, 'to negotiate with the British Broadcasting Company for the broadcasting of Chapel music' had first been granted by the Council on 6 March 1926, and a Sunday Evensong (Psalm 145; Walmisley in D minor; Wesley's, 'In Exitu Israel' and the hymn 'Ye Choirs of New Jerusalem') broadcast by the BBC on 2 May that year was the first such event in the Choir's history.[55] Mann himself was unenthusiastic about broadcasting and recording, and it was as late as 13 October 1928 that the Council sanctioned the first of the Christmas radio broadcasts (which took place barely ten weeks later), by which the College Choir is now universally known. Meanwhile, and despite his misgivings, Mann had, in summer 1927 and 1929, recorded performances of the motet 'Es ist das Heil uns kommen her', op. 29 no. 1 by Brahms, and Bach's 'Auf! Auf! Mein Herz', BWV 441 and 'Gott lebet noch', BWV 461 for HMV. All were sung in English translation. The Brahms was not issued, but the two Bach chorales were released in January 1931, becoming the earliest commercially available recordings of the Choir, and the only

XIV · 'DADDY' MANN AND KING'S COLLEGE CHOIR, 1876–1929

Ill. 221. Annual Photograph of the Chapel Choir, 1927. Cambridge, King's College, KCPH/2/2/2/3.

known surviving recording of it under Mann's direction. These recordings amply bear out his tendency to counter the famous Chapel acoustic by taking the music 'very slowly, and ... with great deliberation and distinctness of enunciation'.[56] They also demonstrate, in places, considerable subtlety of tempo fluctuation, even if the excessive *rallentandi* at the ends of verses and the doubled durations on cadential chords at phrase endings impede the flow quite severely. Blend and ensemble are not wholly equal to those of today's Choir; but dynamic variation and Mann's especial preference for very soft singing, as stressed in his 1910 lecture, are unmistakable.

The Choir of 1927 included two lay clerks and nine choral scholars (see Ill. 221). This constitution of the Choir (four basses, though usually increased to six through the appointment of two volunteers, four tenors, three altos) had been described by Milner-White as 'ideal' or the 'new model' in a report to the Governing Body on 'The Establishment of the Choir', dated 27 February 1926.[57] The report and the 'new model' were both adopted by Congregation in March 1926.[58] Milner-White compared the relative advantages of lay clerks and choral scholars, arguing *inter alia* that expenditure on the men of the Choir was 'an expenditure on *education* as well as the Chapel', and noting that of the seventeen choral scholars who had come up since the War only two could have entered the University 'without emolument'.[59] Lay clerks might have stronger voices, more experience and the advantage of 'stability', but they could not contribute to the general life of the College as choral scholars could; and they were more expensive. Mann's ideal, as Milner-White explained, was 'eventually to have none but Choral-scholars – six basses, four tenors, four altos' (pp. 2–3). This was partly achieved by 1928, when the Annual Report noted (p. 11) the death of Harry Collins, 'tenor lay-clerk of twenty-six years' good service', so that 'the men in the Choir are now all choral scholars'. But the establishment remained eleven in number. Mann would not live to see his 'ideal' Choir fully realised: the increase to the maximum of twelve allowed under the statutes came after his death, in a vote of Congregation on 7 March 1931. The first part of the same vote had brought into being the organ studentship created in his memory by 'subscriptions received, chiefly from members of the College', as noted in the Council's vote of 17 May 1930, recommending the establishment of the award.

The musical strength of the College had been augmented in 1923 by the election on 17 March as a Fellow of Bernhard ('Boris') Ord, an appointment made, according to Wilkinson, 'with an eye to his succeeding Dr Mann as organist'.[60] Wilkinson's claim is challenged, however, by that of Patrick Magee, a chorister under Mann in the mid-1920s. According to Magee's account, 'during my choristership days the assistant organist had been Frank Shepherdson, outstanding both as organist and choirmaster, and it was universally understood that he would succeed Daddy Mann when the time came'. Shepherdson had been organ scholar of Clare College from 1913 to 1916, and a volunteer in King's Choir prior to his admission as assistant organist in November 1923, eight months after Ord's arrival. His unexpected death just two years later, at the age of thirty-eight, was noted at some length in the Annual Report for 1926. Not only was he considered to have done 'much to raise the musical taste and standards of all with whom he was brought into contact', but 'his loss is amongst the greatest that Cambridge has suffered since the war' (p. 5). In Magee's account, the death left 'a vacuum which was never filled. On Dr. Mann's death in 1929 there was no heir apparent, but Bernhard Ord ... was the obvious choice'.[61] Ord's official appointment as Mann's assistant, with a quarterly remuneration of £25, came in May 1929, but he must already have been acting in the same capacity, as witness a touching letter to him from Mann, now nearly seventy-nine:

King's ~~Field~~ Coll:
Cambridge
6. 15 a. m.
9 March
1929

My Dear Ord
Many many thanks for your most beautiful offer. *I thankfully accept the same, with sincerest gratitude.* It will help the services wonderfully – *and make me much happier than I have been.*

I am sorry I did not write last night. *I fear I could not. I was more than over done.*

Now, once more. *From my heart, I thank you.*

Yours as ever.

A. H. Mann[62]

Mann played for both services on Sunday 17 November: Walmisley in B flat in the morning, with the Venite, Psalm 49 and three hymns; in the afternoon, Psalms 79 and 83, Gray in F minor, Naylor's demanding 'Vox Dicentis' (written for Mann and the Choir in 1911) and hymn 492, 'The Lord will come and not be slow'. Two days later he died. The music at his funeral echoed that of the 1918 memorial service, with the Croft and Purcell sentences and parts of the Walford Davies *Requiem*. After the hymn 'Ye Holy Angels Bright' the Dead March from Handel's *Saul* accompanied the coffin to the west door, through which Mann left the Chapel for the last time as the Choir sang the Nunc Dimittis.

'He was the maker of the King's Choir as England knows it'.[63] The Provost's verdict, in his address on 24 November 1929, could hardly have been challenged. It is otiose to debate whether that verdict stands today, in the light of the achievements of Mann's successors. The College undoubtedly chose well in June 1876, and it was no doubt to Mann's advantage to have been appointed in the context of a stated desire for improvement in choral 'efficiency' and dignity of worship. Nevertheless, his single most lasting achievement may have been to redefine that desire far beyond the College's first imagining.

APPENDIX

Mention has been made above of Mann's idiosyncratic performance style in Chapel services, as also of the difficult relations which not infrequently obtained between him and influential members of the fellowship. Both aspects are reflected in the following 'autograph manuscript squib', as the College Archive catalogue (JEN/9) describes it, in the hand of John Edwin Nixon (KC 1859; Fellow, 1862; Dean 1873–83 and 1885–89). Described as both 'legendary eccentric' and 'arch-oddity' by Wilkinson, the Annual Report of 1916 noted upon his death that year Nixon's important role in the establishment of the Choir School and in College music in general, including the encouragement, over a half-century, of informal part-singing in his rooms.[64] Headed 'Classical Stories for Men and Boys', JEN/9 is an undated bifolium of small-format King's College notepaper, the text written in ink.

The sketch of a tombstone with which the document concludes (see Ill. 222), bears the words 'In memoriam A. H. M.' and 'in linked sweetness long drawn out': the quotation is from Milton, *L'Allegro*, lines 135–40:

> And ever against eating Cares,
> Lap me in soft *Lydian* Aires,
> Married to immortal verse
> Such as the meeting soul may pierce
> In notes, with many a winding bout
> Of lincked sweetnes long drawn out...

[1R] CLASSICAL STORIES FOR MEN AND BOYS

Once upon a time there was a Mann called Procrastes who collected together a number of boys and men and established himself in an old building built by a king, for reasons best known to himself.

Now this Procrastes was a very powerful and clever Mann, but also very cruel: and he used to lie in wait, men, boys and all, with bars & staves in their hands to seize hold of any unfortunate tunes that came his way, and if they [1v] happened to have limbs or members with three joints only (for he had curious crotchets about these things) he would shut them up till they grew into four jointed tunes: and if they were too short he used to stretch them out and out (no matter what squealing & crying it led to) to exactly the length he said was the proper length of a tune: and very long that length was.

And this went on till all the ground was strewn with shocking miserable mangled mutilated dis-[2r] jointed broken backed tunes; – and an awful mess they made.

But one day a fairy came by and saw this & heard all the squealing & groaning and determined to punish Procrastes. So she waited her opportunity and one day when Procrastes & his men & boys had got hold of a tune and were pulling it out and out and out and out she waved her wand and suddenly galvanized Procrastes and the rest, with all his and their organs, in such a way that they couldn't [2v] leave go of the tune but had to go on and on and on pulling it out and out and out. It was no use trying to put a stop on it [,] they could not leave go. And they say that even still on very windy nights if you go near that old building you can hear actually the same tune being pulled out and out only you can't see the men or the boys or Procrastes for it is so long ago that they have all crumbled away and have become the mere shadows of skeletons.

Ill. 222. Inscribed tombstone, ink drawing. In John Edwin Nixon, 'Classical Stories for Men and Boys', undated, autograph manuscript squib. Cambridge, King's College, JEN/9, fol. [2]v.

Ill. 223. The east end of King's College Chapel with the eighteenth-century flooring and Detmar Blow panelling. Photograph, *Country Life*; reprinted Christopher Hussey, *King's College Chapel, Cambridge, and the College Buildings* (London: Country Life, 1926).

XV

'A Right Prelude to Christmas': A History of *A Festival of Nine Lessons and Carols*[1]

NICHOLAS NASH

King's College is well known for its royal history, the beauty of its perpendicular Gothic Chapel and daily services, the excellence of its Choir and a long tradition of academic achievement. It is probably even more widely known for one Chapel service which has taken place there every Christmas Eve since 1918, *A Festival of Nine Lessons and Carols*. This began as a gift to the city of Cambridge, but after nearly a century, it has become a gift to the world.

Nine Lessons and Carols has five elements: lessons are read from the Old and New Testaments beginning with the story of the Fall of Man and concluding with the mystery of the Incarnation. The College's Choir sings carols related to the themes of the lessons, and hymns provide the congregation with an opportunity to participate; prayers are offered by the Dean, and the organ scholar plays the preludes and postludes. The strength of the service lies in the ways these elements are balanced one with another; the result both celebrates the end of Advent and affirms that the promise of Christmas will be fulfilled. However, many would be surprised to learn that, while King's has pride of place, the city of Truro in Cornwall has pride of origination, back in 1880. The story of the creation of the service, its development, and its evolving association with King's College is intriguing and complicated, and still not entirely understood.

In December 1876 the new diocese of Truro was carved out from the diocese of Exeter and the Prime Minister, Benjamin Disraeli, offered Edward White Benson the bishopric.[2] Benson was a graduate of Trinity College, Cambridge and had pursued a career in the priesthood with an emphasis on education, particularly as head of Wellington College before becoming in 1872 Chancellor of Lincoln Cathedral. Benson accepted the Prime Minister's offer, was consecrated in St Paul's, London in the spring of 1877 and enthroned in St Mary's Church, the ancient parish church of Truro.[3] One of Benson's first challenges was to hire staff and, with his Cambridge background, it is not surprising that several of them were colleagues from those days. His second task was even more daunting – to build the cathedral church of the Blessed Virgin Mary. Benson wanted to tear down the sixteenth-century church of St Mary's and begin anew, but the members of the vestry preferred to save some of the existing structure and to construct the cathedral around it. The vestry carried the day, and the final design by the Gothic Revival architect John Loughborough Pearson for the new St Mary's Cathedral retained the south aisle from the old church.[4]

Before the diocese was created, the Choir of St Mary's had sung carols around the town on Christmas Eve – a popular tradition in the west country, which was rich in music, thanks to the Wesleys and the Methodist musical tradition, as well as a pervasive love of singing throughout this large rural and mining area.[5] In 1878, a new tradition began when the Choir was brought into old

St Mary's to present a carol service, the result of a suggestion by the Rev'd George Walpole, Benson's new succentor and Director of the Choir, who 'felt that something was needed on Christmas Eve both as a counter-attraction to the public houses and as a right prelude to Christmas'.[6]

In December 1878, the *West Briton Gazette* announced:

> The Choir of the Cathedral will sing a number of carols in the Cathedral tomorrow evening (Christmas Eve)…We understand that this is at the wish of many of the leading parishioners and others. A like service has been instituted in other cathedral and large towns, and has been much appreciated. It is the intention of the Choir to no longer continue the custom of singing carols at the residences of members of the Congregation.[7]

After the service, the same newspaper reported, 'there was a very full congregation, and the service was very much enjoyed'.[8] In 1879, what had been called a Carol Service was now a Festal Service, and it had a new structure: to the carols sung at intervals were added prayers read by Walpole, two lessons read by the Rev'd Chancellor Whitaker, and a sermon preached by Canon Anthony Mason. This development, too, was well received by the congregation.[9] By the autumn of 1880, much of the north side of the choir of old St. Mary's had been removed. The plan to hold services throughout construction was achieved by building a temporary structure described variously as a wooden church or a shed; it held between 400 and 500 persons. While not a perfect solution, and in spite of the lack of heat in winter, the building allowed both services and construction to continue in a reasonably satisfactory way. The plan of the Christmas Eve service also changed – again. According to Arthur Benson, the bishop's son and biographer:

> …my father arranged from ancient sources a little service for Christmas Eve – nine carols and nine tiny lessons, which were read by various officers of the Church, beginning with a chorister, and ending, through the different grades, with the Bishop. This service was afterwards used at Addington, and has spread I believe to other Places.[10]

Another version recounts that 'Bishop Benson, together with his Precentor, Augustus Donaldson, delved back into medieval service books and drew up a Service of Carols, interspersed with nine short lessons. The bishop is also credited with the hierarchical structure of the readers of the lessons – a reflection of a similar tradition at medieval church festivals'.[11] Given George Walpole's previous role in suggesting changes in the services on Christmas Eve, he – and perhaps others – may have participated in the planning of this most recent revision. However, two other reports give all credit to the bishop: for example, Precentor Donaldson wrote, 'perhaps one of the most striking [services] of all is the annual service held on Christmas Eve, when a *Service of IX Lessons*, drawn up by Dr Benson, is used'.[12] Donaldson does not mention himself being involved in the planning process; however, there is in Cornwall a hand-written copy of the spoken part of the first Truro Service, described as 'Note in Benson's hand of arrangements for service of Nine Lessons and Carols'.[13]

At 10 pm on 24 December, 1880, in what was partly old St Mary's and partly the wooden church, the new service, now called *Nine Lessons with Carols* and subtitled *Festal Service For Christmas Eve*, was presented for the first time. The order of service was:

The Lord's Prayer

The Preces[14]

O, Lord Open Though our Lips &c. Gloria Patri

Benediction: With perpetual blessing may the Father everlasting bless us. Amen.

First Lesson: Genesis 3.8–16 (Senior Chorister)

Carol: The Lord at first had Adam made

Benediction: God the Son of God, vouchsafe to bless and aid us. Amen.

Second Lesson: Genesis 22.15–19 (A Lay Choir-man)

Carol: Good Christian men, rejoice

Benediction: May the Grace of the Holy Ghost enlighten us heart and body. Amen.

Third Lesson: Numbers 24.15–18 (A Lay Reader of the Diocese)

Carol: The First Nowell

Benediction: The Almighty Lord Bless us with his Grace. Amen.

Fourth Lesson: Isaiah 9.6–8 (A deacon)

Anthem: For Unto Us a Child is Born (*Messiah*)[15]

Benediction: Christ give us the joys of everlasting life. Amen.

Fifth Lesson: Micah 5.2–5 (A Vicar, Decani Side)[16]

Carol: Bethlehem of noblest cities

Benediction: By the words of the Lord's Gospel be our sins blotted out. Amen.

Sixth Lesson: St Luke 2.8–16 (A Vicar, Cantoris Side)

Anthem: There were shepherds abiding in the fields (*Messiah*)

Benediction: (all standing): May the fountain of the Gospel fill us with the Doctrine of Heaven. Amen.

Seventh Lesson: St John 1.1–15 (Senior Canon, Decani Side)

Carol: O come, all ye faithful

Benediction: The Creator of all things give us his blessing. Amen.

Eighth Lesson: Galatians 4.4–8 (Senior Canon, Cantoris Side)

Carol: One again, O blessed time

Benediction: Unto the fellowship of the citizens above may the King of Angels bring us all. Amen.

Ninth Lesson: 1 John 5.1–5 (The Bishop)

Anthem: Hallelujah Chorus (*Messiah*)

The Magnificat

The Salutation

Collect for Christmas Day

The Blessing

According to the *West Briton Gazette*, 'the service was very hearty and impressive throughout, the singing being particularly good'. The *Gazette* commented also on the fact that 'the lay as well as the

Ill. 224. Note in Bishop Benson's hand of his plan for the first 'Festal Service with Carols' in Truro Cathedral, 1880. Truro, Cornwall Record Office, TCM 538.

clerical element was fully represented, the lessons being read respectively by two choristers (juvenile and adult), layman, deacon, two priests, two canons, and the last by the Lord Bishop'.[17] The *Royal Cornwall Gazette* provided more specifics:

> The order of service…consisted of nine lessons from Holy Scripture, teaching the truth of the incarnation. Before each lesson the reader took his stand beside the Bishop's stall at the gate of the choir, while the Bishop pronounced one of the benedictions anciently used … to which the congregation responded 'Amen'. Each lesson was followed by a carol… developing with the vigour and boldness of carol poetry the thought of the lesson.[18]

Word of the Truro *Nine Lessons with Carols* began to spread, and by 1883 A. J. Mowbray was advertising copies of the *Truro Festal Service* in *The Literary Churchman And Church Fortnightly* for sale at two pence each.[19]

Bishop Benson carried on his frenetic schedule of teaching, preaching, institution building, cathedral construction and visiting, all the while producing a cascade of correspondence, sermons, and diary entries. In November 1882, Archbishop of Canterbury Archibald Tait died, and on Christmas Eve, 1882, Benson's morning post brought him letters from both Prime Minister William Gladstone and Queen Victoria. The Prime Minister was asking Benson to succeed Tait as Primate of All England, and Her Majesty wrote in support of his candidacy. After a few days of consultation

Ill. 225. Eric Milner-White, 1912. Wilfrid Jenkins, photograph. Cambridge, King's College, Coll. Ph. 4.

with family, colleagues and friends, he accepted, was nominated Archbishop on 13 January 1883, confirmed in March, and enthroned at Canterbury at the month's end.[20]

His new and complex responsibilities notwithstanding, Benson brought the service from Truro to the Church of St Mary the Blessed Virgin at Addington Farm in Croydon (also known as Addington Palace), at that time one of the residences of the Archbishops of Canterbury; here the service was held on the Sunday after Christmas.[21] At Addington with its modest Choir, 'the service was altered to meet the needs of a small parish church, and all the carols are of the simple kind that can be sung by everybody'.[22] St Mary Addington was the first church to present the service after Truro.[23] Benson was now in a position to spread word about the service he called 'my Nine Lessons'[24] – and presumably he did so. However, his tenure as Archbishop was relatively brief: in October 1896, whilst visiting former Prime Minister Gladstone, Benson died in prayer during a Sunday service. It would be more than two decades and the end of a world war before *Nine Lessons and Carols* would find its way to Cambridge and to King's Chapel.

Ill. 226. Eric Milner-White in uniform astride a horse, 1912–1915, photograph. Cambridge, King's College, EMW/7/4.

This would be thanks to the efforts of the new young Dean, the Rev'd Eric Milner-White ('Milner', as he was generally called throughout his life by friends). He was born in Southampton in 1884.[25] His father, Henry Milner White, was both a barrister and a successful executive in a department store there, having married the owner's daughter. When Eric was six, his mother died of the Spanish flu, leaving Henry to raise four sons; three years later, Henry remarried, and his new wife and the four boys took to each other extremely well. The next few years were happy ones. Then there was tragedy: all the boys became ill with diphtheria, and, in spite of their step-mother's 'nursing them so devotedly',[26] Norman and Basil, the youngest, succumbed, while Eric and Rudolph (born 1885) survived. Although the impact of these losses for the family must have been devastating, after their recovery both boys flourished.[27] Following preparatory school, Eric Milner-White attended Harrow and came to King's in 1903 with a scholarship in history; he took a double first, as well as an extra year at King's, before leaving in 1907 to attend Cuddesdon Theological College (now Ripon College Cuddesdon), near Oxford. His choice came as something of a surprise to his family, but he was determined, his religious feelings having grown during his years at Harrow and at King's.[28] In 1908 he was made deacon and became curate at St Paul's, Newington, in the London borough of Southwark. The next year he was ordained and spent three years at St Mary Magdalene in Woolwich.

After his upper middle class upbringing and education, his exposure to a wider range of people in south and southeast London was to begin a transformation in him that would continue through the next decade and beyond. He returned to King's as chaplain in 1912, and added to his responsibilities by becoming lecturer in history at Corpus Christi College and chaplain to the Bishop of London.

With the likelihood of conflict increasing in 1914, Cambridge had started to prepare for war. In the words of M. R. James, then Provost of King's:

> ...emergency legislation was devised, the resources of the University placed at the disposal of authority, measures settled with the Town as to action in case of hostile landings...A hospital was fitted up in the cloister of Nevile's Court at Trinity, then transferred to the King's and Clare field, and enormously expanded....Then came camps on Midsummer Common and regimental messes established in College Halls – welcome indeed they were. The young men in King's grew fewer; we had no cadets to replace them, for our only possible building was filled with the nurses of the hospital. Emptier and emptier grew the courts, slower and duller the pulse of life.[29]

On 5 August 1914 war was declared and Milner-White volunteered immediately for service in the British Army. He was accepted, and three months later he was interviewed by John Taylor Smith, the Chaplain General of the British Army. Taylor Smith's notes of their first meeting describe Milner-White as a 'charming fellow, [he] rides, speaks French and German, and desires work at once'. The new conscript signed a contract for a year's service on 26 November 1914 and passed his physical the next day; on 1 December he was appointed Chaplain to the 8th Battalion of the London Regiment.[30] By Christmas he was with the Expeditionary Force at Hospital 13 in Boulogne, France.[31]

Milner-White had exchanged the quiet and reasonably predictable world of Chapel services, students and teaching for an annual contract to serve as a chaplain in the chaos of war. A chaplain's responsibilities included holding regular services, burying the dead, consoling the wounded and the unwell, writing letters home on their behalf, leading recreational activities in quiet moments, and trying to maintain and improve morale, no matter how difficult the situation. Of course, the essence of a chaplain's role was much more than that – as one 'padre' – the term commonly used by the soldiers for a priest – recommended:

> Live with the men, go where they go, make up your mind that you will share all their risks, and more, if you can do any good. Your place is at the front. The men will forgive you anything but lack of courage and devotion – without that you are useless. There is very little spiritual work – it is all muddled and mixed – but it is all spiritual. Take a box of fags in your haversack, and a great deal of love in your heart, and go up to them, live with them, talk with them. You can pray with them sometimes, but pray for them always.[32]

Nothing could have prepared him for the Western Front and the horror of battle – noise, mud, trenches, bombs, machine guns, artillery fire, poison gas, barbed wire, the dead and the dying. His experience helped him 'come to appreciate both the virtues and the limitations of the ordinary man...from now on he fought to keep his thinking and writing balanced to some extent by the needs of ordinary people'.[33] Not all of a chaplain's time was spent on the front lines, of course; some of it was in hospitals and other places away from battle. By February 1917, he had become Senior Chaplain to the 7th Division, the 'Immortal Seventh', with added administrative responsibilities.[34]

Late in his life, he destroyed much of his war-time correspondence; his army records are incomplete and most of the records of the chaplains were destroyed by fire in World War II. But a few letters exist that recount some of his experiences on the Western Front:

> Half an hour later, I was taking my first field funeral.... I headed the little procession in my robes to a place by the wayside already dotted with little crosses. This region is full of guns hidden supremely on every turn. When I got to the grave, at least 50 Artillery men were waiting with bared heads. The service was most impressive, dusk was gathering and the poor blanketed body was lying in the deep dark brown hole, whilst the guns around thundered over the flats with their shrieking gifts.[35]

> (Battle) is indescribable, unimaginable. The fresh night air was itself a rushing road like a waterfall, as a thousand shells tore through it. The dark blue sky was lit up by a summer lightning flash upward from the earth every second. The darker motionless clumps of poplars all round the horizon were continually silhouetted in white flame. The continuous firework of light balls went up from the German trenches. But most awesome was the noise. We felt so powerless against those splitting cracks and roars, and dreamt of the metal tearing its way into the bodies of poor men.[36] I have had another battle – my ninth with this division –; a thing of special horror, became a repulse, in the wind and the rain and the abomination of slough...Without a rest, I could not be of much further use to the army out here; or perhaps ever again to anybody.[37]

By the autumn of 1917, he had been recommended for the Distinguished Service Order (D.S.O.). His Major General wrote:

> I cannot speak too highly of the energy and self-sacrifice with which he has carried out his duties as Senior Chaplain to the Forces. He is not only untiring in his ministry to the Troops, but also carries out the administrative portion of his duties in an exceptional manner. His personal courage is of a high order and is reflected in all his subordinates. I strongly recommend him for reward.
>
> <div style="text-align:right">H. Shoubridge, M. G. (Major General)
7th Division 29–09–17[38]</div>

Milner-White was mentioned in dispatches in the *London Gazette* on 24 December 1917,[39] and was awarded the D.S.O. in the 1918 New Year's Day Honours List.[40] If there was a particular reason for the commendation, it remains unknown, although it was not uncommon for chaplains to receive such awards for exceptional performance of their duties, leadership and valor.

After Milner-White's death in 1963, however, two memorial books were written about him by friends and colleagues, in which he was said to have gone repeatedly into 'no man's land' under fire, to bring back the wounded. At some point in a battle, when all the officers in a unit had been seriously injured or killed, the men asked him to take command.[41] Had he done so – even if he had not fired a weapon – he would have violated his status as a non-combatant: according to David Blake, Curator of the Museum of Army Chaplaincy, 'chaplains were treated as medical personnel for the purposes of the Geneva convention and therefore were classed as non-combatants. Although they

Ill. 227. A group of men in uniform with Eric Milner-White in the centre of the back row, 1912–1915, photograph. Cambridge, King's College, EMW/7/3.

had equivalent military rank, chaplains were not allowed to have any command role or issue military orders'.[42] There has been no independent validation of these war stories; it must have been Milner-White himself who told close friends about these and other experiences in the army.

There was another problem for Milner-White during his wartime chaplaincy. He found himself increasingly troubled by a liturgy that he perceived to be largely irrelevant to the conditions of war. 'We have possessed but one well-known scheme', he wrote. 'It may not be perfect, but it has served – Confession, Lord's Prayer, Creed'.[43] However, many of the troops were not practising Christians, and many Anglican chaplains were torn between the requirements of the Book of Common Prayer (and of John Taylor Smith, the Chaplain General) and the needs of the men in the trenches. Milner-White was open about his opposition to traditional army practices for services during battle, and insisted on praying for the dead, preferred by the troops, but against Taylor Smith's instructions. In a book of essays by army chaplains published in 1918 called *Church in the Furnace*, Milner-White wrote on *Worship and Services*:

> You must listen to the roar and shaking of great guns; must see the poor messy surroundings, where the white linen cloth and the two flickering candles alone speak of things pure and lovely; must feel with the bowed and grimy men in mud brown dress, torn and stained and even bloody; must know that the minutes in front hold, the minutes just past have held, the issues of life, death, and dreadful maiming.

> We are a new race, we priests of France, humbled by much strain and much failure, revolutionaries not at all in spirit but actually in fact; and while often enough we sigh for the former days, the procession of splendid offices and the swell of the organ, these will never again content us unless or until the great multitude also find their approach to God through them.[44]

Ill. 228. Eric Milner-White in clerical dress, no date, photograph. Cambridge, King's College, Coll Ph 90.

By this time, Milner-White's opinions, as well as his actions, might have made him too much of a problem for the conservative Taylor Smith, who had been Chaplain General since 1901 and was an evangelical; his personal style was direct and often confrontational.[45] But perhaps after three years as a chaplain Milner-White had had enough of war. According to his military records, his last annual contract expired on 30 November 1917,[46] and he resigned his commission on 5 January 1918.[47] Taylor Smith was asked to explain Milner-White's reasons for his leaving the Army and he gave three: 'that his college in Cambridge required him to resume work, he had been on active service for three years, and was very tired (which is quite true)'.[48] One curious piece of information on the relationship between Milner-White and Taylor Smith turned up later in George Tibbatts's revision of Henry Brandreth's *History of the Oratory of the Good Shepherd*, an organisation of which Milner-White was a founding member before the war. According to Tibbatts, an Anglican priest, Taylor Smith described Milner-White as 'the blackest sheep of all his Chaplains'.[49] Whilst such a remark was not out of character for Taylor Smith, and no doubt reflected his frustration with Milner-White's outspoken opposition to his strict requirements for services in the course of battle, the comment may reflect a grudging admiration for Milner-White's extraordinary commitment to his men. According to Philip Pare and Donald Harris, 'his commission was terminated, but almost at the same time he received the D.S.O. at the hands of King George V'. This led someone who had known Milner-White slightly in the war to remark some years later that 'they had cashiered him with one hand while giving him the D.S.O. with the other'.[50] The speaker remains unknown, but the remark lives on today in the memory of the Milner-White family.[51] However, while the proximity of events may suggest some connection, it does not prove it; it is possible that the short time between the award of the medal and Milner-White's leaving the army may have led friends and acquaintances to make incorrect inferences about what actually occurred.

Milner-White had long been contemplating returning to King's, though he had also considered other possibilities. His leaving the Army on 5 January 1918 was confirmed again in the London Gazette of 20 February 1918, by which time he was back in Cambridge, having decided to return to King's.[52] During the War, no matter how busy Chaplain Milner-White might have been, he had been able to return to Cambridge when on military leave and so had maintained regular contact with King's, from which he was formally on academic leave. Much of his correspondence with Provost M. R. James concerned his return to the College and its Chapel.

In 1916, James had asked Milner-White to send along his thoughts on the future of King's Chapel; he was thirty-two years old and in the midst of conflict when he described his vision for it. In the cover letter that accompanied the proposals Milner-White expressed concern about the possible reaction to his views and informed James that he had circulated the document first to those closest to

him, including organist Arthur H. Mann ('Daddy' Mann), then 'handing [it] out one by one to members of the Council'.[53] His ideas ranged far beyond the College and the city of Cambridge:

> The extraordinary potentialities of our Chapel for the whole religious life of England tend to be forgotten. At the present moment of utter chaos, and of superb hope in Church as in State, we have a chance which, boldly taken, might make King's one of the most important churches in the land.
>
> In the matter of public worship, no Church in the land is more fitted than ours to take a lead. We are free from ecclesiastical authority which governs even most 'live' cathedrals...We have unrivalled musical resources. It is my passionate conviction that if we could catch and crystallize the wisest principles of liturgical reform in the worship of our Chapel, we should be doing a great work, not only for the college and university, but also for the Church and the Empire.[54]

About 'occasional services', such as the *Festival of the Nine Lessons and Carols* was to be, he wrote:

> Here is a field which can be richly sown, and over which I think no battle is likely to rage. Colour, warmth and delight can be added to our yearly round in many ways. I have suggested several to the Provost, and think he was in general sympathy, perhaps more.

Milner-White provided three examples of such services – 'a memorial service for our own Fallen, a short service of admission for a new choir-boy, and richer provisions for the Church Seasons'.[55]

In March 1918, Milner-White was elected a Fellow of King's.[56] On 11 May 1918, Alan Brooke, who had been Dean since 1893, resigned, and at the same meeting Milner-White was appointed as his successor (as his was the only nomination, he was considered elected).[57] At a meeting a week later it was 'agreed that the Deans be requested to consider what modifications, if any, are desirable for the improvement of Chapel Services'.[58] He was now in a position to begin realizing his vision for the Chapel.

When Milner-White took on the Deanship of the Chapel, Cambridge was changing rapidly, as the University and its colleges planned for the future in peacetime. M. R. James left King's in late summer to become Provost of his beloved Eton College, and Walter Durnford would not be elected as Provost of King's until November. Change was everywhere, and one could not expect King's Chapel to be isolated from it. The War had taken a terrible toll on Britain in many ways, but above all in lives lost. In the period between 1914 and 1918 over 900,000 soldiers of the British Army were killed and more than 2,000,000 wounded.[59] At King's, of the 774 students who served during the war, 174 had been killed.[60] On 2 November of the Michaelmas Term of 1918, the University held the then annual Memorial Service for the Fallen in King's Chapel; nine days later, the Armistice was signed. It would be a long time before life in Cambridge returned to normal.

According to Frank Anderson, who had attended King's Chapel on Christmas Eve throughout the war, the Christmas Eve service in the College at this period was Evensong with several carols added in conclusion.[61] The decision to initiate the *Festival of Nine Lessons and Carols* was Milner-White's, but he might well have taken advice from M. R. James, who in 1882 had spent Christmas in Truro with his lifelong friend Arthur C. Benson, son of Bishop Benson. During that visit James would have been introduced to Truro's *Nine Lessons with Carols*.[62] By now, however, Arthur Benson was Master of Magdalene College, Cambridge, and he might have made mention in passing of the Truro service to

either James or to Milner-White himself. Alternatively, Milner-White might have become aware of the Truro and Addington services independently, realising that the model precisely suited his ideas about 'occasional services'. In any event, his decision to move forward with *Nine Lessons and Carols* was a bold modification of previous practice. One delicate task for Milner-White was to persuade the organist, 'Daddy' Mann, that this new service was a good idea. Mann had served the College as organist 'for more than forty years with great distinction,' wrote Patrick Wilkinson, and 'naturally his tastes were Victorian....But little by little the Dean...won his way'.[63]

The structure of this first service relied heavily on the earlier versions from Truro and Addington. However, the lessons chosen were different, and each was preceded by a benediction (as in the Truro version), as well as by a thematic preface, initiated by Milner-White. In matters of music, Milner-White felt that selections of choral music from Handel's *Messiah* were out of place and he removed them.[64] As Erik Routley points out, 'he included not two congregational hymns but five, and from the first he saw to it that the carols should be carols and not pious Victorian lyrics'.[65] Milner-White also created the bidding prayer, which remains mostly unaltered, save for a few pronominal and gender adjustments in recent times. Here is the original:

> Beloved in Christ, be it this Christmas Eve our care and delight to prepare ourselves to hear again the message of the Angels, and in heart and mind to go even unto Bethlehem and see this thing which is come to pass and the Babe lying in a manger.
>
> Therefore let us hear again from Holy Scripture the tale of the loving purposes of God from the first days of our sin unto the glorious Redemption brought us by this Holy Child; and let us make this Chapel, dedicated to his Pure and lowly Mother, glad with carols of praise.
>
> But first because this of all things would rejoice his heart, let us pray to Him for the needs of the whole world, and all His people; for peace upon the earth He came to save; for love and Unity within the one Church He did build; for brotherhood and goodwill amongst all men, and especially within the dominions of our sovereign lord King George, within this University and Town of Cambridge and in the two royal and religious Foundations of King Henry VI here and at Eton.
>
> And particularly at this time let us remember before him the poor, the cold, the hungry the oppressed; the sick and them that mourn; the lonely and the unloved; the aged and the little children; all those who know not the Lord Jesus, or who love Him not, or who, by sin have grieved His heart of love.
>
> Lastly, let us remember before Him them who rejoice with us, but upon another shore and in a greater light, that multitude which no man can number whose hope was in the Word made flesh, and with whom, in this Lord Jesus, we for evermore are one. These prayers and praises let us humbly offer up to the Throne of Heaven, in the words which Christ himself hath taught us: 'Our Father'....[66]

Hearing the bidding prayer for the first time or the fiftieth, one is struck by its simplicity, breadth, directness, and cadence. It embraces humankind, the multitude which was now a focus for Milner-

Ill. 229. Arthur Henry ('Daddy') Mann seated in (?) his College Room, 1914. J. R. W. Hughes, photograph, detail. Cambridge, King's College, AHM/5/2/3.

White's thinking for the rest of his life. For many at the end of war, the reference to all those 'who rejoice with us but upon another shore and in a greater light' must have been deeply moving, and its impact has not diminished over the decades. Routley said of it that it 'is perhaps the finest thing of its kind in the language since Cranmer'.[67]

The 1918 service opened with the invitatory carol 'Up Good Christian Folk', sung by a quartet from the organ loft on the screen (in all subsequent services, the first piece of music has been the processional 'Once In Royal David's City', with the harmonisation by the organist and Director of the Choir, 'Daddy' Mann). The order of service was as follows:

Invitatory Carol: Up Good Christen Folk *16th Century*

Processional Hymn: Once in Royal David's City *19th Century*

The Bidding Prayer

The Lord's Prayer

Hymn: A Great and Mighty Wonder *M. Praetorius, 17th Century*

Benediction: With perpetual benediction, may the Father everlasting bless us. Amen.[68]

Preface: God announceth in the Garden of Eden that the seed of woman shall bruise the serpent's head.

First Lesson: Genesis 3.8–15 (A Chorister)

Carol: A Virgin Most Pure *Old English, 15th Century*

Benediction: God, the Son of God, vouchsafe to bless and aid us. Amen.

Preface: God promiseth to faithful Abraham that in his seed shall all nations of the earth be blessed.

Second Lesson: Genesis 22.15–18 (A Chapel-clerk)

Carol: Blessed be that Maid Marie *Old English, 16th Century*

Benediction: May the grace of the Holy Ghost enlighten us heart and body. Amen.

Preface: Christ's birth and kingdom is foretold by Esaias.

Third Lesson: Isaiah 9.2,6–7 (An undergraduate member of the College)

Carol: As up the wood I took my way *20th Century, Martin Shaw*

Benediction: The Almighty bless us with His grace. Amen.

Preface: The prophet Micah foreseeth the glory of little Bethlehem.

Fourth Lesson: Micah 5.2–4 (A Fellow)

Hymn: While Shepherds watched their flocks by night
Estes Psalter, 1592, Words, 17th Century

Benediction: Christ give us the joys of everlasting life. Amen.

Preface: The Angel Gabriel visiteth the Blessed Virgin Mary.

Fifth Lesson: St Luke 1.26–33 and 38 (The Vice Provost)

Carol: Unto us is born a Son *Words and Melody, 14th Century*

Benediction: By the words of God's Gospel be our sins blotted out. Amen.

Preface: The Word is Made Flesh

Sixth Lesson: St John 1.1–14 (A Free Church Minister)

Hymn: O come, all ye faithful *18th Century*

Benediction: May the fountain of the Gospel fill us with the doctrine of Heaven. Amen.

Preface: The shepherds go unto the Manger.

Seventh Lesson: St Luke 2.8–16 (The Mayor's Chaplain)

Carol: O night peaceful and blest *Old Carol of Basse-Normandie*

Carol: Childing of a maiden bright *Melody, 11th Century, Words, 14th Century*

Benediction: The Creator of all things give us His blessing now and for ever more. Amen.

Preface: The Wise Men are led by the Star to Jesus.

Eighth Lesson: St Matthew 1.1–11 (The Provost of Eton)

Carol: In dulci jubilo *Melody, 14th Century*

Benediction: Unto the fellowship of the citizens above may the King of Angels bring us all. Amen.

Preface: God maketh us sons through Christ.

Ninth Lesson: Galatians 4.4–7 (The Provost)

Carol: The first Nowell *Old English*

The Magnificat *Charles Wood,
Words, The Metrical Version of Sternhold and Hopkins, 16th Century*

Salutation

Collect For Christmas Day[69]

The Blessing

Recessional Hymn: Hark! The Herald Angels Sing *Mendelssohn 1809–1847,
Words by C. Wesley (1743) and G. Whitefield (1753)*[70]

M. R. James returned from Eton for this first *Nine Lessons and Carols* in King's Chapel; it was perhaps inevitable that on this occasion a reading (the eighth lesson) should be found for him, as former Provost of King's. According to Pare and Harris, 'James came full of apprehension, only to be converted. With characteristic kindliness, he congratulated the Dean immediately afterwards, at the same time frankly confessing the revolution in opinion that he had himself undergone'.[71] Anderson was also present at the first *Nine Lessons and Carols*, of which he observed, 'I was a young man of 16. By then I had taken King's singing for granted – perhaps too much. It was a different service, and I think we all thought – all of us who had been to the previous services – that it was a very good idea and hoped that it would go on as it has'.[72] (Anderson was later to join the Outside Broadcasts Department of the BBC and from 1939 till 1979 produced every *Festival of Nine Lessons and Carols*.)

Having tried the service with a few modifications from the Truro/Addington version, Milner-White found it wanting in several respects, and he set about making changes which met his guiding principles: 'as to structure, the responses must be clear, the movement precise, the postures right, and the congregational element definite'.[73] Nearly four decades later, Milner-White wrote a memorandum that included his memories of the history of the first service and explained the reasons for his alterations, most of which have remained in place since 1919.[74] He explained that Edward Benson 'made the two most important contributions to the service as we know it. In the Middle Ages, the greatest feast days were marked by a series of nine Lessons, and Christmas Day was one of these. The Bishop adopted this liturgical custom to form a backbone of a carol service.... Further, the readers of these lessons formed another sequence climbing upward in rank from a chorister to the Bishop himself'.[75] But Milner-White also acknowledged that:

> the Bishop's scheme, excellent on paper, did not transfer so well into action. The movement was continually held up by a series of rather irrelevant Benedictions between each lection. The singing contained only four carols, with two hymns, three choruses from *Messiah*, and the Magnificat as a climax....These blemishes were at once revealed when the service was tried out in King's College Chapel; and the following year, 1919, it was re-ordered by prefacing it with a Christmas Bidding and Lord's Prayer, by cutting out the Magnificat and Benedictions, and by making the Ninth Lesson, the story of the Incarnation from the St John's Gospel, the supreme climax, for which everybody stood.

Milner-White also insisted on the importance of the lessons:

> their liturgical order and pattern is the strength of the service and prevents it becoming a recital of carols rather than an act of worship...For it is fatally easy to weaken and ruin the devotion, to make it mere community carol singing, by reducing the number of Lessons and doubling the number of carols. As it stands, the service is a fruitful example of the use of ancient forms in a new combination to create action, and a variety of parts, all concentrated upon the coming of our Lord Jesus Christ.[76]

The altered order of service in 1919 was as follows, though, intriguingly, in this version the eighth carol is in fact two early nativity songs:

Processional Hymn: Once in Royal David's City[77] *19th Century*
The Bidding Prayer (congregation standing)

The Lord's Prayer (congregation standing)

Benediction: God, the Son of God, vouchsafe to bless and aid us; and unto the fellowship of the citizens above may the King of Angels bring us all. Amen.[78]

Invitatory Carol: Up! Good Christian Folk and listen *16th Century*

(congregation standing)

(After this carol, congregation shall sit for all carols, except those following the third, sixth, and ninth lessons, in which they are asked to join heartily.)

First Lesson (A Chorister)

Preface: God announceth in the Garden of Eden that the seed of woman shall bruise the serpent's head.

Genesis 3.8–15

Carol: Come listen to my Story *15th Century*

Preface: God promiseth to faithful Abraham that in his seed shall all nations of the earth be blessed.

Second Lesson (A Lay Clerk)

Genesis 22.15–18

Carol: As up the Wood I took my Way *20th Century, Martin Shaw, Words, Selwyn Image*

Preface: Christ's birth and kingdom are foretold by Esaias.

Third Lesson (An Undergraduate of the College)

Isaiah 9.2, 6, 7

Carol: God rest you Merry Gentlemen *Traditional*

Preface: The Prophet Micah foreseeth the glory of little Bethlehem.

Fourth Lesson (A Fellow)

Micah 5.2–4

Carol: Unto us is born a Son *Words and Melody, 14th Century*

Preface: The Angel Gabriel visiteth the Blessed Virgin Mary.

Fifth Lesson (The Vice-Provost)

St Luke 1.26–33 and 38

Carol: Shepherds in the Field abiding *Old Carol of Lorraine*

Preface: St Matthew telleth of Christ's Holy Birth.

Sixth Lesson (A Free Church Minister)

St Matthew 1.18–23

Carol: While Shepherds watched *Este's Psalter, 1592, Words, 17th Century*

Preface: The Shepherds go unto the Manger.

Seventh Lesson (The Mayor's Chaplain)

St Luke 2.8–16

Carols: O Night, Peaceful and Blest *Old Carol of Basse-Normandie*

I Heard an Infant Weeping *17th century*

Preface: The Wise Men are led by the Star to Jesus.

Eighth Lesson (The Lower Master of Eton)

St Matthew 1.1–11

Carol: In Dulci Jubilo *14th Century*

Preface: St. John unfoldeth the great mystery of the Incarnation.

Ninth Lesson (The Provost)

St John 1.1–14

Carol: O Come, all ye Faithful *18th Century*

Collect For Christmas Day[79]

The Blessing

Recessional Hymn: Hark! the herald angels sing *Mendelssohn 1809–1847*

Words by C. Wesley (1743), G. Whitefield (1753)[80]

Changes in the service since 1919 have been minor in most respects. Two lessons were changed in 1919: the sixth lesson, originally, the glorious and highly theological opening of St John's Gospel ('In the beginning was the Word, and the Word was with God…') was replaced with narrative material, the annunciation from Matthew 1.18–23; and the ninth and final lesson, formerly Galatians 4.4–7 (about the son-hood of Christ and and human beings), became the passage from St John's Gospel, Milner-White's 'supreme climax'. Between 1945 and 1950, the fourth lesson, originally Micah 5.2–4 (an address to Bethlehem, describing the Lord's coming to Israel), was altered to prophetic passages from Isaiah that refer more generally to the lands to which Christ will come: Isaiah 35 and 60, 1–6, 19; it changed back to Micah in 1951, but since the introduction of Isaiah 11, 1–9 (on the peace that will follow the advent of the 'rod' that will grow from the 'stem of Jesse') in 1959, the fourth lesson has remained unchanged.

In the *Festival*, the lessons are Milner-White's 'backbone' of the service; the readers are chosen with care and well-rehearsed, and the different voices, often with varying accents, are another reminder of the broad community of faith taking part in the service. The hierarchical order of readers, begun at Truro, continues in a way appropriate for a college chapel, though over the decades the institutional relationships of some of the readers have changed. In 2013, for example, the lessons were read, in this order, by a chorister, a choral scholar, a member of College staff, a representative of the city of Cambridge, a representative of Eton College, the chaplain, the Director of music, the Vice Provost and the Provost. The Dean has never been assigned to read a lesson, except between 1966 and 1969, when the ostentatiously secular Edmund Leach was Provost and did not read the ninth Lesson (though apparently he advised everyone to attend the service for anthropological reasons). In these years the Chapel Dean took the Provost's place – the only occasions in the history of the service that this has occurred.[81]

The carols confirm the message of each lesson, and the singing of the King's College Choir is both breathtaking and deeply moving – for many the music is the heart of the Service, the lessons the spine, both bound together by prayer. Since 1876 the Choir of King's College has been led by the surprisingly small number of five organists or Directors of music, all of whom have contributed distinctive musical settings and traditions to the *Festival of Nine Lessons and Carols*.

'Daddy' Mann, organist from 1876 to 1929, is remembered for his very long tenure and his harmonisation of 'Once in Royal David's City', the processional in every service since 1918 (and as the first item from 1919 onwards). Routley writes of the 'subtle art [with which Mann's] arrangement turns

the homely children's hymn into a processional of immense spaciousness'.[82] For more than half a century the first verse has been sung by a solo chorister, but in the early days all the choristers sang the first, third, and fourth verses, whilst the entire Choir sang verse two, and everyone else sang verses five and six. Bernhard (Boris) Ord directed the Choir from 1929 to 1957 (except for the years 1941–1945 when he was in the army; see Ills. 237 and 238). Ord substantially reoriented the singing style of the Choir and led it on its first foreign tour; his arrangement of the medieval lyric 'Adam Lay Ybounden' was his only piece of published music.[83] When Ord was away, Harold Darke, of St Michael's Cornhill, City of London, became the interim organist, maintaining a complicated schedule both in London and Cambridge throughout his time at King's. His arrangement of Christina Rossetti's 'In the Bleak Mid-Winter' is often performed on Christmas Eve in King's Chapel.[84] Sir David Willcocks, who had been organ scholar before World War II, became Director of Music in 1957 (see Ill. 239); at this time rapid improvements in the art and science of recording began to occur – FM radio, long-play gramophone recordings (first mono, then stereo), audio cassettes and television; at this time recordings by the Choir began to appear more frequently, its reputation spread quickly and its international tours increased. Willcocks collaborated with Reginald Jacques on a book called *Carols for Choirs*, published in 1961; included in it were fifty carols (sixteen of them arranged by Willcocks) and a copy of the order of service for *Nine Lessons and Carols*. The 'Green book', as it came to be known, was another opportunity for church musicians at large to learn about the service as presented in King's Chapel on Christmas Eve.[85] Sir Philip Ledger succeeded Willcocks in 1974 (see Ill. 240); he too contributed a number of arrangements and descants during his brief time at King's before becoming the Principal of the Royal Academy of Drama and Music in Glasgow.

Stephen Cleobury, CBE (see Ills. 241 and 242), arrived at King's from London in 1982, bringing with him the idea of annually commissioning a new carol for Christmas Eve: 'I thought it important that the service should be refreshed each year with new music, and wanted to involve the leading composers of our day, not just "church composers"'. Today, as he observes, 'we have a collection of carols from Lennox Berkeley, Peter Maxwell Davies, Harrison Birtwistle, Giles Swayne, Richard Rodney Bennett, Alexander Goehr, Nicholas Maw, John Tavener and Judith Bingham, to mention just some'.[86] During his more than three decades at King's, these commissions have become a widely admired contribution to the music of Christmas everywhere, another tradition associated with the service, but also the most significant change in the service since 1919. Cleobury has also introduced an array of new carols into the service, and by 2010 the total of commissioned carols and carols new to the service was over 111 and counting.[87] Under his leadership, international tours of the Choir have increased, new recordings appear regularly, audio of selected Chapel services can be heard on the College web-site, and an Easter Music Festival has been added to the Choir's already busy schedule.

When the service began in 1918, its popularity was immediate; as Routley observed, the service 'attracted vast crowds to Cambridge, even before the BBC made it a world institution'.[88] Today, most of those who are fortunate enough to be in the Chapel for *Nine Lessons and Carols* have spent several hours, generally on a chilly Cambridge morning in the queue around the College courtyard. A few particularly hardy folk arrive several days before the service and camp out, but most appear early in the morning of Christmas Eve to stand in a long line in hope of being admitted to the Chapel. The atmosphere is quietly festive – the choral scholars serenade the waiting queues, strangers become acquaintances and tales are told. But when the Chapel doors open, the mood changes and the conversations diminish: everyone hopes for a good seat, preferably on the east side of the organ screen for a direct view of the Choir and the readers, but, ultimately, any seat in the Chapel will do.

The experience of waiting in the Chapel for *A Festival of Nine Lessons and Carols* to begin is probably

Ill. 230. Harold Darke, acting organist of King's 1941–5, and Fellow 1945–9, photograph.

not much different now from what it was decades ago. One reviews the printed order of service, observes other members of the congregation, and perhaps there is a very quiet conversation or two until the prefatory organ music begins. When the Choir enters, there is a hush, interrupted by soft sounds as the men and boys walk to the west door. And then a pause, before the spellbinding moment when the chosen chorister begins the first verse of *Once in Royal David's City*; the Choir joins in the second verse, and during the third, the Choir process into the stalls. When the congregation joins in the last two verses, the relief and joy in their voices is almost overwhelming. The Dean reads the opening prayers, a chorister reads the first lesson, and the sequence of words and music unfolds. At the end of the service, when the whole congregation join in 'Hark! The Herald Angels Sing', the stained glass has turned to black and the Chapel, lit only by candles and sconces, is suffused in darkness. Put simply, the experience of attending *Nine Lessons and Carols* in King's Chapel is unforgettable.

A decade after the first service at King's, thanks to the BBC, another 'congregation' began to 'attend' *Nine Lessons and Carols* – the radio audience. Founded in 1922, the institution originally named the British Broadcasting Company was owned by the companies manufacturing equipment for 'wireless transmission'; on New Year's Day 1927 it became the British Broadcasting Corporation. The new organisation took as its explicit purpose that of 'public service', and John Reith, who had been Managing Director of the Company, became Director General of its successor. He had a deep interest in promoting religion, especially Christianity, and early on services were broadcast from the major English cathedrals. The relationship between King's and the 'old' BBC began in March, 1926, when the College Council authorised 'the Second Bursar in consultation with the Deans to negotiate with the British Broadcasting Company for the broadcasting of Chapel Music'.[89] On Sunday, 2 May 1926 an Evensong service was the first ever broadcast from King's Chapel.[90]

Two years later, in October 1928, the Council authorised 'the use of the Chapel to permit the Carol Service to be broadcasted [sic]' for the first time.[91] It must have been both a delight and something of a surprise to be in one's home on Christmas Eve in range of the BBC transmitters, and to hear – via 5XX Daventry or 2LO London – *Nine Lessons and Carols* live from King's Chapel. Andrew Parker has noted that 'Daddy' Mann was a reluctant participant in the first broadcast, primarily because he thought that the acoustic challenge of the building was too great for the broadcast equipment.[92] Organists and Directors of music have been known to find fault with some aspect of almost any audio representation of one of 'their' performances; for audio engineers, however, a building such as King's College Chapel is an irresistible technical challenge. Nevertheless, what little

evidence we have indicates that the echoing acoustic of the Chapel was indeed a problem. In fact, after the broadcasting successes of 1928 and 1929, the BBC did not broadcast the service in 1930; instead, at the time when in the two previous years services from King's had been heard, the 'National Programmme' offered a concert by The Bournemouth Symphony.[93]

There is not much material available from those years in the BBC Written Archives, so the reasons for the change remain unclear. But there are some clues. In the *Radio Times* of 18 December 1931 there was a note on the page devoted to Christmas Eve programming:

> This is a welcome reappearance of the Christmas Eve Carol Service from King's College.... It is one of the loveliest services to be heard anywhere.... In spite of the unusual arrangement of the Chapel and of the tremendous echo, the first relay of the Carol Service in 1928 was hailed as one of the most successful Outside Broadcasts ever made.[94]

The possibility that the echo was the problem seems to be confirmed by a 1958 BBC press release on the occasion of the thirtieth anniversary of the first broadcast, which noted that 'in 1928 there probably was no intention of putting it on the air every year; indeed, difficulties with the acoustics militated against a complete radio success. In 1930 it was dropped by the BBC but next year the broadcasts were resumed – the awkward acoustics which indeed give King's some of its special character, having been got under control'.[95]

Another more remote explanation of the hiatus is that it might have been linked to a change in BBC policy about what material was permitted to be broadcast in religious programmes. The book *Services For Broadcasting*, published by the BBC in 1930, outlined what was approved: standard versions of the Old and New Testaments, hymns from commonly used hymn books – but very few prayers were authorised.[96] Some of the prayers approved for Christmas included texts similar to Milner-White's bidding prayer, but lacked the strength of his formulation. Under these circumstances, it seems plausible that Dean Milner-White might have decided to refuse attempts by an external, non-religious entity to control the content of a service in the Chapel, especially one as popular as *Nine Lessons and Carols* was by that time.

Nevertheless, the service returned to the air in 1931 and has been heard continuously since. In December 1932, the new Empire Service began to transmit via short-wave, and, just six days after the BBC's director general John Reith inaugurated this new form of transmission, *Nine Lessons and Carols* was heard abroad. Through the 1930s, broadcasters in Italy, Switzerland, France, and the United States took parts of the relay. In 1939, the Empire Service was renamed the Overseas Service; in 1943 it became the General Overseas Service, and on May 1, 1965, it was renamed the BBC World Service. No matter what label on the shortwave broadcaster, Christmas Eve at King's could be heard around the world, as well as on the Home Service of the BBC (though sometimes broadcasting conflicts meant that not every part of Britain could hear the Service live).[97]

The first live stereo American broadcast of the service did not take place until 1979, when getting a good signal across the Atlantic was still a risk. This was my idea. It was based on a conversation with my tearful father one Christmas Eve at least a decade before, when he had been moved by the innocence of the boys' voices on a long-play disc of Willcocks' edited 1964 service. In 1978, I had left a career in education to become programme director at Minnesota Public Radio, a small regional network with a focus on classical music, jazz and news. The era of communications satellites was about to arrive; this meant we would be able to work with broadcasters outside the USA, and also to use a superior broadcast signal. Although we didn't have enough funding to acquire a series from abroad, a live relay of an event

seemed possible. So, remembering that conversation with my father a decade before, I rang BBC Radio and got through to a producer named John Haslam in Outside Broadcasts. I asked him whether we in Minnesota might be able to bring *Nine Lessons and Carols* live to America and distribute it to other stations in our nationwide public radio system. After a very brief pause, John replied, 'Why not?'

There were all kinds of technical, fiscal and internal problems in making that first broadcast happen, but we received great collaborative support from National Public Radio in Washington, DC, and on Christmas Eve in 1979, at 9:00 am in St Paul (3:00 pm in Cambridge), we heard the sounds of the organ in King's Chapel and crossed our fingers. Although the audio quality wasn't quite as good as we had hoped, and the service ran a bit longer than expected, none of that mattered to the listeners. One woman from rural Minnesota preparing her holiday meal wrote: 'I burned my sweet potatoes and I didn't care'; a man in California let us know that he was meditating on world peace on the beach at Malibu and was very pleased to hear the service. Over the next month or so, as there were more cards and letters praising the broadcast than we had ever hoped, we knew that *Nine Lessons and Carols* had become part of Christmas Eve listening throughout the USA. Today about 300 stations carry the service live, and many stations repeat the service on Christmas Day. Throughout Advent, in towns large and small throughout our country, local versions of the King's service are presented in churches of many denominations.

The radio broadcast of the service is now distributed in a variety of ways – and there is something new almost ever year. The most recent broadcast was available in the UK live on Radio 4 and via the internet; in America by ISDN (Integrated Services Digital Network) lines, then by satellite to participating stations; live on the BBC World Service with rebroadcasts through other national partners, as well as by a satellite stream to members of the European Broadcasting Union; on the internet through the BBC's website (both live and archived). In 2018, *Nine Lessons and Carols at King's* will celebrate the centenary of the first Service and the ninetieth anniversary of the first broadcast, making it (since 1931) probably one of the oldest continuous programme traditions in all of radio.

Nearly a century ago and in the midst of war, Eric Milner-White outlined his vision for his College's Chapel: 'we should be doing a great work, not only for the college and university, but also for the Church and the Empire'.[98] And now, for the world. Sir Neville Marriner, whose son Andrew sang in the Choir under Sir David Willcocks, presented the live broadcast in the USA in the early 1980s. He was asked what it was about *Nine Lessons and Carols* that had made it such a tradition:

> Somehow from the moment the first boy starts to sing, there's a shiver that runs down your back. From that moment until the end of the Service and lingering long afterward, you have this extraordinary emotional upheaval which has the habit of recurring. You always think, 'this could never happen to me again.' And when you hear it again, exactly the same thing happens.[99]

The Chapel in postcards

A substantial collection of postcards of King's College today in the College Archive illustrates the many well-known views of the Chapel that have defined its image, such as the elevation from the south, or the front view of the College, whether seen from the north or the south ends of King's Parade. The postcards also reveal the subtle changes made both inside and outside the building over the last one hundred and fifty years; the arrangements at front of the College, for example, have been changed numerous times over this period, while the passageway around the front court was paved only in 1963, an improvement paid for by George ('Dadie') Rylands.

Ills. 231–235. The Chapel as shown over time in postcards.
From the Collection in Cambridge, King's College, CMR/241.

Ill. 236. The Chapel and Screen, *c.*1937–62, glass lantern slide, 8.2 x 8.2 cm. Cambridge, King's College, JS/4/10/9.

XVI

'The most famous choir in the world'? The Choir since 1929[1]

TIMOTHY DAY

In the 1960s the Choir of King's College, Cambridge under Sir David Willcocks' direction was the best-known of all the English choral foundations, its singing instantly recognised by music-lovers all over the world. Even in the early 1920s, however, when the Choir was certainly famous all over England, you could still make out many empty seats in the candle-lit Chapel on Christmas Eve.[2] It was technology that was to change all that.

It was pressure for places on Christmas Eve in the early 1930s, as well as the call by members of the University for their own carol service during term-time, that led to the creation of the Advent Carol Service in 1934.[3] And interest in the singing had been stimulated above all by the broadcasting of the Christmas Eve *Festival of Nine Lessons and Carols*, transmitted in 1928 for the first time, and, except for 1930, broadcast on the radio ever since. As early as 1932 the *Festival* could be described in the *Manchester Guardian* as 'a tradition now on the wireless'.[4] By 1938 the same newspaper's critic considered the broadcast, as he imagined many listeners did, the one programme not to be missed that day.[5] That year the College could report that its carol service was heard throughout the Empire and the United States of America.[6] During the war news reached Cambridge of secret listeners to the Christmas Eve service in Belgium, Holland, Czechoslovakia, and of services of lessons and carols arranged in German and Japanese prisoner-of-war camps.[7] In a ten-minute film about the Blitz made by the Ministry of Information in London for American audiences – 'today England stands unbeaten, unconquered, unafraid' – the commentator explains that on Christmas Eve 'England does what England has done for a thousand years, she worships the Prince of Peace' and the film cuts to a King's treble singing 'Come and behold him, born the King of Angels'.[8] The singing at King's had entered the consciousness of the English as no other choir had ever done. For long periods during the war weekly Evensong was broadcast either from New College, Oxford or from King's – from 'a College Chapel' to prevent identification. But even with wartime wireless reception, the natives at least could be pretty sure about that astonishing acoustic. Organ recitals too began to be broadcast from King's more frequently.

And then after the war for weeks on end weekly Evensong continued to be broadcast from King's. A series of motets was recorded in 1946 to be used by the BBC to fill in spaces regularly on its new Third Programme.[9] In the 1950s several performances of Schütz's *Christmas Story* were relayed by the BBC. Now, with the long-playing disc – the first by King's was issued in 1954 – and the steady stream of discs that appeared in the 1960s (far more than from any other cathedral or College Choir) the style of singing would come under even greater scrutiny and make even greater impact. It was often taken to exemplify the quintessential style of the English cathedral tradition, and that 1960s style has remained a kind of touchstone ever since. When the organist at New College, Oxford said in

2006 that over the past thirty years he had 'moved away from the traditional English sound' he was thinking, if only unconsciously perhaps, of the sound of King's in the 1960s under Sir David Willcocks.[10] Mid-century technology created new audiences for early music and allowed the formation of specialist professional concert-giving groups, choirs like The Sixteen and The Tallis Scholars and the Cambridge Singers, singing English sacred polyphony with women and not boys. A model or prototype of these was the amateur Clerkes of Oxenford who were founded in the 1960s to sing pre-Reformation English music. Encouraged to sing 'like sixteenth-century boys', the high sopranos of the Clerkes had in their minds' ears the live performances of the Choir at Magdalen College, Oxford but also the recordings of King's they knew equally well.[11] The sense of the rightness of *non vibrato* as applied to Baroque music and much earlier repertories too – and not only to vocal works – derived from readings of various historical sources, but the authority of straight-toned performances by King's undoubtedly gave confidence to other musicians. King's at this time also made it impossible, it was said, for Choirs now to sing out of tune.[12] So this singing style of the 1960s had an enormous impact. It has continued to inform singing styles ever since.

How can the style be characterised? The voices blend seamlessly. The ensemble is perfectly disciplined: 't's and 'd's are synchronised with unerring precision. The timbre is unforced; even in *forte* there is no sense of strain, or indeed of drama, or at least not of any emotional outpouring. The tuning is immaculate. The sounds shine with an unearthly silvery glitter. Why did they sing like that?

It had clearly been considered a very good College Choir in 1929. But it was also regarded at that time by many as rather old-fashioned. It had been directed since 1876 by A. H. Mann (1850-1929) – 'Daddy' Mann – who was succeeded on his death by Boris Ord (1897–1961).[13] To some it had seemed old-fashioned three decades earlier. In the 1890s a musical undergraduate at King's called Edward Dent had listened to the Choir singing Mendelssohn's 'Hear my prayer'. The solo treble, in Dent's opinion, 'carried out Mann's hysterical & operatic interpretations with a marvellous fidelity ... everyone thought it extraordinarily beautiful, which it would have been if it had not been so studiedly theatrical'.[14] It was the same with Mann's organ-playing. Dent thought it an advantage – it was much more dignified – when Mann played Bach and had no-one with him in the organ loft to manipulate the stops constantly for unidiomatic 'expressive' effects.[15]

In the 1930s Edward Dent was now Professor of Music at Cambridge and a Fellow of King's. He very rarely went to Evensong. He had avoided Chapel for many years. In his early manhood he had become an unbeliever and ferociously anti-clerical. But then in 1933 he heard the King's Choir sing several times at a conference of the International Musicological Society of which he was now President. He was taken aback. The singing during this 1933 festival was a revelation and would have enormous repercussions all over the world, Dent thought. He had never heard such excellence in music-making in Cambridge before.[16] And it was true that foreign delegates were indeed hugely admiring of the Choir, of the purity of the boys' voices, the perfection of the intonation, the discipline of the ensemble. A French scholar had to remind his readers that, though the Director of this Choir at King's was a consummate professional, the singers were students, amateurs. It was a clear demonstration of the expertise and intensity of musical activity in England 'in the universities and among the cultivated classes'.[17] And the first tour abroad, in 1936 to Scandinavia, was another demonstration of the accuracy of the singing, the assurance of the tuning, the clarity and polish of the tone quality. The discipline was marvelled at, the way that this was maintained with such small physical movements from the Director – and with just one hand, the other holding the music – and the way the Choir maintained discipline even when the Director moved away before the end of a piece to play an organ solo.[18]

Ill. 237. Hugh Bus, *Boris Ord*, 1926, oil on canvas, 68.6 x 52.1 cm. Cambridge, King's College.

The appointment in 1929 of Boris Ord as Director of music – he was to remain in charge until the end of 1957 – was itself evidence of a crucial shift in English attitudes towards music and musicians. Mann was a journeyman musician from a humble background, as were all cathedral musicians in the 1850s, educated as a chorister at Norwich Cathedral. Ord was the son of a Kingsman, educated at Clifton College, an undergraduate at Cambridge himself, an organ scholar at Corpus Christi College. Ord was already a Fellow of King's when he was appointed; Mann was given a Fellowship only when he had been organist for forty-five years. When Mann was appointed he had neither dining rights nor was he allowed to walk in the Fellows' Garden. And Ord was directing not professional lay clerks aged between, say, 25 and 75, as in cathedral Choirs of the time, but undergraduates aged between 18 and 22. The first choral scholar, an undergraduate reading for a degree while singing in the Choir, had been appointed in 1881. One or two of the lay clerks at King's at that time worked for the College in other capacities, as an assistant in the Library, for example. Mostly, though, the nineteenth-century lay clerks had had other kinds of work: they supplemented their incomes from singing in the Choir by working as a weaver, a piano-tuner, a shoemaker, a tailor, the cook of Pembroke College, a music engraver. Only gradually did the choral scholars displace the lay clerks. By the end of the century there were regularly three choral scholars in the Choir at King's. From 1906 until the First World War there were four. In the 1920s – after war-time reductions – the number crept up, four again in 1921, five in 1923, seven in 1924, eight in 1925, ten in 1927, eleven in 1929 and finally twelve in 1930. And, except during the Second World War, twelve more or less it has remained ever since, supplemented with a few, normally two, volunteers. The choral scholars of the 1930s were being directed now by a man sharing their social background, with the same cast of mind, moulded by the same social and cultural forces, a figure to whom they were bound to behave with a certain respect and deference. The choirmaster was a senior member of the university; the singers were all *in statu pupillari*. Rehearsals under Daddy Mann could be terrifying. Rehearsals with Boris Ord were often even more terrifying.[19]

Daddy Mann's attitudes and his gestures in rehearsal were Dickensian in extravagance and vehemence. In rehearsal in the Chapel at King's, a choral scholar reported – as a private Chapel it could be closed during practices – Mann's 'gesticulations and looks of unspeakable anguish' warned the Choir to sing yet softer. He would utter loud cries, and, in moments of 'extreme provocation', bang on the desk as he urged the singers on to 'rare peaks of fortissimo'.[20] Even in rehearsal Boris Ord was never histrionic; in services he would beat with one hand, often with just an index finger.[21] How can we account for this shift in emphasis, this restraining of gestures both physical and vocal? Ord was a man of the deflationary, anti-rhetorical 1920s with anti-Romantic aesthetic ideals and aspirations. He conducted Stravinsky's *The Soldier's Tale* as a young man. And before he went up to Cambridge Ord had studied at the Royal College of Music under Sir Walter Parratt, the organist of St George's Chapel, Windsor. Although Parratt, like Mann, was a journeyman organist, he seems to have assimilated something of the manners and habits and style of the Worcestershire gentlemen at Witley Court in Worcestershire, where he was private organist to the Earl of Dudley when he was in his twenties. He was certainly influenced by the intensity and restraint of the devout Tractarians at Magdalen College, Oxford where he was organist before he went to Windsor. One of the Oxford Movement's 'Tracts for the Times' – it was published in 1838 – was entitled *On reserve in communicating religious knowledge*. Even when a man's heart overflows with strong and deep feeling, with the purest milk of human kindness and Christian charity, yet this sacred reserve, this 'retiring delicacy which exists naturally in a good man', must not be violated by enthusiasm.[22] When in 1882 Parratt was appointed organist of St George's Chapel, Windsor, he told his wife that it would be his

life's work 'to refine' the singing of the Choir.[23] His critics, who included some of the lay clerks at Windsor, found his music-making cold sometimes, devoid of expressiveness. Under much protest he would have a simple little anthem like Richard Farrant's *Lord, for thy tender mercies' sake*, sung 'without any nuance or variation of tone colour whatever in a perfectly level impersonal style'.[24]

It was Parratt too who had moulded not only the attitudes and tastes of Boris Ord, whom he taught at the Royal College of Music, but also of Edward Dent who had listened to the Choir at St George's Chapel, Windsor as a schoolboy at Eton. Here, now, in King's Chapel, listening not to refractory lay clerks but to compliant choral scholars, some of them destined for ordination, Dent recognised something new and authentic.

Before the creation of a Choir school in 1878 the choristers at King's had been local boys, their fathers in the earlier 1870s working as domestic servants, a coal merchant's clerk, a watch-maker, a tailor, a coach painter, the College Chapel Clerk and the College shoe-black, a butcher, a general labourer, a domestic servant, a millwright, a tailor. With the foundation of the boarding-school the boys came from all over England, the earliest boarders being the sons of clergymen in Norwich and Manchester, a surgeon of Piccadilly in London and another one in Newport in Essex, a GP, an inspector of schools.[25]

Where did the choral scholars of the 1930s come from? Most of them came from public schools. Indeed three-quarters of the admissions to King's at this time were from public schools.[26] Hardly any of the choral scholars, though, ever came from the best-known. In the 1890s an officer of the Cambridge University Musical Society who was responsible for testing the qualifications of candidates for admission to its chorus could testify that very few boys from major public schools ever applied and of those who did many could not even read music. If they had sung in their Chapel Choirs they had had the music drummed into them by ear. In most English schools, he thought, music was still rather despised.[27]

There were a considerable number of schools supplying an occasional choral scholar in the 1930s: St Peter's, York; Sir Roger Manwood's School, Sandwich; Aldenham School; St Edmunds, Canterbury; City of London School; King's School, Bruton; Haileybury. One of the four scholars who came up in the Michaelmas term of 1929 had been a chorister at St Michael's College, Tenbury, another at York Minster. There was no forcing ground for choral scholars, no particular schools who specialised in producing them. It was much more individual talent and sometimes, no doubt, a particular teacher, or a clergyman father, or the experience of singing in a cathedral Choir, or – with two or three boys in this first decade of Ord's Directorship – of having sung at King's as a chorister.[28] Of those four scholars who came up in 1929, three became clergymen who were also schoolmasters, the fourth – the son of a clergyman – was a schoolmaster for many years at King's School, Ely. Or the choral scholars of this period might become architects, or diplomats, or lawyers, or chairmen of family firms.

There were, after all, a very small number of choral scholarships offered in total. In 1929 King's was the only university College Choir which contained choral scholars without any lay clerks. There were a few choral scholars in St John's College, Cambridge, and at New College and at Magdalen College, Oxford in the 1930s. It was only from 1949 that St John's and only from 1960 that Magdalen had choral scholars alone. So it was unrealistic to imagine that schools were likely to give much special training to boys who fostered the rather idiosyncratic, not to say eccentric, ambition to sing while they did a university degree.

The singing of the Choir certainly did astonish the listeners at that conference in 1933. All except one. This was the music critic of the *Observer*. The singing? Just the King's College Choir 'as it happens to stand at the moment, with no great voices, and deficient in bass, but a delicate, responsive

instrument admittedly, judging strength without forcing tone, using the resonance of the building without abusing it'.[29] Who was this critic so determined not to be impressed? His name was A. H. Fox Strangways, then in his mid-70s. He was the son of an army officer, educated at Wellington, Oxford, and then Berlin, where he spent two years studying music at the *Hochschule*. Until he was fifty he taught music and German at the school where he had been a pupil. He then retired from schoolmastering and wrote about music. He founded the scholarly journal *Music & Letters*. He was gruff, masculine, learned, open-minded. He was very English: he was not in the habit of bestowing praise unnecessarily.[30] Besides, he knew this setting; he knew these young men. He had taught men like these for decades. And his estimate was in one sense just: these choral scholars did not individually possess voices of astonishing quality. A man like Fox Strangways was comparing these new choral scholars, whose characters and personalities and vocal capabilities he thought he knew so well, with what he conceived of as 'professional singers'. It was perhaps not to be expected that he would see clearly the phenomenon occurring before his very ears on this familiar territory. The point was that the sum of the Choir at King's was more startling and beautiful than its parts.

No doubt the choral scholars themselves would have been self-deprecating and modest about their musical and vocal gifts. They were not attempting to be Wagnerian *Heldentenors* or Russian basses. They were not concerned with vocal prowess at all particularly. A 'reverent, intense, subdued expression is perhaps the final goal of our work...Cumulative expression...must never develop into a showy extravaganza', one famous choirmaster explained.[31] In the rather austere education that the choral scholars had received at their schools there would certainly have been an emphasis on both the moral and physical importance of athleticism. And though not all the choral scholars were outstanding athletes, they all valued the conformity, precision and teamwork that were encouraged and fostered in this society. A famous Cambridge theologian of the second half of the century had been an outstanding rugby player as a Cambridge undergraduate in the 1930s. Why was his favoured position hooker? He liked it in the scrum, he said, because there you could 'do good anonymously ... with no sense of display on the field where people could watch you doing noble things and all that'.[32] At a choral scholarship voice trial Boris Ord was pleased when a candidate confessed that he had not had singing lessons: 'Good. You won't ruin my Choir'.[33] Sir David Willcocks, who was in charge of the Choir from January 1958 until December 1973, once explained that, among his choristers, he 'never had any good singers'.[34]

Willcocks has said that he owed everything to his predecessor. In an obvious sense he did owe a great deal: he was the third holder of the Mann Organ Studentship, established in 1931 (and another indication of the shifting of attitudes towards music and musicians). So Willcocks served an apprenticeship in the Chapel itself. Similarities between the performances of the two Directors are clearly evident. Just as striking are the differences. What changes could be perceived when Ord was succeeded by David Willcocks? Boris Ord was insistent about accurate tuning and meticulous about details in the score and about ensemble. He wished nonetheless to give any performance sweep and intensity; he valued above all spontaneity and the illusion of improvisation. He knew the ferocious energy and ambition and discipline and high standards of a professional opera house; he had worked for several months in his twenties at the Cologne Opera. (He took the name Boris because he was passionate about Mussorgsky's opera *Boris Godunov*.) Boris Ord was not averse to giving the lay clerks free rein on occasion.

Willcocks was much more tightly controlled. Boris Ord was not a chorister, though he and David Willcocks were both educated at the same senior school, Clifton in Bristol. David Willcocks was put on a train when he was nine and sent from Cornwall to be a chorister at Westminster Abbey, under

XVI · 'THE MOST FAMOUS CHOIR IN THE WORLD'? THE CHOIR SINCE 1929

Ill. 238. Antony Barrington Brown, *Boris Ord with a Toy Used to Divert Candidates at Chorister Trials*, 1953–58, photograph, 21.3 x 16.7 cm. Cambridge, King's College, KCAC/1/2/6/10/35/Ord.

Ill. 239. Antony Barrington Brown, *David Willcocks in the Organ Loft*, 1958, photograph, 21.7 x 16.6 cm. Cambridge, King's College, KCAC/1/2/6/10/47/WILLCOCKSD.

the rather severe and distant, reticent and reserved Sir Ernest Bullock. 'He wasn't an emotional man', was the way Sir David put it.[35] He himself had startling musical gifts. When at the examination for his organ scholarship at King's Willcocks was asked to play his Bach piece, he gave the names of a number of large-scale preludes and fugues and, the examiners having chosen, he played the piece from memory.[36] When still a student he conducted the Cambridge Philharmonic Society, the town chorus and orchestra, in the St Matthew Passion, and he did that too from memory.[37] He was a supremely competent organ scholar; he took the three-year course for the B.Mus. in one year and got Firsts in the two sets of exams.[38] He was then called up and became an excellent soldier during the war who was awarded the Military Cross for bravery.[39] He returned to fulfil resident requirements after the war, taking a joint history and economics degree, in which he also got a First.[40]

Willcocks ran his Choirs like an army unit and his orders were obeyed without question, as he expected them to be. Boris Ord once said that even very good musicians have a tendency to hurry just a little when things get very difficult, when the page gets very black. 'But listen to David play.' When all gets really horribly tricky, 'he just slightly steadies himself'.[41] He was meticulous about tuning, obsessive some thought. He would stop and say: 'that note isn't flat but it might be flat'.[42] One choral scholar said that it felt as though you ceased to be an individual person, a personality in your own right. You were a cog in a wheel. It suited anyone in the 1960s coming from a boys' independent school, he said. You never had any doubt as to what you had to do. Willcocks was always very clear and explicit. And you didn't forget it if you failed to meet his demands.[43] His performances were part of a King's tradition; they were clearly idiosyncratic and reflected a highly individual personality and temperament; they were certainly of a piece with mid-twentieth-century prevailing aesthetic norms in musical performance, with very steady tempi and very close adherence to the text. They were moulded in part too by the concern with detail that recording fostered. As early as 1949 a choral scholar wrote to the BBC after listening to a tape of the Christmas Eve transmission with comments on microphone placing and other matters.[44]

The principal duties of the Choir in the 1930s – essentially its only duties – remained the singing of the daily services in the Chapel during the full university terms, continuing after the end of the Michaelmas term until Christmas. A fortnight or so after the ending of the Easter term in June, choral services resumed for about a month, lasting through most of the Long Vacation Term.[45]

The Choir might give occasional concerts in the Chapel, of Tudor or Restoration church music, say, some of them with the Chapel Choirs of St John's and Trinity Colleges. And occasionally there were concerts of choral and organ music, or – while the organ was being rebuilt in 1932 – with choral pieces interspersed with piano solos: Bach, Beethoven and Debussy played by Boris Ord, while the Choir sang Wilbye, Palestrina, Kalinnikoff, Charles Wood, Stanford and Haydn. Occasionally the Choir would visit Eton College and give concerts in the Chapel there, singing both by themselves and with the Eton Choir. There would be occasional extra-liturgical performances of, for example, Charles Wood's *Passion according to St Mark*. There were the carol services. In December 1935 Eric Milner-White sought the boys' parents' permission to take them for 'a holiday with a little singing'[46] and between 19 March and 1 April 1936 the Choir made its first tour abroad, to Sweden, Denmark, Holland and Germany, prefacing the concert they gave in each city with Evensong. This had been instigated by the British Council. But that was the only tour of that decade. There were no commercial recordings made at all in the 1930s though a record of two Bach chorales from Schemelli's *Gesangbuch* made in July 1929 was released in 1931.[47] No other recordings followed until 1950.

Half a century later the Chapel services still remained 'at the centre of the Choir's work', according to the Director.[48] The extra-liturgical activities now were not negligible however. During the academic year 2006–07, for example – which is not at all untypical – the Choir gave concerts at the Abbaye Notre-Dame d'Ambronay in the Rhône-Alpes region of eastern France, at the St Remigiuskirche in Bonn and in Riga Cathedral. They sang music from the fifteenth-century Eton Choirbook in York Minster, Brahms' *German Requiem* in Istanbul, a setting of the Beatitudes by the Estonian composer Arvo Pärt in Tallinn. The years 2006 and 2007 saw the CD release or recording of music by Henry Purcell and the sixteenth-century Franco-Flemish composer Orlande de Lassus, of Brahms' Requiem using the composer's own version of the accompaniment for piano (four hands), and of music by Gibbons, Tomkins and Weelkes, with the Choir accompanied by a viol consort. The choral scholars recorded a disc of motets by Giaches de Wert in an edition specially prepared by one

of them and they sang in Peterborough and Ripon Cathedrals, at the Church of St Mary and All Saints, Fotheringhay in Northamptonshire and at Brocket Hall in Hertfordshire. And then there was Christmas. There was a concert of Christmas music that the Choir gave with the Philharmonia Orchestra in the Royal Albert Hall. The *Festival of Nine Lessons and Carols* was broadcast live from the Chapel as usual. There was the recorded television programme of carols that was transmitted on Christmas Eve.[49]

One important shift in the repertory has been brought about by the introduction of many more celebrations of Sung Eucharist. Up till the 1980s the regular Sunday services had been Matins and Evensong, with Sung Eucharist replacing Matins twice a term. From the mid-1980s there was a Sung Eucharist every Sunday, except for two Sundays a term when Matins would be the morning service. From the Lent term of 1992 there would additionally be a Sung Eucharist on Thursday evenings in place of Evensong. Which meant that a great number of communion services and also of Latin masses were added to the repertory. Now were sung not just the three Byrd masses and Palestrina's Missa 'Aeterna Christi munera' and Vaughan Williams' Mass in G Minor, which had figured in Boris Ord's lists, but Palestrina's Missa Brevis and his Missa 'Dum complerentur', masses by Tye and Josquin and Victoria and Lassus, masses by Mozart and Schubert, Fauré's Messe basse, the Missae Breves of Kodály and Berkeley and Walton, Stavinsky's Mass with double wind quintet, Robin Holloway's *Missa Caiensis* and many others.

Numerous Georgian and Victorian composers quickly disappeared from the lists when Ord took over, the services of men like Clarke-Whitfield and Langdon Colborne and Turle and Smart. New works by Vaughan Williams were swiftly introduced and a setting was made of the Prayer of King Henry VI by Henry Ley, the precentor at Eton. There were works by the Russian composers Rachmaninov and Kalinnikov. There was seventeenth-century music like Purcell's *Jehova, quam multi sunt hostes*, and in 1930 Heinrich Schütz's *Seven Words from the Cross* (1645) was sung, it was thought, for the first time in England.[50] Most noteworthy of all was the sixteenth-century polyphony that entered the repertory, music by Palestrina, Victoria, Byrd, Peter Philips, Batten, Robert Johnson and Thomas Tallis.[51] As a place of learning King's was able to include Latin texts and as a private Chapel able to indulge in liturgical experiment. Ord and Willcocks introduced a small number of new compositions, notably new canticle settings by Howells and Watson and Sumsion and anthems by Hadley and Howells. Philip Ledger, who directed the Choir between 1974 and 1982, brought in compositions by a few living English composers like John McCabe, Graham Whettam and Gordon Crosse. The liturgical repertory remained wide and representative of all periods of Anglican music and the Choir certainly sang most of the best and most famous works in the English cathedral repertory. Much more new music has entered the Chapel service lists in the past thirty years. The most startling development of all has been the commissioning each year of a new carol for the service on Christmas Eve, and mostly not from composers known principally for their church music but from composers familiar in the concert hall and the opera house like Judith Weir, Harrison Birtwistle, Brett Dean, Alexander Goehr, Einojuhani Rautavaara and Dominic Muldowney.[52]

The most significant differences between the Choir of the 1930s and the Choir of recent decades – what it sings and how and where it is listened to – arise from the singers' extra-liturgical activities. How have these additional duties been fitted in? Since the early 1970s most of the services in Advent were usually cut out completely; choral services in the Easter Term were reduced by about a week to eight weeks or just under, and services during the Long Vacation were cut from a month to about three weeks. It was these weeks that could be filled with recording sessions and tours, and days in September too could also be used when the school term had resumed but before the university term

had begun. That first long-playing disc in 1954 was, unsurprisingly, of the Christmas *Festival of Nine Lessons and Carols*, though, even with the new technology, in an abbreviated form. Soon, however, besides one disc of Evensong and another of 'An Easter Matins' – this last with the famous morning canticles written a decade earlier for King's by Herbert Howells – there came two discs of the music of Orlando Gibbons, and one disc of Byrd's five-part Mass and the evening canticles from the Great Service, music which King's had very much made its own in Boris Ord's time. Issued in 1960 was a disc of Bach, not only sacred songs from G. C. Schemelli's *Musikalisches Gesangbuch*, which had been regularly sung since Mann's day, but also the motet *Jesu, meine Freude* BWV 227 (sung in English as 'Jesu, priceless treasure'), not hitherto the staple fare of cathedral and College Choirs. From 1960 there would be regular recording sessions with an orchestra: Bach's St John Passion was released in 1960, Haydn's Nelson mass in 1962, his Missa 'in tempore belli' in 1967 and Handel's Chandos anthems in the later 1960s. Later on, Latin masses being increasingly used liturgically, these too began to appear on disc. All this music had not previously been in the repertory of College or cathedral Choirs.

It may be that certain works did take their place in the Choir's repertory originally because of recording projects; Britten's *Hymn to St Cecilia* and *Rejoice in the Lamb* may be examples of this. Certainly these two works would have been surprising choices for anthems in the Chapel when they were first published, in the 1940s, before the introduction of the long-playing disc. Liturgical duties now had to be intricately woven into the recording and concert engagements for each to be carried out to the very high standards expected by the College and by audiences in the concert hall. And so, for example, in recent times, with heavy recording and touring schedules, an anthem by Purcell might be sung in the course of a broadcast of Choral Evensong during the Easter Term, and, with the idiom in the blood stream, an ode by Purcell could more easily be programmed into a May Week concert in Cambridge, which ode could then be programmed into concerts in June in Cologne and Paris. This might also help the choristers singing Purcell in a concert in the Royal Festival Hall in the November following, though the lower voices perhaps not so much: there might be nine new choral scholars in any particular Michaelmas Term. The inclusion of the Sanctus, Benedictus and Agnus Dei of Bach's B minor Mass in a Founder's Day concert in December would assist the preparation of a performance of the entire work in St John's, Smith Square in March. In between, though, in addition to services – which included the *Festival of Nine Lessons and Carols* – there would be in December the television recording of carols, an appearance at the Royal College of Music, a Christmas programme in the Royal Albert Hall with the Philharmonia orchestra and chorus and, in a live relay from the Chapel, the choristers singing Britten's *A Ceremony of Carols* and joining the BBC Singers in *A Boy was Born*. In January there would be recording sessions for music by Rachmaninov, Penderecki, Stravinsky and Panufnik interspersed with plainsong.[53] The particular kind of alertness and concentration required in the recording studio, the confidence built up through live concert performances and the camaraderie engendered through touring, all no doubt helped raise expectations and develop musical expertise and performing sang-froid.

In 2009 EMI issued a two-CD album entitled *England, my England* containing new recordings as well as re-issues of recordings directed by Stephen Cleobury, who has been Director since 1982, alongside much older ones directed by Philip Ledger and Sir David Willcocks.[54] There was not felt to be any incongruity in this; all the recordings were recognisably of the same Choir. In some ways the tracks that stand out from the rest are the three psalms recorded in Trinity College where the more intimate acoustic imparts a different character to the verbal stresses. The effect is more personal and less majestic in the more restrained acoustic.

Ill. 240. Edward Leigh, *Philip Ledger and the Choristers*, 1978, photograph, 12.7 x 17.2 cm. Cambridge, King's College, KCAC/KCPH/2/23/16.

XVI · 'THE MOST FAMOUS CHOIR IN THE WORLD'? THE CHOIR SINCE 1929

Ill. 241. Stephen Cleobury. Simon Tottman, digital photograph, 2005.

But performing styles never remain static. This is a Choir too whose personnel changes with bewildering rapidity. The wonder may be that its hallmarks qualities do seem strikingly preserved over decades. But there are – must be – continual changes in the sound and the style. When Willcocks had been in charge of the Choir for five years one commentator had the impression that 'those silky voiced and virtuosic choristers and choral scholars are encouraged to sing out more than they previously did. No less beautiful than before, the tone has more body in it'.[55] The recorded performances and personal anecdotes too suggest that in his first years as Director David Willcocks strove to ensure that every tiny nuance accorded with his precise intentions. In time he seemed to be able to rely a little more on his singers assimilating stylistic features for themselves and he allowed them a little more flexibility. From 1960 there were regular recording sessions with orchestra. In order to tell more effectively against incisive strings or powerful brass both boys and men seem to have adopted instinctively a more incisive and energetic manner which they proceeded to cultivate whether actually singing with an orchestra or performing the daily liturgy in Chapel.

The distinctive style of King's in the 1960s was widely imitated and provoked strong reactions too. The Choir of St John's College, Cambridge, not five minutes down the road, cultivated what

quickly became characterised as a 'continental sound', with a timbre considered lively, passionate, vibrant – against the cool sound of King's. The sound of St John's was undeniably akin to the sound and style of the Choir of Westminster Cathedral in the 1950s, whose choirmaster certainly wanted power and resonance from his boys and not the 'emasculated [sound] quality of an angel on a Christmas card' that he considered so many English choristers produced.[56] Leaving aside the reasons for this phenomenon – historical, cultural, social, psychological – the two styles, an 'English' style and a 'continental' style, were readily identified in the 1960s. Stephen Cleobury had been a chorister at Worcester Cathedral from the age of nine (where he was taught by the second organ scholar at King's, Douglas Guest)[57] and an organ scholar at St John's and organist at Westminster Cathedral. So he came to King's in 1982 intimately acquainted with these tonal differences and with insights into the cultivation of different timbres. In 1992 he knew that he had not deliberately set out to change the sound of the Choir, while he was sure that it had changed. He had encouraged the singers to use 'bright forward tone' and Italianate vowel sounds. He thought then that the distinctions and differences between the sounds of the 1960s were disappearing and that choirmasters were attempting to cultivate the best of both worlds, the colour and vibrancy of the so-called continental style and the blend and unanimity of the English.[58]

A choral scholar in the early 1990s considered the tone being encouraged was more 'robust' than before,[59] and one who had been a treble in the Choir considered that at that time the boys 'floated' the sound less and 'projected' more, that they had become louder, that Philip Ledger had encouraged the articulation of incisive consonants and that now there was greater emphasis on open vowels.[60] In the 1960s the Choir sounded like 'disembodied angels'; fifty years later it sounded more like a group of 'earthlings'.[61] That's how one expert choral conductor has characterised it. Blend was no longer quite such a fundamental concern; the timbre and character of individual voices could be allowed to tell in the choral sound. It may be that this shift is a general feature of English Choirs. But then no other Choir quite matched the blended perfection of King's in the 1960s. Maybe the world that had moulded its most characteristic features had already vanished by that decade.

The tone quality and particular techniques cultivated by choral scholars in the later decades of the twentieth century were particularly apt for many early music repertories, contemporary musicology decided. Post-graduate early music singing courses were established from the 1970s. It became possible for a choral scholar to go on and earn a livelihood as a soloist or as a solo singer who also appeared in the numerous expert Choirs which devoted special attention to early music repertoires. There had been occasional choral scholars in Mann's day who had had singing lessons – on them Dr Mann kept a very close eye indeed and if they attempted to throw their voices forward they were promptly checked.[62] In the 1950s there might be one or two at any time who were having lessons.[63] In the 1990s choral scholars were expected to be having vocal tuition, and not only their singing lessons but also their lessons in Alexander Technique were paid for as part of their scholarship. From the late 1980s even the boys had individual singing lessons.

The headmaster of the choristers' school said in 1992 that it was difficult to attract boys from 'the lower economic strata of society' and that the choristers were, by and large, from 'traditional' middle-class families.[64] Because parents wished to see more of their sons, and to visit them at weekends, there has been a tendency for more candidates to apply who live closer to Cambridge. The choral scholars mostly come from the same background. A considerable number of them will have sung as cathedral choristers. They will have received a much better musical education than the choral scholars of the 1930s; many now will have singing lessons as sixth-formers and attend advanced singing courses during vacations.

There is one very striking difference between the choral scholars of David Willcocks' years and those of Stephen Cleobury's: until quite recently it was rare indeed for a choral scholar to have been educated at a major public school. When Eton was appointing a new music master in 1955 the Provost had noted about the successful candidate, 'the great thing is he doesn't look like a musician'.[65] Music scholarships were established at Eton in 1968, long after many other schools, but when a new head of music arrived in 1971 and attempted to consult his colleagues about new arrangements for music lessons only two of the twenty-five housemasters responded to his discussion document.[66] It was only after 1973, the year that the first Oxbridge choral and organ scholarships were won by Etonians, that music could no longer be left out of account. In the past thirty years many more boys from Eton have been choral scholars at King's than from any other school of any kind. And while public schools have continued to fill nearly all the choral scholarships, in the College as a whole three-quarters of yearly admissions in the twenty-first century have been from the state sector.[67]

An undergraduate who came up to King's in 1923 objected to attending Chapel services because he thought that they were not services at all but really concerts.[68] The precise role of the Choir has been a never-ending source of difficulty and dispute, and of amusement and cynicism too. In 1967 members of the College Council, led by Provost Edmund Leach, could not accept that the service televised at Christmas 'had any religious significance whatsoever', either to those in the Chapel or to those watching it in their homes. They were of the opinion that 'the Chapel and the King's Choir warbling away is an image which needs reshaping'. And the Fellow in music at that time thought that, musically, the services at King's belonged to 'the fruity old Victorian tradition', the carol service particularly. The robust secular flavour of traditional carols should be re-captured in performance, he thought, the old medieval repertory explored, elaborate anachronistic arrangements jettisoned and, if the work of contemporary composers was to be used, let them be young modern composers, not old-fashioned fuddy-duddies.[69]

'Our culture is fragmented and secular', an Archbishops' Report on Church Music concluded in 1992, 'and for most people Choral Evensong, for example, has little to offer except beautiful music'.[70]

Which rather begs the question, 'What is *beautiful music?*'

What are these men and women of different faiths and of none who love these sounds using them for? In 1903 and 1904 a Fellow of the College gave a series of lectures entitled *Religion, a Criticism and a Forecast*. He wanted to distinguish between scientific knowledge which he wished to be called truth and a kind of faith which owed nothing to belief in God or to religious doctrine. This kind of faith, he explained, was nearer to music or poetry than to science. It was an attitude marked by adventurousness and expectancy and optimism. It was the attitude of an explorer like Christopher Columbus, setting out with some ideas but with no certainties.[71] One contemporary Cambridge thinker wishes the Church to cultivate a contemplative wisdom, a state of mind or a condition of existing which is common to all kinds of artists and found in every mystical tradition. He sees many people in Christian cultures 'visiting their own churches and monasteries in a Hindu rather than an ecclesiastical spirit'. He does not wish at all to sneer at the 'freelance pilgrim and holy tourist', who may well be a person 'who loves Christian culture and is appropriating something of it in her own way, in order to build it into the myth, the morality and the project of her own life'.[72] Is *this* what some at least of the men and women who love the sounds of the Choir are doing?

At any rate the world doesn't want the singing to stop.

Ill. 242. King's College Choir. Nick Rutter, digital photograph, November 2013.

Epilogue
The Sound of the Chapel

STEPHEN CLEOBURY AND NICOLETTE ZEEMAN

The Chapel's distinctive acoustic has been a recurring theme in many of the chapters of this volume. If the Chapel has the capacity to enhance sound in the most striking ways, it also poses a number of challenges for the speaker, singer and instrumental musician. In this concluding section of the book we asked a number of contemporary practitioners to reflect on their own experience of performing in and composing for the Chapel.[1]

The extraordinary resonance that enables the Chapel to enrich and magnify all sounds 'from the merest whisper to a symphonic roar'[2] is what makes it also notoriously unforgiving to performers. James Bowman observes that 'a solo singer has to keep within certain rules, namely accuracy of intonation and a well focused sound. Anything else will be cruelly thrown back at you'.[3] According to Gerald Finley, 'there is no room for singing below or, indeed, above the pitch, since the slightest smudge will then cover any decent sound that follows'. Solo performance is a real 'test of fortitude':

> for a soloist, the sound ventures away, carried into the grand chasm, and the performer really only hears the results after the whole phrase is over, a bit late to fix it if it's wrong. One bright choral scholar figured out that a single mistake lasting one second during the Christmas Eve broadcast listened to by 30 million people was, in 'listening hours', the equivalent of one person hearing that mistake for one solid year.[4]

It is also true that the Chapel does not in general always respond well to loud sounds – sometimes 'they just end up as a tangled muddle'.[5] Indeed, recalling the potentially 'boomy acoustic' of the antechapel, Judith Weir remembers notable 'examples of "aural porridge", such as a large-scale *Dream of Gerontius* with all the performers squashed under the west window'.[6]

One method of 'softening and polishing the composition of the musicall sounds that arrive at the sence all together' is that long ago proposed by the early eighteenth-century musical antiquarian Roger North:

> between the shell of the main arches and the timber covering, lay an ear to one of the holes thro which cords pass for carrying chaires when the inside of the roof is cleaned, and the organ with the quire sounding, such a delicious musick shall be heard, as I may call the quintessence of harmony, not otherwise to be described.[7]

But there are other methods of achieving musical clarity in the Chapel. A sequence of musical Directors at King's since the time of Boris Ord has insisted on a high degree of vocal precision and consonantal enunciation. The nature of the space demands extreme discipline in intonation, blend and ensemble; for the Choir, this is always a matter of focusing multiple voices on a single vowel or

musical sound in such a way that it will remain clear. Singing psalms provides 'an opportunity to sing long lines of text in almost speech rhythm, but the required togetherness demands the musical instincts of each choir member to come to the fore'; nevertheless, it is the projection of text that poses 'one of the greatest challenges in that magnificent expanse, since even beautiful sounds require differentiation, and the precise nature of consonants means that their delivery must be specially handled'.[8] This is a discipline that means that the singers of the Choir inevitably become highly sensitised to the Chapel acoustic. Nevertheless, as Richard Lloyd Morgan has said, if the Chapel makes you work for the best results, it repays clarity of word and music 'with an unparalleled range of colour, sound and resonance'.

The Chapel's acoustic also contributes to the very recognisable sound of its organ. John Butt has described the most distinctive features of this organ as its 'range of softer sounds, liquid flutes, vocal foundation stops, and some beautiful and (from the point of view of orchestral mimicry) highly realistic solo reeds'. But the organ is also capable of great fire and energy. In the right hands, and if you are listening in the right position, it has a grandeur that is matched by few others of its kind.[9] In fact, the delicacy of the organ as it appears to the eye, perched on top of the Henrician screen, is somewhat deceiving, due to the fact that a substantial number of its largest pipes are secreted within both the north and south sides of the screen; this effectively makes the screen itself into an organ case of much larger dimensions. It is precisely some of these larger pipes within the screen that are responsible for what John Drury has called the 'climactic thunder music' that would 'practically pin him to the floor', even on the occcasion of a modest Chapel procession. Perhaps, he suggests, it was King's Chapel (and not Trinity) to which Tennyson referred when he spoke of hearing

> ...once more in college fanes
> The storm their high-built organs make,
> And thunder music, rolling, shake
> The prophet blazon'd on the panes...[10]

Inevitably, this particular combination of organ and resonant acoustic means that for the organist there is always the risk of 'distortion, and the tunnelling of everything into an immovable mass of sound'.[11] But even this may have its uses: George Benjamin recalls how when providing music for a student performance of Eliot's *Murder in the Cathedral* he purposely used 'dense clusters at the bottom of the organ pedals' to create a 'menacing atmosphere', and as a result 'the whole bulding seemed to vibrate in sympathy with this ominous sound'.[12]

Some have thought that the sound that can be made in the Chapel is the result of its distinctively unadorned rectangularity. According to Thomas Adès, 'the generous acoustic, far from concealing and obscuring detail as some large spaces do, tends more to reveal and clarify it'; this may be, he adds, 'because there is one large, relatively narrow space, with no side chapels, aisles or transepts to confuse the aural image'. It is this feature of the Chapel that has guided Adès in composing for the building.[13] However, the possibility that the box-like quality of the Chapel contributes something to its very particular sound world can be illustrated from a rather different angle in an event witnessed by George Benjamin during a performance of Bach's *St Matthew Passion*:

> One of the most extraordinary moments in the work is the sombre Chorale which follows Jesus' death. This performance took place on a very stormy night, and as the sound of the choir and orchestra faded into silence (after the spine-chilling cadence which concludes the Chorale) a violent gust of wind seemed to strike the east window of the

> Chapel straight on. As I watched the performance from the organ loft, the shock-wave then travelled along the length of the building – so palpable that one could almost see it – to recede with a jolt through the West Window. All of this within a pause, held for dramatic effect, prior to the start of the ensuing recitative (which describes an earthquake). This was one of the most astonishing experiences I've ever had at a performance anywhere.

Judith Weir, in contrast, has stressed that music works in different ways in different parts of the Chapel. Comparing the unified sound of the Choir in broadcast performance with the experience of the Choir in the Chapel, she says: 'sitting listening in the Chapel, it's always the separation of two halves of the Choir that catches my interest, producing fascinating timbral contrasts and enhancing the elegant clarity of polyphonic singing'. Nicholas Marston wonders if 'experience of this phenomenon, whether or not as a chorister, might have influenced the brilliant eight-part writing in Orlando Gibbons' masterpiece "O clap your hands together, all ye people"'. He suggests that

> anyone who has sung that piece, whether in King's or elsewhere, knows how thrilling is the interplay between the two sides of the Choir; I think that only someone who knew what that kind of music feels like from 'inside' the performance could have conceived such writing.[14]

The variable dynamics of the Chapel's spaces have long been exploited in the liturgical processing of the Choir when it moves, singing, from the back of the Chapel through the screen and into the Choir, and then back again. The effect of that climactic moment in the Procession for Advent when the Choir divides into two parts, disappears into the two most easterly sidechapels and sings a Marian carol or motet from inside the chapels (sometimes singing in dialogue) derives partly from the quietness – and seeming distance – of the song, but also from the very particular sense of place produced by music issuing from two doorways. Perhaps Roger North had a point. The screen too brings its own distinctive acoustic, and it is probably no coincidence that the space west of the screen has long been the site of Chapel concerts and plays.

> One or two of the most lovely chamber performances I have heard have been given from the steps of the antechapel just west of the screen. Even a grand piano has sounded warmly clear in there – admirable in a building which predates the modern piano by about 350 years. My guess is that the hard wood of the screen reflects in a very good way.[15]

For Judith Weir, it is precisely the variety of the Chapel's spaces that shapes her thought when composing for the building:

> And so, now I think of the Chapel as having at least three widely different 'aural environments': my first question when composing something for the building is always, where are the singers/musicians/listeners going to be and which direction will they be facing?

Performing in and composing for the Chapel, then, is always partly a matter of allowing the substance of the building to do its own work. Many commentators have observed that the Chapel brings a special aura or 'bloom'[16] to slower and softer music.

> Its real quality is shown when one sings quietly. I remember recording that wonderful aria 'Vouchsafe O Lord' from Purcell's 'Te Deum' accompanied by just two violins and a chamber organ, and the true magic of the acoustic suddenly dawned on me.
> It's an experience I will never forget.[17]

Richard Causton also notes that the structure of the Chapel tends to favour slow movement in music, but shares with others the sense that 'this is more than a question of mere acoustics'.[18]

Catherine Bott suggests something of this when she describes the experience of singing in the Chapel as bringing a sense of 'being blessed by singing under that fan-vaulted roof, which somehow seems to draw every note upwards and outwards, so that one somehow knows that even a pianissimo will make itself heard'.[19] Michael Chance speaks of how the long history of liturgical practice in the Chapel is always present to a performer, but he also observes that the building 'teaches you to work with your performing space, never against it'. For him there is even something companionable about the nature of this collaboration between the Chapel and those who make music in it:

> The smell is the immediate sensation as one enters the Chapel, and then the enormity of the hushed ambience. The smell is both ancient and palpable: the smell of a working environment filled with activity and stillness. Perhaps even the faint tang of incense infuses the dust and the stones. But then the resonance of those stones takes over, a resonance you feel you can touch, which reaches everywhere, taking its time, unhurried and alive. And singing in this friendly glow demands that you listen, wait, never force, always in partnership with the stones. There is a moment when you offer the sound you are making to those stones, just before they take over, when you are both singing. And then you gently yield to them. The final 'n' of an Amen, or the voiced 'd' of Lord, or the sizz of Praise.[20]

For the composer too, the Chapel seems to demand no less than a felt relationship: working with 'a space with a certain kind of acoustic, but also one carrying a particular spiritual charge – sensitises one's relationship to it', Richard Causton says.

> Whereas one can tend to take venues for granted and even some ecclesiastical buildings exude a kind of neutrality, this is a space into which sound must be *offered* and into which it is *received*. This has to do with bearing witness: sounds remain suspended in the air as if frozen in time, and this physical and possibly numinous quality of the Chapel's resonance relates the musical moment to the slower rhythms of the building stretching over days, weeks and years.

Notes to the Essays

I

King's College Chapel: Aesthetic and Architectural Responses
Jeremy Musson

1. John Milner, 'Observations on The Means necessary for further illustrating ecclesiastical Architecture of the Middle Ages in a letter from the Rev. John Milner, M.A., F. S. A. to Mr Taylor, dated Winchester Feb 15, 1800', in T. Wharton and others, *Essays on Gothic Architecture* (London: J. Taylor, 1807), pp. xi–xiii (p. xvi). The author would especially like to thank Patricia McGuire and Peter Monteith of the King's College Archives (KCA) for their generous help and support, and Nicky Zeeman and Jean Michel Massing for their wise editing and guidance, and John Goodall, John Maddison, Olivia Horsfall-Turner and Roger Bowers for invaluable discussions.

2. Robert Willis and John Clark, *The Architectural History of the University of Cambridge*, 2 vols (Cambridge: University Press, 1886), vol. 1, pp. 476–484; John Saltmarsh, *King's College: A Short History* (Cambridge: Pevensey Press, 1958), pp. 35–40; Graham Chainey, 'King's College Chapel Delineated', *Proceedings of the Cambridge Antiquarian Society*, 80 (1991), 38–61; Tim Rawle, *Cambridge* (London: Andre Deutsch, 1993), pp. 116–23; John Goodall, 'A Sublime Botch', *Country Life*, December 17, 2008, 56–61.

3. Francis Woodman, *The Architectural History of King's College, Chapel* (London: Batsford, 1986), pp. 23–35, and Goodall, 'A Sublime Botch', pp. 58–59.

4. Goodall, 'A Sublime Botch', p. 59 and in discussions with the author.

5. *The Will of King Henry the Sixth*, ed. M. R. James and J. W. Clark ([Cambridge]: privately printed, 1896), p. 7.

6. Willis and Clark, *The Architectural History*, vol. 1, pp. 476–478.

7. John Nichols, *Progresses of Queen Elizabeth*, 3 vols (London: J. Nichols, 1823), vol. 1, p. 163; this and numerous additional quotations can also be found in Graham Chainey, *In Celebration of King's College Chapel* (Cambridge: Pevensey Press, 1987), of which only a few are cited as exemplary of changing and different views.

8. William Harrison, *Description of England*, published as part of Raphael Holinshed, *The Historie of England* (London: Abraham Fleming, 1557; repr. New York: Dover Publications, 1994), p. 69.

9. William Camden, *Camden's Britannia, Newly Translated into English*, ed. Edmund Gibson (London: A. Swalle, 1695), p. 403.

10. John Evelyn, *Memoirs illustrative of the Life of John Evelyn*, ed. William Bray (New York: G. P. Putnam, 1870), 31 August 1654 (p. 239); all the more interesting as Evelyn was a champion of the classical style.

11. Thomas Fuller, *History of the University of Cambridge from the Conquest to the Year 1634*, ed. John Nichols (London: Thomas Tegg, 1840), p. 110.

12. Richard Colebrande's Travel Diary, 1647, New Haven, Yale University, Beinecke Rare Books and Manuscripts Library, MS Osborn B 266, p. 104; thanks to Olivia Horsfall-Turner for drawing my attention to this and other valuable early references.

13. Roger North, *Further Writings of Roger North on Architectural Topics*, ed. Howard Colvin and John Newman (Oxford: Clarendon Press, 1981), pp. 108–112.

14. Celia Fiennes, *The Illustrated Journeys of Celia Fiennes, 1685–1712*, ed. Christopher Morris (London: Macdonald, 1988), pp. 79–80.

15. Rawle, *Cambridge*, p. 19.

16. William Stukeley, *Itineararum Curiosum* (London: for the author, 1724), p. 37; he also describes the roof of Hereford Cathedral by the same comparison (p. 67).

17. Terry Friedman, *James Gibbs* (New Haven and London: Yale University Press, 1984), p. 225; James Gibbs, *Book of Architecture* (London: for the author, 1728), p. ix.

18. Friedman, *Gibbs*, pp. 226–229.

19. James Bentham, *The History and Antiquities of the Cathedral and Conventual Church of Ely* (Cambridge: University Press, 1771), p. 41.

20. Anna Chalcraft and Judith Viscardi, *Strawberry Hill: Horace Walpole's Gothic Castle* (London: Frances Lincoln, 2007), pp. 80–85, show that Walpole cited Henry VII's chapel, Westminster, as the inspiration for the gothic gallery he created at his home; but there was probably also a nod to King's Chapel here.

21. Horace Walpole, *The Yale Edition of Horace Walpole's Correspondence*, 48 vols, ed. W. S. Lewis (New Haven and London: Yale University Press, 1937–1983), Walpole to William Cole, 22 May 1777 (vol. 1, pp. 45–46).

22. William Gilpin, *Observations on Several Parts of the Counties of Cambridge, Norfolk, Suffolk and Essex* (London: T. Cadell and W. Davies, 1809), p. 11.

23. Richard Payne-Knight, *An Analytical Enquiry into the Principles of Taste* (London: T. Payne, 1805), p. 164.

24. John Milner, 'Observations on The Means necessary', p. xvi.

25. Richard Dallaway, *Observations on English Architecture* (London: J. Taylor, 1806), pp. 173 and 176.

26. Thomas Rickman, *An Attempt to discriminate the Styles of English Architecture* (Liverpool: J. & J. Smith, 1817), p. 122.

27. John Soane, Royal Academy Lecture v, London: Soane Museum, Case 39, p. 16.

28. Royal Commission on Historic Monuments of England (henceforth RCHME), *City of Cambridge* (London: Her Majesty's Stationery Office 1959), vol. 2, pp. 207–208, gives the date and authorship; the idea that this refers to King's College is my own suggestion.

29. Tim Brittain-Catlin, *The English Parsonage in the Early Nineteenth Century* (Reading: Spire Books, in association with English Heritage, 2008), pp. 107, 152–154, 163.

30. A. W. N. Pugin, *The True Principles of Pointed or Christian Architecture* (London: Hughes, 1841), pp. 7–8, n. 1.

31. Ibid.

32. John Ruskin, 'The Lamp of Truth', in *The Seven Lamps of Architecture* (London: Smith Elder, 1849), p. 63.

33. Charles Eastlake, *A History of the Gothic Revival* (London: Longmans, 1872), pp. 170–171.
34. Gavin Stamp, 'George Gilbert Scott, jun., and King's College Chapel', in *Architectural History*, 37 (1994), 153–164, (pp. 155–158).
35. Ibid., p. 155; from George Gilbert Scott, *An Essay on the History of English Architecture prior to the Separation of England from the Roman Obedience* (London: Simpkin and Marshall, 1881), pp. 180–186.
36. Henry James, *English Hours* (Boston: Houghton, Mifflin & Co., 1905), p. 264.
37. Christopher Hussey, *King's College Chapel* (London: Country Life, 1926), p. 9.
38. Kenneth Clark, *History of the Gothic Revival* (London: John Murray, 1992), p. 106.
39. Nikolaus Pevsner, *An Outline of European Architecture* (Harmondsworth: Penguin, 1943; revised edn, 1983), pp. 157–160.
40. David Watkin, *English Architecture* (London: Thames and Hudson, 2001), pp. 72–73.
41. *The Will of King Henry the Sixth*, ed. James and Clark, p. 9; and Allan Doig, *The Architectural Drawings Collection of King's College, Cambridge* (Amersham: Avebury, 1979), p. 18.
42. Saltmarsh, *King's College*, p. 35; Francis Woodman, *The Architectural History of King's College Chapel* (London: Routledge & Kegan Paul, 1986), pp. 132–3, notes that while John Harvey (*The Perpendicular Style* [London: Batsford, 1978], p. 299), dated the design to *c*.1450, the paper on which the design was drawn has been identified as sixteenth century (BL Cotton MS Aug.I.i.2).
43. Saltmarsh, *King's College*, p. 43, n. 14.
44. Willis and Clark, *The Architectural History*, vol. 1, pp. 88–89.
45. Ibid., vol. 1, pp. 89–92; Patrick Monahan, 'The Jewel of the Backs', *Country Life*, April 24, 2013, 76–80 (p. 77).
46. Willis and Clark, *The Architectural History*, vol. 1, p. 90, as paraphrased by Willis and Clark; King's College replied far from being a nuisance the old Clare Hall building protected them from wind and sun.
47. Ibid., vol. 1, p. 118 (from the appendix, which is a transcription of the original exchange).
48. Nikolaus Pevsner, *Buildings of England: Cambridgeshire* (Harmondsworth: Penguin, 1970; revised edn 1983), pp. 56–57, calls it 'Gothic Survival', but this overlooks the possibility of a more deliberate homage to King's College Chapel.
49. Doig, *The Architectural Drawings*, p. 23.
50. David Roberts, *The Town of Cambridge as it Ought to Be Reformed: the Plan of Nicholas Hawkesmoor, and a set of eight drawings by Gordon Cullen* (Cambridge: privately printed at the University Press, 1955), p. 31, shows one hypothetical reconstruction.
51. Doig, *The Architectural Drawings*, p. 23.
52. Friedman, *Gibbs*, pp. 232–237.
53. Gibbs, *Book of Architecture*, p. ix; and Doig, *The Architectural Drawings*, plate 10.
54. Doig, *The Architectural Drawings*, pp. 32–33; and A. T. Bolton, *The Architecture of Robert and James Adam, 1758–1794*, 2 vols (London: Country Life, 1922), vol. 2, pp. 173–180; while taking a bold neo-classical approach, Adam's proposals do not overly exceed the scale of the Gibbs Building and thus also defer to the Chapel's vast scale.
55. John Martin Robinson, *James Wyatt 1746–1813: Architect to George III* (New Haven and London: Yale University Press for the Paul Mellon Centre for Studies in British Art, 2012), p. 214; Howard Colvin, *Biographical Dictionary of British Architects, 1600–1840* (New Haven and London: Yale University Press for the Paul Mellon Centre for Studies in British Art, 2008), pp. 1122–24.
56. Doig, *The Architectural Drawings*, p. 33.
57. Ibid.; and Willis and Clark, *The Architectural History*, vol. 1, pp. 564–5.
58. Doig, *The Architectural Drawings*, pp. 36–42.
59. Ibid., p. 42.
60. Ibid., p. 64; this objection had been foreseen by Provost Augustus Austen Leigh, who, in a letter of April 1869, said that the public interest would require works of greater quality and expense than the College could run to: see Doig, *The Architectural Drawings*, p. 63.
61. Chainey, 'King's College Chapel Delineated', p. 59.
62. RCHME, *City of Cambridge*, Part 1, p. 16.
63. Woodman, *The Architectural History*, Appendix I, 'Repairs to the Fabric post–1515', pp. 216–217; Graham Chainey, 'The East End of King's College Chapel', *Proceedings of the Cambridge Antiquarian Society* 83 (1994), 141–65; and KCA, KCC/326, Robert Maguire and Keith Murray, 'Report on the arrangement of the interior of the chapel', 1961, with conjectural plans of different periods of arrangement of the east end; Kenneth Fincham and Nicholas Tyacke, *Altars Restored: The Changing Face of English Religious Worship, 1547–c.1700* (Oxford: Oxford University Press, 2007), pp. 58–61, review the evidence of treatment of altars from the accession of Edward VI onwards, and note that during the reign of Elizabeth altars are usually moved westward from the east end, and sometimes replaced with seating or tombs.
64. Willis and Clark, *The Architectural History*, vol. 1, pp. 523–525; G. G. Scott, Appendix A, in Thomas Carter, *King's College Chapel: Notes on its History and Present Condition* (London: Macmillan, 1867), pp. 68–77; Woodman, *The Architectural History*, p. 242.
65. Chainey, 'The East End', p. 142; Chainey proposed the third bay partly on an analogy with Trinity College Chapel's early arrangements as garnered from a late seventeenth-century source in Willis and Clark, *The Architectural History*, vol. 2, p. 574; Trinity Chapel was modelled on that of King's but completed in 1567. See Roger Bowers below, 'Chapel and Choir, Liturgy and Music, 1444–1644', p. 268. An altar is, however, not shown in the Smythson plan for Trinity, *c*.1609 – illustrated by Mark Girouard in 'The Smythson Collection of the Royal Institute of British Architects', *Architectural History*, 46 (1962), 21–184 (pp. 29–30, 67) – so the arrangement described in Willis and Clark may well be a later arrangement. KCA, KCAR/4/1/1/23, Mundum Book (1611), 'Reparaciones Novi Templi', shows a payment for 'white tiles' employed in association with works to the east end, but the altar's exact location and extent are difficult to determine. Fincham and Tyacke (*Altars Restored*, p. 61) note the significance of the Smythson plan, since direct evidence of the treatment of the altars in Oxford and Cambridge college chapels is scarce; they also note the tradition that Charles I personally requested the replacing of the communion table altarwise (p. 81).
66. Chainey, 'The East End', p. 142; Chainey persuasively posits the identity of the carver, 'M. Antonio' as Torrigiano's assistant at Westminster Abbey, Antonio del Nunziato; he argues that the form of the altar may have followed the model of the altar provided for Henry VII's chapel there.
67. Willis and Clark, *The Architectural History*, vol. 1, pp. 522–524; Carola Hicks, *The King's Glass: a story of Tudor*

power and secret art (London: Chatto and Windus, 2007), pp. 197–8; and, for Goad and the sale of vestments, Stephen Wright, 'Goad, Roger (1538–1610)', *Oxford Dictionary of National Biography*, ed. Brian Harrison (Oxford: Oxford University Press, 2004), vol. 22, pp. 532–534 (p. 533); see also Abigail Rokison below, 'Drama in the Chapel', p. 242.

68 Carter, *King's College Chapel*, pp. 58–59; Nichols, *Progresses of Queen Elizabeth*, vol. 1, p. 158.

69 Chainey, 'King's College Chapel Delineated', p. 40.

70 Ibid., p. 49; and see nn. 63 and 65.

71 Willis and Clark, *The Architectural History*, vol. 1, pp. 523–524.

72 Ibid., pp. 525–30, for Cole's account; the 1641 puritan report that describes both the form of the altar and the current ritual is cited in Chainey, 'The East End', p. 146; Willis and Clark, *The Architectural History*, vol. 1, p. 522, also suggest the possibility that this might have been the site of the original altar.

73 Hicks, *The King's Glass*, pp. 199–201.

74 Ibid., p. 200.

75 Ibid.

76 Thomas Salmon, *The Foreigner's Companion through the Universities of Cambridge and Oxford* (London: William Owen, 1748), p. 37.

77 Willis and Clark, *The Architectural History*, vol. 1, p. 525.

78 Henry Malden, *An Account of King's College Chapel* (Cambridge: Fletcher and Hodson, 1769; repr. Scolar Press for King's College, Cambridge, 1973), p. 35.

79 Willis and Clark, *The Architectural History*, vol. 1, pp. 525–6; the marble pavement of the choir and sanctuary is shown in the sketch by antiquary William Stukeley, of around 1705 (KCA, KCC/279). See Ill. 162.

80 Friedman, *Gibbs*, pp. 234–236 (see fig. 260; 'The Altar peece for King's College at Cambridge', London, Victoria & Albert Museum: VAM E.3672–1913); Gibbs, *Book of Architecture*, plate 32, shows the plan of the Chapel; Chainey, 'The East End', p. 148, notes that, given the pillars visible on the plan, Gibbs may have provided a more elaborate design for an altar, possibly under a baldacchino.

81 KCA, KC/GB/4/1/1/1, Governing Body Minutes, May 15, 1772, first item on p. 211.

82 Allan Doig, 'James Adam, James Essex and an Altarpiece for King's College, Cambridge', *Architectural History*, 31 (1978), 79–82 and 118–119; KCC/280, folio of correspondence, 'Altarpiece 1742–75', p. 7.

83 Ibid., p. 9.

84 The Adam classical design, both elevation and plan, can be found at KCA, KCC/JA 1, 1 & 2 (see Doig, *The Architectural Drawings*, p. 29, and plate 11); the corresponding gothic design, and the design showing the position of the proposed altar in the Chapel in relation to the east window, are in Sir John Soane's Museum, London: SM Adam volume 31/22 and SM Adam volume 31/23.

85 Doig, 'James Adam, James Essex', pp. 80–81; Thomas Cocke, *The Ingenious Mr Essex, Architect, 1722–1784. A Bicentenary Exhibition* (Cambridge: Fitzwilliam Museum, 1984), p. 11.

86 Willis and Clark, *The Architectural History*, vol. 1, p. 527.

87 See Jean Michel Massing below, 'The Altarpieces in the Chapel of King's College, Cambridge', pp. 120–23; also Chainey, 'The East End', p. 153.

88 Carter, *King's College Chapel*, p. 76.

89 Ibid., Appendix A (dated 1866) by G. G. Scott, RA [ie Senior], p. 83; Stamp, 'George Gilbert Scott, jun.', p. 164.

90 Stamp, 'George Gilbert Scott, jun.', pp. 158, 160–161, 164; it is interesting to note that at one point Maguire and Murray were eager to incorporate these candle standards in their re-ordering proposals in the 1960s.

91 Doig, *The Architectural Drawings*, pp. 60–6; Burges was approached in 1872 and submitted his report in 1874; *The Architectural Designs of William Burges*, ed. Richard Popplewell Pullan (London: Speaight for R. P. Pullan, 1883), plate 63.

92 KCA, KCC/84, M. R. James, 'King's College Chapel, Cambridge', 1905, pamphlet, p. 2.

93 Ibid.

94 Ibid.

95 M. R. James, *Eton and King's: Recollections, Mostly Trivial, 1875–1925* (London: Williams and Norgate, 1926), pp. 228–229.

96 KCA, KCC/60, 'Messrs Bodley and Garner's Report on Their Design for a Reredos, November 7, 1894', printed pamphlet for the College committee, dated January, 1895, p. 1. Thanks to Michael Hall for advice on the story of this commission; Bodley withdrew from the fray leaving Thomas Garner to continue discussions, and thus it was Garner who designed the altar-table and those embroidered hangings which were installed. Garner also at one point was required to debate the legality of a stone altar; see KCA, PP/MRJ/C, letter from Thomas Garner to A. Austen-Leigh.

97 KCA, MRJ/C/2(2), printed letter from M. R. James 'for the use of the two committees', 26 January 1895.

98 Hussey, *King's College Chapel*, p. 31; Chainey, 'The East End', p. 155, refers to an internal College report of 1896; some of the Essex panelling can be seen in the passage east of the Hall.

99 KCA, MRJ/C/2 (5), letter from Augustus Austen Leigh, May 19 (1899).

100 Chainey, 'The East End', p. 155.

101 KCA, KCC/84, M. R. James, 1905 pamphlet, p. 2; and Chainey, 'The East End', p. 155.

102 KCA, KCC/84, M. R. James, 1905 pamphlet, p. 2 ; Wilkins' survey was published in 1807, in *The Architectural Antiquities of Britain*, 4 vols (London: Longman, Hurst, Rees and Orme, 1807–1814), vol. 1, opposite p. 22, showing the layout as executed by Essex (the access to the turrets is wrongly marked); the RCMHE survey (dated 1955) in RCHME, *City of Cambridge*, 1959, part 1, p. 103, shows exactly the floor level as finished by Garner.

103 KCA, KCC/14/1, unsigned draft of letter from the Provost, dated March 8, 1903; Thomas Garner's unhappy reply of April 16, 1903 is in the same file.

104 Letter in the archives of the Society for the Protection of Ancient Buildings, London, 'King's College, Cambridge' file; Lethaby's letter is dated on receipt 5/5/1905; it refers to a copy of Lethaby's report, but this is not enclosed, as returned to him, but a copy of this is to be found in KCA, KCC/14/1, in a more precise handwriting than Lethaby's, so presumably drafted by an assistant.

105 KCA, KCC/14/1, two letters from Lethaby, dated 17 May, 1903 and 23 March, 1903. Lethaby was reluctant to nominate the 'young' architects himself, but this shows that younger architects were under discussion.

106 KCA, KC/GB/4/1/1/10, Minutes of the Governing Body, 11 March 1905, 'Chapel Reredos', to which is also attached the 'Report of the Reredos Committee', February 1905; it is not quite clear if the briefing drawn up for the College by

Lethaby in May 1903 (in KCC/14/1) was actually circulated, but the file also contains letters and specifications from Poynter, Blow and Carter, dated June 1903. Carter even produced a printed pamphlet, KCA, KCC/14/7; Poynter was selected by the Reredos Committee, but Blow's design voted for by the Governing Body, as noted in Chainey, 'The East End', p. 156. A letter from C. R. Ashbee, 10 December, 1903 (KCA, KCC/14/1), was a petition on behalf of the Guild of Handicraft to be allowed to do the actual work, but the work went to the Cambridge firm of carvers, Rattee and Kett, as noted in Chainey, 'The East End', p. 156.

107 KCA, KC/GB/4/1/1/10, Minutes of the Governing Body, 11 March 1905, 'Chapel Reredos', to which is also attached the 'Report of the Reredos Committee', dated February 1905, which lists all the requested modifications which had been agreed; KCA, KCC/14/2, refers to the full scale model by Mr Royall of Keeble Ltd.; see also KCA/12/3–5.

108 KCA, KCC/131 and KCC/84, M. R. James, pamphlet, 1905, p. 3.

109 KCA, KCC/14/5–7.

110 KCA, KCC/133–136, mostly dated May 1914, drawings only.

111 Lancelot Wilkinson, *A Century of King's: 1873–1972* (Cambridge: King's College, 1980), p. 129.

112 KCA, KCC/72 is a rare photograph of the reredos with the Skeaping figures in situ; Wilkinson, *A Century of King's*, pp. 129–131; Chainey, 'The East End', p. 157.

113 See Peter Jones below, 'The College and the Chapel', pp. 176–78

114 Adrian Hastings, *A History of English Christianity 1920–1990* (London: SCM Press, 1991), pp. 436–473; and Don Cupitt, *The Sea of Faith* (London: BBC Books, 1984), pp. 26–34; Jean Michel Massing has observed to the author that it was said by older Fellows that there were serious religious objections to the 1960s arrangement among the Fellows on the grounds that the Rubens altar painting chosen was too Catholic in character.

115 KCA, KCC/405, Dean's Chapel Fabric Correspondence, and especially KCC/326, Robert Maguire and Keith Murray, 'Report on the arrangement of the interior of the chapel', 1961; the practice had just completed a radical re-ordering of St Paul's, Bow Common.

116 KCA, KCC/326, Maguire and Murray, 'Report on the arrangement of the interior of the chapel', p. 12.

117 Wilkinson, *A Century of King's*, p. 130.

118 KCA, KC/GB/4/1/2/20, includes a report 'A Proposed Gift' prepared by Noel Annan for the May 1961 meeting of the Governing Body; Jaffé urged Annan to accept the gift for the College, given the painting's importance; Jaffé also presented the proposals to the press (as reported in *Cambridge News*, April 22, 1964), and personally drafted certain key internal reports, such as 'The Second Report of the College Committee, April 19, 1965'. He also suggested the purchase of a baroque frame from a church in Zundert in the Netherlands, an idea abandoned quite quickly on account of its scale. Alec Vidler, *Scenes from a Clerical Life* (London: Collins, 1977), p. 163, was oddly reticent about the whole re-ordering: 'All I need say about this is that I was in favour of the decision that was finally taken'.

119 KCA, KC/GB/4/1/2/20, Minutes of the Governing Body, 'Gift of the Adoration of the Magi', 6 May, 1961.

120 KCA, KCC/405 and KCA: KCC/397 include reports by numerous additional technical experts on, for example, conservation issues such as whether the environment of the Chapel was appropriate etc.

121 KCA: KCC/326, Maguire and Murray 'Report on the arrangement', p. 20; see also Robert Maguire, 'Annual Lecture, 1995: Continuity and Modernity in the Holy Place', *Architectural History*, 33 (1996), 1–18, which gives an account of how a canopy can make an object gain significance in a large space.

122 KCA, KCC/36, Maguire and Murray, 'Report on the arrangement', p. 24; a copy of the account of the early part of the re-ordering discussions, written by Robert Maguire in August 2013 at the request of Charles Saumarez Smith, shown to the author by the Rev'd Victor de Waal. Mr Saumarez Smith's recent researches into the social and cultural context of the placing of the Rubens, 'Rubens and King's', are forthcoming.

123 KCA, KC/405: typed copies were filed for 'The use of the Chapel Adornment Committee'.

124 KCA, KCC/395, notes by the Domus Bursar, undated, possibly June 1967.

125 KCA, KCC/405, Nikolaus Pevsner, 'Report on the Placing of Rubens' Adoration of the Magi in King's College Chapel', p. 1, undated but likely to be late 1961, as Summerson's letter of comment is dated 28 October 1961, and those of Anthony Blunt and Geoffrey Webb are both dated 1 December 1961.

126 Ibid.

127 Robert Maguire, Letter to Editor, *The Independent*, 30 December 1992; and copy of an account of the early part of the re-ordering, written by Robert Maguire in August 2013.

128 KCA, KCC/405, letter from John Saltmarsh to Victor de Waal, 26 November 1961.

129 KCA, KCC/405, 'Third Report of the College Committee', November 1965; Michael Jaffé had recommended Sir Martyn Beckett, Bt. Beckett was better known as a country house architect at the time; see John Martin Robinson, *The Latest Country Houses* (London: Bodley Head, 1983), pp. 119–124. Beckett trained with A. S. G. Butler; his drawings were largely destroyed at his death (according to his son Sir Richard Beckett, Bt., letter to the author, 9 September 2013). There is a 1968 floor plan for the pattern of the marble floor, altar and stalls, in KCA, KCC/340, and one sketch for a baroque pedimented frame published in Rodney Tibbs, *King's College Chapel: The Story and the Renovation* (Lavenham: Terence Dalton, 1970), p. 86.

130 KCA, KCC/327, comments on the first proposals by Beckett, report by Victor de Waal, dated 16 May 1963.

131 *Cambridge Evening News*, 23 April, 1964, cutting in KCA, KCC/395, and KCA, KCC/405; and Chainey, 'The East End', p. 163.

132 Stamp, 'Sell the Rubens', *Apollo*, vol. 159, no. 507, May 2004, 88–89; Tibbs, *King's College Chapel*, pp. 40–41, includes a photograph of the exposed brick arches; the lowering of the floor and the disturbance of the remains was a highly controversial element of the 1968 works.

133 Woodman, *The Architectural History*, Appendix VII, pp. 242–243; Chainey, 'The East End', p. 163; the floor levels are also discussed in KCC/326, Maguire and Murray report, 1961, pp. 24–25, 34–35.

134 KCC/405, The Third Report of the College Committee, November 1965, pp. 30–31.

135 Document quoted by Graham Chainey, in his letter to the editor, 'A Season for Crying in the Chapel', *The Independent*, 24 December 1992, but I have not been able to locate the original in the archives at King's College.

136 Astragal, *Architect's Journal*, 11 December, 1968, 1368–1369.

137 Anon., *The Illustrated London News*, December 1968, cutting in the College Archives, KCA, KC/PAM 1.

138 Jaffé's letter, 31 May 1968, and a copy of Pesvner's response are in the *Buildings of England* papers, National Buildings Record, Swindon – thanks to Simon Bradley for drawing them to my attention; Nikolaus Pevsner, *Buildings of England: Cambridgeshire* (London: Penguin, 1970), pp. 106–7.

139 Graham Chainey, 'A Season for Crying in the Chapel'; also Chainey, 'The East End', p. 163, includes a long list of strong views about the reordering.

140 Gavin Stamp, 'Sell the Rubens'; there have been some warmer supporters, such as Rodney Tibbs who celebrated the work in his book *King's College Chapel*, which included a foreword by and interviews with Beckett. Chainey, 'The East End', p. 164, notes that vandalism to the painting in 1974, led to much stricter security.

141 The interest of visiting tourists was observed by the author and confirmed in discussions with the current custodians of the Chapel in 2013–2014, including deputy chapel administrator, Ian Griffiths. This is reflected, for instance, in the fact that while during Lent the side-doors of the triptych are closed for services, they are kept open for the visiting public, reflecting the eighteenth-century observation cited above that any work to the east end would be 'a work of public view'.

II

The Structure and Construction of the Chapel
JOHN OCHSENDORF AND MATTHEW DEJONG

1 The authors would like to thank Professors Jacques Heyman and Nicholas Bullock for generously sharing their knowledge of the Chapel vault and for inspiring this study. Engineering students James McInerney, Ian Trzcinski, and William Plunkett conducted original research to support this work.

2 The construction of the Chapel is covered in detail in several well-known books. In particular, the most thorough treatments can be found in Robert Willis and John Clark, *The Architectural History of the University of Cambridge*, 4 vols (Cambridge: Cambridge University Press, 1886); Royal Commission on the Historical Monuments of England (RCHME), *An Inventory of the Historical Monuments in the City of Cambridge*, pt. 1 (London: HMSO, 1959); Walter Leedy, *Fan Vaulting: A study of Form, Technology, and Meaning* (Santa Monica: Arts and Architecture Press, 1980); and Francis Woodman, *The Architectural History of King's College Chapel and Its Place in the Development of Late Gothic Architecture in England and France* (London: Routledge, Kegan and Paul, 1986).

3 RCHME, *An Inventory*, p. 100.

4 Ian Trzcinski, 'Laser scanning the fan vault of King's College Chapel', unpublished fourth year project, Department of Engineering, Cambridge University, 2011.

5 RCHME, *An Inventory*, p. 102.

6 Leedy, *Fan Vaulting*, p. 142. For more on Westminster Abbey and the Vertues, see Jacques Heyman, 'An observation on the fan vault of Henry VII Chapel, Westminster', *Architectural Research Quarterly*, 4:4 (2000), 357–372.

7 Leedy, *Fan Vaulting*, p. 141.

8 Robert Willis, 'On the construction of the vaults of the Middle Ages', *Transactions of the Royal Institute of British Architects*, 1:2 (1842), 1–69.

9 John Britton and Edward Wedlake Brayley, *The Beauties of England and Wales: Or Delineations, Topographical, Historical, and Descriptive, of Each County* (London: Vernor and Hood, 1801), p. 50.

10 Leedy, *Fan Vaulting*, p. 143.

11 The level crown has provided a comfortable walking surface for generations of visitors, and the extrados of the vault is noticeably eroded in some locations due to foot traffic over the centuries.

12 Leedy, *Fan Vaulting*, p. 141.

13 Frederick MacKenzie, *Observations on the Construction of the Roof of King's College Chapel* (London: John Weale, 1840).

14 James McInerney, Ian Trzcinski, and Matthew DeJong, 'Discrete element modelling of masonry using laser scanning data', *8th International Conference on Structural Analysis of Historical Constructions* (SAHC), Wroclaw, Poland, 2012.

15 MacKenzie, *Observations on the Construction*, Plate 4.

16 Jacques Heyman, *The Stone Skeleton: Structural Engineering of Masonry Architecture* (Cambridge: Cambridge University Press, 1995).

17 Ibid., p. 173.

18 William Bland, *Experimental Essays on the Principles of Construction in Arches, Piers, Buttresses, etc: made with a view to their being useful to the Builder*, 3rd edition (London: Virtue, 1867).

19 Heyman, *The Stone Skeleton*, p. 173.

20 Bland, *Experimental Essays*, p. 121.

21 J. Heyman, 'Spires and fan vaults', *International Journal of Solids and Structures*, 3 (1967), 243–257.

22 J. Heyman, *Equilibrium of Shell Structures* (Oxford University Press, 1977), p. 104.

23 After Heyman, *The Stone Skeleton*, p. 81.

24 Heyman, 'Spires and fan vaults', p. 252.

25 Jacques Heyman, 'Calculation of abutment sizes for masonry bridges', *Colloquium on History of Structures*, International Association of Bridge and Structural Engineers, 1982 (London: Institution of Structural Engineers, 1984), pp. 115–120.

26 McInerney et al., 'Discrete element modelling of masonry'.

27 Philippe Block, 'Thrust Network Analysis, Exploring three dimensional equilibrium' (unpublished PhD Dissertation, Department of Architecture, Massachusetts Institute of Technology, 2009), p. 117.

28 McInerney et al., 'Discrete element modelling of masonry' and Block, 'Thrust Network Analysis', p. 117.

29 The restoring moment of the buttress is approximately 2700kN x 3.4m = 9,180kNm. This neglects the additional

restoring moment provided by the weight of the vault, which is approximately 315 kN x 5.8m = 1,830kNm. The overturning moment at the base of the buttress due to the vault thrust is approximately 170kN x 20m = 3,400kNm. This gives a safety factor against overturning of 9,180kNm/3,400kNm = 2.7. If the stabilising weight of the vault is considered, then the safety factor against overturning is increased to approximately 3.2.

30 Victor Sabouret, 'Les voûtes d'arêtes nervurées', *Le génie civil*, 3 March, 1928.

31 Letter from George Gilbert Scott to King's College regarding the Chapel roof, 9 October 1860: KCA, KCC/371.

32 The weight of the timber and lead roof can be estimated at 100 kg per square metre (20 pounds per square foot), giving a vertical load on each wall of approximately 45kN and a horizontal thrust of approximately 90kN. The horizontal thrust acts at a height of approximately 26m, giving an overturning moment of 90kN x 26m = 2,340 kNm. Thus, if the lead and timber roof were to thrust fully on the buttresses, the total overturning moment would be increased from 3,400kNm to 5,740kNm and the safety factor against overturning would be reduced from approximately three to a safety factor of approximately two.

33 MacKenzie, *Observations on the Construction*, plate 2.

III

Glassy Temporalities: The Chapel Windows of King's College, Cambridge
James Simpson

1 George Herbert, 'The Windows', *The Complete English Poems*, ed. John Tobin (London: Penguin, 1991), p. 61 (line 13).

2 For the architectural history of the chapel, see Francis Woodman, *The Architectural History of King's College Chapel* (London: Routledge and Kegan Paul, 1986). See also the excellent book by Carola Hicks, *The King's Glass: A Story of Tudor Power and Secret Art* (London: Chatto and Windus, 2007), both for the building and, more obviously, the windows.

3 Hicks, *The King's Glass*, p. 16. The earliest professional scholarship on the installation of the windows known to me can be found in W. J. Bolton, 'King's College Chapel Windows, Cambridge', *Archaeological Journal* 12 (1855), 153–72.

4 Hicks, *The King's Glass*, pp. 38–39.

5 For the full text of the indenture, see Woodman, *The Architectural History of King's College Chapel*, pp. 158–60.

6 Hicks, *The King's Glass*, p. 88. *The Oxford Dictionary of National Biography* (henceforth *ODNB*) entry on Richard Foxe is a little more circumspect with regard to the certainty of Foxe's input into the windows' conception; see http://www.oxforddnb.com.ezp-prod1.hul.harvard.edu/view/article/10051?docPos=4, consulted 10 September 2013.

7 See Richard Foxe, *ODNB*.

8 Woodman, *The Architectural History of King's College Chapel*, p. 160, and Hicks, *The King's Glass*, pp. 92–93.

9 The text of the first memorandum of payments to Flower is transcribed in Kenneth Harrison, *The Windows of Kings College Chapel Cambridge: Notes on the History and Design* (Cambridge: Cambridge University Press, 1952), p. 1. See pp. 1–3 for a full list of memoranda. See also Hicks, *The King's Glass*, p. 93, and Hilary Wayment, *The Windows of King's College Chapel, Cambridge: a Description and Commentary*, Corpus Vitrearum Medii Aevi. Great Britain. Supplementary vol. 1 (London: British Academy and Oxford University Press, 1972), Appendix B, pp. 123–27 (p. 123).

10 Harrison, *The Windows of King's College Chapel*, p. 4.

11 I observe the numerical formula for referring individual windows used by Kenneth Harrison and Hilary Wayment, starting with Window 1 in the north-west corner, and ending with great western as Window 26. For a visual outline of the scheme, see Harrison, *The Windows of King's College Chapel*, p. 40. Relevant window numbers will henceforth be inserted in the text. I refer to single narrative sequences within a given window according to the accepted practice: 'a' for lower left; 'b' for upper left; 'c' for lower right; 'd' for upper right.

12 My understanding of the dating is derived in part from Harrison, *The Windows of King's College Chapel*, pp. 39–40, and, more recently, with significant refinements, Wayment, *The Windows of King's College Chapel*; see also the summation of that book: Hilary Wayment, *King's College Chapel Cambridge: The Great Windows. Introduction and Guide* (Cambridge: Provost and Scholars of King's College Cambridge, 1982), pp. 6–7.

13 He left a wholly traditional will, which is transcribed in Harrison, *The Windows of King's College Chapel*, pp. 6–7, and Wayment, *The Windows of King's College Chapel*, Appendix C, p. 123.

14 Hicks, *The King's Glass*, p. 100.

15 Hicks, *The King's Glass*, p. 93. Spelling here has been modernized. See also Wayment, *The Windows of King's College Chapel*, Appendix C, pp. 123–4 (p. 124).

16 Hicks, *The King's Glass*, p. 125. See also Wayment, *King's College Chapel Cambridge: The Great Windows*, pp. 7–9.

17 Hicks, *The King's Glass*, p. 135.

18 Wayment, *King's College Chapel Cambridge: The Great Windows*, p. 7.

19 Harrison, *The Windows of King's College Chapel*, p. 2.

20 The entire programme can be viewed online, at http://www.therosewindow.com/pilot/Cambridge-Kings/table.htm. See also Wayment, *The Windows of King's College Chapel*, p. 6.

21 Erich Auerbach's essay remains the most perceptive: 'Figura', *Scenes from the Drama of European Literature* (Minneapolis: University of Minnesota Press, 1984; first published 1959), pp. 11–26.

22 The following three paragraphs drawn from James Simpson, *Burning to Read: English Fundamentalism and its Reformation Opponents* (Cambridge, MA: The Belknap Press of Harvard University Press, 2007), chapter 6.

23 For the history of late antique and medieval Biblical scholarship, see Henri de Lubac, *Exégèse médiévale: les quatres sens de l'Écriture*, vols 41, 42 and 59 of *Théologie*, 2 vols. in 4 (Paris: Aubier, 1959–64); Beryl Smalley, *The Study of the Bible in the Middle Ages* (Notre Dame, IN: University of Notre Dame Press, 1964); and Gilbert Dahan, *L'Exégèse chrétienne de la Bible en Occident médiéval XII–XIV siècle* (Paris: Cerf, 1999).

373

24 Galatians 4.22–26; 1 Corinthians 10.11; though the force of the historical idea is lost in the frequent translation of 'figura' (the Vulgate reading) in this passage as 'example'; thus William Tyndale, *Tyndale's New Testament*, ed. David Daniell (New Haven: Yale University Press, 1989), p. 252.

25 William Tyndale, *The Obedience of a Christian Man*, ed. David Daniell (London: Penguin, 2000), p. 156.

26 Dahan, *L'Exégèse chrétienne de la Bible*, p. 436.

27 See, for example, the fifteenth-century lyric 'Nova, Nova: Ave fit ex Eva', in *Ancient English Christmas Carols*, ed. Edith Rickert (New York: Duffield, 1915), p. 30.

28 The design of Window 13 breaks with the two standard sources routinely cited for the program of the King's windows, the *Biblia Pauperum* and the *Speculum Humanae Salvationis*, where the Crucifixion is set within a typological scheme. See *Biblia Pauperum: A Facsimile and Edition*, edited by Avril Henry (Ithaca, NY: Cornell University Press, 1987), p. 98, and *Das deutsche Speculum Humanae Salvationis*, ed. Arnold Pfister (Basel: Frobenius, 1937), fol. 52v. For the earliest scholarship on the undoubted relation between the King's programme and the programmes in these books, see George Scharf, 'Artistic Notes on the Windows of King's College Chapel', *Archaeological Journal* 12 (1855), 356–73 (with a table of correspondences at 371–3). Those correspondences noted, it should be recognised that there are also many differences between the King's programme and these books (which also differ between themselves). The books contain many scenes not in the windows; they arrange many of the scenes differently; and, above all, what I have described as the lateral narrative of the New Testament scenes is not continuous in the books as it dramatically is in the windows.

29 See, for example, *Das deutsche Speculum Humanae Salvationis*, fol. 14r.

30 The temple scene derives from the *Biblia Pauperum* and the standard fall of the idols from the *Speculum Humanae Salvationis*. For discussion of this topos, and its origin in the Apochryphal Gospel of the Pseudo-Matthew, see Michael Camille, *The Gothic Idol: Ideology and Image-Making in Medieval Art* (Cambridge: Cambridge University Press, 1989), pp. 1–9.

31 For which see James Simpson, *Under the Hammer: Iconoclasm in the Anglo-American Tradition*, The Clarendon Lectures (Oxford: Oxford University Press, 2010), chapter 2.

32 Martin Luther, *On the Bondage of the Will*, in *Luther and Erasmus: Free Will and Salvation*, trans. E. Gordon Rupp, A. N. Marlow, Philip S. Watson, Paul Althaus and B. Drewery (Philadelphia: The Westminster Press, 1969), pp. 110–11. See also Paul Althaus, *The Theology of Martin Luther*, trans. Robert C. Schultz (Philadelphia: Fortress Press, 1966; first published 1962), pp. 75–77.

33 'The Preface of Master William Tyndale that he made before the Five Books of Moses called Genesis', in William Tyndale, *Tyndale's Old Testament*, ed. David Daniell (New Haven: Yale University Press, 1992), pp. 3–4.

34 'A Prologue into the Second Book of Moses called Exodus', in Tyndale, *Tyndale's Old Testament*, ed. Daniell, p. 84.

35 'A Prologue into the Third Book of Moses called Leviticus', in Tyndale, *Tyndale's Old Testament*, ed. Daniell, p. 148.

36 The words are those of Nicholas Udall, in his translation of Erasmus' Paraphrase of the New Testament; see Desiderius Erasmus, *The first tome or volume of the Paraphrase of Erasmus upon the newe testamente* (London, 1548), RSTC, 2854.4, image 10.

37 Both citations here from Tyndale, *The Obedience of a Christian Man*, p. 156.

38 Thomas Aquinas, *Summa Theologiae*, ed. Thomas Gilby, 60 vols (London: Eyre and Spottiswoode, 1968), 1a 1,10 (vol. 1, p. 40).

39 Tyndale, *The Obedience of a Christian Man*, pp. 158–9.

40 Ibid., p.160.

41 See Simpson, *Burning to Read*, chapter 6 and further references for that larger story.

42 William Tyndale, *The Pathway into the Holy Scripture*, in William Tyndale, *Doctrinal Treatises and Introductions to Different Portions of the Holy Scriptures*, ed. Henry Walter (Cambridge: Cambridge University Press, 1848), p. 28.

43 *The First Tome or Volume of the Paraphrase of Erasmus upon the New Testament*, trans. Nicholas Udall (London, 1548), image 10.

44 The phrase is cited from the moment in Spenser's *Faerie Queene* when Guyon demolishes the Bower of Bliss: 'But all those pleasant bowers and Pallace brave, Guyon broke downe, with rigour pittilesse'; see Edmund Spenser, *The Faerie Queene*, ed. Thomas P. Roche (London: Penguin, 1987), Book 2, Canto 83, lines 1–2.

45 Martin Bucer, *A treatise declaring and showing…that pictures and other images…are in no wise to be suffered in the temples or churches* (London, 1535), image 49. This paragraph is drawn from Simpson, *Under the Hammer*, chapter 2.

46 The long story is recounted magisterially in Margaret Aston, *England's Iconoclasts, I: Laws Against Images* (Oxford: Clarendon Press, 1988). See also Simpson, *Under the Hammer*, from which the following four paragraphs are drawn.

47 For a detailed narrative, see Aston, *England's Iconoclasts*, chapter 6, and Nicholas Tyacke and Kenneth Fincham, *Altars Restored: The Changing Face of English Religious Worship, 1547–c.1700* (Oxford: Oxford University Press, 2007), chapters 1 and 2.

48 *Visitation Articles and Injunctions*, ed. Walter Howard Frere and William McClure Kennedy, Alcuin Club Collections, 15, 3 vols (London: Longmans, Green, 1910), p. 5.

49 *Visitation Articles and Injunctions*, ed. Frere and Kennedy, p. 38.

50 Thomas Cranmer, *Miscellaneous Writings and Letters of Thomas Cranmer*, ed. John E. Cox, Parker Society (Cambridge: Cambridge University Press, 1846), pp. 509–11 (p. 510). For discussion of this injunction, see Aston, *England's Iconoclasts*, pp. 254–66.

51 *Statutes of the Realm*, ed. T. E. Tomlins, et al., 11 vols (Dawsons, 1810–1828; repr. 1963), 3 and 4, Edward VI, c. 10 (vol. 4, pp. 110–111). Archbishop Cranmer had already in February 1547 required the destruction of all images in churches; see *Miscellaneous Writings and Letters of Thomas Cranmer*, ed. Cox, pp. 509–11.

52 Cited from Aston, *England's Iconoclasts, I*, p. 300. Fincham and Tyacke point out that while historians are generally agreed that 'the teaching of the latter [the 1559 Elizabethan injunctions] was more moderate than the Edwardian injunctions of 1547', they go on to say this: 'Yet we are confronted with the paradox here that the accompanying articles are more radical than their 1547 equivalent'. See Tyacke and Fincham, *Altars Restored*, p. 37.

53 Wayment, *The Windows of King's College Chapel, Cambridge: A Description and Commentary*, p. 35; and Hicks, *The King's Glass*, p. 166.

54 Hicks, *The King's Glass*, p. 163.

55 Wayment, *King's College Chapel Cambridge: The Great Windows*, p. 34.

56 Hicks, *The King's Glass*, p. 163.

57 Harrison, *The Windows of King's College Chapel*, pp. 12–15.

58 Nicholson's letter is transcribed by Harrison, *The Windows of Kings College Chapel*, p. 15.

59 For which see Margaret Aston, 'Puritans and Iconoclasm, 1560–1660', *The Culture of English Puritanism, 1560–1700*, ed. Christopher Durston and Jacqueline Eales (Basingstoke: Macmillan, 1996), pp. 92–122, and Julie Spraggon, *Puritan Iconoclasm during the English Civil War* (Woodbridge, Suffolk: Boydell, 2003).

IV

Provost Robert Hacumblen and his Chantry Chapel
Nicola Pickering

1 Also spelt Hacomplaynt, or Hacumblene.

2 Wasey Sterry, *Eton College Register* (Windsor: Eton College, 1943), p. 152.

3 Nick Sandon, 'Hacumblen, Robert' in *Oxford Dictionary of National Biography*, ed. by H. G. Matthew and Brian Harrison (Oxford: Oxford University Press, 2004), p. 406; Charles Cooper and Thompson Cooper, *Athenae Cantabrigienses* (Cambridge: Deighton, Bell, 1858), p. 34.

4 Sandon, 'Hacumblen, Robert', p. 406.

5 A saltire is a *heraldic* symbol in the form of a diagonal *cross*. The inclusion of a lily connected Hacumblen to King's College, as it is a symbol of the Virgin, patroness of the College.

6 KCA, KC/KCAR/I, *Aristotelis Ethica Nichomachea cum Comment.* (by R. Hacumblen); see Montague Rhodes James, *A Descriptive Catalogue of the Manuscripts in the Library of King's College, Cambridge* (Cambridge: Cambridge University Press, 1895), pp. 20–1.

7 Eton, Eton College Archive, MS 178, Eton College Choirbook, 23, fols 42v–44, c.1500–1505; *Eton Choirbook*, ed. by Frank Harrison (London: Royal Musical Association, Stainer & Bell, 1967), pp. 12–17. See also Magnus Williamson, *The Eton Choirbook. Facsimile and Introductory Study* (Oxford: DIAMM Publications, 2010), p. 59. For a different view, see Roger Bowers below, 'Chapel and Choir, Liturgy and Music, 1444–1644', pp. 263–66.

8 Sandon, 'Hacumblen, Robert', p. 406.

9 Emily Howe, Henrietta McBurney, David Park, Stephen Rickerby, Lisa Shedkede, *Wall Paintings of Eton* (London: Scala, 2012).

10 With thanks to Professor Iain Fenlon, Fellow of King's College, Cambridge for his advice and comments.

11 Sandon, *Hacomplaynt, Robert* (Grove Music Online) <http://www.oxfordmusiconline.com/subscriber/article/grove/music/12133>; last accessed 21 September 2013.

12 Frank Harrison, *Music in Medieval Britain* (London: Routledge and Paul, 1963), p. 34.

13 'Hacomplaynes Gaude' is cited in an inventory of King's College of 1529 but is now lost: Nicholas Sandon, *Hacomplaynt, Robert* (Grove Music Online) <http://www.oxfordmusiconline.com/subscriber/article/grove/music/12133>; last accessed 21 September 2013; Sandon, 'Hacumblen, Robert', p. 406.

14 John Saltmarsh, *Carving in King's College Chapel* (Cambridge: King's College Cambridge, 1970), p. 30.

15 Hilary Wayment, *Kings College Chapel Cambridge. The Side Chapel Glass* (Cambridge: Cambridge Antiquarian Society and King's College Cambridge, 1988), p. 5; Saltmarsh, *Carving in King's College Chapel*, p. 29.

16 Thomas J. P. Carter, *Kings College Chapel: notes on its history and present condition* (London, Macmillan, 1867), pp. 36–37.

17 KCA, KCAR/KCC/413, Agreement with John Wastell, Henry Semark and Robert Hacumblen for building the stone roof of the Chapel, about May 1512; KCAR/KCC/416, Agreement with Thomas Wastell and Robert Hacumblen for building finials on twenty-one buttresses and one tower of the Chapel, 4 January 1513; KCAR/KCC/418, Agreement with Thomas Wastell and Robert Hacumblen for building three towers of the Chapel, 4 March 1513; KCAR/KCC/415, Agreement with Thomas Wastell and Robert Hacumblen for building stone roofs of porches and sixteen chapels and porches, 4 August 1513; transcripts of these documents can be seen in Robert Willis and John Willis Clark, *The Architectural History of the University of Cambridge*, (Cambridge: Cambridge University Press, 1988), vol. 1, pp. 608–619

18 KCA, KCAR/KCC/408, Agreement with Galyon Hone, Richard Bond, Thomas Reve, James Nicholson and Robert Hacumblen for glazing the east window, the west window and 16 other windows in King's College Chapel, 30 April 1526; KCAR/KCC/409, Agreement with Francis Williamson and Simon Symondes for glazing four windows, two on each side, of King's College Chapel, 3 May 1526.

19 Bryan Little, *Cambridge Discovered* (Cambridge: W. Heffer, 1960), p. 58.

20 Royal Commission on the Historical Monuments of England (hereafter RCHM), *Inventory of the Historical Monuments of the City of Cambridge* (London: HMSO, 1988), p. 103.

21 Hilary Wayment, *The Windows of Kings College Chapel Cambridge*, Corpus vitrearum medii aevi, supplementary volume 1 (London: British Academy by Oxford University Press, 1972), p. 2.

22 KCA, KC/KCAR/CMR/71, Memorandum of payment from Thomas Larke from Robert Hacumblen to be delivered to Barnard Flower, 30 November 1515.

23 Wayment, *The Windows of Kings College Chapel*, p. 3.

24 KCA, KC/PP/JS/1/67, The Papers of John Saltmarsh, 'The Side Chapels', draft of the chapter, 1964, p. 175.

25 Cooper and Cooper, *Athenae Cantabrigienses*, p. 34.

26 KCA, KCAR/3/3/1/1/1, Ledger Book, vol. 1, fol. 278v.

27 John Warrior, *Kings College Chapel Cambridge* (Cambridge: Tim Rawle Associates, 1994), p. 24.

28 William Cole, *Parochial Antiquities of Cambridgeshire*, vol. 1, 1742, London, British Library, MS Add. 5802, fols 85–86; William Cole, *History of King's College Cambridge*, 1745, London, British Library, MS Add. 5814, fols 82–84.

29 Ibid.

30 William Cole, *Parochial Antiquities of Cambridgeshire*, vol. 1, 1742, British Library, MS Add. 5802, fols 85–86.

31 William Cole, *Parochial Antiquities of Cambridgeshire*, vol. 1, 1742, British Library, MS Add. 5802, fols 85–86; Henry Malden, *An Account of King's College Chapel in Cambridge* (Cambridge: 1769; repr. Cambridge: Scholar Press for King's College Cambridge, 1973): this publication was in fact written on Malden's behalf by some students of the College.

32 For a thorough assessment of the side chapel glass, see Wayment, *King's College Chapel, Cambridge. The Side Chapel Glass*. The following analysis draws on this study.

33 KCA, KC/PP/JS/1/65, The Papers of John Saltmarsh, 'Parts of chapters for the history of the chapel (1)', c.1964; KC/PP/JS/1/66, The Papers of John Saltmarsh 'Parts of chapters for the history of the chapel (2)', c.1964.

34 The whole of this light is intact and original.

35 The figure has replacement glass towards the head.

36 Luke 1.28: 'gratia plena Dominus tecum benedicta tu in mulieribus' ('[thou that art] full of grace, the Lord is with thee: blessed art thou among women'); Luke 1.38: 'ecce ancilla Domini fiat mihi secundum verbum tuum' ('Behold the handmaid of the Lord; be it unto me according to thy word').

37 Replacement glass at the bottom of the light where in other lights there is a pedestal, and at the Virgin's head. The letters IHS stand for Iesus Hominum Salvator ('Jesus, Saviour of men').

38 Replacement glass at the bottom of the light where other lights have a pedestal.

39 Replacement glass to the left of the hand of the figure.

40 KCA, KC/KCAR/Ledger Book 1, fol. 278–9, Robert Hacumblen's will, 1528.

41 Although of course his will had already been proven in September of that year and his successor appointed on 26 September.

42 William Cole, *Parochial Antiquities of Cambridgeshire*, vol. 1, 1742, British Library, MS Add. 5802, fols 85–86.

43 Gertrud Schiller, *Iconography of Christian Art*, 2 vols (London: Lund Humphries, 1971), vol. 2, p. 51.

44 Wayment, *Kings College Chapel Cambridge. The Side Chapel Glass*, p. 203.

45 Wayment, *Kings College Chapel Cambridge. The Side Chapel Glass*, p. 198; Montague Rhodes James, *A Guide to the Windows of Kings College Chapel Cambridge* (Cambridge: King's College Cambridge, 1930), p. 39.

46 William Cole, *Parochial Antiquities of Cambridgeshire*, vol. 1, 1742, British Library, MS Add. 5802, fols 85–86; see sketch by Thomas Willement in British Library: MS Add. 34866, fol. 82, Thomas Willement, *Drawings of Ancient Stained Glass*, 1824.

47 See Matthew 27.48: 'And one of them at once ran and took a sponge, filled it with sour wine, and put it on a reed and gave it to him to drink.'

48 Schiller, *Iconography of Christian Art*, vol. 2, pp. 91, 109.

49 Ibid., vol. 2, pp. 96–98.

50 Ibid., vol. 2, p. 211.

51 The angels and centaurs of this window correspond in style with those of the sun's mouth and woman's face of the inside windows (numbers 8 and 9) and so probably derive from the same workshop and date to the 1520s; see Wayment, *Kings College Chapel Cambridge. The Side Chapel Glass*, p. 203.

52 Angels as servants, venerating, adoring or swinging censers were commonly used to stress the divine nature of Christ.

53 The angels are executed in a lighter, more drawn manner than that seen in the figures of the Latin Doctors and the Evangelists, which are more modelled. This perhaps suggests two different hands.

54 Evangelists are also found on the brass lectern which Hacumblen gave to the College.

55 A creature symbolic of Henry VII's Welsh roots, referencing ancient Britain. The creature is a replacement, although its background may be original.

56 This animal was the beast of the Beauforts, going back to Edward III and his Lancastrian heirs. The animal is a replacement, although its background may be original.

57 The glass of this light dates to the original glazing.

58 The glass of this light is not original.

59 A symbol of Henry VII's reign and marriage to Elizabeth of York, which combined the red rose of Lancaster and the white rose of York. The glass of this light is not original.

60 Adopted as the symbol of the triumphant House of Lancaster with the accession of Henry VII. The glass of this light is not original.

61 The glass of this light is not original.

62 The King is crowned and holds a second crown upon a book, this crown may refer to Henry's martyrdom or saintliness, and the book to his piety.

63 James, *A Guide to the Windows of King's College Chapel Cambridge*, p. 39.

64 Montague Rhodes James, 'On Some Fragments of Fifteenth-century Painted Glass from King's College Chapel', *Proceedings of the Cambridge Antiquarian Society* 9 (1894), 3–12.

65 Wayment, *The Windows of Kings College Chapel*, p. 121.

66 Francis Blomefield, *Collectanea Cantabrigiensia* (Norwich: Printed for the Author, 1750), p. 130.

67 Wayment, *Kings College Chapel Cambridge. The Side Chapel Glass*, p. 194.

68 William Cole, *Parochial Antiquities of Cambridgeshire*, vol. 1, 1742, British Library, MS Add. 5802, fols 85–86.

69 Malden, *An Account of King's College Chapel*, p. 30.

70 Wayment, *Kings College Chapel Cambridge. The Side Chapel Glass*, p. 195.

71 See note 38 above.

72 KCA, KC/PP/JS/1/65, The Papers of John Saltmarsh, 'Parts of chapters for the history of the chapel (1)', c.1964; KC/PP/JS/1/66, The Papers of John Saltmarsh 'Parts of chapters for the history of the chapel (2)', c.1964.

73 Wayment, *Kings College Chapel Cambridge. The Side Chapel Glass*, p. 195.

74 Herbert Druitt, *A Manual of Costume as Illustrated by Monumental Brasses* (London: The De la More Press, 1906), p. 94; This tomb slab was moved when the monument to Lord Blandford was installed in the chantry soon after 1703. It is likely this was originally situated in front of the altar at the east side of the chantry. This is why the wooden stall and desk now appear to have been placed over Hacumblen's tomb. The floor was also rearranged in the eighteenth century and only some original slabs remain.

75 Alternatively 'O Christ, be thy wounds my pleasing remedy'; *Hore beate virginis marie ad usum Sarum* (Paris: Antoine Verard, 1503–05); San Marino California, Huntington Library, HM 36701, 2. fols 3v–4v, Devotions, Flanders, 16th century.

76 Schiller, *Iconography of Christian Art*, vol. 2, p. 18.

77 Information kindly provided by Mr Nicholas Rogers, FSA, Archivist at Sidney Sussex College, Cambridge, and Vice-President of the Monumental Brass Society; J. Roger Greenwood, 'Haines's Cambridge School of Brasses', *Transactions of the Monumental Brass Society*, 11 (1969), 2–12.

78 Carter, *Kings College Chapel*, p. 33; KCC, KC/PP/JS/1/65, The Papers of John Saltmarsh, 'Parts of chapters for the history of the chapel (I)', c.1964; KCC, KC/PP/JS/1/66, The Papers of John Saltmarsh 'Parts of chapters for the history of the Chapel (2)', c.1964.

V

The Altarpieces in the Chapel of King's College, Cambridge
JEAN MICHEL MASSING

I would like to thank Keith Christiansen, Ann Sutherland Harris, Kristen Lippincott, Elizabeth McGrath, Patricia McGuire, Ann Massing, Thierry Morel, Jeremy Musson, Aurélie Petiot, Sheila Russell and Nicolette Zeeman for their advice. I would like to dedicate this article to Sunny Pal and his family.

1 For the architecture of the Chapel, see Francis Woodman, *The Architectural History of King's College Chapel and Its Place in the Development of Late Gothic Architecture in England and France* (London: Routledge & Kegan Paul, 1986).

2 Robert Willis and John Willis Clark, *The Architectural History of the University of Cambridge and of the Colleges of Cambridge and Eton*, 4 vols. (Cambridge: University Press, 1886), vol. 1, pp. 465–534; *Royal Commission of Historical Monuments, England. An Inventory of the Historical Monuments in the City of Cambridge*, 2 vols. (London: HMSO, 1959), vol. 1, pp. 105–131; see also Jeremy Musson, pp. 39–58.

3 Willis and Clark, *The Architectural History*, p. 465; Graham Chainey, 'The east end of King's College Chapel', *Proceedings of the Cambridge Antiquarian Society*, LXXXIII (1994), Cambridge 1995, p. 141 (pp. 141–165, for an extensive discussion of the remodelling of the choir).

4 Willis and Clark, *The Architectural History*, p. 482; Woodman, *The Architectural History*, p. 196.

5 Willis and Clark, *The Architectural History*, p. 523; Chainey, 'The east end', p. 142.

6 Willis and Clark, *The Architectural History*, p. 523; Chainey, 'The east end', pp. 142–143.

7 Willis and Clark, *The Architectural History*, p. 523; Chainey, 'The east end', p. 143.

8 Thomas John Proctor Carter, *King's College Chapel: Notes on its History and Present Condition* (London: Macmillan & Co., 1867), p. 144; Chainey, "The east end", p. 144.

9 Willis and Clark, *The Architectural History*, p. 528.

10 *Royal Commission*, p. 115; for the plan, see Graham Chainey, 'King's College Chapel delineated', *Proceedings of the Cambridge Antiquarian Society*, LXXX (1991), Cambridge, 1992, p. 40.

11 Willis and Clark, *The Architectural History*, pp. 523–524.

12 *Royal Commission*, p. 115; Chainey, "The east end", pp. 143–146.

13 Willis and Clark, *The Architectural History*, p. 524.

14 Henry Malden, *An Account of King's College-Chapel in Cambridge* (Cambridge: Fletcher and Hodson, 1769), p. 35.

15 Willis and Clark, *The Architectural History*, p. 525.

16 Willis and Clark, *The Architectural History*, p. 526.

17 Willis and Clark, *The Architectural History*, pp. 526–527; Chainey, 'The east end', pp. 149–151.

18 For example, John Phillips, *The Reformation of Images: Destruction of Art in England, 1535–1660* (Berkeley, CA: University of California Press, 1973).

19 Jerry D. Meyer, 'Benjamin West's *St Stephen Altar-piece*: A study in late eighteenth-century Protestant church patronage and English history painting', *The Burlington Magazine*, CXVIII (1976), pp. 634–641.

20 William Hole, *The Ornaments of Churches Considered, with a Particular View to the Late decoration of the Parish Church of St Margaret, Westminster* (Oxford: printed by W. Jackson, 1761).

21 Meyer, 'Benjamin West's *St Stephen Altar-piece*', p. 635.

22 Thomas Wilson, in Hole, *The Ornaments of Churches*, p. 36; Meyer, 'Benjamin West's *St Stephen Altar-piece*', p. 635.

23 John Romney, *Memoirs of the Life and Works of George Romney* (London: Baldwin and Cradock, 1830), pp. 136–137; see also Thomas Humphry Ward and William Roberts, *Romney: A Biographical and Critical Essay with a Catalogue Raisonné of his Works*, 2 vols. (London: T. Agnew and New York: Scribners, 1904), vol. 2, p. 199; Arthur B. Chamberlain, *George Romney* (London: Methuen, 1910), p. 94; Graham Chainey, 'King's College Chapel delineated', p. 46; Chainey, "The east end", p. 151. The unfinished composition may have been lot 87, "Religion, ditto [a large study]" in the Christie's sale of his works on 27 April 1807: see Patricia Jaffé, *Fitzwilliam Museum, Cambridge: Drawings by George Romney*, Exhibition catalogue (Cambridge: Cambridge University Press, 1977), p. 20. Finally Thomas Orde bought two important paintings by Romney, *Mirth* and *Melancholy*, at the Society of Artists in 1770: Alex Kidson, *George Romney 1734–1802*, Exhibition catalogue, Liverpool, Walker Art Gallery, 8 February – 21 April 2002, and elsewhere (London: National Portrait Gallery, 2002), pp. 27–28 and 80–82, nos. and figs. 28–29.

24 Romney, *Memoirs*, p. 259.

25 Romney, *Memoirs*, p. 259.

26 For the most complete account, see Yvonne Romney Dixon, *"Designs from Fancy": George Romney's Shakespearean Drawings*, Exhibition catalogue, Washington, D.C., Folger Shakespeare Library, 10 November 1998 – 20 March 1999 (Seattle and London: University of Washington Press, 1998), esp. pp. 104–105 and 219–221, pls. 65, 66 and 93. See also Elisabeth Johnston ed., *George Romney, Paintings and Drawings*, London, Kenwood (London: London County Council, 1961), pp. 31 and 35, nos. 53 and 72; Patricia Milne Henderson [Patricia Jaffé], *The Drawings of George Romney*, Exhibition catalogue, Northampton, Mass., Smith College Museum of Art, May – November 1962, (Northampton 1962), under nos. 6–7; Patricia Jaffé, *Fitzwilliam Museum, Cambridge:*, pp. 19–20, nos. 28–29; Kidson, *George Romney*, pp. 27–28 and 111, no. and fig. 53.

27 Harold E. Wethey, *The Paintings by Titian*, 3 vols. (London: Phaidon, 1969–1975), vol. 1: *The Religious Paintings*, resp. pp. 74–76, no. 14, pls. 17–19 and 21–22, and 122–123, no. 86, pls. 136–138; Patricia Jaffé, *Drawings of George Romney*, p. 20 (no. 29) has also linked a head study in the Fitzwilliam Museum to Titian's *Assumption*.

28 Cambridge, Fitzwilliam Museum, B.V. 48.

29 Cambridge, Fitzwilliam Museum, B.V. 47; for a drawing showing such a position, also Kidson, *George Romney*, pp. 27–28 and 111, no. and fig. 53.

30 Ellis Kirkham Waterhouse, 'Some frescoes and an altar-piece by Gerolamo Siciolante da Sermoneta', *The Burlington Magazine*, CXII (1970), pp. 104.

31 [Jack Weatherburn Goodison and Edward Alfred Jones,] *Catalogue of the Plate, Portraits and other Pictures at King's College, Cambridge*e (Cambridge: University Press, 1933), p. 91, The manuscript *Catalogue of Pictures &c. Bought at Rome by myself*, compiled by the 5th Earl of Carlisle (Castle Howard, J14/30/1), lists, as no. 8, 'A descent from the Cross by Danielo de Volterra'. Chainey, "The east end", p. 151, n. 87, informs that "[William] Cole told Horace Walpole on 17 December 1780 that it had cost £400, adding: 'Mr Essex tells me the light [in the Chapel] will not suit it'".

32 Girolamo Siciolante da Sermoneta, *Deposition*, ca. 1568–73, oil on panel, 230 x 180 cm, Cambridge, King's College. For the painting, see also *Gentleman's Magazine*, London April 1781, p. 189; *The Farington Diary*, John Greig ed., 8 vols. (London: Hutchinson, 1924), vol. 3, p. 107; *Illustrated London News*, 1 February 1964, p. 175; Nikolaus Pevsner, *Cambridgeshire* (Harmondsworth: Penguin, 1945), p. 87; Francis Haskell, 'Pictures from Cambridge at Burlington House', *Burlington Magazine*, 102 (1960), pp. 71–72; Waterhouse, 'Some frescoes and an altar-piece', pp. 104–107, fig. 51; Goodison, 'The Siciolante altar-piece', *Burlington Magazine*, CXII (1970), p. 311 (the attribution to Siciolante 'originally put forward by Professor Waterhouse in September 1936, was confirmed by Arthur Ewart Popham in 1948, and was re-affirmed by Phillip Pouncey in 1951'); Edmondo Angelini, *Hieronimus Sermoneta* (Quaderni de storia e tradizioni locali, 4) (Sermoneta: Comune di Sermoneta, 1982), pp. 79, 86, with ill.; John Hunter, Teresa Pugliatti and Luigi Fiorani, *Girolamo Siciolante da Sermoneta (1521–1575). Storia e critica*, (Roma: Fondazione Camillo Caetani, 1983), pp. 123–25, fig. 58; John Hunter, *Girolamo Siciolante da Sermoneta, pittore da Sermoneta (1521–1575)* (Rome: "L'Erma" di Bretschneider 1996), pp. 73, 211–13 and 105–7, no. 4, fig. 82. More recently, see Mary Kempski, Daniela Leonard, Emma Rebecca Boyce, with Jean Michel Massing, 'Conservation and technical study of Siciolante da Sermoneta's *Deposition of Christ*, from King's College Chapel, Cambridge', *Hamilton Kerr Institute Bulletin*, 4 (2013), pp. 7–19 (I have repeated here part of my contribution to that article). For a drawing by Siciolante of the Virgin (Stockholm, Nationalmuseum), Per Bjurström and Börje Magnusson, *Nationalmuseum. Italian Drawings: Umbria, Rome, Naples* (Stockholm: Nationalmuseum, 1998), no. and fig. 565 (see Ill. 83).

33 Bernice F. Davidson, 'Some early works by Girolamo Siciolante da Sermoneta', *The Art Bulletin*, 48 (1966), pp. 56–57, fig. 5; for the best account, see Hunter, *Girolamo Siciolante da Sermoneta*, pp. 26–27, 106, 258 and 127–31, no. 12, fig. 11; and for a sixteenth-century drawing after the Dead Christ (Windsor, Royal Library), John Hunter, 'The drawings and draughtsmanship of Girolamo Siciolante da Sermoneta', *Master Drawings*, XXVI (1989), pp. 6–8, fig. 4.

34 Adolfo Venturi, *Storia dell'arte italiana*, 11 vols. (Milan: U. Hoepli, 1932), vol. IX, pp. 547–592.

35 This is confirmed by a mezzotint made by William Pether in 1783 after a drawing by the German-born draughtsman and miniature painter Benjamin Diemar and published by his brother Emmanuel Mathias, a London publisher. Lettered below the image is a dedication from Benjamin to the Earl of Carlisle: "This Plate engraved from a Capital-Painting by Daniel da Volterra, / The Gift of His Lordship as an Altar-Piece for King's-College Chapel, Cambridge"; *Daniel da Volterra pinx.t // B: Diemar delin:t // W. Pether sculp.t // Publish'd by E: M: Diemar, No: 377, Strand Oct:r 1st: 1783. A List of the principal Pictures at Castle Howard* records 'A drawing [presumably by Benjamin Diemar] made for the engraving of the Altar-piece at King's College Chapel, by Daniel Volterra': see *Castle Howard, its Antiquity and History: The Ancestral Home of the Howards* (London: Mitre Press, 1931), p. 17.

36 For the conservation of the painting, see Mary Kempski et al., 'Conservation... of Siciolante da Sermoneta's *Deposition of Christ*'; the restoration team included Daniela Leonard, KC 2006). Its conservation was funded by Sunny Pal (P. K. Pal, KC 1955) and his family (see p. 16, fig. 19, for a digital reconstruction of the original coloring of the altarpiece, by Chris Titmus of the Hamilton Kerr Institute; see also Ill. 85 here).

37 Pieter Paul Rubens, *Adoration of the Magi*, 1633, oil on panel, 328 x 246.5 cm, Cambridge, King's College. Provenance: Louvain, Convent of the Dames blanches, suppressed in 1783; sold by auction, Brussels, 12 September 1785, *Maisons religieuses supprimées aux Pays-Bas*, lot 1324, to Jean-Baptiste Horion, Brussels [fl. 8.400]; sold, from his collection in Brussels, 1 September 1788, lot 27, to 'Donckers, pour l'Angleterre' [fl. 8.000]; in the collection of the Marques of Lansdowne; Sale Lansdowne House, Berkeley Square, 19 and 20 March 1806, lot 57 to Lord Grosvenor [800 guineas]; by descent in the Grosvenor family; sold after the death of Hugh Richard Arthur, Duke of Westminster, London, Sotheby & Co., 24 June 1959, *Catalogue of Important Old master Paintings*, lot 14, to Major Alfred Ernest Allnatt through a London dealer; given by him to King's College, Cambridge in 1961.

38 For the basic sources, Edward van Even, 'Renseignements sur un tableau que Rubens exécuta, en 1633, pour le couvent des Dames blanches, à Louvain', *Bulletin-Rubens*, 1, 1882, pp. 99–104 (esp. pp. 100–101).

39 Jean François Marie Michel, *Histoire de la vie de P. P. Rubens* (Brussels: chez Æ. de Bel, 1771), p. 194.

40 "Item, aen het belt op den hoogen aultaer es t'Antwerpen gemaeckt, ten huyse van Myn heer Rubbens daer voer betaelt vant schilderen als oyck vant paneel, tsamen daer voer betaelt die zomme van IXc XX gulden": van Even, 'Renseignements', pp. 101–102.

41 Van Even, 'Renseignements', p. 104 ; for the later provenance, see above n. 32.

42 For the bibliography of the work, comprehensive until the time it was acquired by the College, Guillaume Paul Mensaert, *Le peintre amateur et curieux* (Brussels: Chez P. de Bast, 1763), p. 275; Jean-Baptiste Descamps, *Voyage pittoresque de la Flandre et du Brabant* (Paris: chez Dessaint, 1769), p. 104; Michel, *Histoire*, p. 194 ; Derival de Gomicourt, *Le Voyageur dans les Pays Bas autrichiens*, 2 vols. (Amsterdam: chez Changuion, 1782), vol. 2, p. 281; John Young, *A Catalogue of the Pictures at Grosvenor House* (London: Published by The Proprietor, 1820), p. 44, no. 136, pl. 44 [etching by Young]; Gustav Friedrich Waagen, *Kunstwerke und Künstler in England und Paris*, 3 vols. (Berlin: In der Nicolaischen Buchhandlung, 1837-1839), vol. 2, p. 115; Anna Brownell Jameson, *Companion to the Most Celebrated Private Galleries of Art in London* (London: Saunders and Otley, 1844), p. 271, no. 115; John Smith, *A Catalogue Raisonné of the Works of the Most Eminent Dutch, Flemish, and French Painters*, 9 vols. (London: Smith and son, 1829-42), vol. 2, p. 55, no. 156 and 218-219, no. 776; British Institution, June 1849, *Catalogue of Pictures by Italian, Spanish, Flemish, Dutch, French and English Masters: with which the proprietors have favoured the Institution* (London 1849), no. 127; Edward van Even, *Louvain monumental : ou, Description historique et artistique de tous les édifices civils et religieux de la dite

ville (Louvain: Fonteyn, 1860), pp. 264-266; van Even, 'Renseignements', pp. 99-104; Max Rooses, *L'œuvre de Rubens*, 5 vols. (Antwerp: J. Maes, 1886-92), vol. I, pp. 232-233, no. 176 and V, 1892, p. 318, no. 176; Frederick Whiley Hilles, *Letters of Sir Joshua Reynolds* (Cambridge: Cambridge U.P., 1929), pp. 129-130, 134, 136 and 138-139 [letters to the Duke of Rutland, 1785]; London, Royal Academy of Arts, *Catalogue of the Exhibition of 17th Century Art in Europe* (London: Royal Academy of Arts, 1938), p. 53, no. 94; Leo van Puyvelde, *Rubens* (Paris – Brussels: Elsevier, 1952), p. 156; Bruges, *L'art flamand dans les collections britanniques*, August – September 1956 (London: Editions de la Connaissance, 1956), no. 69; London, Sotheby, 24 June 1959, pp. 10-13, lot 14 [text by Ludwig Burchard]; Julius S. Held, *The Oil Sketches of Peter Paul Rubens*, 2 vols. (Princeton: Princeton University Press, 1980), vol. I, pp. 457-58; Michael Jaffé, *Display & Devotion: Rubens's Adoration of the Magi, King's College Chapel* [Cambridge: King's College] 1984 ; Michael Jaffé, *Rubens. Catalogo complete* (Milan: Rizzoli, 1989), p. 334, no. 1095 and (because of mislabelling) fig. 1094; Joshua Reynolds, *A Journey to Flanders and Holland*, Harry Mount ed. (Cambridge: Cambridge University Press, 1996), pp. 142 and 144. The picture will be studied in the forthcoming volume by Hans Devisscher and Hans Vlieghe on the *Infancy of Christ* in the *Corpus Rubenianum Ludwig Burchard*, vol. V. See also *supra*, n. 37.

43 For the iconography of the Magi in Flemish art, Jean Michel Massing, 'The Black Magus in the Netherlands from Memling to Rubens', in *Black is Beautiful: Rubens to Dumas*, Elmer Kolfin and Esther Schreuder eds., Exhibition catalogue, Amsterdam, De Nieuwe Kerk, 26 July – 26 October 2008 (Amsterdam: De Nieuwe Kerk and Zwolle: Waanders, 2008), pp. 32–49 (esp. pp. 47–48, fig. 13, for the King's College painting); Jean Michel Massing, *From the "Age of Discovery" to the Age of Abolition: Europe and the World Beyond* (*The Image of the Black in Western Art*, 3.2) (Cambridge, Mass.: Harvard University Press, 2011), pp. 281–282, fig. 187; Elizabeth McGrath, 'Rubens and his black kings', *Rubensbulletin: Koninklijk Museum voor Schone Kunsten Antwerpen*, 2 (1908), pp. 87–100 (esp. p. 99, fig. 7).

44 Julius S. Held, 'Rubens' King of Tunis and Vermeyen's portrait of Mūlāy Aḥmad', *The Art Quarterly*, 3, 1940, pp. 173–181 and 176, fig. 2; Marjorie E. Wieseman, in Peter C. Sutton (ed.), *The Age of Rubens*, Exhibition catalogue, Boston, Museum of Fine Arts, 22 September 1993 – 2 January 1994, and elsewhere (Boston: Distributed by Harry N. Abrams, 1993), pp. 235–237, no. 9, with ill.; Jean Michel Massing, *From the "Age of Discovery"*, pp. 132–137.

45 Julius S. Held, *Selected Drawings*, I (New York: Phaidon, 1959), no. 63 and II, pl. 72.

46 Held, *The Oil Sketches*, I, pp. 457–58, no. 330, pl. 325.

47 Held, *The Oil Sketches*, I, pp. 457–58. According to Rooses, *L'œuvre de Rubens*, 5, 1892, p. 138, a copy of the altarpiece is in the Douai museum; see *Trésors des musées du Nord de la France*, III : *La peinture flamande au temps de Rubens*, (Lille: Association des conservateurs de la région Nord – Pas de Calais, 1977), p. 192.

48 Rodney Tibbs, *King's College Chapel, Cambridge: The Story and the Renovation* (Lavenham: Dalton, 1970); Chainey, 'The east end', pp. 158–164, delves into this story. Only an outline of the discussion can be provided here.

49 Cambridge, King's College Archive Centre, JS/2113, pp. 29–35, for the alternative. In a later dated 29 November 1961, the Reverend V. A. De Waal was not especially preoccupied with the removal of the Blow and Billery panelling, but he thought that the removal of Cornelius Austin's seventeenth-century panelling should be reconsidered. JS/2/13.

50 For example, the editorial, 'Rubens at King's', *The Burlington Magazine*, CXI (1969), p. 413.

51 Cambridge, King's College Archive Centre, KCC/326.

52 Cambridge, King's College Archive Centre, KCGB/6/2/4.

53 Letter by Reverend Victor Alexander De Waal (KC 1959), in JS2/13; also 'Rubens at King's', p. 413.

54 The debate concerning the framing of the altarpiece is for another article.

55 Willis and Clark, *The Architectural History*, p. 486. Woodman, *The Architectural History*, pp. 196, for Henry VI's original plan of having a high altar, at least eight altars in the side chapels and at least two in front of the screen. For the changes in the paving, Woodman, *op. cit.*, pp. 242–43. For the Hacumblen chapel, see Nicola Pickering, pp. 101–113.

56 Gert Van Lon, *Madonna in the Rosary*, 1512–20, oil on panel, ca. 160.2 x 100 cm, Cambridge, King's College. This painting is first recorded in Carl Wilhelm Krüger extensive collection of early German paintings sold by him to the National Gallery in London in 1857: London, Christie and Manson, *Catalogue of Pictures not required for the National Gallery, consisting chiefly of a portion of the Krüger Collection*, Saturday, February 14, 1857, p. 6, no. 17 (for this collection, see Michael Levey, *National Gallery Catalogues, The German School* (London: National Gallery, 1959), pp. 112–114). Following an Act of Parliament, the Gallery was allowed to resell some of them, including the *Madonna in the Rosary*, at Christie's on 14 February 1857. The subsequent whereabouts of the Madonna is not known until it was purchased by Mrs H. S. Ashbee in 1886 or 1887, in a sale of bankrupt stock in Cheapside. From her it passed by descent to her son who gave the painting, which had by then lost its early provenance, to King's College in 1931. See *Verzeichniss der Gemälde-Sammlung des Geheimen Regierungs-Rathes Krüger zu Minden* (Minden: J. C. C. Bruns, 1848), p. 14, no. I.33 (republished by Rolf Fritz, 'Der Katalog der Gemäldesammlung Krüger zu Minden', *Westfalen*, XXIX (1951), p. 89); *Catalogue of the... Pictures*, p. 91; Pevsner, *Cambridgeshire*, p. 93; *Royal Commission*, p. 128; Wieland Koenig, *Studien zum Meister von Liesborn*, (Quellen und Forschungen zur Geschichte des Kreises Beckum, VI) (Beckum: Verein für die Geschichte des Kreises Beckum, 1974), pp. 76–77, no. 33, pl. 110; Michael Wessing, *Gert von Lon. Ein Beitrag zur Geschichte der spätgotischen Malerei Westfalens* (Frankfurt am Main and New York: P. Lang, 1986), pp. 77–80 and 151–152, fig. 23; Jean Michel Massing, 'Gert van Lon's *Madonna in the Rosary*', *Hamilton Kerr Institute Bulletin*, I (1988), pp. 72–75; Jean Michel Massing and Aurélie Petiot, 'In the frame: Gert van Lon, C. R. Ashbee and the Chapel of King's College, Cambridge', *Burlington Magazine*, CLIV (2012), esp. pp. 412–413, fig. 47. In the present article I have adapted my earlier account of the painting.

57 For the iconography of the Rosary, Eithne Wilkins, 'Rosenkranz', *Lexikon der christlichen Ikonographie*, 8 vols (Rome: Herder, 1968–1976), vol. 3, cols. 568–572; Cologne, Erzbischöfliches Diözesan-Museum, *500 Jahre Rosenkranz*, 25 October – 15 January 1976, Cologne 1975. For early representations, van den Oudendijk Pieterse, *Dürers Rosenkranzfest en de ikonografie der duitse rozenkransgroepen van de XVe en het begin der XVIe eeuw* (Amsterdam: Uitgeversbedrijf "De Spieghel", 1939). For the symbolism of cherries, see Ingvar Bergström, 'Disguised symbolism in "Madonna" pictures and still life', *Burlington Magazine*, XCVII, London 1955, p. 304.

58 For his life, Wessing, *Gert von Lon*, pp. 8–16 and 248–249; for the documents, see pp. 231–247 and 251–262.

59 Provenance: *Nonnenkloster in Soest* (An old label indicating that the panel came from a *Nonnenkloster* in Soest is

59. mentioned in the *Catalogue of the... Pictures*, p. 91; this label, now lost, must have been an extract from the *Verzeichniss der Gemäldesammlung... Krüger*, p. 14, which claims that the painting came "Aus einem Nonnenkloster in Soest".

60. Paul Pieper, *Die deutschen, niederländischen und italienischen Tafelbilder bis um 1530* (Westfälisches Landesmuseum für Kunst und Kulturgeschichte Münster... Bestandskataloge) (Münster: Aschendorff, 1986), pp. 293-298, esp. 295-296.

61. Massing and Petiot, 'In the frame', p. 412. On his life, see Alan Crawford, *C. R. Ashbee Architect, Designer and Romantic Socialist* (New Haven and London: Yale University Press, 1985).

62. *Annual Report*, November 16, 1935. On Ashbee's frame, see Massing and Petiot, 'In the frame', pp. 414–416.

63. Massing and Petiot, 'In the frame', p. 412. Letter dated June 1932 from C. R. Ashbee to the Dean of King's College, Eric Milner-White (Cambridge, King's College Archive Centre, KC/KCAR/KCC/364); Jean Michel Massing and Aurélie Petiot, 'Appendix to "In the frame: Gert van Lon, C. R. Ashbee"', online Supplement to the *Burlington Magazine*, CLIV (2012), p. 2.

64. Jean Michel Massing and Aurélie Petiot, 'Appendix to "In the frame"', pp. 1–2.

65. Massing and Petiot, 'In the frame', p. 414.

66. Master of the Von Groote Adoration, *Triptych with the Adoration of the Magi, the Nativity and the Flight into Egypt*, ca. 1515–1520, oil on panel: central panel, 118 x 85.8 cm; wings, 118 x 43 cm. each; overall size, 118 x 171.7 cm. Provenance: probably Robert Finck, Brussels; Paris, H. Barcilon; from whom acquired by the previous owner who sold it in New York, Sotheby's, 28 January 2010, lot 152; acquired, through the good will of Johnny Van Haeften, by King's College and given by P. K. (Sunny) Pal (KC1955) and his family to King's for the Chapel. First mentioned by Georges Marlier, *La Renaissance flamande: Pierre Coeck d'Alost* (Brussels: R. Finck, 1966), pp. 136–138, fig. 62; New York, Sotheby's, 28 January 2010, *Important Old Master Paintings, including European Works of Art*, lot 152: as Jan van Dornicke, formerly known as "The Master of 1518". The purchase was announced, and the triptych reproduced, in 'A Kingsman's Thank You', in *King's Parade: Magazine for Members and Friends of King's College, Cambridge*, Cambridge, Spring 2012, pp. 14–15.

67. Marlier, *La Renaissance flamande*, pp. 137–138, fig. 62.

68. Max Jakob Friedländer, 'Der Antwerpener Meister von 1518', *Amtliche Berichte aus den königlichen Kunstsammlungen*, 29 (1907–1908), cols. 227-229; see also Friedländer, 'Die Antwerpener Manieristen von 1520', *Jahrbuch der königlich preuszischen Kunstsammlungen*, 36 (1915), pp. 81-86. See also Annick Born, in *Extravagant! A Forgotten Chapter of Antwerp Painting 1500-1530*, *Catalogue*, Peter van den Brink and Maximiliaan P. J. Martens eds., Exhibition catalogue, Antwerp, Koninklijk Museum voor Schone Kunsten Antwerpen, 15 October – 31 December 2005, and elsewhere (Antwerp: Koninklijk Museum voor Schone Kunsten, 2005), p. 196 and, for Jan Mertens van Dornicke, *idem*, p. 225.

69. Jochen Sander, in *Extravagant!*, pp. 154-155, no. 64, with ills.

70. Paul Kaplan, *The Rise of the Black Magus in Western Art* (Ann Arbor: UMI Research Press, 1985), for this iconography.

71. A comparison between the central part in the photograph of Marlier's book and the present state shows that numerous repaints must have been removed when it was cleaned, sometime before its sale.

72. Dan Ewing, 'Magi and merchants: the force behind the Antwerp Mannerists' Adoration pictures', *Jaarboek Koninklijk Museum voor Schone Kunsten Antwerpen 2004/05*, Antwerp 2006, pp. 281-294.

73. Ewing, 'Magi and merchants', pp. 275-299.

74. See for example Ewing, 'Magi and merchants', pp. 278 and 280, with specific examples.

75. Dan Ewing, in *Extravagant!*, pp. 64-67, no. 21, with ills; for the Städel's Adoration of the Magi, see Jochen Sander, in *Extravagant!*, pp. 156-157, no. 65, with ill.

76. Marlier, *La Renaissance flamande*, pp. 138-142, figs 64-68. All together there are at least ten copies and later versions based on the Cambridge altarpiece, which beg further study.

77. I have adopted something of Jochen Sander's definition of the style of the artist, in *Extravagant!*, p. 154.

78. Carlo Maratta, *Virgin and Child, with the young John the Baptist*, oil on canvas, 97 x 74 cm. Provenance: given to the College in 1963 by A. C. H. Parker-Smith (KC. 1902) in memory of his nephew George James Frazer, Scholar (KC 1951), who died climbing in Pakistan in 1959.

79. *Aedes Walpolianae: or, A Description of the Collection of Pictures at Houghton-Hall in Norfolk, the Seat of the Right Honourable Sir Robert Walpole, Earl of Orford, The Second Edition with Additions* (London 1752), p. 58; Larissa Dukelskaya and Andrew Moore eds., *A Capital Collection: Houghton Hall and the Hermitage*, (New Haven and London: Yale University Press, 2002), pp. 228 and 137, no. and fig. 43; Svetlana Vsevoložkaja, *Museo Statale Ermitage: La pittura italiana del Seicento* (Milano: Skira, 2010), pp. 156 and 228, no. and fig. 140, with full bibliography; Thierry Morel, in Houghton Hall, King's Lynn, *Houghton Revisited: The Walpole Masterpieces from Catherine the Great's Hermitage*, Exhibition catalogue, 17 May – 29 September [recte 24 November] 2013 (London: Royal Academy of Arts, 2013), pp. 166 and 230, no. and fig. 34. Visiting this exhibition led to the identification of the artistic context of the King's College painting, independently made by Kristen Lippincott and by me: see Kristen Lippincott, *An Introduction to King's College Chapel* (Cambridge: King's College, 2013), p. 82, with ill.

80. A more precise attribution will be made easier with the publication of the *Catalogue raisonné* of the artist's painting announced by Stella Rudolph. Of interest, but not directly relevant, is a print by Maratta of the Virgin and Child, with the young John the Baptist: Paolo Bellini, *L'opera incisa di Carlo Maratti* (Pavia: Museo Civico, Castello Visconteo, 1977), pp. 33-35, no. 1.

VI

The Great Glass Vista: A Condition Survey of the Stained Glass in King's College Chapel
STEPHEN CLARE

1. Stephen Clare Stained Glass Consultancy, 'An investigation into the condition of the stained glass with recommendations towards a conservation strategy' (2010).

2. The present Glaziers Hall is at Montague Close at the foot of London Bridge in Southwark. The original Hall, probably at Old Fish Street Hill in the City, was destroyed in the great fire of 1666.

3. The twenty five great windows to the Chapel at King's College are each five metres wide and 12 metres high.

4. The position of King's Glazier was a coveted one on the royal payroll. Window 2, the only complete window by Flower, depicts a golden table offered to Apollo, the presentation and marriage of the Virgin, and the marriage of Tobias and Sara (windows are referred to in the standard manner, numbered from the most western window on the north side round the east end and back down the south side, culminating in the west window). See H. G. Wayment, *The Windows of King's College Chapel Cambridge*, Corpus Vitrearum Medii Aevi (Oxford: Oxford University Press 1972), pp. 49–51. This volume follows Wayment's method of numbering the windows, running from the most western window on the north side round the east end and back along the south side to the west window, 1–26.

5. Kenneth Harrison, 'Glazing in England: the Southwark School', in Wayment, *The Windows of King's College Chapel*, pp. 9–11 (pp. 9, 10).

6. Wayment, *The Windows of King's College Chapel*, pp. 82–85.

7. See Walter Rosenhain, *Glass manufacture* (London: Constable and Company, 1915), pp. 148–176.

8. Steve Clare, 'Stained Glass', in *Art, Craft and Conservation* (London: Robert Hale, 2013), pp. 130–132.

9. This study relied heavily on the expertise and goodwill of the College archivist, Patricia McGuire.

10. KCA, KCC/61/1 and 2.

11. The stained glass cement is the linseed oil/ chalk putty, which is brushed beneath the flanges of the lead to waterproof the panels. Over time the cement degrades and becomes friable.

12. The reason for the Gloucester survey was to evaluate the cheapest and least obnoxious form of heating fuel. At Gloucester it was reported that at times 'the smell of brimstone was almost unbearable' (Gloucester Cathedral Archives, AP/001/Box 1, Survey of Cathedral Heating).

13. In February 1867, R. Wightman, a minor canon at York Minster wrote a glowing recommendation of the Gurney stoves in place at York with references to King's College Chapel. In that letter the weekly coke consumption of the stoves installed at King's is clearly set out. Costs were estimated at 1d per hour per stove (Gloucester Cathedral Archives: AP/001/Box 1, Survey of Cathedral Heating).

14. For documentation of this job, estimated at a cost of £72.00, see KCA, KCC/56/5. The file shows that the same company also proposed (unsuccessfully) to install a hot-water radiator system with radiators running along the top of the choir stalls and behind the altar.

VII

The College and the Chapel
PETER MURRAY JONES

1. I should like to acknowledge the great help given to me by the Archivist of King's College, Dr Patricia McGuire, without whose assistance this chapter could not have been written.

2. The background to the fountain commission is described at http://www.kings.cam.ac.uk/archive-centre/archive-month/august-2010.html

3. As directed in the Founder's statutes of 1453, these requiem masses were to continue in perpetuity. The Chapel was also to provide other forms of divine service, of course.

4. John Saltmarsh, 'The Side Chapels', unpublished manuscript in KCA, PP/JS/1/67, p. 141. This part of the chapter draws extensively on Saltmarsh's meticulous analysis of the building, decoration and use of the side chapels.

5. Endowments of chantries are recorded in the College Ledger Books (KCA, KCAR/3/3/1/1). William Towne, for example, gave 60 marks: Ledger Book 1, fols. 167v–8; see A. B. Emden, *Biographical Register of the University of Cambridge to 1500* (Cambridge: University Press, 1963), pp. 592–3.

6. London, BL, Additional MS 5802, fol. 94r. For William Cole, see John D. Pickles, *Oxford Dictionary of National Biography*.

7. Saltmarsh, 'Side Chapels', pp. 155–6; Emden, *Biographical Register*, p. 308.

8. Robert Willis and John Willis Clark, *The Architectural History of the University of Cambridge, and of the Colleges of Cambridge and Eton*, 4 vols (Cambridge: University Press, 1886), vol. 1, p. 489.

9. KCA, KCAR/4/1/4/20, Bursars Particular Books (1587–8), 'Reparacio novi templi': '30 foote of glasse to Mr Provosts chappell wyndow, 20s.'.

10. Eric Milner-White, 'The Royal Chantry in King's College Chapel', *The Cambridge Review*, 11 October 1935, p. 11; Saltmarsh, 'Side Chapels', p. 159.

11. London, BL, Additional MS 5802, fols 78v, 79v.

12. KCA, PP/CRA/1/2, quoted by Graham Chainey, *In Celebration of King's College Chapel* (Cambridge: Pevensey, 1987), p. 51. For Ashbee and the Chapel, see Jean Michel Massing and Aurélie Petiot, 'In the Frame: Gert van Lon, C. R. Ashbee and the Chapel of King's College, Cambridge', *Burlington Magazine*, 154 (2012), 412–16.

381

13 Records for funerals and memorial services (as well as marriages and baptisms) may be found in KCA, CSV/21.

14 Statutes of King's College, cap. 31, in James Heywood and Thomas Wright, *The ancient laws of the fifteenth century, for King's College, Cambridge, and for the public school of Eton College* (London: Longman, Brown, Green and Longmans, 1850), pp. 93–5.

15 John Saltmarsh, *King's College: a Short History* (Cambridge: Cambridge University Press, 1958), p. 26, quoting KCA, KCAC/2/1/2, Protocollum Book (1577–1627), p. 22.

16 On difficulties in controlling disputations in this period see Victor Morgan, *A History of the University of Cambridge*, vol. 2: *1546–1750* (Cambridge: Cambridge University Press, 2004), pp. 128–31. See also William T. Costello, *The Scholastic Curriculum at Early Seventeenth-Century Cambridge* (Cambridge, MA: Harvard University Press, 1958), pp. 14–31.

17 John Gascoigne, *Cambridge in the Age of Enlightenment: Science, Religion and Politics from the Restoration to the French Revolution* (Cambridge: Cambridge University Press, 1989), p. 7.

18 Saltmarsh, *King's College*, pp. 68–9; Willis and Clark, *Architectural History*, vol. 3, p. 504.

19 Saltmarsh, *King's College*, p. 55, quoting KCA, KCAC/2/1/1, Protocollum Book (1500–78), p. 246.

20 Goad's answers to accusations against him, 1576, printed in Heywood and Wright, *Ancient Laws*, pp. 229, 233, as described by Saltmarsh, *King's College*, p. 47. See also W. D. J. Cargill Thompson, 'Notes on King's College Library, 1500–1570, in particular for the period of the Reformation', *Transactions of the Cambridge Bibliographical Society*, 2 (1954), 38–54 (p. 38).

21 KCA, KCAR/4/1/4/3–5: Bursars Particular Books (1569–70), 'Expensis necessarie'; (1570–71) 'Custus Ecclesie': 'for rubbing the deskes in the librarie, 12d'; 'Margaret pro purgacione the librarie, 4d'; 'for colouring of the library chamber, 6d'; (1571–2), 'Expensis necessarie': 'pro Cappe for binding the ould bibles and coveringe them, 25s'; 'for a newe booke emptus Londonini, 4s 2d'. There are similar entries in subsequent years.

22 The donors book is KCA, MS Lib. 1. It was begun *c*.1612, with Walsingham's name written calligraphically.

23 Willis and Clark, *Architectural History*, vol. 1, pp. 538–40.

24 Nicholas Hobart (1) and Thomas Crouch (2).

25 William Cole in London, BL, Additional MS 5802, fol. 97.

26 Occasional reference to acquisition of these are found in the College Archives. Two pictures of heavenly constellations were given by John Banister, the surgeon to the Queen (on Banister, see Andrew Griffin, *ODNB*) and payment for their frames was made in 1590–1 (KCA, KCAR/4/1/4/23, Bursars Particular Books (1590–91), 'Expensis necessarie').

27 Transcribed in Willis and Clark, *Architectural History*, vol. 3, pp. 398–400.

28 London, BL, Additional MS 5802, quoted by Willis and Clark, *Architectural History*, vol. 1, p. 540, and by John Saltmarsh, 'The Muniments of King's College', *Cambridge Antiquarian Society's Communications* 33 (1933), 83–97 (p. 84), on which this account relies.

29 KCA, KCAC/2/1, Protocollum Book (1500–1578), p. 154. For Guest, see Jane Freeman, *ODNB*.

30 KCA, KCAC/2/2, Protocollum Book (1577–1627), pp. 19, 23, 29, 43. Augustus Austen-Leigh, *King's College* (London: F. E. Robinson, 1899), pp. 73–85, describes the 'disorders' of these years, and the Visitor's attempts to end them.

31 KCA, KCAC/2/2, Protocollum Book (1577–1627), p. 251.

32 KCA, KCAC/2/4, Protocollum Book (1678–1728), p. 167: 'publicis precibus et divinis officiis in sacello infrequentius esset'.

33 Meaning that they could not be excused from Chapel.

34 Original MS in KCA, Coll. 19.3; TS copy in Library, p. 7. Quoted by Austen-Leigh, *King's College*, p. 246.

35 Christopher Brooke, *A History of the University of Cambridge*, 4: *1870–1990* (Cambridge: Cambridge University Press, 1993), p. 111. See also Ross Harrison below, 'The Start and Stop of Simeon', p. 225.

36 *Augustus Austen Leigh Provost of King's College, Cambridge: A Record of College Reform*, ed. William Austen Leigh (London: Smith, Elder, 1906), pp. 118–21. The signed manuscript of the 1871 petition is in KCA, KC/71, the printed version in CSV/38.

37 L. P. Wilkinson, *A Century of King's 1873–1972* (Cambridge: King's College, 1980), pp. 10–11.

38 KCA, KCAC/5/1.

39 *Charles Vickery Hawkins: Memorials of his Life*, ed. W. H. Waddington and J. T. Inskip (London: Hodder and Stoughton, 1896), pp. 165–6.

40 KCA, PP/EJD/3/1. E. J. Dent noted in his diary for 11 November 1904 that he had received a copy from 'M' (probably H. O. Meredith, an Apostle), and showed it to 'Ted', probably E. S. P. Haynes (I owe these identifications to Karen Arrandale). See William C. Lubenow, *The Cambridge Apostles, 1820–1914: Liberalism, Imagination, and Friendship in British intellectual and professional Life* (Cambridge: Cambridge University Press, 1998).

41 *St John's College Cambridge: A History*, ed. Peter Linehan (Woodbridge: Boydell Press, 2011), p. 408.

42 KCA, KCGB/5/1/4/7.

43 See below, Nicolette Zeeman, 'The Chapel Imagined, 1540–1830', pp. 204, 207–8; Abigail Rokison, 'Drama in the Chapel', pp. 243–47.

44 The 1689 election is described best in Saltmarsh, *King's College*, pp. 62–5. An absolute majority of Fellows present was needed to elect a Provost. See also the colourful narrative account by John Reynolds (*c*.1705) printed in Charles Henry Cooper, *Annals of Cambridge*, 5 vols (Cambridge: Cambridge University Press, 1908), vol. 5, pp. 478–81. Original letters and documents, including the votes cast, are in KCA, KCP/22.

45 John Nichols, *Illustrations of the Literary History of the Eighteenth Century ...* (New York: Kraus Reprint Corp., 1966), vol. I, pp. 95–6. The scrutators' reports of 10 of the 11 votes taken in 1743 survive in KCA, KCP/22; they confirm that six of Thackeray's supporters gave in by the eleventh vote, and either transferred their votes to George, or did not vote.

VIII

A Spanish Choirbook and Some Elizabethan Book Thieves

Iain Fenlon

1. M. R. James, *A Descriptive Catalogue of the Manuscripts other than Oriental in the Library of King's College, Cambridge* (Cambridge: Cambridge University Press, 1895), pp. 67–8.

2. The manuscript measures 79.8 cm in height and 21.2 cm in width. The ruled space is 64.1 cm x 39.5 cm, and there are twelve lines of text per page. The boards measure 85.3 cm × 57.1 cm.

3. The book contains just sixteen complete psalms and a number of incomplete ones.

4. George Edmund Street, *Gothic Architecture in Spain*, 2 vols (London: John Murray, 1914), pp. 17–18.

5. The diary, which is written in Latin, is kept in the Vatican Library as Reg. Lat. 666, having passed through the collections of Queen Christina of Sweden. For the best general introduction to the manuscript see Jeanne Odier, 'Voyage en France d'un jeune Morave, 1599–1600', *Mélanges d'archéologie et d'histoire* 53 (1926), 140–73. The portions of the diary relating to Waldstein's time in England are translated with an introduction and running commentary in *The Diary of Baron Waldstein: A Traveller in Elizabethan England*, ed. G. W. Groos (London: Thames and Hudson, 1981).

6. *Paul Hentzner's Travels in England during the Period of Queen Elizabeth*, ed. R. Bentley (London: Edward Jeffrey, 1797); Clare Williams, *Thomas Platter's Travels in England* (London: Jonathan Cape, 1937).

7. For a detailed account of the episode of the Duke and the Order of the Garter, see W. Brenchley Rye, *England as seen by Foreigners, in the Days of Elizabeth and James the first, comprising Translations of the Journals of the two Dukes of Wirtemberg* (London: John Russell Smith, 1865), pp. lv–ciii. For Shakespeare's depiction, see *The Merry Wives of Windsor*, Act IV, scene v.

8. *The Diary of Baron Waldstein*, p. 73.

9. The book that Waldstein saw, a copy of the Fust and Schoeffler edition of 1465, printed on vellum and illuminated, is still in Emmanuel College Library. For a brief description and discussion of the illuminations see J. J. G. Alexander, 'Foreign illuminators and illuminated manuscripts', *The Cambridge History of the Book in Britain*, 3, ed. Lotte Hellinga and J. B. Trapp (Cambridge: Cambridge University Press, 1999), pp. 47–64 (p. 63).

10. See above, Peter Murray Jones, 'The College and the Chapel', pp. 168–74.

11. *The Diary of Baron Waldstein*, pp. 106–7 (first line emended and translation altered).

12. See the letter from G. W. Groos to A. N. L. Munby, Benghazi, 17 March 1972, and Munby's reply of 21 March 1972 in which he enquired whether the missing verses had been transcribed by Waldstein. That they had is revealed in a further letter from Groos, Benghazi, 19 May 1972; Groos subsequently supplied photographs of the verses as copied by Waldstein into the Vatican manuscript. This documentation is kept in the Librarian's interleaved copy of the James catalogue in the King's College Archive.

13. James, *A Descriptive Catalogue*, p. 67. James's opinion was probably based on an eighteenth-century label, which had probably been previously kept with the manuscript, and which was laid down to the front endpaper when the manuscript was restored in the nineteenth century. It reads 'From the library of Osonius [sic] Bp of Cadiz in the latter of Q[uee]n Eliz[eth] by Earl of Essex'.

14. For overviews see Julian Stafford Corbett, *The Successors of Drake* (London: Longmans, Green and Company, 1900), and R. B. Wernham, *The Return of the Armadas. The Last Years of the Elizabethan War against Spain, 1595–1603* (Oxford: Clarendon Press, 1994). For different perspectives see Magdalena de Pazzis Pi Corrales, 'The view from Spain: distant images and English political reality in the late sixteenth century', and Bernardo J. Garcia Garcia, 'Peace with England, from convenience to necessity, 1596–1604', both in *Material and Symbolic Circulation between Spain and England, 1554–1604*, ed. Anne J. Cruz (Aldershot: Ashgate, 2008), pp. 13–27 and 135–149.

15. Stephen and Elizabeth Usherwood, *The Counter-Armada, 1596: The Journall of the 'Mary Rose'* (London: The Bodley Head, 1983), pp. 16–17. This edition with commentary of Lambeth Palace Library MS 250, a diary in the hand of Sir George Carew, Master of Ordnance and Captain of the 'Mary Rose', is particularly valuable as the 'only account...undistorted by hindsight' (p. 20).

16. A. de Castro: *Historia del saqueo de Cádiz por los ingleses...escrita por fr. Pedro de Abreu. Publicase con otras relaciones contemporaneas y documentos illustratorios* (Cádiz: Revistamédica, 1866), p. 2.

17. Corbett, *The Successors of Drake*, p. 116.

18. Cruz, 'Vindicating the *Vulnerata*', p. 48.

19. Peter Davidson, 'The solemnity of the Madonna Vulnerata, Valladolid, 1600', *The Triumphs of the Defeated. Early Modern Festivals and Messages of Legitimacy*, ed. Peter Davidson and Jill Bepler (Wiesbaden: Harrossowitz, 2007), pp. 39–54.

20. Castro, *Historia del saqueo*, p. 7.

21. P. S. Allen, 'Books brought from Spain in 1596', *English Historical Review* 31 (1916), 606–10 (pp. 609–10), gives a figure of seventeen. However, only nine of the volumes now in Hereford contain an inscription indicating that they were removed from Cadiz.

22. Gerald Aylmer and John Tiller, *Hereford Cathedral. A History* (London: Hambledon Press, 2000), p. 518, n.35. The 1618 purchase involved thirty-three works in thirty-one volumes. I am grateful to Rosemary Firman of Hereford Cathedral Library both for this information and that in the previous footnote.

23. Edinburgh, National Library of Scotland, MS 1905 is a sixteenth-century Spanish antiphoner copied on vellum, with elaborate penwork initial letters, bound in oak boards with brass mountings and cornerpieces; for a summary description see *National Library of Scotland Catalogue of Manuscripts Acquired since 1925*, 8 vols to date (London: HMSO, 1938–92), vol. 2, p. 18. The inscription by Hoby is on the first fly leaf, now laid down to the inside of the upper cover; the name of Peter Norris and the date 1602 occur on fol. 1. MS 1905 was presented to the Society of Antiquaries of Scotland by Charles Hope Weir of Craigehall in 1792; see William Smellie, *Account of the Institution and Progress of the Society of Antiquaries of Scotland* (Edinburgh: Society of the Antiquaries of Scotland, 1782), p. 160. A letter in the archive of the Society (now in the Museum of Scotland) offering the manuscript to the Antiquaries states that Hope Weir had bought it some years earlier from a 'virtuoso', that is a professional musician (see the letterbook for the years 1781–82, fol. 316, and the Minutes of the Society, November 1780–November 1784, p. 145). MS 1905 was transferred to the National Library of Scotland in 1934. I am very grateful to Ross Anderson for his guidance.

24. For a list of those knighted at Cadiz, see Usherwood, The Counter-Armada, 1596, pp. 87–8.

25 M. M. Coignet, *Instruction aux princes pour garder la foy promise contenant un sommaire de la philosophie chrestienne & morale, & devoir d'un homme de bien. En plusieurs discours politiques sur la verité et le mensonge* (Paris: Jacques de Puy, 1584), translated by Sir Edward Hoby as *Politique Discourses upon Trueth and Lying: An Instruction to princes to keepe their faith and promise: containing the summe of Christian and moral philosophie, and the duetie of a good man in sundrie politique discourses upon trueth and lying* (London: John Windet for Ralph Newberrie, 1586).

26 London, Lambeth Palace Library MS 250; see above, note 15.

27 Gustav Ungerer, *A Spaniard in Elizabethan England: The Correspondence of Antonio Perez's Exile*, 2 vols (London: Tamesis, 1975). *The Historie of Aracuana* is preserved in Lambeth Palace Library MS 688.

28 Bernardino de Mendoza, *Theórica y pratica de la guerra* translated as *Theorique and practice of warre. Written to Prince Philip Prince of Castil…translated out of the Castilian tonge into English by Sir Edward Hoby knighted. Directed to Sr. George Carew* ([Middelburg]: printed by Richard Schilders, 1597).

29 *The Naval Tracts of Sir William Monson in Six Books*, ed. M. Oppenheim, 6 vols (London: Navy Records Society, 1902–), vol. 1, p. 354.

30 Usherwood, *The Counter-Armada, 1596*, p. 101

31 K. M. Pogson, 'A grand inquisitor and his library', *Bodleian Library Record*, 3 (1922), 239–44. A list of the books donated by Essex appears in the Bodleian Library *Registrum Benefactorum* for 1600; see also I. Michael 'How Don Quixote came to Oxford: The Two Bodleian Copies of Don Quixote, Part I (Madrid: Juan de la Cuesta, 1605), in *Culture and Society in Hapsburg Spain. Studies presented to R. W. Truman by his Pupils and Colleagues on the Occasion of his Retirement*, ed. Nigel Griffin, Clive Griffin, Eric Southworth and Colin Thompson (London: Tamesis, 2001), pp. 95–120.

32 Diôgo Barbosa Machado, *Bibliotheca Lusitana historica, critica, e cronologica*, 4 vols (Lisbon: Antonio Isidoro da Fonseca, 1741–59), vol. 2, pp. 31–34.

33 Pogson, 'A grand inquisitor and his library', p. 240.

34 For the works by Portuguese authors see the listings in T. F. Earle, *Portuguese Writers and English Readers. Books by Portuguese Writers Printed before 1640 in the Libraries of Oxford and Cambridge* (Oxford: Oxford Bibliographical Society, 2009).

35 Fernando Martins Mascarenhas, *Tractatus de auxiliis divinae gratiae* (Lyon: H. Cardon, 1605).

36 Tomás Luis de Victoria, *Motecta festorum totius anni cum communi sanctorum. Quae partim senis, partim quinis, partim quaternis, alia octonis vocibus concinuntur* (Rome: Gardano, 1585).

37 It is described in John Milsom, *Christ Church Library Music Catalogue 2004* (http://library.chch.ox.ac.uk/music/; last accessed December 2013).

38 W. W. Rouse Ball and J. A. Venn, *Admissions to Trinity College, Cambridge*, 5 vols (London: Macmillan, 1913), vol. 2, p. 115.

39 Interestingly, the remarks of Sir William Monson in *The Naval Tracts*, ed. Oppenheim, vol. 1, p. 354, record that the 'library was brought into England by us, and many of the books bestowed upon the new-erected library of Oxford', which leaves the impression that not all of the volumes from the raid on Faro were donated to Bodley.

40 Documents in the College archives indicate that the book was re-bound in late 1597 o.s. See KCAR/4/1/4/30: 'Expensis necessarie', Term Nat.: 'Solut(is) Jones stationarius pro ligando Cales psalter ut patet per billam viiis'. The same information is repeated in KCAR/4/1/1, Mundum Book (1598). I am grateful to Peter Jones and Patricia McGuire for alerting me to these references.

41 Usherwood, *The Counter-Armada, 1596*, pp. 84–5.

42 Fray Pedro de Abreu, *Historia del saqueo de Cádiz por los inglese en 1596*, ed. Manuel Bustos Rodríguez (Cádiz: Universidad de Cádiz, 1966), p. 256.

43 Castro, *Historia del saqueo*, p. 28, which reports that the invaders left with 'un espoio valuado en mas de octo milliones, despues de haber puesto fuego por despedida á los templos y casas principals de la ciudad'.

44 Oxford, Corpus Christi College, MS 297, fols 23–24v, cited in Paul E. J. Hammer, 'Myth-making: politics, propaganda and the capture of Cadiz in 1596', *The Historical Journal* 40 (1997), 621–42 (p. 625).

45 Hammer, 'Myth-making', p. 624.

46 The translation is taken from *The Diary of Baron Waldstein*, p. 106.

47 Hammer, 'Myth-making', pp. 621–642.

48 L. W. Henry, 'The Earl of Essex as strategist and military organizer (1596-7)', *English Historical Review* 68 (1953), 363–93.

49 Ungerer, *A Spaniard in Elizabethan England*, p. 171.

50 Hammer, 'Myth-making', p. 628.

51 Hammer, 'Myth-making', pp. 632–3.

52 Ungerer, *A Spaniard in Elizabethan England*, pp. 191–2.

53 For a discussion see Hammer, 'Myth-making', pp. 636–7.

54 R. Hakluyt, *The Principall Navigations. Voiages and Discoveries of the English Nation* (London: George Bishop, Ralph Newberie, and Robert Barker, 1598). See Charles E. Armstrong, 'The "Voyage to Cadiz" in the second edition of Hakluyt's "Voyages"', *Papers of the Bibliographical Society of America* 49 (1955), 254–62; *The Hakluyt Handbook*, ed. D. B. Quinn, 2 vols (London: The Hakluyt Society, 1974), vol. 2, pp. 490–97.

55 Armstrong, 'The "Voyage to Cadiz"', pp. 260–61.

56 Arthur Mayger Hind, *Engraving in England in the Sixteenth and Seventeenth Centuries*, 3 vols (Cambridge: Cambridge University Press, 1952–64), vol. 1, pp. 267–8 and plate 150.

57 Hammer, 'Myth-making', p. 639.

58 The Rogers engraving presumably dates from the earlier phase of the Irish campaign.

59 Hind, *Engraving in England*, vol. 1, pp. 245–6, and plate 126.

60 See above, p. 192.

61 Henry Kamen, *Philip of Spain* (New Haven and London: Yale University Press, 1997), chapters 10 and 11.

62 Richard L. Kagan, *Lucrecia's Dreams: Politics and Prophecy in Sixteenth-century Spain* (Berkeley and Oxford: University of California Press, 1990), especially pp. 90–93.

63 Cambridge University Library, MS Gg. VI. 19. See *A Catalogue of the Manuscripts Preserved in the Library of the University of Cambridge*, 5 vols (Cambridge: Cambridge University Press, 1856–1867), vol. 3, pp. 222–223, where the manuscript is incorrectly dated to 1588. The text, which is anonymous, also circulated in an English translation thought to have originated from within the Essex circle; see Ungerer: *A Spaniard in Elizabethan England*, p. 275.

64 Cambridge University Library, MS Gg. VI. 19, fol. 292. For the symbolism of the pomegranate, whose many seeds contained in a tough skin functioned as a symbol of the unity of the many under one authority, see James Hall, *A Dictionary of Subjects and Symbols in Art* (rev. edn, London: Murray, 1979), p. 249.

65 Cambridge University Library, MS Gg. VI. 19, fol. 123v.

66 *The Diary of Baron Waldstein*, pp. 106–7.

67 'A pare of gloves given to ye Earle of Essex, 10s', KCA, KCAR/4/1/4/27, Bursar's Particular Books (1594/5), 'Expense Necessarie'. For the presentation of gloves to Queen Elizabeth, see Charles Henry Cooper, *Annals of Cambridge*, 5 vols (Cambridge: Warwick and the University Press, 1842–1908), vol. 2, p. 191; see also vol. 2, pp. 185, 199. I am grateful to Peter Jones for his contributions at this point.

68 'William Temple (1554/5–1627)', *Oxford Dictionary of National Biography*, ed. H. C. G. Matthew and Brian Harrison (Oxford: Oxford University Press, 2004); http://libsta28.lib.cam.ac.uk:2072/view/article/27121?docPos=2; last accessed 9 April 2014. Temple was a Fellow of King's from 1576–83.

69 KCA, KCAR/4/1/4/29, Particular Book (1596–7), 'Custus Ecclesie', Term Bapt.

70 The receipt for the work (which was carried out by H. R. Wiseman), dated 8 August 1855, is preserved in KCA, KC/6/1/19 (formerly LIB/10/1), booksellers and binders receipts 1837–64: 'MS Very Large Folio, many leaves repairing, Stout Oak Boards, Bevilled & French Polished Brass Ornaments cleaned and fastened, New brass slips &c. Half Stout Morocco, Antique Style £4.10s'. I thank Peter Jones who located this document for me. In this period Wiseman's business operated from 9, Trinity Street, Cambridge (*Cambridge Directory*).

IX

The Chapel Imagined, 1540–1830

Nicolette Zeeman

1 I would like to record here warm thanks to the many who have contributed invaluable references and advice for this essay: perhaps above all Peter Jones and Patricia Mcguire, but also Roger Bowers, Timothy Easton, Maggie Goodall, Jeremy Musson and Tilly Zeeman.

2 See A. Austen Leigh, *King's College* (London: Robinson, 1889), p. 57; for a reconstruction of the groundplan, see J. W. Clark, 'On the old Provost's Lodge of King's College', *Cambridge Antiquarian Communications* 4 (1876–80), 285–312 (p. 287).

3 Robert Willis and John Willis Clark, *The Architectural History of the University of Cambridge and of the Colleges of Cambridge and Eton*, 4 vols (Cambridge: Cambridge University Press, 1886), vol. 1, pp. 534–5; and Roger Bowers below, 'Chapel and Choir, Liturgy and Music, 1444–1644', p. 259. To imagine what the Chapel might have looked like during the building hiatus of 1485–1508, when the first five bays of the choir were completed and temporarily walled in, but the rest of the building only low foundation walls, we might compare early images of Cologne Cathedral with its choir complete but nave and transepts raised only to the first elevation (Ill. 154). On the building hiatus, see Willis and Clark, *The Architectural History*, vol. 1, pp. 489–90; Francis Woodman, *The Architectural History of King's College Chapel* (London: Routledge & Kegan Paul, 1986), pp. 153–7.

4 Peterhouse, for example, worshiped in the chancel of Little St Mary's until the seventeenth century; see C. Roman, *Peterhouse. The College and the Chapel* (Cambridge: Peterhouse, [1973]), [p. 3].

5 See J. Willis Clark and Arthur Gray, *Old Plans of Cambridge 1574 to 1798…reproduced in Facsimile*, 2 parts (Cambridge: Bowes & Bowes, 1921), pp. 19–20; Georg Braun and Franz Hogenberg, *Cantebrigia*, 1575, in *Civitates orbis terrarum*, 3 vols ([Coloniae Agrippinae, 1572]–1618), vol. 2.

6 See Austen Leigh, *King's College*, p. 32.

7 Visible in front of the eastermost bay are the clock tower and some kind of paling; behind this must have been the entrance to the Chapel used by the Provost, and also by Elizabeth I on her visit in 1564; see Willis and Clark, *The Architectural History*, vol. 1, pp. 532–4; and Abigail Rokison below, 'Drama in King's College Chapel', pp. 243–46.

8 Clark and Gray comment on the sporadic gates (*Old Plans*, p. 6).

9 Noting this feature of Lyne, see Clark and Gray, *Old Plans*, p. 10. For the layout of this area with alleys, trees, a cemetary and a bowling green, and for the fish ponds and pigeon house beyond the river, see Edmund Carter, *The History of the University of Cambridge* (London: printed for the author, 1753), pp. 162–3; Leigh, *King's College*, pp. 201–2.

10 See the antiquary William Cole (1714–1782), who stayed for seventeen years at King's while studying, among other things, the College and the surrounding area, cited in Austen Leigh, *King's College*, p. 173.

11 The Latin term *ecclesia* appears regularly in the College accounts, as in the heading 'Custus ecclesie' ('expenditure of the church'); for early references to the Chapel in English as a 'church', see Charles Henry Cooper, *Annals of Cambridge*, 5 vols (Cambridge: Warwick and the University Press, 1842–1908), vol. I, p. 229; vol. 2, pp. 185–6, 192. For use of the term *templum*, see below.

12 I would like to record at the outset how much this essay owes to *In Celebration of King's College Chapel*, compiled by Graham Chainey (Cambridge: The Pevensey Press, 1987), itself dependent on *King's College Chapel. Comments and Opinions* (Cambridge: King's College, 1956).

13 Austen Leigh, *King's College*, p. 111. For University use of the Chapel when it was not possible to hold services in Great St Mary's in 1557/8, see Cooper, *Annals*, vol. 2, p. 114; and for Chapel use at the 1559 Visitation of the University, see vol. 2, pp. 157–8. William Cole notes that in the eighteenth century the University celebrated in the Chapel annually on 30 December (see London, BL, MS Add. 5802, fol.117/110r); and for University attendance on Lady Day, 25 March, see Henry Malden, Chapel Clerk, *An Account of King's College Chapel in Cambridge* (Cambridge: Fletcher and Hodson, 1769; repr. Menston: Scolar Press, 1973), p. 66 (for the actual authorship of this volume, see the prefatory Note). For University use of the Chapel in the nineteenth century when Great St Mary's was being repaired, see Congregation Minutes (1779–1808), 25 July, 1804, and Congregation Minutes (1855–66), 25 November, 1862 (KCA, KCGB/4/1/1/80).

14 *The Diary of Samuel Pepys*, ed. Robert Latham and William Matthew, 11 vols (London: Bell, 1970–83) vol. 3, p. 224 (1662); vol. 8, p. 468 (1667).

15 Cooper, *Annals*, vol. 3, pp. 249–50; vol. 3, pp. 321, 549, 591; vol. 4, p. 10.

16 Cooper, *Annals*, vol. 3, p. 533.

17 The letter is from J. Talbot; see *Calendar of the Manuscripts of the Marquis of Bath preserved at Longleat Wiltshire*, 5 vols, Royal Manuscripts Commission (London: Her Majesty's Stationary Office, 1904–80), vol. 3, p. 426.

385

18 Edmund Carter, *History of the University of Cambridge*, p. 162.

19 'A Trinity Man' [J. M. F. Wright], *Alma Mater: Or Seven Years at the University of Cambridge*, 2 vols (London: Black, Young and Young, 1827), vol. 1, p. 98.

20 *The Diary of John Evelyn*, ed. E. S. De Beer, 6 vols (Oxford: Clarendon Press, 2000), vol. 3, p. 138.

21 *The Journeys of Celia Fiennes*, ed. Christopher Morris (London: Cresset Press, 1949), p. 65.

22 Ibid. pp. 158, 32–3. On seeing the Cathedrals of Ely and Peterborough from King's 'on a clear day', see also 'A Trinity Man', *Alma Mater*, vol. 1, p. 98.

23 Cooper, *Annals*, vol. 3, pp. 549, 591.

24 'Description of England and Ireland', in *The Antiquarian Repertory*, ed. Francis Grose and Thomas Astle, 4 vols (London: Edward Jeffery, 1807–9), vol. 4, pp. 549–622 (p. 619). See also Francis Burman in 1702: 'A Visit to Cambridge', in J. E. B. Mayor, *Cambridge under Queen Anne. Illustrated by Memoir of Ambrose Bonwicke and Diaries of Francis Burman and Zacharias Conrad von Uffenbach*, ed. Montague Rhodes James (Cambridge: Deighton, Bell, and Bowes and Bowes, 1911), pp. 115–20 (p. 116).

25 Edmund Carter, *The History of the University of Cambridge* (London: printed for the author, 1753), p. 156.

26 Cole, London, BL, MS Add. 5802, fols 112/105r, 110/103r.

27 Malden, *An Account of King's College Chapel*, p. 36; 'A Student', *Tour of the University of Cambridge. In a Letter to a Friend* (no date), printed in *The British Tourists*, ed. William Mavor, 6 vols (originally published 1798; London: Richard Philips, 1809), vol. 6, pp. 199–237 (p. 213).

28 Fiennes, *Journeys*, p. 65.

29 Maria Edgeworth (1813) in *Letters from England 1813–1844*, ed. Christina Colvin (Oxford: Clarendon Press, 1971), p. 37. On listening to music through the holes in the vaults, see the *Epilogue*, below, p. 364.

30 Dorothy Wordsworth (1810), in *The Letters of William and Dorothy Wordsworth*, ed. Ernest de Selincourt, 8 vols (2nd edn, Oxford: Clarendon Press, 1967–93), vol. 2, p. 433.

31 *The Cambridge University Almanack 1833* (Cambridge: J. and J. J. Deighton); reproduced in Chainey, *In Celebration*, p. 31.

32 'Chapel and Choir' below, p. 276.

33 Edmund Carter, *History of the University of Cambridge*, p. 162.

34 'Chapel and Choir' below, p. 280.

35 Cooper, *Annals*, vol. 3, pp. 478–9. The military dimension of the Chapel is still in evidence a hundred years later when, on 4 May, 1763, 'nine colours taken at Manilla [Phillipines]...were carried in procession to King's College Chapel by the scholars of the college, accompanied by the fellows, the organ playing and the choir preceding them singing Te Deum. The colours were erected on each side of the altar rails', while the University Orator and a Fellow made a speech in Latin (Cooper, *Annals*, vol. 4, p. 327); by 1769, they were being displayed on the organ screen (Malden, *An Account*, p. 38).

36 Edmund Carter, *History of the University of Cambridge*, p. 159; James Woodforde, *Diary of a Country Parson 1758–1802*, ed. John Beresford (Norwich: Canterbury Press, 1996), p. 120.

37 *The Yale Edition of Horace Walpole's Correspondence*, ed. W. S. Lewis et al., 39 vols (New Haven: Yale University Press, 1937–74), vol. 34, p. 62 (23 August, 1789); Cole, London, BL, MS Add. 5802, fol. 109/102r.

38 Malden, *An Account of King's College Chapel*; James Cooke, Chapel Clerk, *An Historical and Descriptive Account of King's College Chapel* (Cambridge: no publisher, 1829); W. P. Littlechild (Chapel Clerk), *A Short Account of King's College Chapel* (Cambridge: Heffer and Sons, 1921).

39 'A Student', *Tour of the University of Cambridge. In a Letter to a Friend*; Thomas John Procter Carter, *King's College Chapel. Notes on its History and Present Condition* (London: MacMillan, 1867).

40 KCGB/4/1/1/7, Ordinary Congregation, 11 November, 1870 (pp. 168–9); General Congregation, 30 November, 1870 (p. 180); General Congregation, 9 December, 1871 (p. 228); General Congregation, 13 February, 1872 (pp. 238–9). See Nicholas Marston below, '"As England knows it": "Daddy" Mann and King's College Choir, 1876–1929', pp. 305–6.

41 Cooper, *Annals*, vol. 2, p. 201.

42 See Abigail Rokison below, 'Drama in King's College Chapel', p. 243.

43 See *Records of Early English Drama. Cambridge*, ed. Alan H. Nelson, 2 vols (Toronto: University of Toronto Press, 1989), pp. 237, 239–41 (trans. pp. 1137, 1140–41); on the reformist ecclesiology of the early years of Elizabeth's reign, see Christopher Haigh, *Elizabeth I* (Harlow: Longman, 2001), pp. 27–46.

44 Abraham Hartwell, *Regina Literata*, cited in *Records of Early English Drama*, pp. 239–41 (trans. pp. 1138–42); the commentary of Nicholas Robinson also speaks of this as a 'theatrum regale', alternating between describing the Chapel itself as a 'sacellum regium' and a *templum* (ibid. pp. 236–7; trans. pp. 1136–7).

45 See KCA, KCAR/4/1/1/11, Mundum book (1541–2), 'Reparationes facte circa novi templi'; but see also Mundum book (1536–7), 'Custus ecclesie', for a payment of five and a half pence to 'Willelmi Birlyngham 'pro iic smale Nayle ad usum novi templi' ('for two hundred smalls nails for use [in] the new temple'). I thank Peter Jones and Roger Bowers for these references; the terminology was also noticed by Thomas Carter, *King's College Chapel*, pp. 6–7.

46 See KCA, KCAR/4/1/1/64, Mundum Book (1799/1800), p. 86; Mundum Book (1800/1801), p. 86. For use of the phrase *novum templum* under other headings, see KCA, KCAR/4/1/1/37, Mundum Book (1688/89), 'Custus ecclesie'; Mundum Book (1750/51), 'Feoda et regarda', pp. 76–77; Mundum Book (1751/2), 'Feoda et regarda', pp. 76–9.

47 J. F. Niermeyer, *Mediae latinitatis lexicon minus* (Leiden: Brill, 1976), 'templum', sb.; *Oxford English Dictionary*, 'temple', sb. I. 2; many early modern examples to be found in *The Early Modern English Dictionaries Database* (http://homes.chass.utoronto.ca/~ian/emedd.html); last accessed 3 January, 2014.

48 See Achsah Guibbory, *Ceremony and Community from Herbert to Milton. Literature, Religion and Cultural Conflict in Seventeenth-Century England* (Cambridge: Cambridge University Press, 1998), p. 74.

49 See Guibbory, *Ceremony and Community*, pp. 59–78; Jim Bennett and Scot Mandelbrote, *The Garden, the Ark, the Tower, the Temple. Biblical Metaphors of Knowledge in Early Modern Europe* (Oxford: Museum of the History of Science, Oxford, in association with the Bodleian Library, 1998), especially pp. 135–56. For examples of the Temple of Jerusalem as a model of the Church/universe, see respectively: John Lightfoot, *The Temple. Especially as it Stood in the Days of Our Saviour* (London: Andrew Crook, 1650), p. 6; T. Blackwell, *Letters concerning Mythology* (London: no publisher, 1748), Letter 16 (pp. 245–6).

50 See G. Lloyd Jones, *The Discovery of Hebrew in Tudor England. A Third Language* (Manchester: Manchester University Press, 1983), pp. 97–98 and 180–220 (especially p. 192); Stephen G. Burnett, *Christian Hebraism in the Reformation Era (1500–1660). Authors, Books and the Transmission of Jewish Learning* (Leiden: Brill, 2012), pp. 27–32.

51 See Richard Rex, *Henry VIII and the English Reformation* (2nd edn, Basingstoke: Palgrave MacMillan, 2006), pp. 167–70; also Pamela Tudor-Craig, 'Henry VIII and King David', *Early Tudor England: Proceedings of the 1987 Harlaxton Symposium*, ed. Daniel Williams (Woodbridge: Boydell Press, 1989), pp. 183–205; John N. King, *Tudor Royal Iconography. Literature and Art in an Age of Religious Crisis* (Princeton: Princeton University Press, 1989), pp. 54–89; Carola Hicks, *The King's Glass. A Story of Tudor Power and Secret Art* (London: Pimlico: 2007), pp. 159–65. As with use of the word *templum*, Davidic and Solomonic royal iconography can also be found in the medieval period, but in the sixteenth century it is imbued with new meaning: for Henry these claims signalled direct divine sanction, the lack of papal mediation (see Tudor-Craig, 'Henry VIII and King David', pp. 189, 191; King, *Tudor Royal Iconography*, pp. 56, 59, 76, 81; Hicks, *The King's Glass*, pp. 161–4). We might compare the attribution of these associations to the Escorial in the course of the sixteenth century; see Henry Kamen, *The Escorial. Art and Power in the Renaissance* (New Haven: Yale University Press, 2010), pp. 86–116.

52 Rex, *Henry VIII*, p. 169.

53 [Edward Fox,] *Opus eximium de vera differentia regiae potestatis et ecclesiasticae et quae sit ipsa veritas ac virtus utriusque* (London: Tho[mas] Berthelet[us], 1534), fols 36r–37v, 44v; for Fox Jerusalem and the Temple are historical exemplars of the institutions of religion (see fol. 56v; also 14r–v, 61r).

54 Willis and Clark, *The Architectural History*, vol. 1, p. 476 (1509); p. 608 (1512); pp. 611–17 (1514, 1513, 1626).

55 On this paradox, see James Simpson above, 'Glassy Temporalities: The Chapel Windows of King's College, Cambridge'.

56 Its stained glass is also full of grand, temple-like buildings: see Hicks, *The King's Glass*, p. 124. Hicks also argues that changing ecclesiastical politics must have made it possible to read the Old and New Law in the two 'levels' of the windows in these terms (p. 159).

57 See Hilary Wayment, *The Windows of King's College Chapel Cambridge. A Description and Commentary* (London: The British Academy, 1972), plate 61 and p. 4; Tudor-Craig, 'Henry VIII and David', p. 191; King, *Tudor Royal Iconography*, pp. 85–9. On the political and Davidic connotations of the screen, see also Lucy Churchill, 'A Re-appraisal of the Iconography of the Choir Screen at King's College Chapel, Cambridge', *Notes and Queries* 16 (2014), 204–6. On the early date of window 12,3 and its attribution to Barnard Flowers, the first King's Glazier to work in the Chapel, see Wayment, *The Windows*, pp. 22–24; and Steve Clare above, 'The Great Glass Vista', p. 137.

58 Lightfoot, *The Temple*, pp. 30–31, 49, 51; there seem also to be implicit Chapel parallels in Lightfoot's descriptions of the steps up the roof gable, the double roof, ceiling holes for support ropes and 'shew-bread table' of the Temple (pp. 57, 75, 84).

59 *Les Delices de la Grand' Bretagne et d'Irelande*, 8 vols (originally published in 1707; Leiden: Pierre Vander, 1727), vol. 1, pp. 125–6.

60 See Harrison below, 'The Start and Stop of Simeon', p. 235, citing Charles Smyth, *Simeon & Church Order. A Study of the Origins of the Evangelical Revival in Cambridge in the Eighteenth Century* (Cambridge: University Press, 1940), p. 129, quoting Joseph Farington's Diary (13 September 1805).

61 Thomas Fuller, *The History of the University of Cambridge* [originally published in 1655], ed. Marmaduke Prickett and Thomas Wright (Cambridge: Deighton and Stevenson, 1840), p. 151; Edmund Carter, *History of the University of Cambridge*, p. 157.

62 See Christopher Chippindale, *Stonehenge Complete* (rev. edn, London: Thames and Hudson, 1994), pp. 43–125; Alexandra Walsham, *The Reformation of the Landscape. Religion, Identity and Memory in Early Modern Britain and Ireland* (Oxford: Oxford University Press, 2011), pp. 296–308.

63 Chippindale, *Stonehenge Complete*, pp. 47–8, 66–8, 96.

64 William Stukeley, *Stonehenge. A Temple restor'd to the British Druids* (London: W. Innys and R. Manby, 1740), p. 10; *Abury. A Temple of the British Druids* (London: printed for the author, 1743), pp. iv, 1–14, 101–2; see Chippindale, *Stonehenge Complete*, pp. 84–5; and Walsham, *Reformation of the Landscape*, pp. 305–8. For Jones, Newton and Woods, see Tessa Morrison, 'Solomon's Temple, Stonehenge, and Divine Architecture in the English Enlightenment', *Parergon* 29 (2012), 135–63.

65 Fuller, *History of the University*, p. 154; at p. 151, he also compares the luminaries of King's to the citizens of Athens.

66 Walsham, *Reformation of the Landscape*, pp. 148–9, 296–306 (for the use of the term *chapel* to refer to a non- or pre-Christian site, see p. 302). See also Silvia Mergenthal, '"The Architecture of the Devil": Stonehenge, Englishness, English Fiction', *Landscape and Englishness*, ed. Robert Burden and Stephan Kohl (Amsterdam: Rodopi, 2006), pp. 123–35. William Smith, *The Particular Description of England, with the Portratures of Certaine of the Chieffest Cities & Townes* (1588): London, BL, MS Sloane 2596, fol. 35v.

67 'Verses in Memory of King Henry VI', *Fugitive Pieces in Verse and Prose* (Strawberry Hill, 1758), p. 2 (Walpole also observes that Henry's 'godlike mind' must now 'From Superstition's papal gloom [be] refin'd', p. 3).

68 R. Ackermann, *A History of the University of Cambridge*, 2 vols (London: printed for R. Ackermann, 1815), vol. 1, p. 196; 'A Trinity Man', *Alma Mater*, vol. 1, p. 96.

69 William Gilpin, *Observations on Several Parts of the Counties of Cambridge, Norfolk, Suffolk and Essex* (London: T. Cadell and W. Davies, 1809), p. 11; see also Walsham, *Reformation of the Landscape*, p. 296.

70 William Stukeley, *The Commentaries, Diary, & Commonplace Book, & Selected Letters* (London: Doppler Press, 1980), p. 35.

71 'Verses in Memory of King Henry VI', p. 4.

72 Fiennes, *Journeys*, p. 65. [Edward Ward,] *A step to Stir-Bitch-fair with remarks upon the University of Cambridge* (London: How, 1700), pp. 113–14

73 John Ruskin compared the towered Chapel to an upside-down table and claimed that it would look much better if the 'legs' were knocked off: see *The Seven Lamps of Architecture* (London: Cassell, 1909), p. 181.

74 On late medieval and early modern cradles, see Victor Chinnery, *Oak Furniture. The British Tradition. A History of Early Furniture in the British Isles and New England* (Woodbridge: Antique Collectors' Club, 1979), pp. 397–9.

75 See Chinnery, *Oak Furniture*, figures 3.471 and 3.474.

76 On such cribs, with two more illustrations from France and the Netherlands, see Gabriele Finaldi, *The Image of Christ* (London: National Gallery, 2000), pp. 54–5, plate 24 and fig. 16.

77 See, for example: Paul Hentzner's *Travels in England, during the Reign of Queen Elizabeth*, trans. Horace [Walpole] (London: Jefery, 1797), p. 40; Jorevin de Rocheford, *Travels; The Travels of Peter Mundy 1597–1667*, ed. John Keast (Redruth: Dyllansow Truran, 1984), p. 55; Beeverell, *Les Délices*; Francis Burman and Zacharias Conrad von Uffenbach, in Mayor, *Cambridge under Queen Anne*, pp. 115–20, 123–98. See also Iain Fenlon above, 'A Spanish Choirbook and some Elizabethan Book Thieves', p. 184.

78 See *Horace Walpole's Strawberry Hill*, ed. Michael Snodin, with the assistance of Cynthia Roman (New Haven, CN: Yale University Press, 2009), pp. 45–6 and fig. 65; Anna Chalcraft and Judith Viscardi, *Strawberry Hill. Horace Walpole's Gothic Castle* (London: Frances Lincoln, 2007), p. 84.

79 Horace Walpole, *A Description of the Villa of Mr. Horace Walpole* (Strawberry Hill: Thomas Kirgate, 1784; repr. London: Gregg Press, 1964), p. 6.

80 Letter to William Mason, 2 May 1777, *Correspondence*, vol. 28, p. 306; Letter to William Cole, 22 May 1777, *Correspondence*, vol. 2, p. 45. For the College Library, whose relevance here Jeremy Musson reminds me of, see Peter Jones above, 'The College and the Chapel', pp. 168–74.

81 Letter to the Countess of Ossory, 9 October 1776 (*Correspondence*, vol. 32, p. 322); on 3 January 1779 he wrote to Cole after a storm, 'Lady Pomfret's Gothic house in my street lost one of the stone towers, like those at King's Chapel' (*Correspondence*, vol. 2, p. 135).

82 For his interest in heraldry and his large collection of medieval and later heraldic glass from the Netherlands and England, as well as his special focus on Tudor insignia, 'all of which he would have seen in abundance in the windows of King's College Chapel', see *Horace Walpole's Strawberry Hill*, ed. Snodin, p. 64.

83 Willis and Clark, *The Architectural History*, vol. 1, pp. 478–9. The contracts for the windows are almost identical to those for Henry VII's Chapel: see vol. 1, pp. 498; Wayment, *The Windows*, p. 5.

84 On the heraldry of the Chapel, see Willis and Clark, *The Architectural History*, vol. 1, pp. 578–94.

85 See Woodman, *The Architectural History*, p. 155.

86 For the screen, organ case and stalls, see Willis and Clark, *The Architectural History*, vol. 1, pp. 583–8; for the windows, see Wayment, *The Windows*, p. 37.

87 'Description', in *Antiquarian Repertory*, vol. 4, p. 618.

88 Cole, London, BL, MS Add. 5802, fols 101/94r, 108/101r. An even more chivalric response to the Chapel perhaps achieved its apogee in Kenelm Henry Digby (1800–80), who, as an undergraduate 'resolved to be a knight, and getting into King's College Chapel at nightfall, kept his vigil there till dawn': Bernard Holland, *Memoir of Kenelm Henry Digby* (London: Longmans, Green and Co, 1919), p. 9.

89 *A Critical Edition of the Letters of Joseph Mead 1626–1627, contained in British Library Harleian MS 390*, ed. David Anthony John Cockburn (unpublished PhD Dissertation, University of Cambridge, 1994), p. 690; also Cooper, *Annals*, vol. 3, p. 198.

90 *The Autobiography and Correspondance of Sir Simonds d'Ewes during the Reigns of James I and Charles I*, ed. James Orchard Halliwell, 2 vols (London: Richard Bentley, 1845), vol. 1, p. 359.

91 John Stow, *The Annales, or Generall Chronicle of England...after him continued and augmented with matters forreyne, and domestique, auncient and moderne, unto the ende of this present year 1614* (London: Thomas Adams, 1615), p. 886.

92 Stuart Boulter, 'Graffiti on the Tower Roof of St Michael, Cookley', *Church Archaeology* 4 (2000), 55–8; Warwick Rodwell, with Caroline Atkins, *St Peter's, Barton-upon-Humber, Lincolnshire: A Parish Church and its Community*, 2 parts (Oxford: Oxbow Books, 2011), pp. 510–13; Rodwell, *The Archaeology of Churches* (Stroud: Amberly, 2012), pp. 221–4; Timothy Easton, 'Plumbing a Spiritual World', *Society for the Preservation of Ancient Buildings* (Winter, 2013), 40–47 (pp. 40, 46); and personal communication.

93 Cole, London, BL, MS Add. 5802, fols 110/103r–111/104r. The graffiti in the Chapel stairs and roof space still require study: see Freeland Rees Roberts Architects, *Conservation Management Plan for King's College Chapel, Cambridge* (May, 2005), p. 108 (KCA, KCAR/8/5/6).

94 See also the inscription on the north roof of the side chapels, pictured in Freeland Rees Roberts, *Conservation Management Plan*, p.141.

95 *Lexicon Balatronicum* (London: C. Chappel, 1811), no pagination. I thank Christopher Brooks for this reference.

X

The Start and Stop of Simeon

Ross Harrison

The primary source, on which all later accounts chiefly draw, is William Carus, *Memoirs of the Life of the Rev. Charles Simeon, M.A.* (London: Hatchard and Son, 1847). This is a compendium of over 800 pages of fragments of journals and autobiography, as well as letters and some connecting text. Quotations in the text from these are taken from here; also letters to Simeon from Wilberforce and the description of how he wanted to see more of this 'contrite, broken spirit', reprinted from a contemporary periodical. The chief supplement to this for original material is Abner William Brown, *Recollections of Conversation Parties of the Rev. Charles Simeon, M.A.* (London: Hamilton, Adams, & co., 1863), dedicated to 'those Cambridge men who, as undergraduates, attended Mr Simeon's public and private ministrations'. This is a sizeable work of nearly 380 pages, consciously intended to give a better view of Simeon in action than can be gleaned from Carus and based on the time of the author's undergraduate residence between 1827 and 1830. All descriptions of Simeon's conversation parties, apart from the one just mentioned from Carus, are taken from here, including quotations of remarks attributed to Simeon at these gatherings.

A few of Simeon's many sermons are reprinted in a volume edited by Arthur Pollard entitled *Let Wisdom Judge: University Addresses and Sermon Outlines* (London: Inter-Varsity Fellowship, 1959). The quotations from the sermon on Catholic emancipation is however taken from Carus, who reprints several pages of it. A copy of William Tucker's *The Old Court of King's College, Cambridge 1822–1825* (Cambridge: King's College, ?1892) is in King's College Library. There is also a small amount of additional material in H. C. G. Moule, *Charles Simeon* (London: Methuen, 1892); Moule solicited material from Francis Close and he himself attended Bradshaw's funeral where Simeon's coffin was still visible.

John Wesley's meetings with Simeon are mentioned in Wesley's *Journal*; the first was on 20 December 1784: *The Journal of the Rev. John Wesley*, ed. Nehemiah Curnock, 8 vols (London: Robert Culley and Charles H. Kelly, 1909–16), vol. 7, p. 39. Macaulay's description of Simeon in the letter to his sister is in George Otto Trevelyan, *Life and Letters of Lord Macaulay* (London: Longmans, 1908), vol. 1, p. 50. The sermons about Simeon after his death are

reprinted in the *Pulpit*, 29 (1836), 217–18, which also has the most complete description of his funeral. There is another full description of the death and funeral in Carus and Close's remark on it is taken from Moule. The funeral occurred during Rowland Williams' first term at King's and is described in *The Life and Letters of Rowland Williams* (London: Henry S. King, 1874).

The Anglican catechism is quoted from the 1662 *Book of Common Prayer*. Thomas Wilson (1663–1755) was bishop of Sodor and Man. His frequently reprinted work on the Lord's Supper first appeared in 1734, with its 19th edition in 1779 (the year that Simeon read it): *A short and plain instruction for the better understanding of the Lord's Supper* (London: J. F. and C. Rivington, 1779). John Henry Newman reprinted other works of Bishop Wilson among the Tracts for the Times series for which he was responsible and which appeared between 1833 to 1841, when his bishop commanded him to stop. He reprinted work of Wilson as Tracts numbers 37, 39, 42, 44, 46, 48 and 50 (all 1834) as well as 53, 55, 65 and 70 (all 1835) (London, Rivington). John Keble wrote Bishop Wilson's life: *The Life of the right reverend Father in God, Thomas Wilson, D. D.: Lord Bishop of Sodor and Man compiled chiefly from original documents* (Oxford: John Henry Parker, 1863).

The leading twentieth-century accounts of Simeon are Charles Smyth, *Simeon & Church Order* (Cambridge: Cambridge University Press, 1940) and Hugh Evan Hopkins, *Charles Simeon of Cambridge* (London: Hodder & Stoughton, 1977). The remark attributed to Willis Clark is taken from Hopkins (p. 220), who also has a chapter on the Simeon Trust. More on the early history of the Trust can be found in Wesley Deane Balda, '"Spheres of influence": Simeon's Trust and its implications for evangelical patronage' (unpublished PhD dissertation, Cambridge University, 1981). Charles Smyth's main thesis is that Simeon was effective in keeping evangelicals inside the established church (hence his concentration on 'church order'); his book contains a considerable amount of the background on the older evangelicals (such as John Berridge and Henry Venn) in the countryside west of Cambridge. More about Simeon's relations with the younger *John Venn and the Clapham Sect* can be found in Michael Hennell, John Venn and the Clapham Sect (London: Lutterworth Press, 1958), which contains many letters between Venn and Simeon. Hennell's later *Sons of the Prophets: Evangelical leaders of the Victorian Church* (London: SPCK, 1979) has a description of the Cheltenham of Francis Close. See also Boyd Hilton, *The Age of Atonement: The Influence of Evangelism on Social and Economic Thought, 1785–1865* (Oxford, Oxford University Press, 1988).

XI

Drama in King's College Chapel

ABIGAIL ROKISON

1. 'University Orders for the Royal Visit', London, BL, MS Harley 7033, cited in *Records of Early English Drama: Cambridge (REED)*, ed. Alan H. Nelson, 2 vols (Toronto: University of Toronto Press, 1989), vol. 1, p. 228. I would like to express my gratitude to Patricia McGuire and Peter Jones for their generous archival help in the preparation of this chapter.
2. George Charles Moore Smith, *College Plays Performed in the University of Cambridge* (Cambridge: Cambridge University Press, 1923), p. 2.
3. *REED*, ed. Nelson, vol. 1, p. 61; vol. 2, p. 1087 (translation altered).
4. Ibid., vol. 2, p. 710.
5. Ibid., vol. 2, p. 715.
6. This would, at least initially, have taken place in the Old Chapel which collapsed in 1536–7; see Clifford Davidson, *Festivals and Plays in Late Medieval Britain* (Aldershot: Ashgate, 2007), p. 7.
7. Ibid., p. 6.
8. 'King's College Statutes' in *REED*, ed. Nelson, vol. 2, p. 1064.
9. E. K. Chambers, *The Medieval Stage*, 2 vols (Oxford: Oxford University Press, 1903), vol. 1, p. 368.
10. *REED*, ed. Nelson, vol. 1, pp. 79–80.
11. Robert Hornback, 'The Reasons of Misrule Revisited', *Early Theatre* 10 (2007), 35–65 (p. 39).
12. *REED*, ed. Nelson, vol. 2, p. 731.
13. Ibid., vol. 1, pp. 180–81.
14. Ann Rosalind Jones and Peter Stallybrass, *Renaissance Clothing and the Materials of Memory* (Cambridge: Cambridge University Press, 2000), p. 192.
15. Stephen Greenblatt, *Learning to Curse: Essays in Early Modern Culture* (New York: Routledge, 1990), p. 162.
16. Hornback, 'Misrule', pp. 36–50.
17. *REED*, ed. Nelson, vol. 1, p. 123.
18. Ibid., vol. 1, pp. 189–90.
19. Hornback, 'Misrule', p. 56.
20. *REED*, ed. Nelson, vol. 1, p. 189; vol. 2, p. 1128 (translation altered); vol. 1, p. 181.
21. John Saltmarsh, *King's College: a Short History* (Cambridge: Cambridge University Press, 1958), p. 47.
22. Siobhan Keenan, 'Spectator and Spectacle: Royal Entertainments at the Universities in the 1560s', *The Progresses, Pageants, and Entertainments of Queen Elizabeth I*, ed. Jayne Elisabeth Archer, Elizabeth Goldring and Sarah Knight (Oxford: Oxford University Press, 2007), p. 42. All the texts – Mathew Stokys' English account, Nicholas Robinson's *Commentarii Hexameri Rerum Cantabrigiae Actarum* and Abraham Hartwell's poem *Regina Literata* – are contained in *REED*, ed. Nelson, vol. 1, pp. 232–241. See also F. S. Boas, *University Drama in the Tudor Age* (Oxford: Clarendon Press, 1914); Alan H. Nelson, *Early Cambridge Theatres* (Cambridge: Cambridge University Press, 1994); and Keenan, 'Spectator and Spectacle'.
23. Glynne Wickham, *Early English Stages*, 4 vols (London: Routledge, 1963), vol. 1, pp. 248–50; E. K. Chambers, *The Elizabethan Stage*, 4 vols (Oxford: Clarendon Press, 1923), vol. 1, pp. 226–7; Leslie Hotson, *Shakespeare's Wooden O* (London: Rupert Hart-Davies, 1959), pp. 161–3; Richard Leacroft, *The Development of the English Playhouse* (London: Methuen, 1973).
24. *REED*, ed. Nelson, vol. 1, p. 229.
25. Boas, *University Drama*, p. 93.
26. John Nichols, *The Progresses and Public Processions of Queen Elizabeth*, 3 vols (London: J. Nichols, 1788–1821), vol. 1, p. 188.

27 *REED*, ed. Nelson, vol. 1, p. 237; vol. 2, p. 1137.
28 Nelson, *Early Cambridge*, p. 10.
29 Ibid., p. 63.
30 In 1552–3 Robert Bell, a joiner, and two servants were paid for four days work in putting up the stage for a production of *Hippolytus*, and one and a half days work for taking it apart (*REED*, ed. Nelson, vol. 1, p. 179; vol. 2, p. 1126).
31 Stokys in *REED*, ed. Nelson, vol. 1, p. 234.
32 Boas, *University Drama*, p. 92.
33 *REED*, ed. Nelson, vol. 1, p. 236; vol. 2, p. 1136 (translation altered).
34 Nelson, *Early Cambridge*, pp. 13, 106.
35 Stokys in *REED*, ed. Nelson, vol. 1, p. 234.
36 Dana F. Sutton (ed.), 'Appendix: The "Houses" in Academic Drama', appendix to 'Abraham Fraunce, *Victoria* (1953)': A hypertext critical edition by Dana F. Sutton, *The Philological Museum*, 16 June, 2000 rev. 20 May 2001, http://www.philological.bham.ac.uk/victoria/houses.html; last accessed 23 June 2013.
37 *REED*, ed. Nelson, vol. 1, p. 234.
38 Nelson, *Early Cambridge*, p. 13.
39 Ibid.
40 Following her initial visit to King's Chapel on her arrival in Cambridge (on Saturday, 4 August) 'the Queens Majestie came forthe of her traverse, and went towards the lodging by a privy way, made through the east window of the north vestry door as before': Charles Henry Cooper, *Annals of Cambridge*, 5 vols (Cambridge: Warwick and the University Press, 1842–1908), vol. 2, p. 191. One might therefore surmise that this private route was similarly taken by the Queen from her lodgings to the Chapel for the various productions. For an image of this NE entry point, see Ill. 159.
41 Nelson, *Early Cambridge*, p. 13.
42 Keenan, 'Spectator', p. 42.
43 Douglas Paine, 'Academic Drama at Cambridge c.1522–1581' (unpublished PhD dissertation, University of Cambridge, 2007), p. 100.
44 *REED*, ed. Nelson, vol. 1, pp. 225–26.
45 Boas, *University Drama*, p. 93.
46 *REED*, ed. Nelson, vol. 1, p. 237; vol. 2, p. 1137.
47 Paine, 'Academic Drama', p. 99.
48 Nelson, *Early Cambridge*, p. 64.
49 Stokys, in *REED*, ed. Nelson, vol. 1, p. 235. The evidence for evangelical anti-Catholic dramas of misrule at Cambridge collected by Hornback provides a suggestive context for this iconoclastic play ('Misrule').
50 Boas, *University Drama*, pp. 94–5; *Oxford Dictionary of National Biography*, http://libsta28.lib.cam.ac.uk:2091/view/article/27974; last accessed 28 March 2014.
51 *REED*, ed. Nelson, vol. 1, pp. 1140–41; vol. 2, pp. 239–41. Hornback notes that the anti-Catholic Nicholas Robinson, who praised the 'wonder' of Udall's play was in 1552 at Queens' College involved in a comedy for which he had 'taken downe...ii kassokes of sylke' ('Misrule', p.47); for Robinson, see *REED*, ed. Nelson, vol. 1, p. 237; vol. 2, pp. 1137–8.
52 See above, n. 22.
53 *REED*, ed. Nelson, vol. 1, p. 241; vol. 2, p. 1141.
54 Stokys, in *REED*, ed. Nelson, vol. 1, p. 235.
55 Robinson, in *REED*, ed. Nelson, vol. 1, p. 238; vol. 2, p. 1138.
56 King's College, Hatcher's Book, in *REED*, ed. Nelson, vol. 1, p. 243.
57 Nelson, *Early Cambridge*, pp. 40, 63.
58 The Dering Manuscript, Cambridge, CUL, Add. 2677 (Art. 1), fol. 3; *REED*, ed. Nelson, vol. 1, p. 539.
59 *REED*, ed. Nelson, vol. 1, p. 540.
60 Ibid, vol. 1, p. 539.
61 Phineas Fletcher, *Sicelides* (London: William Sheares, 1631), fol. A1r.
62 Cooper, *Annals*, vol. 3, p. 71, n.
63 *REED*, ed. Nelson, vol. 2, p. 756.
64 Paine, 'Academic drama', p. 91.
65 *REED*, ed. Nelson, vol. 2, p. 714.
66 Cooper, *Annals*, vol. 4, p. 257.
67 Ibid., vol. 4, p. 232.
68 The Garrick Club, *The Album of the Cambridge Garrick Club* (Cambridge: Metcalfe and Palmer, 1836), pp. 1–2.
69 George Rylands, 'The Kingsman', *Essays on John Maynard Keynes*, ed. Milo Keynes (Cambridge: Cambridge University Press, 1979), pp. 39–48 (p. 42).
70 T. J. Cribb, 'Obituary: George Rylands', *The Independent*, 20 January 1999, http://www.independent.co.uk/arts-entertainment/obituary-george-rylands-1075032.html; last accessed 8 September 2013.
71 Cribb, 'Obituary: George Rylands'; Noel Annan [and others] 'George Humphrey Wolferstan Rylands 1902–99. A Memoir' (Cambridge: published by King's College, 2000), pp. 10–14, 16, 21.
72 KCA, KCGB/5/2/1/3, Votes of College Council (1924–1949), 2 February.
73 See Winton Dean, 'Edward J. Dent: A Centenary Tribute', *Music and Letters* 57 (1976), 353–61; Philip Radcliffe, *E. J. Dent* (Rickmansworth: Triad Press, 1976), pp. 7, 9. Dent's essay appeared in *The Oxford History of Music*, general ed. Sir W. H. Hadow, *Introductory Volume*, ed. Percy C. Buck (Oxford: Oxford University Press, 1929), pp. 184–221. On Dent, see also Timothy Day below, '"The Most Famous Choir in the World?" The Choir since 1929', p. 348.
74 Robert Speight, *William Poel and the Elizabethan Revival* (London: Heinemann, 1954), p. 71.
75 George Rowell, *The Old Vic Theatre, a History* (Cambridge: Cambridge University Press, 1993), p. 342.
76 The full cast, as listed in the programme: Reyner Barton, Neil Curtis, D. Hay Petrie, Hilton Edwards, Ronald Nicholson, John Laurie, Henry Cohen, Agnes Carter, Jane Bacon, Dorothy Druce, Wilfred Walter, Dorice Fordred, Florence Saunders, Robert Glennie and Molly Francis. The theatre programme for *Everyman*, The Old Vic Theatre, 1923–4, can be found in Bristol University Theatre Collection. (OVP/PG/000/000106/1).
77 See L. P. Wilkinson, *Kingsmen of a Century. 1873–72* (Cambridge: King's College, 1981), p. 88; http://www.cambridgegreekplay.com/history/wilkinsonessay.html; last accessed 6 April 2014. Durnford's name appears on the list of those who attended the ADC dinner for *Agamemnon* on 27 November 1900.
78 KCA, EJD/4/27, Letter from Lilian Baylis to Edward Dent, 2 February 1924.
79 Rowell, *The Old Vic*, p. 106.
80 Recording of Lilian Baylis, c.1934, contained in Bristol University Theatre Collection, TCM/000348.

81 Anonymous, 'Review of "Everyman" at King's Chapel', *The Granta*, 25 April 1924, p. 353.

82 Ibid.

83 KCA, Annual Report (1962), p. 11; (1963), p. 10.

84 Sydney Castle Roberts, *Adventures with Authors* (Cambridge: Cambridge University Press, 1966), p. 144.

85 Raymond Leppard, *Raymond Leppard on Music* (White Plains, N.Y.: Ro/Am Music Resources, 1993), p. 383. See also Wilkinson, *Kingsmen of a Century*, p. 92.

86 Pamela King, 'York Mystery Plays', *A Companion to Medieval English Literature and Culture c.1350–c.1500*, ed. Peter Brown (Oxford: Wiley–Blackwell, 2009), pp. 491–506 (p. 503).

87 All quotations from Stephen Culverwell, 'Pageant: A Pageant of Paul', *The Cambridge Review*, 2 February 1963, p. 245.

88 Programme, '*The Play of Daniel*, presented by The Lambeth Players and the St Bartholomew Singers', p. 2.

89 Ibid., pp. 4, 7.

90 Kate Normington, *Medieval English Drama* (Cambridge: Polity, 2009), p. 37.

91 Andrew Lawrence-King, 'Serious Fun', http://www.ahorie.net/Serious_Fun.htm; last accessed 13 November 2013.

92 KCA, Annual Report (1981), p. 18 (see comment about difficult accoustics).

93 The production consisted of four plays extracted from the medieval cycle plays, 'The Temptation', 'Simon the Leper', 'The Betrayal of Christ' and 'Christ's Passion': see KCA, SCH/43. See *The Chester Mystery Cycle*, R. M. Lumiansky and David Mills, Early English Text Society, ss 3 and 8 (London: Oxford University Press, 1974, 1986), Plays 12, 14, 15 and 16a. The performance in the Chapel was the culmination of a brief tour to churches in Cambridge and Suffolk. Briggs was headmaster from 1959–1977.

94 Programme note, Programme for *Go Down, Moses* (KCA, SCH/44, King's School file). Gerald Peacocke, 'Three Elephants: Reflections on the Spoken Word in King's College Chapel' in *KCCA Yearbook* 2007, pp. 20–24 (p. 23).

95 Hattie Trustcott and Alison M. Curry, 'Archbishop Killed in Kings', Review of *Becket*, *Varsity*, 28 February, 1997, p. 17.

96 Niall Wilson, private email correspondence with author.

97 James Lewis, private email correspondence with author.

98 Wilson, private email correspondence with author.

99 Nancy Napper Canter, 'Review of Spanish Tragedy', *The Tab Online*, 9 November, 2012, http://cambridge.tab.co.uk/2012/11/09/the-spanish-tragedy; last accessed 23 May 2013.

100 Lewis, private email correspondence with author.

101 Wilson, private email correspondence with author.

102 Gerald Peacocke, 'Three Elephants', p. 23.

103 Ibid., pp. 20, 23.

104 Having praised the contribution of the atmosphere to the production of *Murder in the Cathedral*, the College Annual Report goes on to note the problems caused by 'the acoustic' (King's College Annual Report, October 1981, p. 18).

105 Trustcott and Curry, 'Archbishop Killed in Kings', p. 17.

106 Simon Scardifield, private email correspondence with author.

107 Emails from Derek Buxton to Chris Till, 21 January 2003, at 12.18 and 16.51 (KCA, KCAR/8/7/2/1, Concert/Event files (Tourist Liaison Office).

108 The Pembroke Players Japan Tour is an annual tour. In 2008 the production had begun in London, before touring to ten different venues in Japan during September.

109 Emma Hogan, 'A Midsummer Night's Dream', *Varsity Online*, 12 October, 2008, http://www.varsity.co.uk/reviews/1020; last accessed, 23 May 2013.

110 Lewis, private email correspondence with author.

111 Eric Walter White, *Benjamin Britten, His Life and Operas* (2nd edn, Berkeley: University of California Press, 1983), p. 214.

112 Ibid, pp. 22–23.

113 George Benjamin, private email correspondence with Stephen Cleobury.

114 Napper Canter, 'Review'.

115 Fred Maynard, 'Review of The Spanish Tragedy', *Varsity Online*, 8 November, 2012, http://www.varsity.co.uk/reviews/5253; last accessed 23 May 2013.

116 Napper Canter, 'Review'.

117 Wilson, private email correspondence with author.

118 Wilson, private email correspondence with author.

119 Hogan, 'Review'.

120 Lewis, private email correspondence with author.

121 Lewis, private email correspondence with author.

XII

Chapel and Choir, Liturgy and Music, 1444–1644
Roger Bowers

1 KCA, KCAR/4/1/1/1, Mundum Book (1447/48), 'Custus ecclesie'; KCAR/4/1/1/8, Mundum Book (1498/9), 'Custus ecclesie'.

2 *The Ancient Laws of the Fifteenth Century for King's College, Cambridge and for the Public School of Eton College*, ed. James Heywood and Thomas Wright (London: Longman, Brown, Green, & Longmans, 1850), pp. 107–10, 113–18, 144.

3 *The Ancient Laws*, ed. Heywood and Wright, pp. 20–21, 72–3, 107–8, 112, 119, 122–3, 141, 155, 167–9.

4 *The Ancient Laws*, ed. Heywood and Wright, pp. 21, 67–71, 78, 120–1, 133; Robert Willis and John Willis Clark, *The Architectural History of the University of Cambridge*, 4 vols (Cambridge: University Press, 1886), vol. 1, pp. 552, 555, 568; John Saltmarsh, 'King's College', *The Victoria History of the County of Cambridgeshire and the Isle of Ely*, ed. Louis Francis Salzman et al., 9 vols (London: published for University of London Institute of Historical Research by Oxford University Press, 1938–89), vol. 3, p. 388.

5 *The Ancient Laws*, ed. Heywood and Wright, pp. 69, 78 (bursar as supervisor); 69, 108, 121 (training of choristers); 28, 152, 479 (rights to election at Eton).

6 *The Ancient Laws*, ed. Heywood and Wright, pp. 20–1.

7 KCA, King's College Accounts 344; 345; 347, fols 6r, 8v, 10r, 11r.

8 London, The National Archives, MS E 101 408/25, fol. 1 v; MS E 403/771, m. 11r. Herbert Chitty, 'Henry VI and Winchester College', *Notes and Queries*, 12th series, 1 (1916), p. 482. KCA, King's College Accounts 266.

9 KCA, KCAR/4/1/1/1, Mundum Book (1447/8), 'Pensiones'; Mundum Book (1448/9), 'Pensiones'; KCAR/4/1/6/1, Liber communarum (1447/8); KCAR/4/1/1/1, Mundum Book (1448/9), 'Custus equitancium'; KCAR/4/1/1/2, Mundum Book (1450/1), 'Custus equitancium'; KCAR 1/2/16, vol. 1, no. 12a.

10 KCA, King's College Accounts 344; 684, fols 3r–v, 7r; KCAR/4/1/1/2, Mundum Book (1450/1), 'Custus ecclesie'; KCAR/4/1/6/1, Liber communarum (1450/1), 19 September; KCAR/4/1/1/3, Mundum Book (1456/7), 'Custus ecclesie', 'Expense necessarie'; KCAR/4/1/1/5, Mundum Book (1467/8), 'Custus ecclesie', 'Expense necessarie'; KCAR/4/1/1/8, Mundum Book (1482/3), 'Custus novi edificii'; King's College Accounts 346, fol. 7v.

11 KCA, King's College Accounts 22, 345, 346, 684; KCAR/4/1/1/7, Mundum Book (1476/7), 'Recepcio forinseca'.

12 Saltmarsh, 'King's College', pp. 379, 380. KCA, KCAR/4/1/1/4, Mundum Book (1465/6), 'Pensiones'; KCAR/4/1/1/5, Mundum Book (1467/8), 'Pensiones'; KCAR/4/1/6/3, Liber communarum (1466/7 and 1468/9).

13 Willis and Clark, *Architectural History*, vol. 1, pp. 319–20. KCA, KCAR/4/1/1/4, Mundum Book (1466/7), 'Recepcio forinseca', 'Feoda et regarda', 'Custus novi edificii'; KCAR/4/1/1/5, Mundum Book (1467/8), 'Expense necessarie'; Mundum Book (1472/3), 'Expense necessarie'; Mundum Book (1473/4), 'Expense necessarie'. In 1506 this school was superseded by that newly founded at Jesus College.

14 KCA, King's College Accounts 346, fol. 2r.

15 KCA, KCAR/4/1/1/8, Mundum Book (1482/3), 'Pensiones'; KCAR/3/3/1/1/1, Ledger Book, vol. 1, fol. 134r.

16 *A Short-Title Catalogue of Books printed in England, Scotland and Ireland, and of English Books printed abroad, 1475–1640*, compiled Alfred W. Pollard and Gilbert R. Redgrave, revised William A. Jackson, Frederic S. Ferguson and Katharine F. Pantzer, 3 vols (London: Bibliographical Society, 1976–91), no. 17723.

17 Roger Bowers, 'To chorus from quartet: the performing resource for English church polyphony, c.1390–1559', in *English Choral Practice, 1400–1625*, ed. John Morehen (Cambridge: Cambridge University Press, 1995), pp. 1–47 (pp. 20–34).

18 *The Eton Choirbook*, ed. Frank L. Harrison, 3 vols, Musica Britannica 10–12 (London: published for the Royal Musical Association by Stainer & Bell, 1956–61).

19 KCA, KCAR/4/1/6/7, Liber communarum (1481/2).

20 KCA, KCAR 4/1/5/1, fols 9v, 12v–22r; KCAR 4/1/5/6, unfoliated; KCAR/4/1/1/8, Mundum Book (1482/3), 'Expense necessarie'.

21 KCA, KCAR/4/1/1/3, Mundum Book (1456/7).

22 KCA, KCAR/4/1/1/8, Mundum Book (1496/7), 'Custus ecclesie'.

23 KCA, KCAR/3/3/1/1/1, Ledger Book, vol. 1, fol. 167r. KCAR/4/1/1/10, Mundum Book (1507/08), 'Custus equitancium'.

24 KCA, KCAR/4/1/1/8, Mundum Book (1498/9), 'Feoda et regarda'; KCAR/4/1/1/9, Mundum Book (1499/1500), 'Custus equitancium'. John M. Ward and Fiona Kisby, 'Farthing, Thomas', *The New Grove Dictionary of Music and Musicians*, 2nd edition, ed. Stanley Sadie and John Tyrrell (London: Oxford University Press, 2000).

25 KCA, KCAR/4/1/1/9, Mundum Book (1499/1500), 'Custus ecclesie', 'Feoda et regarda'; Mundum Book (1500/01), 'Custus ecclesie'; Mundum Book (1502/3), 'Custus equitancium'; Mundum Book (1506/7), 'Custus equitancium', 'Feoda et regarda'; Elias Ashmole, *The Institution, Laws, and Ceremonies of the Order of the Garter* (London: printed by J. Macock for Nathanael Brooke, 1672), pp. 487, 558.

26 KCA, KCAR/4/1/6/10, Liber communarum (1498/9), week 50; KCAR/4/1/1/9, Mundum Book (1499/1500), 'Custus ecclesie', 'Feoda et regarda'; Mundum Book (1500/1), 'Custus ecclesie'; KCAR/4/1/6/9, Liber communarum (1490/1), week 11.

27 KCA, KCAR/4/1/1/9, Mundum Book (1500/1), 'Expense necessarie'.

28 Cambridge University Library, Add. MS 7350 (Box 1); Peter J. Croft, 'The "Friar of Order Gray" and the nun', *Review of English Studies*, new series 32 (1981), 1–16 (pp. 8–14).

29 KCA, KCAR/4/1/1/9, Mundum Book (1502/3), 'Custus ecclesie'; (1503/4), 'Custus ecclesie'.

30 KCA, KCAR/4/1/1/10, Mundum Book (1507/8), 'Restitutio creditorum'. Andrew Chibi, 'Blythe, Geoffrey', *The Oxford Dictionary of National Biography*, ed. Colin Matthew and Brian Harrison, 60 vols (Oxford: Oxford University Press, 2004).

31 KCA, KCAR/4/1/1/9, Mundum Book (1502/3), 'Custus ecclesie', 'Expense necessarie'; Mundum Book (1503/04), 'Custus ecclesie', 'Expense necessarie'; KCAR/4/1/1/10, Mundum Book (1508/9), 'Custus ecclesie', 'Feoda et regarda'.

32 David Greer, 'Cowper, Robert', 'Hampshire, Richard'; John Bergsagel and Roger Bowers, 'Rasar, William', *New Grove Dictionary of Music and Musicians*. Roger Bowers, 'Cowper, Robert', 'Perrot, Robert', *Oxford Dictionary of National Biography*. Charles F. Abdy Williams, *A Short Historical Account of the Degrees in Music at Oxford and Cambridge* (London: Novello, Ewer and Co, 1893), pp. 121, 154. Magnus Williamson, 'Affordable splendour: editing, printing and marketing the Sarum Antiphoner (1519–20)', *Renaissance Studies* 26 (2012), 60–87 (pp. 66–67).

33 KCA, KCAR/4/1/1/9, Mundum Book (1499/1500), 'Expense necessarie'; KCAR 4/1/5/3, fol. 114r.

34 Nothing in the Provost's known biography renders it likely that he himself was the composer.

35 Andrew Chibi, 'Fox, Edward', *Oxford Dictionary of National Biography*. Roger Bowers, 'The vernacular litany of 1544 during the reign of Henry VIII', in *Authority and Consent in Tudor England. Essays presented to C. S. L. Davies*, ed. George W. Bernard and Steven J. Gunn (Aldershot: Ashgate, 2002), pp. 151–78.

36 Malcolm Kitch, 'Day, George', *Oxford Dictionary of National Biography*.

37 KCA, KCAR/4/1/1/10, Mundum Book (1509/10), 'Custus ecclesie', 'Expense necessarie'; KCAR/4/1/1/10bis, Mundum Book (1510/11), 'Custus ecclesie'; Mundum Book (1515/16), 'Expense necessarie'; Mundum Book (1518/19), 'Expense necessarie'; King's College Accounts 22, fol. 30r.

38 KCA, King's College Accounts, 22, fol. 46r. For full text, and identifications, see Frank L. Harrison, *Music in Medieval Britain*, 2nd edition (London: Routledge and Paul, 1963), pp. 432–3.

39 KCA, KCAR/4/1/1/10, Mundum Book (1532/3), 'Custus ecclesie', 'Expense necessarie'.

40 KCA, KCAR/4/1/1/10, Mundum Book (1509/10), 'Feoda et regarda'; KCAR/4/1/1/10bis, Mundum Book (1510/11), 'Custus equitancium'; Mundum Book (1518/19), 'Feoda et regarda'; KCAR/4/1/1/10, Mundum Book (1532/3), 'Feoda et regarda', 'Custus equitancium'; KCAR/4/1/1/11, Mundum Book (1535/6), 'Custus equitancium'; Mundum Book (1536/7), 'Custus equitancium'; Mundum Book (1541/2), 'Custus equitancium', 'Feoda et regarda'; Mundum Book (1545/6), 'Custus ecclesie'.

41 KCA, KCAR/4/1/1/10, Mundum Book (1532/3), 'Custus ecclesie'.

42 KCA, KCAR/4/1/1/10, Mundum Book (1509/10), 'Reparaciones apud Cantabrigiam'; KCAR/4/1/1/10bis, Mundum Book (1510/11), 'Expense necessarie'.

43 Willis and Clark, *Architectural History*, vol. 1, pp. 344–5. KCA, KCAR/4/1/1/10, Mundum Book (1532/3), 'Reparaciones apud Cantabrigiam'; KCAR/4/1/1/11, Mundum Book (1545/6), 'Expense necessarie', 'Reparaciones apud Cantabrigiam'.

44 His known career indicates a birth-date of c.1505, so that he cannot be identified with the boy named Tye already a chorister by December 1508.

45 KCA, Compotus Bursariorum (1537/8), 'Billa'; Compotus Bursariorum (1538/9), 'Billa'.

46 Will, 1519: see KCA, KCAR/3/3/1/1/1, Ledger Book, vol. 1, fol. 249r.

47 Williams, *Degrees in Music*, pp. 121, 154. R. Bowers, 'Music and worship, to 1642', *A History of Lincoln Minster*, ed. Dorothy M. Owen (Cambridge: Cambridge University Press, 1994), pp. 47–76 (pp. 61, 76).

48 *A Biographical Dictionary of English Court Musicians, 1485–1714*, compiled Andrew Ashbee and David Lasocki, 1 vol. in 2 (Aldershot: Ashgate, 1998), pp. 24–5, 240, 761.

49 *The Acts and Monuments of John Foxe: a New and Complete Edition*, ed. Stephen R. Cattley, 8 vols (London: R. B. Seeley and W. Burnside, 1837–41), vol. 8, p. 378 (described mistakenly as a conduct, 1539).

50 John Caius, *Historiae Cantebrigiensis Academiae ab urbe condita, Liber Primus* (London: In ædibus Iohannis Daij, 1574), p. 68.

51 KCA, KCAR/4/1/1/11, Mundum Book (1536/7), 'Expense necessarie', 'Custus ecclesie', 'Reparaciones apud Cantabrigiam'. For the 'organ-loft': KCAR/4/1/1/16, Mundum Book (1570/1), 'Custus ecclesie'.

52 KCA, KCAR/4/1/1/11, Mundum Book (1536/7), 'Reparaciones apud Cantabrigiam'.

53 KCA, KCAR/4/1/1/11, Mundum Book (1541/2), 'Reparaciones novi templi'; KCAR/4/1/1/12, Mundum Book (1547/8), 'Reparaciones apud Cantabrigiam'; John Nichols, *The Progresses and Public Processions of Queen Elizabeth*, 2 vols (London: no publisher, 1788), vol. 1, p. 12 (year 1564). In 1598/9 choristers' book-desks were made (KCA, KCAR/4/1/1/20, Mundum Book (1598/9), 'Expense necessarie'), possibly surviving as the present desks of the choral scholars.

54 The erstwhile location of the high altar appears clearly on Smythson's plan of c.1607–11 (Ill. 20).

55 KCA, KCAR/4/1/1/11, Mundum Book (1544/5), 'Reparaciones novi templi'. Graham Chainey, 'The east end of King's College Chapel', *Proceedings of the Cambridge Antiquarian Society*, 83 (1994), 141–65 (p. 142).

56 References in 'Exhibitio chorustarum', hitherto copious, cease at KCA, KCAR/4/1/1/11, Mundum Book (1536/7).

57 Bowers, 'The vernacular litany of 1544', pp. 151–78.

58 Jane Freeman, 'Guest, Edmund'; Malcolm Kitch, 'Day, George', *Oxford Dictionary of National Biography*.

59 KCA, KCAR/4/1/1/12, Mundum Book (1547/8), 'Expense necessarie'.

60 Alan Bryson, 'Cheke, John', *Oxford Dictionary of National Biography*.

61 Thomas Rymer, *Foedera: Conventiones, Literæ, et Cuiuscunque Generis Acta Publica, inter Reges Angliæ et Alios quosvis Imperatores, Reges … ab Anno 1101 ad Nostra usque Tempora Habita aut Tractata*, 10 vols, 3rd edn (The Hague: Johannes Neulme, 1739–45), vol. 6, part 3, pp. 168–9.

62 KCA, KCAR/4/1/1/12, Mundum Book (1548/9), 'Pensiones'. Two lay clerks remained in employment, but for other duties.

63 KCA, KCAR/4/1/1/12, Mundum Book (1548/9), 'Expense necessarie'.

64 KCA, KCAR/4/1/4/2.

65 Charles Henry Cooper, *Annals of Cambridge*, 5 vols (Cambridge, 1842–53, 1908), vol. 2, p. 82.

66 KCA, KCAR/4/1/1/13, Mundum Book (1553/4), 'Expense necessarie', 'Feoda et regarda'; King's College Accounts 47.

67 KCA, KCAR/4/1/1/13, Mundum Book (1554/5 – 1557/8), 'Pensiones' (Fellows, scholars).

68 KCA, KCAR/4/1/1/15, Mundum Book (1564/5), 'Expense necessarie'. Nichols, *Progresses and Public Processions*, vol. 1, pp. 11, 25 (year 1564). KCA, KCAR/4/1/1/13, Mundum Book (1555/6), 'Reparaciones apud Cantabrigiam'; KCAR/4/1/1/14, Mundum Book (1561/2), 'Expense necessarie'.

69 KCA, KCAR/4/1/1/12–13, Mundum Books (1552/3 – 1557/8), 'Expense necessarie', 'Custus ecclesie'; King's College Accounts 22, fols 87r–87v; KCAR/3/3/1/1/1, Ledger Book, vol. 1, fol. 386v.

70 KCA, KCAR/4/1/1/13, Mundum Book (1553/4), 'Custus ecclesie', 'Expense necessarie'; Mundum Book (1554/5), 'Custus ecclesie'; Mundum Book (1556/7), 'Expense necessarie'.

71 KCA, KCAR/4/1/1/13, Mundum Book (1553/4), 'Expense necessarie'; Mundum Book (1557/8), 'Custus ecclesie', 'Expense necessarie'.

72 Cooper, *Annals of Cambridge*, vol. 2, pp. 112–24.

73 Record of the expense involved, entered annually under 'Exhibitio chorustarum', ceases after 1550.

74 KCA, KCAR/4/1/1/13, Mundum Book (1555/6), 'Pensiones'; KCAR/3/3/1/1/1, Ledger Book, vol. 1, fol. 385r.

75 KCA, KCAR/4/1/1/14, Mundum Book (1558/9), 'Custus ecclesie'.

76 The few references to items 'said or sung' were clearly oversights, accidentally preserved as the Prayer Book of 1549 was revised into that of 1552.

77 Injunction 49: *Visitation Articles and Injunctions of the Period of the Reformation*, ed. Walter Howard Frere and William M. Kennedy, 3 vols, Alcuin Club, 14–16 (London: Longmans, Green, 1910), vol. 3, pp. 22–3.

78 Margaret L. Kekewich, 'Baker, Philip', *Oxford Dictionary of National Biography*.

393

79 KCA, KCAR/4/1/1/14, Mundum Book (1558/9), 'Custus ecclesie', 'Expense necessarie'; KCAR/4/1/1/15, Mundum Book (1566/7), 'Custus ecclesie', 'Expense necessarie'; KCAR/4/1/1/14, Mundum Book (1563/4), 'Custus ecclesie'.

80 KCA, KCAR/4/1/1/14, Mundum Book (1558/9), 'Pensiones' ('Mr Addams'); cf. KCAR/4/1/1/14, Mundum Book (1560/61), 'Pensiones'.

81 Cf. KCA, KCAR/4/1/1/14, Mundum Books (1561/2) and (1562/3), 'Exhibitio chorustarum'; thereafter, see Mundum Books, 'Pensiones' (except KCAR/4/1/1/16–17, Mundum Books 1570–77).

82 KCA, KCAR/4/1/1/15, Mundum Book (1564/5), 'Expense necessarie'; KCAR/4/1/1/24, Mundum Book (1618/19), 'Expense necessarie'.

83 Roger Bowers, 'The Prayer Book and the musicians, 1549–1662', *Cathedral Music* (2002), issue 2, 36–44.

84 KCA, KCAR/4/1/1/14, Mundum Book (1558/9), 'Feoda et regarda'; Mundum Book (1560/1), 'Custus ecclesie'; Mundum Book (1561/2), 'Custus ecclesie'; Mundum Book (1562/3), 'Custus ecclesie'; KCAR/4/1/1/15, Mundum Book (1567/8), 'Custus ecclesie'; Mundum Book (1568/9), 'Custus ecclesie'.

85 London, British Library, Add. MSS 30480–3. In 1615 these were owned by a Thomas Hamond; there appear signatures of his brothers George Hamond (the name of a lay clerk, 1613–15) and Robert Hamond, this latter being the name of a nephew of an earlier Thomas Hamond (see KCA, KCAR/3/3/1/1/3, Ledger Book, vol. 3, p. 121), who was Master of the Choristers 1587–92, 1598–1605. See Margaret Crum, 'A seventeenth-century collection of music belonging to Thomas Hamond, a Suffolk land-owner', *The Bodleian Library Record*, 6 (1957), 373–86.

86 KCA, KCAR/4/1/1/13, Mundum Book (1557/8), 'Pensiones'; Mundum Book (1558/9), 'Pensiones'; KCAR/3/3/1/1/1, Ledger Book, vol. 1, fol. 384v. He was known in Add. MSS 30480–3 as either 'R.' or 'Robart'; perhaps there had arisen confusion with the chorister Robin (= Robert) Addams (1563–7).

87 KCA, KCAR/4/1/1/14, Mundum Book (1561/2), 'Expense necessarie'; KCAR/4/1/1/15, Mundum Book (1564/5), 'Custus ecclesie', 'Expense necessarie'.

88 Nichols, *Progresses and Public Processions*, vol. 1, pp. 7–12 (year 1564); London, British Library, Harley MS 7033, fol. 114r/127r. On the visit, see also Nicolette Zeeman above, 'The Chapel Imagined: 1540–1830', pp. 207–8; and Abigail Rokison, 'Drama in King's College Chapel', pp. 243–6.

89 Cooper, *Annals of Cambridge*, vol. 2, pp. 224–5, 245–7.

90 Bowers, 'The Prayer Book and the musicians', pp. 36–44.

91 KCA, KCAR/4/1/1/16, Mundum Book (1574/5), 'Custus ecclesie'; see Ill. 90.

92 KCA, KCAR/4/1/1/16, Mundum Book (1570/1), 'Recepcio forinseca'.

93 G. Williams, 'Ecclesiastical vestments, books, and furniture in the Collegiate Church of King's College, Cambridge', *The Ecclesiologist*, 20 (1859), 304–15 (p. 314); KCA, KCV 49, fol. 136r.

94 The 'verse' style of composition was not taken up at large until the late 1580s; see Roger Bowers, 'Ecclesiastical or domestic? Criteria for identification of the initial destinations of William Byrd's music to religious vernacular texts', in Richard Turbet, *William Byrd: a Research and Information Guide*, 3rd edition (New York and London: Routledge, 2012), pp. 134–60 (pp. 147–8).

95 KCA, KCAR/4/1/1/16, Mundum Book (1571/2), 'Custus ecclesie'; Mundum Book (1572/3), 'Custus ecclesie'; KCAR/4/1/1/17, Mundum Book (1576/7), 'Custus ecclesie'; Mundum Book (1577/8), 'Custus ecclesie'; Mundum Book (1578/9), 'Custus ecclesie'; Mundum Book (1579/80), 'Feoda et regarda'.

96 KCA, KCAR/4/1/1/17, Mundum Book (1580/1), 'Custus ecclesie'; KCAR/4/1/1/18, Mundum Book (1586/7), 'Feoda et regarda'.

97 Though no certainty is possible, this apparently was not the 'Mr Wilkinson' who, associated with Trinity College 1609–12, composed in rather a later style. I am grateful to Dr Ian Payne for help in elucidating this point.

98 KCA, KCAR/4/1/1/16, Mundum Book (1574/5), 'Reparaciones apud Cantabrigiam'; KCAR/4/1/1/18, Mundum Book (1583/4), 'Reparaciones apud Cantabrigiam'; Mundum Book (1586/7), 'Reparaciones apud Cantabrigiam'; KCAR/4/1/1/20, Mundum Book (1593/4), 'Reparaciones apud Cantabrigiam'; Mundum Book (1595/6), 'Reparaciones apud Cantabrigiam'; KCAR/4/1/1/26, Mundum Book (1631/2), 'Reparaciones apud Cantabrigiam', 'Expense necessarie'.

99 'Exhibitio chorustarum' sections of Mundum Books.

100 John Gray, 'King's College School in 1564', *Proceedings of the Cambridge Antiquarian Society*, 56 (1964), 88–102 (p. 95, n.5).

101 KCA, KCAR/4/1/1/16, Mundum Book (1572/3), 'Expense necessarie'; Mundum Book (1574/5), 'Expense necessarie', 'Reparaciones apud Cantabrigiam'; KCAR/4/1/1/19, Mundum Book (1590/1), 'Reparaciones apud Cantabrigiam'. This replaced Jesus College grammar school, closed in 1570.

102 KCA, KCAR/4/1/1/19, Mundum Book (1589/90), 'Custus ecclesie'; Mundum Book (1591/2), 'Custus ecclesie'.

103 John Harley, *Orlando Gibbons and the Gibbons Family of Musicians* (Aldershot: Ashgate, 1999), pp. 17–24, 273.

104 KCA, KCAR/4/1/1/20, Mundum Book (1594/5), 'Custus ecclesie'; Mundum Book (1597/8), 'Custus ecclesie'.

105 KCA, KCGB 3/7/1, fols 70r, 83r.

106 Record of acquisitions for Hall: 'Miscellaneous' ('Expense necessarie'); for Chapel: 'Chapel expenses' ('Custus ecclesie').

107 KCA, KCAR/4/1/1/19, Mundum Book (1592/3), 'Expense necessarie'; Mundum Book (1593/4), 'Expense necessarie'; KCAR/4/1/1/20, Mundum Book (1594/5), 'Expense necessarie'; cf. KCAR/4/1/1/15, Mundum Book (1564/5), 'Expense necessarie'; KCAR/4/1/1/24, Mundum Book (1618/19), 'Expense necessarie'.

108 KCA, KCAR/4/1/1/20, Mundum Book (1598/9), 'Expense necessarie'.

109 *The Life of the renowned Doctor Preston, writ by his pupil Master Thomas Ball, D.D., Minister of Northampton, in the year 1628*, ed. Edward W. Harcourt (London: Parker and Co, 1885), p. 5.

110 Orlando appears unlikely to be identifiable with the chorister admitted in 1596 and recorded solely as 'Gibbins'; the two careers actually overlapped, and anyway, aged over 12 in 1596, Orlando was (by statute) too old for admission.

111 KCA, KCGB 3/7/1, fols. 70r, 83r, 110v, 143r. Will: KCAR/3/3/1/1/3, Ledger Book, vol. 3, pp. 121–2.

112 KCA, KCAR/3/3/1/1/3, Ledger Book, vol. 3, p. 250; also Ian Payne, *The Provision and Practice of Sacred Music at Cambridge Colleges and Selected Cathedrals, c.1547–c.1646* (New York and London: Garland, 1993), pp. 272, 304.

113 KCA, KCAR/4/1/1/20, Mundum Book (1598/9), 'Custus ecclesie'; KCAR/4/1/1/21, Mundum Book (1601/2), 'Custus ecclesie'; Mundum Book (1604/5), 'Expense necessarie', 'Feoda et regarda'.

114 KCA, KCGB 3/7/1, fols 40r, 42r, 52r, 64r, 68r, 73r, 79r, 89r, 97v, 103r, 104r; ibid., fol. 136r (response).

115 KCA, KCAR/4/1/1/21, Mundum Book (1604/5), 'Custus equitancium'.

116 Nicholas Thistlethwaite, 'The organ of King's College, Cambridge, 1605–1802', *BIOS Journal*, 32 (2008), 4–42 (p. 8); Philip Brett, 'Paston, Edward', *Oxford Dictionary of National Biography*.

117 KCA, KCAR/4/1/1/21, Mundum Book (1604/5), 'Feoda et regarda'.

118 Even after allowing for inflation, the expenditure of £396 3s 9d appears much to exceed the £164 15s 7¾d paid at Exeter Cathedral in 1513/14; see Stephen Bicknell, *The History of the English Organ* (Cambridge: Cambridge University Press, 1996), p. 40.

119 KCA, KCAR/4/1/1/21, Mundum Book (1604/5), 'Custus ecclesie', 'Expense necessarie', 'Reparaciones apud Cantabrigiam'; KCAR/4/1/1/22, Mundum Book (1605/6), appendix. On this organ, see John Butt below, 'The Chapel Organ – A Harmonious Anachronism?', pp. 291–2.

120 Christopher Kent, 'Dallam, Thomas', *Oxford Dictionary of National Biography*.

121 For greater detail see Thistlethwaite, 'The organ of King's College', pp. 19–21.

122 Bicknell, *History of the English Organ*, plate 14 (p. 81).

123 Saltmarsh, 'King's College', p. 391 and n. 5.

124 KCA, KCAR/4/1/1/23, Mundum Book (1613/14), 'Expense necessarie'; Mundum Book (1616/17), 'Expense necessarie' (indicating that the organ remained on the Chapel floor, and had not in 1613 been removed to the rood-loft).

125 KCA, KCAR/4/1/1/22, Mundum Book (1605/6), 'Custus ecclesie', 'Feoda et regarda'; Payne, *Provision and Practice of Sacred Music*, pp. 75–7.

126 KCA, KCGB 3/7/1, fols 325r, 347r.

127 Crum, 'A seventeenth-century collection of music', pp. 383, 386.

128 KCA, KCAR/4/1/1/22, Mundum Book (1605/6), 'Custus ecclesie' (also Payne, *Provision and Practice of Sacred Music*, p. 76); KCA, KCAR/4/1/1/22, Mundum Book (1606/7), 'Custus ecclesie'; Mundum Book (1609/10), 'Custus ecclesie'; Mundum Book (1608/9), 'Feoda et regarda'; Mundum Book (1609/10), 'Feoda et regarda'.

129 See S. John D. Mitchell, *A History of the Perse School, 1615–1976* (Cambridge: Oleander Press, 1976), pp. 11–21.

130 KCA, KCAR/4/1/1/22, Mundum Book (1610/11), 'Custus ecclesie'; KCAR/4/1/1/23, Mundum Book (1612/13), 'Custus ecclesie' (Sanctus bell); (1611/12), 'Custus ecclesie' (inaugural Communion).

131 KCA, KCAR/4/1/1/23, Mundum Book (1611/12), 'Pensiones'; Mundum Book (1614/15), 'Feoda et regarda'; and years following.

132 KCA, KCAR/4/1/1/22, Mundum Book (1610/11), 'Feoda et regarda'; KCAR/4/1/1/23, Mundum Book (1614/15), 'Feoda et regarda'.

133 KCA, KCAR/3/3/1/3, Ledger Book, vol. 3, pp. 513–15.

134 KCA, KCAR/4/1/1/22, Mundum Book (1610/11), 'Custus ecclesie', 'Feoda et regarda'; KCAR/4/1/1/23, Mundum Book (1612/13), 'Expense necessarie'; Mundum Book (1613/14), 'Expense necessarie'.

135 KCA, KCAR/4/1/1/23, Mundum Book (1615/16), 'Expense necessarie'; KCAR/4/1/1/24, Mundum Book (1617/18), 'Custus ecclesie'; Mundum Book (1618/19), 'Custus ecclesie'.

136 Nicholas W. S. Cranfield, 'Collins, Samuel', *Oxford Dictionary of National Biography*.

137 KCA, KCAR/4/1/1/24, Mundum Book (1617/18), 'Feoda et regarda'; Mundum Book (1618/19), 'Pensiones'; KCAR/4/1/6/26, Liber communarum (1617/18 – 1619/20); KCAR/4/1/1/24, Mundum Book (1622/3), 'Feoda et regarda'; KCAR/4/1/1/25, Mundum Book (1626/7), 'Feoda et regarda'; Mundum Book (1625/6), 'Expense necessarie'. Organist at St Paul's by 14 June, 1621: London, Guildhall Library, MS 25630/6, fol. 446r.

138 KCA, KCAR/4/1/1/24, Mundum Book (1622/3), 'Feoda et regarda', 'Soluciones pro liberatura'.

139 KCA, KCAR 1/2/16, vol. 2, no. 2.

140 Payne, *Provision and Practice of Sacred Music*, p. 95, n.5, and pp. 304–5.

141 KCA, KCAR/4/1/1/25, Mundum Book (1626/7), 'Feoda et regarda'.

142 Ian Payne, 'Loosemore, Henry', *Oxford Dictionary of National Biography*.

143 London, British Library, Harley MS 7019, fol. 76r; Chainey, 'The east end of King's College Chapel', p. 146.

144 See Jeremy Musson above, 'King's College Chapel: Aesthetic and Architectural Responses', pp. 40–41.

145 KCA, KCAR/4/1/1/26, Mundum Book (1632/3), 'Feoda et regarda'; Mundum Book (1635/6), 'Custus ecclesie'; Cooper, *Annals of Cambridge*, vol. 3, p. 283.

146 KCA, KCAR/4/1/1/26, Mundum Book (1634/5), 'Custus ecclesie'.

147 *Records of Early English Drama: Cambridge*, ed. Alan H. Nelson (Toronto: University of Toronto Press, 1989), pp. 738–46.

148 KCA, KCAR/4/1/1/26–27, Mundum Books (1631/2 – 1639/40), 'Expense necessarie' and/or 'Feoda et regarda'.

149 Payne, *Provision and Practice of Sacred Music*, pp. 149–50, 338–49.

150 KCA, KCAR/4/1/1/26, Mundum Book (1630/1), 'Expense necessarie'.

151 KCA, KCAR/4/1/1/25, Mundum Book (1627/8), 'Feoda et regarda'; Mundum Book (1628/9), 'Expense necessarie'; Mundum Book (1629/30), 'Custus ecclesie'; KCAR/4/1/1/26, Mundum Book (1630/1), 'Custus ecclesie'.

152 Payne, *Provision and Practice of Sacred Music*, pp. 73–4, 114–16, 430; John Morehen, 'Loosemore, Henry', *New Grove Dictionary of Music and Musicians*.

153 KCA, KCAR/4/1/1/27, Mundum Book (1636/7), 'Feoda et regarda'.

154 New York, Public Library, MS Drexel 5469. Thurston Dart, 'Henry Loosemore's organ book', *Transactions of the Cambridge Bibliographical Society*, 3 (1959–63), 143–51 (with full inventory); John Morehen, 'The Gibbons-Loosemore mystery', *Musical Times*, 112 (1971), 959–60.

155 Cooper, *Annals of Cambridge*, vol. 3, pp. 275–83.

156 Payne, *Provision and Practice of Sacred Music*, pp. 304–5.

157 KCA, KCAR/4/1/1/27, Mundum Book (1642/3), 'Expense necessarie', 'Reparaciones novi templi'; KCAR/4/1/1/28, Mundum Book (1643/4), 'Expense necessarie'.

XIII

The Chapel Organ – a Harmonious Anachronism?

JOHN BUTT

1. I am most grateful to Roger Bowers, Stephen Cleobury, Timothy Day, Nicholas Marston, Nicholas Thistlethwaite and Mark Venning, for their help in preparation of this essay. Many thanks are also due to Harrison and Harrison for access to their archives, and to the long-suffering staff in the Archive at King's.

2. Although much about the sixteenth-century English organ remains conjectural, a reconstruction of three organs between 2002 and 2010 by Goetze and Gwynn, based on the implications of surviving fragments, has helped at least to clarify the ways in which such organs differed in construction and tone from instruments of the following century. See John Harper, 'Sonic Ceremonial in Sixteenth-Century English Liturgy', *BIOS Journal* 35 (2011), 6–29, and Dominic Gwynn, 'The Origins of the English Style in Church Organ-Building', *BIOS Journal* 30 (2006), 116–30.

3. Roger Bowers notes four occasions between 1451 and 1468: KCA, KCAR/4/1/1, Mundum Books (1450), 'Custus ecclesie'; Liber Communarum (1450–51), week beginning 19 September; Liber Communarum (1456, 1467), 'Custus ecclesie', 'Expense necessarie'. See also, José Hopkins, 'King's College, Cambridge, and the First Queen Elizabeth: a Royal Progress', *BIOS Journal* 35 (2011), 20–27 (see p. 20).

4. Bowers has identified the relevant entries in the KCA, KCAR/4/1/1, Mundum Books (1507), 'Restitution creditorum', 'Custus ecclesie'; Mundum Books (1508), 'Restitutio creditorum'; Mundum Books (1509, 1515), 'Custus ecclesie'.

5. KCA, KCAR/4/1/1 (1536), 'Reparaciones Cantebrigie'. Nicholas Thistlethwaite, 'The Organ of King's College, Cambridge: 1605–1802', *BIOS Journal* 32 (2008), 4–42 (see p. 5). Incidentally, references to the present Chapel as the 'new chapel' still persist into the early nineteenth century, even though the old chapel had collapsed in 1537. See KCA, KCAR/4/1/1, Mundum Books (1801–6), where repairs to the Chapel are listed as 'Reparationes Novi Templi'.

6. Harper, 'Sonic Ceremonial', pp. 14–16.

7. Ibid., p. 17.

8. Thistlethwaite, 'The Organ of King's 1605–1802', pp. 6–8; Hopkins, 'A Royal Progress', p. 23.

9. KCA, KCAR/4/1/1, Mundum Book. The contents have been transcribed and analysed in several modern publications, most recently in Thistlethwaite 'The Organ of King's 1605–1802'.

10. Thistlethwaite, 'The Organ of King's 1605–1802', p. 11; Hopkins, 'A Royal Progress', p. 23.

11. The only comparable five-tower case surviving in Britain today is that for the 'Milton Organ' in Tewkesbury Abbey, originally built for Magdalen College Chapel, Oxford by Dallam's son Robert (see Ill. 204).

12. Thistlethwaite, 'The Organ of King's 1605–1802', pp. 35–36.

13. Ibid., pp. 23–24. Roger Bowers suggests that this is the most likely time for the move of the organ, 'Item Magistro Dallam pro reparandis organis ut patet [per billam] £22 0s 0d': KCAR/4/1/1, Mundum Book (1634), 'Custus ecclesie'. Bowers also notes that the erection of a barrier to protect the organ in 1616/17 suggests that the organ was still located at floor level.

14. Thistlethwaite, 'The Organ of King's 1605–1802', p. 25. Bowers has identified a record that suggests the case was entirely dismantled in 1644: 'Solut' Martin et Cowen pro opere circa le Organ case 2s 0d. Solut' Ashley pro taking downe the Orgaine case 3s 4d': KCAR/4/1/1, Mundum Book (1643), 'Expense necessarie' (term beginning Midsummer).

15. *The Shorter Pepys*, ed. Robert Latham (London: Guild Publishing, 1986), p. 145.

16. For details of the history of the organ during the Restoration era and eighteenth century, see Thistlethwaite, 'The Organ of King's 1605–1802', pp. 25–29.

17. See Nicholas Thistlethwaite, 'Dr Mann and the Organ of King's College, Cambridge: 1857–1912', *BIOS Journal* 29 (2005), 19–44 (see p. 21).

18. The commissioning of a completely new organ seems to be implied by the College Congregation Minutes of 3 December 1801: 'Agreed that a new Organ be built in the Chapel and that the expense of it be paid out of the Chest Account'; and on 5 April the following year, the minutes state that it was 'Agreed with Mr Avery to build an organ according to proposals submitted by him to the College'. See KCGB/4 1717–1998, volume for 1779–1808.

19. Ibid., 12 November 1803.

20. Thistlethwaite, 'Dr Mann', p. 21; Andrew Freeman 'The organs at King's College Cambridge', *The Organ* 8 (1929), 129–38 (p. 133).

21. KCA, KCAR/4/1/1, Mundum Book (1809), p. 77.

22. All this information is from Thistlethwaite, 'Dr Mann', pp. 21–25.

23. Freeman, 'The organs at King's College Cambridge', p. 133.

24. *The Musical Standard*, June 6, 1868, p. 233.

25. This material on the Mann era is all derived from Thistlethwaite, 'Dr Mann'; but see also Nicholas Marston below, ' "As England Knows it": "Daddy" Mann and King's College Choir, 1876–1929'.

26. The information from the Ord era is derived from Nicholas Thistlethwaite, 'Boris Ord and the Reconstruction of the Organ in King's College Cambridge: 1932–4', *BIOS Journal* 31 (2007), 6–40, unless otherwise referenced. But see also Timothy Day below, '"The Most Famous Choir in the World?" The Choir since 1929', pp. 348–55.

27. Order of Service, 28 April 1934, archive on the organ of King's College Cambridge, Harrison and Harrison, Durham.

28. Two schemes, a month apart, survive from Hill, Norman and Beard: 23 November and 23 December 1931. While these are very similar, the second one adds a comment about revoicing the pipework 'to produce an even and sonorous build-up of fine tone quality, without undue power, suitable to the acoustics of the Chapel'. This sounds very much as though it is playing towards Ord's tastes and his sensitivity to the acoustics. See KCA, KCAR 8/1/14, file on the organ rebuild.

29. It seems that Ord may not have been the intended successor to Mann when he was appointed a Fellow, according to Patrick Magee: 'During my choristership days the Assistant Organist had been Frank Shepherdson, outstanding both as organist and choirmaster, and it was universally understood that he would succeed Daddy Mann when the time came. But sadly Sheppy died in 1926 at the early age of 38, leaving a vacuum which was never filled. On Dr. Mann's death in 1929 there was no heir apparent, but Bernhard Ord (better known as Boris), already a Fellow of the College, was the obvious choice'. See Patrick Magee, *A Journal: The Days of Patrick Connor Magee*, typed manuscript, King's College, Cambridge: KCHR/8/9,

p. 22. On the other hand, Patrick Wilkinson noted that Ord had been appointed back in 1923 'with an eye to his succeeding Dr Mann as Organist'. See Patrick Wilkinson, *A Century of King's 1873–1972* (Cambridge: King's College, 1980), p. 82. See also Marston below, 'As England knows it', p. 314; and Timothy Day, '"The Most famous Choir in the World?" The Choir since 1929', pp. 350–51. I am most grateful to Timothy Day and Nicholas Marston for providing these references. The possibility of Ord being considered as Mann's successor only in the final years of the latter's life would make his subsequent development all the more remarkable.

30 The term 'neo-classical' can refer to a multitude of things, including a literalistic reliance on past models. But in its musical usage between the world wars it tends to refer to an objectifying impulse within composition and performance, accompanied by references to eighteenth-century formal procedures and gestures (thus reacting against the late Romanticism and Expressionism that were so often seen as coterminous with the excesses of World War I). In Ord's case, it may be reflected in a small but perceptible influence from the German 'Orgelbewegung' – a movement that sought to restore the clarity and purity of the 'classical' organ, which in retrospect is very much part of a turn within modernism.

31 The only substantial element of Ord's plans that was never executed was his preference for 'state of the art' stop mechanism, namely, the luminous stop system developed by John Compton. Although there is evidence that Harrison found this distasteful (Letter from Ord to Harrison, 10 April 1932, archive on the organ of King's College Cambridge, Harrison and Harrison, Durham), it appears in all three of the Harrison schemes (KCA, KCAR 8/1/14), and John Compton himself sent three quotes for the system to Harrison in 1931 (referring to a request from Harrisons of 24 June, Archive at Harrison and Harrison). It may well be that it was Ord himself who lost enthusiasm for the Compton system, since there is, on a copy of the second Harrison scheme of 23 October 1931, in King's College Archives, written in pencil after the typed reference to the Compton system, 'or other system approved by Mr Bernhard Ord'. It is interesting to speculate as to whether the Compton system, had it been adopted, would have survived up to the present day – it still features on several prominent Compton organs, such as that at Downside Abbey, which was of particular influence on Ord.

32 Letter from Ord to Harrison, 10 April 1932, archive on the organ of King's College Cambridge, Harrison and Harrison, Durham. The reference to the organ at 'the City Hall' presumably refers to that of Newcastle-upon-Tyne, which had been completed by Harrisons just three years previously.

33 Archive on the organ of King's College Cambridge, Harrison and Harrison, Durham.

34 Personal communication; Venning has also recently discussed this issue with the former heard voicer of the firm, Peter Hopps, and asked the firm to check the pipework again; they confirm that only the case pipes date from before the nineteenth century. Harrison and Harrison's very detailed list of the composition and makers of all the new ranks is transcribed in Thistlethwaite, 'Boris Ord', pp. 35–38.

35 The diapason chorus provides the 'fundamental' organ sound, which is traditionally intended to emulate the human voice rather than specific instruments.

36 Handwritten notes from 1968, archive on the organ of King's College Cambridge, Harrison and Harrison, Durham.

37 Letter from Willcocks to Harrison and Harrison, 19 February 1968, archive on the organ of King's College Cambridge, Harrison and Harrison, Durham.

38 Pencil addition in second scheme, signed 24 May 1932 (KCA, KCAR 8/1/14, File on the organ rebuild).

39 Notes from July 1992, archive on the organ of King's College Cambridge, Harrison and Harrison, Durham.

40 Letter from Stephen Cleobury to Mark Venning, 13 June 1988, archive on the organ of King's College Cambridge, Harrison and Harrison, Durham.

41 I remember that, when some of the case pipes still provided the bottom of the double diapason, in the early 1980s, there were certain times of day when this stop was unusable if the sun was shining brightly, owing to the expansion (and thus flattening in pitch) of the pipes concerned.

XIV

'As England knows it': 'Daddy' Mann and King's College Choir, 1876–1929
Nicholas Marston

1 Gwen Raverat, *Period Piece: A Cambridge Childhood* (London: Faber & Faber, 1981), p. 223.

2 Raverat, *Period Piece*, p. 223.

3 *The Times*, 20 November 1929; quoted from the College memoir, *Arthur Henry Mann* (Cambridge: Cambridge University Press, 1930), p. 19.

4 Edward J. Dent, 'Arthur Henry Mann: 1850–1929', *The Monthly Musical Record*, 50 (1 January 1930), p. 4; *Cambridge News*, 20 November 1929. For more on Mann's choral ideals and rehearsal techniques, and Dent's reactions to them, see Timothy Day, '"The Most Famous Choir in the World?" The Choir since 1929', below, pp. 348–50.

5 For a general account see A[ugustus] Austen Leigh, *King's College* (London: F. E. Robinson, 1899), esp. pp. 289–91; *Augustus Austen Leigh: Provost of King's College, Cambridge: A Record of College Reform*, ed. William Austen Leigh (London: Smith, Elder, 1906), esp. pp. 114–21, 168–9; L. P. Wilkinson, *A Century of King's: 1873–1972* and *Kingsmen of a Century: 1873–1972* (Cambridge: King's College Cambridge, 1980).

6 See Robert J. Henderson, *A History of King's College Choir School, Cambridge* (Cambridge: King's College School, 1981). Congregation minutes for the period 1875–1932 are at KCA, KCGB/4/1/1/8–14; Council minutes 1882–1930 are at KCGB/5/1/4/1–10; and Provost and officers' minutes 1871–82 at KCGB/6/26/1. I am very grateful to Patricia McGuire and Peter Monteith for their tireless assistance in the College Archive Centre. It should be noted that, at the time of writing, one of Mann's choristers (John Davidson [David] Briggs) of 1927 remains alive.

7 KCA, KCAR 3/1/2/4/1, p. 73.

8 KCA, CSV/80.

9 The present-day distinction between Dean of Chapel and Lay Dean was not yet effective at this period; there were usually two Deans in office who shared sacred and secular duties between

397

them. The close involvement of the precentor with the work of the Choir is indicated by a Provost and officers' minute of 19 April 1875 that Mr Bengough, 'so long as he continues Precentor, be expected to conduct the practises of the Choir, and that Mr Amps during the practises be required to preside at the Organ'. On 28 June that year it was agreed, in the wake of Bengough's resignation, 'that Mr Amps be requested to conduct the regular practices of the Choir and select the Music for the Services in Chapel pending the appointment of a Precentor'.

10 This draft vote and Okes's (draft) letter are found at KCA, KCC/52.

11 On this and the Tests Act see William Austen Leigh, *Augustus Austen Leigh*, pp. 116–21.

12 KCA, CSV/1.

13 KCA, KCC/15.

14 KCA, KCC/45.

15 M. R. James, *Eton and King's: Recollections, Mostly Trivial, 1875–1925* (London: Williams & Norgate, 1926), pp. 231–3.

16 For a sense of this practice in an earlier era, see Thomas H. Case, *Memoirs of a King's College Chorister* (Cambridge: W. P. Spalding, 1899), pp. 12–15.

17 These rules build on an earlier set, adopted by the Provost and officers in February 1873, prior to the establishment of the Choir School. A ban on resorting 'to Public Houses, or Billiard Rooms' in the 1873 set was replaced in the latter by a general prohibition on being out of bounds or loitering.

18 *Eastern Daily Press*, 21 November 1929; *Cambridge News*, 20 November 1929.

19 This suggests that the pattern of two full practices each week, established in 1869, was still operative.

20 KCA, KCC/42.

21 Okes's note of 1877 and letter of 1883 are both found at KCA, KCC/42.

22 Nevertheless, it should be noted that in his 1926 'Report on Chapel Expenditure' (see below), Eric Milner-White quoted an annual allowance of only £20 for purchase of new music.

23 KCA, KCC/53.

24 The deliberations in Congregation during 1875–77 concerning extra seating for the lay clerks and choristers (see above) may have been intended to address this issue ahead of Mann's raising it. A portion of this discussion in Mann's letter is unfortunately missing.

25 See an entry in the diary of the English scholar and essayist A. C. Benson for May 1904: 'Rather nice little story of Mann asking if in Holy Week if the service was to be unaccompanied, if the Provost [Augustus Austen Leigh] might not sing. Winds up in what might have been unpleasant interview Mann/Austen Leigh, where AL asked M if he sang too loud, out of tune, wish him to sing lower or not wish me to sing at all. "Yes," says Mann. "Well, it shows how one can live in a fool's paradise for years. It never occurred to me that I was particularly audible, or that I made any difference to the service." Mann tells him tactfully that voices often as they gain power, lose tone ...'. I am grateful to Karen Arrandale for providing this reference.

26 KCA, KCAR/3/2/3/8, p. 38, signed and end-dated 17 July 1882.

27 Dent, 'Arthur Henry Mann', p. 3.

28 Mann's position *vis-à-vis* the College officers, and Austen Leigh in particular, must have been rendered particularly sensitive because of the considerable private financial generosity which lay behind the musical reform of the Chapel during his first decades. The Austen Leigh brothers' support of the Choral scholarship initiative was especially notable: only seven years after the inaugural scholarship of 1880 did a Congregation agree – by one vote – 'that it is desirable that the College should contribute towards the expenses of the Choral Scholarships that may hereafter be provided by private liberality'.

29 KCA, KCC/53.

30 KCA, JEN/1/LEIGH.

31 KCA, JEN/1/LEIGH.

32 KCA, OB/1/1052/A; 29 June 1882. It was presumably also for financial reasons that Mann had earlier accepted the post of organist at Jesus College in 1880: the Provost and officers, perhaps surprisingly, agreed to this on 21 February provided that his duties in King's were not affected. In the event he served at Jesus for one year only, being succeeded in 1881 by Frederick Bowman. My thanks to Mark Williams and Peter Glazebrook of Jesus College for this information. Later, in 1894, Mann was to join the staff of the Leys School on a part-time basis; he was Director of music there until 1922 and gave organ lessons in King's Chapel to pupils from the School. I am grateful to John Harding, Archivist of the Leys School, for this information.

33 *Daily News*, [?]15 June 1910.

34 KCA, KCAR 3/1/2/4/1, p. 35. The recipient was presumably Robert Lynam Knight (KC 1887), who graduated in 1892.

35 KCA, KCAR 3/1/2/4/2, pp. 68, 70.

36 'College Correspondence: King's', *The Cambridge Review*, 37, no. 917 (1 December 1915), 140.

37 KCA, KCAR 3/1/2/4/6, p. 272. The absence of any composer's name suggests that Psalm 51 and the two preceding Psalms were sung to Anglican chant. Even if this were not the case, it is highly unlikely that Psalm 51 would have been sung to the famous setting by Allegri: Mann evidently preferred that by Stainer.

38 'A Commination, or Denouncing of God's Anger and Judgements against Sinners', is appointed in *The Book of Common Prayer* principally for use on Ash Wednesday.

39 KCA, KCAR 3/1/2/4/7, pp. 109 (1917) and 83 (1916).

40 Andrew Parker, 'Mann, Arthur Henry', *Oxford Dictionary of National Biography* (http://www.oxforddnb.com/view/article/34851; last accessed 21 October 2013).

41 KCA, AHM 1/6. Page references follow in the text.

42 From *The Times* obituary, in *Arthur Henry Mann*, p. 19.

43 Rosamond Lehmann, *Dusty Answer* (Harmondsworth: Penguin Books, 1983), pp. 122–3.

44 See Abigail Rokison, 'Drama in the Chapel' above, p. 248.

45 KCA, KCAR/3/1/2/4/9, p. 180 (Report, p. 6).

46 Wilkinson, *A Century*, p. 68.

47 See KCA, KCAR/8/2/1/6A.

48 See Nicholas Nash, '"A Right Prelude To Christmas": A History of *A Festival of Nine Lessons and Carols*' below. James, *Eton and King's*, pp. 238–9 gives an impression of the pre-war Christmas Eve service, from which Milner-White may have drawn the opening processional singing of 'Once in Royal David's City' when he revised the structure of the *Nine Lessons and Carols* in 1919.

49 Wilkinson, *A Century*, p. 69.

50 For the Order of Service see KCA, KCAR 3/1/2/4/8, p. 186. A marked-up organ loft copy (which identifies the Gibbons hymn tune) for what was evidently the 1921 service, when the completed Memorial Chapel was dedicated by the visitor, can be viewed at http://kccaonline.org/choir_archive_documents/archive_doc_0005.pdf. Milner-White's report is EMW/2/4 (unpaginated; here p. [8]). For a different view about Gibbons, see Roger Bowers, 'Chapel and Choir, Liturgy and Music, 1444–1644', above, p. 276.

51 Services were now usually suspended at four points during the year: for a fortnight or so after 27 December, for a period in March/April, usually following Easter Monday or Tuesday, for a fortnight in late June and early July, and for part of August and all of September.

52 The paragraph continues: 'Incidentally it leaves the clergy standing futilely at the Altar sometimes for as long as twenty minutes while the congregation turn their backs on it. It practically makes an important service out of the X Commandments. If there is to be a quiet celebration [of Holy Communion] at noon, let it all be quiet, and the break made at the end of Matins. If we were not used to it, the present custom would seem anomalous to the last degree. It has been given up generally through the country as a mistaken tradition; and surely it is time we do so too.' The Ante-Communion service is that part of the Communion Liturgy up to and including the 'Prayer for the whole state of Christ's Church', which may be used independently of the consecration and celebration of Holy Communion of which it forms the first part in *The Book of Common Prayer*.

53 Accounts of Mann's musical tastes correctly stress his staunch allegiance to a Victorian repertoire that was certainly becoming outdated during the last decade or so of his life. The increased prominence of Tudor repertoire in the music lists after 1918, as also of more contemporary music, is attributed by Wilkinson (*A Century*, p. 95) to Milner-White's influence; but it would be mistaken to think that Gibbons, Byrd, and Tallis were completely unrepresented hitherto.

54 Other traditions had yet to be established: the Allegri *Miserere* was sung on a Wednesday during Lent in 1920 and 1921 (3 March and 16 February respectively); but its performance on Ash Wednesday or Good Friday, or both, dates only from 1930, after Mann's death.

55 I am grateful to Patricia McGuire and Peter Monteith for help in establishing the correct date of this broadcast and the repertoire sung. Sunday 2 May 1926 was the Fourth Sunday after Easter, which may account for the date of the broadcast being given as 4 May in some sources.

56 From *The Times* obituary, in *Arthur Henry Mann*, p. 19.

57 KCA, KCAR/3/1/2/4/9, p. 182 (Report, p. 1).

58 The immediate impetus for Milner-White's report appears to have been the suggestion, by the First Bursar, J. M. Keynes, that the position of assistant alto lay clerk be discontinued. Milner-White's report was a sequel to one (KCA, KCAR/3/1/2/4/9, p. 180) on 'Chapel Expenditure' dated 16 February, in which he had rehearsed the possibilities for finding economies (hence the relative costings of supplies of candles noted above), and (on Report, p. 3) compared the £950 cost of the 'ideal model' to that of about £1150 for the pre-War full complement (six Lay Clerks, four Choral Scholars). In closing he claimed (p. 7) that 'the Choir alone of Westminster Abbey costs £8500 a year, a sum more than twice as large as our total expenditure on the maintenance of Chapel and Choir School; and our result is both more satisfactory and more famous'.

59 Report, p. 2. Recall the 1897 changes, noted above, to the financial benefits of a choral scholarship in relation to the possibility of University entrance.

60 Wilkinson, *A Century*, p. 82.

61 Patrick Magee, 'A Journal: The Days of Patrick Connor Magee', KCA, KCHR/8/9, p. 22. I am grateful to Timothy Day for bringing Magee's memoir to my attention.

62 KCA, BO/1/2.

63 *Arthur Henry Mann*, p. 7.

64 Wilkinson, *A Century*, pp. 6, 25. It is possible that the specific target of Nixon's lampoon was the chanting of the Psalms under Mann's direction. In his 1910 lecture (see above) Mann had noted that 'the first part [of a chant] has three bars, the second part has four', as also that rhythmic flexibility was permissible only in the first, or 'reciting', bar; but Nixon may equally have been making a more general point. Nor is it clear whether his manuscript was intended to be read aloud, or intended for any audience other than himself. The tone, too, is difficult to gauge: although if affectionate at all, it seems only partly so.

XV

'A Right Prelude To Christmas': A History of *A Festival of Nine Lessons and Carols*
Nicholas Nash

1 Thanks to Dr Patricia McGuire, Archivist of the King's College Archive Centre, Cambridge, and her assistant Peter Monteith; Else Boonen at the BBC Written Archives, Reading; the Cornwall Record Centre, Truro; the Cornwall Studies Library, Redruth; the Archives at Trinity College, Cambridge; the University of Birmingham Archives; David Blake, Curator of the Museum of Army Chaplaincy, Amport; and Rhodope Woods, Rosemary Veitch, and the late Ursula Milner-White, relatives of Eric Milner-White. Nicolette Zeeman has been an extremely helpful and very patient editor, as has Jean Michel Massing, her co-editor. The late John Haslam, CVO, at the BBC supported the American radio broadcast of *Nine Lessons and Carols* from the beginning and so changed my life. Throughout this project Karen Lundholm has been by my side; her curiosity, commitment, research skills, and advice have been helpful both with and beyond words.

2 Mark D. Chapman, 'Benson, Edward White (1829–1896)', *Oxford Dictionary of National Biography*, ed. H. C. G. Matthew and Brian Harrison (Oxford: Oxford University Press, 2004), online edition, Oct 2009, http://www.oxforddnb.com/view/article/2139"; last accessed 1 April, 2014.

3 F. W. B. Bullock, *A History of The Parish Church of St Mary* (Truro: A. W. Jordan, 1948), pp. 116–117.

4 Bullock, *A History of The Parish Church of St Mary*, pp. 119–121.

5 Erik Routley, *The English Carol* (London: Herbert Jenkins, 1958), pp. 84–88. Here, Routley posits, the conditions were right for the proliferation of folk music and carols – that is, 'a settled agricultural society and a remoteness from progressive civilisation'; a somewhat primitive map displays the places at which traditional carols from the *Oxford Book of Carols* were first recorded, a proxy measurement indicating the richness of the inheritance of carols from the West Country, that part of the country 'encountered and enlightened by [John] Wesley'.

6 W. J. Margetson, *G. H. S. Walpole, A Memoir* (London: Wells, Gardner, Darton & Co. Ltd, 1930), p. 8.

7 *West Briton Gazette*, 23 December 1878.

8 *West Briton Gazette*, 30 December, 1878.

9 *West Briton Gazette*, 29 December, 1879.

10 Arthur Christopher Benson, *The Life of Edward White Benson, Sometime Archbishop of Canterbury*, 2 vols (London: Macmillan, 1899), vol. 1, p. 471.

11 Penny Cleobury, 'How did the Festival of Nine Lessons and Carols start?', *The King's College Choir Book*, ed. Penny Cleobury and Jonathan Rippon (Chichester: Phillimore, 1997), p. 20.

12 Augustus B. Donaldson, *The Bishopric of Truro, 1877–1892* (Rivington: London, 1902), p. 287.

13 Truro, Cornwall Record Office, *Service of IX Lessons*, TCM 538.

14 *Preces* are short petitions, said or sung as 'versicle and response' by the officiant and congregation respectively.

15 The service contained three anthems from Handel's *Messiah*.

16 'Decani' refers to the side of the church occupied by the Dean, typically the south side of the chancel, and 'Cantoris' refers to the north side occupied by the cantor.

17 *West Briton Gazette*, 30 December, 1880, p. 3.

18 *Royal Cornwall Gazette*, 30 December, 1880, p. 5.

19 *The Literary Churchman And Church Fortnightly*, 9 November, 1883, p. 495.

20 Benson, *Edward White Benson*, vol. 1, pp. 547–556; vol. 2, pp. 3, 5–7.

21 Benson, *Edward White Benson*, vol. 1, p. 639. Arthur Benson describes the service at Addington as follows: 'On the Sunday after Christmas Day we used to have a service originally drawn up by him for Truro Cathedral, called "Nine Lessons with Carols". The first three of these short lessons, consisting of five or six verses each, were read by Choir-boys, the next two by Choir-men, the following three in succession by one of the Chaplains, the Curate, and the Vicar of the parish, and the last by the Archbishop, who also gave a benediction before each of the nine carols'.

22 Routley, *The English Carol*, p. 230.

23 The Rev'd Jeanne Males, Vicar, St Mary, Addington, correspondence with author, 2014.

24 Benson, *Edward White Benson*, vol. 2, p. 242.

25 At birth Eric was named in the same pattern as his father, that is, Henry Milner White, with no hyphen. The census records of 1891 show no hyphen; Milner-White's relations attribute the insertion of the hyphen to his father after the award of a knighthood and the celebration of his second marriage; this was confirmed in a note to the author by Ursula Milner-White in April 2013. However, *Eric Milner Milner-White*, the title of Robert Tinsley Holtby's memorial book (Chichester: Phillimore on behalf of the Friends of York Minster, 1991), while correctly titled, remains unique in the Milner-White literature.

26 Ursula Milner-White, Note to author, April 2013

27 Philip Pare and Donald Harris, *Eric Milner-White 1884–1963, A Memoir* (London: SPCK, 1965), pp. 7–8. The Very Rev'd Phllip Pare was educated at King's College, Cambridge, and The Rev'd Donald Harris had been chorister, choral scholar and, briefly in the early 1930s, chaplain at King's College, Cambridge; both had been in Cambridge during Milner-White's time at King's.

28 On Ash-Wednesday in 1906, Milner-White had a vision of Christ who turned and spoke to him. 'That was the moment of conversion.... Very shortly after, I wrote to my People who were abroad, saying casually, "I sometimes feel that I would after all be a parish priest than a Harrow master"'; KCA, PP/EMW/2/16.

29 Montague Rhodes James, *Eton and King's. Recollections, Mostly Trivial, 1875–1925* (Cambridge: Cambridge University Press, 1926), pp. 262–3

30 British Army Records, Eric Milner-White WO339/34916 (Kew: National Archives) unpaginated.

31 KCA, PP/EMW/6/7, Henry Milner-White, *My Life – from Father's Diaries 1883–1914*, transcribed by Eric Milner-White in the 1950s; entry dated 25 December 1914.

32 D. F. Carey, *Studdert Kennedy: War Padre* (London: Hodder & Stoughton, 1929), p. 139, as quoted in Peter Howson, *Muddling Through, The Organisation of British Army Chaplaincy in World War I* (Solihull: Helion and Company, 2013), p. 14.

33 Pare and Harris, *Eric Milner-White 1884–1963*, p. 20.

34 *Supplement to the London Gazette*, 21 July, 1917, p. 7433.

35 Milner-White, Letter to M. R. James, 5 June 1915 (KCA, MRJ/D/Milner-White).

36 Milner-White, Letter to M. R. James, 15 June 1915 (KCA, MRJ/D/Milner-White).

37 Milner-White, Letter to M. R. James, 28 October 1917 (KCA, MRJ/D/Milner-White).

38 Bishop Henry Lewellyn Gwynne, *War Diary*, University of Birmingham Archives, CMS/ACC/Z1. Gwynne, Deputy Chaplain General, kept a ledger book to track the activities of 'his' chaplains on the Western Front; the entry is a transcription by his aide of the D. S. O. recommendation for Eric Milner-White.

39 *Supplement to the London Gazette*, 24 December, 1917, Issue 30445, p. 13490.

40 *Supplement to the London Gazette*, 1 January, 1918, Issue 30450, p. 24.

41 Pare and Harris, *Eric Milner-White*, pp. 18–19.

42 David Blake, *Personal communication*, February 2014. Blake is the Curator of the Museum of Army Chaplaincy, Amport.

43 Eric Milner-White, 'Worship and Services', *Church in the Furnace*, ed. F. B. MacNutt (London: Macmillan, 1919), p. 178.

44 Milner-White, 'Worship and Services', pp. 188, 176.

45 E. L. Langston, *John Taylor Smith (1860–1938)*, Great Churchman Series 15 (Watford: Church Room Book Press, nd); http://churchsociety.org/issues_new/history/smith/iss_history_smith_intro.asp; last accessed 17 April 2014.

46 British Army Records, *Eric Milner-White* (National Archives, Kew), unpaginated.

47 British Army Records, *Eric Milner-White*; also published in *Supplement to The London Gazette*, Issue 30534, p. 2271, 20 February, 1918.

48 British Army Records, *Eric Milner-White*.

49 Henry R. T. Brandreth, *A History of the Oratory of the Good Shepherd* [originally published 1958], rev. George Tibbatts as *A History of the Oratory of the Good Shepherd: The First Seventy Five Years* (The Almoner: Oratory of the Good Shepherd, Berks, 1988), p. 8.

50 Pare and Harris, *Eric Milner-White*, p. 19.

51 Recorded conversation with the late Ursula Mary Milner-White, Rhodope Woods and Rosemary Veitch (Salisbury, 15 April 2013).

52 Patrick Wilkinson, *Eric Milner-White, 1884–1963. Fellow, Chaplain and Dean, Dean of York: A Memoir* (Cambridge: King's College, 1963), p. 12.

53 Eric Milner-White, *Letter to M. R. James*, 13 July 1916; KCA, MRJ–C–4.

54 Eric Milner-White, *The Chapel*; KCA, MRJ–C–4, pp. 3–4. Milner-White retyped this document in 1918. Presumably, it was this copy circulated to the Council following his appointment/election as Dean (KCA, EMW/2/4).

55 Milner-White, *The Chapel*, p. 10.

56 Wilkinson, *Eric Milner-White*, p. 12.

57 Votes of King's College *Congregation*, 11 May, 1918; KCA, KCGB/4/1/1/12 (Item VIII a).

58 King's College Council minutes, (18 May, 1918); KCA, KCGB/5/1/4/8. On the two College Deans at this period, see Nicholas Marston above, '"As England knows it": "Daddy" Mann and King's College Choir, 1876–1929', n. 9.

59 Chris Baker, citing statistics collected in the 1920s from the Central Statistical Office and from Official History of the Medical Services: *The Long, Long Trail*; http://www.1914–1918.net/faq.htm; last accessed 2 April 2014.

60 L. P. Wilkinson, *Kingsmen of a Century 1873–1972* (Cambridge: King's College, 1981), p. 352 (Wilkinson's accounting of the dead included those who had been expected to enroll for Michaelmas Term, 1914).

61 Recorded interview with Frank C. K. Anderson, December 1982.

62 Michael Cox, *M. R. James, An Informal Portrait* (Oxford: Oxford University Press, 1986), pp. 56–57.

63 Wilkinson, *A Century of King's*, p. 95.

64 Milner-White, *The Festival of Nine Lessons and Carols*. Milner-White writes of the singing at Truro that it 'contained only four carols, with two hymns, three choruses from the Messiah, and the Magnificat'. At Truro, the service was described as 'IX Lessons with Carols', and Milner-White's alteration of the name makes clear his preference for a better balance of words and music.

65 Erik Routley, *The English Carol*, p. 230.

66 *A Festival of Nine Lessons and Carols in King's College Chapel upon Christmas Eve 1918* (Cambridge: J. B. Peace, at the University Press, 1918); KCA, KCAR 3/1/2/4/7.

67 Routley, *The English Carol*, p. 230 (Routley claims the bidding prayer did not appear until 1919, but the order of service for 1918 includes it).

68 The benedictions were the same used at Truro and Addington; the reading of a preface before each lesson was added by Milner-White, and when a lesson was replaced, presumably the Dean responsible provided a preface for it.

69 The Collect for Christmas Eve did not replace the Collect for Christmas Day until 1966; see Emma Disley, 'The history of the First Broadcast', *King's College Foundation News*, Winter, 2003, no. 12.

70 From KCA, KCAR/3/1/2/4/7, *A Festival of Nine lessons and Carols in King's College Chapel upon Christmas Eve 1918*.

71 Pare and Harris, *Eric Milner-White*, p. 24.

72 Frank Anderson, Recorded Interview.

73 Holtby, *Eric Milner Milner-White*, p. 25. Sometime Dean of Chichester, Holtby was a choral scholar at King's, where he read theology and later served briefly as acting chaplain.

74 KCA, Cambridge.coll/21/1, Eric Milner-White, *The Festival of Nine Lessons and Carols* (Cambridge: King's College, 1952).

75 Milner-White, *The Festival of Nine Lessons and Carols*, p. 1. He may have thought the Truro benedictions 'irrelevant', but he did retain the first one for the 1919 service at King's.

76 Milner-White, *The Festival of Nine Lessons and Carols*, p. 2.

77 Since 1918, 'Once in Royal David's City' has been the processional; since 1919 it has been the opening music.

78 Benedictions of this type have not recurred in the service since 1919.

79 No explanation as to why the Collect for Christmas Eve was not used until 1966 has been found.

80 KCA, CSV/103, *A Festival of Nine Lessons and Carols in King's College Chapel upon Christmas Eve 1919* (Cambridge: J. B. Peace, at the University Press).

81 See the order of service in KCA, CSV/103, *King's College Chapel. A Festival of Nine Lessons and Carols on Christmas Eve* (Cambridge: University Printing House, 1966), p. 28; the same is true of all the services up till 1970. Brought up a Christian and very interested in Christianity from an anthropological point of view, Leach remained suspicious of institutional religion: see Stephen Hugh-Jones, 'Edmund Leach 1910–1989' (Cambridge: King's College, Cambridge, 1989), pp. 31–2, 34–6.

82 Routley, *The English Carol*, p. 231.

83 Trevor Beeson, *In Tuneful Accord. The Church Musicians* (London: SCM Press, 2009), Kindle edition, location 3223.

84 Richard Waters, *Choral Journal*, October 2007, pp. 19–29. Harold Darke composed 'In the Bleak Mid-Winter' in 1909 at the age of 21, the first of seven carols he wrote over the next seven years, six of which were still in print in 2007.

85 Reginald Jacques and David Willcocks, *Carols for Choirs* (London: Oxford University Press, 1961). Willcocks' extraordinary career is remembered in William Owen, *A Life in Music. Conversations with David Willcocks and Friends* (Oxford: Oxford University Press, 2008).

86 Stephen Cleobury, 'Preparing for a Festival of Nine Lessons and Carols', *Organists' Review*, February, 2009, pp. 38–41.

87 Emma Disley, programme notes for audio disc, *Nine Lessons and Carols*, King's College, 2012, p. 5.

88 Routley, *The English Carol*, p. 249.

89 KCA, KCGB/5/1/4/10, King's College Council Minutes, 6 March, 1926, p. 8.

90 Nicholas Marston has established that the date of the first broadcast was 2 May 1926 and not 4 May. The confusion in some sources may have resulted from the fact that Sunday 2 May that year was the fourth Sunday after Easter; see '"As England knows it": "Daddy" Mann and King's College Choir, 1876–1929' above, p. 399, n. 55.

91 KCA, KCGB/5/1/4/10, King's College Council Minutes, 13 October, 1928, p. 114.

92 Andrew Parker, 'King's College Choir History', *The King's College Choir Book*, pp. 1–8 (p. 5).

93 *Radio Times*, 19 December, 1930, p. 833.

94 *Radio Times*, 18 December, 1931, p. 957.

95 BBC Press Service, Christmas at Cambridge, 28 November 1958; BBC Written Archives, Outside Broadcasts Sound Cambridge: File 7, R30/233/7.

96 Author unknown, *Services for Broadcasting* (London: The British Broadcasting Corporation, 1930).

97 Parker, *The King's College Choir Book*, pp. 6–8 (Parker here describes the early years of wireless transmission of the service in detail).

98 Eric Milner-White, *The Chapel*, p. 2.

99 Sir Neville Marriner, interview with author, 1982.

XVI

'The Most Famous Choir in the World?' The Choir since 1929

Timothy Day

1. This chapter could not have been written without the expertise and unfailing assistance of Patricia Maguire and Peter Monteith in the Archive Centre, to whom the author is most grateful.
2. Internal memo from Outside Broadcasts manager to Director-General BBC dated 22 October 1957; BBC Written Archives Centre, File R30/233/6: Outside Broadcasts – Sound. Cambridge: King's College, File 6 1954–1957.
3. KCA, Annual Report (1935), p. 19.
4. *Manchester Guardian*, 27 December 1932, p. 10. See also Nicholas Nash above, '"A Right Prelude To Christmas": A History of *A Festival of Nine Lessons and Carols*'.
5. *Manchester Guardian* 27 December 1938, p. 10.
6. KCA, Annual Report (1939), p. 19.
7. J. T. Sheppard, Provost of King's College, Cambridge, 'Carols from King's College', *Radio Times*, December 19–25, 1948, p. 4.
8. https://www.youtube.com/watch?v=aGK5EsGzKIg; last accessed 10 September 2013.
9. KCA, Annual Report (1946), p. 26.
10. Edward Higginbottom in Graham Topping, 'The sound of life', *Oxford Today* (Michaelmas, 2006), p. 21.
11. Sally Dunkley, private communication.
12. John Rutter in *A Life in Music: conversations with Sir David Willcocks and Friends*, ed. William Owen (Oxford: Oxford University Press, 2008), p. 273.
13. On Mann, see Nicholas Marston above, '"As England knows it": "Daddy" Mann and King's College Choir, 1876–1929'.
14. E. J. Dent, diary entry for 14 March 1897; KCA, EJD/3/1/3.
15. E. J. Dent, diary entry for 7 June 1896; KCA, EJD/3/1/1.
16. In a letter to Clive Carey quoted in Hugh Carey, *Duet for Two Voices: an informal biography of Edward Dent compiled from his letters to Clive Carey* (Cambridge: Cambridge University Press, 1979), p. 143.
17. Paul-Marie Masson, 'Le Congrès International de Cambridge', *Revue de musicologie* 14, 48 (November, 1933), p. 217.
18. Ster Broman, *Sydsvenska Dagbladet*, 22 March 1936. From the cuttings in the 'Foreign Tour 1933' file, KCA, KCAR/8/3/9/1.
19. See *Arthur Henry Mann 16 May 1850–19 November 1929*, privately printed for King's College, 1930; Philip Radcliffe, *Bernhard (Boris) Ord 1897–1961*, privately printed for King's College, 1962.
20. Seiriol Evans, 'A Victorian Choirmaster', a talk given to the Church Music Society in May 1965, typewritten script, pp. 4–5; KCA, KCAR/8/4/2.
21. David Willcocks in *A Life in Music*, ed. Owen, p. 41; BBC TV 1954 broadcast: http://www.youtube.com/watch?v=Rr6yZ-deibU; last accessed 7 July 2012.
22. Isaac Williams, *On reserve in communicating religious knowledge*, Tracts for the Times 80 (London: J. G. & F. Rivington, 1838), p. 55.
23. Sir Donald Tovey and Geoffrey Parratt, *Walter Parratt: Master of the Music* (London: Oxford University Press, 1941), p. 149.
24. Sir William Harris in 1947, quoted in Frederic Hodgson, *Choirs and Cloisters – Sixty Years of Music in Church, College, Cathedral and Chapels Royal* (London: Thames, 1988), p. 69.
25. 'A Register of the Choir in the Kings [sic] College of Blessed Mary and Saint Nicholas in Cambridge 1860'; KCA, KCAR/8/3/1.
26. L. P. Wilkinson, *A Century of King's 1873–1972* (Cambridge: King's College, 1980), p. 164.
27. Comment from Mr Sedley Taylor in Louis N. Parker, 'Music in our public schools', *Proceedings of the Musical Association* (1893–1894), 97–113 (p. 109).
28. See R. H. Bulmer and L. P. Wilkinson, *A Register of Admissions to King's College, Cambridge 1919–1958* (London: King's College Association, 1963).
29. A. F. S., 'Festival of English Music', *Observer*, 6 August 1933, p. 11.
30. Eric Blom, Richard Capell et al., 'A. H. Fox Strangways', *Music & Letters*, 29, 3, July 1948, 229–237.
31. Walter S. Vale, *The Training of Boys' Voices* (London: Faith Press, 1932), pp. 71–72.
32. Owen Chadwick interviewed by Alan Macfarlane on 29 February 2008, Department of Social Anthropology, Cambridge: http://www.dspace.cam.ac.uk/handle/1810/198014; last accessed 3 October 2011.
33. Robert Tear, *Tear Here* (London: Deutsch, 1990), p. 88.
34. Sir David Willcocks (speaker), recorded in Cambridge on 15 October, 2004; extract on British Library CD 1CDR 0022895, a disc of illustrations used during a British Library Saul Seminar.
35. *A Life in Music*, ed. Owen, p. 18.
36. Ibid., p. 36.
37. Ibid., p. 75.
38. Ibid., pp. 42–43.
39. Ibid., pp. 57–58.
40. Ibid., p. 74.
41. Ibid., p. 165.
42. Ibid., p. 266.
43. Tim Brown, ibid., pp. 183–4.
44. Letter from Kenneth Harrison to Frank Anderson dated Boxing Day 1949, BBC Written Archives Centre File R30/233/4: Outside Broadcasts – Sound. Cambridge: King's College, File 4.
45. KCA, KCAR/8/2/1 contains term cards, service sheets and service programmes for everyday services not celebrating special occasions between 1840 and 2013.
46. KCA, Annual Report (1949), p. 23.
47. HMV B 3707 (10" 78 rpm disc; British Library shelfmark: 1CS0059509.)
48. Stephen Cleobury, Choir Retrospect July 1998 to June 1999: ttp://www.kccaonline.org/choir_reports_pages/choir_retrospect_july_1998_to_june_1999.html; last accessed 14 July 2013.
49. Stephen Cleobury, Choir Retrospect July 2006 to June 2007: http://www.kccaonline.org/choir_reports_pages/choir_retrospect_2006_2007.html; last accessed 14 July 2013.
50. KCA, Annual Report (1930), pp. 13–14.

51 KCA, Annual Report 1931, p. 14.

52 Booklet notes by Stephen Cleobury accompanying EMI 5 58070 2 (2 CDs; released 2005), 'On Christmas Day'; booklet notes by Emma Disley accompanying THE CHOIR OF KING'S COLLEGE, CAMBRIDGE KGS 0001 (2 CDs; released 2012), 'Nine Lessons & Carols'.

53 Stephen Cleobury, Choir Retrospect July 1995 to June 1996: http://www.kccaonline.org/choir_reports_pages/choir_retrospect_july_1995_to_june_1996.html; last accessed 11 July 2013. Stephen Cleobury, Choir Retrospect July 1996 to June 1997: http://www.kccaonline.org/choir_reports_pages/choir_retrospect_july_1996_to_june_1997.html; last accessed 11 July 2013.

54 EMI 2 28944 0 (2 CD set).

55 Christopher Grier, *The Listener*, 2 January 1964, pp. 36, 38.

56 George Malcolm, 'Boys' voices', *English Church Music* 1967, pp. 24–27; this article appeared originally in the 1962 Aldeburgh Festival Programme Book.

57 Stephen Cleobury in Part 1 of an interview with Peter Mathias recorded in Cambridge on 4 September, 2008: http://www.youtube.com/watch?v=8iV5xIukjfk; last accessed 12 September 2013.

58 Stephen Cleobury, from transcripts of interviews recorded in preparation for the 1992 BBC Omnibus documentary on the Choir, KCA, KCAR/8/3/20, RW31, p. 2.

59 Robert Rice, from transcripts of interviews, KCA, KCAR/8/3/20, RW31, pp.70–71.

60 Paul Robinson, from transcripts of interviews, KCA, KCAR/8/3/20, pp. 66–68.

61 John Rutter in *A Life in Music*, ed. Owen, p. 272.

62 Evans, 'A Victorian Choirmaster', p. 4; KCA, KCAR/8/4/2.

63 Brian Head, choral scholar 1955–58; volunteer 1958–59; private communication.

64 Gerald Peacocke, from transcripts of interviews recorded in preparation for the 1992 BBC Omnibus documentary on the Choir; KCA, KCAR/8/3/20, RW31, p. 58.

65 Richard Osborne, *Music & Musicians of Eton* (London: The Cygnet Press, 2012), p. 164.

66 Ibid., p. 197.

67 *Cambridge University* Reporter 139, special issue 17 (20 April 2009), pp. 15–16.

68 Tribute to Hugh Spottiswoode [KC 1923], KCA, Annual Report (1961), p. 60.

69 Edmund Leach, paraphrasing Philip Brett, paper for members of the Council dated [23] January 1967, KCA, KCGB/5/1/4/23, pp. 1–2.

70 *In Tune with Heaven: the Report of the Archbishops' Commission on Church Music* (London: Hodder & Stoughton and Church House Publishing, 1992), paragraph 640, p. 216.

71 G. Lowes Dickipnson, *Religion: a criticism and a forecast* (London: George Allen and Unwin Ltd, 1911), p. 93.

72 Don Cupitt, 'We are grateful to art' in *Radicals and the future of the church* (London: SCM, 1989), pp. 76–77.

Epilogue: The Sound of the Chapel
Stephen Cleobury and Nicolette Zeeman

1 Unless otherwise indicated, the citations that follow all derive from private email correspondence with Stephen Cleobury and Nicolette Zeeman in the course of April and May 2014. We are enormously grateful to all the contributors for the energy and thoughtfulness they put into this.

2 Chaplain and baritone Richard Lloyd Morgan.

3 Countertenor James Bowman.

4 The baritone Gerald Finley is a former choral scholar.

5 James Bowman.

6 The composer Judith Weir is a former student of King's College, and now Master of the Queen's Music.

7 *Roger North's The Musicall Grammarian 1728*, ed. Mary Chan and Jamie C. Kassler (Cambridge: Cambridge University Press, 1990), p. 209.

8 Gerald Finley.

9 John Butt is a former organ scholar at King's College (see above, pp. 287–301).

10 John Drury is a former Dean. Alfred Tennyson, *In Memoriam*, 87, 5–8, in *The Poems of Tennyson*, ed. Christopher Ricks (London: Longmans, 1969), p.938; compare perhaps William Wordsworth, *Ecclesiastical Sonnets* 43–45 (*The Poetical Works of William Wordsworth*, ed. E. de Selincourt, 4 vols (Oxford: Clarendon Press, 1940–44), vol. 3, pp. 405–6.

11 John Butt.

12 The composer George Benjamin is a former student of King's College.

13 The composer Thomas Adès is a former student of King's College.

14 Nicholas Marston sings in King's Voices (and see above, pp. 303–21. For the composer Orlando Gibbons, see Roger Bowers above, 'Chapel and Choir, Liturgy and Music, 1444–1644', p. 275.

15 Judith Weir.

16 The word is John Butt's.

17 James Bowman.

18 The composer Richard Causton is a Fellow of King's College and University Lecturer in Composition.

19 The soprano Catherine Bott is also a broadcaster.

20 The countertenor Michael Chance is a former choral scholar.

Select Bibliography

Brooke, Christopher, *A History of the University of Cambridge 4: 1870–1990* (Cambridge: Cambridge University Press, 1993).

Chainey, Graham (compiled), *In Celebration of King's College Chapel* (Cambridge: The Pevensey Press, 1987).

Chainey, Graham, 'The East End of King's College Chapel', *Proceedings of the Cambridge Antiquarian Society* 83, (1994), 141–65.

Carter, Edmund, *The History of the University of Cambridge* (London: printed for the author, 1753).

Carter, Thomas John Proctor, *King's College Chapel. Notes on its History and Present Condition* (London: Macmillan, 1867).

Case, Thomas H., *Memoirs of a King's College Chorister* (Cambridge: W. P. Spalding, 1899).

[Clare, Stephen] Stephen Clare Stained Glass Consultancy, *An Investigation into the Condition of the Stained Glass with Recommendations towards a Conservation Strategy* (2010).

Clark, J. Willis, and Arthur Gray, *Old Plans of Cambridge 1574 to 1798...reproduced in Facsimile*, 2 parts (Cambridge: Bowes & Bowes, 1921).

Cleobury, Penny, and Jonathan Rippon, eds, *The King's College Choir Book* (Chichester: Phillimore, 1997).

Cooke, James, Chapel Clerk, *An Historical and Descriptive Account of King's College Chapel* (Cambridge: no publisher, 1829).

Cooper, Charles Henry, *Annals of Cambridge*, 5 vols (Cambridge: Warwick and the University Press, 1842–1908).

Doig, Allan, *The Architectural Drawings Collection of King's College, Cambridge* (Amersham: Avebury, 1979).

Emden, A. B., *Biographical Register of the University of Cambridge to 1500* (Cambridge: Cambridge University Press, 1963).

Freeland Rees Roberts Architects, *Conservation Management Plan for King's College Chapel, Cambridge* (May, 2005).

Fuller, Thomas, *The History of the University of Cambridge* [originally published in 1655], ed. Marmaduke Prickett and Thomas Wright (Cambridge: Deighton and Stevenson, 1840).

Harrison, Hugh, *Conservation Report: King's College Chapel: Choir Stalls* (September, 2013).

Harrison, Kenneth, *The Windows of King's College Chapel Cambridge: Notes on the History and Design* (Cambridge: Cambridge University Press, 1952).

Henderson, Robert J., *A History of King's College Choir School, Cambridge* (Cambridge: King's College School, 1981).

Heywood, James, and Thomas Wright, *The Ancient Laws of the Fifteenth Century, for King's College, Cambridge, and for the Public School of Eton College* (London: Longman, Brown, Green and Longmans, 1850).

Hicks, Carola, *The King's Glass: A Story of Tudor Power and Secret Art* (London: Chatto and Windus, 2007).

James, M[ontague] R[hodes], *Eton and King's: Recollections, Mostly Trivial, 1875–1925* (London: Williams & Norgate, 1926).

James, M[ontague] R[hodes], and J[ohn] W. Clark, eds, *The Will of King Henry the Sixth* ([Cambridge]: privately printed, 1896).

Leader, Damian Riehl, *A History of the University of Cambridge 1: The University to 1546* (Cambridge: Cambridge University Press, 1988).

Leigh, A. Austen, *King's College* (London: Robinson, 1889).

Leigh, William Austen, ed., *Augustus Austen Leigh: Provost of King's College, Cambridge: A Record of College Reform* (London: Smith, Elder, 1906).

Lippincott, Kristen, *An Introduction to King's College Chapel* (Cambridge: King's College, 2013).

SELECT BIBLIOGRAPHY

Littlechild, W. P., (Chapel Clerk), *A Short Account of King's College Chapel* (Cambridge: Heffer and Sons, 1921).

Loggan, David, *Cantabrigia illustrata, sive, Omnium celeberrimæ istius Universitatis collegiorum, aularum, bibliothecæ academicæ scholarum publicarum sacelli coll: regalis nec non totius oppidi ichnographia* (Cantabrigiæ: Quam proprijs sumptibus typis mandavit & impressit, [1690]).

Malden, Henry, Chapel Clerk, *An Account of King's College Chapel in Cambridge* (Cambridge: Fletcher and Hodson, 1769; repr. Menston: Scolar Press, 1973).

Morgan, Victor, with a contribution by Christopher Brooke, *A History of the University of Cambridge 2: 1546–1750* (Cambridge: Cambridge University Press, 2004).

Owen, William, ed., *A Life in Music: Conversations with Sir David Willcocks and Friends* (Oxford: Oxford University Press, 2008).

Saltmarsh, J[ohn], 'King's College', *The Victoria History of the Counties of England: A History of the County of Cambridge and the Isle of Ely 3: The City and University of Cambridge*, ed. J. P. C. Roach (Oxford: Oxford University Press, 1959), pp. 376–408.

Saltmarsh, John, *King's College: A Short History* (Cambridge: Pevensey Press, 1958).

Searby, Peter, *A History of the University of Cambridge 3: 1750–1870* (Cambridge: Cambridge University Press, 1997).

Tibbs, Rodney, *King's College Chapel: The Story and the Renovation* (Lavenham: Terence Dalton, 1970).

Wayment, Hilary, *King's College Chapel Cambridge. The Side Chapel Glass* (Cambridge: Cambridge Antiquarian Society and King's College, Cambridge, 1988).

Wayment, Hilary, *The Windows of King's College Chapel Cambridge. A Description and Commentary*, Corpus Vitrearum Medii Aevi. Great Britain. Supplementary vol. 1 (London: The British Academy, 1972).

Wilkinson, L. P., *A Century of King's 1873–1972* (Cambridge: King's College, 1980).

Wilkinson, L. P., *Kingsmen of a Century: 1873–1972* (Cambridge: King's College Cambridge, 1980).

Willis, Robert, and John Clark, *The Architectural History of the University of Cambridge*, 2 vols (Cambridge: Cambridge University Press, 1886).

Woodman, Francis, *The Architectural History of King's College Chapel* (London: Routledge & Kegan Paul, 1986).

Ill. 243. Restoring the roof bosses, King's College Chapel, Cambridge. Edward Leigh, photograph, 1968. Cambridge, King's College, Coll. Ph. 968.

Contributors

Roger Bowers retired in 2005 from his office of Reader in Medieval and Renaissance Music, University of Cambridge. His interests, represented in his book *English Church Polyphony: Singers and Sources from the Fourteenth Century to the Seventeenth* (Ashgate, 1999), encompass all manner of aspects of the interaction between the composition of music in England, the nature of the forces which the Church and social elites saw fit to furnish for its performance, and the political and religious considerations applied by those whom the musicians were constrained to serve and please. He also works on music in northern Italy around 1600, and is preparing a volume to be entitled *Mantua and Monteverdi: the Mass, Motets and Vespers of 1610*.

John Butt is Gardener Professor of Music at Glasgow University and Music Director of Edinburgh's Dunedin Consort. He is also a former student, Organ Scholar and Fellow of King's College. He has published widely in the field of Bach, seventeenth to eighteenth-century music and musical modernity, and has a large discography as both organist (Harmonia Mundi) and conductor (Linn). His recording of Handel's *Messiah* received a Gramophone award in 2007 and two further discs have received nominations.

Stephen Clare, ACR, FMGP, is a stained glass conservator in private practice; he is National Stained Glass Adviser to the National Trust, consultant in recent years to the Cathedrals of Winchester and Gloucester, to St George's Chapel, Windsor Castle, and to King's College Chapel, Cambridge. He is author of *Stained Glass, Art, Craft and Conservation* (Hale Books, 2013). He is at present supervising the conservation of the great east window at Wells Cathedral, the celebrated Jesse Tree window circa 1340 known as 'the golden window', one of the greatest works of English medieval art.

Timothy Day was a music curator in the British Library for many years and between 2006 and 2011 he was a visiting senior research fellow at King's College London. He is a cultural historian and the author of *A Century of Recorded Music: Listening to Musical History* (Yale University Press, 2000).

Matthew DeJong is a Lecturer in Structural Engineering at the University of Cambridge, and a Fellow of St Catharine's College. He earned his PhD at the Massachusetts Institute of Technology.

Iain Fenlon is Professor of Historical Musicology in the University of Cambridge and a Fellow of King's College. In the course of his career he has been affiliated to a number of other academic institutions including Harvard University; All Souls College, Oxford; New College, Oxford; the École Normale Supérieure, Paris; and the University of Bologna. His most recent books are *The Ceremonial City: History, Memory and Myth in Renaissance Venice* (Yale University Press, 2007); *Piazza San Marco* (Harvard University Press, 2009); and a collection co-edited with Inga Groote, *Heinrich Glarean's Books: The Intellectual World of a Sixteenth-Century Musical Humanist* (Cambridge University Press, 2013).

Ross Harrison is Emeritus Quain Professor of Jurisprudence at University College London. His most relevant books to his contribution here are *Bentham* (Routledge, 1983) and, as editor and contributor, *Henry Sidgwick* (Oxford University Press, 2001). He has also written books on metaphysics, democracy, and the political philosophy of Hobbes and Locke as well as editing and contributing to five other jointly authored works about philosophy and law.

Peter Murray Jones is Fellow and Librarian at King's College, Cambridge. His research interests include College history and the history of early medicine. His publications include *Medieval Medicine in Illuminated Manuscripts* (British Library, 1997) and *De Arte Phisicali et de Cirurgia* by John Arderne (Fri Tanke, 2014).

Nicholas Marston is Reader in Music Theory and Analysis in the Faculty of Music, and a Fellow and Director of Studies in Music at King's College. He has been a member of King's Voices since 2001, and performs with many other choral ensembles. His most recent book, *Heinrich Schenker and Beethoven's 'Hammerklavier' Sonata*, was published by Ashgate in 2013.

Jean Michel Massing, FSA, is Professor in History of Art and Fellow of King's College, Cambridge. In the last few years he has been working on the relationships between European and Non-European cultures, especially Africa and the Pacific. He co-organised *Encompassing the Globe: Portugal and the World in the 16th & 17th Centuries*, held in Washington, DC, Arthur M. Sackler Gallery, in 2007, in Brussels, Palais des Beaux-Arts in 2007–2008 and in Lisbon, Museu Nacional de Arte Antiga in 2009. His most recent publications include: *From the 'Age of Discovery' to the Age of Abolition: Europe and the World Beyond* (*The Image of the Black in Western Art*, 3.2) (Cambridge, MA, 2011); with Sally-Ann Ashton, *Triumph, Protection & Dreams: East African Headrests in Context*, Exhibition catalogue, Cambridge, The Fitzwilliam Museum (Cambridge, 2011); edited with Elizabeth McGrath, *The Slave in European Art: From Renaissance Trophy to Abolitionist Emblem* (Turin, 2012); with Gauvin Alexander Bailey and Nuno Vassallo e Silva, *Marfins no Império Português/Ivories of the Portuguese Empire* (Lisbon, 2013).

Jeremy Musson is a freelance architectural historian, author and lecturer. A former assistant curator for the National Trust in East Anglia, he was Architectural Editor of *Country Life* magazine from 1998 to 2007. His recent publications include *English Ruins* (Merrell, 2011), *Up and Down Stairs* (John Murray, 2009), a chapter on the Edwardian Gothic Revival former Middlesex Guildhall in *The Supreme Court of the United Kingdom: History, Art, Architecture* (Merrell, 2010) and an article on 'Jane Austen and Joseph Bonomi' in *The Georgian Group Journal*, 21 (2013). He has sat on the Council for the Care of Churches and currently sits on the Fabric Advisory Committee of Ely Cathedral.

Nicholas Nash (AB Harvard College, 1962; PhD University of Minnesota, 1975). A former teacher and school administrator, he became Vice-President for Programming at Minnesota Public Radio in St Paul and initiated the first live stereo American broadcast of *A Festival of Nine Lessons and Carols* in 1979. The programme has been heard annually since and on nearly three hundred public radio stations in the United States. He lives in White Bear Lake, Minnesota, and maintains contact with King's via the internet and frequent visits to Cambridge.

John Ochsendorf is the Class of 1942 Professor of Architecture and Engineering at the Massachusetts Institute of Technology. He earned his PhD in engineering at Cambridge and is a Member of King's College.

Nicola Pickering is currently a curator at Eton College. She read her BA in History at Oxford University, and then undertook an MA in Curating at the Courtauld Institute and an MPhil in the History of Art and Architecture at the University of Cambridge. She completed her PhD at King's College, London in 2013, sponsored by the Arts and Humanities Research Council. Previously she she has worked as a curator with the National Trust, at Historic Royal Palaces, the Royal Collection Trust, the National Portrait Gallery and Dulwich Picture Gallery.

Abigail Rokison is Lecturer in Shakespeare and Theatre at the Shakespeare Institute, University of Birmingham. Her main area of research is Shakespeare in performance, about which she has written a number of chapters and journal articles. Her first monograph, *Shakespearean Verse Speaking* (Cambridge University Press, 2010), won the inaugural Shakespeare's Globe first book award; her second monograph is *Shakespeare for Young People: Productions Versions and Adaptations* (Arden Bloomsbury, 2013).

James Simpson is Donald P. and Katherine B. Loker Professor of English at Harvard University (2004–). Formerly Professor of Medieval and Renaissance English at the University of Cambridge, he is an Honorary Fellow of the Australian Academy of the Humanities. He was educated at the Universities of Melbourne and Oxford. His most recent books are *Reform and Cultural Revolution* (Oxford University Press, 2002); *Burning to Read: English Fundamentalism and its Reformation Opponents* (Harvard University Press, 2007); and *Under the Hammer: Iconoclasm in the Anglo-American Tradition* (Oxford University Press, 2010).

Nicolette Zeeman is a Fellow at King's College and a Senior Lecturer in the Faculty of English, University of Cambridge. Recent publications include: *Piers Plowman and the Medieval Discourse of Desire* (Cambridge University Press, 2006) and, edited with Dallas G. Denery and Kantik Ghosh, *Uncertain Knowledge. Scepticism, Relativism and Doubt in the Middle Ages* (Brepols, 2014). She has also written on Chaucer, song, scholasticism, devotional literature, medieval literary theory and psychoanalysis; she is currently finishing a book entitled *Arts of Disruption. Conflict and Contradiction in Medieval Allegory*, and projecting a monograph on image use and idolatry in the literature and culture of the Middle Ages.

List of Illustrations

FRONT COVER. Portcullis boss, vault of King's College Chapel, Cambridge. Mike Dixon, photograph, 2011.

BACK COVER. Buttress sculptures, west end of the south elevation of King's College Chapel, Cambridge. Mike Dixon, photograph, 2011.

Ill. 1. FRONTISPIECE. Henry Storer, *The Gateway, Old King's*, 1828, watercolour. Cambridge, King's College. Adrian Boutel and Elizabeth Upper, photograph.

Ill. 2. Jan Stradtmann, *Night Climbers of Cambridge*, from the series *Night Climbers of Cambridge*, 2007, digital photograph.

Ill. 3. *Collegii regalis apud Cantabrigienses Sacellum / King's College Chapel in Cambridge*, c.1706-12, engraving with hand-colouring. Cambridge, King's College, KCC/123 (KCAR/8/1/1/7).

Ill. 4. Augustus Pugin, *View of the Antechapel of King's College, with Choristers*, 1815, watercolour. Cambridge, King's College. Adrian Boutel and Elizabeth Upper, photograph.

Ill. 5. King's College. Detail of facsimile of John Hamond, *Cantebrigia*, engraved by Augustine Ryther and Petrus Muser, 22 February 1592, in J. Willis Clark, *Old Plans of Cambridge*, 2 parts (Cambridge: Bowes and Bowes, 1921), part 2.

Ill. 6. The east end of the Chapel seen from the screen. Mike Dixon, photograph, 2011.

Ill. 7. The Chapel with scaffolding and the stalls and screen boxed in during restoration. Edward Leigh, photograph, 1968. Cambridge, King's College, Coll. Ph 972.

Ill. 8. James Essex, *Ground Plan of King's College Chapel*, c.1756, drawing in India ink. London, British Library, Cartographic Items Additional MS 6776, fol.10.b.

Ill. 9. View of King's College Chapel. Detail of the frontispiece to Thomas Fuller, *The History of the University of Cambridge, from the Conquest to the Year 1634*, ed. Marmaduke Prickett and Thomas Wright (Cambridge; London: University Press, J. W. Parker, 1840). Cambridge, King's College.

Ill. 10. David Loggan, *Prospectus Cantabrigiae Occidentalis / The Prospect of Cambridge from the West*, engraving. In David Loggan, *Cantabrigia illustrata...* (Cantabrigiæ: Quam proprijs sumptibus typis mandavit & impressit, [1690]), pl. 5.

Ill. 11. Scale of foot-print of King's College Chapel compared to surrounding colleges. Detail of David Loggan, *Nova & accuratissima celeberrime universitatis oppidique cantabrigiensis ichnographia*, 1688, engraving. In David Loggan, *Cantabrigia illustrata...* (Cantabrigiæ: Quam proprijs sumptibus typis mandavit & impressit, [1690]), pl. 6. Cambridge, King's College.

Ill. 12. James Gibbs, *The East Prospect of King's College in Cambridge, as intended to be finished*, 1741, engraving. Cambridge, King's College.

Ill. 13. Canaletto (Giovanni Antonio Canal), *Interior of Kings College Chapel*, 1746–1755, oil on canvas. Richmond, Virginia Museum of Fine Arts, 2002.53. Gift of Mrs. Elizabeth Golsan Schneider, in memory of her mother, Mrs. Florence Ramage Golsan. Travis Fullerton, photograph.

Ill. 14. Barak Longmate, *Design for Proposed Campanile*, King's College Chapel, 1793, pen, ink and wash drawing on paper. Cambridge, King's College. Adrian Boutel and Elizabeth Upper, photograph.

Ill. 15. Gordon Cullen, *The Forum Seen from the Marketplace (as in Hawksmoor)*. In David Roberts, *The Town of Cambridge as it Ought to be Reformed: The Plan of Nicholas Hawksmoor* (Cambridge: Printed privately at the University Press, 1955).

Ill. 16. James Wyatt, *Proposal (Perspective looking north to King's Parade)*, 1795, pen and watercolour. Cambridge, King's College, KCD/628. Adrian Boutel and Elizabeth Upper, photograph.

Ill. 17. William Wilkins, *Perspective towards the Southwest from King's Parade*, c.1823, watercolour. Cambridge, King's College. Adrian Boutel and Elizabeth Upper, photograph.

Ill. 18. Lewis Vulliamy, No. 1. *View of the Front towards Trumpington Street of a Design for King's College. Nisi utile nil pulchrum*, c.1822–23, pencil and wash. Cambridge, King's College, CMR/83.

Ill. 19. Ground Plan of Provost's Lodge (showing buildings removed from around the Chapel during Wilkins' rebuilding). In Robert Willis, *Architectural History of the University and Colleges of Cambridge and Eton*, ed. John Willis Clark (Cambridge: University Press, 1886).

Ill. 20. Robert Smythson, *Designs by Reginald Ely (1438–1471) of King's College Chapel: Survey Plan*, c.1609. Detail of drawing A188. London, RIBA Library Drawings Collection, SC229/I/4.

Ill. 21. Survey of King's College Chapel. Detail of James Gibbs, *The Quadrangle of Kings College as its now begune*, engraving, 25.5 x 38. In James Gibbs, *A Book of Architecture: Containing Designs of Buildings and Ornaments* (London: Printed for W. Innys and R. Manby, J. and P. Knapton, and C. Hitch, 1728), pl. [32].

Ill. 22. James Adam, *Elevation of Design for Altarpiece*, [1768], paper. Cambridge, King's College, KCC/277 (KCAR/8/1/2/1).

Ill. 23. James Adam, *Design for Altarpiece, Classical, showing relationship to east window*, [1768], pen and pencil on laid paper. London, Soane Museum, SM Adam volume 31/22.

Ill. 24. James Adam, *Design for Altarpiece, Gothic*, [1769], pen, pencil and wash on laid paper. London, Soane Museum, SM Adam volume 31/23.

Ill. 25. James Essex's altarpiece. Detail of Richard Bankes Harraden, *View of the Choir of King's College*, Cambridge, 1797, watercolour on paper. Cambridge, King's College. Adrian Boutel and Elizabeth Upper, photograph.

Ill. 26. *Interior of King's College Chapel* (looking east from the organ loft to the altar), before 1896, photograph. Cambridge, King's College, KCPH/5/2.

Ill. 27. J. C. Stadler after F. Mackenzie, *The Choir. King's Chapel*, aquatint. In Rudolph Ackermann, *A History of the University of Cambridge, Its Colleges, Halls, and Public Buildings* (London: Printed for R. Ackermann, by L. Harrison and J.C. Leigh, 1815), pl. VI. Oxford, Sanders of Oxford.

Ill. 28. William Burges, *Design for a New Altar Screen, King's College Chapel, Cambridge*, June 1874, pen and wash drawing on paper. Cambridge, King's College Library, KCC/76.

Ill. 29. Copy distributed to Fellows of King's College, Cambridge, of George Bodley and Thomas Garner, *Design for New Altar*, 1895, paper. Cambridge, King's College, KCC/145.

Ill. 30. John Roffe, after John Linnell Bond, after William Wilkins, *Ground Plan with the Groining &c. of the Roof of King's College Chapel, Cambridge*, 29 September 1805, engraving. In John Britton, *The Architectural Antiquities of Great Britain*, vol. I (London: Longman, Hurst, Rees, and Orme [etc.], 1807).

Ill. 31. King's College Chapel: With Traces of Destroyed Buildings Visible in 'Crop-Marks', 1955. In *An Inventory of the Historic Monuments in the City of Cambridge* (London: Her Majesty's Stationery Office, 1988; first printed 1959).

Ill. 32. Detmar Blow, *The Proposed Reredos and Panelling shown in the context of the east end of King's College Chapel*, signed and dated, 'D. Blow, 1906', oil on canvas. Collection of Simon Blow.

Ill. 33. Full-scale plaster model of Detmar Blow's proposed reredos for King's College Chapel. Edgar Allan Basebe, photograph. Cambridge, King's College, KCC/144 (KCAR/8/1/2/1).

Ill. 34. John Rattenbury Skeaping's Wooden Statues of Virgin Mary, Jesus and St Nicholas (installed 1957–60 in the reredos designed by Detmar Blow and Fernand Billerey), [1964], photograph. Cambridge, King's College, Coll Ph 718.

Ill. 35. Ronald A. Chapman, *Peter Paul Rubens' Adoration of the Magi Being Installed Temporarily in the Antechapel for a Period of Experiment*, April 1961, photograph. Cambridge, King's College, KCC/467.

Ill. 36. Adrian Boutel and Elizabeth Upper, *East End of King's College Chapel*, 2014, digital photograph.

Ill. 37. James Wyatt, Proposal (Perspective of the front court towards the east), 1795, pen and watercolour. Cambridge, King's College. Adrian Boutel and Elizabeth Upper, photograph.

Ill. 38. William Wilkins, Elevation: The eastern frontage of the screen, 1823, wash drawing. Cambridge, King's College, KCD/510. Adrian Boutel and Elizabeth Upper, photograph.

Ill. 39. James Gibbs, Unexecuted design for screen and companion building to Gibbs Building, 1741, Watercolour. Cambridge, King's College. Adrian Boutel and Elizabeth Upper, photograph.

Ill. 40. James Wyatt, Proposal (Perspective looking north to King's Parade), 1795, pen and watercolour. Cambridge, King's College, KCD/628. Adrian Boutel and Elizabeth Upper, photograph.

Ill. 41. Three bays of roof vaulting, King's College Chapel, Cambridge. Mike Dixon, photograph, 2011.

Ill. 42. Diagrammatic sketch indicating the building progress over time.

Ill. 43. Sectional view through the vault taken midway between the transverse rib and the boss stone, extracted from a laser scan of the vault.

Ill. 44. Fan vaulting of King's College Chapel. Mike Dixon, photograph, 2011.

Ill. 45. Partial plan view of the fan vaulting and supporting structure.

Ill. 46. Upper surface of Peterborough Cathedral fan vault showing complex geometry of the stone blocks.

Ill. 47. LEFT: Transverse section of the Chapel by Frederick MacKenzie (1840); and RIGHT: from a three-dimensional laser scan (2011).

Ill. 48. Blondel's rule for buttress sizing applied to King's College Chapel to demonstrate the relative stability of the buttresses.

Ill. 49. William Bland investigated the stability of the Chapel using scale models of wooden blocks constructed according to the proportions of this rudimentary section.

Ill. 50. LEFT: An example membrane assumption of compressive forces in a fan vault (left), and RIGHT: a 2D depiction of the resulting forces for a typical bay of the Chapel vault.

Ill. 51. Recent structural models of the Chapel fan vault. (a) Discrete element model and simplified geometry of vault (2011); and (b) thrust network analysis solution for internal compressive forces in vault (2009).

Ill. 52. Internal compressive lines of force in the Chapel vault and buttresses.

Ill. 53. Cross-section of the vault and roof of King's College Chapel by MacKenzie from 1840.

Ill. 54. Scan showing cross-section of two bays of vaulting, including the ties inserted by G. G. Scott.

Ill. 55. Variation in vault height measured in cm above the bosses (from laser scan data) for each of the 12 bays.

Ill. 56. Barnard Flower (attr.), *Annunciation*, 1515–31, stained-glass window. Cambridge, King's College Chapel, Window 3a. Adrian Boutel, photograph, 2014.

Ill. 57. Plan of King's College Chapel showing the window numbering.

Ill. 58. Barnard Flower (attr.), *Temptation of Eve*, 1515–31, stained-glass window. Cambridge, King's College Chapel, Window 3b. Adrian Boutel, photograph, 2014.

Ill. 59. James Nicholson, *Harrowing of Hell*, before 1535, stained-glass window. Cambridge, King's College Chapel, Window 15c. Adrian Boutel, photograph, 2014.

Ill. 60. Dirk Vellert(?), *The Exodus*, before 1535, stained-glass window. Cambridge, King's College Chapel, Window 15d. Adrian Boutel, photograph, 2014.

Ill. 61. School of James Nicholson(?), *Jonah Spewed out by the Whale*, before 1535, stained-glass window. Cambridge, King's College Chapel, Window 16b. Adrian Boutel, photograph, 2014.

Ill. 62. School of James Nicholson(?), *Resurrection*, before 1535, stained-glass window. Cambridge, King's College Chapel, Window 16a. Adrian Boutel, photograph, 2014.

Ill. 63. Galyon Hone, Tomas Reve or Dierick Vellert(?), *Fall of the Idols*, before 1535, stained-glass window. Cambridge, King's College Chapel, Window 5c. Adrian Boutel, photograph, 2014.

Ill. 64. Brass lectern given by Robert Hacumblen to King's College Chapel. Cambridge, King's College Chapel. Adrian Boutel and Elizabeth Upper, photograph.

LIST OF ILLUSTRATIONS

Ill. 65. Robert Hacumblen ('Robert Hacomplaynt'), *Salve regina mater misericordiae*. In the Eton Choirbook, 1490–1502, illuminated manuscript. Eton, Eton College, MS. 178, 51r.

Ill. 66. Plan of King's College Chapel. In Robert Willis and John Willis Clark, *The Architectural History of the University of Cambridge, and of the Colleges of Cambridge and Eton*, 4 vols (Cambridge: University Press, 1886), fig. 42.

Ill. 67. Wooden reading desk/stall, early sixteenth century. Cambridge, King's College Chapel, Tomb Chapel (Hacumblen's Chantry). Adrian Boutel and Elizabeth Upper, photograph.

Ill. 68. Wood panelling, early sixteenth century. Cambridge, King's College Chapel, Tomb Chapel (Hacumblen's Chantry). Adrian Boutel and Elizabeth Upper, photograph.

Ill. 69. Vault ceiling, 1512. Cambridge, King's College Chapel, Tomb Chapel (Hacumblen's Chantry). Adrian Boutel and Elizabeth Upper, photograph.

Ill. 70. Vault ceiling, 1512. Cambridge, King's College Chapel, Tomb Chapel (Hacumblen's Chantry). Adrian Boutel and Elizabeth Upper, photograph.

Ill. 71. Plan of the inside windows of Tomb Chapel (Hacumblen's Chantry), King's College Chapel, Cambridge.

Ill. 72. View of the inside windows of Tomb Chapel (Hacumblen's Chantry), from within. King's College Chapel, Cambridge. Adrian Boutel and Elizabeth Upper, photograph.

Ill. 73. Plan of the outside windows of Tomb Chapel (Hacumblen's Chantry), King's College Chapel, Cambridge.

Ill. 74. View of the outside windows of Tomb Chapel (Hacumblen's Chantry), King's College Chapel, Cambridge. Adrian Boutel and Elizabeth Upper, photograph.

Ill. 75. Memorial to Robert Hacumblen, *c*.1530s, brass and stone. Cambridge, King's College Chapel, Tomb Chapel (Hacumblen's Chantry). Adrian Boutel and Elizabeth Upper, photograph.

Ill. 76. Detail of memorial to Robert Hacumblen, *c*.1530s, brass and stone. Cambridge, King's College Chapel, Tomb Chapel (Hacumblen's Chantry). Adrian Boutel and Elizabeth Upper, photograph.

Ill. 77. Pieter Paul Rubens, *Adoration of the Magi*, 1633, oil on panel. Cambridge, King's College. Adrian Boutel and Elizabeth Upper, photograph.

Ill. 78. Richard Bankes Harraden, *View of the Choir of King's College, Cambridge* (detail), 1797, watercolour on paper. Cambridge, King's College. Adrian Boutel and Elizabeth Upper, photograph.

Ill. 79. After George Romney, *Portrait of Thomas Orde*, 1777, oil on canvas. Cambridge, King's College. Adrian Boutel and Elizabeth Upper, photograph.

Ill. 80. George Romney, *Mater dolorosa*, 1776, on paper. Cambridge, Fitzwilliam Museum, B.V. 48.

Ill. 81. George Romney, *Mater dolorosa*, 1776, on paper. Cambridge, Fitzwilliam Museum, B.V. 47.

Ill. 82. Girolamo Siciolante da Sermoneta, *Deposition*, *c*.1568–73, oil on panel. Cambridge, King's College.

Ill. 83. Girolamo Siciolante da Sermoneta, *Study for the Virgin* in the King's College *Deposition*, *c*.1568–73, black chalk, brown and white brush work on blue paper. Stockholm, Nationalmuseum.

Ill. 84. George Romney, *Portrait of Frederick Howard, 5th Earl of Carlisle*, oil on canvas. Cambridge, King's College. Adrian Boutel and Elizabeth Upper, photograph.

Ill. 85. Girolamo Siciolante da Sermoneta, Digital Reconstruction by Chris Titmus, of the Hamilton Kerr Institute, of the original colours of the *Deposition*, *c*.1568–73, oil on panel. Cambridge, King's College.

Ill. 86. Pieter Paul Rubens, *Adoration of the Magi*, 1633, oil on panel. Cambridge. King's College. Adrian Boutel and Elizabeth Upper, photograph.

Ill. 87. Pieter Paul Rubens, *Sketch of the King's College Adoration of the Magi*, *c*.1633, oil on panel. London, Wallace Collection.

Ill. 88. Gert Van Lon, *Madonna in the Rosary*, 1512–20, oil on panel. Cambridge, King's College.

Ill. 89. Master of the Von Groote Adoration, *Adoration of the Magi*, 1515–20, oil on panel. Cambridge, King's College.

Ill. 90. Master of the Von Groote Adoration, *Adoration of the Magi* (detail of the black king), 1515–20, oil on panel. Cambridge, King's College.

Ill. 91. Carlo Maratta and workshop, *Virgin and Child with the Young John the Baptist*, oil on canvas. Cambridge, King's College.

Ill. 92. Carlo Maratta, *Virgin and Child with the Young John the Baptist*, 1700–1713, oil on canvas. Leningrad, Hermitage, GE 1560.

Ill. 93. The vaulting at the east end, King's College Chapel, Cambridge. Mike Dixon, photograph, 2011.

Ill. 94. Interior of King's College Chapel. Stephen Clare, photograph, 2010.

Ill. 95. Fan vaulting of King's College Chapel. Stephen Clare, photograph, 2010.

Ill. 96. Scaffolding erected to allow conservation work to the south elevation of King's College Chapel. Stephen Clare, photograph, 2010.

Ill. 97. Barnard Flower (attr.), *Marriage of Tobias and Sara*, 1515–31, stained-glass window. Cambridge, King's College Chapel, Window 2. Stephen Clare, photograph, 2010.

Ill. 98. Detail of Barnard Flower (attr.), *Presentation of the Virgin*, 1515–31, stained-glass window. Cambridge, King's College Chapel, Window 2. Stephen Clare, photograph, 2010.

Ill. 99. Detail of Barnard Flower (attr.), *Presentation of the Virgin*, 1515–31, stained-glass window. Cambridge, King's College Chapel, Window 2. Stephen Clare, photograph, 2010.

Ill. 100. Galyon Hone's flatter pictorial style. Detail of Hone Group of Glaziers, *Adoration of the Magi*, 1526–31, stained-glass window. Cambridge, King's College Chapel, Window 4. Stephen Clare, photograph, 2010.

Ill. 101. Design elements across stone mullions. Detail of Hone Group of Glaziers, *Adoration of the Magi*, 1526–31, stained-glass window. Cambridge, King's College Chapel, Window 4. Stephen Clare, photograph, 2010.

Ill. 102. Glass paint and silver stain. Detail of Hone Group of Glaziers, *Adoration of the Magi*, 1526–31, stained-glass window. Cambridge, King's College Chapel, Window 4. Stephen Clare, photograph, 2010.

Ill. 103. Detail of Francis Williamson, *Nativity*, 1526–31, stained-glass window. Cambridge, King's College Chapel, Window 3. Stephen Clare, photograph, 2010.

Ill. 104. Serpent. Detail of Francis Williamson, *Fall of Man*, 1526–31, stained-glass window. Cambridge, King's College Chapel, Window 3. Stephen Clare, photograph, 2010.

Ill. 105. Eve grasping the Forbidden Fruit. Detail of Francis Williamson, *Fall of Man*, 1526–31, stained-glass window. Cambridge, King's College Chapel, Window 3. Stephen Clare, photograph, 2010.

Ill. 106. Dirk Jacobsz Vellert, *Three Designs for Stained Glass Windows*, c.1538, pen and brown ink, grey wash over black chalk on paper. Brunswick, Maine, Bowdoin College Museum of Art, 1811.109. Stephen Clare, photograph, 2010.

Ill. 107. Hawthorn tree with six tiny circles cut from a single piece of green glass, with tiny white florets inserted. Detail of tracery lights, stained-glass window. Cambridge, King's College Chapel, Window 24. Stephen Clare, photograph, 2010.

Ill. 108. The cylinder process.

Ill. 109. Flattening the glass sheets.

Ill. 110. First stage of the crown process: a large flute is produced.

Ill. 111. The 'crown' of the glass.

Ill. 112. Painting on glass on a light box at Holy Well Glass. Stephen Clare, photograph, 2012.

Ill. 113. Varied yellow stains on the face of King Solomon. Detail of Galyon Hone, *Queen of Sheba*, 1526–31, stained-glass window. Cambridge, King's College Chapel, Window 4. Stephen Clare, photograph, 2010.

Ill. 114. Modern glazier leading a panel. Stephen Clare, photograph, 2010.

Ill. 115. Graffiti ('peirce wendy, roge pimp nave'), seventeenth century. Cambridge King's College Chapel, Window 24. Stephen Clare, photograph, 2010.

Ill. 116. Dirt layers on the stonework at a high level on a stained-glass window in King's College Chapel, Cambridge. Stephen Clare, photograph, 2010.

Ill. 117. Rivulets in dirt layer caused by condensation on a stained-glass window in King's College Chapel, Cambridge. Stephen Clare, photograph, 2010.

Ill. 118. 'Mill marks' in the centre of the lead on a stained-glass window in King's College Chapel, Cambridge. Stephen Clare, photograph, 2010.

Ill. 119. Corroded external bars and subsequently damaged stone and glass on a stained-glass window in King's College Chapel, Cambridge. Stephen Clare, photograph, 2010.

Ill. 120. Exposed bar ends and repointing with lime mortar on a stained-glass window in King's College Chapel, Cambridge. Stephen Clare, photograph, 2010.

Ill. 121. Exposed bar ends and repointing with lime mortar on a stained-glass window in King's College Chapel, Cambridge. Stephen Clare, photograph, 2010.

Ill. 122. Exposed bar ends and repointing with lime mortar on a stained-glass window in King's College Chapel, Cambridge. Stephen Clare, photograph, 2010.

Ill. 123. A stained-glass window in King's College Chapel, Cambridge, after conservation, 2010. Stephen Clare, photograph, 2010.

Ill. 124. Damage from earlier repairs on a putto. Detail of Francis Williamson, *Nativity*, stained-glass window. Cambridge, King's College Chapel, Window 3. Stephen Clare, photograph, 2010.

Ill. 125. Test area of cleaning chosen to allow inspection from ground level. Detail of Barnard Flower (attr.), *Marriage of Tobias and Sara*, c.1515, stained-glass window. Cambridge, King's College Chapel, Window 2. Stephen Clare, photograph, 2010.

Ill. 126. Advertisement from the London Warming and Ventilation Company Ltd., 1874. Cambridge, King's College, KCC/375.

Ill. 127. A Gurney stove (patented 1856) similar to those installed in King's College Chapel. Bude, The Castle.

Ill. 128. Storage locations during World War II.

Ill. 129. Detail of Distant view of King's College Chapel from the north west, barges on river in foreground, c.1800, pencil, watercolour and crayon. Cambridge, King's College. Adrian Boutel and Elizabeth Upper, photograph.

Ill. 130. Richard Bankes Harraden, *King's College Chapel and Clare Hall*, engraved by Elizabeth Byrne, 1797, proof print with hand-colouring. Cambridge, King's College. Adrian Boutel and Elizabeth Upper, photograph.

Ill. 131. Henry Hugh Armstead, *Founder's Fountain* (above: King Henry VI; below: Religion holding a model of King's College Chapel on the Bible and Philosophy holding a scroll and a book), 1874–79, bronze and Cornish grey granite (originally Portland stone). Cambridge, King's College, Front Court.

Ill. 132. Coat of Arms of Roger Goade (Provost 1569–1610) and King's College, 1610, stained-glass window. Side chapel window 28e3, King's College Chapel, Cambridge. Adrian Boutel and Elizabeth Upper, photograph.

Ill. 133. *Sir Francis Walsingham*, 1587, oil on panel. Cambridge, King's College. Adrian Boutel and Elizabeth Upper, photograph.

Ill. 134. Original calf binding with chain of *Index bibliothecae Regalis Collegii* (Donor's Book), manuscript. Cambridge, King's College Library, Lib.1. Adrian Boutel and Elizabeth Upper, photograph.

Ill. 135. Francis Walsingham's name written calligraphically, *Index bibliothecae Regalis Collegii* (Donor's Book), manuscript. Cambridge, King's College, Lib.1, fol. [163]r. Adrian Boutel and Elizabeth Upper, photograph.

Ill. 136. Bookcase (with cartouche NH for Nicholas Hobart), 1659. Cambridge, King's College Chapel, side chapel L. Adrian Boutel and Elizabeth Upper, photograph.

Ill. 137. 'Articles, Conditions and Covenants upon which the Provost and other officers of King's Coll. in Cambridge have admitted Michael Mills Scholar of the said College to be Keeper of the Public Library of the said College', c.1685, ink on paper. Cambridge, King's College, KCAC/6/1/1. Elizabeth Upper, photograph.

Ill. 138. Wooden chest belonging to Henry VII, made before 1508, standing next to book-case in side chapel. S. S. Martin, photograph. Cambridge, King's College, Coll. Ph. 1198.

Ill. 139. Richard Bankes Harraden, *Interior of the Chapel looking East from the West End*, 1831, watercolour. Cambridge, King's College. Adrian Boutel and Elizabeth Upper, photograph.

Ill. 140. Binding of Cambridge King's College, MS 41. Fifteenth-century Psalter, manuscript on vellum, 46ff. Adrian Boutel and Elizabeth Upper, photograph.

Ill. 141. 'Deus ultionum' (Psalm 93). In Cambridge, King's College, MS 41, fol. lvi v. Adrian Boutel and Elizabeth Upper, photograph.

LIST OF ILLUSTRATIONS

Ill. 142. Initial D of 'Deus ultionum' (Psalm 93). In Cambridge, King's College, MS 41, fol. lvi v. Adrian Boutel and Elizabeth Upper, photograph.

Ill. 143. Augustine Ryther, *The Sea Coastes of Andaluzia*, dated 1587, engraving with hand-colouring. In Lucas Janszoon Waghenaer, *The Mariners Mirrour...*, trans. Anthony Ashley ([London]: [Henry Haslop], 1588). London, British Library, Maps C.8.b.4.

Ill. 144. Anton van den Wyngaerde, *View of Cadiz*, 1567, pen and ink with watercolour. Vienna, Österreichische Nationalbibliothek, MS. Min 41, fol. 75.

Ill. 145. Edward Hoby, Inscription ('Este libro era de Sto. Jago de Cadiz de los de la Compañia de Jesus, y tomado en el uiage de la armada Jnglesa alla 1596'). Flyleaf of Antiphoner, late sixteenth century, manuscript on vellum, c.1596. Edinburgh, National Library of Scotland, MS 1905.

Ill. 146. Signature of Robert Westhawe. In Tomàs Luis de Victoria, *Motecta festorum totius anni, cum communi sanctorum...* (Rome: Alessandro Gardano, 1585). Oxford, Christ Church College, Mus. 1, title page.

Ill. 147. William Rogers, *Robert Devereux, 2nd Earl of Essex*, 1598–1600, engraving. London, British Museum, 1863,0214.496.

Ill. 148. Thomas Cockson, *Robert Devereux, 2nd Earl of Essex*, 1599–1602, engraving. London, British Museum, O,7.283.

Ill. 149. Title page, *La anatomia de Espanna*, 1598, illuminated manuscript on paper. Cambridge, University Library, Gg.6.19.

Ill. 150. Peacock on pomegranate with motto 'A tverto o derecho nvestra casa hasta el techo', *La anatomia de Espanna*, 1598, illuminated manuscript on paper. Cambridge, University Library, Gg.6.19, fol. 292 [148].

Ill. 151. Roof space above the vault looking west, King's College Chapel, Cambridge. Bill Knight, photograph.

Ill. 152. South corridor at vault-level, looking east, King's College Chapel, Cambridge. Bill Knight, photograph.

Ill. 153. James Malton, King's College from King's Parade, 1794, watercolour. Cambridge, King's College. Adrian Boutel and Elizabeth Upper, photograph.

Ill. 154. Adolphe Rouargue, after Eduard Gerhardt (or another 'Gerhardt'), *Langen Aufriss*, from the series *Dom zu Coeln* (Aachen and Cologne: Ludwig Kohnen and J. E. Renard, c.1830–70), etching on chine collé. London, British Museum, 1954,1103.139.

Ill. 155. King's College. Detail of Richard Lyne, *Cantebrigia*, 1574, engraved broadside.

Ill. 156. King's College. Detail of Georg Braun and Franz Hogenberg, *Cantebrigia*, 1575, engraving. In Georg Braun and Franz Hogenberg, *Civitates orbis terrarum*, 3 vols ([Coloniae Agrippinae, 1572]–1618), vol. 2.

Ill. 157. King's College. Detail of facsimile of John Hamond, *Cantebrigia*, engraving on nine sheets, engraved by Augustine Ryther and Petrus Muser, 22 February 1592. In J. Willis Clark, *Old Plans of Cambridge*, 2 parts (Cambridge: Bowes and Bowes, 1921), part 2.

Ill. 158. King's College. Detail of William Smith, *Cambridge*, ink drawing. In William Smith, *The Particular Description of England, with the Portratures of Certaine of the Chieffest Citties & Townes*, 1588, manuscript, 1588. London, British Library, Sloane MS 2596, fol. 64v.

Ill. 159. Exterior of the North Side of King's College Chapel, c.1509–47, drawing on three sheets. London, British Library, Cotton MS Augustus I i 2.

Ill. 160. E. Challis, *King's College Chapel between the Fan Vaulting and the Timber Roof*, 1833, monochrome wash. Cambridge, King's College. Adrian Boutel and Elizabeth Upper, photograph.

Ill. 161. *Crowning of Solomon*, before 1535, stained-glass window. Cambridge, King's College Chapel, Window 12. Photograph, Adrian Boutel, 2014.

Ill. 162. William Stukeley, *North Elevation of Chapel seen from Within*, 1705, pen and ink on paper. Cambridge, King's College, KCC/279. Adrian Boutel and Elizabeth Upper, photograph.

Ill. 163. English, Child's cradle with turned posts, c.1680, oak. James Gooch, photograph.

Ill. 164. German, Christ Crib, 1340–1350, oak, plaster and parchment. Cologne, Museum Schnutgen, A 779.

Ill. 165. South Netherlandish (Brabant), Christ Crib, fifteenth century, wood, polychromy, lead, silver-gilt, painted parchment, silk embroidery with seed pearls, gold thread and translucent enamels. New York, Metropolitan Museum of Art, 1974.121a.

Ill. 166. William Fells, Lion and unicorn supporting the arms of Charles I with the garter and motto of the Order of the Garter, stall panel, north side stalls (fifth from the eastern end), 1633, elm wood. Cambridge, King's College Chapel, Cambridge. Mike Dixon, photograph, 2011.

Ill. 167. Royal Arms with the Garter motto. On (?)English, Page Alms dish, 1668–69, engraved silver-gilt. Cambridge, King's College. Adrian Boutel and Elizabeth Upper, photograph.

Ill. 168. Shoe shape, with saltire cross, nineteenth century, inscription on the lead roof of St Ethelbert's Church, Tannington, Suffolk. Timothy Easton, photograph.

Ill. 169. Plan of images inscribed on lead roof of tower of St Michael's Church, Cookley, Suffolk. Stuart Boulton and Suffolk County Council Archaeological Service.

Ill. 170. Shoe shape and inscription, north side of main roof of King's College Chapel, Cambridge, post 1860s. Mike Dixon, photograph, 2011.

Ill. 171. Augustus Pugin, *King's Chapel, South Porch*, c.1815, watercolour. Cambridge, King's College. Adrian Boutel and Elizabeth Upper, photograph.

Ill. 172. James Northcote, *Charles Simeon*, 1810, oil on canvas. Cambridge, King's College. Adrian Boutel, photograph.

Ill. 173. Rail added for Charles Simeon ('Saint's Rest'), installed between 1812 and 1836, iron. Cambridge, King's College, G staircase. Adrian Boutel and Elizabeth Upper, photograph.

Ill. 174. Adrian Boutel, *View of King's Bridge*, 2014.

Ill. 175. August Edouart, Silhouette of Charles Simeon, 1828, black and white paper. Cambridge, King's College. Adrian Boutel and Elizabeth Upper, photograph.

Ills. 176–183. August Edouart, Silhouettes of Charles Simeon, 1828, black and white paper. Cambridge, King's College. Adrian Boutel and Elizabeth Upper, photographs.

Ill. 184. Profile of Charles Simeon, 1800–36, engraving. Cambridge, King's College, KCAC/1/4/Simeon/2. Adrian Boutel and Elizabeth Upper, photograph.

Ill. 185. Letters marking the grave of Charles Simeon (1759–1836), late nineteenth century. Cambridge, King's College Chapel. Adrian Boutel and Elizabeth Upper, photograph.

Ill. 186. God commanding the Flood, tympanum on west side of screen (south end), 1530–36. King's College Chapel, Cambridge. Mike Dixon, photograph, 2011.

Ill. 187. Torso with body armour and halberd, detail of ornamental pilaster on west side of screen (south end), 1530–36. King's College Chapel, Cambridge. Mike Dixon, photograph, 2011.

Ill. 188. Sacrificial bull's head, detail of ornamental pilaster on west side of screen (north end), 1530–36. King's College Chapel, Cambridge. Mike Dixon, photograph, 2011.

Ill. 189. Greyhound supporting shield, Provost's stall, east side of screen, 1530–40. King's College Chapel, Cambridge. Mike Dixon, photograph, 2011.

Ill. 190. Ornamental armored head with halberds, detail of ornamental pilaster on west side of screen (south end), 1530–36. King's College Chapel, Cambridge. Mike Dixon, photograph, 2011.

Ill. 191. Performance of Thomas Kyd, *The Spanish Tragedy*, performed by Marlowe Society and Perchance Theatre (King's College Chapel, Cambridge, 7–9 November 2012). Nick Rutter, photograph.

Ill. 192. Cover of playbill for *The Play of Daniel*, performed by the Lambeth Players and the St Bartholomew Singers (King's College Chapel, Cambridge, 27–28 June 1964). Collection of Abigail Rokison.

Ill. 193. Title page of playbill for *The Play of Daniel*, performed by the Lambeth Players and the St Bartholomew Singers (King's College Chapel, Cambridge, 27–28 June 1964). Collection of Abigail Rokison.

Ill. 194. The Chapel screen viewed from the west side. Photograph, *Country Life*; reprinted Christopher Hussey, *King's College Chapel, Cambridge and the College Buildings* (London: Country Life, 1926). Cambridge, King's College, KCAR/8/9/2/15.

Ill. 195. Cherub, Provost's stall, east side of screen, 1530–40. King's College Chapel, Cambridge. Mike Dixon, photograph, 2011.

Ill. 196. Informal musical workings with the name of [Alexander or Henry] Eccleston, *c.*1480. In Mundum Book 1456–1459. Cambridge, King's College, KCAR/4/1/1/3, fol. 61v.

Ill. 197. Text of carol 'There was a Friar of Order Grey', for recreational use in King's College hall, *c.*1500. Cambridge, University Library, Add. MS 7350 (Box 1).

Ill. 198. Inventory of volumes of polyphonic music available for singing in Chapel, 1529. Cambridge, King's College, KCA/22, fol. 46r.

Ill. 199. King's College and its neighbourhood as in 1593. Detail of facsimile of John Hamond, *Cantebrigia*, engraving on nine sheets, engraved by Augustine Ryther and Petrus Muser, 22 February 1592. In J. Willis Clark, *Old Plans of Cambridge*, 2 parts (Cambridge: Bowes and Bowes, 1921), part 2.

Ill. 200. Parts of two leaves discarded from a fifteenth-century antiphoner: gold leaf, and inks (red, blue, black), on parchment. Detail of inside rear cover (outer folio) of Bursar's Book 1549–50. Cambridge, King's College, KCAR/4/1/4/2.

Ill. 201. Text of royal licence to impress singing-boys and men, issued to King's College by King Philip and Queen Mary, 1554. Cambridge, King's College, KC/47 (KCGB/1/I).

Ill. 202. Part of the east side of the Great Court of King's College. Robert Willis and John Willis Clark, *The Architectural History of the University of Cambridge*, 4 vols (Cambridge: Cambridge University Press, 1886), vol. I, p. 552. Reduced from David Loggan, *Collegii Regalis sacelli facies Occidentem spectans*, in David Loggan, *Cantabrigia illustrata. . .* (Cantabrigiæ: Quam proprijs sumptibus typis mandavit & impressit, [1690]), pl. 11.

Ill. 203. Richard Adams, canticle *Nunc dimittis*, *c.*1560, tenor voice. In a manuscript in octavo, *c.*1565. London, British Library, Add MS 30482, ff.17v-18r.

Ill. 204. Case (*c.*1632) of a Great Organ by Robert Dallam now in Tewkesbury Abbey, Gloucestershire, photograph, *c.*1942. English Heritage, NBR A43/6357.

Ill. 205. Henry Loosemore, organ accompaniment of the anthem 'O Lord, increase our faith', holograph, *c.*1633. In a bound manuscript. New York, New York Public Library, MS Drexel 5469, pp. 208–9.

Ill. 206. William Fells, Greyhound supporting the arms of Henry VII with the garter and motto of the Order of the Garter, detail of stall panel, north side (twelfth from eastern end), 1633, elm wood. King's College Chapel, Cambridge. Mike Dixon, photograph, 2011.

Ill. 207. William Fells, Cherub supporting coat of arms of Eton College, detail of stall panel, north side (eleventh from eastern end), 1633, elm wood. King's College Chapel, Cambridge. Mike Dixon, photograph, 2011.

Ill. 208. William Fells, Cherubs supporting coat of arms of Eton College, stall panel, north side stalls (eleventh from eastern end), 1633, elm wood. King's College Chapel, Cambridge. Mike Dixon, photograph, 2011.

Ill. 209. William Fells, Angels supporting the coat of arms of King's College, stall panel, south side (first at eastern end), 1633, elm wood. King's College Chapel, Cambridge. Mike Dixon, photograph, 2011.

Ill. 210. Richard Bankes Harraden, *Interior of King's College Chapel looking West from the Altar*, 1797,watercolour. Cambridge, King's College. Adrian Boutel and Elizabeth Upper, photograph.

Ill. 211. Chaire case of the organ (view from the east), seventeenth century. Cambridge, King's College Chapel. Mike Dixon, photograph, 2011.

Ill. 212. Upper case of the organ (view from the east), seventeenth century. Cambridge, King's College Chapel. Mike Dixon, photograph, 2011.

Ill. 213. West case of the organ (view from the west), seventeenth century. Cambridge, King's College Chapel. Mike Dixon, photograph, 2011.

Ill. 214. First page of organ details relating to Thomas Dallam, 1605–06. In Mundum Book (1605–11). Cambridge, King's College, KCAR/4/1/1/23.

Ill. 215. David Loggan, *Sacelli regalis apud Cantabrigienses Prospectus Interior ab Occidentali*, etching. In David Loggan, *Cantabrigia illustrata. . .* (Cantabrigiæ: Quam proprijs sumptibus typis mandavit & impressit, [1690]), pl. 12. Cambridge, King's College.

Ill. 216. *Arthur Mann at Old Organ*, 1914–16, photograph. Cambridge, King's College, AHM/5/2/02.

Ill. 217. John Maynard Keynes to Harrison & Harrison, Organ Builders, 30 May 1932. Durham, Archives of Harrison & Harrison, Organ Builders.

Ill. 218. Wilkins' Screen, 1829, graphite and watercolour. Cambridge, King's College. Adrian Boutel and Elizabeth Upper, photograph.

LIST OF ILLUSTRATIONS

Ill. 219. Services at King's College Chapel, Cambridge, 9–22 June 1890. In *King's College Chapel: List of Services, May 12 to June 22, 1890*. Cambridge, King's College, CSV/2, fol. [2]v.

Ill. 220. Arthur Henry Mann, proposed 'accenting' of the General Confession at Morning and Evening Prayer. In Arthur Henry Mann, *Suggestions for Improvements of Various Parts of Our Sacred Services*, April 1910 - July 1917, typescript with manuscript annotations. Cambridge, King's College, AHM 1/6, pp. 9-10.

Ill. 221. Annual Photograph of the Chapel Choir, 1927. Cambridge, King's College, KCPH/2/2/2/3.

Ill. 222. Inscribed tombstone, ink drawing. In John Edwin Nixon, 'Classical Stories for Men and Boys', undated, autograph manuscript squib. Cambridge, King's College, JEN/9, fol. [2]v.

Ill. 223. The east end of King's College Chapel. Photograph, *Country Life*; reprinted Christopher Hussey, *King's College Chapel, Cambridge, and the College Buildings* (London: Country Life, 1926).

Ill. 224. Note in Bishop Benson's hand of his plan for the first 'Festal Service with Carols' in Truro Cathedral, 1880. Truro, Cornwall Record Office, TCM 538.

Ill. 225. Eric Milner-White, 1912. Wilfrid Jenkins, photograph. Cambridge, King's College, Coll. Ph. 4.

Ill. 226. Eric Milner-White in uniform astride a horse, 1912–1915, photograph. Cambridge, King's College, EMW/7/4.

Ill. 227. A group of men in uniform with Eric Milner-White in the centre of the back row, 1912-1915, photograph. Cambridge, King's College, EMW/7/3.

Ill. 228. Eric Milner-White in clerical dress, no date, photograph. Cambridge, King's College, Coll Ph 90.

Ill. 229. Arthur Henry ('Daddy') Mann seated in (?)his College room, 1914. J. R. W. Hughes, photograph (detail). Cambridge, King's College, AHM/5/2/3.

Ill. 230. Harold Darke, Acting organist of King's 1941–5, and Fellow 1945–9.

Ills. 231–235. The Chapel as shown over time in postcards. From the Collection in Cambridge, King's College, CMR/241.

Ill. 236. The Chapel and Screen, *c.*1937–62, glass lantern slide. Cambridge, King's College, JS/4/10/9.

Ill. 237. Hugh Bus, *Boris Ord*, 1926, oil on canvas. Cambridge, King's College. Adrian Boutel and Elizabeth Upper, photograph.

Ill. 238. Antony Barrington Brown, *Boris Ord with a Toy Used to Divert Candidates at Chorister Trials*, 1953–58, photograph. Cambridge, King's College, KCAC/1/2/6/10/35/Ord.

Ill. 239. Antony Barrington Brown, *David Willcocks in the Organ Loft*, 1958, photograph. Cambridge, King's College, KCAC/1/2/6/10/47/WILLCOCKSD.

Ill. 240. Edward Leigh, Philip Ledger and the Choristers, 1978. photograph. Cambridge, King's College, KCAC/KCPH/2/23/16.

Ill. 241. Stephen Cleobury. Simon Tottman, digital photograph, 2005.

Ill. 242. King's College Choir. Nick Rutter, digital photograph, November 2013.

Ill. 243. Restoring the roof bosses, King's College Chapel, Cambridge. Edward Leigh, photograph, 1968. Cambridge, King's College, Coll. Ph. 968.

Copyright acknowledgements

We thank the following institutions and people for permission to reproduce these illustrations:

Block, Phillipe: Ill. 51.

Blow, Simon: Ill. 3.

Boulton, Stuart, and Suffolk County Council Archaeological Service: Ill. 16.

Bowdoin College Museum of Art, Brunswick, Maine. Bequest of the Honorable James Bowdoin III: Ill. 10.

British Library, London, Board of Trustees: Ills. 8, 143, 147, 148, 154, 158, 159, 160, 203

Christ Church, Oxford: Ill. 14.

Clare, Stephen, by permission of the Provost & Fellows of King's College, Cambridge: Ills. 94, 95, 96, 97, 98, 99, 100, 101, 102, 103, 104, 105, 107, 112, 113, 114, 115, 116, 117, 118, 119, 120, 121, 122, 123, 124, 125, 128

Cornwall Record Office, Truro: Ill. 22.

DeJong, Matthew: Ills. 47 RIGHT, 54, 55

Easton, Timothy: Ill. 16.

English Heritage: Ill. 20.

Eton College, Windsor: Ill. 6.

Fitzwilliam Museum, Cambridge: Ills. 80 and 81

Gooch, James: Ill. 16.

Harrison & Harrison, Organ Builders: Ill. 21.

King's College, Cambridge, by permission of the Provost & Fellows: Ills. FRONT AND BACK COVERS, 1, 3, 4, 6, 7, 9, 10, 11, 12, 14, 16, 17, 18, 22, 25, 26, 28, 29, 34, 35, 36, 37, 38, 39, 40, 41, 44, 56, 58, 59, 60, 61, 62, 63, 64, 67, 68, 69, 70, 72, 74, 75, 76, 77, 78, 79, 82, 84, 85, 86, 88, 89, 90, 91, 93, 126, 129, 130, 131, 132, 133, 134, 135, 136, 137, 138, 139, 140, 141, 142, 153, 160, 161, 162, 166, 167, 170, 171, 172, 173, 175, 176, 177, 178, 179, 180, 181, 182, 183, 184, 185, 186, 187, 188, 189, 190, 194, 195, 196, 198, 199, 200, 206, 207, 208, 209, 210, 211, 212, 213, 214, 215, 216, 218, 219, 220, 221, 222, 223, 225, 226, 227, 228, 229, 230, 231, 232, 233, 234, 235, 236, 237, 238, 239, 240

Knight, Bill: Ills. 151 and 152

McInerney, James: Ill. 51.

Mason & Basebe: Ill. 3.

Metropolitan Museum of Art, New York, Art Resource/Scala, Florence, 2013: Ill. 16.

National Library of Scotland, Edinburgh: Ill. 14.

Nationalmuseum, Stockholm: Ill. 8.

New York Public Library for the Performing Arts, Astor, Lenox and Tilden Foundations, Music Division: Ill. 20.

Österreichische Nationalbibliothek, Vienna: Ill. 14.

Pickering, Nicola: Ills. 71 and 73

Plunkett, William, 2014: Ills. 43, 45, 48, 49, 50, 52

RIBA Library Drawings & Archives Collections, London: Ill. 2.

Rutter, Nick: Ills. 191 and 242

Sanders of Oxford: Ill. 2.

[Soane, Sir John], Sir John Soane's Museum, London, The Trustees: Ills. 23 and 24

Stradtmann, Jan, 2007: Ill. 2

Tagishsimon 2008 - CC-BY-SA-3.0: Ill. 12.

Tottman, Simon: Ill. 24.

University Library, Cambridge: Ills. 149, 150, 197

Virginia Museum of Fine Arts, Richmond: Ill. 1.

Wallace Collection, London, The Trustees: Ill. 87.

Index

Abraham, 83
Abreu, Pedro de, 186, 191
Ackermann, Rudolf, 211
Adam, 82
Adam, James, 43-45
Adams, John, 36
Adams, Richard, 272-73
Adams, Robert, 37
Addington Palace, 327
Aelst, Pieter Coecke van, 129
Albert, Prince Consort, 20
Ahmad, Mulay, bey of Tunis, 124
Aldenham School, Hertfordshire, 351
Alexander the Great, 208
Allen, Richard, 167
Allnatt, Alfred Ernest, 13, 55-56, 123
Amner, John, 281
Amps, William, 295-96, 305, 312
Anderson, Frank, 333
Annan, Noel, 55
Anne, St, 81, 90
Anne, Queen of England, 20, 33
Angell, John, 266
Anouilh, Jean, 252
Antwerp, 129-31, 189
Argentine, John, 163, 263
Armstead, Henry Hugh, 161-62
Ashbee, Charles Robert, 13, 128-29, 132, 166
Ashley, Anthony, 192
Atkins, Robert, 249
Atkinson, Richard, 270
Auden, Wystan Hugh, 250
Austen-Leigh, Augustus, 177, 305, 307, 309-11
Austin, Cornelius, 20, 115, 117, 168, 284
Avery, John, 15, 292-95
Azores, 194

Bach, Johann Sebastian, 299, 348, 355, 357, 366
Backhouse, R., 206-07
Baker, Philip, 268, 272-73, 291
Banbury, 263
Barnby, Joseph, 305
Barton, John, 248

Basa, Domenico, 190
Basebe, Edgar Allan, 54
Basel, 189
Bath Abbey, 65
Baylis, Lilian, 15, 21, 249
Bayreuth, 311
Beames, Finn, 255
Beaufort, Lady Margaret, 19, 263
Beauvais Cathedral, 250
Beckett, Sir Martyn, 57-58, 126
Bedford, 263
Beer, Jan de, 131
Beethoven, Ludwig van, 355
Belgium, 347
Benjamin, George, 254, 365
Bennett, Richard Rodney, 340
Benson, Arthur Christopher, 333
Benson, Edward White, 323-24, 326-27
Bentham, James, 29-30
Berkeley, Lennox, 340, 356
Berlin, 352
Besançon, 124
Beves, Donald, 248
Billerey, Fernand, 13, 125
Bingham, Judith, 340
Birtwistle, Harrison, 340, 356
Biscoe, Henry, 307, 309, 312
Bishop West's Chapel, Ely, 49
Bland, William, 12, 51, 69-70
Blomefield, Francis, 110
Blow, Detmar, 51, 53, 56, 126
Blow, John, 292
Blunt, Anthony, 57, 126
Bodleian Library, Oxford, 189
Bodley, George, 50
Bodley, Thomas, 189
Boleyn, Anne, 238, 252
Bologna, 189
Bolt, Robert, 252
Bond, Richard, 140
Bosch, Hieronymous, 138
Boston, 261, 270
Boston, William, 261
Boulter, John, 254
Boulter, Stuart, 219
Boulogne, 184
Bower, Richard, 266
Boyce, William, 312
Bradford, 224

Bradshaw, Henry, 21, 166, 237
Brahms, Johannes, 311, 316, 355
Bramley, Richard, 272
Brassie, Robert, 163, 270-71
Braun, George, 200, 203
Briggs, David, 252
Bristol, 299, 352
Britten, Benjamin, 252, 357
Brocket Hall, Hertfordshire, 356
Brooke, Alan England, 311, 333
Brooke, Rupert, 315
Brown, Thomas, 290
Browning, Oscar, 310
Bryant, Jacob, 173
Bude Castle, Cornwall, 155
Buckingham, 263
Buckingham, Duke of, 217
Bull, John, 281
Bullock, Ernest, 354
Burges, William, 49
Burghley House, Lincolnshire, 184
Burgos Cathedral, 181
Burke, Edmund, 209
Burne-Jones, Edward, 51
Buxtehude, Dieterich, 299
Byrd, William, 281, 316
Byron, George Gordon, 227, 356-57

Canaletto (Giovanni Antonio Canal), 30-31
Cadiz, 10, 14, 19, 185-86, 191-94
Calais, 163, 184
Camden, William, 26, 189
Cameron, Rev. P. G. S., 250
Campana, Cesare, 192
Canary Islands, 129
Canter, Nancy Napper, 253
Canterbury, 184
Canterbury Cathedral, 252
Carew, George, 189
Carleton, Dudley, 246
Carter, Edmund, 204-6, 211
Carter, Thomas, 10, 53
Carter, Thomas John Proctor, 47-49, 207
Carus, William, 236

417

INDEX

Catherine the Great, Empress of Russia, 132
Causton, Thomas, 273
Cavaillé-Coll, Aristide, 296
Cawkett, Daniel, 282
Cecil, Robert, 291
Cecil, William, 175, 184
Centon, Roger, 266
Chadderton, William, 291
Chainey, Graham, 58
Challis, E., 206–7
Chamberlain, John, 246
Charles I, King of England, 19, 216, 280, 292
Charles II, King of England, 20, 204–5, 209
Charles V of Spain, Holy Roman Emperor, 195
Chedworth, John, 261
Cheke, John, 268–70
Cheltenham, 224
Chichester, 224
Chile, 189
Chivers, Chris, 254
Christ Church, Oxford, 190
Christ's College, Cambridge, 185
Churchill, John, 102, 113
Cicero, Marcus Tullius, 184
City of London School, 351
Clapham, Harold, 177
Clare College, Cambridge, 34–36, 202, 318
Clark, John Willis, 235
Clark, Kenneth, 33, 40, 57, 126
Clarke-Whitfield, John, 356
Cleobury, Stephen, 21, 340, 357, 360–62
Clerk, William, 262
Close, Francis, 236
Cockson, Thomas, 194, 197
Coignet, Mathieu, 189
Coimbra, University of, Portugal, 189
Colborne, Langdon, 356
Cole, Henry, 270
Cole, William, 20, 30, 40–41, 101, 106–7, 115, 165–66, 168, 173, 205, 214, 216, 219
Colebrande, Richard, 27
Columbus, Christopher, 130, 362
Collins, Samuel, 40, 279, 280–81
Cologne, 357
Copleston, John, 178
Constable, William Henry, 103
Cornysh, William, 263, 266
Corpus Christi College, Cambridge, 297, 329
Cowper, Robert, 263, 266

Crane, William, 266
Croft, William, 315, 319
Cromwell, Oliver, 41–42
Cromwell, Thomas, 242
Crosse, Gordon, 356
Crouch, Thomas, 167–168
Croydon Manor (later Croydon Palace), 140
Cuffe, Henry, 192
Cullen, Gordon, 36
Culverwell, Stephen, 250
Czechoslovakia, 347

Dallam, Robert, 291
Dallam, Thomas, 16, 19, 277, 287, 291–93
Dallaway, James, 32
Darke, Harold, 341
David, King, 208–9
David, Gerard, 138
Davies, Henry Walford, 315, 319
Davies, Peter Maxwell, 340
Davies, Scrope, 227
Day, George, 263, 265, 268–69
Dean, Brett, 356
Debussy, Claude, 355
Denmark, 355
Dent, Edward Joseph, 248, 303, 348
Devereux, Robert, 10, 19, 185–86, 189, 191–97
Disraeli, Benjamin, 323
Doggett, John, 263
Donaldson, Augustus, 324
Donatello (Donato di Niccolò di Betto Bardi), 55
Donne, John, 250
Dornicke, Jan van, 129
Doughtie, Edward, 188
Dover, 184
Dowsing, William, 20, 41, 292
Dring, Celste, 255
Duke, Harold, 340
Dunford, Walter, 249, 315, 333
Dunstable, John, 266
Durham, 299
Durnford, Hugh, 311, 315

Eastlake, Charles, 33
Easton, Timothy, 219
Ecclestone, Alexander, 262
Ecclestone, Henry, 262
Edgeworth, Maria, 205, 207
Edmundsbury Cathedral, 250
Edouart, August, 230, 232–33
Edward VI, Prince and King of England, 16, 19, 40, 80, 115, 242, 268, 270, 291

Edward VII, King of England, 311
Egypt, 84, 130
Elizabeth I, Queen of England, 11, 13, 15, 19, 25–26, 40, 115, 174, 184, 186, 189, 192–94, 196, 204, 207, 241–42, 244–46, 248, 270–71, 273
Eliot, Thomas Stearns, 252, 365
Eltham Palace, Greenwich, 140
Ely, 205
Ely Cathedral, 281, 299
Elvey, George, 310–311
Emmanuel College, Cambridge, 185
Erasmus, Desiderius, 245
Ercilla, Alonso de, 189
Essex, James, 13, 20, 26, 45–47, 49–50, 117, 126, 133, 214–16
Ethiopia, 130
Eton College, 40, 49, 97–98, 101, 107, 224, 245, 248, 261–63, 284, 305, 333, 351, 355–56
Eton College Chapel, 33, 47
Evans, Joyce Conwy, 58
Eve, 82, 84
Evelyn, John, 26, 204–5
Ewes, Simonds d', 217
Ewsden, Laurence, 279

Farthing, Thomas, 263
Faro, 189, 191
Fauré, Gabriel, 356
Fayrfax, Robert, 263, 266
Fells, William, 20, 284–85
Fido, John, 277–78
Field, Walter, 261–63
Fiennes, Celia, 27–28, 204–5, 212–13
Fletcher, Phineas, 246
Flower, Barnard, 19, 78, 80, 85, 137–40, 142, 154
Fordred, Dorice, 249
Fox, Edward, 209, 263
Fox Strangways, Arthur Henry, 352
Foxe, Richard, 12, 80, 98–100, 140
France, 184, 292, 342
Frank, César, 299
Freeland, Henry, 151
Frevyll, Humphrey, 263
Friedländer, Max Jacob, 129
Friedrich I of Württenberg, 184
Fry, Christopher, 253
Fuller, Thomas, 26, 27, 209, 211

418

INDEX

Gama, Vasco da, 130
Gardano, Alessandro, 190
Garner, Thomas, 50–51
Geeres, John, 280
George I, King of England, 20
George II, King of England, 20
George VI, King of England, 21, 332
George, Margaret, 165
George, William, 178
Geseke, Germany, 127
Gibbons, Edward, 276
Gibbons, Orlando, 19, 276, 281, 355
Gibbs, James, 28, 30, 36–37
Gilpin, William, 30–31, 211
Gladstone, William, 326
Gloucester, 154
Goad, Roger, 13, 128, 164–65, 168, 175, 273, 279
Goad, Thomas, 168
Goer, Alexander, 340, 356
Gonville and Caius College, Cambridge, 177, 204
Goss, John, 312
Gossaert, Jan, 138
Gravesend, 184
Gray, Alan, 315
Gray, Cecil, 299
Great St Mary's Church, Cambridge, 202, 226, 231, 235–36, 270
Greenwich, 184
Greet, Ben, 249
Grey, Lady Jane, 270
Guest, Douglas, 361
Guest, Edmund, 174, 268

'Hacumblen', composer, 263
Hacumblen, Robert, 12, 19, 97–100, 103–4, 107–8, 113, 140, 163, 263, 265–66
Hadley, Patrick, 356
Haileybury School, Hertfordshire, 351
Hakluyt, Richard, 193
Hall, Peter, 248
Halliwell, Edward, 243, 245

Hamond, John, 18, 201, 203, 205, 267
Hamond, Thomas, 276–77
Hampshire, William, 263
Hampton Court, Richmond upon Thames, 184
Handel, George Frideric, 248, 292, 299, 312, 319, 334, 357

Harraden, Richard Bankes, 116–17, 160, 180, 286
Harris, Renatus, 292
Harrison, Arthur, 16, 21, 288, 297, 299–300
Harrison, William, 26
Hartcliffe, John, 178
Hartwell, Abraham, 208, 243
Hatton, Christopher, 184
Hatton, Richard, 263
Hawkins, Henry, 192
Hawksmoor Nicholas, 36
Haydn, Joseph, 309, 355, 357
Hedgeland, John Pike, 150
Henry VI, King of England, 9, 19, 24, 34, 40, 63, 79–80, 98, 100, 106–7, 110, 115–16, 161, 163, 216, 224, 238, 259, 261, 268, 284, 316, 356
Henry VII, King of England, 19, 24, 80, 98, 109, 174, 216, 263, 268
Henry VII Chapel, Westminster Abbey, 26, 33, 65, 184
Henry VIII, King of England, 19, 24, 41, 80–81, 98, 117, 163, 208–9, 238, 252, 263, 266, 268
Hentzer, Paul, 184
Herbert, George, 208
Hereford, 224
Hermitage, St Petersburg, 132
Heyman, Jacques, 12, 70–71
Hill, Arthur, 297
Hill, Thomas, 295–96
Hobart, Nicholas, 168, 171
Hoby, Edward, 189
Hogekyns, John, 163
Hogenberg, Franz, 200
Holland, 347, 355
Holloway, Robin, 356
Hone, Galyon, 80, 140
Hooper, Edmund, 281
Horwood, William, 266
Howard, Charles, 186, 191
Howard, Frederick, 5th Earl of Carlisle, 13, 45, 120,
Howard, Katherine, Queen of England, 80
Howells, Herbert, 316, 356, 357
Huddleston, Tristan, 308
Hullyer, John, 266
Huntingdon, 267
Hussey, Christopher, 33

India, 235
Ipswich, 224
Ireland, 194

Isabella of Portugal, Holy Roman Empress, 195
Istanbul, 355
Italy, 184, 189, 342

Jacobi, Derek, 248
Jacques, Reginald, 340
Jaffé, Michael, 55–56, 58
James I, King of England, 19, 34, 41, 116, 204, 209, 216–17, 246, 292
James II, King of England, 178
James, Henry, 33
James, Montague Rhodes, 10, 20–21, 50–55, 110, 181, 307, 311, 332–33, 337
Jane, Queen of England, 268
Jerome, St, 123
Jerusalem, Temple of, 14, 208–11
Jesus Christ, 81–82, 84–90, 121–22, 133, 208, 214
Jesus Green, Cambridge, 266
Joachim, 90
John the Apostle, St, 121
John the Baptist, St, 132
Johnson, Robert, 356
Jonah, 90
Jones, Inigo, 211
Jordan, Thomas, 277, 279–80
Joseph II, Holy Roman Emperor, 123
Joseph of Arimathea, 121, 123, 129–30
Josephus, Flavius, 130
Josquin (Josquin de Prez), 356

Kalinnikov, Vasily, 355–56
Keble, John, 226
Kelley [artisan], 115
Kempe, Charles Eamer, 150
Keynes, John Maynard, 161, 247–48, 297–98
Kings Lynn, 266
King's School, Bruton, 351
King's School, Ely, 351
Kitzburg Castle, Germany, 129
Knight, Richard Payne, 31
Kodály, Zoltán, 356
Kyd, Thomas, 240, 252

Lambe, Walter, 266
Laud, William, 40, 280–81
Laurie, John, 249
Lassus, Orlande de, 355–56
Lawrence-King, Andrew, 252
Lazarus, 82

419

INDEX

Leach, Edmund, 339, 362
Ledger, Philip, 21, 340, 356–57, 361
Lehmann, Rosamond, 315
Leigh, Austen, 51, 204
Leigh, Edward, 24, 358
Lethaby, William Richard, 51
Lewis, James, 252–55
Ley, Henry, 299, 356
Lightfoot, John, 209
Lincoln Cathedral, 25, 31, 266
Lloyd Morgan, Richard, 254, 266, 364
Loggan, David, 28–29, 200, 292, 294
Lon, Gert van, 13, 21, 126–28
Lon, Johannes van, 127
London, 163, 184, 261, 268, 351
Longmate, Barak, 35
Loosemore, Henry, 20, 280–81
Louvain, 123
Low Countries, see Netherlands
Lugge, John, 281
Luther, Martin, 12
Lyne, Richard, 200, 203

Macaulay, Thomas, 224
Mace, Stephen, 280
Mackarness, Henry Smith, 176
Madeira, 129
Madrid, 190
Magdalen College, Oxford, 178, 277, 348, 350, 351
Magdalene College, Cambridge, 226, 333
Magee, Patrick, 318
Maguire, Robert, 125–26
Malden, Henry, 102, 115
Malton, James, 199
Manchester, 351
Manila, 10, 20
Mann, Arthur Henry ('Daddy'), 16–17, 296–98, 303–21, 333–34, 339–41, 348, 350, 357, 361
Mann, William, 304
Mapperley, William, 266
Maratta, Carlo, 13, 132–33
Maria, Henrietta, 19, 204
Marienkirche, Lübek, 129
Marlier, Georges, 129
Marriner, Andrew, 343
Marriner, Neville, 343
Mary Magdalene, 82, 121
Mary, the Virgin, 81, 84, 121, 123, 126, 129–30, 132, 260–61, 268

Mary I, Queen of England, 15, 19, 40, 115, 163, 174, 266, 270–71, 275, 291
Mary, William and, Queen of England, 178
Mascarenhas, Ferdinand Martins, 189
Mason, Anthony, 324
Master of Liesborn, 127
Master of the Von Groote Adoration, 13, 21, 129
Maw, Nicholas, 340
Maximilian I, Holy Roman Emperor, 195
McCabe, John, 356
McKellen, Ian, 248
Mead, Joseph, 217
Medici, Cosimo de, 204
Mendoza, Bernardino de, 189
Mendelssohn, Felix, 295, 303, 311, 348
Mengs, Anton Raphael, 132
Merlin, 211
Middleton, Henry, 156
Millington, William, 178
Mills, Michael, 168, 172
Milton, John, 32, 283
Milner, John, 31
Milner-White, Eric, 10, 17, 21, 128–29, 161, 315–18, 327–34, 337, 339, 342–43, 355
Milner-White, Henry, 328
Monk, William, 266
Monmouth, Geoffrey of, 211
Monson, William, 189
More, Thomas, 252
Morley, Thomas, 281
Moses, 82, 84, 211
Mowbray, A. J., 326
Mozart, Leopold, 309
Mozart, Wolfgang Amadeus, 248, 299, 356
Muldowney, Dominic, 356
Munby, Alan Noel Latimer ('Tim'), 56
Mundy, John, 277
Mundy, William, 273
Murray, Keith, 125–26
Muser, Petrus, 18, 267
Mussorgksy, Modest Petrovish, 352
Muti Papazurri Chapel, Rome, 121
Muzeum Narodowe, Poznan, 121

Nash, John, 37–38
Naylor, Edward, 318

Nede, John, 266
Netherlands, 12, 136, 140, 143, 185, 292
New College, Oxford, 167, 347, 351
Newark, 270
Newman, Henry, 226
Newmarket, 178, 204
Newport, 270, 351
Newton, Fogge, 279
Newton, Isaac, 178, 211
Nicholas, St, 81
Nichols, John, 243
Nicholson, James, 86, 140
Nicodemus, 121–22
Nineveh, 90
Nixon, John Edwin, 307, 309–10, 319
Norfolk, 277
Norwich, 351
Notre-Dame d'Ambronay, Abbey, 355
Nonsuch Palace, Surrey, 184
Normandy, 143
North, Roger, 27, 364, 366
Northampton, 224, 263
Northcote, James, 222
Norwich, 266
Norwich Cathedral, 278
Nunn, Trevor, 248
Nunziato, Antonio del, 40

Okes, Richard, 166, 237, 305, 307, 309–11
Ord, Bernhard (Boris), 16–17, 21, 248, 288–89, 297–300, 318, 340, 348–50, 352–53, 355–57, 364
Orley, Bernard van, 140
Osório, Jerónimo, 185, 189
Ovid (Publius Ovidius Naso), 246
Oxford, University of, 184

Pal, Prabir Kumar (Sunny), 13, 129
Palestrina, Giovanni Pierluigi da, 355–56
Pallavicini, Niccolò Maria, 132
Panufnik, Andrzeij, 357
Paris, 141, 189, 357
Parker, John, 263
Parker-Smith, Archibald Colin Hamilton, 13, 132
Parrat, Walter, 350–51
Parry, Hubert, 316
Pärt, Arvo, 355
Patrick, Richard, 279
Paul, St, 82–83

420

Peacocke, Gerald, 253–54
Pearson, John Loughborough, 50, 323
Pease, Lancelot, 292
Penderecki, Krzysztof, 357
Pepys, Samuel, 204, 292
Perrot, Robert, 263
Perse, Stephen, 279
Peterborough, 270
Peterborough Cathedral, 356
Peterhouse College, Cambridge, 184
Petrie, D. Hay, 249
Pevsner, Nikolaus, 33, 57–58, 126
Philip, Prince and Duke of Edinburgh, 21
Philip II, King of Spain, 270
Philip III, King of Spain, 188, 194
Philips, Peter, 356
Pistoia, Leonardo da, 121
Plautus (Titus Maccius Plautus), 244
Platter, Thomas, 184
Poel, William, 248–49
Pollye, Richard, 272
Portugal, 189
Potenger, Richard, 44
Poynter, Ambrose, 51
Pratt, John, 295, 312
Preston, John, 276
Preston, Thomas, 243, 246
Prior, Camille, 249–50
Prior, Matthew, 204
Pugin, Augustus Welby Northmore, 32–33, 220
Purcell, Henry, 248, 292, 312, 315, 319, 355–57
Pygott, Richard, 266

Queens' College, Cambridge, 178, 242

Rachmaninoff, Sergei, 356, 357
Randall, John, 312
Rasar, William, 263
Raverat, Gwen, 303
Rautavaara, Einojuhani, 356
Reith, John, 341–42
Remigiuskirche, Bonn, 355
Reubke, Julius, 299
Reve, Thomas, 140
Richard III, King of England, 19, 80
Rickman, Thomas, 32
Riga Cathedral, 355
Ringwood Church, Hampshire, 163

Ripon Cathedral, 345
Robinson, Nicholas, 243, 246
Rocheford, Jorevin de, 205, 216
Rochester, 184
Rochester Cathedral, 250
Roderick, Charles, 117, 175, 178
Rodwell, Warick, 219
Roffe, John, 52
Rogers, William, 193, 197
Rome, 190
Romney, George 13, 45, 117–19
Romney, John, 117–19
Rossetti, Christina, 340
Rouargue, Adolphe, 200
Royal Albert Hall, 297, 356–57
Royston, 205
Rubens, Peter Paul, 10, 21, 55–56, 115, 123–25, 133, 287
Ruskin, John, 33
Rylands, George ('Dadie'), 247–48, 250, 315, 344
Ryther, Augustine, 18, 187, 267

St Edmund's School, Canterbury, 351
St Edward's Church, Cambridge, 226, 231
St George's Chapel, Windsor, 33–34, 350
Germany, 136, 143, 189, 292, 297–98, 355
St John's College, Cambridge, 177, 184, 242–46, 250, 351, 355, 357, 361
St Mary's Cathedral, Truro, 17, 20, 323
St Mary's Church, Fairford, 140
St Mary and All Saints Church, Fotheringhay, 356
St Michael's College, Tenbury, 351
St Paul's Cathedral, London, 31–32, 209, 279, 323
St Peter's School, York, 351
St Stephen's Church, Walbrook, London, 117
Salamanca, 189
Salisbury Cathedral, 32, 263
Salmon, Thomas, 41–42
Saltmarsh, John, 57, 103, 174
Sampson, John, 263
Samsion, Herbert, 356
San Giovanni dei Fiorentini, Rome, 121
San Petro, Church of, Perugia, 53
Santa Sophia, Istanbul, 33
Savoy Chapel, the Strand, London, 140

Scardifield, Simon, 253
Scandinavia, 238, 292
Schemelli, Georg Christian, 355, 357
Schütz, Heinrich, 347, 356
Schweizer, Albert, 298
Scott, George Gilbert, Junior, 33, 49
Scott, George Gilbert, Senior, 38–39, 47–49, 74–76, 306
Schilders, Richard, 189
Schubert, Franz, 356
Seneca, Lucius Annaeus, 244
Siciolante da Sermoneta, Girolamo, 13, 20, 45–47, 118, 120–22, 132
Sheba Queen of, 209
Sheldonian Theatre, Oxford, 205
Shepherdson, Frank, 318
Sheppard, John, 273
Shoubridge, Herbert, 330
Sidney Sussex College, Cambridge, 185, 205
Simeon, Charles, 10, 14, 20, 176, 209, 221–37
Sir Roger Manwood's School, Sandwich, 351
Sittingbourne, 184
Smart, Henry Thomas, 356
Smedley, Edward, 205–06
Smith, Edward, 279
Smith, John Taylor, 329, 331–32
Smith, Robert, 175
Smith, William, 201, 203, 211, 279
Smithson, John, 115, 291
Smythson, Robert, 40–41
Snape, Adams, 36, 41
Soane, John, 32
Soame, Robert, 184
Soest, Germany, 128
Solomon, King, 208–9
Soper, Edward, 217
Sophocles, 243
Southwark Cathedral, 252
Spain, 181, 185–86, 194
SS Apostoli, Church of, Rome, 121
Strawberry Hill, Twickenham, 30
Stadler, Joseph Constantine, 48
Stamp, Gavin, 58
Stanford, Charles Villiers, 299, 355
Stanford-on-Avon Church, 277
Staresmore, Thomas, 280
Stephen, Thoby, 177
Stephens, Thomas, 263

INDEX

Stravinsky, Igor, 298, 350, 356–57
Stocket, Lewis, 243
Stokys, Matthew, 243–44
Stow, John, 217
Straits of Gibraltar, 185
Street, George Edmund, 181
Stukeley, William, 28, 211–13
Suffolk, 277
Summerson, John, 57, 126
Suthley, William, 262
Swayne, Giles, 340
Sweden, 129, 355
Switzerland, 342
Sygar, John, 263

Tallinn, Estonia, 355
Tallis, Thomas, 356
Tanner, Joseph Robson, 177–78
Tatt, Archibald, 326
Taverner, John, 266, 340
Temple, William, 196
Tennyson, Alfred, 176, 365
Terence (Publius Terentius Afer), 244
Tewkesbury Abbey, 277
Thackeray, George, 110, 236
Thamer, Thomas, 292
Thomas, Percy A., 304
Thompson, Ian, 254
Till, Chris, 253
Tomkins, Giles, 279–81
Tomkins, John, 277–78
Tomkins, Thomas, 276, 278–79, 355
Towne, William, 163
Trinity College, Cambridge, 177, 184, 204, 235, 246, 282, 305, 323, 355, 357
Truro, 323, 327, 334, 337, 339
Tucker, William Hill, 175–76, 226–27, 229, 231, 235
Tuddenham, Erasmus, 278
Tudway, Thomas, 312
Turges, Edward, 262, 266
Turtle, G. F., 219
Tye, Christopher, 266, 273, 356
Tyndale, William, 12

Udall, Nicholas, 208, 243, 245
United States of America, 342, 347
University College, Oxford, 248

Vaga, Perino del, 121
Valladolid, 186

Vellert, Dirk, 87, 140–42
Venice, 192
Venn, Henry, 226
Venn, John, 226
Venning, Mark, 300
Vermeyen, Jan Cornselisz, 124
Vertrue, Robert, 65
Vertrue, William, 65
Victoria, Queen of England, 20, 311, 326
Victoria, Tomás Luis de, 190, 356
Vidler, Alec, 55–56
Vulliamy, Lewis, 38

Waal, Victor de, 55, 57
Waldstein, Zdenkonius Brtnicensis, 19, 184, 195, 197
Wales, 13
Waller, Frederik S., 154
Walpole, George, 324
Walpole, Horace, 20, 30, 45, 206, 211–12, 214–16
Walpole, Robert, 132
Walsingham, Francis, 169–70
Walton, William, 356
Ward, Adolphus, 248
Ward, Edward, 212–13
Ward, John, 281
Ware, 266
Wastell, John, 13, 65, 98, 115
Watkin, David, 34
Watkyns, John, 266
Watson, Wilfred, 356
Watts, George Frederic, 51
Wayment, Hilary, 110
Weaver, James, 279
Weaver, Thomas, 20, 284
Webb, Geoffrey, 57
Webb, T. H., 305
Weelkes, Thomas, 276, 281, 355
Weir, Judith, 356, 364, 366
Wellington, Oxford, 352
Wells, William, 167
Wendy, Peirce, 148
Wert, Giaches de, 355
Wesley, John, 233
Wesley, Samuel, 316
Westhawe, Robert, 190
Westminster Abbey, 32, 65, 184, 250, 352, 361
Westminster Hall, London, 140
Westley, John, 34
Whettam, John, 356
Whitaker, the Rev'd Chancellor, 324

Whitaker, William, 185
White, Robert, 273
Wickham, John, 269–70
Widor, Charles-Marie, 303
Wilberforce, William, 223–24, 228
Wilbye, John, 355
Willcocks, David, 21, 300, 340, 343, 347–48, 352–57, 360, 362
Wilkins, William, 32, 34, 37–38
Wilkinson, Thomas, 274, 318–19
William, and Mary, King of England, 20, 178, 204
Williams, Vaughan, 298–99, 356
Williamson, Francis, 137–40, 153
Willis, Robert, 40
Wilson, Niall, 252–53
Wilson, Thomas, 117
Winchester Cathedral, 25, 31, 80
Windsor Castle, 184
Windsor Chapel, Windsor Castle, 25, 31
Woderlark, Robert, 261
Wood, Charles, 299, 312, 316, 355
Wood, John, 211
Woodock, Clement, 272
Woodcock, Edmund, 280
Woodforde, James, 206
Woodroffe, 20, 40, 115, 168
Worcester Cathedral, 361
Wordsworth, Dorothy, 206, 207
Wray, Daniel, 178
Wren, Christopher, 68
Wyatt, James, 37

Wyatville, Jeffry (previously Jeffry Wyatt), 32, 37
Wylde, George, 275
Wylkynson, Robert, 263, 266
van den Wyngaerde, Anton, 187
Wykeham, William, 167

York Minster, 25, 31, 351
York Minster Chapterhouse, 25, 31
York Place (later the Palace of Whitehall), 140
Yorke, Philip, 178

Zeverdonck, Anna van, 123–24